Vitamin Ph

New Perspectives in Photography

Imprint

Phaidon Press Limited
Regent's Wharf
All Saints Street
London N1 9PA

Phaidon Press Inc.
180 Varick Street
New York, NY 10014

www.phaidon.com

First published 2006
Reprinted 2007
©2006 Phaidon Press Limited
All works © the artists
ISBN 978 0 7148 4656 9

A CIP catalogue record of this book is available from
the British Library.

Designer: Julia Hasting

Printed in China

All works are in private collections or the artist's collection
unless otherwise stated.

Acknowledgements:
The publishers would like to give special thanks to the
artists, nominators and authors who contributed to
Vitamin Ph. We would like to thank the following galleries
and institutions for their assistance:
303 Gallery, New York; Air de Paris, Paris; Alexander and
Bonin, New York; Alison Jacques Gallery, London; D'Amelio
Terras, New York; Andréhn-Schiptjenko, Stockholm; Andrew
Kreps Gallery, New York; Galerie Anita Beckers, Frankfurt;
Anthony Reynolds, London; The Approach, London;
Art: Concept, Paris; Association Seydou Keïta, Bamako;
Barragán Foundation, Birsfelden; BintaZarah Studios, New
York; Blum & Poe, Los Angeles; Galeria Brito Cimino, São
Paulo; Galeria Casa Triangulo, São Paulo; Casey Kaplan
Gallery, New York; Galerie Chantal Crousel, Paris; Christopher
Grimes Gallery, Santa Monica; Cohan and Leslie, New York;
Corvi-Mora, London; Counter Gallery, London; Galerie Crone
Andreas Osarek, Berlin; Galerie EIGEN + ART, Berlin; Edwynn

Houk Gallery, New York; fiedler contemporary, Cologne;
Flatland Gallery, Utrecht; Fraenkel Gallery, San Francisco;
galleria francesca kaufmann, Milan; Frehrking Wiesehöfer,
Cologne; Frith Street Gallery, London; Gagosian Gallery, New
York; Goodman Gallery, Johannesburg; Greenberg Van Doren
Gallery, New York; Greene Naftali Gallery, New York; Guelman
Gallery, Moscow; Hatje Cantz Verlag, Ostfildern (Ruit); Hauser
& Wirth, London, Zurich; Galeria Helga de Alvear, Madrid;
Jack Shainman Gallery, New York; JM Patras, Paris; Kerlin
Gallery, Dublin; Konrad Fischer Galerie, Düsseldorf; Gallery
Koyanagi, Tokyo; Kunstmuseum, Basel; Kurimanzutto, Mexico
City; Leslie Tonkonow Artworks + Projects, New York;
Lombard-Freid Projects, New York; Luhring Augustine, New
York; Luis Campaña Gallery, Cologne; Marc Foxx Gallery, Los
Angeles; Mary Goldman Gallery, Los Angeles; Matthew Marks
Gallery, New York; Maureen Paley, London; Metro Pictures
Gallery, New York; Michael Stevenson Gallery, Cape Town;
Galerie Michel Rein, Paris; The Modern Institute, Glasgow;
Multimedia Complex for Actual Arts, Moscow; Murray Guy,
New York; Museu de Arte Moderna de São Paulo, São Paulo;
Galerie Neu, Berlin; neugerriemschneider, Berlin; Galeri Nev,
Istanbul; Nicole Klagsbrun Gallery, New York; Pace/MacGill
Gallery, New York; Pekin Fine Arts, Beijing; Peres Projects,
Los Angeles, Berlin; Perry Rubenstein Gallery, New York;
Peter Kilchmann Gallery, Zurich; The Photographers' Gallery,
London; Photographs Do Not Bend Gallery, Dallas;
Photoworks, Brighton; The Project, New York; Galleria
Raffaella Cortese, Milan; Ratio 3, San Francisco; Regen
Projects, Los Angeles; Ruth Benzacar Gallery, Buenos Aires;
Ruzicska Galerie, Salzburg; Salon 94, New York; Scalo
Publishers, Zurich; Sean Kelly, New York; Galerie Sfeir-
Semler, Hamburg, Beirut; ShanghART, Shanghai; Solomon
Projects, Atlanta; Sommer Contemporary Art, Tel Aviv;
Sonnabend Gallery, New York; Stephen Friedman Gallery,
London; Sutton Lane, London; Taka Ishii Gallery, Tokyo; Tanya
Bonakdar Gallery, New York; Team Gallery, New York; Union
Gallery, London; Van Zoetendaal, Amsterdam; Galeria
Vermelho, São Paulo; Victoria Miro Gallery, London; Wako
Works of Art, Tokyo; Wallspace, New York; Wetterling Gallery,
Stockholm; White Cube, London; Galerie Xippas, Paris; Yossi
Milo Gallery, New York

Picture Credits:
©Association Seydou Keïta, Bamako p 7 #5; ©Barragan
Foundation, Birsfelden p 151 #3, pp 152–153 #4–6;
Luigi Stavale p 129 #1

Vitamin Ph: New Perspectives in Photography is a global up-to-the-minute survey of current international developments in contemporary photography. Photography continues to be a central pillar of artistic practice, and **Vitamin Ph** presents the outstanding artists who are engaging with and pushing the boundaries of the medium.

Vitamin Ph follows the success of *Vitamin P: New Perspectives in Painting* and *Vitamin D: New Perspectives in Drawing*, presenting a cross-generational survey of contemporary artists from forty-one countries. Chosen from more than 600 nominations by prominent international critics, curators and artists, **Vitamin Ph**'s 121 established and emerging artists were selected on the basis that they have made a significant contribution to photography (in its widest sense) in the last five years.

Vitamin Ph allows you to look at the medium in detail, to study photography's unique properties, in relation to itself, in relation to contemporary art, and in relation to the world at large. At a time when anyone can take a photograph, and photography permeates every aspect of contemporary culture, this ubiquitous and democratic medium is constantly evolving through new technologies and the speed of global information distribution.

In his incisive introductory essay for **Vitamin Ph**, TJ Demos explores the ways in which photography reflects the twenty-first-century world—the effects of globalization, the slipping boundaries of the medium, the ways in which it permeates other media and the wider world, and photography's continuing fascination with documentary modes.

Photography continues to provoke questions in relation to its status as a purveyor of the world around us, questions of representation, truth, fiction, aesthetics, narrative ambiguity, autobiography and the nature of reality itself. **Vitamin Ph** contributes to these international debates on contemporary photography while providing an accessible overview and concise reference book.

[1] [4]
[2] [5]
[3]

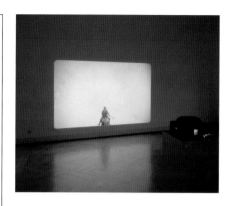

Photography Beyond Photography—Consider three examples of recent artistic practice. First, Belgian artist David Claerbout produces large-scale video projections using archival photographs that are digitally manipulated to endow the still images with subtle signs of movement. In one piece, reflections of a setting sun move quietly across a building's façade, while in another, tree leaves flicker in an otherwise frozen landscape. In his video installations, photography mimics time's passage, unleashing uncanny effects of movement and life.

Next, American artist Sean Snyder downloads amateur snapshots from the Internet, taken by American soldiers stationed in the current conflict in Iraq, and presents them in a grid format. Most of the images depict stereotypical scenes: exotic desert sunsets, smiling children receiving sweets from US troops, unveiled caches of rebel weapons, and bombed-out, gaudy palaces. Their arrangement encourages comparisons that betray the ideology of the soldier-photographers who took them.

Lastly, consider Rachel Harrison's mixed-media assemblages, where photographs from pop culture (sometimes stills from television shows) are fastened to slipshod wooden constructions of abstract forms that evoke amateur stage sets and a kind of dishevelled minimalism. Fragmentary and out of place, the snapshots appear stranded, the meaning of the strange juxtapositions between photography and sculpture never explained.

It is a stretch to call these artists "photographers". Yet their work represents some of the most provocative uses of photography in recent art. Surveying the last five years of artistic practice, one might conclude that today there is no longer any such thing as "photography". Considering the eclectic grouping above, how could one extract a simple definition of the medium? In each case, photography is pressed towards its limits, becoming one term within an expanding series of artistic operations, none of which can be reduced to a unified medium. The examples above suggest a diverse range of practices that *verge* on the photographic; although none are completely *contained* within it—indeed some artists included here would not consider themselves photographers. There is no organizing principle or dominant technology that guarantees "photography" a singular or unproblematic meaning today.[1] Has photography finally met its end, transforming into so many post-photographic forms, multimedia installations and digital-video hybrids?

Alternatively, one could reach the opposite conclusion. Far from being obsolete, photography has returned with a vengeance as a distinct medium, with practitioners reinvigorating one of its most traditional forms, the documentary image. Consider David Goldblatt's depictions of the social and economic disparity in post-apartheid South Africa, often featuring critical views outside what would traditionally be found in media coverage; Liu Zheng's unofficial typology of Chinese subjects, including photographs of both real Chinese individuals and highly realistic wax dolls; and Simryn Gill's anthropological account of Malaysia as seen through its domestic interiors. Reviving and creatively developing diverse documentary lineages traced back to Walker Evans, August Sander and Diane Arbus, these artists exploit photography for its ability to capture the exterior world, to bear witness to experience within real social and political conditions. This documentary turn appears just as true for contemporary art photography arising out of past postmodern practices, which tended to privilege *image* over *subject*, in favour of highly contrived, staged or serialized representations, as found in the work of Cindy Sherman or

Barbara Kruger. Even as current photographers delve into fiction, they still maintain a connection to documentary functions: while The Atlas Group/Walid Raad pushes the meaning of his photographs into imaginary archives and invented narratives, he does so to excavate all the more effectively the trauma of the recent Lebanese civil war; and while Gregory Crewdson creates highly artificial cinematographic photographs evocative of Hollywood unreality, his tableaux nevertheless reflect on the dark psychology that haunts suburban existence in America.

What is remarkable about contemporary art photography is the seemingly paradoxical relationship between these two developments—the medium's diffusion across a varied mix of conventions, materials and technologies, which would seem to deny the clarity of meaning, and the reinvention of documentary representation, which stresses a focused access to its subject matter. Roughly thirty years ago, one encountered exactly the opposite. While it was clear to critics at that time that contemporary art had progressed into a post-medium condition—the legacy of projected images from the 1960s and '70s, photo-text hybrids of Conceptual art, and sculptural collages and multimedia assemblages—a parallel development revealed a shift in representation, whether photographic, filmic or painted, towards the "picture". Demoting the value of subject matter, the notion of the "picture" emphasized photography as an image referring first and foremost to its own reproduced conditions, so that "underneath each picture there is always another picture", as the critic Douglas Crimp observed.[2] In Sherman's "Untitled Film Stills" (1977-82), for example, the photograph does not document an original or a reality; rather, it depicts an endless cycle of representations of representations, loosely alluding to classic Hollywood cinema. Sherman's masquerade, in other words, refers not to any single film, but to many and none, announcing the very repetition—of a gesture, an expression, a style—encountered in classic cinema of the 1950s. Today, this relationship between medium and representation has shifted: the rejection of the purity of the medium by some artists now corresponds to the insistence on photography's traditional documentary capacities by others, who wish to convey evidence and faithfully reproduce the visual world, rather than generate endless signs of signs.

Reinventing Documentary Photography—There are several ramifications. The return to documentary practice invalidates past pronouncements of the so-called crisis of the real, according to which visual experience was understood to have succumbed to the "spectacle"; that is, the commercialized realm of appearance encountered in television, advertisements and film.[3] During the 1980s, this visual realm enthralled photography, when it was mimicked by many artists, including Victor Burgin, Richard Prince and Kruger, to the point where it appeared that actual lived existence had been eclipsed by representations of representations, as if one lived one's whole life in front of a television. And despite more recent forecasts of the demise of photographic truth in the face of digitization, current documentary practitioners refuse to give up the belief that photography is capable of penetrating deeply into reality's web, as Walter Benjamin claimed long ago.[4] Still, the advances of the Postmodernists, which developed a sensitivity towards representational complexity, now equip emergent documentary strategies with greater sophistication. It is clear, for instance, that artists no longer naively proclaim the status of the image as

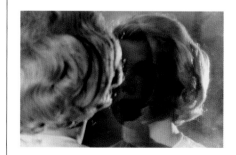

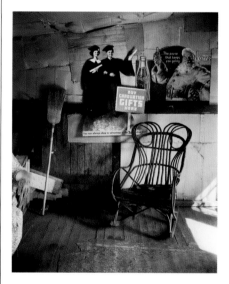

[1] **Matthew Buckingham**, Image of Absalon to be Projected Until it Vanishes, 2001, 35 mm slide projection and text, dimensions variable, installation view
 Kunstmuseum, St Gallen
[2] **Walker Evans**, Interior Detail, Coal Miner's House, West Virginia, USA, 1935, silver gelatin print, 24.1 x 19 cm, 9 x 7 inches, collection Walker Evans Archive,
 The Metropolitan Museum of Art, New York
[3] **Cindy Sherman**, Untitled Film Still, 1980, silver gelatin print, 5.9 x 9 cm, 15 x 23 inches
[4] **Bernd and Hilla Becher**, Watertowers, 1980, nine black-and-white photographs, each 45.7 x 55.9 cm, 18 x 22 inches
[5] **Seydou Keïta**, Untitled #313, 1956–7, silver gelatin print, 51 x 61 cm, 20 x 24 inches or 28 x 36 cm, 11 x 14 inches

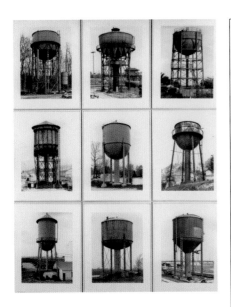

evidence capable of delivering an unambiguous meaning, far less offering an objective truth.[5] Photographers have learned the lesson that "reality" remains available only through the practices that represent it. Which is to say, documentary photography, long thought historically exhausted in contemporary art, is now being reinvented.

What informs these two recent developments—the reinvention of documentary practice in contemporary photography, and the fragmentation of the medium of photography into a hybrid condition—are the historical circumstances of our current era, where Postmodernism's cultural "schizophrenia", according to which the world was viewed as a disorientating field of empty and fragmented signs, has transformed into globalism's tendency towards unification and standardization.[6] Integrally related to the growth of multinational capitalism, globalism defines a transition towards advancing forms of communication and expanded options of geographic mobility that have connected the world's distant points. Its growth has been met with mixed reaction in the art world and beyond. While new technologies have inspired hopes of worldwide modernization and betterment, including the promise of medical advances, environmental fixes, expansion into new markets, and the freedoms of easy travel, these same forces also threaten to homogenize social life under the unified rule of a single global culture. And while some celebrate the spread of democratic institutions throughout a newly interconnected planet, others see an increase in economic disparity and military domination, giving rise to demands for equality, participation and self-determination made by an excluded multitude.[7]

Current photographic practice both reflects and negotiates these conflicts. The present return to documentary photography attests to a newfound movement where artists, on an increasingly global scale (as the present selection shows), use the camera to expose and validate the diverse conditions of everyday life that normally go unrepresented within mainstream Western media. This strategy—used by Goldblatt in his views of South Africa or Liu in his images of contemporary China—exploits photography's democratic power in a fresh way. In addition, artists embrace the medium of photography as an identity that can interact with the outside world in creative ways—as when Claerbout places it in relation to video technologies, Harrison introduces it into foreign environments, and Snyder situates it next to language-based representational systems. These practices act as allegories with deeper social, political and ethical implications, proposing innovative ways of expressing identity's relation to difference, and revealing experimental ways of being and belonging in a global world. Rather than the end of photography, we are now encountering its various outcomes in the advancing age of globalization.

Photography in the Global Field—Contemporary photography negotiates globalization in complex ways, mirroring the very instability and controversial nature of the term within broader cultural, socio-political and economic debates.[8] The view of globalization as a force of standardization creeping into all previously uncolonized spaces, for instance, is corroborated by several artistic practices included here, such as Frank Breuer's typologies of storage sites, both of shipping containers and generic corrugated metal warehouses, which starkly capture the geography of post-industrial sameness. Working from the model of Bernd and Hilla Becher, Breuer's focus on

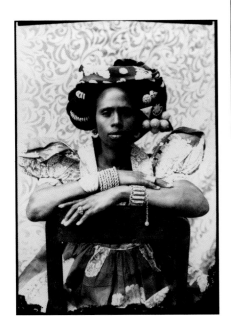

dehumanized wastelands expunged of signs of labour accompanies his process of serial documentation, also mechanical and de-individualized, which resonates with the work of other Becher students such as Thomas Ruff and Andreas Gursky. Showing a similar homogenization of subjects are the "photonotes" of Hans Eijkelboom. Standing on street corners in various urban centres, the artist catalogues striking patterns of clothing, expression and demeanour of passersby who all look relatively similar. Eijkelboom reverses photography's ability to document specific qualities, so that it exposes generality instead. These artists depict a globe beset by the increasing uniformity of public spaces.

Conversely, the ambivalent effects of cultural intermixing have also received attention within recent photography. Documenting re-enactments of Native American life performed in popular, contemporary German festivals, complete with teepees and feather headdresses, Andrea Robbins and Max Becher trace their origins in the American entertainment industry and how its fantasy-based conception of the American West has spread into foreign contexts. Robbins' and Becher's work does more than just expose cultural imperialism; it also reveals a glimmer of mass-cultural resistance in the re-enactor's desire to escape from the regimented life of German modernity. The bizarre unity of differences also occurs in terms of class, as when the artists documented "Global Village", Habitat for Humanity's "poverty theme park" in Georgia, where concerned tourists can visit and peer into the shacks of simulated slums, conveniently and safely doing so without the burden of actually interacting with poor people in the American South. Other artists, such as Zwelethu Mthethwa, have trained their sights on migration itself. His vivid colour images depict migrant labourers in South Africa within the interiors of their settlement shanties, their walls decorated with newspapers and magazine advertisements. Immersed in poverty and transience, these figures are shown nevertheless to surround themselves with the happy imagery of commercial products, using all available resources to recoup a positive sense of home. Like the portrait sitters in the studios of Malian photographers Seydou Keïta and Malick Sidibé, Mthethwa's subjects comport themselves proudly in front of the camera, allowing the artist to acknowledge both their debasement in poverty—where advertisements succour the pain of economic abjection—and their embrace of unexpected creativity and resistance within it.

Still others, such as Goldblatt in South Africa and the Palestinian artist Emily Jacir in Israel, have portrayed the difficulties that occur when political and cultural differences rise up to counter an otherwise borderless world. In her "Trackers" series (2005), the Palestinian artist Ahlam Shibli focuses her lens on the extremely complicated situation of those Palestinians of Bedouin descent who have enlisted in the Israeli Army. They volunteer largely because of the material benefits and privileges it promises, but consequently they must undertake the psychologically challenging balancing act of dual allegiances that it entails. Once nomadic, these Bedouin have settled down geographically, while their erstwhile mobility now takes on political proportions. In her humble images of their banal everyday routines, Shibli declines to deliver any message of explicit support or sensationalized condemnation, instead favouring a documentary mode that portrays simple moments of military comradery and the content domestic

[1]
[2]
[3]

[4]

life of these soldiers who, employed to defend Israel, must hide their uniforms in fear of retribution when they return to their villages at the day's end.

While these practices are surely diverse, each artist edges photography into nuanced relations with an increasingly interconnected and sometimes deeply troubled world. Some confirm pessimistic views of globalization, such as those of Marxist literary critic Fredric Jameson, who has highlighted the economic and cultural standardization that gradually destroys regional forms of uniqueness and particularity.[9] Many others, however, depart from these dark conclusions, and examine the inevitable "indigenization" of global forces when introduced into local fields, as argues cultural anthropologist Arjun Appadurai, for whom globalization proposes an unresolved zone of interaction *between* homogeneity and heterogeneity.[10] While such theorization merely begins to articulate the very complexity and contradictions of current developments, it does offer a useful framework for situating the stakes of current photography, which creatively maps our relation to an ever-shifting world.

Expanding Archives—Consider "A Life Full of Holes: The Strait Project" (1998-2004) by French-Moroccan artist Yto Barrada, which explores the transitional culture surrounding the Strait of Gibraltar, where the Mediterranean Sea narrowly divides North Africa from Europe. Composed of video, photography, documentary materials and textual description, the project emphasizes the indeterminacy of this area, situated geographically between the economic promise of the West and the perceived desperation of underdeveloped North Africa, and emotionally between the artist's expatriate life in France and her homesick memories of Morocco. One seemingly abstract image poignantly depicts the connections between perceptual and psychological registers: appearing abstract at first, the photograph depicts a close-up shot of an old shipping container's metal wall that has been partially eaten away by rust. It could be found anywhere. Offering a perspective from the interior, the image proposes an indigenous meaning when located in relation to Moroccan port culture: it is as if we are given a stowaway's hopeful viewpoint that peers outwards through the holes towards a clear blue sky. That the pattern also reads as a coded map of some distant land defines the émigré's powerful desire of transformation, which is capable of turning virtually any image into a make-believe plan of escape.

Barrada's project exemplifies recent work that joins diverse systems of representation to chart transnational spaces. Sensitive to the ambiguities of the medium and to relays between documentation and aesthetic construction, between which it operates, Barrada's work evokes practices of an older generation of artists, such as Allan Sekula, whose image- and text-based projects, especially his photographic cycle "Fish Story" (1991-2), stand today as challenging and provocative models for the documentary investigation into changing social topographies under advanced capitalism. In Barrada's project, the dispersal of the medium into image and text powerfully evokes the fragmented experience of exile.

The fragmentation that defines social experience today marks photography's image itself as well, as in Bulgarian artist Luchezar Boyadjiev's collages. Depicting urban space as the site of clashes between traditional Islamic and European cultures, his collages map cosmopolitan life in Eastern European cities, such as Istanbul. Digitally imposed

English-language billboards appear to invade the sky of his street photographs, while at the same time, his use of European avant-garde montage technique playfully migrates into the construction of Turkish urbanism. In a similar vein, the digital montages of Nigerian artist Fatimah Tuggar mix African and Euro-American visual idioms by joining images from Western advertising with those of traditional village life to form rich and complex scenes. Fashionably dressed models are seen gardening next to third world huts, while the African inhabitants, in other pieces, appear to wander disconnectedly into McDonald's and middle-class offices.

As archives of shifting, cross-cultural social realities, the projects of Boyadjiev and Tuggar emphasize the fragmented materiality of the collage structure and refuse to hide its representational disjunctions. Not only does this condition express social hybridity in material terms, but such work also undermines earlier assumptions of photography's ability to index a totality of knowledge or function as a universal language. Rather than assuming the seemingly neutral and scientific epistemology of past photographic paradigms, these artists allow their personal desires, biographic circumstances and political introspection to define their imagery. Such priorities recall both earlier European artistic precedents, such as Hannah Höch's collages, "From an Ethnographic Museum" (1924-5), which create multiracial combinations by integrating fragments from European advertisements and images of tribal artefacts, as well as post-war examples of shocking geopolitical juxtapositions—particularly Martha Rosler's "Bringing the War Home" (1966-72), which introduces scenes from the war in Vietnam into the private interiors of model American homes, explosively linking the comforts of domestic wealth to the violence of foreign invasion. But today these amalgams are produced by artists with origins and identifications in lands outside the dominant art centres of Europe and America—a further facet of the newly diversified world of contemporary photography.

Other artists also address the archive, both as a kind of image-based map of global institutions, and as an organizational tool of power and knowledge, in order to interrogate its terms and develop their own counter-archives. British artist Nils Norman, for instance, documents the changing landscape of urban spaces given over to private interests, wherein urban planning subtly encourages social behaviours supportive of commercial activity. Strategically designed street furniture and high-tech surveillance systems endow city space with the function (and symbolic power) of an enormous panopticon, discouraging vagrancy and homelessness.

His examination of these disciplinary mechanisms, evident in metropolises from New York City to Tel Aviv, takes the form of books, posters and billboards, wherein photography is set among critical and corroborative texts, or sometimes positioned directly within public space. Relying on a similar array of materials, Snyder explores the convergence of the visual and ideological systems of the US Army and mass media in the war in Iraq, uncovering a frightening potential near-future where state power will usurp independent information sources and generate, distribute and thus control the news. This idea is powerfully symbolized in Snyder's image showing an American soldier equipped with a video camera strapped to his machine gun, prepared to engage the enemy and document the battle at once. Created through diverse materials, such as newspaper articles, maps and researched analysis, in addition to

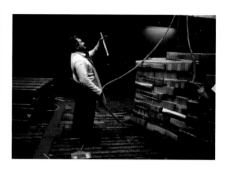

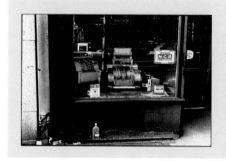

[1] **Allan Sekula**, Dockers Unloading Frozen Fish, Vigo, from the series "Fish Story", 1989–95, silver dye-bleach print, 63 x 80 cm, 24.5 x 31 inches
[2] **Martha Rosler**, from the series "The Bowery in two inadequate descriptive systems" (detail), 1974–5, silver gelatin prints, 45 panels,
 each 25.4 x 55.9 cm, 10 x 22 inches
[3] **Martha Rosler**, from the series "Bringing the War Home" (detail), c. 1967–72, photomontage, dimensions variable
[4] **Jeff Wall**, Picture for Women, 1979, transparency in lightbox, 163 x 229 cm, 64 x 90 inches, Collection Centre Pompidou, Paris

photography and video, these projects constitute the most recent counter-archives—in the words of Snyder—that expose and challenge the authority of military-technological-informational power that is gradually colonizing the planet.

By spreading information over different media, these artists break up representation into complex photographic and text-based systems. Inasmuch as this condition forces one system of representation to confront another critically—for instance, a quotation of text will question an image's meaning, or vice versa—it signals the ultimate insufficiency of each, betraying the fact that no subject can be fully represented, whether by one medium or several together. And by joining these disparate elements together, these counter-archives open new lines of possible interpretation to the viewer, as well as proposing new sources of antagonism meant to elicit debate and counter globalism's false ideology of social consensus. This decision to use a diversity of materials partly draws on the conceptual practices and institutional critiques of Robert Smithson and Dan Graham, who also set photography next to language. Yet the critical exposure of current geopolitical formations also responds to the political photographic projects of Sekula and Rosler, which figure as provocative models for current practice. Particularly relevant is Rosler's "Bowery Series in Two Inadequate Descriptive Systems" (1974-5), which analyses photography and language as ideological structures that produce, rather than merely describe, social identities (in this case, stereotypes of the "drunk"); each system, however, is revealed by Rosler to be ultimately incomplete, more about visual and verbal creations than actual reality.

The photographic work of Snyder and Norman challenges postmodernist photography in turn, especially the work of those artists of the late 1970s and '80s who returned to the "picture" as the central object of photographic investigation. While Smithson, Graham and Ed Ruscha earlier assaulted the aesthetic and commercial appeal of photojournalism with anti-aesthetic, amateurized constructions, such as Ruscha's photo-books of parking lots and gas stations, later practitioners, such as Jeff Wall, have argued that such Conceptual art ultimately failed to free photography from its representative functions. However, the resulting return to what Wall termed "the picture" as "the central category of contemporary art by around 1974" could only proceed through a head-on confrontation with the dominant condition of visual experience during that time: the spectacle.[11] Photographic practices of the 1980s directly addressed this condition through the appropriation of commercial imagery, as in work by Burgin, Prince and Kruger, and in Wall's fictional documentaries presented within commercial lightboxes. The danger of such pastiches, however, risked an unintended complicity with the spectacle they contested. In the meantime, the spectacle itself has become globalized. Current artists, such as Norman and Snyder—and one could add Matthew Buckingham and Joachim Koester—are clearly wary of this trajectory; they consequently turn to mixed-media constructions and the legacy of Conceptual art in order to reject aestheticization where it beautifies globalization and celebrates it uncritically, and to undertake instead nuanced analyses of its social and political ramifications.

Photography Between Fact and Fiction—A further line of practice revealed by *Vitamin Ph*'s present survey is the reinvention of documentary photography by artists who have drawn fact and fiction into suggestive uncertainty. This development is exemplified in the project of The Atlas Group/Walid Raad, which uses photography, video, performance and installation-based presentations to set authentic documents within fabricated frameworks alluding to the Lebanese civil war. Raad's work adopts a bureaucratic organization that lends a certain credibility to its imagined subject, even while the apparent eccentricity of his stories invalidates the truthful and objective presumptions of the official archives of the media or the state. Raad's project crystallizes at the point where traumatic experience meets the imaginative powers of storytelling. This formula expresses a deeply subjective relation to actual events, which appears here to be no less meaningful than the tales of conventional history.

The American artist Zoe Leonard similarly plays on photography's documentary factuality in order to scrutinize historical knowledge by spotlighting subjects beneath the radar of the established accounts of the past. This includes one installation, "The Fae Richards Archive" (1996), that reconstructs the supposed life of an African American actress from the silent movie era, assembling fake documentary material, including artificially aged photographs, to support its case. By relying on conventional presentation strategies that normally legitimate their subjects, such as the use of museum vitrines, Leonard contrives the story of this imaginary figure to appear real. In doing so, she simultaneously sheds light on the shortcomings of popular history, which often excludes subjects on the basis of race and gender. And by rewriting history, she commemorates anonymous figures from the past.

These projects—the strategies of which are also witnessed in An-My Lê's scenes of simulated Iraqi villages constructed as stage-sets in the California desert for US military exercises, and Sarah Pickering's ironic mimicry of military explosions through her carefully photographed pyrotechnics—mine the ambiguous border between reality and artifice, neither allowing fixed meanings, nor lapsing into pure unreality. This carefully staged indeterminacy between fact and fiction serves multiple purposes: it signals a critical awareness of the assumptions of objectivity by past documentary traditions and reveals their ideological blind spots. It also emphasizes how photography not only may access a past, but produces and authorizes something new—an identity, a history, an experience—through its very visualization, as in Leonard's example. Its powerful effects are additionally clear in Lê's ability to render visible the artificial mechanisms that motivate soldiers in actual warfare. Her photographs focus on how the American military in its fictitious "Iraq" carefully reproduces the graffitied political slogans—such as "Kill Bush" and "Good Saddam"—that they expect to encounter in the actual theatre of battle. This added realism, though only imagined by US soldiers, functions to inflame their own aggression, enacting a self-fulfilling prophesy.

These practices interfere with the temporal expectations of traditional photography so that a shift in tenses occurs. Roland Barthes famously argued that photography represents the "that has been" of the past, referring to the medium's ability to index an earlier moment in time. Recent experimental photography has transformed this once-privileged tense into the far less secure future perfect—the "that will have been"—which proposes documenting a potential reality to come, or a new prospective past.[12]

This new engagement playfully exchanges the seeming conclusiveness of history—the past as definitively captured—for an anticipatory memory or a future representation, by which photography reveals coming virtual realities, projects new possibilities back in time and forms emerging communities of viewers.

The Performative—What has emerged is a new arena within which photography not only reflects upon the real world and the lived experience within it, but also recognizes difference, hope and possibility through an imagination that creatively redefines the relation between reality and representation. Exemplary here is Catherine Opie's subtle and diverse use of photography, which emphasizes the instability of the subject. Opie's images complicate the nature of identity by showing the body in a range of roles, transgressive and traditional alike—from loving mother to sadomasochistic lover. Her photographs—whether portraits of others or herself—are intimate and shot close up, which invites a certain familiarity and compassion on the part of the viewer, for her strategies dramatically humanize her subjects. But one can still never fully know the sitter based on her single images: like Collier Schorr's quasi-documentary images of androgynous youths set in contrived scenes before the camera, none of which appear definitive or timeless, Opie's images open the self to multiplicity.

Similarly, Nikki S Lee's images record the artist's migratory identity as she assimilates into various microcultures— yuppies, punks, Latinos, seniors—achieved through the artifice of make-up, fashion and amateur-like photographic snapshots. Instead of projecting a fictitious identity into fake cinematic fragments, decentring the self historically, as in Sherman's "Untitled Film Stills", Lee modifies herself transculturally, recording her body as it travels through scripted gestures and researched masquerades, but where no fundamental identity exists. In these works, repetition acts as a force not of homogenization, but of disruption, as Gilles Deleuze might say; not a duplication of the same but a cycle that replaces static being with endless becoming. While the practices of Opie and Lee, as well as Anna Gaskell, might be seen in the tradition of film and acting, they also suggest that photography offers the possibility of gaining freedom from the rigid construction of gender by emphasizing fluidity, the creative mixing of categories and visual ambiguity.

In this context, representation only makes sense when the subject is not assumed to exist prior to it. In other words, photography becomes "performative", which defines a mode of representation that *produces* the effects it describes. Prefigured in the art of Sherman and Wall, and more recently, of Gabriel Orozco and Philip-Lorca DiCorcia, these photographic models appear increasingly sensitive to the process whereby bodies materialize in front of the camera at singular and representative moments that are themselves necessarily incomplete and transitory, which photography not only depicts but creates: "there can be no reference to a pure body that is not at the same time a further formation of that body", argues Judith Butler.[13] These innovative forms of photography continually reconstruct their subjects and consequently make the same argument.

Conclusion—The extremely diverse and provocative photography of *Vitamin Ph* invites us to contemplate forms of visual experience beyond the framework of a single truth, beyond the certainty of history's chronology and beyond the static definition of subjectivity. By doing so, the current directions of photographic practice intersect at a point where they offer an ethical engagement with the world, according to which artists both critically expose existing intolerable conditions and suggest creative and desirable possibilities beyond them. When the past is revealed to be inconclusive, the present is endowed with ever new sources of freedom; and where art is successful in exposing the strangeness of the self, it may reveal ways of relating to others with renewed compassion and tolerance. Consequently life becomes the object of continual negotiation, rather than passive submission to already established regimes. This is achieved, as shown in the present survey, through new forms of documentary photography that throw the subject into transition, disrupt the boundary between fact and fiction, and blur history's linearity. Such strategies undo the traditional assumptions of photographic factuality and avoid the pitfalls of stereotyping that have occurred when past documentary practices have objectified their subjects and grounded them in an oppressive truth understood as an essential and inescapable state. Photography's new ethical engagement is also advanced through the hybridization of the medium, whereby artists situate photography in relation to foreign materials and non-photographic procedures. Photography's shifting make-up, consequently, forbids its essential definition by any single technology and invites ongoing transformations. In such cases, the photographic medium faces what is beyond itself—including text, sculpture and video—which opens up experimental ways of perceiving and responding to otherness. In the same way, photography's documentary representation asks viewers to focus on different subjects, cultures and conventions with a newfound openness. In today's climate of war and terror, these salutary developments are welcome.
—TJ Demos

1 Perhaps there never was one, as photography has always been resistant to its status as a medium, long rejected by Modernism, consigned to a permanent crisis of identity.

2 Douglas Crimp, "Pictures", in *Art After Modernism: Rethinking Representation* (New York: New Museum of Contemporary Art, 1984), p 186.

3 See Guy Debord, *The Society of the Spectacle*, trans D Nicholson-Smith (New York: Zone Books, 1995).

4 For further discussion of digital photography, see Lev Manovich, "The Paradoxes of Digital Photography", and Martin Lister, "Introduction to the Photographic Image in Digital Culture", in *The Photography Reader*, ed L Wells (London: Routledge, 2003).

5 For a critical assessment of past documentary photography, see Abigail Solomon-Godeau, "Who is Speaking Thus? Some Questions about Documentary Representation", in *Photography at the Dock: Essays on Photographic History, Institutions and Practices* (Minneapolis: University of Minnesota Press, 1991).

6 On Postmodernism's schizophrenic condition, see Fredric Jameson, "The Cultural Logic of Late Capitalism", in *Postmodernism, or The Cultural Logic of Late Capitalism* (Durham: Duke University Press, 1992).

7 This conflict is articulated in Michael Hardt and Antonio Negri's *Empire* (Cambridge: Harvard, 2000) and *Multitude: War and Democracy in the Age of Empire* (New York: Penguin, 2004).

8 For a useful introduction to these issues, see Niru Ratnam, "Art and Globalization", in *Themes in Contemporary Art*, ed G Perry and P Wood (New Haven, Conn, and London: Yale University Press in association with The Open University, 2004).

9 See Fredric Jameson, "Notes on Globalization as a Philosophical Issue", in *The Cultures of Globalization*, ed F Jameson and M Miyoshi (Durham and London: Duke University Press, 1998).

10 Arjun Appadurai, "Disjuncture and Difference in the Global Cultural Economy", *Modernity at Large: Cultural Dimensions of Globalization* (Minnesota: University of Minneapolis Press, 1996), p 32.

11 For Wall the "picture" refers to a convention of image-making continuous with nineteenth-century history painting, rather than a strictly postmodern condition of the image. Jeff Wall, "'Marks of Indifference': Aspects of Photography in, or as, Conceptual Art", in *Reconsidering the Object of Art: 1965-1975*, ed Ann Goldstein and Anne Rorimer (Los Angeles: Museum of Contemporary Art, 1995), p. 266.

12 This suggests a move from the photographic theorization in Roland Barthes' *Camera Lucida* (1980) to Gilles Deleuze's *Cinema 2: Time Image* (1985), which, in its attention to virtual conditions, although dedicated to film, becomes newly relevant for photography as it becomes temporalized within video and enters into digital processes.

13 Judith Butler, *Bodies that Matter* (New York, Routledge, 1993), pp 10 and 188. See particularly the chapter "Arguing with the Real".

[1] **Guggenheim Bilbao 2006**, from the series **"Islamic Project"**, 2003, digital collage, inkjet print on paper,
 80 x 120 cm, 31 x 47 inches

[2] **Episode 1, #7**, from the series **"Action Half Life"**, 2005, digital collage, inkjet print on canvas,
 150 x 225 cm, 59 x 88.5 inches

[3] **Last Riot 2, #3**, from the series **"Last Riot"**, 2005, digital collage, inkjet print on canvas,
 diameter 150cm, 59 inches

The core of AES (Tatiana Arzamasova, Lev Evzovich and Evgeny Svyatsky) group's work is a complex mixture of politics, history, media imagery, cultural and artistic references, fashion and forewarning. For some specific projects, including most of their recent ones, they have incorporated fashion photographer Vladimir Fridkes, becoming **AES+F group**. They gained media attention following their "Islamic Project" (begun 1996), which comprised a series of manipulated photographs depicting popular tourist sites in Western cities, refashioned by Islamic culture. The project was a response to Samuel Huntington's political thesis that warned of the imminent conflicts between the Western and Islamic worlds, based on their different and irreconcilable social and cultural heritage, and a keen rise in Westerners' fears about Islam.

Their recent photographs have continued to explore power conflicts and a dystopic vision of the future. The series "Action Half Life" (begun 2003) portrays a kind of post-human world inhabited by aggressive children fighting against an invisible enemy. They are all teenagers, young and beautiful, engaged in a game-like war; their small bodies dressed in pure white clothes—issues of race and genetic purity come to mind—carry oversized guns and their eyes are fixed somewhere out of the frame. In the series "Last Riot" (begun 2005) the military landscape persists, but now the children fight amongst themselves. Their poses are rooted both in art history and advertising; they move in a somewhat kitsch environment provided with a few key commodities. Like Donna Haraway's cyborgs in her 1991 "Cyborg Manifesto", they seem to be "the illegitimate offspring of militarism and patriarchal capitalism, not to mention state socialism". They too seem to have denied their parents, their origins, their histories and their roots.

AES+F group work with carefully selected teen models and precise photomontage techniques. Image manipulation and mannered poses are employed ironically to mimic and subvert popular media imagery. The use of such young, "perfect" bodies suggests a universe where getting older is no longer an option; a universe caught in a controlled, eternal present. The absence of pain and suffering in the struggles implies that emotions and sentiments are also outlawed. The use of children feels disturbing despite the austere, classical aura of the images. The "Last Riot" series in particular alludes to Baroque foreshortening and Neoclassicism's hieratic poses; three of the works are *tondos*, a popular format in Neoclassical French art taken from Renaissance painting.

In contrast they also reference video games, fashion advertising, science fiction movies and computer animation. "Action Half Life" carries overtones of Social Realism and its rhetoric of collective heroism; one of AES+F group's objectives for this series was to explore contemporary heroism. But there is no bravery, no illusion, no eagerness in their protagonists' attitude, just indifference and boredom. As the artists have stated, "This world celebrates the end of ideology, history and ethics."—Rodrigo Alonso

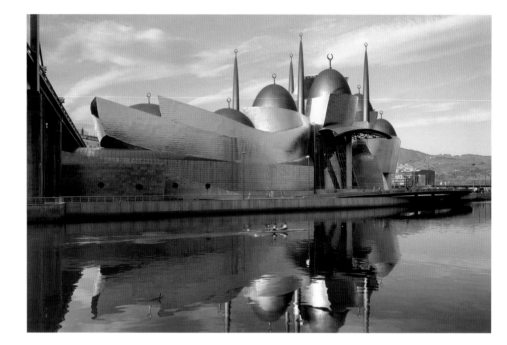

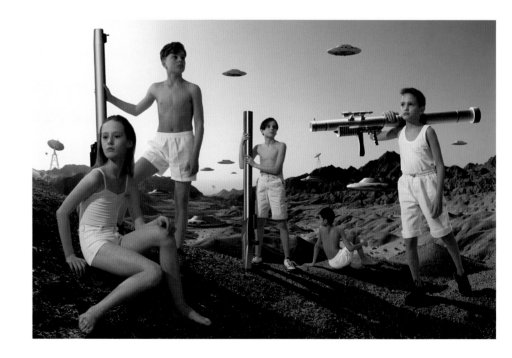

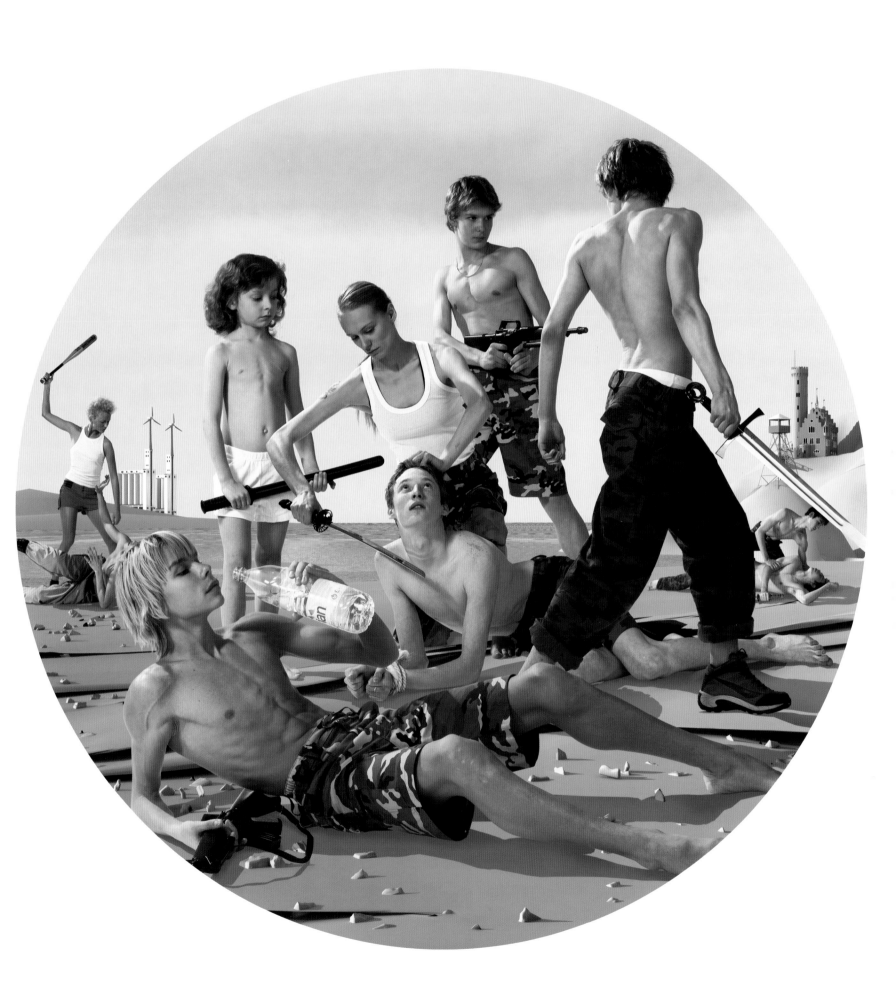

[1] **Billboard**, 2002-4, C-print, 35 x 50 cm, 14 x 19 inches
[2] **Blue Moon**, 2005, found postcard, 9 x 14 cm, 3.5 x 5.5 inches
[3] **Untitled**, 2005, C-print, 35 x 50 cm, 14 x 19 inches

Armando Andrade Tudela's initial photographic projects confronted the geography and economy of his home country, Peru, whilst deploying modes of photography associated with 1960s Conceptual art. "Camión" (2003), his first major series, was presented as a small artist's book and as a slide show. All the images showed lorries on Peruvian motorways and in lay-bys, each one brightly decorated with a colourful abstract design. The photographs were casually taken, often from a moving vehicle. No attempt was made to centre the photographic subject nor to render the lorry in perfect lighting conditions: this archive was assembled on the move. Because of their amateurish appearance and their mode of presentation, the photographs conjured up the feel of Ed Ruscha's early pictures of gas stations, while the subject matter recalled John Baldessari's *The Back of all the Trucks Passed While Driving from Los Angeles to Santa Barbara, California, Sunday 20 January 1963* (1963). In the contemporary context of elaborate and large-scale digital photography, Andrade Tudela's redeployment of "de-skilled" photography seemed urgent but his series posed new questions to those raised by Ruscha and Baldessari: to what extent do the truck's designs recall the traditions of Latin American abstraction? Are these individual designs almost obsolete, soon to be eclipsed by the rationalized logos of global freight corporations?

Andrade Tudela continued to explore the subject of abstraction in his next series with photographs also taken on Peruvian roadsides. Here he found disused structures formerly used to display massive adverts. One group of images showed skeletal metal structures that would have held up the panels; another showed the metal structures with the panels intact. But there were no adverts visible: they had been entirely or partially removed and the panels were laid bare. The first structures in the first group called to mind mid-century modernist sculptures made from found lengths of metal such as those by Mark di Suvero. The empty panels meanwhile recalled the abstract paintings of Ellsworth Kelly. There was a utopian dimension to the series, as the photographs suggested that abstraction can be discovered anywhere, but also a sense of pessimism. The degradation of the billboards bore witness to the vicissitudes of a developing economy. Abstraction can be found, but only in a wasteland.

Photographs like *Billboard* (2002-4) were carefully taken, each from the same distance to the subject and printed singly rather than reproduced in an artist's book. The latter format has continued to serve Andrade Tudela, particularly to confront the history of Brazilian sculpture. In 2005 he took a number of record sleeves of Caetano Veloso's 1972 album *Transa* and joined them together by their seams into a form that could be manipulated into a number of different configurations. Though this form was precisely based on Lygia Clark's *Bichos* (a series of hinged metal objects dating from the early 1960s), Andrade Tudela's work coupled the memory of Clark's neo-concretism with that of Tropicalia, a slightly later Brazilian avant-garde group with which Veloso was associated. His photographs documented the sculpture in its various possible arrangements, and were photocopied and bound in a limited edition publication.

Most recently, Andrade Tudela has stepped away from making photographs in series. Enigmatic individual images show singular subjects. One image, a portrait of his friend, is overexposed by a double flash, so that the figure is almost bleached out to invisibility. Another shows a view down to a floor covered with cheap plastic tiles. One has lifted slightly revealing a small dark aperture. If the image recalls Andrade Tudela's interest in the order of geometric abstraction, so too the rupture in the grid reminds us that abstraction is now present in ruins alone.—Mark Godfrey

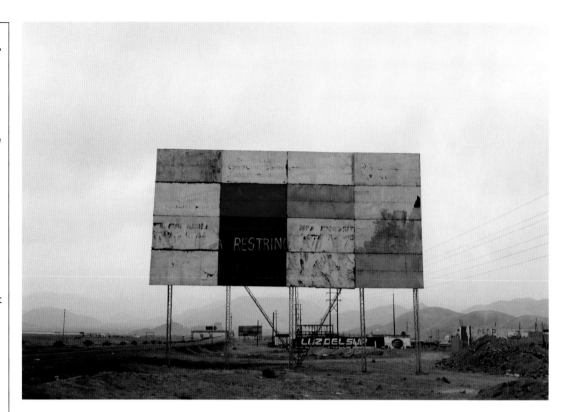

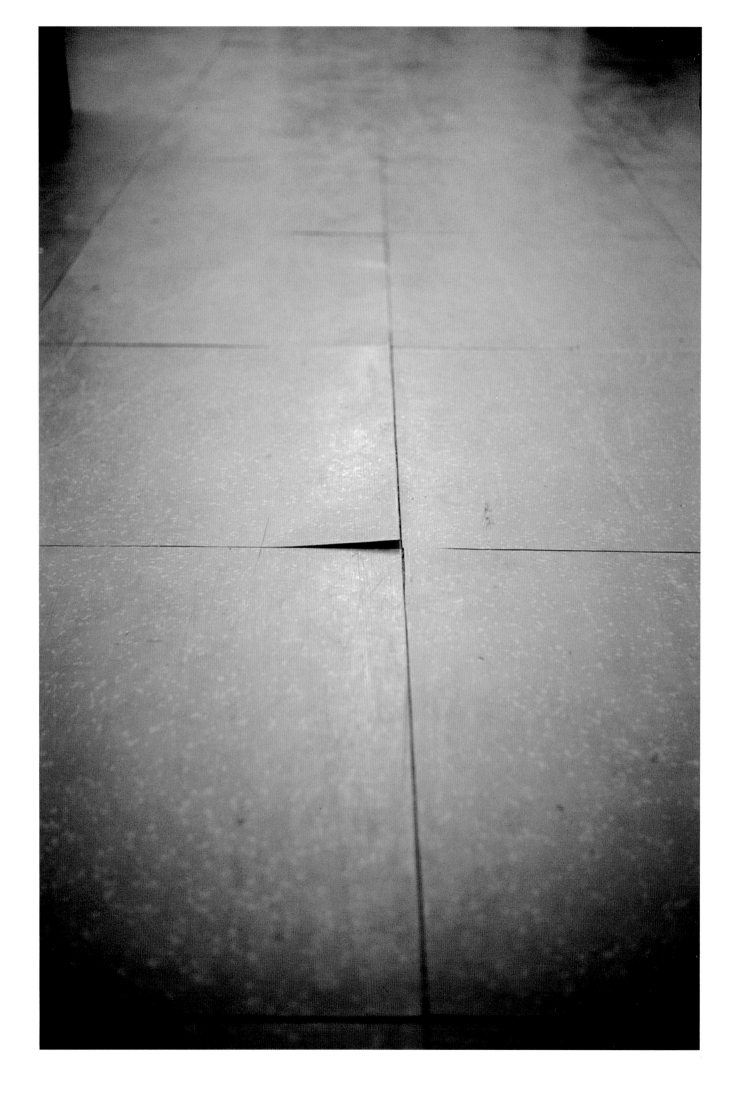

Alexander Apostól's digitally manipulated photographs focus predominantly on the built environment in Venezuela, his country of origin. Apostól is particularly interested in the failure of the modernist experiment and how it has manifested itself in the urban landscape in Latin America. He is mainly concerned with the architecture of the 1940s to the 1960s, the result of the economic and social boom due to the exploitation of the country's enormous oil reserves. During that time the city of Caracas grew into a modern metropolis and the unprecedented development of the built infrastructure was translated into a modernist architecture of grandiose and monumental ambitions. In the last decades economic growth in the region slowed and the modernist project faltered. As a result, the modernist architectural dream that was partially realized in Caracas is now largely a modern ruin in a state of neglect, abandon and dilapidation. It is this aspect of the urban environment that Apostól turns his attention to in the series "Residente Pulido" [Polished Residence] (2001). These photographs depict a series of modernist apartments, but rather than presenting the buildings as they are, he digitally manipulates the photographs, blocking off their doors, windows or any possible access points. The names he gives to the buildings are taken from well-known porcelain brands such as Sèvres, Meissen and Rosenthal. The result is an architecture of elegance and fragility but also polish. In the continuation of this series, "Residente Pulido – Ranchos" (2003), the buildings are rougher, and appear to be hybrids of modernist residences and Caracas barrios [squatter cities]. In manipulating the buildings in his images, he not only negates their functional aspects but transforms them into forbidding monolithic structures, impenetrable concrete and brick monuments that function as metaphors for botched development, a failed utopia, social decline and a misguided belief in progress. This "pictorial" fortification, the deliberate obstruction of entry into the buildings, can also be read as a metaphor for social exclusion and a denial of access to the potential threat of criminals, since Caracas is known to have a very high crime rate.

A similar conceptual interest underlies Apostól's most recent series, "Skeleton Coast" (2005), which was shot on Margarita Island in Venezuela, the hub of the country's mass tourist industry. During the 1980s tourist boom there was a lot of investment in property development for leisure. Following the financial crisis that ensued, many of these lucrative businesses went bankrupt, leaving projects uncompleted. It is these unfinished buildings—or rather their cement skeletons—that Apostól poignantly captures. Hollow, stark and purposeless, they stand as architectural dinosaurs, ghosts of economic ambition, entrepreneurial graveyards. Like "Residente Pulido", "Skeleton Coast" is also about failure and misdirected ambition, the difference being that the aspiration behind the original modernist experiment was completely other than the avaricious drive of the property developers. Though these photographs are specific to a local situation they reveal an urban symptomatology that can be seen in many countries with developing economies where economic opportunism usually finds its best proponent in ad hoc, questionable property development. Myriad similarly environmentally and socially disparaging stories have been written and continue to be written with the rise of urbanism, the global metropolis and the phenomenon of the mega-city.—Katerina Gregos

[1] **Sèvres**, from the series **"Residente Pulido"**, 2001, digital photograph,
150 x 200 cm, 60 x 78 inches

[2] **# 4**, from the series **"Skeleton Coast"**, 2005, digital photograph, 75 x 175 cm, 30 x 70 inches

[3] **# 5**, from the series **"Residente Pulido. Ranchos"**, 2003, digital photograph, 150 x 200 cm,
60 x 78 inches, collection Museo de Arte Contemporáneo de Castilla y León, León

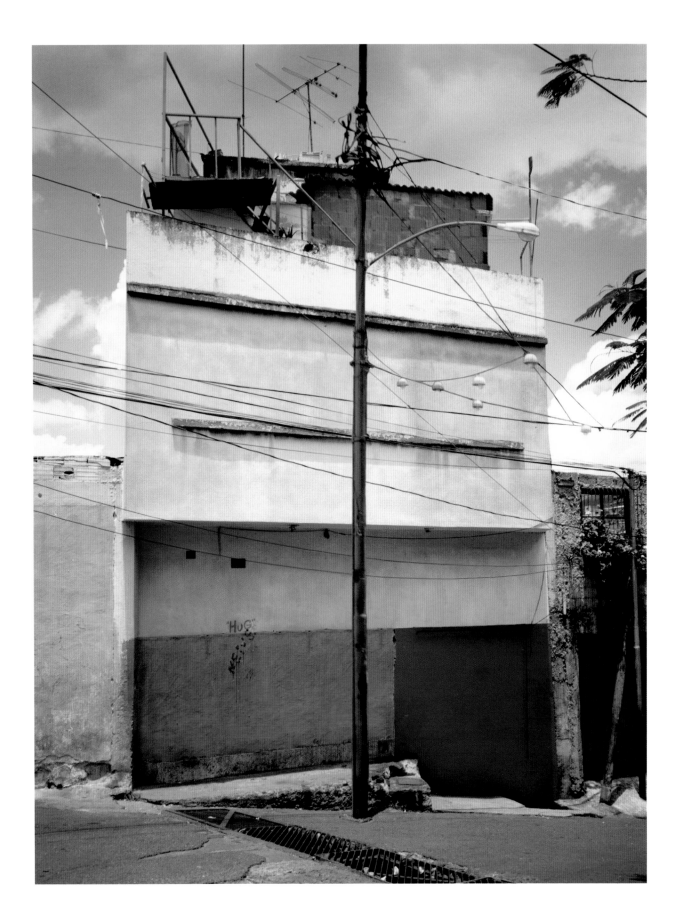

[1-3] **Notebook Volume 38: Already Been in a Lake of Fire**, 2001, three from a set of nine inkjet prints,
30 x 40 cm, 11.5 x 15.5 inches

[4] **Sweet Talk: The Hilwé Commission (1992–2004) Plate 355**, 2004, inkjet print,
110 x 110 cm, 43.5 x 43.5 inches

[5] **Sweet Talk: The Hilwé Commission (1992–2004) Plate 389**, 2004, inkjet print,
110 x 110 cm, 43.5 x 43.5 inches

The recent work of **Walid Raad** is frequently exhibited as **The Atlas Group**, a non-profit-making research foundation founded by Raad to examine the contemporary history of Lebanon, and the Lebanese Civil Wars (1975-1991) in particular. The discourse on The Atlas Group inevitably focuses on the veracity of the foundation, referring to it as imaginary or fictitious, underscoring critical questions raised in Raad's work: what gets to count as information, who authors history and what does it mean to write or speak about war? Raad's use of a foundation to circulate much of his recent work underlines the position of the artist as a source of knowledge, among other roles that we imbue with unchecked authority. More significantly, The Atlas Group strategically points towards the possibility of collectivity as a form of political agency within art production, while highlighting the arbitrary divide between the real and the invented, lived experience and history.

An overarching concern in Raad's work is the production (or lack) of recorded contemporary history and the post-war experience in Lebanon, questioning how knowledge is produced, circulated and archived. Work produced by The Atlas Group takes on multiple forms including single channel videos, public lectures/presentations by Raad, a website and digital photographs. Many of Raad's photographic works are considered documents from The Atlas Group Archive, and as such are stored and subsequently exhibited as files or dossiers under three different headings: type A (authored files), type FD (found files) and type AGP (Atlas Group Productions).

Under the category "AGP" is a series of numbered inkjet prints titled "Already Been in a Lake of Fire" (2001). The prints contain cut-out photographs of various cars, which correspond to the exact make, model and colour of those used as car bombs in the Lebanese wars. The collages of cars are superimposed on to white backgrounds composed as notebook pages, complete with Arabic text detailing statistics related to the explosions and their casualties. Here Raad performatively deploys the authoritarian language of government and nonprofit agencies as both an organizing structure for the photographs, and a mode of critique against the presumed neutrality and authenticity of classification systems.

The medium that holds all the disparate objects and images comprising The Atlas Group in a suspended state is archival protocol. However anachronistic, each object and/or idea collected under Raad's rubric emphasizes the normative conditions that determine the access, display and dissemination of cultural information. The conventions of the archive function as a cultural interface for Raad to manipulate. To this end, the public presentation of material from The Atlas Group Archive evokes Hannah Arendt's notion of the "space of appearance", the idea that meaning comes through a collective, public space, suggesting that art can engage as a form of cultural participation rather than as a form of reification or edification. Reviewing material from the Archive implicates readers in the proliferation of accepted historical narratives and raises the question: can there be an ethical archive? The audience produces meaning not simply through a reductive conceptual notion of "completing the artwork", but through the continued circulation of ideas and, more importantly, questions.
—Gloria Sutton

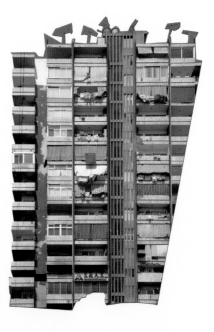

[1-2] **Rebecka As Anonymous**, 2004, black-and-white poster, two-sided reversed print on paper,
200 x 160 cm, 79 x 62.5 inches

[3] **Rebecka As Anonymous**, 2004, poster, two-sided reversed print on paper, 200 x 160 cm, 79 x 62.5 inches

Since the mid-1990s, **Miriam Bäckström** has focused on the staging of life in her art. Known mainly as a photographer, she has in recent years produced video, sound-based work and projects in a variety of found and produced media that consistently question the antagonistic and by no means straightforward relationship between truth and lie, document and fiction. Bäckström makes evident the degree to which fabrication and fact are in particular enmeshed in our construction of self. The desire for authenticity in life exists in conflict with the unavoidable and essential "act" of being, consisting of a process of learned and instructed behaviour, tastes, routines and attitudes.

Until very recently Bäckström's work was characterized by the total absence of the human figure, though this absent presence was the determining force in the image. Bäckström's photographs suggest an indirect mode of portraiture, or an almost anthropological dissection of circumstance, and many of her series of works to date have concentrated on interiors, both real and staged. Friends, acquaintances mainly from her native Sweden, have allowed Bäckström to photograph their living spaces, which are presented in the midst of daily life and activity, as if the occupants had left the room only momentarily. Bäckström has also photographed the homes of the recently deceased, their living spaces now unnaturally orderly, awaiting the efficient disposal and dispersal of their personal belongings. The desperate attempts of Stockholm's homeless to establish personal space has also been documented by Bäckström in a series of exterior interiors that, given the temporary nature of the structural supports, suggest not only the fragility of their existence, but also a degree of transportability not normally associated with notions of "home". Alongside these "genuine" portraits of living spaces Bäckström has photographed a variety of staged interior spaces, from film sets to "model homes" in newly constructed environments, or from museum re-enactments of period interiors to IKEA's interior displays.

Seen together, these works demonstrate Bäckström's interest in questioning notions of the authenticity of experience and environment. Our ability to construct new narratives in life is contained or limited by what we know and yet the contradictory desire persists to search for "truth" and understanding through a reading of what is, potentially, a fabrication (whether partial or total). Not only is it impossible to define what is purely fabricated and what is entirely truthful; it is perhaps in fact the confusion between these two that is of most interest, the uncertainty itself allowing for the type of unscripted self-consciousness that otherwise rarely manifests itself in our unbroken routine.

The first part of Bäckström's recent major project, consisting of interviews and images and the video *Rebecka* (2004), is an extension of the concerns she has addressed in photographic form. For this project Bäckström met on multiple occasions with the well-known Swedish actress Rebecka Hemse, developing a script from their conversations that was ultimately used for a filmed conversation between artist and actress. In the video we see Hemse sit before the camera, playing "herself", answering questions that are posed off-screen by Bäckström. The conversation is such that we are convinced of its authenticity, even when Hemse reaches for her script to check her lines for this "natural" conversation. Our desire to believe that what we are witnessing is the real Hemse, rather than the actress Hemse performing a role, is of course a misguided conception of the very nature of self and a reflection of our inability to come to terms with the complex relationship between the personal and the public, the real and the staged.—Jessica Morgan

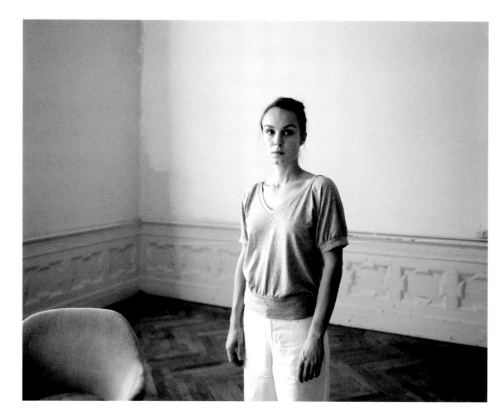

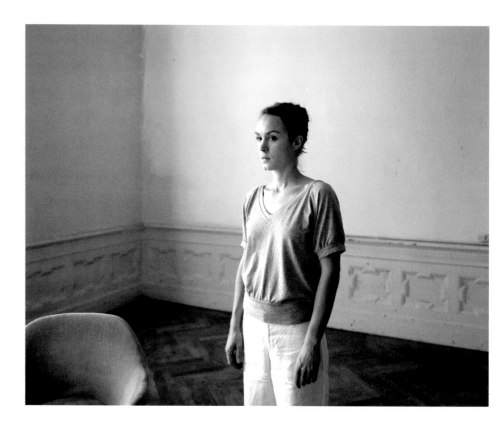

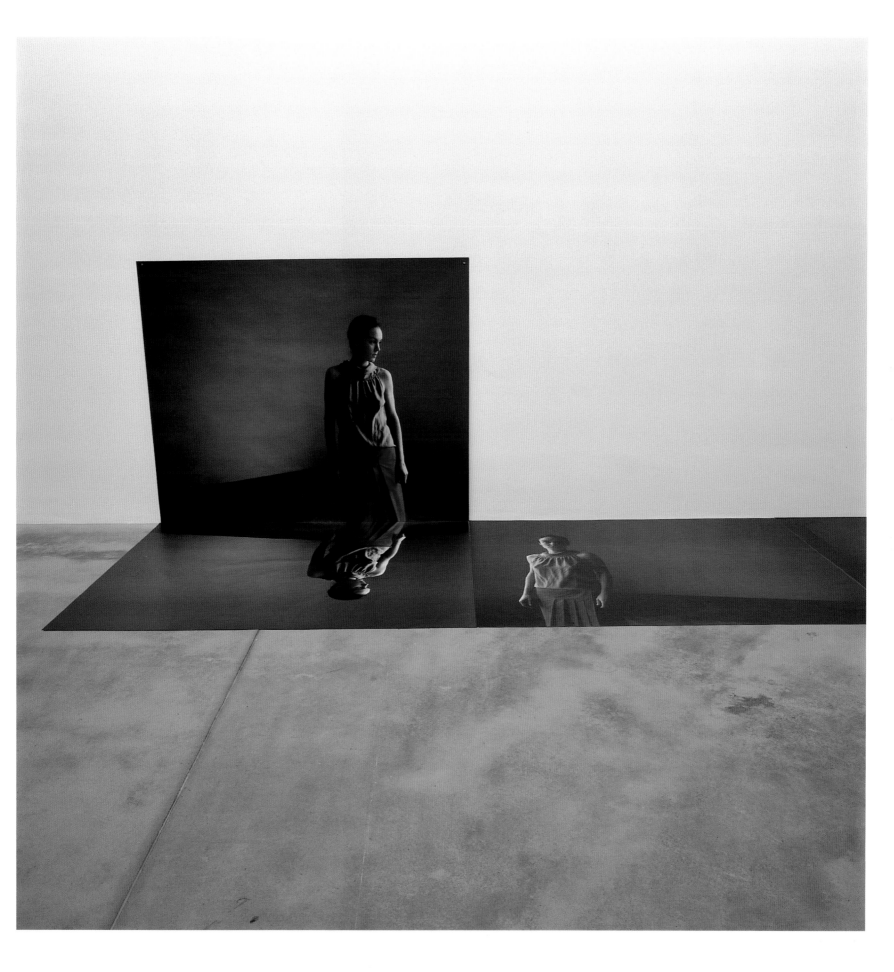

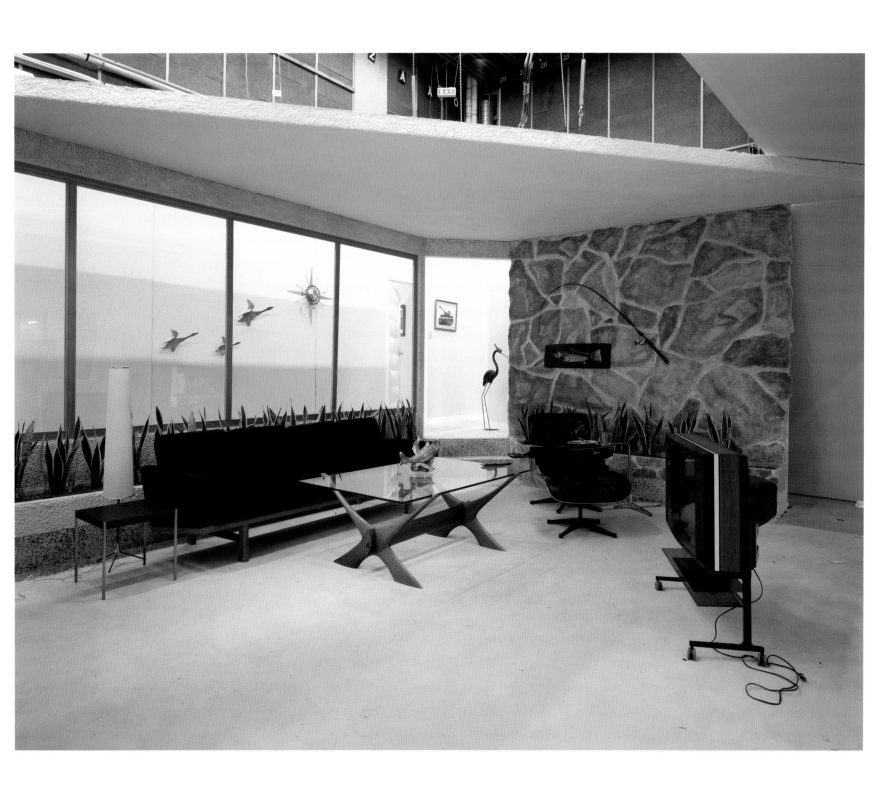

Yto Barrada's personal history is intimately interwoven with her photography, video and sculptural work. Barrada was born in Paris and educated in Tangier, and her work is informed by her experience of living both within and between these two parallel geopolitical realities: between the Occident and the Orient, between hope and despair. Using film and photography, Barrada presents the viewer with a series of snapshots of everyday life that have symbolic significance on both a personal and political level in a format that operates beyond the confines of the traditional documentary aesthetic.

In "A Life Full of Holes: The Strait Project" (1998-2004), her most extensive project to date, Barrada brings together photographs, video, archival material and texts that examine the unique character of the Strait of Gibraltar. Indelibly marked by history, Tangier lies at the crossroads of civilizations, a gateway to the African continent whilst simultaneously gazing out across at Europe. It is this symbolic, physical and historical site, sandwiched between the promises of the West and the realities of North Africa, that Barrada tenderly portrays in her photographs of the city and its people—from those attracted from rural Morocco to the bright lights of the city, emigrant workers returning home from Europe, to those dreaming of a future across the Strait.

Infused with a sense of poetry, Barrada's work explores issues of migration, diaspora, access and exclusion. A picture within a picture, *Papier peint (Wallpaper) – Tangier* (2001), depicts an idyllic alpine vista, mountains crowned with snow and verdant pastures, testifying to the riches that lie just beyond the Strait of Gibraltar. In stark contrast, Barrada's photographs of desolate abandoned sites both in and on the outskirts of Tangier depict the city as a pit stop—a place to congregate before one reaches a final destination. *Foundations – Abandoned Construction Site – Asilah* (2003) shows flimsy foundations left to ruin and decay in the muddy waters, whilst *Vacant Plot – Tangier* (2001) shows an empty green field populated by grazing sheep, adjacent to a residential building. The suggestion here is that the sheep are the only inhabitants of the city content to stay put.

Taken from awkward angles, Barrada's photographs often show people on the move or about to make a journey: people waiting at a rainy bus stop or in a run-down departure lounge; blurred figures making a quick escape across rocky slopes; young boys clambering through torn fences; young girls silhouetted against an advertisement of a ferryboat headed for far-flung places. Barrada's subjects rarely gaze directly at the camera, mirroring the furtive nature of the activities captured in her photographs—such as the man facing a wall, embracing another man (*Rue de la Liberté – Tangier* [2000]).

Employing a variety of photographic styles, from photojournalism to painterly landscapes, Barrada's images of Tangier speak of a harsh political reality where freedom of movement across the Strait has become the domain of the privileged few.—Alona Pardo

[4] Crevasse (Landslip) – Cromlegh de Mzora, from the series "A Life Full of Holes:
 The Strait Project", 2001, C-print, 60 x 60 cm, 23.5 x 23.5 inches

[5] Usine 1 (Factory 1) – Conditionnement de crevettes dans la zone franche (Prawn processing
 plant in the Free Trade Zone) – Tangier, from the series "A Life Full of Holes:
 The Strait Project", 1998, C-print, 103 x 103 cm, 40 x 40 inches

Erica Baum uses documentary-type photographs to record systems of knowledge such as book indices and library card catalogues, and, more recently, theatrical scripts and board games. What interests her are the oblique references, odd coincidences and startling reductions that occur when ideas and objects are translated into text. Baum's black-and-white, film-based photographs focus us also on materials— a smudged and bent index card, or the stroke of graphite against toothy paper. And in her recent series of work entitled "Them" (2004), she presents haunting, surreal images that pretend to be character studies but profoundly question the believability of photographs.

Baum's approach to making art is conceptually driven. Her card catalogue photographs call to mind Robert Morris's 1962 work, *Cardfile*, which in fact is an object (the cardfile itself) filled out to document Morris's daily activities and intellectual investigations, but we usually see it in black-and-white images that look a lot like Baum's. The connection is more than superficial. Baum shares that generation's insistence that objects are always part of a larger system, and thereby evidence of ideologies. Morris employed bureaucratic and linguistic systems to pry open a relatively narrow definition of artistic "experience", as did such artists as Art & Language with their *Index* of 1972. In a similar way, Baum's work insists on displacing what would normally be visual with text. In a series of works made in the Photoarchive at the Frick Collection in New York, Baum photographed the reverse sides of the index cards filed for each photograph of a work of art. (The archive is a hangover from an earlier episode when art historians needed central places to study images, an idea encapsulated in André Malraux's idea of the *Musée Imaginaire*. Baum is interested in this dying practice, now obviated by better publications and digital archives.) In *Untitled (Swans Amputees)* (1998) we are made aware of a referencing system itself outdated in art history, one based on subject matter rather than artist or style (twentieth-century art made it irrelevant). We are left to wonder which painting (or even what type of painting) could ever contain both those images, but perhaps more interesting is that any picture necessarily exceeds its textual counterpart.

In "Them" Baum photographed parts of a 1930s board game called *Physogs*, one we would probably like to forget. A little like *Scrabble*, players try to make an ideal face by choosing pieces in turn, each showing a different set of eyes, nose and mouth. The numbers on each piece direct you to a Key Book that tells you what "type" of person you made (happy, sullen, etc). *Physogs*, of course, is a watered-down version of the nineteenth-century practice of physiognomy, which proposed that a person's character could be judged by his or her appearance. Baum herself plays with the possibilities—two of her photographs use the same set of eyes with different noses and mouths, and indeed, each composite face suggests a different emotion. This is not an exercise in nostalgia, however; it is more likely a warning about current practices of racial profiling and biometrics. Baum's practice lightly and deftly reminds us that images and texts are systems of representation—bound to specific historical agendas, partial, flawed, often misguided, but rife with sensibility in the most offhand places.—Alison Green

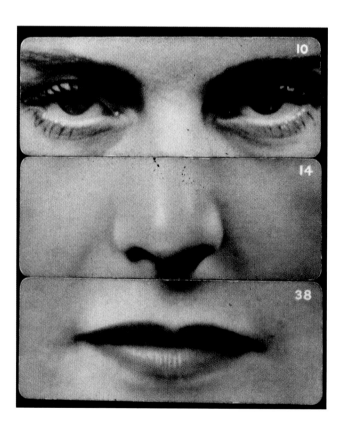

Subversive activities

Suburban homes

118-12
A

Swans
Amputees

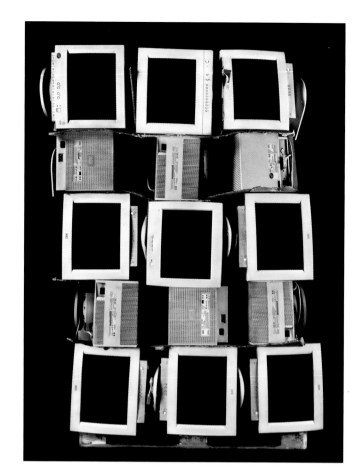

After receiving a fine art degree in 1987, Paris-based photographer **Valérie Belin** studied the philosophy of art—with a focus on Minimalism—at the Sorbonne, and her education has left its mark on the black-and-white photographs she has produced during the past twenty years. These pictures, printed in medium to large formats, are marked by formal restraint, overabundant detail, amplified contrast between black and white, and a cool, keen intelligence. Much like the photographs themselves, in which it is easy to lose sight of the whole image when one is peering closely at details, it can be difficult to grasp Belin's project as a whole, especially considering that in recent years she has photographed crisp packets, bodybuilders, brides wearing traditional Moroccan wedding dress, robots, transsexuals, crashed cars, lace, hunks of meat, mannequins and ornate mirrors. Although Belin works in series, her individual photographs are not conceptually subservient to those in which they are grouped. With their plethora of finely described detail and their serial presentation, they hover somewhere between "specific objects", to use Donald Judd's term for minimalist sculptures, and illustration of a type. Their location in this liminal space between individuation and exemplification is perhaps the strongest thread connecting these disparate but similarly made photographs. One commentator, extrapolating from one of Belin's series, characterized this ambiguous zone as akin to an *entre-deux*, a French term for a thin strip of lace inserted between two larger pieces of fabric.

Within this overarching framework, it is tempting to draw connecting lines linking several of Belin's photographic series: one can consider the instability of identity when looking at her portraits of mannequins, models, Michael Jackson impersonators and transsexuals; reflect upon the ways we alter or disguise our bodies when looking at her photographs of bodybuilders and brides in Moroccan wedding gowns; and ponder the nature of seeing and photographic mediation when looking at her early images of ornately framed mirrors or recent pictures of crisp packets and discarded computer equipment. Belin has refrained from commenting on these connections, ascribing neither iconographic nor thematic unity to her subject matter.

Each picture stands on its own, and, in its austerity, frontality and particularity, is a forceful presence, a revelatory description of the surface of an object via the light reflected off it or passing through it. Of course, no matter how "realist" her pictures are, they are never solely documentary or archival, a fact emphasized by the confusion, at close range, between the surface texture of what she is photographing and the grain of the print itself. Belin's photographs are perhaps better considered as re-embodiments rather than reproductions of her subjects. Their austerity belies their immense complexity.
—Brian Sholis

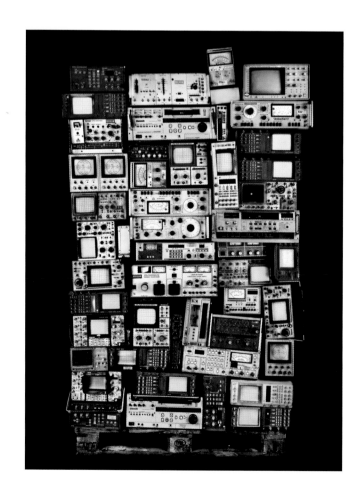

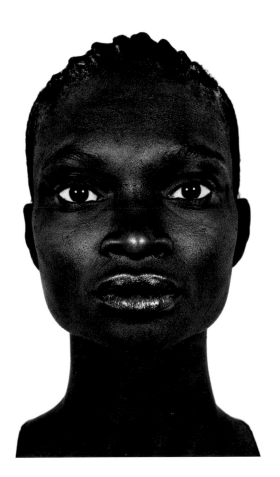

Walead Beshty's conceptually based projects address the instability of objects, sites and situations in contemporary culture, while demonstrating the shortcomings of the various photographic approaches developed to represent these phenomena. Drawing on myriad, often contrasting precedents in the history of photography—from the detached and programmatic methodology of photoconceptualists such as Dan Graham and Ed Ruscha, to more pictorially orientated figures such as Francis Frith and Stephen Shore—his work constitutes a crisis of how the subject is constructed in the process of image making. Beshty's projects have alternately examined the spectacle of consumption in the post-war era, the gradual obsolescence of building types in the contemporary American landscape, and the increasingly fraught relationship of humankind to the natural environment. In doing so, he creates photography of uncertainty and doubt, simultaneously representing the complicated use-value of things in the world and the limitations of photographically visualizing this dynamic.

Beshty established himself through such projects as "The Phenomenology of Shopping" (2001-3) (in which the artist's often prone or limp body is depicted as thrust or placed into store displays to address our lust for and absorption by commercial merchandise) and "Dead Mall" (2002-4), a series of twenty black-and-white images of a range of eclipsed American shopping centres. His more recent series, such as "The Excursionist Views" (2001-5), and "Island Flora" (2005), depart from these more specific examinations of consumer economics and its discontents, instead concentrating upon depopulated structures and spaces that occupy an interstitial presence in contemporary society. "The Excursionist Views" incorporates aspects of the now defunct visual mode of stereography—a device popular in the nineteenth century in which two identical images were presented and viewed in tandem to give the illusion of three-dimensionality—to depict vernacular American architectural structures whose utopian modernist design proved incompatible with social realities and led to their lapse in use. Beshty's series alludes to Jacob Riis's images of the New York slums at the end of the nineteenth century, which offered a safe visual excursion into the dire world of the impoverished underclass, prompting reflection on the similarly unproblematized photographic tradition in recent decades of fetishizing unpopulated architectural structures as sculptural objects, without fully accounting for their social function and/or political import. His "Excursionist Views" thus encourages a more active engagement of the viewer in their evocation of a disturbingly arrogant tendency on the part of urban planners to privilege form over function.

"Island Flora" focuses on the lush tropical vegetation moored on central highway reservations, presenting a view that is immediately paradisal but ultimately indicative of humankind's more disturbing instinct to force nature to conform to its more petty desire for an artificially aestheticized landscape. Beshty's attention to an utterly overlooked characteristic of the contemporary use of nature also prompts reflection on how other photographers have treated the subject. The vertical orientation and monumental scale of the images departs sharply from other pictorial representations of the landscape that tend towards a more horizontal format redolent of painting, asserting a physical presence in relationship to the viewer that underscores their sublime revelation of an unconsidered and unappreciated natural beauty.—Dominic Molon

[1] **#5 (Rte 110 and Rte 10 interchange)**, from the series **"Island Flora"**, 2005, colour photograph,
248.9 x 91.4 cm, 98 x 36 inches

[2] **#6 (Rte 101 South Bound)**, from the series **"Island Flora"**, 2005, colour photograph,
248.9 x 91.4 cm, 98 x 36 inches

[3] **#7 (Service Rte 1)**, from the series **"Island Flora"**, 2005, colour photograph, 248.9 x 91.4 cm, 98 x 36 inches

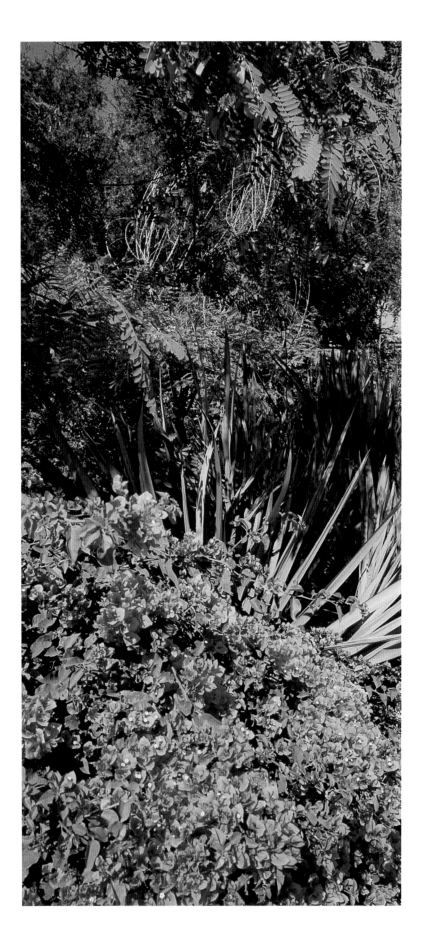

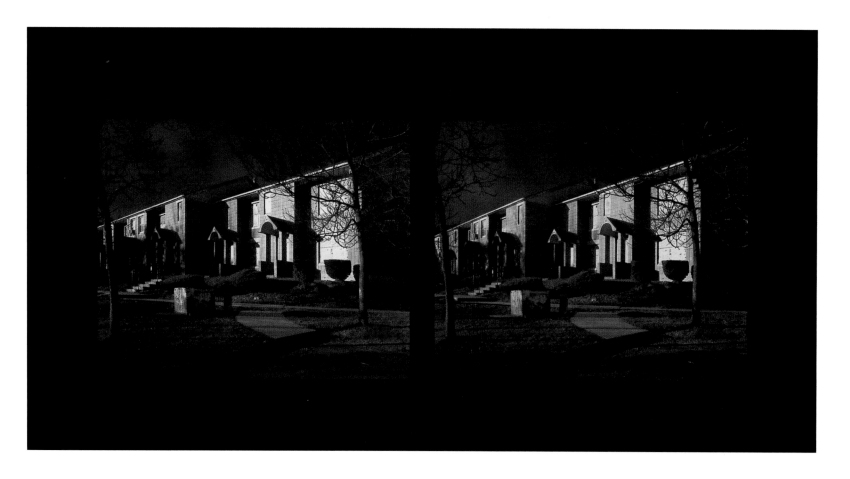

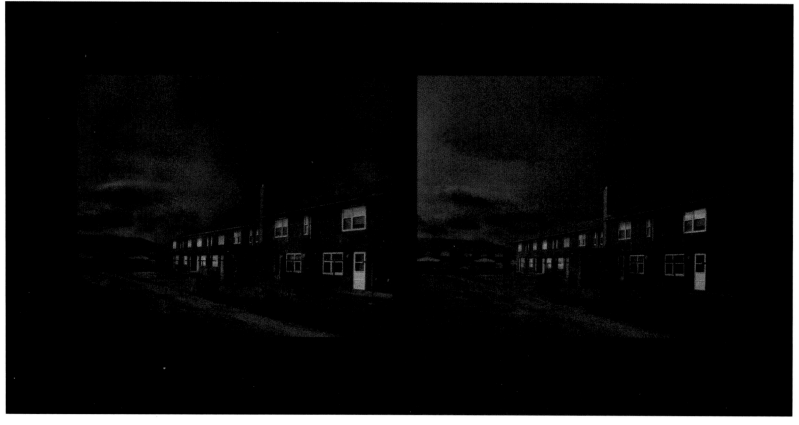

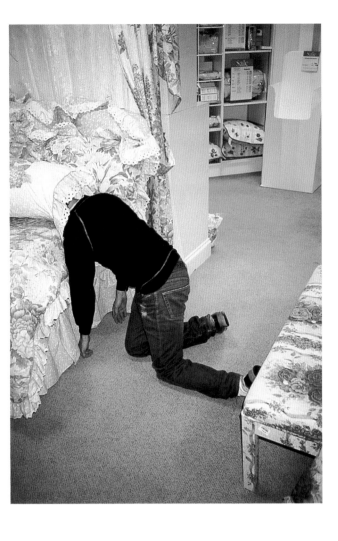

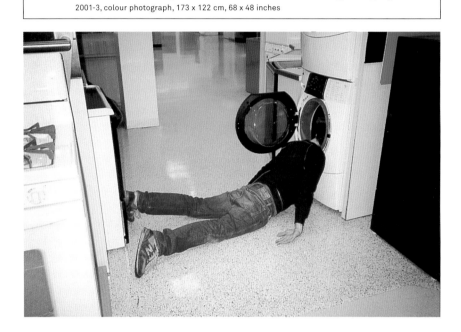

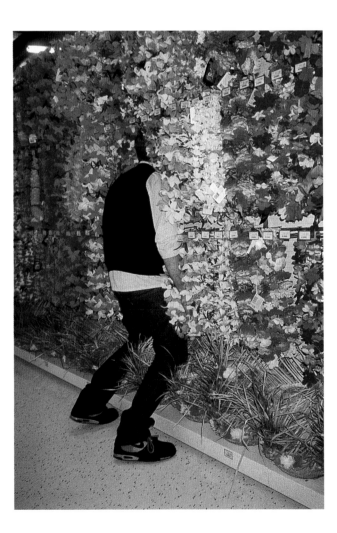

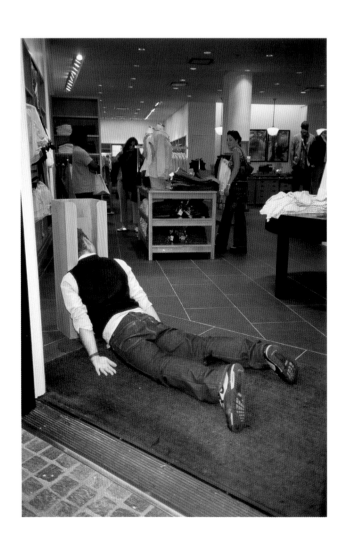

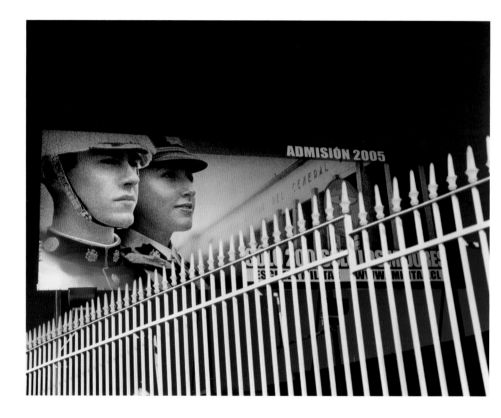

The sharp, saturated tones typical of the images of William
Eggleston and the other pioneers of colour photography
in the 1970s can be seen as a continuation by other means
of the clean, linear, and spontaneous aesthetic of the
"straight" photography of the century's early years; fulfilling
as black and white perhaps never quite could, Sadakichi
Hartmann's call for an expression that would be "vast and
varied, popular, vulgar, common and yet unforeseen."
By the 1990s an alternative approach to colour had begun
to emerge in the work of a number of photographers,
Rut Blees Luxemburg among them—one in which immediacy
would be replaced by slower forms of concentration
and clarity of form overwhelmed by shades, nuances and
sometimes even the downright Old-Masterish haziness
that had seemingly been banished from photography along
with the pictorialism of the late nineteenth century.
In her work of the mid-'90s, given the telling designation
"A Modern Project", Blees Luxemburg pictured the bleak and
looming architecture of contemporary urban peripheries—
multi-storey car parks, housing blocks, flyovers—but with
a melancholic monumentality as unexpected as it is
emotionally precise: seen at night, the essential vacancy
and desolation of these sites is revealed. And she did this
by using slow shutter speeds to capture such scenes
using the available light of street lamps and ambient
signage, disclosing an unnoticed colour-world: no modernist
crispness here, but rather suffused and strangely mellow
though acidic tonalities that might not have displeased
Rembrandt or Tintoretto, yet achieved through specifically
photographic means.

No wonder, then, that when I first encountered Blees
Luxemburg's work with her "Liebeslied" series shown in
1999, my first impulse was to ask the artist whether the
images—not the distant panoramas of "A Modern Project"
but close, intimate views of scruffy urban detail,
decontextualized—had been shot in Venice. Somehow the
painterliness, smouldering romanticism and tinge of
decadence seemed to imply such a setting, but, as I was
quickly informed, all the pictures were of workaday London,
the dark water flowing through so many of them not the
Canale Grande but the Thames, all transmuted by the
artist's patient eye into an otherworldly yet distressed
place irrigated by a deep but inviting Lethe.

For all that, Blees Luxemburg remains a sort of reporter or
documenter, perhaps something like what the Situationists
would have called a psychogeographer, and in the last few
years she seems to be bringing this dimension of her project
into clearer focus: some naggingly commonplace fact
always returns her stubborn gaze. Billboards, statuary and
insignia imbue the urban scene with a discursive dimension
that counterpoints Blees Luxemburg's penchant for exquisite
poetic reverie with the traces of an alienated authority. An
unnamed violence lurks somewhere in the background. And
yet something as abject as the random splotches of chewing
gum on the pavement (*The Kiss* [2003]) manages to become
one of what Luxemburg once called the "entryways into the
psyche of cities" that are her subject.—Barry Schwabsky

[1] **Admision**, from the series **"Tropic of Capricorn"**, 2005, C-print on aluminium, 150 x 180 cm, 59 x 71 inches

[2] **The Kiss**, from the series **"Ffolly"**, 2003, C-print on aluminium, 140 x 180 cm, 55 x 71 inches, collection Queensland Art Gallery, South Brisbane

[3] **Ffolly**, from the series **"Ffolly"**, 2003, C-print on aluminium, 140 x 180 cm, 55 x 71 inches

**Rut Blees
Luxemburg**

[4] [5]
 [6]

[4] **Immobilière**, from the series **"Phantom"**, 2003, C-print on aluminium, 90 x 115 cm,
 35.5 x 45 inches

[5] **Lust Passing Present**, from the series **"Tropic of Capricorn"**, 2005, C-print on aluminium,
 120 x 160 cm, 47 x 63 inches

[6] **The Libidinal Sofa**, 2003, C-print on aluminium, 130 x 180 cm, 51 x 71 inches,
 collection Tate, London

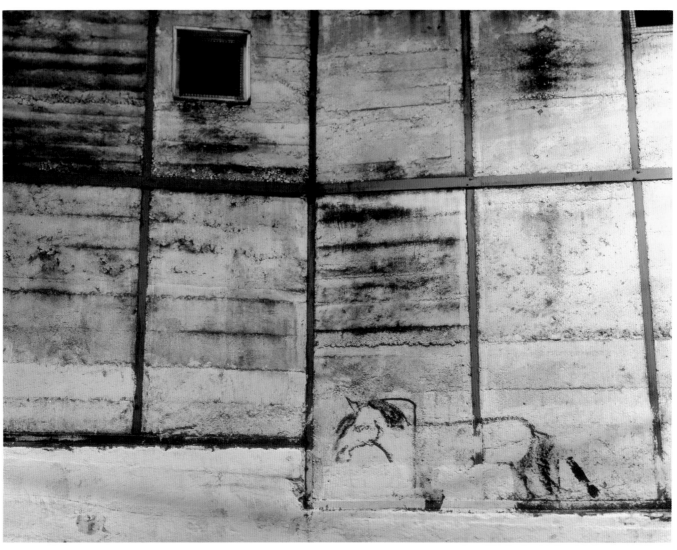

Luchezar Boyadjiev's work could be seen as a literalization of the notion that contemporary art is both an urban and a cosmopolitan phenomenon. At least that is the impression one gets when considering the two main arteries in his recent work. The ongoing "Guided Tour" series (begun 2003) explores the way contemporary art produced in one urban context is perceived in another—as part of his contribution to a large international show or biennial, the artist gives guided tours through the venue to visitors. Animating the space in between the works, sometimes for hours and sometimes for the benefit of a single visitor, Boyadjiev reveals the human and cosmopolitan nature of contemporary art. By linking artwork produced in one city by a specific individual to the perception of another individual living in the city where the work is displayed, the artist constructs temporary communities of people who briefly exist in a space with alternative characteristics.

The second line of Boyadjiev's recent work—the exploration of, and sometimes intervention into, the visual environment and dynamic interface of the city—is specifically photographic. His starting point is the notion of the city as a reflection of significant aspects from the lives of the inhabitants, from economic and social hierarchies to the political agenda and hidden structures of local power. The idea is not so much to investigate and/or interfere with readings of public imagery, but rather to map out the site-specific points at which global and local interests clash and collide. For Boyadjiev photography is as much a process of "visual crawling" around the city as it is the end product, the still image. His photographic works are either cycles of single city shots creating a linear montage, an alternative and individual mapping of the city, or digital montages creating a Dadaistic reshuffling of the status quo. The handwritten or typed text that often accompanies these works functions as a spinal cord, contextualizing as much as narrating the image. The artist takes an approach to photographing various cities that both localizes their specific visual identity and navigates the viewer through their cosmopolitan aspects. Repeating this compositional structure reveals elements that link different urban contexts as well as demonstrating the interplay of local and global on a human scale.

Boyadjiev's visual approach is best characterized as "double-take" collage. It does not matter what exactly constitutes the first or the second take on a view—the straight documentary photograph, the montage, the text or the sequence of the works. The relevant aspect is the constant double take between the position of the local and that of the tourist. For are we not, as the artist seems to be suggesting, always both inhabitants of and visitors to our own cities?—Vasif Kortun

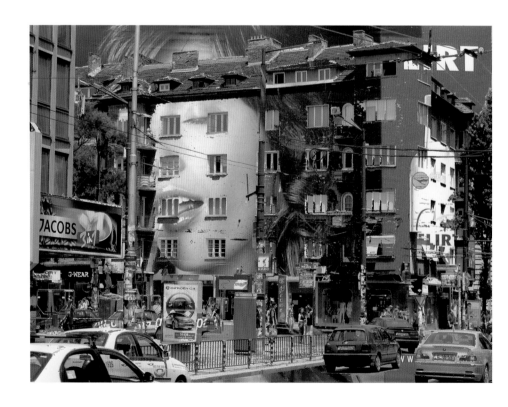

I imagined that I am a Visual Operative of the EU on a mission to evaluate the visual environment of Istanbul ahead of the negotiations.

The EU will certainly not encourage the new advances more then the old practices for it supports the cultural heritage and diversity in a member country…
Make sure you join in before such little but beautifully local and exotic shops and street economy practices have disappeared altogether from the face of the city!

[1] Untitled (Lexington, MA, USA), from the series "Poles", 2004, C-print on Diasec, 37.6 x 47 x 1.8 cm, 14.5 x 18.5 x 0.5 inches

[2] Untitled (Somerville, MA, USA), from the series "Poles", 2004, C-print on Diasec, 37.6 x 47 x 1.8 cm, 14.5 x 18.5 x 0.5 inches

[3] Untitled (St Niklaas B), from the series "Containers", 2000, C-print on Diasec, 57 x 76 x 2.2 cm, 22 x 29.5 x 1 inches

[4] Untitled (Antwerpen B), from the series "Containers", 2002, C-print on Diasec, 57 x 71 x 2.2 cm, 22 x 27.5 x 1 inches

Cologne-based photographer **Frank Breuer** was among the last to study under Bernd Becher at the Kunstakademie in Düsseldorf. Among Becher's students who have since risen to art-world prominence—Thomas Struth, Thomas Ruff, Candida Höfer, Andreas Gursky, Axel Hütte—Breuer's style can be described simultaneously as the most filial to and divergent from the black-and-white typological archive of industrial architecture captured by the master and his wife, Hilla, during the last forty-five years. Like them, Breuer has exclusively photographed the man-made environment, focusing for the past seven years on self-explanatory series titled "Logos", "Containers", "Warehouses", "Details" (a variation on his warehouse photographs) and, most recently, "Poles"; he has likewise resisted the urge to print his photographs on the heroic scale indulged by many of his contemporaries. Unlike the what-you-see-is-what-you-get Bechers, however, Breuer's photographs occasionally distort his subject matter. By placing structures against backgrounds that provide no context, which allows for radical confusions of scale, and by framing many of his compositions in such a manner as to achieve something approaching abstraction, Breuer sneaks a palpable subjectivity into his seemingly deadpan images.

Almost all of Breuer's pictures place their subjects at the centre of the composition, grant them a little breathing space, and set them against near-white skies that produce diffuse, natural light; they could be anywhere, shot at any time of day. However, most are taken around the edges of major cities. Collectively they document how methods of distribution, whether of material goods or immaterial "meaning", have replaced the sites of industrial production the Bechers recorded for posterity. The anonymous façades belong not to factories but to warehouses, the shipping containers move goods from port to port, the logos traffic in brand capital, and the wires extending in every direction from the poles disperse electricity, telephone conversations and cable television. Given that First-World societies take the free flow of goods and information for granted, Breuer's presentation of the infrastructure that underlies that movement can be read politically; he encourages us not only to see what we normally would ignore but, through repetition, teaches us to look at it closely, searching for marks of distinction.

Breuer began shooting "Poles" while a visiting lecturer at Harvard, and many of the pictures were taken in the small towns that encircle Boston. An American eye registers hints of the stateside suburban landscape not only in the familiar lines on the road, but also in the blandness of the flat-roofed buildings and near-colourless winter foliage, and discovers that the light in the American north-east is not unlike that in northern Europe. Placing the German photographer in American environs brings his relationship to American precursors to the fore, including Walker Evans (who frequently photographed signage), 1950s and '60s road masters like Robert Frank and Garry Winogrand, and Harry Callahan, whose own abstract pictures of crisscrossing electricity wires are an unsung mid-century achievement. And yet these pictures—cool, patient, rigorous—remain unmistakably Breuer's.—Brian Sholis

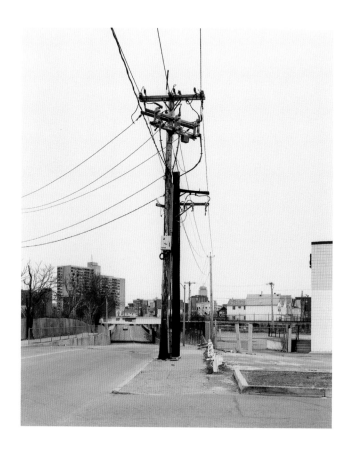

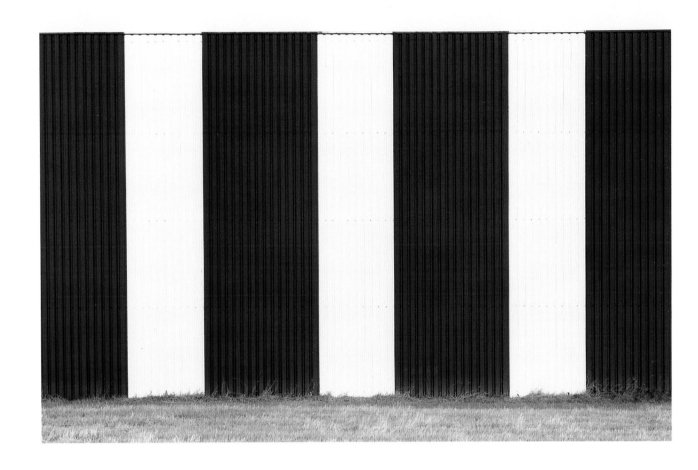

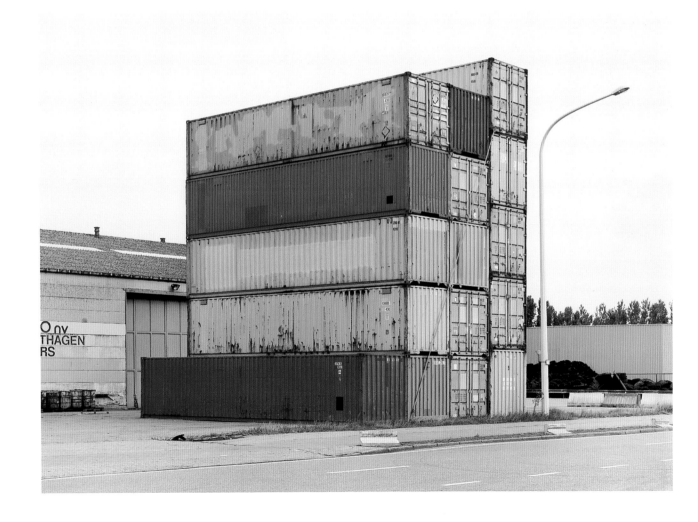

[1] Skeletons, 2002, C-print mounted on aluminium, laminated, 122 x 155 cm, 47.5 x 60.5 inches
[2] Blue Brothers, 2006, C-print mounted on aluminium, laminated, 122 x 155 cm, 47.5 x 60.5 inches
[3] We are such animals, 2004, C-print mounted on aluminium, laminated, 122 x 155 cm, 47.5 x 60.5 inches

Though there are clear formal distinctions to be made between **Olaf Breuning**'s video installations and his still photographs, the two are intrinsically linked by their shared absence of text, narration or script. Breuning's deft formal strategy of making reality appear stranger and more alienating than fiction confirms that his works are a meditation on the mysterious nature of identity itself. Breuning's two-channel video projection *Home* (2003) is the Swiss artist's most expansive work to date. A twenty-first century film noir made during a twelve-month trip around the world—with stops at the base of the Brooklyn Bridge; Manchester, England; an alpine ski resort; Machu Picchu, Peru; the Grand Canyon; Pennsylvania Amish country; the Las Vegas strip and the kitschy Madonna Inn in central California—*Home* draws its plot, or rather plots, from a range of media sources including European death metal music videos and straight-to-video Hollywood horror flicks, while conveying all the linearity and character development of a David Lynch film. The work offers a mesmerizing visual overview of the leitmotifs and cultural codes that Breuning has been mining in his photographic practice since first exhibiting internationally in 1997. Many of Breuning's photographs are populated by delusional asexual characters, desperate bands of half-dressed young white men, cheap motels and stunning scenery in exotic locales. Not only are his photographs about the human psyche navigating the compressed time-space continuum of today's digital culture, but his large-scale colour prints actually seem to be made from inside it—all in an effort to reject communicability as an intrinsic value in contemporary photography.

In most of his video works, such as *Woodworld* (1998), *Gum Glum Glee* (1999), *Knights* (2000) and *Group* (2001), Breuning's characters remain silent, and if they do speak, it is to lip-synch mindlessly to an eclectic musical soundtrack or to grunt in an effort to emote a zombie-like presence. Likewise the accompanying photographs, given the same titles as the videos, are shot while on set and usually have no text or linguistic tropes, functioning more as establishing shots or production notes.

Breuning also produces sets of photographs that are not overtly attached to video pieces, such as *Skeletons* (2002), *Mr Hand, Mrs Ass, Mrs Knee and M. Foot* (2004) and *Horse Farm* (2004). These works convey Breuning's ongoing interest in group dynamics, material accumulation and his droll sense of humour. While they may circulate as single photographs, they are still the result of an arduous production shoot in which he frequently serves as director, producer, editor and all the roles in between, often persuading friends to sit in elaborate poses.

Most recently, Breuning has taken to staging large-scale photographs that could have been digitally rendered, but instead are staged in a rudimentary fashion. For example, in *Easter Bunnies* (2004) Breuning affixed buck-toothed smiles and rabbit ears to metal armatures positioned in front of the sacred monuments on Easter Island. The image collapses the polarities of stupidity and holiness, but more significantly, the photograph is a confirmation that the artist was actually there. Even in the single photographic works, Breuning takes us back to an indelible moment in the video *Home*, in which a character resembling Breuning vomits the words "I Exist" in red blood on to pristine snow.
—Gloria Sutton

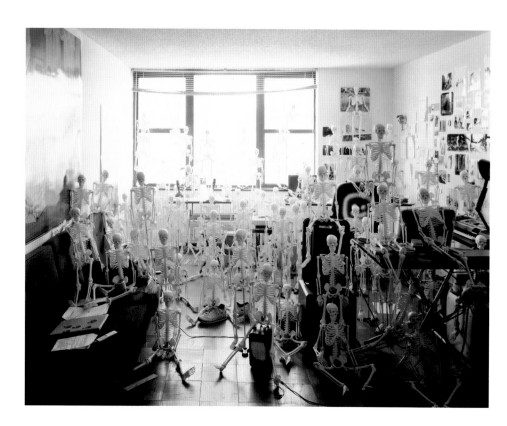

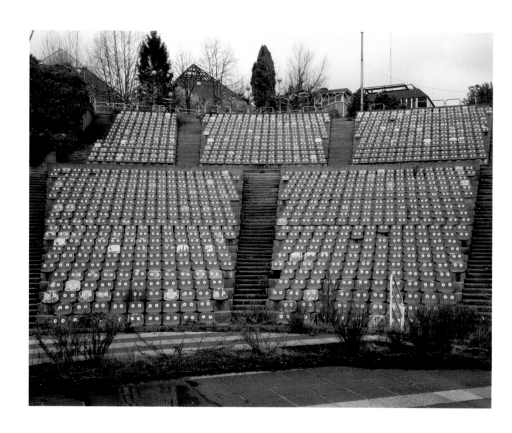

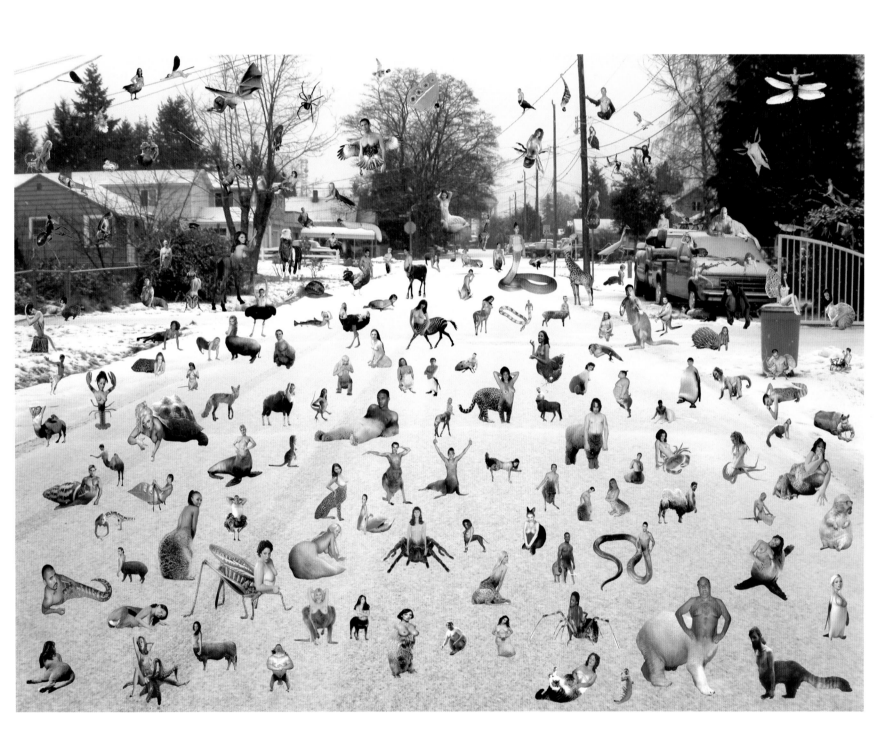

**Olaf
Breuning**

[4] [5]

[4] **Cat**, 2002, C-print mounted on aluminum, laminated, 122 x 155 cm, 46.5 x 60.5 inches
[5] **Peter**, 2005, C-print mounted on aluminum, laminated, 122 x 155 cm, 46.5 x 60.5 inches

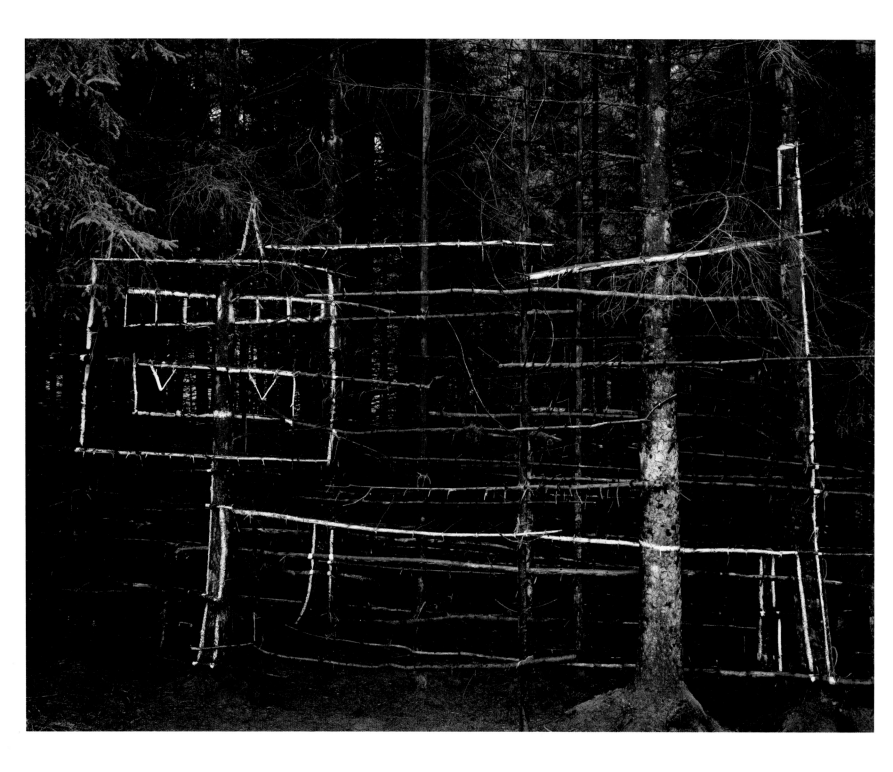

[4] **Cat**, 2002, C-print mounted on aluminum, laminated, 122 x 155 cm, 46.5 x 60.5 inches
[5] **Peter**, 2005, C-print mounted on aluminum, laminated, 122 x 155 cm, 46.5 x 60.5 inches

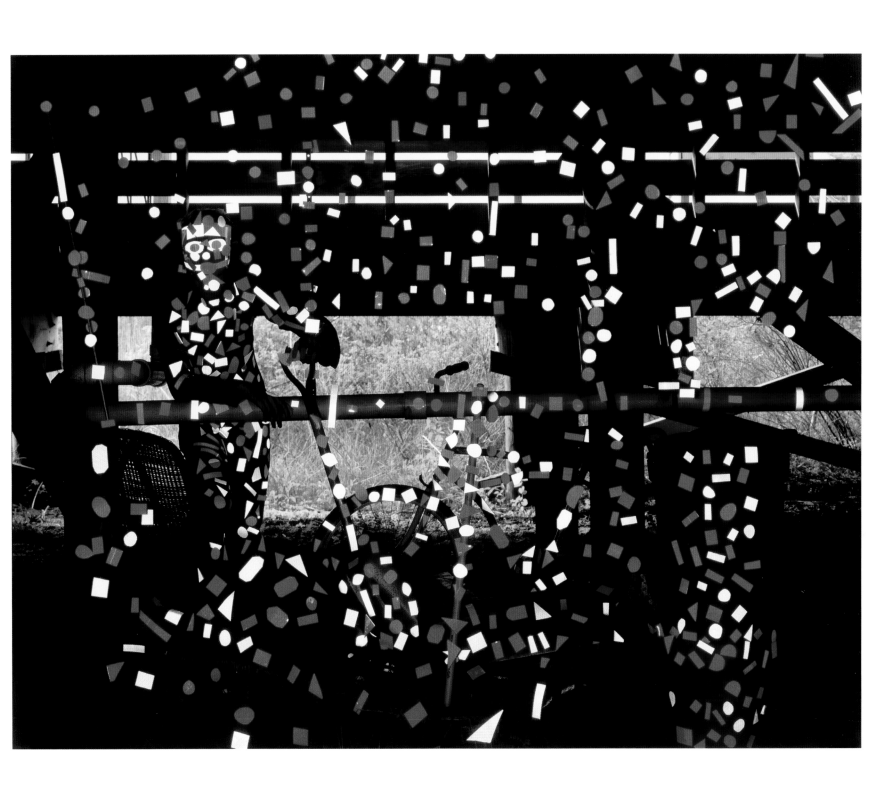

Since its inception, photography has had a tangled and difficult relationship with the notion of capturing truth. Artists working with this medium frequently play with an inherent ambiguity, whereby the camera cannot help but capture real things, and yet at the same time an accumulated body of theory and practice has made us sceptical. As Richard Bolton points out in his introduction to *The Contest of Meaning, Critical Histories of Photography* (1996), truth or meaning is not located solely within the image, but instead is "established through interpretative conventions that exist outside of the image—conventions that are socially and institutionally constructed". **Gerard Byrne** positions his practice within this territory, and it provides him with a rich seam of material—worked through in photographic form, as well as in video and to a lesser extent performance and installation.

For Byrne, the theatre presents an interesting comparison to photography because in conventional terms, as a means of presenting information, one takes the real as its point of departure while the other is essentially grounded in fiction. A series of photographs from 2001, taken on the sets of Samuel Beckett's *Waiting for Godot*, and Reginold Rose's *Twelve Angry Men* examines what happens when one medium makes an intervention into the other. These images show the sets from different perspectives; the camera roams around the stage, often adopting the positions of the characters in the play, going where they go and seeing what they see. Byrne grounds the theatrical make-believe with its mechanical gaze but at the same time produces a group of prints that provide open-ended material for imaginative speculation.

Byrne's video works also employ theatrical procedures, using actors to animate texts that he finds in old periodicals. *Why it's Time for Imperial, Again* (1999) does this to comic effect, staging a fake conversation between Frank Sinatra and the Chairman of Imperial (a car manufacturer), which was originally used for an advertisement in *National Geographic Magazine*. Another, *New Sexual Lifestyles* (2003), brings to life a text from a 1972 copy of *Playboy* magazine in which swingers debate the pros and cons of the sexual revolution. These works produce a concertina effect and as the original material evolves through different formats, we become aware of the authenticity content of the actor's performances and conscious of the different techniques and mechanisms that are used to transmit the texts.

A series of photographs called "In the News" (begun 2001) loosely addresses the editorial notion of topicality, suggesting images that might appear in different sections of a newspaper. In *Sold Out* (2004) a group of teenagers spray graffiti on to the side of a construction hoarding in Dublin's Smithfield Market. You get the impression from their relaxed demeanour that this is an action condoned by the council and the property developers, whose brand new luxury apartments are going up on the other side of the wall. The title refers to the apartments themselves (which have literally sold out) and also to the element of youthful delinquency that has been incorporated into the gentrification process sweeping through this once poor neighbourhood. We are presented with protagonists engaged in an act that seems determined by the surroundings in which it occurs. They are "in the news" but not "making the news". The public space of the square appears as an environment in which behaviour is channelled along certain lines, and "the news" becomes a format where we see ourselves as staged participants, within the larger course of social and historical events.
—Grant Watson

Having started photographing her family at the age of fifteen using her father's Canon, **Elinor Carucci** has continued to do so ever since. Some of this work, from 1993 onwards, is gathered in her first book *Closer* (2002), a photographic diary of lusciously coloured images, ranging from extreme close-ups to semi-staged portraits. The intimacy of many of these images—which often feature herself and her family in the nude, casually acknowledging the camera's presence—have led to comparisons with the work of diarists such as Nan Goldin and Sally Mann. The comparison with Goldin does not adequately describe the composed, painterly nature of many of Carucci's images, with her beautiful, apparently functional family a world away from the characters depicted in Goldin's classic cycle, *The Ballad of Sexual Dependency* (1986). However, Goldin's words in the foreword to *The Ballad* resonate with Carucci's approach to photography: "People in the pictures say my camera is as much a part of being with me as any other aspect of knowing me. It's as if my hand were a camera." This assimilation of the camera into every-day life is something that Carucci has achieved, seeing the family members in her images as collaborating on her medi-tations on relationships, identity and intimacy.

One of her early photographs, *Mother puts on my lipstick* (1993), shows her mother applying a bright red lipstick to her daughter's lips. This maternal act literalizes the phrase "make-up", as the face of the artist is made up into the image of her mother's, who appears only as the controlling hands holding her daughter's face still, the nails painted a matching shade of scarlet. Carucci's relationship to her glamorous mother, and to femininity in general, is a theme that runs through her photography, from the imprint of a zip left on soft flesh, to the portraits of three generations of her family—from herself to her grandmother.

In the series "Crisis" (2001-3), Carucci remains focused on intimate relationships as she documents the tension between herself and her husband Eran, depicting scenes of emotional difficulty that most photographers would keep private. Carucci's comments register her own awareness of the boundaries that are crossed in her work: "I was surprised by the fact that I needed so much to make pictures, that I was pushing my own limits. I wanted to look at us. I wanted to be able to see the beauty in those painful moments, to create, to feel myself and who I am because everything else felt out of control."

In another recent series Carucci moves outside the domestic sphere, turning her camera on her public performances as a belly dancer in New York. Taken in the years following Carucci's move from her home town of Jerusalem to New York in 1995, this series has more of a reportage feel than the meditative work with her family. Using a panoramic camera, and collaborating with her husband Eran, this series moves between the heady excitement of the performance to the awkward, private moments of getting changed in cramped bathrooms. The panoramic format captures the movement and vibrancy of these dances, with Carucci's presence recorded as a magical flurry of sparkle and cloth, a kind of reworking of the Surrealist category "*explosante-fixe*" (which was also pictured by Man Ray in 1934 as a dancer's whirling costume), relocated to the centre of an everyday family party. Seen alongside images of Carucci getting ready on an underground train or shaving her legs, this series addresses the divisions between public and private selves, celebrating the moments of preparation and repose as much as those filled with glamour and noise.—Catherine Grant

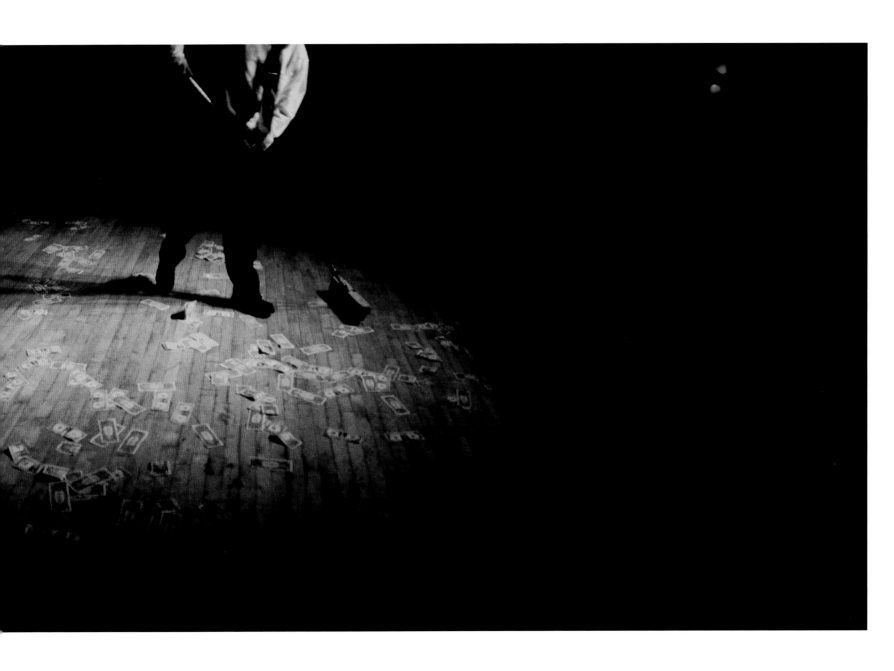

[2] [3]
 [4]

[2] **Guilt**, from the series **"Crisis"**, 2002, C-print, 76.2 x 101.6 cm, 30 x 40 inches
[3] **Eran and I**, from the series **"Crisis"**, 2001, C-print, 76.2 x 101.6 cm, 30 x 40 inches
[4] **First tears over another man**, from the series **"Crisis"**, 2002, C-print,
 76.2 x 101.6 cm, 30 x 40 inches

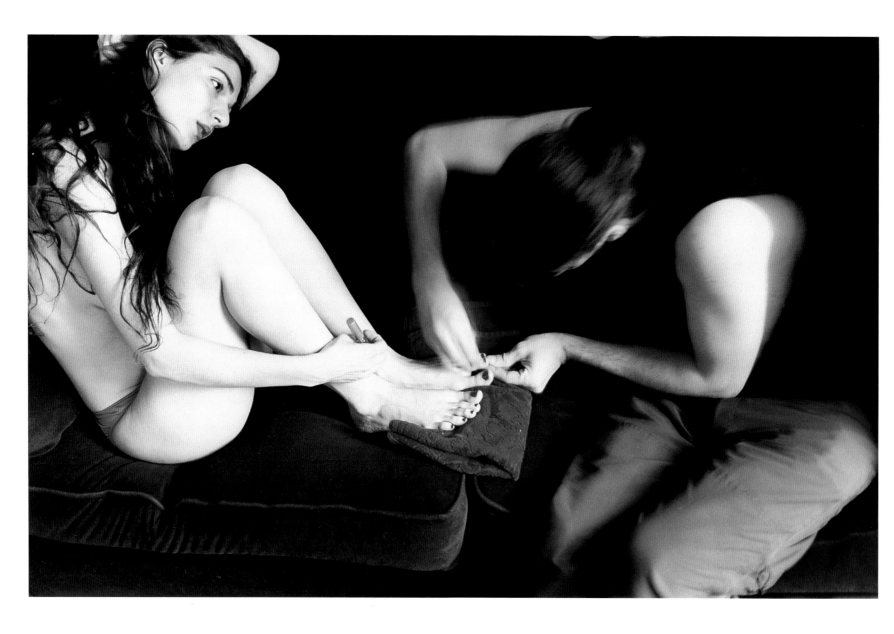

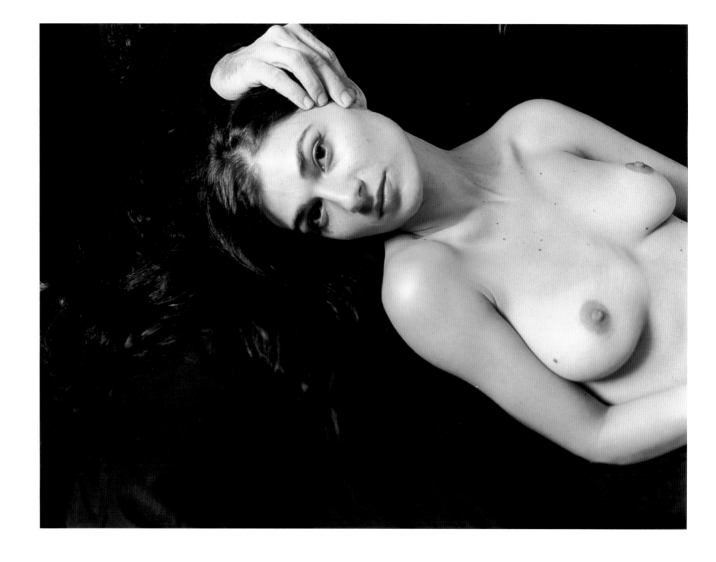

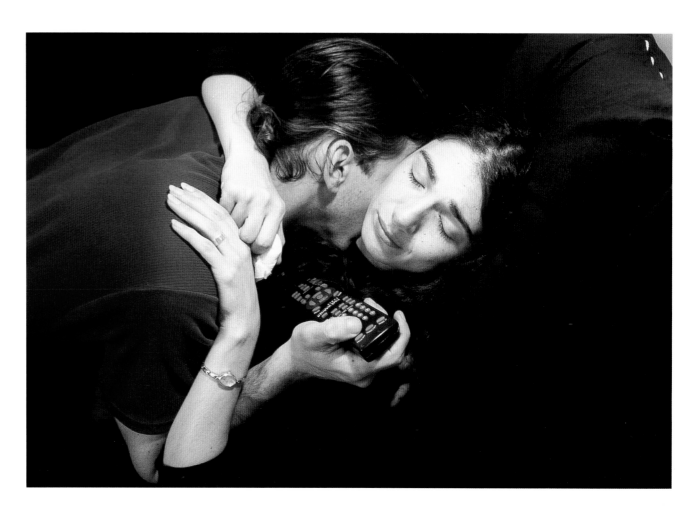

David Claerbout's practice touches on the phenomenological divide between photography and film to startling effect. In a series of projected images he has been making since the late 1990s-including *Retrospection* (2000), *Reflecting Sunset* (2003), *Vietnam, 1967, near Duc Pho (reconstruction after Hiromishi Mine)* (2001), and *The Shadow Piece* (2005) Claerbout appropriates enigmatic early twentieth-century photographs and introduces them into video streams within installation formats. The once snapshot-sized images are enlarged to architectural scale and thrown into filmic temporality. Creating a mesmerizing perceptual experience, these "moving stills" emphasize both the still contemplative duration of photography and the illusion of movement found in film. Responding to the desire to enliven immobile figures from the past, they thereby dramatize the traumatic relation to historical time that characterizes photography. *The Shadow Piece* images a modern office building's interior, its floor patterned with long shadows rhythmically intertwining with a spiral staircase's sweeping railing. Projecting this archival photograph into a twenty-five minute video, Claerbout intervenes in the image by digitally adding figures who move about its upper portion, shown in the same black and white tones as the photographic source. Many pass by on the sidewalk, others walk up to the door and try to gain entrance. The illusion is convincing and uncanny: bridging past and present, it is as if the artist brings the photograph's subject back to life, or transports us into the living past; yet this magical resurrection, or journey through time, is only partial and placed in check by the glass doors that remain ultimately closed, granting access only to light. Barring passage to bodies, *The Shadow Piece* betrays its ultimate inaccessibility, despite the artist's virtual incursions.

The signs of movement are similarly achieved both in the reflections of the setting sun that gradually move across the facade of a 1930s-era Italian building in *Reflecting Sunset*, and in the environmental effects of shifting luminosity in the photograph of the imminent crash of a broken-up American fighter plane still in flight in *Vietnam, 1967, near Duc Pho*. These pieces point to a certain end of analogue photography in the age of digital reproduction. Claerbout's work dwells in that very moment when we realize that photography's claims to objectivity and truthfulness-although never totally secure from earlier manual manipulations-have now completely surrendered to the fictional effects of digital processes. The unanswered question is whether this development will lead towards a heightened experience of historical amnesia as the past is overwhelmed by technological appropriation, or if this emerging photographic condition, which is effectively allegorized in Claerbout's practice, will instead initiate a newly appreciated realization that history has always been insecure and subject to the political and ideological prerogatives concurrent with its production. Whichever the answer, Claerbout's work encourages a slowing down of perception and a heightened visual contemplativeness, particularly in his backlit transparencies, such as *Nightscape Lightbox* (2002-3), which, when viewed in dark conditions as the artist intends, drops luminous experience to degree zero. In this age of increasing speed and growing inattentiveness this can only be salutary. —TJ Demos

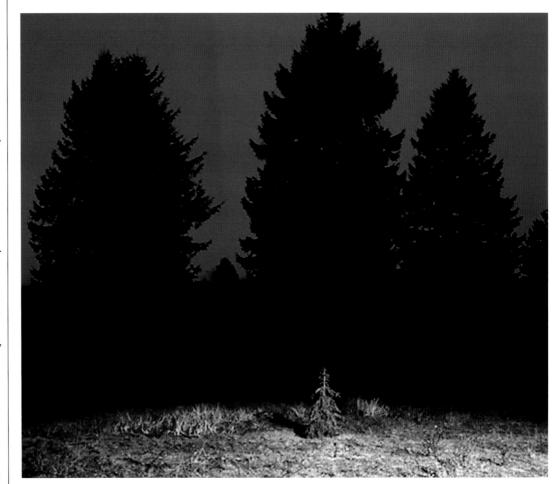

[1] **Nightscape Lightbox (fourth)**, 2002-3, black anodized aluminium lightbox, cibachrome mounted on plexiglas with protection layer,
 125 x 146 x 20 cm, 49 x 57 x 8 inches
[2-5] **Retrospection**, 2000, black-and-white video still, single channel video installation with sound, 200 x 150 cm, 79 x 59 inches (variable), 16 minutes
[6] **The Shadow Piece**, 2005, black-and-white video still, single channel video installation, digital betacam transferred to DVD, dimensions variable,
 25 minutes

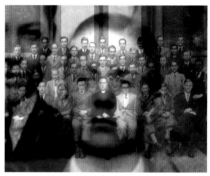
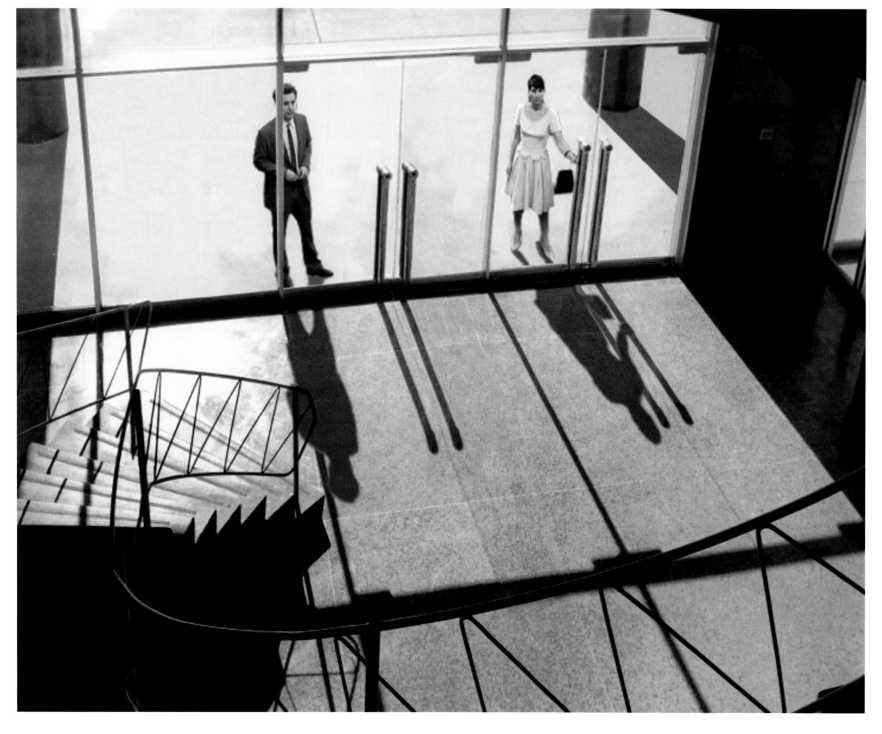

Anne Collier explores interiors in every sense of the word. Her practice seldom ventures outdoors, her intellectual appetite is for psychological themes and, more often than not, her pictures deal with others through the cipher of herself. For some years, emotional content was regarded as an unwelcome contaminant of art associated with sentimental family portraits and cloying marketing campaigns. Collier's practice reconsiders the messy world of affective expression, paying particular attention to the way photographs act as transitional objects and repositories of displaced feeling.

Self-portraits are a key feature of Collier's oeuvre. *Mirrorball* (2004), for example, plays with artistic self-image in a way that echoes the art of Francesca Woodman and Lucas Samaras. Reflected in a battered disco ball that has seen too many late nights, Collier is reduced, like a Cubist muse, into a fragmented heap. However, her Cyclopean eye looks at the viewer, revealing her desire to make contact and insisting on her authorship. With a streak of dark humour, in the even white light of a daytime studio, *Mirrorball* suggests a fear of falling apart and warns against the dangers of tantalizing self-absorption.

In *Songwriter* (2004) Collier engages in another kind of existential experiment by positioning a found photograph as her alter ego. Here Collier is literally self-effacing as she holds an album cover bearing the life-size head of an impossibly happy folk singer above her own body. As well as suggesting that we come to understand ourselves through representation, it implies the impossibility of direct expression and, ironically, the straightforwardness of appropriation.

Even when Collier works in the genre of still life, the images often feel like displaced self-portraits—something that differentiates her from other artists who appropriate popular imagery, such as Richard Prince. In *Crying* (2005) the beautiful actress Ingrid Bergman weeps in isolation. Her sorrow is visually contained by the album frame; her unstable emotion is surrounded and counterbalanced by the absolute solidity of the minimal black-and-white landscape with its perfectly balanced horizon.

Literalization and metaphor often play it out in Collier's pictures. In *Problems 2* (2005), a work that speaks to the dry conceptual photography of Christopher Williams, a self-help cassette tape labelled "Problems" has had its insides pulled out. The ruined, unravelled tape becomes an Abstract Expressionist composition—a spoof on the beliefs and excesses of another artistic age, but also an object of identification for those of us who have been there.

Collier's photography is full of compelling contradictions. It feels cooked and raw, forged and authentic, sad and droll. For all her use of herself in her work, Collier's practice is not egocentric. On the contrary, her restrained photographs stay well clear of the obsessive nightmares of narcissism.
—Sarah Thornton

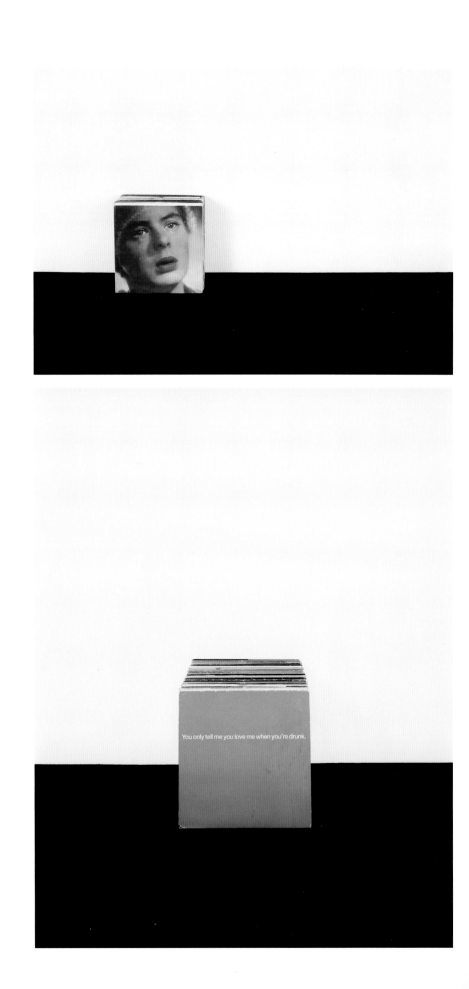

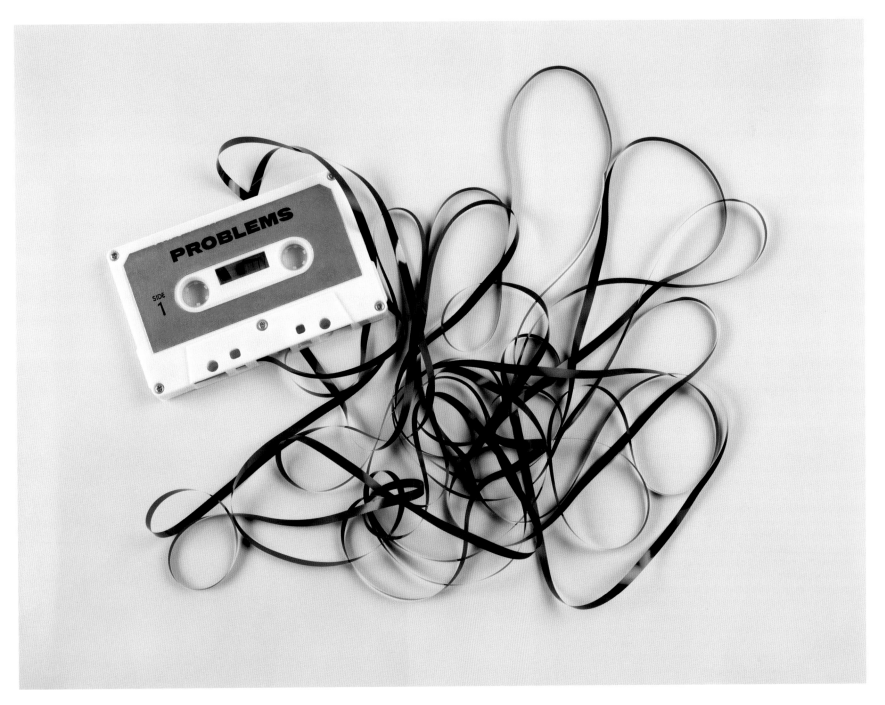

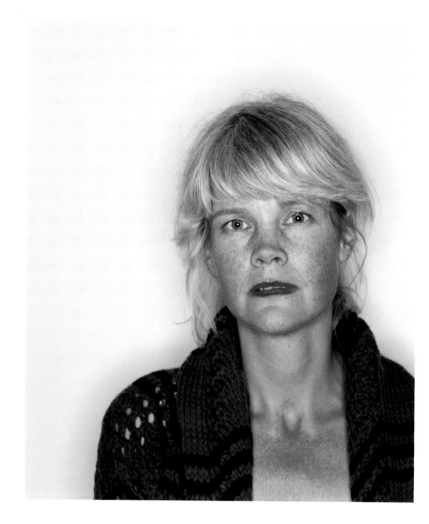

It is customary to say an artist was "Born here, lives and works there," but British-born artist **Phil Collins** can be difficult to pin down geographically. Although he is more or less based in the UK, it may be more accurate to say that Collins works in places where human dignity valiantly triumphs over considerable adversity. To date, his photographs and videos have taken him to Belfast, Belgrade, Bethlehem and Baghdad, and the art that he has made in these ravaged locales is notable for its insistent focus on individual subjects. Collins substitutes specificity for the generalizations typically proffered by media outlets, creating lyrical portraits of the damage done to those beset by hardship. He would be the first to say, however, that he is by no means a one-man "Photographers Without Borders", and it is his self-conscious acknowledgement of the exchanges, material or otherwise, required by his practice that has increasingly taken centre stage in his art.

Many of the photographs Collins took early in this decade are suffused with an intimacy that betrays his relationship to his subjects. Sinisa, the artist's boyfriend, is pictured in cool, blue, morning half-light; Sanja, plainly pretty but with eyes ringed by sleeplessness, is shown the morning after her boyfriend Vlada left for the army. These individuals have placed their trust in Collins and, in exchange, he has depicted them humanely, effectively showing how societal upheavals inflect but by no means halt the mundane charms of everyday life.

The projects Collins has undertaken more recently can be said to shift the priorities of these earlier works. Rather than highlight the ways in which his subjects' lives are inextricably linked to the places where they live and to events they cannot control, many of these photographs offer those he focuses on a temporary flight from routine and, to those watching, the guilt-ameliorating fantasy of uncomplicated identification with subjects who, after their time with Collins, often return to lives more difficult than our own. One can connect to the Iraqis in *baghdad screentests* (2002) or the young Palestinians in *they shoot horses* (2004) through Collins's use of Warhol's filmic strategy as a mediating device. But the inorganic, occasionally even contractual, relationship Collins now has with his "stars" complicates our empathy, highlighting the inequalities of any such relationship, even an artistic one that makes use of a "documentary" aesthetic.

This is especially true of "free fotolab" (2005), a series of photographs not even taken by the artist. Instead Collins offers to pay the fees to develop his subjects' personal snapshots in exchange for the right to use pictures from the film roll in whatever manner he chooses. This leads to a level of intimacy that surpasses even the tenderest of his early portraits, albeit a seemingly intrusive one that can be more difficult to look at. Another such instance is the series "*you'll never work in this town again*" (begun 2004), where Collins examines art world relationships, in particular those between the artist and curator. Shot against a white wall, these characters are individually portrayed directly after receiving a hard slap across the face from Collins, thus provoking a rather astonished and unguarded grimace and perhaps eliciting empathy and even envy.

Collins's work has ranged fully across the methodological spectrum, from passionate involvement to businesslike interaction, all the while maintaining a specificity and precision—through his focus on the individual—that ultimately drives us towards compassion.—Brian Sholis

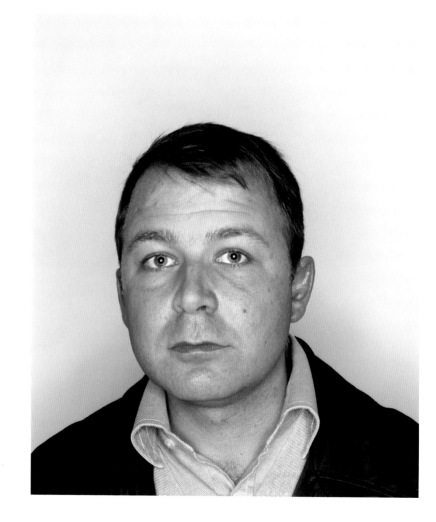

[1] **you'll never work in this town again (bettina)**, from the series **"you'll never work in this town again"**, begun 2004, lightjet print on Fuji Crystal Archive paper reverse mounted behind Diasec, 100 x 80 cm, 45 x 32 inches

[2] **you'll never work in this town again (anders)**, from the series **"you'll never work in this town again"**, begun 2004, lightjet print on Fuji Crystal Archive paper reverse mounted behind Diasec, 100 x 80 cm, 45 x 32 inches

[3] **you'll never work in this town again (pernilla)**, from the series **"you'll never work in this town again"**, begun 2004, lightjet print on Fuji Crystal Archive paper reverse mounted behind Diasec, 100 x 80 cm, 45 x 32 inches

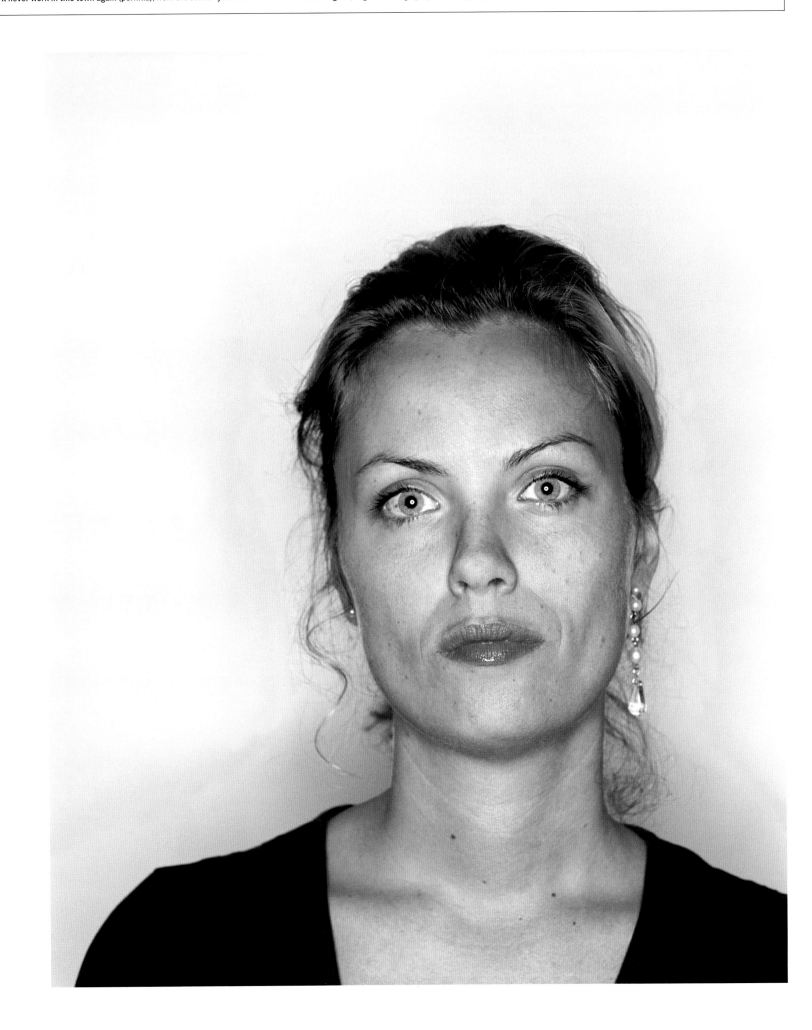

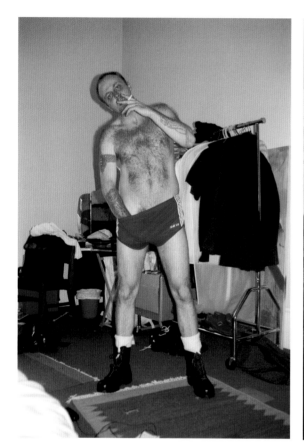
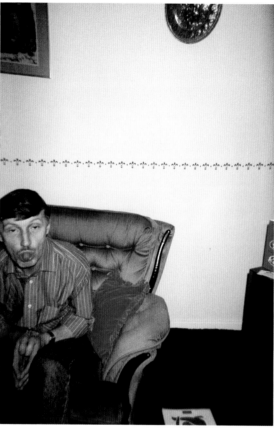
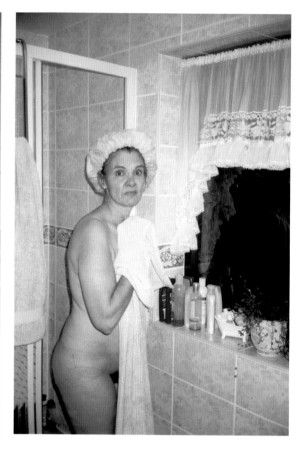

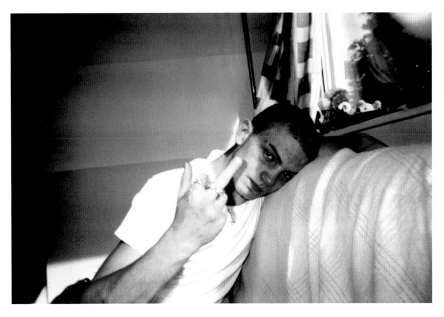

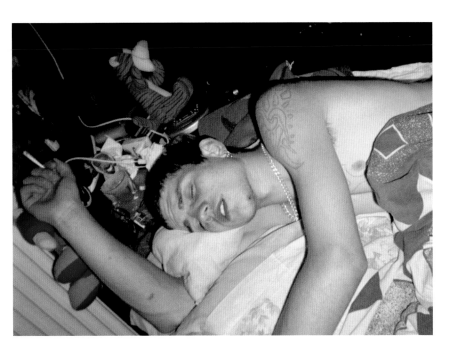

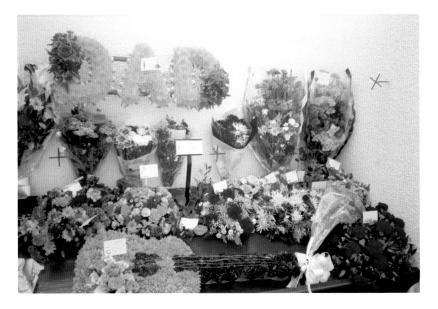

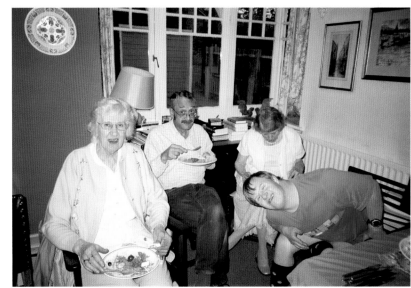

[1] [3]
[2] [4]
 [5]

[1] **Giggle**, from the series **"Double Life"**, 2002, Durst-Lambda photograph, 76.2 x 101.6 cm, 30 x 40 inches,
 collection Microsoft, The Columbus Museum of Art, Ohio, The Dallas Museum of Art, Texas

[2] **Kitchen Tension**, from the series **"Double Life"**, 2002, Durst-Lambda photograph, 76.2 x 101.6 cm,
 30 x 40 inches, collection Los Angeles County Museum of Art, Los Angeles, Museum of Fine Arts, Houston

[3] **The Conversation**, from the series **"Double Life"**, 2002, Durst-Lambda photograph, 76.2 x 101.6 cm,
 30 x 40 inches, collection The Museum of Fine Arts, Houston

[4] **The Space Between**, from the series **"Double Life"**, 2002, Durst-Lambda photograph, 76.2 x 101.6 cm,
 30 x 40 inches, collection Los Angeles County Museum of Art, Los Angeles

[5] **Sunset**, from the series **"Double Life"**, 2005, Durst-Lambda photograph, 76.2 x 101.6 cm, 30 x 40 inches

Since 2002 **Kelli Connell** has been working on the series "Double Life", in which a relationship between two women appears to unfold. Moments of intimacy, argument and repose are presented to the viewer in a documentary style, with attention paid to the changing emotional landscape of a relationship—from first flirtations to a comfortable domesticity. The two characters also appear to change from image to image—at times presented as butch and femme, polarized in their dress and attitude, at others appearing to be each other's double. This doubling points to the aspect of Connell's work that becomes evident after looking at a number of the photographs carefully. These are not documentary shots of a couple, but digital montages of one model playing both parts.

The model in the photographs is often mistaken for the artist, as one of the narratives being played out in this series is the relationship of the self to others, and the enactment of different aspects of the self in fantasy as well as reality. Utilizing the potential for photography to "fake" encounters is not new, with photographers from Henry Peach Robinson to Jeff Wall having used double exposures to present multiple selves for the viewer. Connell's work takes this doubling one step further, however, exploring the potential of digital technology to depict a seamless interaction between characters to fool the eye into believing these are "real" scenes — especially disconcerting in images where the two characters touch each other, or an emotional tension is built up in their fictitious gazes at each other.

Working with her friend Kiba Jacobson as the model for these photographs, Connell explains how Jacobson's ability to appear both masculine and feminine appealed to her, as well as her ability to act out the different scenes across the series. Jacobson's similar physical appearance to Connell also adds to the presentation of various selves, with Connell standing in for the "other" character in the setting up of the shots, with her hand or back sometimes remaining in the final montage.

Possible readings of this series range from a photographic diary of an imaginary lesbian couple, with one character trying on all the parts, to a disruption of identity categories in which each photograph plays with gestures, costumes and settings, so that the women depicted are multiplied beyond a narrative of two people's romance. In an image such as *Giggle* (2002), the two women are literally doubles of each other, with the same white shirt and hairstyle, as if the moment of laughter has created a visual similarity in the pair, or the model is laughing with herself, depicted literally on the photographic surface. This contrasts with the realism of scenes such as *Convertible Kiss* (2002), where the rational reading of the image (that the two characters are the same woman) is constantly undone by the emotional charge between them. Viewing Connell's images results in a kind of vertigo, as an emotional engagement is built up through the convincing nature of these fictional moments, whilst being constantly undercut by the knowledge of the images' construction. Like the strange, uncanny spaces of such digital manipulators as Wendy McMurdo, Connell confronts the viewer with the continuing desire to believe the photograph's stories.—Catherine Grant

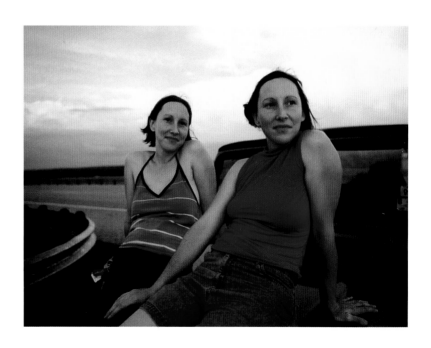

The subject in **Eduardo Consuegra**'s photographs is urban space — more specifically Bogotá, his native city. A bustling metropolis of nearly eight million people, Bogotá has suffered the effects of an accelerated and anarchic growth since the 1950s. It could be said that in terms of urban development it is still a young city (despite its 450 years), as even the most consolidated neighbourhoods are undergoing constant transformation due to urban property speculation and the changes in zoning and land use.

Consuegra uses a large-format camera with a closed diaphragm, giving an extremely ample depth-of-field that allows the images to be read as pure surface. Thus, the different layers of the city he portrays (historical, stylistic) are subsumed within a unifying foreground. This tension between the multiple layers depicted and the homogeneous surface of the photograph, between the reality of the city and the reality of the image, renders uncanny these otherwise banal images. Take, for example, the "Zona Rosa" series of 2001. Built in the 1950s as a residential area, the Zona Rosa deteriorated during the '80s as a result of the increase in demand for gated condominiums or high-rise apartments. The houses were recycled into shops, boutiques and bars, or torn down and replaced by malls. Recently the Zona Rosa has become an area for shopping and intense night-life. Shot in the early morning — devoid of any lights, activity or human presence that would animate the buildings — the photographs crudely show the absurd juxtaposing of styles and scales.

It has been noted that the modern project for the city was abandoned before it could be completed; in many Latin American cities this is rendered visible, but in the form of caricature. Urban sedimentation would require a certain time for the city to assimilate the continuous historical layering that constitutes its history. But here buildings are built and destroyed with a rapidity that negates any possibility of a unified or homogeneous urban profile. The city can merely respond to ever-changing zoning laws, consumer trends, commercial interests and the pressures of the real-estate market.

Consuegra's series "Centro Internacional" [International Business Centre] (2003-4), also in Bogotá, are no different in essence. Shot from above, the photographs show what the eye of the streetwalker seldom sees: the nondescript roofs, the vacant lots turned into parking spaces, the makeshift constructions of the terraces. In this area, which was the main business centre in the 1960s and '70s, construction has stalled. The main businesses have gone elsewhere, leaving the buildings as "ghosts of modernity" in a space cast aside by further modernization. As Consuegra has stated, "maybe construction did not stop for good, but it took another path, devoid of any utopian concept but also without a postmodern conscience." Many would have a hard time trying to elicit stylistic meaning from this architectural potpourri — Consuegra's unaltered photographs confront the viewer with an image that has the visual complexity and stylistic paradox of a photographic collage. They show the effects of urban development gone awry because of its unmediated subjection to the logic of capital. —José Roca

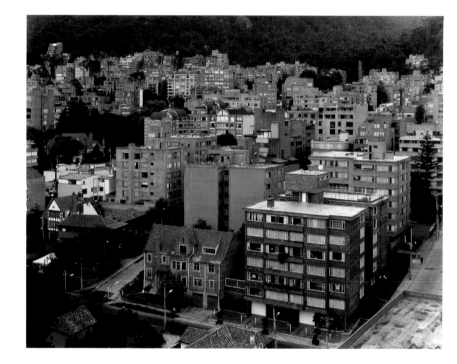

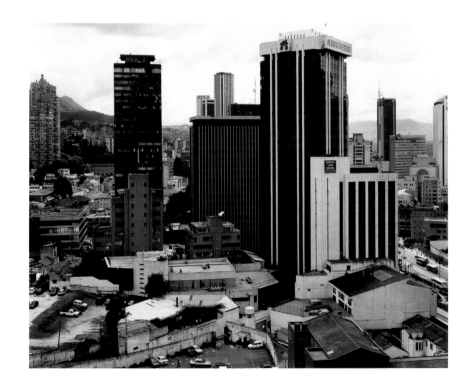

[1] **74th Street 5th Av**, from the series **"Rosales"**, 2003, C-print, Kodak Portra, 76.2 x 88.9 cm, 30 x 35 inches

[2] **30th Street 7th Av (downtown Bogotá)**, from the series **"Centro Internacional"**, 2003, C-print, Kodak Portra, 76.2 x 88.9 cm, 30 x 35 inches

[3] **14th Av 82nd Street**, from the series **"Zona Rosa"**, 2001, C-print, Kodak Portra, 50.8 x 63.5 cm, 20 x 25 inches

[4] **14th Av 81st Street**, from the series **"Zona Rosa"**, 2001, C-print, Kodak Portra, 50.8 x 63.5 cm, 20 x 25 inches

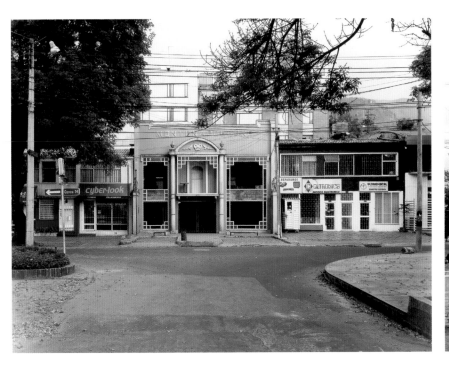

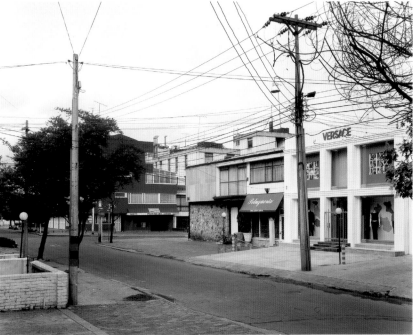

Sharon Core trained as a painter and worked as a pastry cook and food stylist before entering the Yale University Masters in Fine Art programme to study photography. She graduated along with a group of now prominent female photographers, among them Justine Kurland, Malerie Marder and Katy Grannan, interested in using the camera to stage oblique narratives (often featuring women). But, with a few exceptions, Core seems less interested in storytelling than in developing a conceptualist approach to consumption. Her photographs update longstanding painterly traditions, infusing them with a Bacchanalian spirit.

Two early series, titled "Eating" and "Drunk", are emblematic of this sensibility. The former, mostly shot in 1998, consists of close-up portraits of women, set against a monochromatic background, mid-bite. The latter, made between 1998 and 2000, is comprised of men and women pictured with as much detail, but in an inebriated state. Core set up an improvised studio in rooms adjoining bars or parties and invited her subjects to pose, glassy-eyed, for the camera. These are traditional portraits of decidedly non-traditional subjects, a theme Core pushed further in 2002 with a project that updated the "company" portraits of seventeenth-century Dutch painter Frans Hals. She presented diverse groups—from employees of Bijenkorf, a large Amsterdam department store, to squatters living at Overtoom 301, a multifunctional independent arts venue whose slogan is "no culture without subculture"—seated at long tables, enjoying fish suppers.

But it was an encounter with Wayne Thiebaud's 2001 Whitney Museum of American Art retrospective that inspired Core to make the photographs for which she has achieved widest acclaim. His early 1960s paintings, featuring a uniquely American comestible bounty—cakes, pies, diner-style sandwiches and hot dogs—presented a perfect fusion of her early interests, sending her back into the kitchen and off on a metaphysical inquiry that poses more questions than it answers. Since that time Core has recreated Thiebaud's canvases as three-dimensional constructions, baking the cakes and pies, building the shelves and shop displays, and arranging the lighting in an act of near-perfect mimicry. She photographed the results, and presented those pictures printed the same size as the canvas each was based on, provoking thoughts about the relationships between photography and painting and between originals and appropriations. But one must also take into consideration the complications that arise from the fact that Thiebaud himself supposedly painted from memory; that Core worked from photographic reproductions of the paintings rather than the canvases themselves; and that our mental images (and opinions) of Thiebaud's work surely, if subtly, inflect how we view these photographs. An established artist once said that one is lucky to have two or three good ideas over the course of a career. From the way these questions surround but do not engulf Core's seemingly simple gesture of appropriative recreation, it's clear that she has found one of hers.—Brian Sholis

[1] **Bakery Trucks**, 2005, C-print, dimensions variable
[2] **Drive-Thru**, 2005, C-print, dimensions variable
[3] **5 Hot Dogs**, from the series **"Thiebauds"**, 2003, C-print, 45.7 x 61 cm, 18 x 24 inches, collection
The Zabludowicz Collection, London

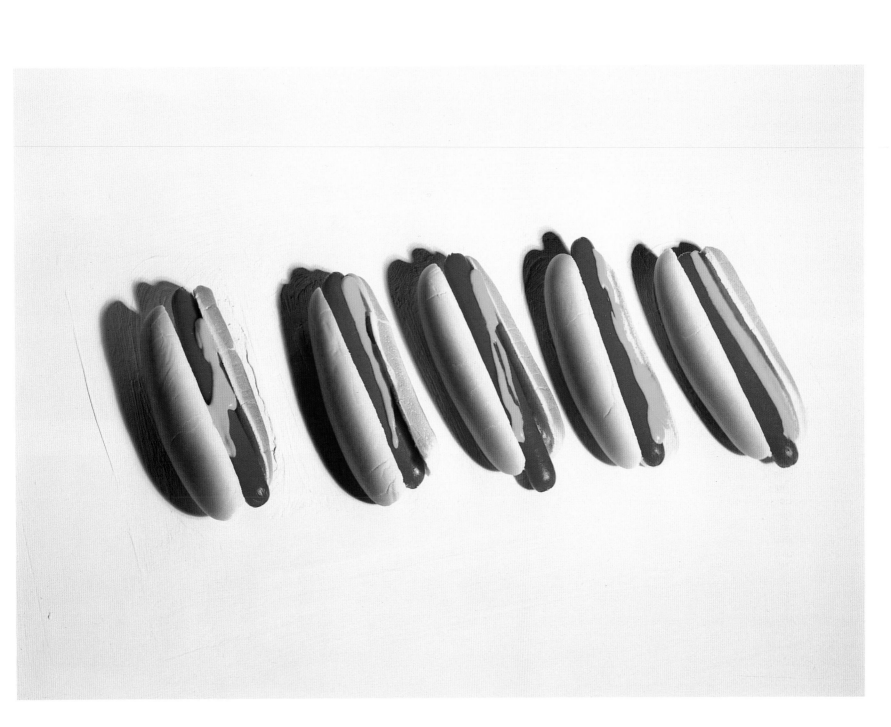

[1] [3]
[2]

[1] São Paulo (10), from the series "Quartos", 1998, colour photograph, 183 x 230 cm, 71.5 x 89.5 inches
[2] Installation view, "Pratos tipicos" at "Arte Cidade III", Moinho Matarazzo, São Paulo, 1997,
 plotter on vinyl, 250 x 310 cm, 97.5 x 121 inches
[3] Tijolo à vista, from the series "Arquitetura Informal", 2003, colour photograph,
 100 x 150 cm, 39 x 58.5 inches

Rochelle Costi's photography is anthropological in scope. She has become known for her insightful photographs, which probe private spaces and dwellings, everyday human habits and urban living conditions, predominantly in Brazil, her home country. Costi has often focused on the aesthetics of domesticity in search of not only telling cultural signifiers but also indirect forms of human portraiture. In the series "Quartos" [Bedrooms] (1998) the artist presents a variety of bedrooms belonging to people from different social strata. These interiors are shown without their inhabitants, but nevertheless contain a plethora of visual detail, enough to conjure an idea of the absent person. Costi offers a glimpse into the personal tastes, social status and living conditions of people from all walks of life, indirectly providing a piercing glimpse into the way they physically shape their most private spaces. Though these images are quite matter-of-fact in their presentation, Costi's talent for pinpointing the ritualistic, obsessive or even indifferent way people arrange their material possessions gives them a magical quality. From the Baroque-like opulence and abundance of some quarters, clearly belonging to the more affluent, to the spartan rooms that seem to resemble monastic cells, Costi offers broad insight into what she calls "the typologies of privacy".

This interest in everyday life and the banal or inconsequential aesthetics of the ordinary is also captured in the series "Pratos Tipicos" [Traditional Dishes] (1994-7). She presents the daily routines of the less privileged in photographs of dishes filled with simple meals taken close-up, from above. Though this is certainly not haute cuisine, Costi presents it lavishly, as if it were. Working on a large scale, she focuses on and monumentalizes the daily staple of working people, merging "low" iconography with "high" aesthetics, inviting the viewer into an enhanced common reality.

Recently Costi has turned her gaze from the private to the public and has become interested in buildings and architecture as an expression of social situations and conditions. In "Arquitectura Informal" [Informal Architecture] (2003) she focuses on improvised, makeshift dwellings to speak about living conditions and the survival strategies of people living on the margins of society; whilst in "Casa Cega" [Blind House] (2002), she focuses on properties that, due to lengthy legal procedures or difficulties in selling, have been boarded up by their owners to avert squatters, thus depriving these houses of any useful life.

A social interest runs through most of Costi's works. In her photographs issues of social rank, economic status and identity are all dealt with but in a manner that is neither judgmental nor heavy-handed. She possesses an acute eye for the simple and the unassuming, treating all her subject matter as if it were equally important. She presents even the most ordinary things as if they are larger than life, and renders all her images in rich, technicolor detail, demonstrating that the humble and the commonplace may also possess a lavish beauty or sense of opulence. — Katerina Gregos

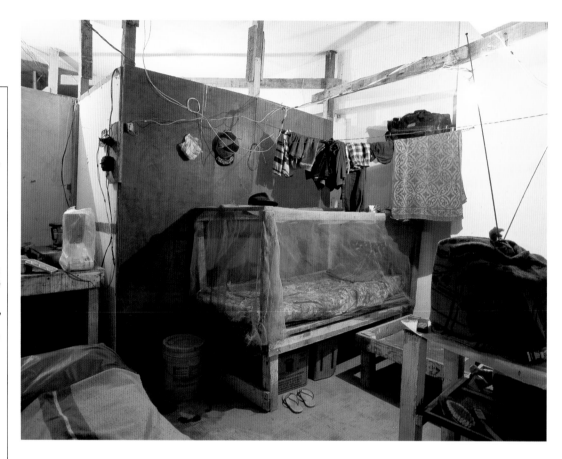

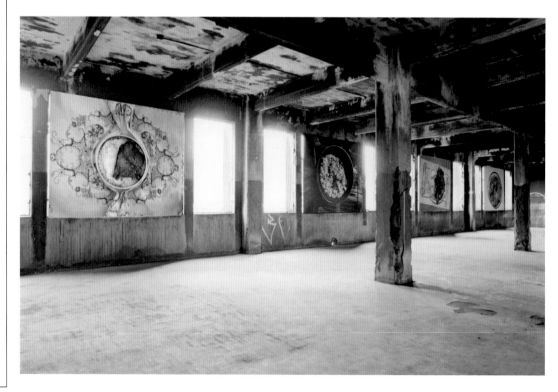

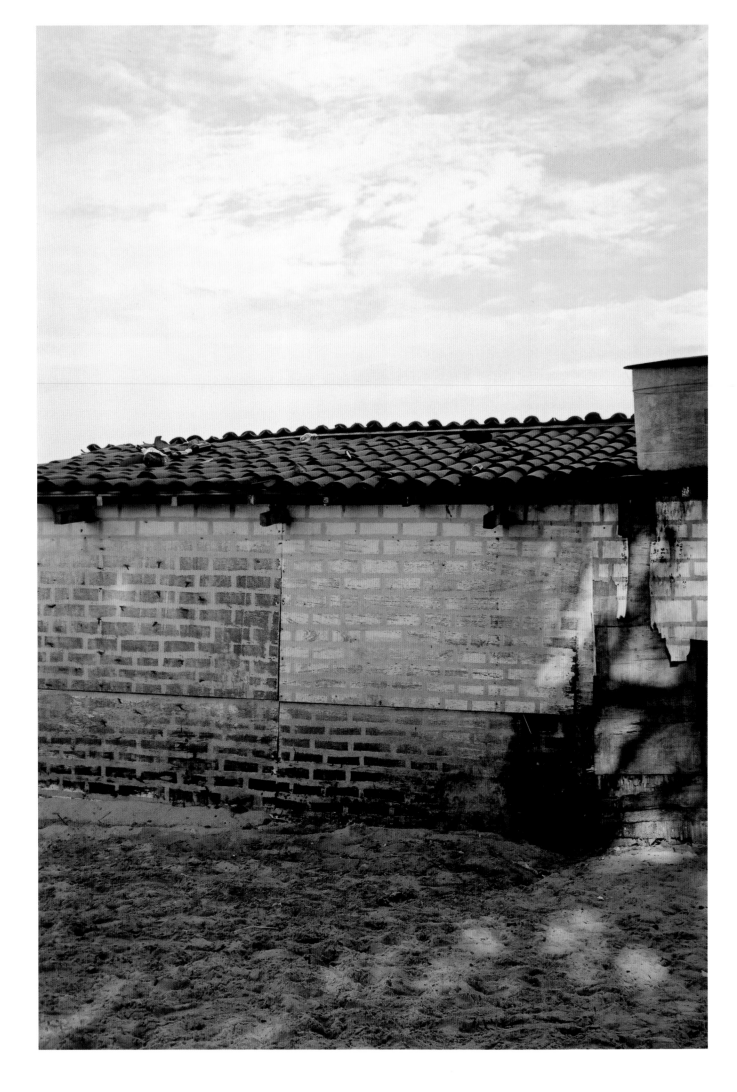

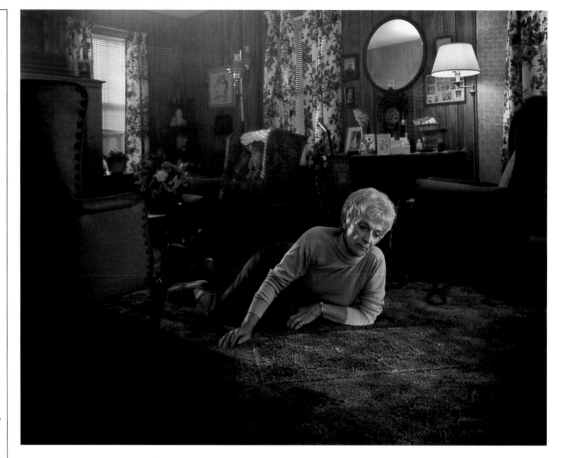

Dystopic communities, desolated streets and abandoned intersections riddle the photography of **Gregory Crewdson**. Close your eyes and imagine a scene from *ET*, *Close Encounters of the Third Kind* or *Poltergeist*. A seductive swathe of colour washes over a suburban community and the magic of cinema stirs every dresser, driveway, fire hydrant and cul-de-sac. This twenty-first-century ability, to dream in filmic terms, is the wellspring for Crewdson's work. His "Hover" (1996-7), "Twilight" (1998-2002) and "Beneath the Roses" (2003-6) series take place in the languorous summer air of a suburban community where all things paranormal, bizarre and fantastic creep out from the woods. Pregnant women eerily sleepwalk out of their homes; strange accidents demand the attention of the town fire department; an ominous and alluring light glows from the trunk of a car. In the hands of Crewdson, the home becomes the site of amazing cinematic voyages not so far from the popular iconography of Steven Spielberg and the gritty surrealism of David Lynch.

Cinema is the proper place to start, as Crewdson, with every new photographic series, has increasingly taken the role of director and applied the cinematic techniques of film to photography. The scale has increased steadily over the years, with him now employing the assistance of sets, gaffers, costume designers, grips and make-up. His photographs read as staged productions and this sense of reflexivity is critical. While Crewdson surely appreciated Cindy Sherman's filmic sensibility, he was also attracted to the lush visual landscapes of painters like Edward Hopper whose famous 1942 painting, *Nighthawks*, captures an alienated, specifically American, loneliness. Hopper's moody paintings presented a brooding America hiding in the cracks of its cities. In essence, Crewdson took Hopper to a suburban movie theatre.

While Crewdson has become the pioneer of large-scale narrative photography, he began with a more diminutive setting. His first series of works, "Natural Wonder" (1992-7), depicted an artificial natural world. The images were seductive in their colour (blue birds, robin eggs, butterflies), yet haunting in their contrived qualities. Like his later work, "Natural Wonder" felt staged, forced and uncanny. Crewdson followed up this series with "Hover". A series of silver gelatin prints, all shot from a film crane, depicted paranormal and bizarre activities such as crop circles, fire emergencies and dirt piles in the town of Lee, Massachusetts.

Crewdson's epic "Twilight" series upped the ante significantly with large format digital C-prints depicting settings far more produced, arranged and designed. Cinematic tropes are used as central characters, such as the cascading light from the sky produced by a 12kW lamp. The series brought a lush palette of colour to Crewdson's fantastic imagination — in particular the cool blue of twilight itself. "Twilight" vacillated from subtle images to highly comic: a man digs through his floor covered in sod, a bear invades the home, a woman floats in her partially submerged living room. His most recent series, "Beneath the Roses", continues these explorations, but this time, the fantastic has become more subdued, as the landscape magically fills the frame.— Nato Thompson

[1] **Untitled**, from the series **"Twilight"**, 1999, laser direct C-print, 127 x 152.4 cm, 50 x 60 inches

[2] **Untitled**, from the series **"Twilight"**, 1999, laser direct C-print, 127 x 152.4 cm, 50 x 60 inches

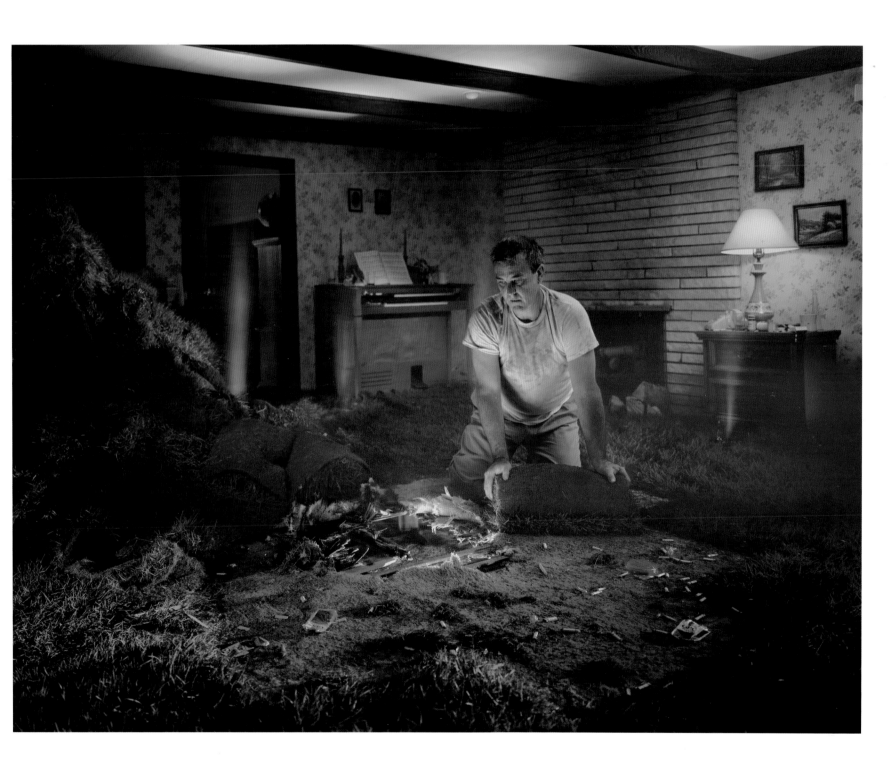

[3] [4]

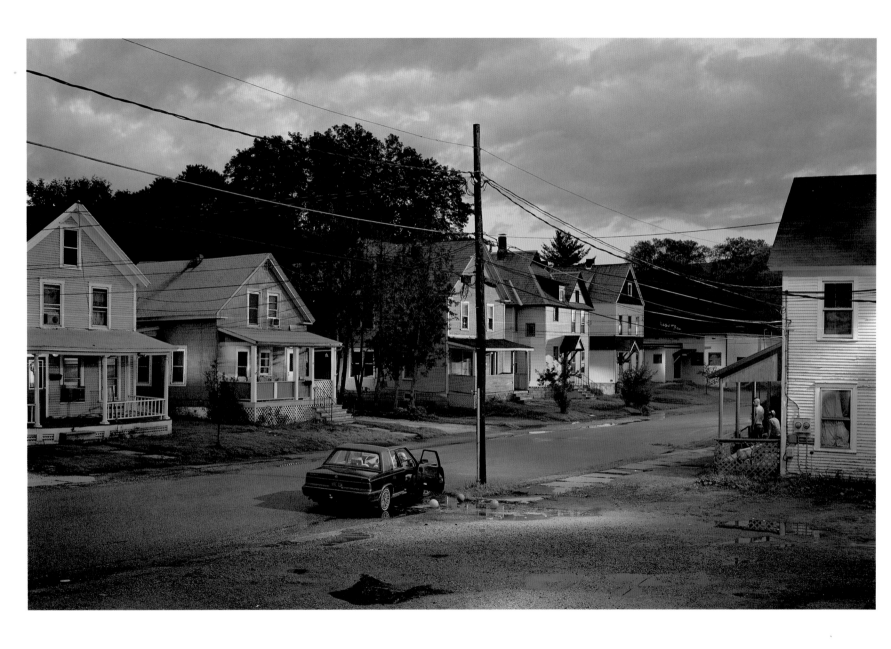

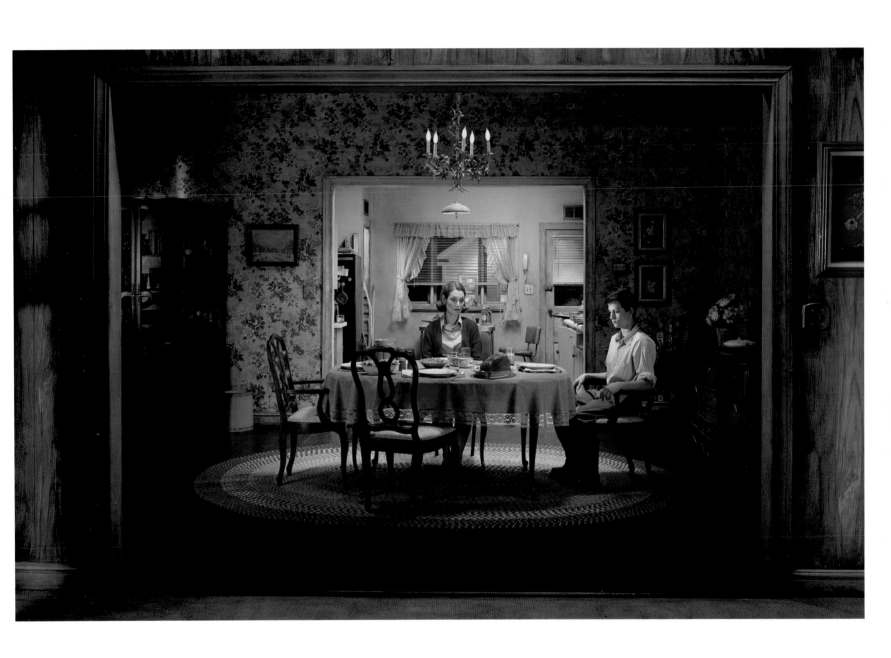

In describing Alberto Giacometti's paintings, Jean-Paul Sartre characterized them as "questioning apparitions" —images with the power to address us not as affirmations, but as interrogations. **Nancy Davenport**'s photographs are similarly "questioning". But if Sartre saw in Giacometti's art the examination of a universal existential condition, the query that animates Davenport's work could only be formulated in our current day. "Now," her images demand, "that the utopian dreams associated with the project of modernity have all but vanished, what is left of the social groups who once served as their incarnation?" These groups were the students and the workers and, with them, the guerrillas. Their object was revolution, their spaces of operation were those emblems of the international welfare state — the university, the factory and the urban housing project. It is thus no coincidence that the three major bodies of work that Davenport has created in the past five years comprise images of college campuses, of the workers' lounge of an aluminium processing plant and of those quintessential late-modernist apartment blocks known as "white brick wonders". Davenport depicts these sites as haunted by their once revolutionary potential. The photographs in "Campus" (2004) are devoid of students, populated rather by the fortress-like brutalist architecture embraced by North American universities in order to prevent the return of the student uprisings of the 1960s. The overall-clad men and women in "Workers" (2005) toil for a Norwegian corporation in the process of outsourcing its operations to China, leaving behind a singular form of wreckage. Lost in balconies or descending from uncertain ropes, the masked figures who wreak ambiguous acts of terror in Davenport's "Apartments" (2001) appear less on the march to a new world than lost in a history whose movement has come to a standstill. They seem more like characters of Giacometti than of Aleksandr Rodchenko.

Davenport's interrogation links these outmoded avatars of revolution to a faith in photography that, in our digital age, has been rendered similarly obsolete: what Henri Cartier-Bresson described as its power to capture "the simultaneous recognition, in a fraction of a second, of the significance of an event". Davenport's work at once mourns and mocks the possibility of such a "decisive moment"— whether in photography or politics. In *Library* (2004) a swirling stack of leaflets buoyed by a gust of wind appears poised to do battle with an impassive brick building. In *Classroom # 1* (2004) the sun bursts into the site of learning as if to impart a transforming illumination. Digitally doctored, these moments are clearly products of Davenport's calculated effort — both phantoms and negations of the belief in a decisive turning point that analogue photography and revolutionary politics share. It is in this double movement that one uncovers the deeper implications of Davenport's inquiry: how to represent, and thus imagine, an emergent social group that — coming into being where the utopian dreams of those earlier groups lie buried — could induce a break in a world without horizon? In their hints of rupture, in their mysterious shinings, in their curious stillness, this, ultimately, is the question that Davenport's images pose. — Margaret Sundell

[1] **Box Props**, from the series **"Illilluminations"**, 2005, C-print, 60.9 x 76.2 cm, 24 x 30 inches

[2] **White Tiger**, from the series **"Illilluminations"**, 2005, C-print, 88.9 x 114.3 cm, 35 x 45 inches

[3] **Searchlights**, from the series **"Illilluminations"**, 2005, C-print, 111.7 x 142.2 cm, 44 x 56 inches

A rumour about the landscape of New York City: the major avenues recreate the topography of the American South West — the deep canyons, the stone walls of russet, ginger, grey. As the story goes, the exploration of the American West was contemporaneous with the rising buildings of the city — the architects and the populace recreated the Western dream of a vast frontier. Just around the next corner, at the end of Broadway, there is freedom.

Now, the West is a grid of highways, underground cables, dams ... The latest frontier, the Internet, has also succumbed to civilization; monthly bills are collected. Where painters of the Hudson River school captured the notion of an American promised land, and Ansel Adams looked at a majestic, if endangered, national identity, **Tim Davis** is the cartographer of the American corpse. This is the United States that Robert Crumb backdrops with a crisscrossing of telephone poles, fuse boxes and an inexhaustible array of urban warts.

But death is beautiful. Whether it is Caravaggio giving us his Judith and Holofernes, Matthew Brady on a Civil War battlefield, or Cindy Sherman posing the slayed hand of a murder victim, the human impulse is not only to flinch in horror, but to revere. We cannot escape our predator/scavenger nature — we revel in death.

Davis, with cruel precision, documents the beauty of our dying environment. *Searchlights* — from the series "Illilluminations" (2005) — captures an intersection of slushy snow, post-war houses, trees and myriad overhead cables. *Box Props* (from the same series) portrays the ersatz screen graphic of a cardboard computer. In his series "My Life in Politics" (2004) Davis extended his argument to the arena of politics, with such evidence as *Oval "Office"*. We live in a lifeless world, engineered by a lifeless democracy. We prefer the coffin; it's neater.

With inclusive acuity, Davis examines the terrain — physical and psychological — that we have manifested. The sultry colours and surfaces of "Illilluminations" are indicative of the cultural seductions that take place, even if we don't understand them. Why would we be enticed by a huge toy tiger (*White Tiger*)? Why are the melted light bulbs so irresistible (*Bad bulbs*)? In this artificial garden of our own creation — shopping malls and potato chip bags — we are perfectly blind to our stewardship, that we are the gardeners. With *Empire State Building Flashes* Davis neatly illustrates our insensible relationship to our manufactured ecosystem. From the top of the Empire State Building, the flashes of tourist cameras go off, illuminating nothing. We look, and document, and end up seeing nothing.

It is apropos, in this moment of so many figurative deaths — the death of literature, the death of art — that Davis should choose to see the grandeur of our voluntary euthanasia. In the lore of vampires and zombies, the temptation of death is one of eternal life. To give up who you are, your "soul", is the only prerequisite to immortality. As humanity is on the brink of this transition, Davis looks through the eyes of our possible (or perhaps inevitable) future; even the undead see beauty. — John Reed

Photography figures in many different ways in **Tacita Dean**'s practice. First, there are the photographs that accompany her larger book, sound and film projects. For instance, to make *Jukebox* (2000), she recorded twenty-four hours of sound in various locations including Alaska and Fiji, and later reproduced location photographs in accompanying publications. These serve a documentary purpose and some are deliberately provisional; in contrast, many of the images published in her book *Teignmouth Electron* (1999) were very carefully composed. One photograph is an aerial view on to Donald Crowhurst's wrecked trimaran, an image that recalls a famous photograph of a work that figures importantly in Dean's practice, Robert Smithson's *Spiral Jetty* (1970).

Dean has also made some self-contained series of photographs, though it is rare for her to undertake such projects. "Fritzland" (2000/3) comprises seventeen images of a new housing complex in Berlin. Dean's architectural subject matter and upward viewpoints recall the photographs of Albert Renger-Patzsch, but the project discards his forward-looking exhilaration. The constructions Dean pictured were never finished: the buildings were at their most complete in her photographs. Another series, "Lord Byron Died" (2003), shows six black-and-white close-up views of graffiti etched into the Temple of Poseidon at Cape Sounion in Greece. The inscriptions date back to the mid-nineteenth century, the moment of the birth of analogue photography, and its death provides the context for these images. As analogue photographs they are indexical signs — the records of light on light-sensitive paper. They show two more indexes: scratched letters and shadows falling on them. At the moment of digitization, Dean parades indexicality in triplicate.

A frequent visitor to flea markets, Dean has used found photographs and postcards in various ways. Sometimes she has gathered flea market photographs into collections. "Found Ice: Berlin, August 2000" (2000), published in the magazine *TRANS>*, included fifteen black-and-white photographs of European winters, some of which document strange glacial ice-sheets seeming to invade cities. For "Dead Budgie Project" (2002) Dean enlarged six found images and printed them as photogravures, a format that altered the grain and tonality of original black-and-white prints, pushing photography closer to drawing and monumentalizing what started as private images. In her book *Floh* (2001) she gathered hundreds of found photographs from various cities and reprinted them without commentary. Some had been mistakenly exposed, or badly focused, but others bore signs of their original owner's affection or annoyance: a woman's name inscribed under her image, a scratched-out face. And in projects such as "The Russian Ending" (2002) and "Blind Pan" (2004) Dean enlarged found images and covered their surfaces with inscriptions, using still photographs as the starting point for imagined narratives.

These three categories are not always distinct, for it is possible to find your own photographs. Dean visited Prague in 1991 and took rolls and rolls of film. When the developed photographs were returned to her, she had no memory of having taken them: they appeared to her as an archive without memory, a record not of her past, but *the* past. Eleven years later she had them reprinted. In exhibition, the "Czech Photos" are presented in a small wooden box. Like WG Sebald's character Austerlitz (in the novel *Austerlitz* [2001]), the viewer is free to finger through them, placing them on the table, "laying out these photographs the wrong way up, as if playing a game of patience ... Arranging them in an order depending on their family resemblances, or withdrawing them from the game."— Mark Godfrey

[1] **Lord Byron Died 1824**, from the series "**Lord Byron Died**", 2003, black-and-white photograph, 40 x 60 cm, 15.5 x 23.5 inches

[2] **Joseph von Eichendorff Died 1857**, from the series "**Lord Byron Died**", 2003, black-and-white photograph, 40 x 60 cm, 15.5 x 23.5 inches

[3] **Arthur Rimbaud Died 1891**, from the series "**Lord Byron Died**", 2003, black-and-white photograph, 40 x 60 cm, 15.5 x 23.5 inches

[4-15] From the series "**Czech Photos**", 1991/2002, 12 of 326, black-and-white photographs, each 8 x 11 cm, 3 x 4.5 inches, presented in wooden filing box with table and chair

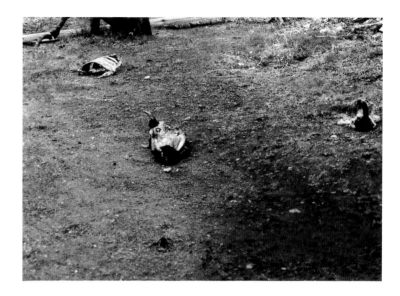

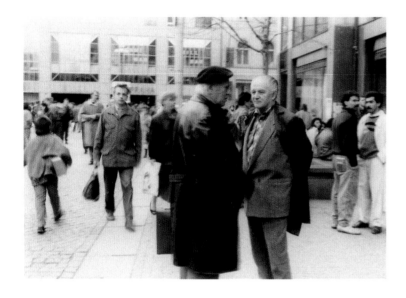

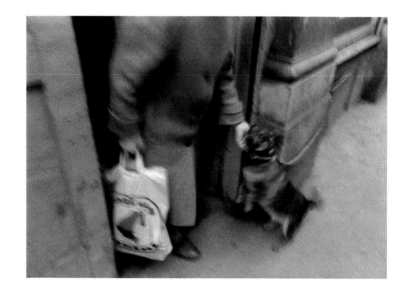

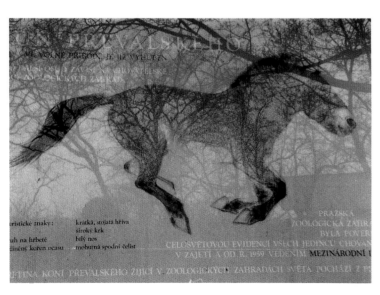

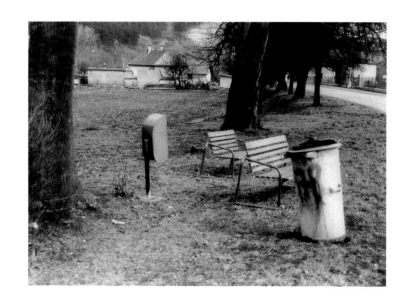

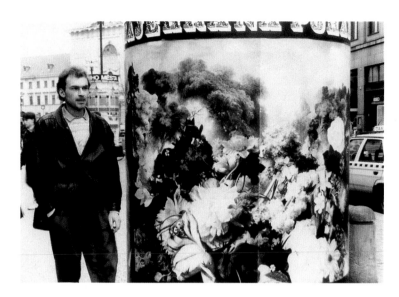
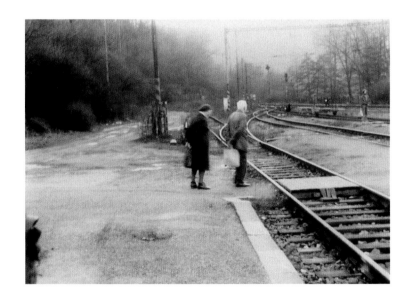
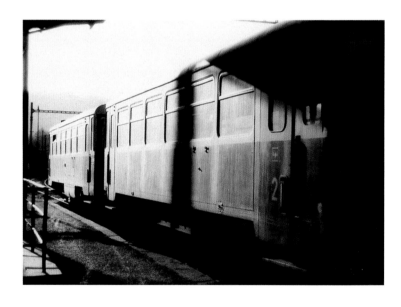
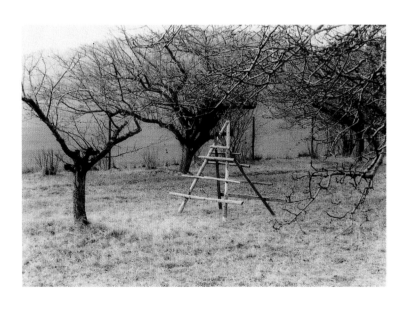
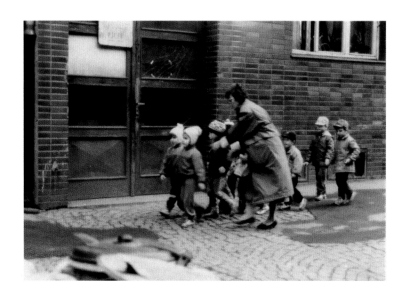

[1] **Friday 15th April**, from the series "**Photonotes**", 2005, C-print, 80 x 60 cm, 31 x 23.5 inches

[2] **Friday 31st December**, from the series "**Photonotes**", 2004, C-print, 80 x 60 cm, 31 x 23.5 inches

Although Dutch artist **Hans Eijkelboom** cannot be considered an artist from the most recent generation—he has been making work since the early 1970s—he has been working in the margins of the international art and photography world on a very topical project "Photonotes" (begun 1992), a project that is only now coming to its final phase. "Photonotes" deals with the concept of individual identity in a world of mass consumption.

Five to six days a week, at a fixed time and for a maximum of two hours, Eijkelboom goes to one of his favourite locations in the streets of Amsterdam (or sometimes New York and other cities) to take photographs. His favourite spots are very crowded places in or near shopping malls. Thousands of people come here daily to shop, and here he seeks confrontation with city life; more specifically, confrontation as an individual with the masses which for Eijkelboom is a typical part of life in the big city. It both defines and challenges our identity as individuals.

Already in his early work, when he created installations and perfomances, Eijkelboom was fascinated by the concept of individual identity. He focused on how people dress at different occasions—exhibition openings for instance—in order to underline their individuality within a specific social group. In the course of time he focused more on the interchanges between his own identity and that of others, and photography became a crucial medium for him. He reflected in these early, more conceptual, works on the effects of different clothing—as in his self-portraits made while dressed in the clothes of his friends. Later he became more interested in the relation between identity and a world view. Looking for a method to visualize his daily observations and experiences, Eijkelboom started to make his daily "Photonotes".

Having arrived at his location for that day, Eijkelboom observes the crowd. Initially he has no idea of what he will photograph. After a while, however, particular details start to draw his attention; for example, the way people are dressed or behave, or the objects that they are carrying, and he subsequently starts to focus on these details: the colour of raincoats, shopping bags that look alike or the fact that there are a lot of mothers and daughters walking together. He behaves like a spy, he dresses inconspicuously and he hides his camera against his chest (so that he does not look through the viewfinder when making a photograph). In this way, he creates a series of photographs every day, which he mounts sytematically on large sheets of paper. The title of each "Photonote" is the date on which it was made. Sometimes they are published in the form of small booklets which Eijkelboom sends to a limited number of friends and other interested people.

For more than ten years Eijkelboom has created a fascinating, systematic archive of images that provides us with a unique overview of, for instance, fashion in the Netherlands—a sociological study as much as an anthropological one. The space where he makes his photographs still has the connotations of a democratic space, in the sense that it is truly public. However, we know that it is not a "free" space, but in fact highly controlled —by security, by CCTV and also by commercial interests, tightly focused and designed for shopping and consuming. The many similarities between what people wear and what they do in these spaces pose serious questions about how free we are to choose our identities. There is ultimate freedom to buy what we want in order to shape who we want to be. But it appears that in the end there are only so many possibilities that people can actually (and consciously?) choose from.—Frits Gierstberg

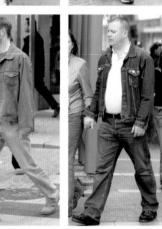

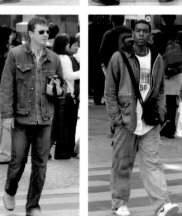

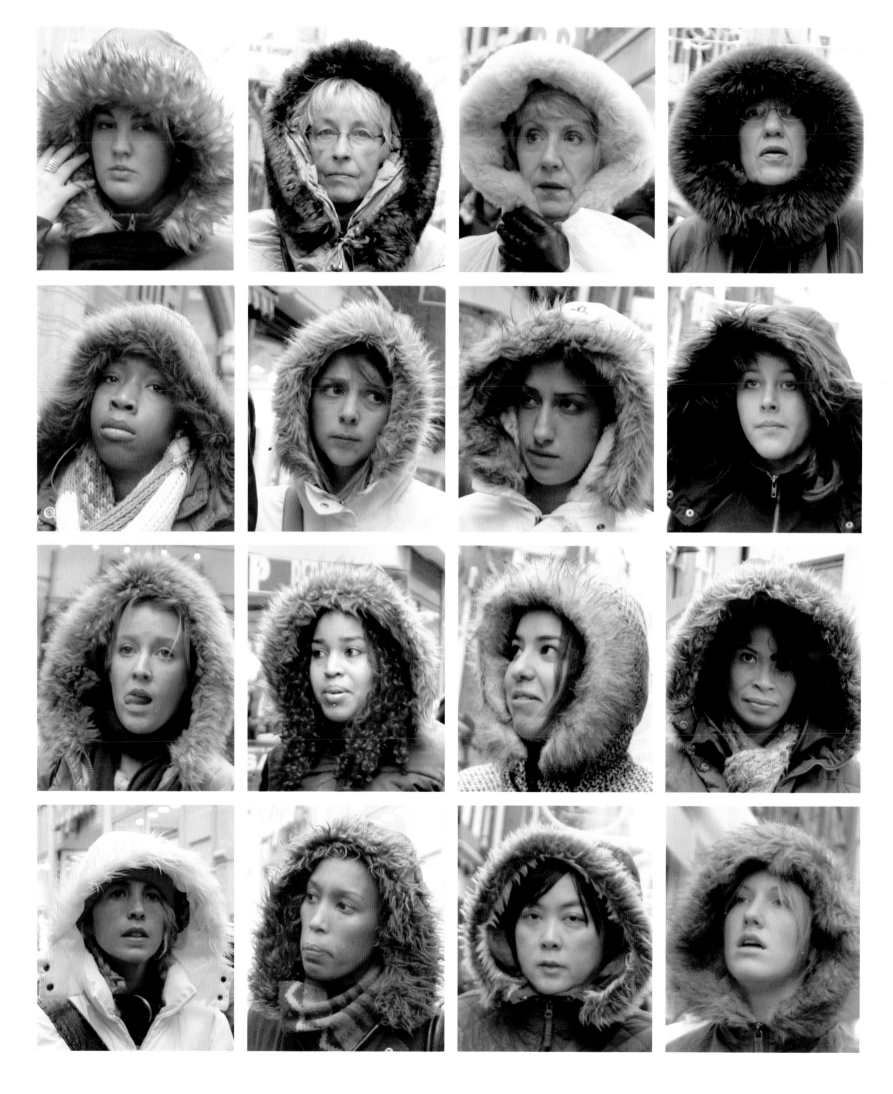

[1]

Olafur Eliasson is best known for large-scale installations that probe the limits of perception, using the most fundamental of materials—water, light—to create complex optical effects of an immateriality that becomes, paradoxically, intensely sensual. These spectacular works —most famously, the "sun" in *The Weather Project* (2003) constructed in Tate Modern's turbine hall—have tended to overshadow Eliasson's photography, which is superficially concerned with documenting the landscape of his ancestral Iceland. But however indirect the relationship between the two bodies of work, they ultimately deal in the same basic concerns and illuminate each other in surprising ways.

Eliasson was born—and later educated—in Denmark, but his family is of Icelandic origin and he spent a considerable part of his childhood there. Its desolate volcanic landscapes and enormous skies, drenched in the oblique, refracted Arctic light, are subliminally present in his installations, and overtly in the photography.

The mature photographic works started in 1994, inspired by annual hiking trips in Iceland. *Island series* (1997) assembles fifty-six images of coastal islets in a grid pattern. *Cave series* (1998) explores dark glacial crevices and faults, and the forty-eight images of *Jokla series* (2004) explore Iceland's landscape. Eliasson has also begun to branch out into the man-made, as in the seventy-two images of *Reykjavik series* (2003).

The grid and the repetitive imagery recall Bernd and Hilla Becher's "typologies", and the encyclopedic concern, with its relationship to the "major" work, reminds one of Gerhard Richter's ongoing "Atlas" project. But Eliasson's photographs differ significantly from either one in their relentless focus on perception itself, rather than the object of that perception. Superficially, his work might seem to have a romantic character, evoking the grandeur of natural phenomena. But the concerns that underlie Eliasson's work have more to do with how self and society shape the way we perceive nature.

The initial impetus for the Iceland photographs came from 1950s military photographs that were later published as maps for hikers. For Eliasson, this just underlies how we "produce" nature in the act of looking, and how misleading is any attempt to "see" outside of the social context. This landscape is already "reproduced". In an unpublished interview with Hans-Ulrich Obrist, Eliasson talks about his work as a kind of library: "There are two different kinds of libraries: one that simply compiles data ... and the other, [with] a trajectory ... [that] produces its surroundings." Time and movement are important for Eliasson's way of looking. He uses a mobile home as a studio during his summer ramblings in Iceland. Underlying all the photo series is a sense of shifting perspective and movement. It is this tension—between stasis and dynamism, between its direct, emotive appeal and a self-reflexive concern with phenomenology —that makes Eliasson's work compelling. "The work is not so much the spectacle of a fake sun," he once said, referring to the Tate Modern installation, "but a person's individual encounter with his own reflection." —Jonathan Napack

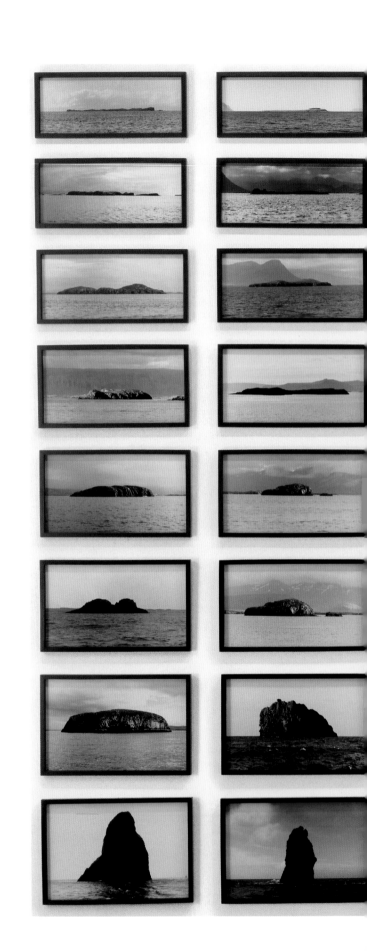

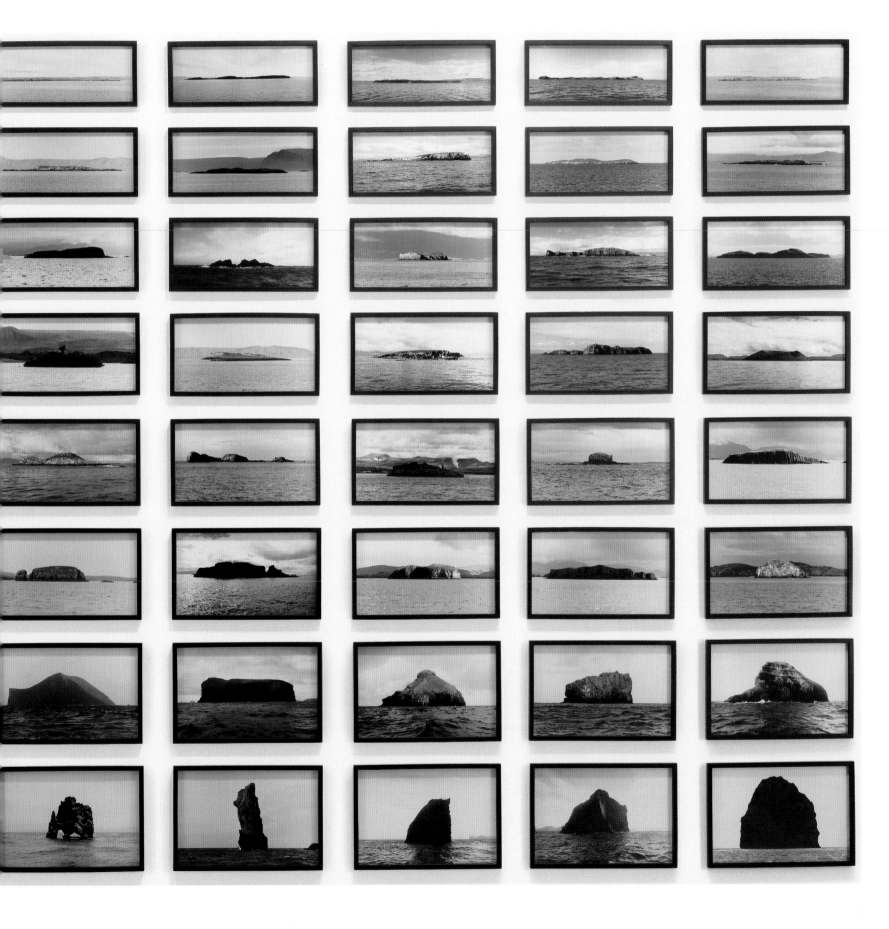

The photographs of **JH Engström** develop additional momentum and meaning when viewed as a sequence. An old man lies on a bed, his hands clasped tightly together, his face turned to one side and his eyes closed. Is he dead or just asleep? The next image shows a parking lot, an expanse of dust and gravel flanked by high windowless walls, a deserted scene, apart from one or two irregularly parked cars. The next, four white plastic chairs around a table standing in tall grass under a tree. Assembled together and titled "Haunts" (2005), but lacking a specific subject, these images conjure up not so much the spectral or the uncanny but rather something as undefined as an atmosphere or a set of poetic correspondences. The work is romantic —but Engström's elegant use of composition and acute observation guard against it falling into being sentimental or kitsch.

To a certain extent the works are also autobiographical, a search for identity, reflecting the milieu within which the artist himself circulates, and depicting the people and places that have personal significance for him. An earlier series of photographs, "Trying to Dance" (made between 1998 and 2002 in Sweden and Brooklyn, New York), explore a similar territory to "Haunts". This title suggests a bittersweet sense of endeavour, something like the feelings of an adolescent imitating the footwork of a virtuoso. However, in his photographic work Engström himself is very much the virtuoso, deploying a fluid variety of techniques including the painterly use of coloured tints, images shot from diverse angles and different depths of field, unusual crops and the suggestive juxtaposition of subject matter.

In the presentation of this work it seems that no single photograph is complete and no one method of making a photograph completely satisfactory. Instead the images are shown as chronological sequences in books and arranged in grids or looser constellations on the gallery wall. This format allows for a stream-of-consciousness style of interpretation on the part of the viewer, who is able to imagine various narratives and, above all, experience the entire piece as a singular statement. In this way the individual prints are collected together into a poetic whole where photography functions like a novel, whose complex structure proceeds intact through a web of different locations and temporalities.

Shots of the figure taken in bare rooms, paired down images, are surreal and oddly constructed but at the same time resonant of feelings, emotional registers and different states of being. Here light is used to define the figure as a sculptural proposition and to integrate it within the formal composition of its surroundings. It floods down from above, illuminating the head of a young man sitting in a chair—it forms a twinkling bead in the eye and a silhouette running along the contours of the body.

Formative experiences for the artist include working as an assistant to Mario Testino, and (after graduating from a course in photography at Gothenburg University) spending three years taking photographs in a hostel for homeless women in Stockholm. His images of these women and their possessions manage to salvage moments of intimacy and beauty from tough real-life drama, without putting a gloss on their situation. Some of his nude studies are reminiscent of Francesca Woodman. Perhaps because of this background, Engström's practice tends towards an account of human presence, shown directly in portraiture, and also represented through the environments which people either inhabit or traverse. —Grant Watson

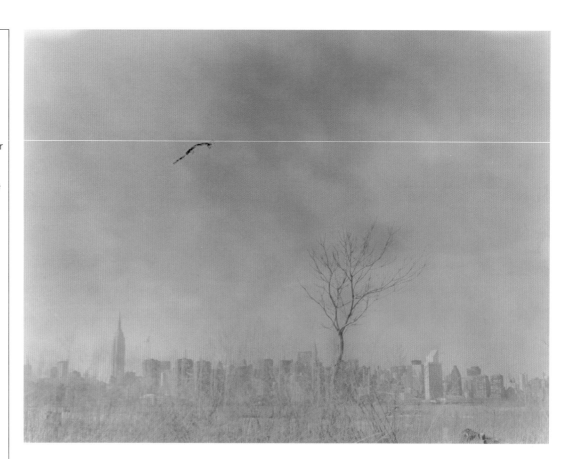

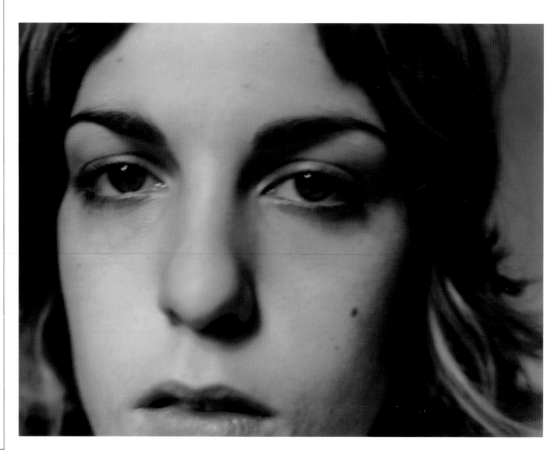

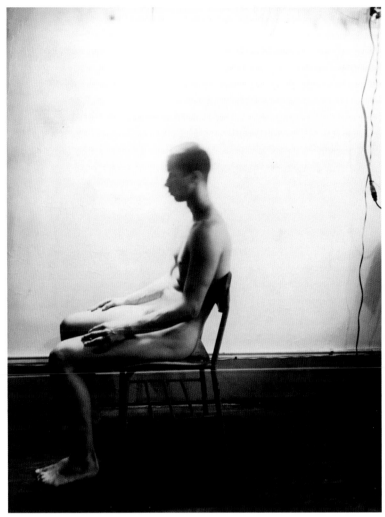

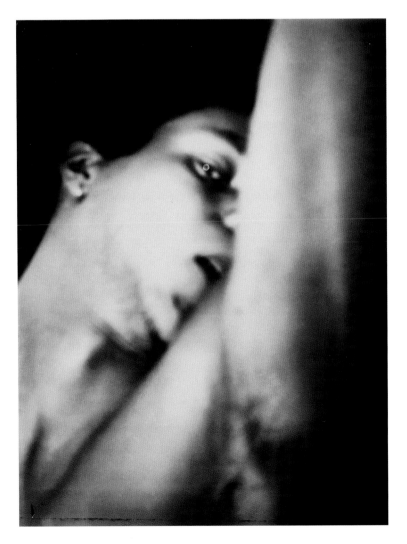

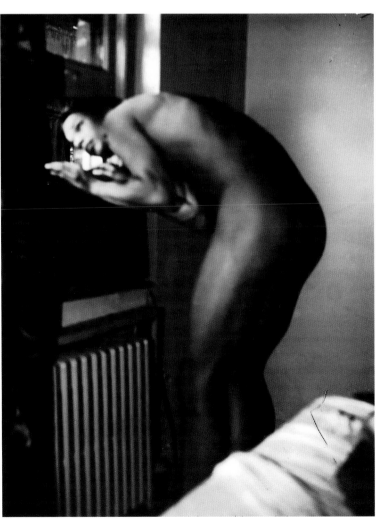

Lalla Essaydi is among several contemporary photographers from the Middle East, Gulf and North African regions who engage image and text, the body and the spaces it inhabits in order to explore a range of aesthetic, political and cultural topics. In her recent series "Converging Territories" (2003-4) Essaydi situates the female body in various locations, using visual and written motifs to convey multiple meanings. Her representation of space is both physical and psychological, visually articulating the important relationship between memory and experience and the tensions between confinement and fluidity in the Moroccan culture in which she grew up. She accentuates the importance of physical space by constraining her female subjects within an enclosed area. In many of her photographs women's bodies overlap. This layering makes them appear confined as well as decorative, calling into question broad presumptions about Arab culture and Islam while simultaneously referencing Western and Orientalist fantasies.

Essaydi carefully considers the relationship between personal and social realms through the poses, gestures, clothing, activities and the shared sense of community among the women depicted. She drapes them in willowing cotton *haiks*, suppressing and hiding their bodies. What lies beneath the surface is not revealed. Yet the viewer is intensely drawn to the external texture covering these women's bodies by Essaydi's overt interplay between her images and the text; autobiographical in nature, it conveys the artist's personal memories and experiences. Upon closer inspection, a subversive element lingers in these women's use of henna, the female art of adornment, to write calligraphy, a traditionally male art form. This hennaed calligraphy, performed by Essaydi herself on the women's clothing and walls, transforms these confined spaces into a more personal realm; they become private spaces of creative transgression for Essaydi and for the women pictured.

The intricate, detailed work in this series demonstrates her broader aim to reinvent the cultural pictures of her country, Arab women, the role of the photographer and the power of the image. She utilizes these constructed spaces to address the past and the present, as well as the possibilities that gender subversion holds for the malleable nature of identity. In so doing, she also expresses her concern for the ways in which identity—the way one sees oneself and the way one is seen by others—is subject to change. This notion is presented clearly in Essaydi's fragmentation of certain images. There is a sense that a piece of each picture could be removed or replaced. It is as if these women's visual identities—their bodies and faces—could, at their own discretion, suddenly transform. Essaydi quietly and poetically insists upon this visual and psychological instability. In turn, this presentation continually challenges static perceptions of her subjects and the ways in which they, and by extension Essaydi herself, have occupied myriad public and private spaces.
—Isolde Brielmaier

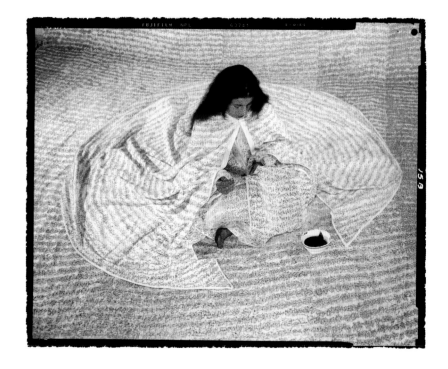

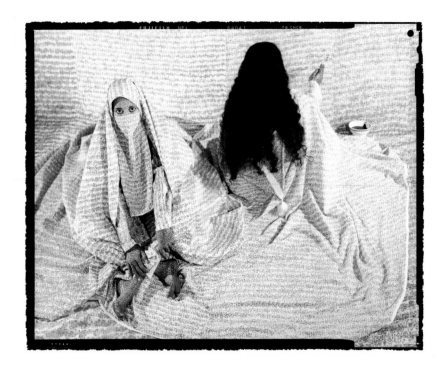

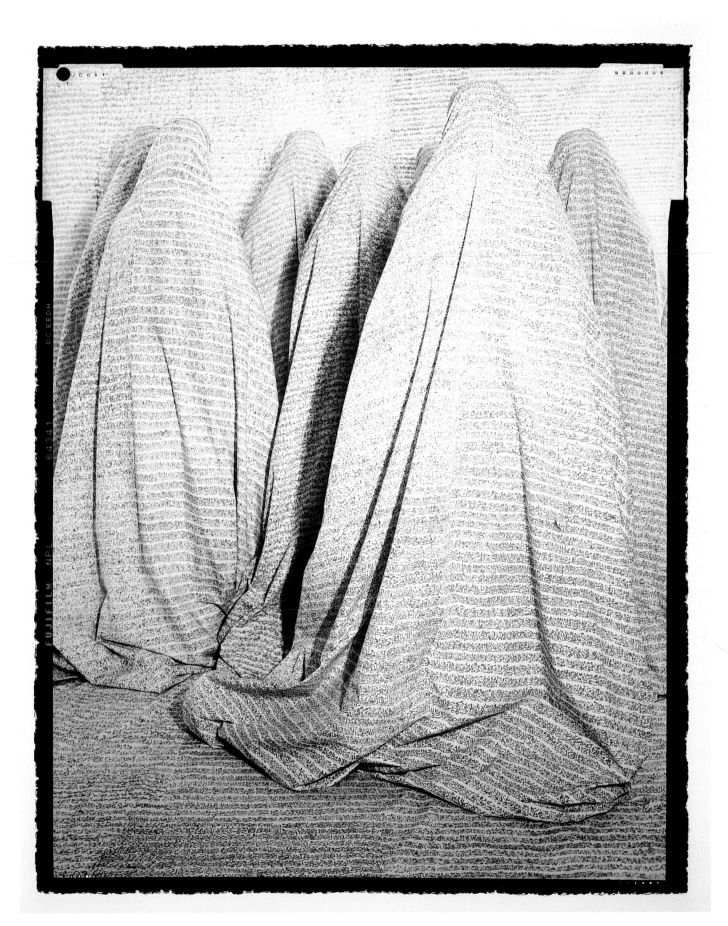

[1] **10th Street Bridge, Atlanta**, 2003, C-print, 76.2 x 96.5 cm, 30 x 38 inches
[2] **Hammerhead**, 2004, C-print, 76.2 x 60.9 cm, 30 x 24 inches
[3] **Great Neck Mall Sign**, 2005, C-print, 127 x 101.6 cm, 50 x 40 inches

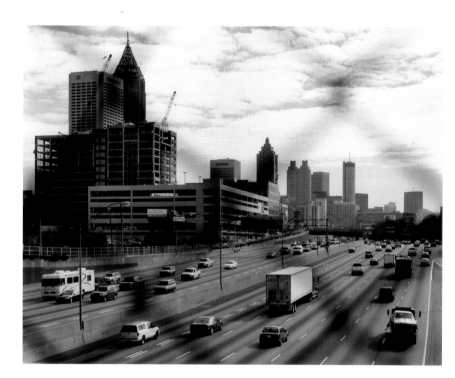

Encountering a **Roe Ethridge** photograph and viewing a Roe Ethridge exhibition are markedly different experiences. This is a rare thing in the contemporary art world, as most photographers work in easily defined series and present them uniformly. Since the late 1990s, however, the New York-based artist's heterogeneous practice—he has made still lifes, arch-Romantic nature scenes, portraits and digitally altered pictures, all in a style that blends "the deadpan and the sublime", according to the photography critic Vince Aletti —has manifested itself in exhibitions that offer seemingly radical juxtapositions of these diverse photographic typologies. Each picture is printed and framed according to its own specifications, and Ethridge's attention to these details is borne out by his consistently proven expert eye for individual compositions.

Ethridge filters the happened-upon elegance and promiscuity of subject matter typified by European photo-diarists like Wolfgang Tillmans and Jürgen Teller, who also work as commercial photographers, through a distinctly American vernacular. His portraits of interstates (*10th Street Bridge, Atlanta* [2003]), strip mall signage (*Great Neck Mall Sign* [2005]) and suburban domesticity—even his artist's-book titles (*Spare Bedroom* [2004] and *County Line* [2005])— seem like a middle-class version of Richard Prince's rural machismo, celebrity worship and biker beauties. Ethridge's outdoor scenes are not rugged mountains bathed in red sunlight, but the snowy, pastoral environs of the upstate New York waterways, captured with a 4 x 5 camera.

"Everything seems to end up in a magazine sooner or later", the artist has noted. Indeed, Ethridge's commercial work (for such clients as the *New York Times Magazine*) merges seamlessly with his "art" photographs, which have also been reproduced frequently on the printed page. The levelling effect of print reproduction (in *County Line*, a boat at sea is followed by signage from a strip mall, then a watermelon on the kitchen counter, part of a house in the forest, and night-time lightning likewise seen through trees, all printed roughly the same size) has inflected Ethridge's practice, in which the networks that bind together his photographs are as invisible to the public as those that bring together the products in a Harry & David catalogue or the pages in a magazine.

A magazine is an apt metaphor, and one that Ethridge used to describe an early solo exhibition; he views each show as a containing structure that produces relationships —albeit temporary ones subject to later revision. Yet, as several commentators have noted, a golden thread of lyricism runs through pictures that might otherwise seem as banal as those found in a stock photo catalogue. Aleatory as well as intellectual connections abound in Ethridge's practice, which seems to only expand laterally, yet having nowhere to go because it is everywhere at once.—Brian Sholis

Clea

PETLAND
DISCOUNTS

Liquors

Library

BAGEL MAN

Peter Fraser, who has been working as a photographer for more than twenty years, describes his practice as "coming to the same problem over and over again, but approaching it from different angles". His subject is the world of objects and more generally the characteristics of matter itself, or what he calls "the stuff of the universe". This subject is as broad as his working method is precise, and subsequently he brings to it a wide-ranging perspective as well as a finely tuned eye for detail.

In a recent series of photographs—"Untitled" (2001-4)—he looks closely at man-made objects, considered in relation to their environments and the elements that support, surround or rub up against them. A playful invocation of this layering, and the interplay between the human and non-human, occurs in a picture of a birdhouse nailed to a tree. In this work a tree supports a wooden structure made by human hands, which in turn contains a nest made by a bird using twigs from the tree. However, this is not an allegorical image. So the birdhouse is not intended to signify "home" or "shelter", just as a book balanced on a glass plate in another photograph is not intended to suggest the consumption of knowledge. Instead the subject of the image draws you into a consideration of itself at a specific moment in time, rather than beyond itself towards a broader narrative, context or symbolic register.

In "Deep Blue", a photographic series made between 1994 and 1996, Fraser points towards the potential of man-made objects to exhibit signs of intelligence. These works were inspired by the real example of IBM's Deep Blue (a computer that beat chess champion Gary Kasparov in 1996), and also by the fictional example of HAL in Stanley Kubrick's *2001: A Space Odyssey*, a machine that took the contest between human and artificial intelligence one step further. For this project Fraser documented some of the most sophisticated products of human invention, complex technologies that frequently needed to be shot in controlled conditions with the artist wearing protective clothing. In the book *Material* (2002) Fraser once again engages with the high-tech end of material manipulation; in this case the equipment used for the study of matter at subatomic levels (from research undertaken in the physics department at Strathclyde University). These images are shown alongside photographs taken by Fraser of the most abject detritus of human activity —such as the nameless substances that collect under the sink. By juxtaposing the two the artist suggests a sort of aesthetic equivalence between the different categories of matter that pass through human hands, perhaps proposing that with sufficient attentiveness human perception can tease out minor epiphanies from the most unexpected and diverse aspects of the material world.—Grant Watson

[1] **The First Intellectual**, 2000, C-print, 193 x 127 cm, 75.5 x 49.5 inches

[2] From the series **"Don't worry, It will be better..."**, 2000, C-print, 86 x 120 cm, 33.5 x 47 inches

[3] From the series **"Breeze"**, 2000, C-print, 78 x 150 cm, 30.5 x 58.5 inches

Yang Fudong's work marks a watershed in Chinese art. He was the first from the truly "post-'89" generation to achieve international exposure. But perhaps more importantly, he was the first artist from China to exhibit outside the "Chinese art" ghetto, with important shows at Tate Modern, Castello di Rivoli, "Documenta 11", "50th Venice Biennale" and "Dakar Biennial" (2004). Living in a country whose generation gaps are more like chasms, those who lived through the catastrophe of the 1960s and '70s became iconoclastic in the extreme, mistrusting any ideology or power structure. Yang's generation, though, has never known anything but the ersatz capitalism of the post-Deng era.

The practice of these artists is more familiar and more globalized than that of an older generation who had to evolve their own approaches in a time of international isolation. But despite a technique that seems at first sight internationalized, Yang's iconography is inward-looking, even nationalistic, with its historical allegories and ever-present obsession with 1930s Chinese cinema. Ironically, it is exactly those elements that seem appealingly "exotic" to Westerners. Much of the strong impression that Yang made in the West was a response to his film installations, such as *Backyard! Hey, the Sun is Rising* (2001), *An Estranged Paradise* (2002) and *Seven Intellectuals of the Bamboo Forest* (begun 2003), with their cool, masterful beauty. But in the Chinese context, these works were seen less as romantic than as complex parodies, playing with a familiar language of pre-war Shanghai cinema.

While most of Yang's work is film or video, some of his key work is photographic. In 2000, when he first emerged on the Chinese art scene, Yang contributed an ambitious large format series, "Shenjia Alley: Fairy" (2000), to a show called "Useful Life", which included work by several Shanghai artists who would later become well known (such as Yang Zhenzhong and Hue Jieming). "Shenjia Alley: Fairy" played with Chinese conventions of courtesan paintings. But most important was his contribution to "Fuck Off", the seminal "underground" show curated by Ai Weiwei and Feng Boyi as a riposte to the 2000 "Shanghai Biennial". *The First Intellectual* became, on its own, a seminal piece of contemporary Chinese art, as much for what it says about the dilemma of intellectuals in post-Deng China as for its intrinsic qualities.

The First Intellectual consists of a single, startling scene: a young man in a business suit, in a cityscape of skyscrapers, bloodied, bewildered, a brick in his hand. For many Chinese, this image summed up the post-Mao era: the movement of intellectuals from the centre of society to its periphery. This marginalization was accompanied by economic opportunities, but these just deepened a sense of futility. "One wants to accomplish big things, but in the end it doesn't happen," Yang told Hans-Ulrich Obrist in an interview for the 2003 exhibition "Camera". "[*The First Intellectual*] doesn't know if the problem stems from him or society."

This is a recurrent theme elsewhere in Yang's work, though the obscurity (to Westerners) of his references makes it less obvious. *Seven Intellectuals of the Bamboo Forest*, perhaps his best-known work overseas, refers to a group of scholars who took refuge during the chaotic century after the fall of the Han Dynasty. The subliminal message is one of retreat from society and from politics.—Jonathan Napack

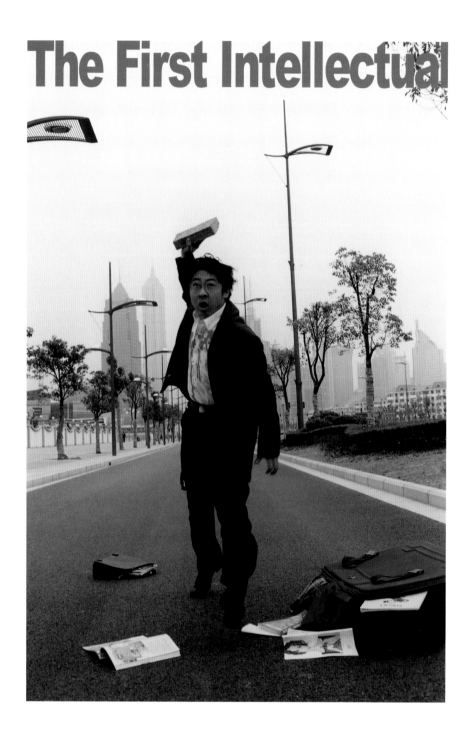

The First Intellectual

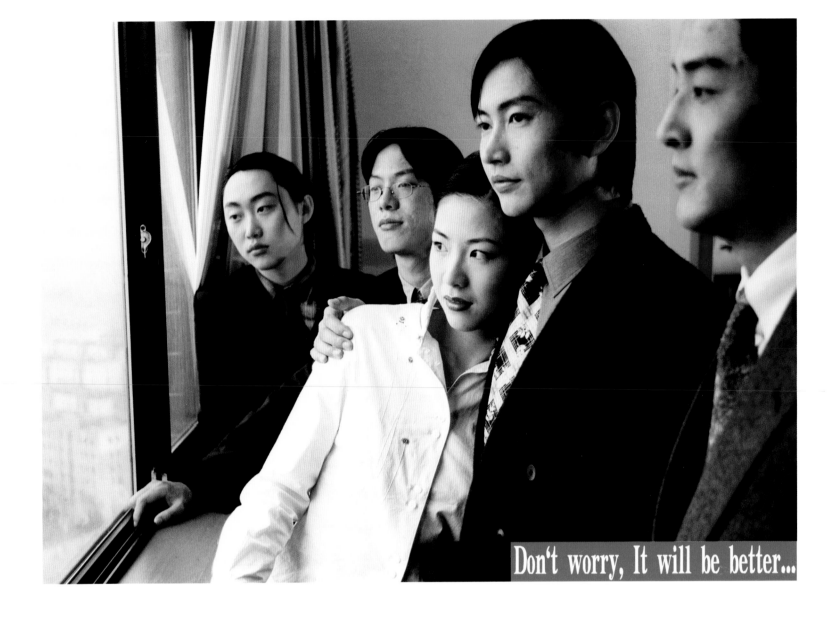

Don't worry, It will be better...

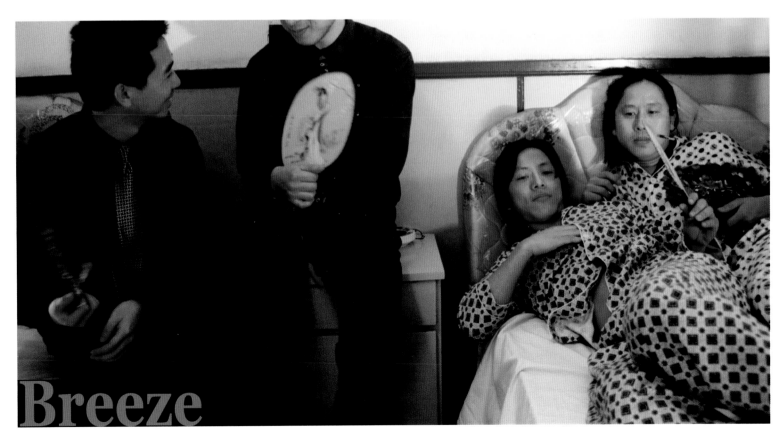

Breeze

[1]
[2]
[3]

HP Lovecraft, the American author and unspoken master
of the "weird" genre of supernatural tales, wrote in his
1927 essay "Supernatural Horror in Literature" that "the
oldest and strongest emotion of mankind is fear, and the
oldest and strongest kind of fear is of the unknown."
Anna Gaskell's masterful photographic compositions would
have made Lovecraft proud. Large scale and richly coloured,
her disturbing, staged tableaux are set in the landscape
of nightmares: shadowy forests, looming Victorian mansions
and late-night hospitals. Pubescent actors lurk through
these scenes, avatars of vulnerability and unfettered
emotional states, caught in mysterious and often violent
acts. The contrast between the eerie tone and the fresh, young
faces of her characters strikes a familiar, if uncomfortable,
chord of the personal horrors of adolescence. Gaskell
crops these frozen scenes with a cinematic flair recalling
both film noir and horror flicks, hinting at the unspeakable
through dramatic lighting and steep camera angles.

Narrative lies at the heart of Gaskell's projects. Each series
is loosely centred around a vaguely expressed story — be it a
specific work of fiction, a stranger-than-life tale, a personal
memory, or any combination of the three — that unfolds
over a succession of fragmented views. Alice, dressed in her
iconic white stockings and "Mary Janes", first appears in
Gaskell's "wonder" series (1996-7) as a pair of identical
twins, transforming Wonderland into an eerie psychological
canvas for the theme of internal struggle. Alice re-emerges
in "override" (1997), this time as part of an entire gang of
doubles who beat one another in a stark forest setting.
In repetition, Alice becomes an arrested character, caught
in the constant retelling of her story until she is crowded
out by her clones, all of whom are valid, none of whom are
original. Mimicking the natural evolution of stories, both
series draw us in with familiar narratives that are then twisted
into something new. No story is ever told the same way
twice, just as none carries the same meaning for any two
listeners.

Gaskell's constructed images find their roots in the earliest
days of photography, in Julia Margaret Cameron's fantastic
images of Victorian childhood. Acknowledging the fictive
nature of the medium, staged photography has more lately
emerged as a trenchant commentary on an increasingly
media-induced reality. Gaskell's productions, drawing on an
almost commercial visual style, further the debate by laying
bare the constructed "truth" of narrative in general and
photographic images in particular.

Recently, Gaskell's work has moved away from specific,
recognizable fictions towards the broader question of how
storytelling is structured. The "Untitled" series of 2004 is
set in yet another forest, but this time it is a fabricated wood
with a painted sky that is, literally, a stage set. Now the
young characters wander about without a story, leaving us
on our own to decide whether they are lost or whether they
have escaped the inevitable fate of all tales: an ending.
In this way Gaskell's photographs seduce us, accessing
our most common and simplest emotion—anxiety—or what
Lovecraft describes as "the thrill of the chimney-corner
whisper or the lonely wood."— Dina Deitsch

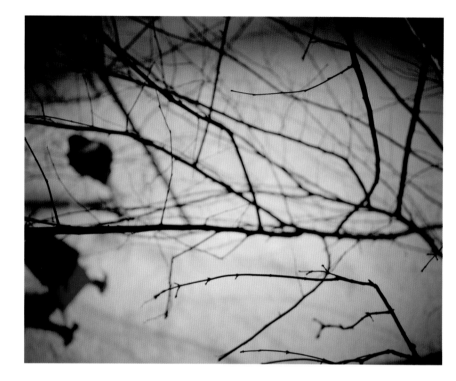

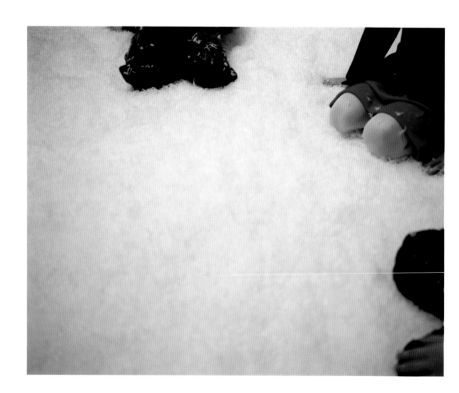

[1] **# 108**, from the series **"Untitled"**, 2004, C-print, 181.6 x 223.5 cm, 71.5 x 88 inches
[2] **# 109**, from the series **"Untitled"**, 2004, C-print, 181.6 x 223.5 cm, 71.5 x 88 inches
[3] **# 111**, from the series **"Untitled"**, 2004, C-print, 181.6 x 223.5 cm, 71.5 x 88 inches

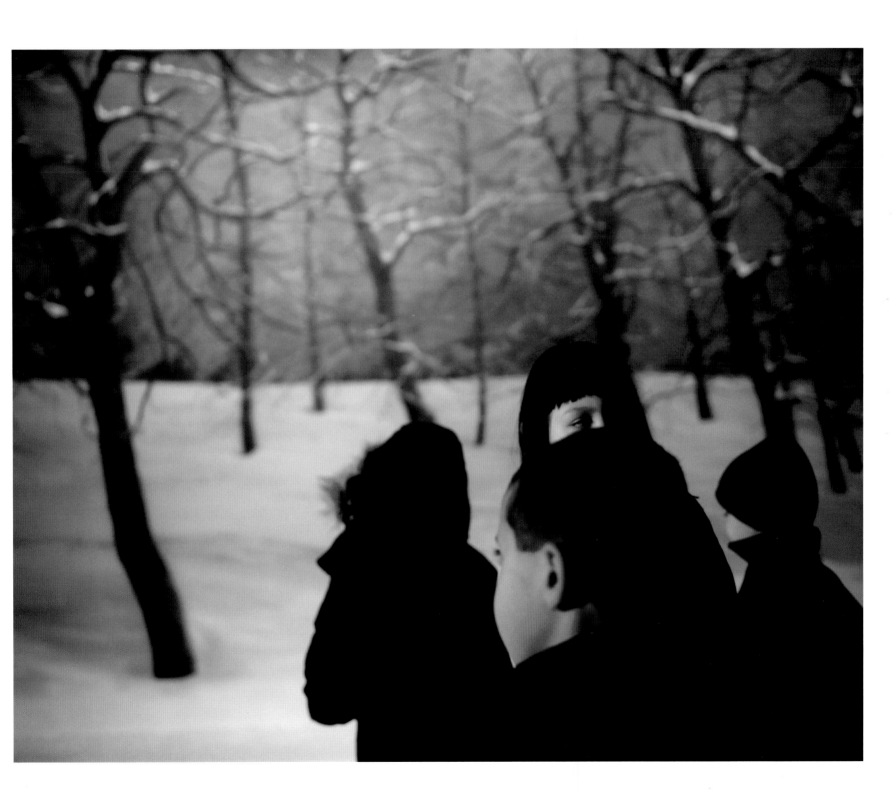

[4] [5]

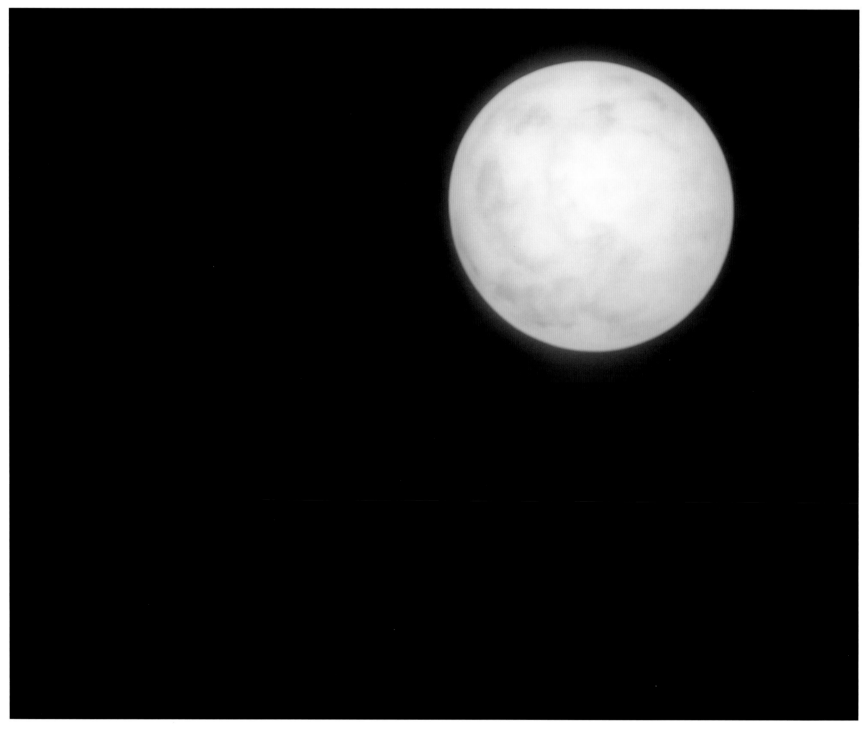

[4] # 106, from the series "Untitled", 2004, C-print, 181.6 x 223.5 cm, 71.5 x 88 inches
[5] # 120 (1991), from the series "Untitled", 2005, C-print, 181.6 x 223.5 cm, 71.5 x 88 inches

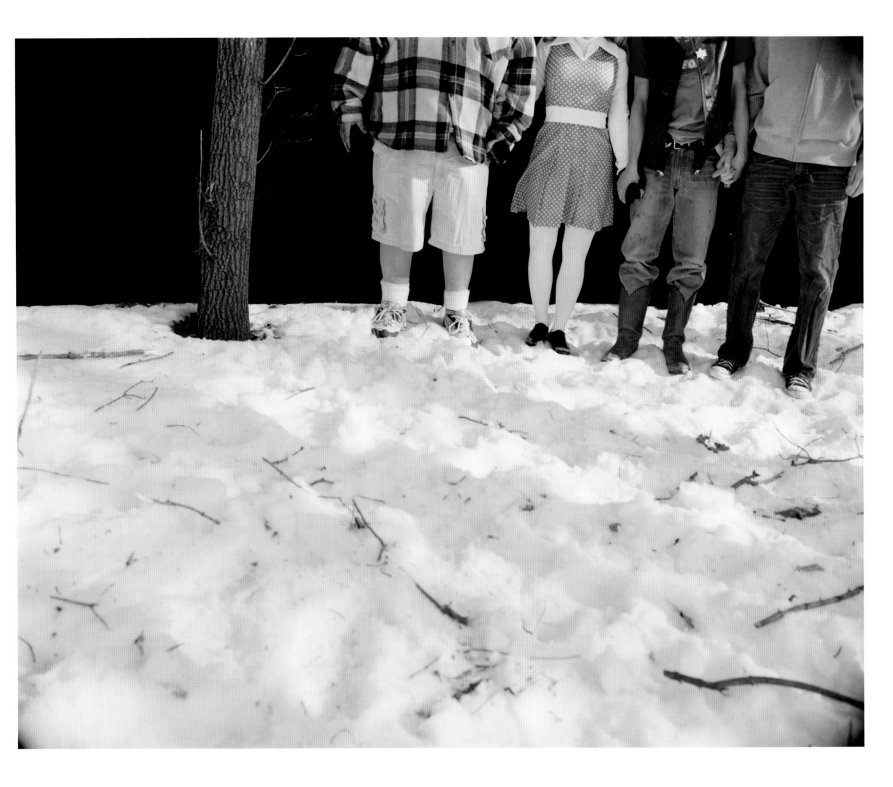

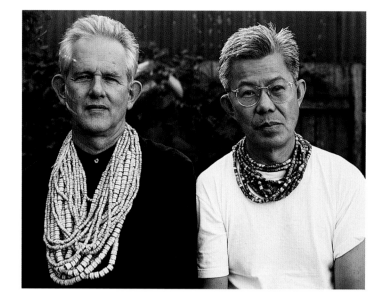

A photographer, sculptor, collector and compulsive reader, **Simryn Gill** adapts disciplines and tropes such as cultural anthropology, linguistics, systems of classification and processes of distribution in an attempt to search for coherence in her understanding of the world. The search remains futile but the process of discovery and understanding sheds light not only on our surroundings but also on the very disciplines whose aspects she employs. Gill's undertakings are characterized by the research normally associated with academic pursuit but have ties to the work of early twentieth-century photographers such as August Sander, whose use of the photographic image hovered ambiguously between objective recording and subjective fascination. Many of Gill's projects stem from a Sander-like investigation of type, inflected by the artist's own personal understanding of her diasporic background as a Malaysian-born Indian who currently resides in Australia.

Gill has worked with a range of materials, including books, plant materials like seeds and skins, photographs and found objects. Her photographic projects have characteristically been ambitious and extensive undertakings involving the gathering of images over a series of months or even years. "Dalam" (2001) consists of an extraordinary 260 photographs of the interiors of homes in Malaysia. The result of a two-month trip, Gill's images represent not only the homes of friends and relatives but also the artist's movements and associations as she approached locals, those she met through taxi rides or transactions, or simply introduced herself to by knocking on their door. The resulting images are an archive of the diversity of living conditions from the mess of family life to the spartan existence of poverty, from luxurious or intricate furnishings to the functionally organized home. Furniture and objects revealingly display both the distinctly Asian context as well as the contemporary fusion of East and West, new and old that permeates Malaysian life.

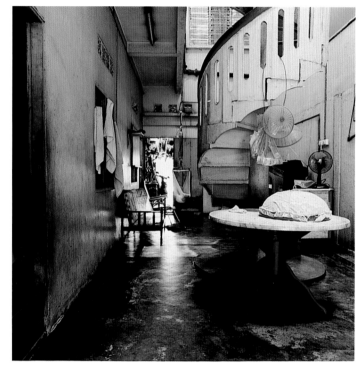

For "Standing Still" (2000-3), Gill's subject was also Malaysia and again involved extensive travel and research. The 116 images document the abandoned and dilapidated buildings that are scattered across the Malaysian peninsula. The climate and vegetation are such that the process of deterioration and reclamation by nature is dramatic, and many of the buildings chosen by Gill are already partially obscured by plants and foliage. As with "Dalam", the contrast of architectural detail is striking, ranging from old, colonial-style homes to new tower blocks or storage facilities left unoccupied. Some of the most arresting images are of such recent constructions, which are typified by the postmodern condition of diluted contemporary architectural styles. These mid-rise towers with their concrete façades are now decorated with vines or the odd tree that has taken root on a balcony or roof, suggesting a futuristic impression of a post-apocalyptic world.

A series of portraits, marking an unusual appearance of the human form in Gill's work, documents its subjects wearing beaded necklaces. "Pearls", an ongoing project of Gill's, perfectly summarizes the artist's associative approach. The beads have in fact been made by Gill and are the laborious result of the process of tearing and rolling lines cut from a book, such that each necklace represents one volume. The volumes themselves, which range from classic works of fiction to sales catalogues, are selected by the subjects and then given to the artist in order to be transformed into this wearable form. The process of translation, reanimation and finally distribution (the beads stay with the owner and are to be worn rather than displayed museum-style) reflects Gill's ongoing investigation of knowledge and understanding, culture and assimilation.—Jessica Morgan

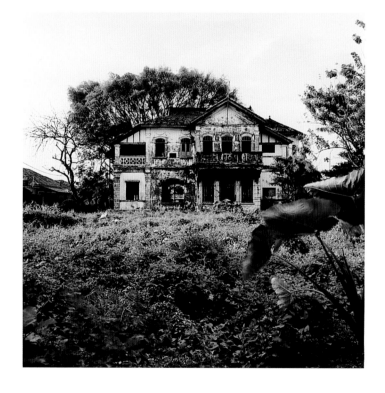

[1] **Pearls, Sydney, 2003. Sydney University academics in a suburban back garden. Left: Lin Yutang, My Country and My People. London: Heinemann, 1962, and Joseph Conrad, Under**
 Western Eyes. Harmondsworth: Penguin, 1996; right: The Sensational Spiderman, November #33. New York: Marvel Comics, 2001, 2003, black-and-white photograph, dimensions variable

[2] **Dalam #154**, from the series "**Dalam**", 2001, C-print, 27.5 x 27.5 cm, 10.5 x 10.5 inches

[3] **Standing Still #66**, from the series "**Standing Still**", 2000-3, C-print, 31.5 x 31.5 cm, 12.5 x 12.5 inches

[4] **Dalam #229**, from the series "**Dalam**", 2001, C-print, 27.5 x 27.5 cm, 10.5 x 10.5 inches

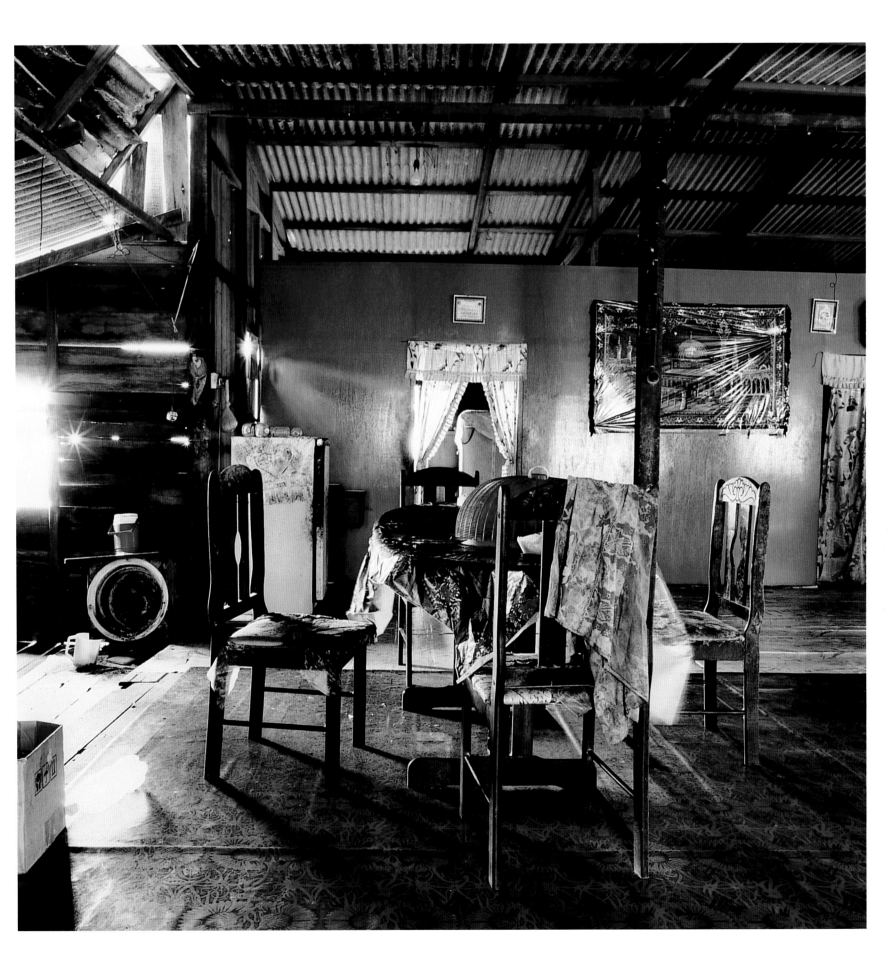

First recognized for ambiguous, unsettling photographic "narratives" that riff on tropes of youth, in particular schoolboy life, **Anthony Goicolea**'s work describes a myriad array of fantastical worlds. By turns humorous and horrific, gorgeous and grotesque, these mythical environments and the seemingly ritualistic activities that take place within are transparently artificial but nonetheless emotively jarring. Goicolea's style of slight, deliberate excess enhances the surreal unease of the work: a palette just too saturated to be real, activities seemingly recognizable but upon inspection inexplicable — meticulously staged compositions both seductively precise and disturbingly frozen. When figures populate the work, they are almost exclusively the artist, self-portraits transformed first through theatrical make-up, costume and lighting, and then digitally duplicated and manipulated.

The foggy, decrepit graveyard on the damp shores of *Lake* (2004), strewn with discarded clothes, might at first be a still from any number of horror movies, teenagers choosing a deliciously macabre site on which to pitch their tent, to sneak away for sex. Closer inspection reveals it to be a specifically male encounter, and its character cloudier — the shadowy forms partly illuminated in the tent might be romantically entwined, but simultaneously propose a more violent transgression. The seeping mist hanging over the recumbent boys in *Morning Sleep* (2004) throws an air of danger over the potentially innocent scene. The dead fire, the feeble dawn light, the black flags drooping over the boys lying face down on the grass suggest something more than an all-night game of "capture the flag" — more the outcome of an illicit bacchanal, latent violence stirring its surface, than the exhaustion of rosy-cheeked youth.

Goicolea's photographs often appear as fragments of a larger narrative, almost arbitrarily mingling elements from a selection of familiar tales, more Brothers Grimm than the Hollywood-sanitized version proffered in much American mass media. Like the fairytales and myths that they evoke, his images externalize hidden aspects of human nature and make them symbolically tangible. Of late the story often seems subsumed to the formal or atmospheric effect. His Breughel-like approach to a total composition allows a single event to exist seamlessly within the larger capture of existence, where abnormality is read as emphatic reality rather than deviancy. Recent images rely less on the figure to provide content, retaining the suggestion of human presence but abstracting even more fully the depiction of action. *Cherry Island* (2002) describes a seemingly idyllic, paradisal setting, but just this side of too clear, too perfectly composed.

Goicolea's deft synthesis of hauntingly beautiful, often malevolent interior worlds remains both recognizable and yet utterly uncanny. Drawing on familiar narratives and characters of male youth, both impotent and violent, raging in adolescent flux, he taps into the darker, ambiguous underbelly of contemporary life via these specific and metaphorical instances of intense, often ritualistic, emotional experience. In the contemporary world, we have been led both to fear and to desire the state of youth — a conflict that Goicolea mines repeatedly to varying effect. He explores the ongoing anxieties and failures of memory, desire, violence and will — not as an end in itself, but as a means to understand a world often seemingly devoid of the recognition of its own complexity. — Shamim M Momin

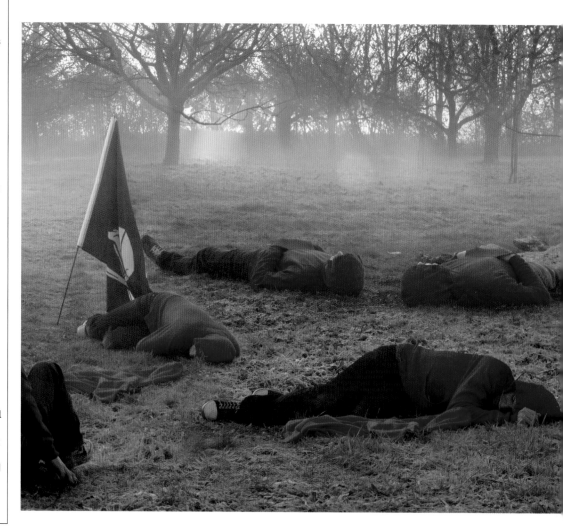

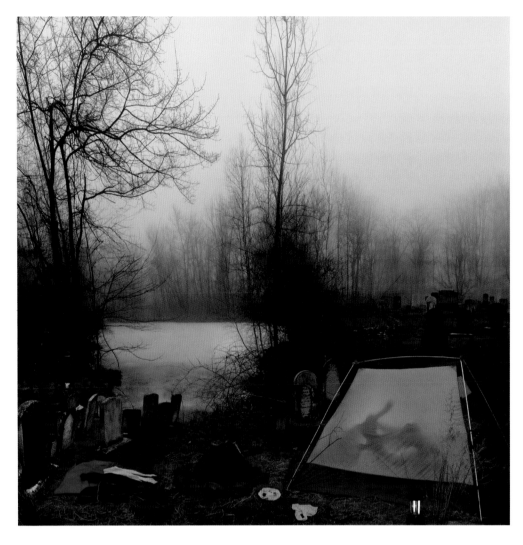

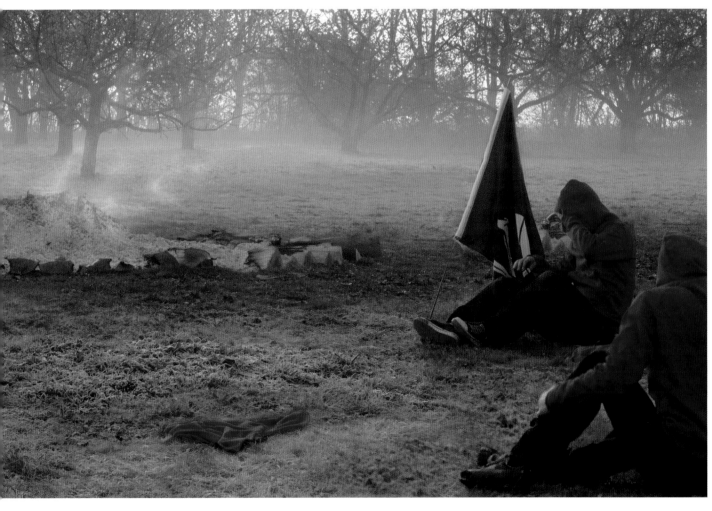

Anthony
Goicolea

[3]

[3] **Cherry Island**, 2002, C-print, 68.6 x 180.3 cm, 27 x 71 inches

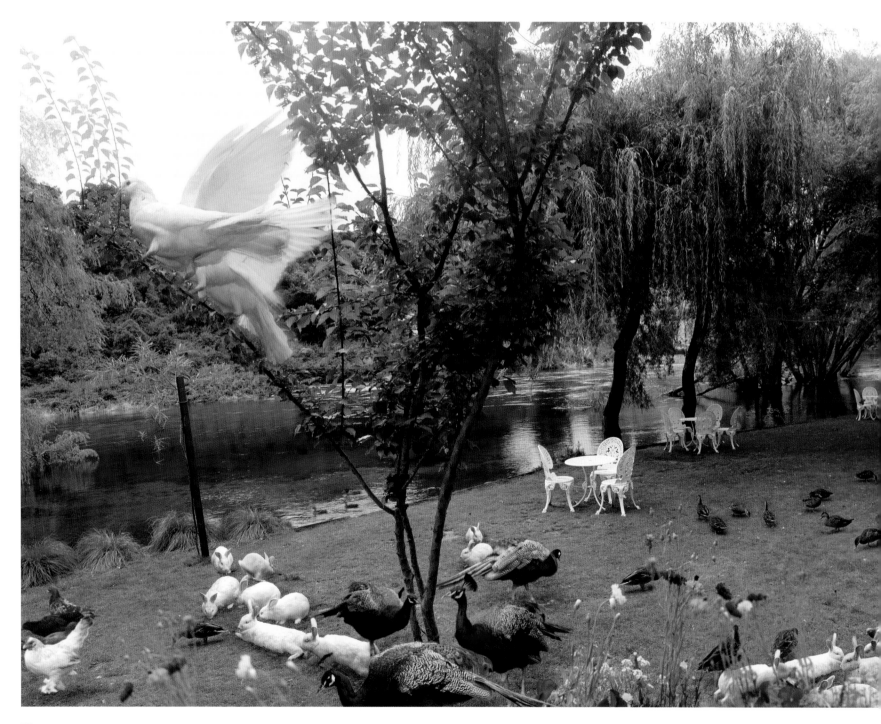

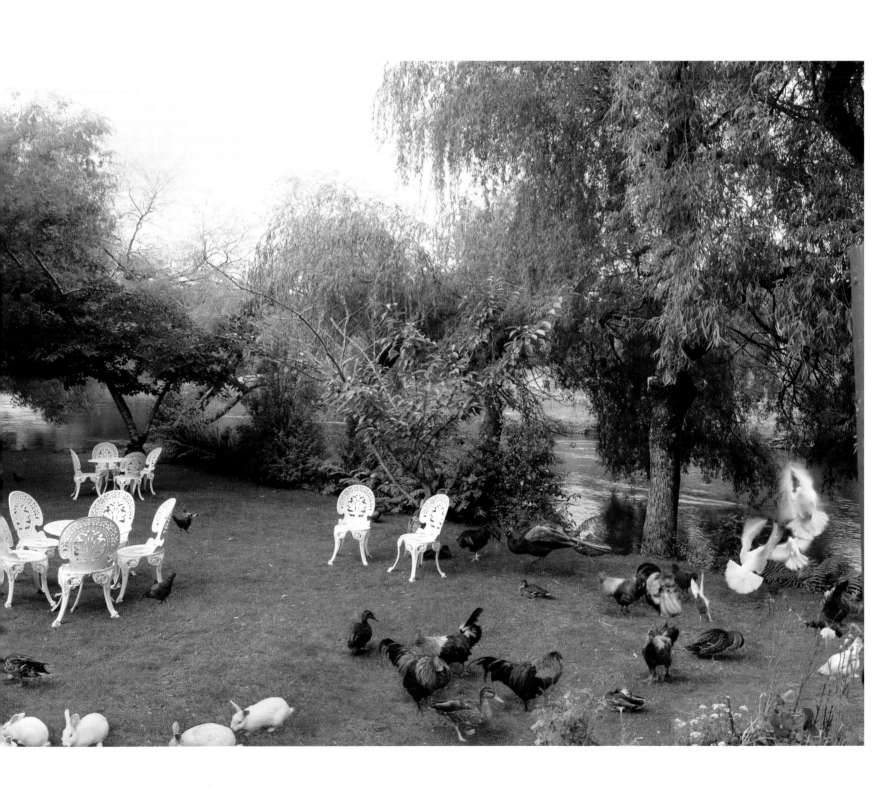

[1] [2]

Henri Cartier-Bresson began capturing what he later termed "the decisive moment" around the same time that the Surrealists were at their interwar peak. **Geert Goiris** possesses the uncanny ability to fuse the iconic force of Cartier-Bresson's pictures with the imaginative strangeness, if not the drama, of the Surrealists' work. Goiris uses the term "traumatic realism" to describe a series of loosely connected photographs, taken during the past six years, in which each shot depicts the point of rupture where one world inexplicably slips through the seams of another. *Blast #3* (2001) literalizes this idea with its yellow fireball hovering in a forest clearing. The juxtaposition is jarring, but is softened by a visual parallel between the filigreed lines of the explosion's outward movement and the arcing leaves of the green ferns touched by its light. The tension in this picture is gentle yet insistent, suspending the viewer between knowledge that the moment captured was staged and the desire to believe it is an apparition.

Goiris's photographs, in which strangeness is made plain, consistently evoke this feeling. The dreamlike quality of each image is offset by his naturalistic technique. The ostensible subject of each picture is usually centred in the composition as in *Hotal Siaulai* (2003), buffeted by ample amounts of foreground and background space; the lighting is even (and often natural). Paired with Goiris's unwillingness to introduce overarching narratives, this undercuts the assumption that irony must be at play; there is nothing strange (and nothing to fall back on) but the pictures themselves. So the viewer encounters an albino wallaby, paws crossed, pausing on the clipped grass of a formal garden or park, or a rhinoceros resting in the middle of an open field cushioned by fog as in *Rhino in Fog* (2003), and slowly learns to accept these lucid oddities as familiar. Goiris often photographs in northern Europe, though his specific locations are not immediately recognizable, and the grey skies that hang low over many of his images seal in their content; his ethereal visions will not drift away.

A human presence, almost always unseen, marks many of the pictures described above; an unsentimental regard for past ambitions characterizes others. *Ministry of Transportation* (2003) depicts the heroically scaled eponymous building, an architectural rendition of roadways crossing at right angles that towers above humbler structures. Yet, with ivy climbing its support columns, its obsolescence is apparent: nature is reclaiming what man had wrought with its resources. *Futuro* (2002) is likewise a portrait of a modernist architectural experiment now seemingly entering a long winter of disuse. Both photographs compress the extended duration of such cyclical transformations into poignant moments that are, like all of Goiris's photographs, scrupulously observed. — Brian Sholis

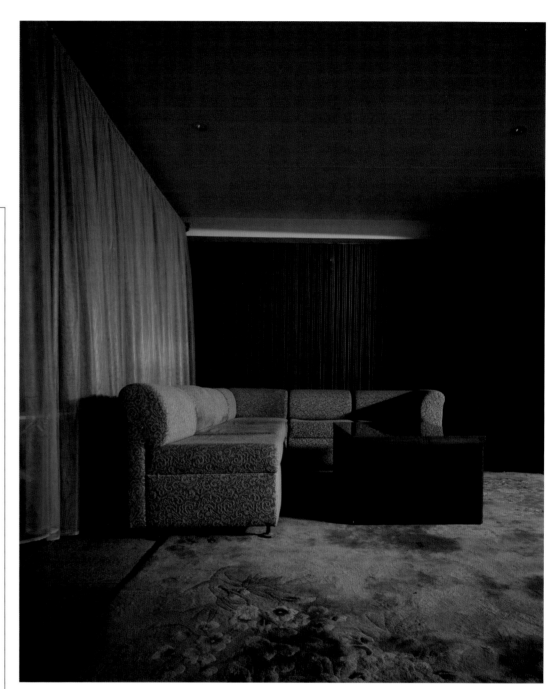

[1] **Hotel Siaulai**, 2003, Lambdaprint, 100 x 120 cm, 39.5 x 47 inches
[2] **Ministry of Transportation**, 2003, Lambdaprint, 157 x 125 cm, 62 x 49 inches, collection
 Ministerie van de Vlaamse Gemeenschap, Brussels

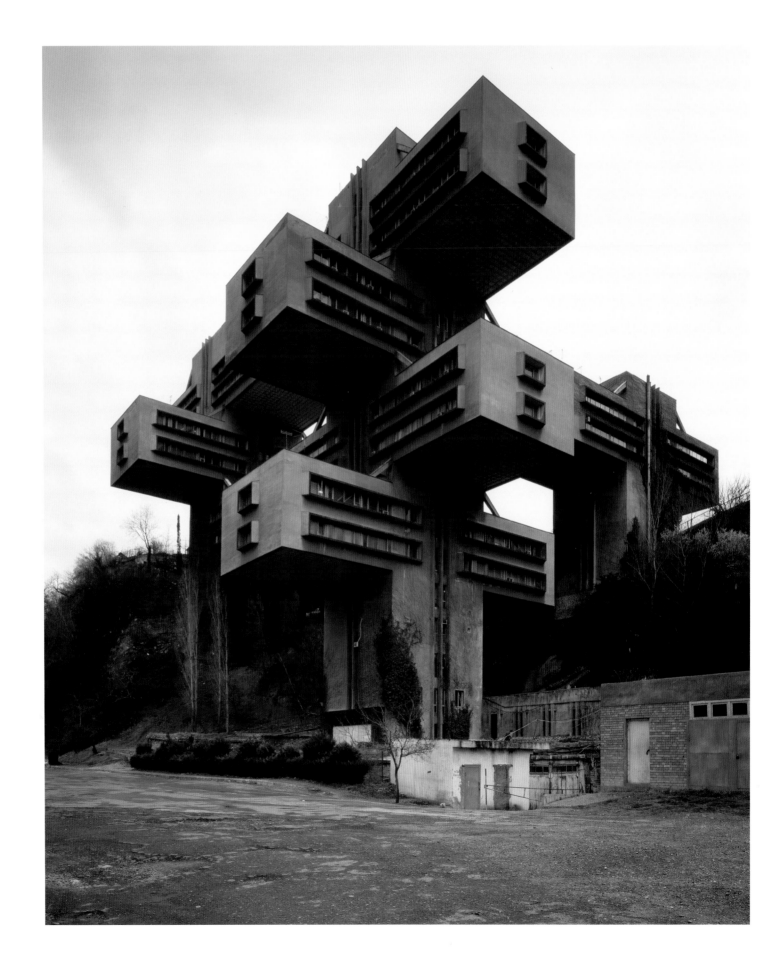

[3] [4]

[3] **Abyss**, 2000, Lambdaprint, 100 x 130 cm, 39.5 x 51 inches, collection Seattle Art Museum,
 Seattle, LaSalle Bank Photography Collection, Chicago
[4] **Rhino in Fog**, 2003, Lambdaprint, 100 x 130 cm, 39.5 x 51 inches, collection Musée d'Art Moderne
 de la Ville de Paris, Paris

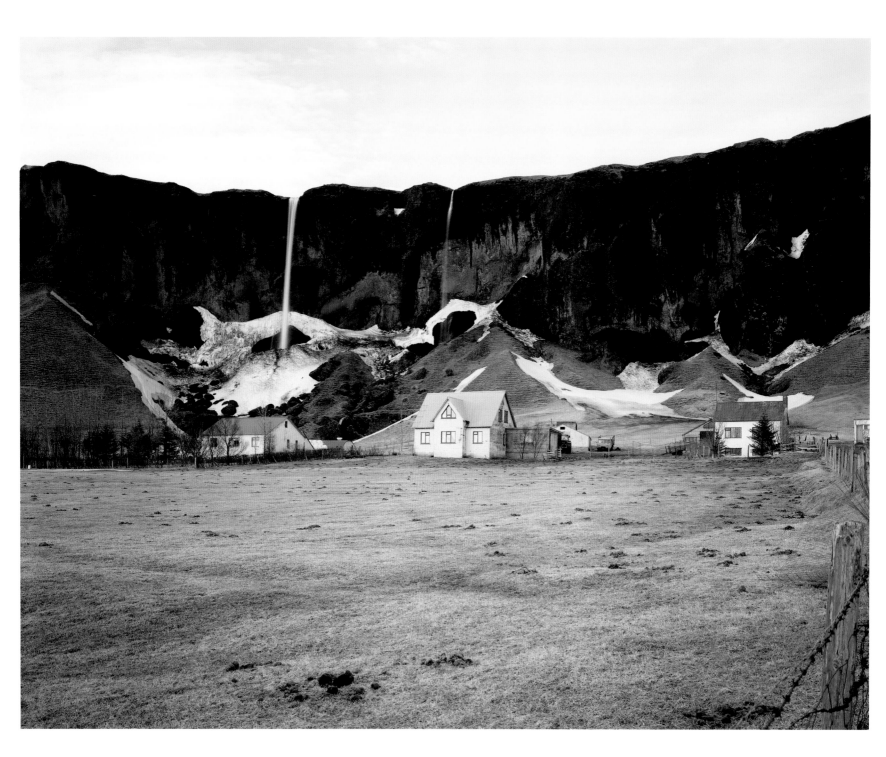

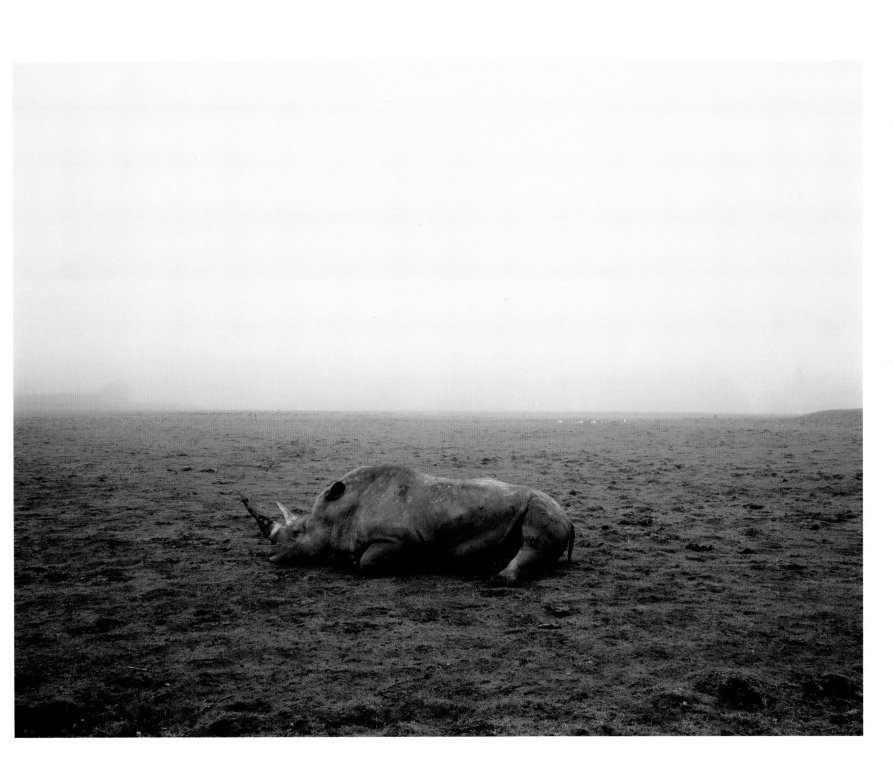

For more than fifty years **David Goldblatt** photographed
the banality of prejudice and racial inequality in apartheid
and post-apartheid South Africa. His magnificently eloquent
black-and-white documentary photographs showed everyday
scenes steeped in toxic tensions, barely suppressed hatreds
and surprising affections. Refraining from mockery or easy
assumptions, he portrayed Afrikaners with as much empathy
and interest as his black subjects, illustrating how the
apartheid system of exploitation ultimately benefited neither
group. It was only in 1998, four years after the end of
apartheid, that he finally started photographing in colour.

Since 2000 Goldblatt has been photographing urban
and rural South Africa. He has presented a series of images
depicting the development and advertising of luxury gated
housing complexes and golf courses built around an exposed
sewage pipe, which the developers' advertisements
conveniently fail to mention. The titles of his sharp, brutal
images are direct and journalistic. His photographs powerfully
engage assumptions about the aftermath of apartheid.
Goldblatt states, "Notwithstanding our many problems,
I am full of hope for this country."

In an image from 2002, three boys stand knee-deep in
murky, potentially toxic water, elaborated by the title, *In an
old mineshaft of the abandoned Pomfret Asbestos Mine,
Augusto Luta washes his clothes while Augusto Mokindo,
Ze Jono and Ze Ndala stop for a photograph in the water in
which they and other children of the village swim. The water
is almost certainly contaminated by blue asbestos. Pomfret,
North West Province. 25 December 2002* (2002). A dry and
plain patch of land becomes infused with historical portent
when coupled with the title, *Crosses erected by white
farmers on June 16 2004 in commemoration of and protest
against farm murders, Rietvlei, on the N1, near Polokwane,
Limpopo. 19 June 2004* (2004). Once this information is
absorbed, the faint, frail-looking white crosses seen in the
near distance begin to overwhelm their setting, demonstrating
how history has transformed the landscape of South Africa.

Goldblatt was born in 1930 in Randfontein, a town forty
kilometres (twenty-five miles) outside Johannesburg. His
grandparents emigrated from Lithuania, bringing his parents
as children to South Africa, where his paternal grandfather
started a general dealer's shop in Randfontein that, in time,
his father took over and turned into a men's clothing store.
As an adolescent, he became inspired by the leading
photography magazines of the time, such as *Life*, *Look* and
Picture Post, and after matriculating in 1948 he worked briefly
as a wedding photographer in the hopes of progressing to
editorial magazine work. "Mainly my job was bumping guests
with 'good' cameras so as to ensure that only my boss got
usable photographs", recalls Goldblatt. Disillusioned, he
went to work for his father and stayed in the family business
for ten years until he completed a university degree and
returned to photography.

Goldblatt expresses his ambitions during this time by
explaining, "The National Party was elected to power in 1948
and my photography in the early '50s attempted to tell the
world about events relating to the increasingly oppressive
regime that they imposed on the country and, in particular,
its black peoples." However he failed to have work published
and came to realize that he was neither suited to nor really
interested in photographing events so much as the conditions
that gave rise to them. "With this understanding," he states,
"I began increasingly to look at our values and how we
express them. That has been my principal preoccupation
ever since."—Ana Finel Honigman

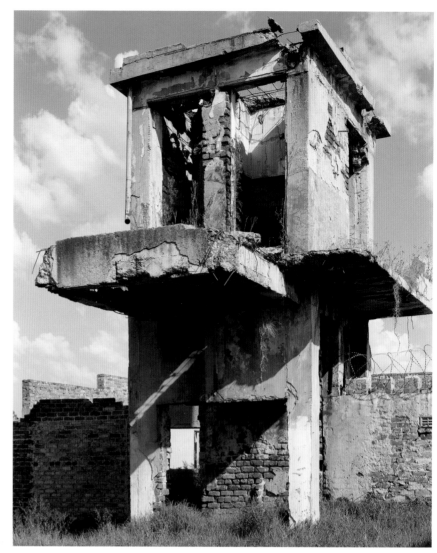

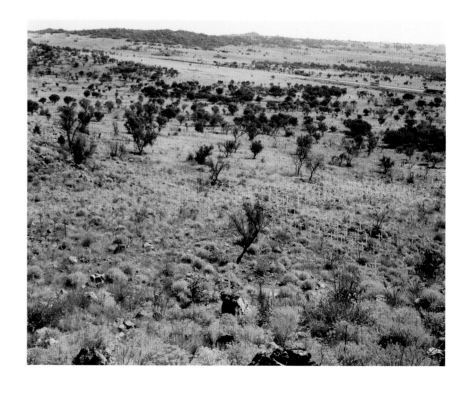

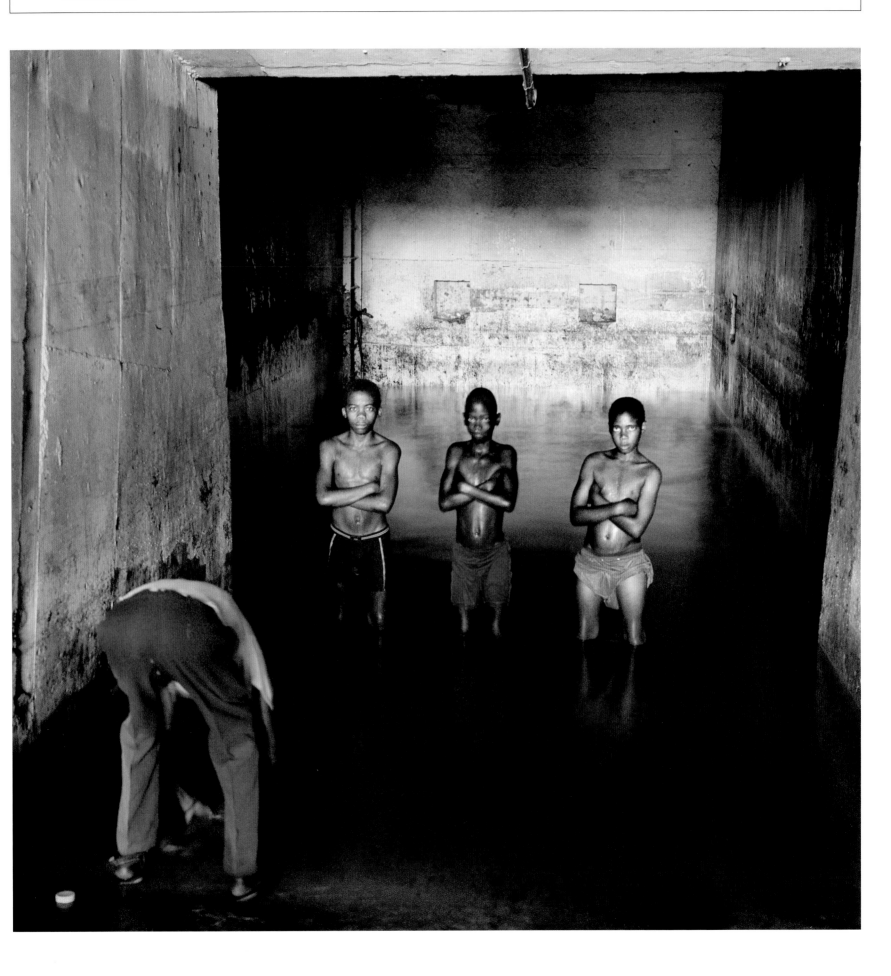

Katy Grannan	Kg	[1]	[2]
			[3]
			[4]

Katy Grannan's portraits have a stillness and an attention to detail that resonates with nineteenth- and early twentieth-century portrait photography, unlike today's emphasis on the snapshot and the mutability of the digital image. She uses a large format camera, and her collaborations with her models have a seriousness that rework the importance that a visit to the photographic studio must have had in pre-Kodak times, the outcome presenting the document of a person's identity, to be framed and revered.

In Grannan's early series — "Poughkeepsie Journal" (1998), "Dream America" (1999-2000) and "Morning Call" (2001-4) — she went to the models' houses to take their photographs, presenting a portrait of their home as much as of themselves. She finds her models mainly through advertisements placed in local newspapers, and the photographic session is often the only time that Grannan and the sitter meet, an anonymous encounter that has been repeatedly focused on in writings about her work. This detail lends allure to Grannan's images, the exchange between strangers that is enacted before the camera. However, a more interesting aspect of her work is the way in which the pose and gaze of her sitters engage the viewer, a document of both how they want to be represented, and the sum of all the small details that are beyond their control. In her black-and-white "Morning Call" series there are similarities with EJ Bellocq's portraits of prostitutes from around 1912, or Walker Evans's Depression-era photographs, where the wariness of the models' engagement with the camera is overlaid with an intimacy and an attention to texture, pattern and light that elevates the images into essays on the aspirations and dreams of small-town America.

In the series "Sugar Camp Road" (2002-3), and "Mystic Lake" (2004), Grannan takes her models into the landscape, posed in settings chosen by them. Whilst "Sugar Camp Road" uses the landscape to frame the images in a similar compositional manner to her interior work, "Mystic Lake" employs a claustrophobic overhead perspective, the models gazing up at the camera as they recline in the undergrowth or lie half submerged in water. This series features many male models, unlike her earlier work where young female sitters predominate, leading to a new dynamic in the resulting portraits. The encounters with unknown men, women and children laid out before the camera take on the qualities of a seduction or an assault, with many of the images showing their subjects in states of undress and vulnerability. Credited with their first name and year of birth, the models in this series are categorized as if they were a variety of specimens laid out on glass slides, the images ready for the scrutiny of the viewer. The continuing engagement with the portrait photograph takes her work beyond its initial reception in the mid 1990s, as part of the Yale School of young female photographers engaged with issues of adolescence and gender, into a broader consideration of the way in which America pictures itself for the camera's gaze.— Catherine Grant

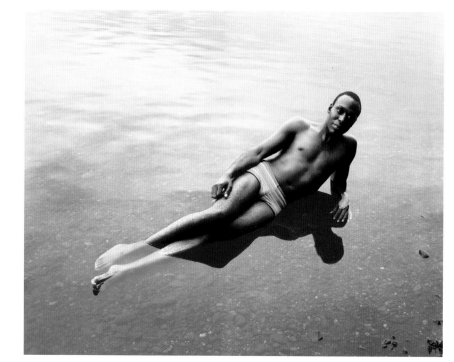

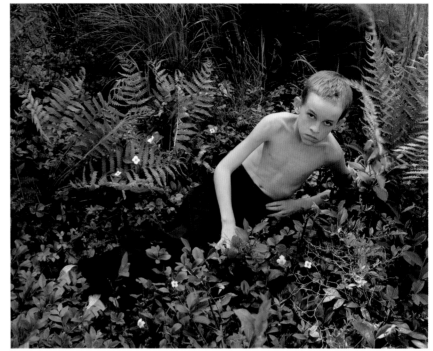

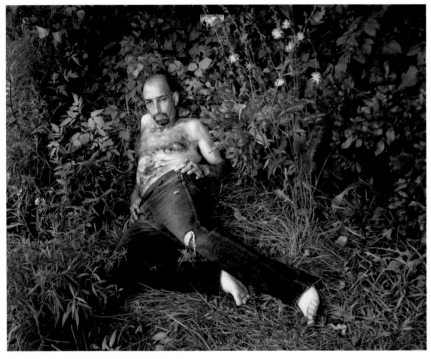

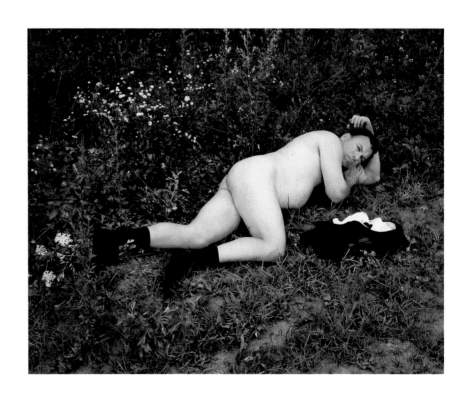

[1] **Tu Casa Es Mi Casa.** The lock from the door of 8 Gascoigne Place, London (my house), was removed and installed on the door of 291 Church Street (Apexart Gallery), for the duration of the exhibition. A hundred copies of my key were cut, displayed and free to take. **Apexart, New York**, 2003, C-print, 30 x 19.9 cm, 11.5 x 8 inches

[2] **Until we kiss again**, 2004, C-print, 30 x 19.9 cm, 11.5 x 8 inches

[3-5] **Running pink line, Basel: Pink thread extended across the boundary of 3 properties,** 2005, lightjet print, 30 x 19.9 cm, 11.5 x 8 inches

A pink thread extends across several properties in the Swiss city of Basel, coming in and out of windows, suspended above ground level, impervious to title deeds, fences and any of the other mechanisms that define the difference between public and private space. The pink thread delineates its own territory and at the same time materializes a thought, a subversive thought perhaps, and makes it concrete. **Mauricio Guillen**'s work invests simple formal gestures with subtle political implications. Trained principally as a photographer, he has extended his practice into various media including video, performance installation and elegantly turned sculptures that reference a minimal/conceptual tradition.

Guillen's subject is the world—the man-made world, its normative systems and demarcations of ownership, its production of meaning, measure and value. His work seems to suggest that despite appearances, these things are not set in stone but instead are subject to constant change, a process in which we can intervene. Romanticism plays an important role in Guillen's practice. In *Until we kiss again* (2004), two envelopes (presumably from parted lovers) have their respective adhesive strips attached to one another in a surrogate kiss. As well as romantic love, the artist plays with a romantic conception of freedom from the rigid structures and systems within which individuals and societies operate. Some works address this literally in the sense of making something available "for free". In *Nothing Personal*, shown in Frankfurt in 2003, several objects are arranged in a sculptural configuration in the corner of the gallery. These include a carpet, two plants, a chair, a pencil, some Post-it notes and a telephone, which visitors are able to use without charge for the duration of the show. In *Ideological Inversions, consumed supermarket products turned inside out and re-inserted in a circulation system* (2004), freedom takes the form of "freedom from"—a temporary respite from the continual streaming of images with which capitalism attempts to invest every man-made surface. Here a number of cardboard packages are neatly inverted so that their graphic message is concealed inside, leaving the exterior blank.

Closely relating to this work are a series of photographs called "May 1st" (2002). These depict shop fronts in Mayfair in central London on Labour Day voluntarily boarded up by their owners for fear of vandalism and looting. The artist was interested in how this parade of upmarket boutiques, that in normal circumstances use their windows to lay on a display of merchandise, suddenly went into hiding. He captures the temporary plywood and chipboard façades that were erected overnight with his camera, and describes these structures as a "24 hour architectural solution", a testament to the power of rumour, which alone managed to bring about this self-imposed curfew. Looking at these various works, we can see how the idea of freedom is imagined, configured and realized with a precision that gives this term a material and conceptual support—and how the camera allows him to orchestrate a fluid relay between this idea, the material world and the photographic record.—Grant Watson

[1-2] **Untitled**, from the series **"Brixton"**, 2002, C-print, 26 x 38.6 cm, 10 x 15 inches

[3] **Untitled**, from the series **"Forest"**, 2000-5, C-print, 26.3 x 17.3 cm, 10.5 x 6.5 inches

[4] **Untitled**, from the series **"Forest"**, 2000-5, C-print, 50.5 x 34 cm, 19.5 x 13.5 inches

During the past twenty years **Jitka Hanzlová**, a Czech photographer based in Essen, Germany, has compiled a striking body of portraits. Whether her photographs are of women she has encountered on her travels (the series "Female" [1997-2000]); people and places in the tiny village in northern Bohemia where she grew up ("Rokytnik" [1990-4]); or, more recently, quiet forest scenes taken just outside that village ("Forest" [2000-5]), a ceremonial air, compositional directness and a muted colour palette unite her images. "Rokytnik", which can be considered Hanzlová's first mature series, was undertaken only after the Velvet Revolution, when the photographer was allowed to return to the place where she was raised. The pictures form an oblique portrait of a locale that remained essentially the same, while Hanzlová, exiled in Germany, experienced profound change. The pictures—of farmers, women, children, individual trees, clothes hung on a washing line —seem tentative, gentle, as if the photographer were using the camera as a means for reconciling her memories of the place with its condition at the time she took them.

The great empathy those pictures presented is evident in all of Hanzlová's subsequent photographs. In the late 1990s she began photographing women that she chanced upon in public places; the resultant series, "Female", functions as both a typological archive and an essay in individuality. The women, of diverse ages, races and physical characteristics, are presented in half- or three-quarter-length portraits and look fixedly into Hanzlová's lens. Perhaps because Hanzlová spends time getting to know these happened-upon subjects before beginning to photograph them, their faces divulge much despite their impassive expressions. "Brixton", a series of photographs commissioned in 2002 by the Photographers' Gallery in London, is similar in format and respectful directness. When exhibited, these pictures, primarily of black women and girls resident in the vibrant enclave on the city's south side, are interspersed with still lifes and domestic interiors. The inanimate objects are often set before windows imparting a gauzy light that both contrasts with the clarity with which Hanzlová describes her human subjects and presages the dreamily atmospheric pictures that she has made in recent years.

The images of "Forest" are shot in the wooded areas outside Rokytnik. The photographs are devoid of human subjects and possess an estranging quality: in one image a blurry tree trunk slices vertically through the composition like a dark lightning bolt, surrounded by pale moonbeams. The forest serves as a counterbalancing force, an "other", both to the village and to Hanzlová's practice. It is a place where fantasy blends with reality, the past with the present, the unconscious with reason; it opens a new avenue for her practice, at once highly personal—Hanzlová played among these groves as a young girl—and abstract.—Brian Sholis

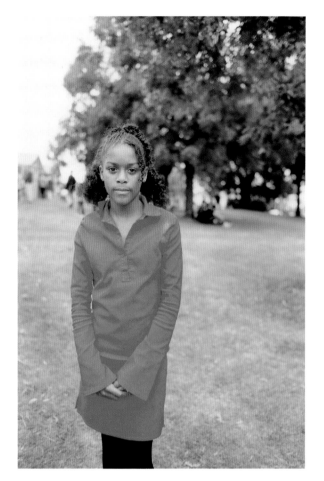

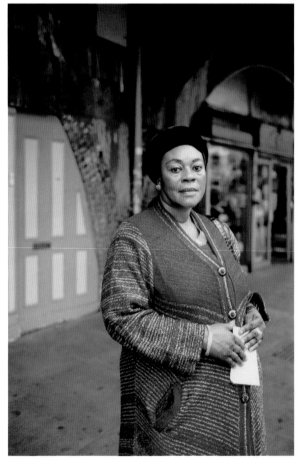

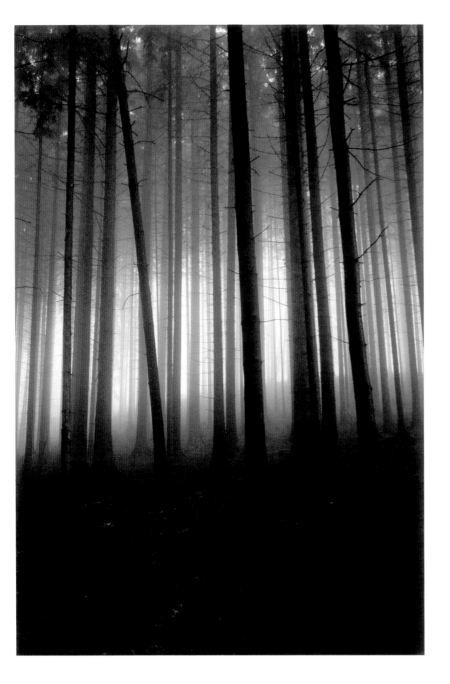

[1]
[2]
[3]

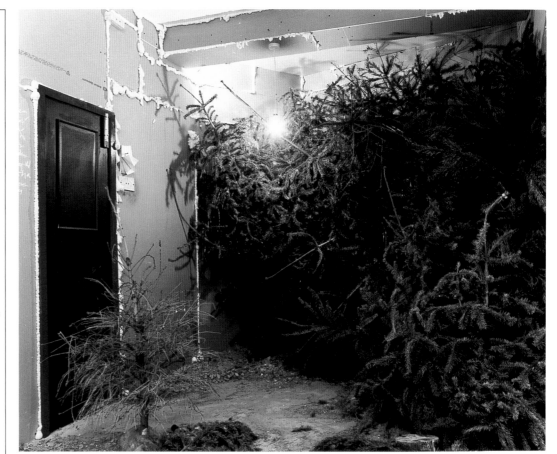

Underground bunkers, back rooms and overlooked corners both harbour and generate **Anne Hardy**'s psychological dramas. Hardy is interested in the literary cusp between naturalism and magical realism, where the potential of contemporary humanity, whether dark or ridiculous, can be teased into an image teeming with evidence of past events. It is fairly obvious at first sight that her interiors are constructed rather than found spaces, yet they are extrapolations of vivid scenarios that maybe, just maybe, could actually exist. In *Untitled IV (balloons)* (2005), a room with a skylight and technical diagrams on blackboards around the walls seems to have been the unlikely venue for festivities. Balloons, streamers and a pile of cigarette butts, incongruous among the sloppily fixed ceiling tiles, perhaps speak of the celebration of a technological breakthrough or the unbridled outburst of pent-up technocrats' frustration.

Hardy creates spaces beyond public access that tend to dam some sort of chaos. *Lumber* (2003) is the resting place of dozens of discarded Christmas trees, which suggests the seedy machinations of a society that likes to suppress degradation and the spoils of its own excess. Objects and materials that signify the fragility or pathos of our desires suffuse these interiors. Mattresses left on street corners are literally dirty laundry aired in public; Hardy presses them into service as walls of a den bristling with defunct light bulbs and cabling. Elsewhere a ceiling—with dark-green scalloped Artex, electrical conduits, utilitarian fan and light fitting—has been augmented with stick-on stars in a vain attempt at prettification of a lost cause.

Throughout this series dystopic architecture is an uneasy backdrop for sinister events: butterflies trapped behind modernist windows or a solarium containing tropical plants but no signs of animal life hint at failed experiments. Or there might be a sense that something apocalyptic has happened outside these buildings. The glass windows of a control panel, bedecked with dials and levers, give out on to a huge drift of fallen leaves, as if the building has beenburied. We are often left with the distinct feeling that technology's command will never quite vanquish nature. Hardy translates this cinematic scenario into political terms: in the post-Cold War era, when a single enemy can no longer be identified, there is a paranoia attached to hidden networks, whether human, natural or supernatural. These scenes, then, of the possible fallout, disintegration, dissipation and degradation of material objects are analogous to personal and collective fates—a literary tradition that can be traced back through Kurt Vonnegut, JG Ballard and George Orwell.

Also in line with this literary, and indeed filmic, genre, Hardy's process and subject matter spark an internal contradiction, which lends a metafictional edge to straightforward fantasy. She repeatedly demonstrates how human control is inevitably relinquished to the chaotic universe, yet her interiors are themselves constructions. The internal logic of these theatrical set-like spaces ascribes to the artist the role of literary narrator with uncontested control over the relaying of events, and yet their fragmentary nature confounds such absolute authorship. These interiors present us with a realism that does not attempt the total recall of static phenomena, but rather the confusion of experience.—Sally O'Reilly

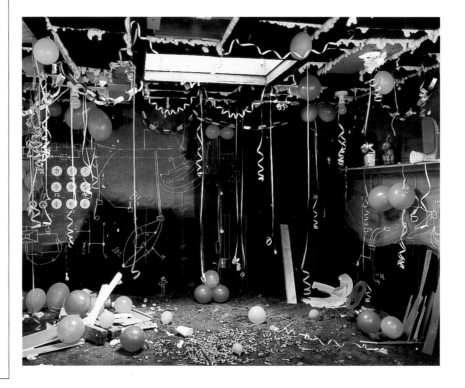

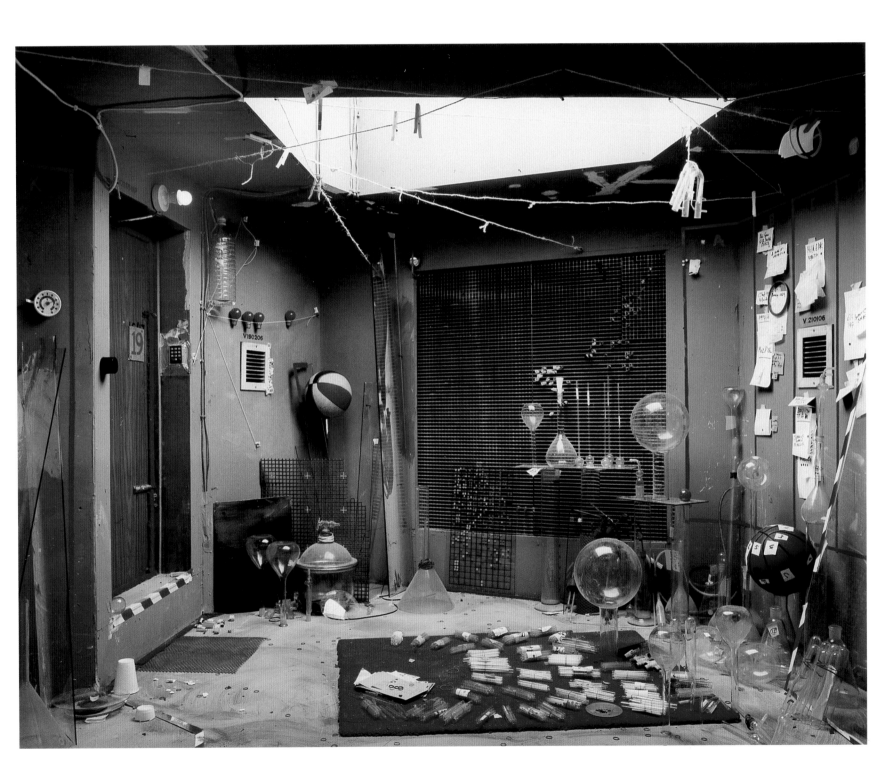

[1] **Untitled**, from the series **"Perth Amboy"**, 2001, C-print, 40.6 x 50.8 cm, 16 x 20 inches
[2] **Untitled**, from the series **"Perth Amboy"**, 2001, C-print, 33.7 x 48.3 cm, 13 x 19 inches

To include **Rachel Harrison** in a publication devoted to established and emerging photographers raises an immediate question: in what way can her work be classified as photography? While Harrison consistently employs photographic images (either those she shoots or finds), they are typically coupled with sculptural elements in the artist's distinctive image-object amalgams. Almost despite herself, Harrison assumed the mantle of "photographer" with "Perth Amboy" (2001)—a series documenting the contemporary pilgrims who flocked to a home in Perth Amboy, New Jersey, after a supposed sighting of the Virgin Mary. While initially presented together with an elaborate sculptural installation, the images in "Perth Amboy" have taken on an afterlife as independent works. As such, they both offer a point of entry into Harrison's photographic practice and illuminate the extent to which it cannot be isolated from her larger artistic project.

Take, for example, a work from this series: filling the frame, lying flush with its edges, is a standard white window frame —the type one expects to find in a similarly generic suburban home (as is indeed the case here, one learns from other images in the series). The bottom half of the window contains three horizontal safety bars, an act of customization but one that hardly individuates its owners, indicating nothing more than participation in the predictable category of suburban dwellers who have or once had young children. From behind the bars a woman's face emerges from the darkness— shocking less for its ghostly pallor than for the way its irreducible specificity contrasts with the utter banality of what surrounds it. This contrast is echoed by the tension between the image's combined subject and function as "window" and the haze of breath that coats the glass in front of the woman's face as well as by her outstretched hand, which presses forcefully against the window's pane. In both these pairings Harrison stages a confrontation between what can be considered photography's opposing poles. To photography's simulacral status as a copy without an original (embodied by the mass-produced window frame), Harrison contrasts the medium's ability to capture an unrepeatable moment in time. In relation to its identity as an illusionistic image (embodied by the window itself), she insists on photography's physicality as an indexical trace.

Here one sees a persistent feature of Harrison's work: a high degree of formal and discursive rigour matched by an insistence on identity as a play of opposing terms rather than a series of immutable properties—a combination that both preserves the critical potential of medium-specificity while rendering irrelevant simplistic, medium-based classifications of Harrison's work. In its entwinement of mass-produced visual sign and singular physical trace, the aforementioned image elaborates within the single medium of photography precisely the dialectic that Harrison's work stages elsewhere through a collision between photography and sculpture, as they operate within the still paradigmatic frameworks of Minimalism and Pop. As critic Saul Anton observed in *Artforum*, November 2002, while "reject[ing] any priority of the three-dimensional object over the image, submitting Minimalism to Pop's—and popular culture's —all-devouring maw … Harrison folds Minimalism's object back into the image, recognizing the insistent objecthood of the image." It is precisely this oscillating indeterminacy between image-as-object and object-as-image that marks Harrison's forays into photography and links it to her work as a whole.—Margaret Sundell

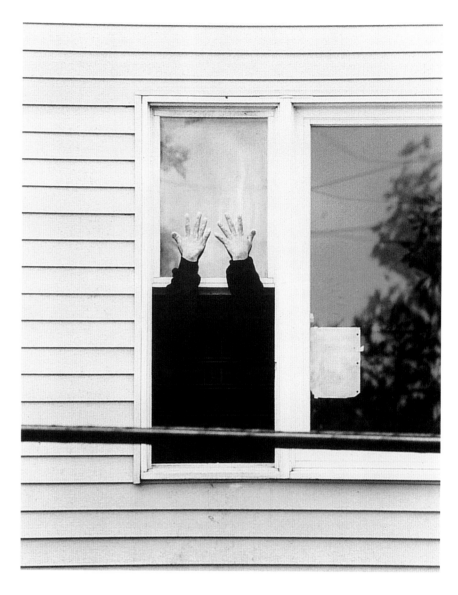

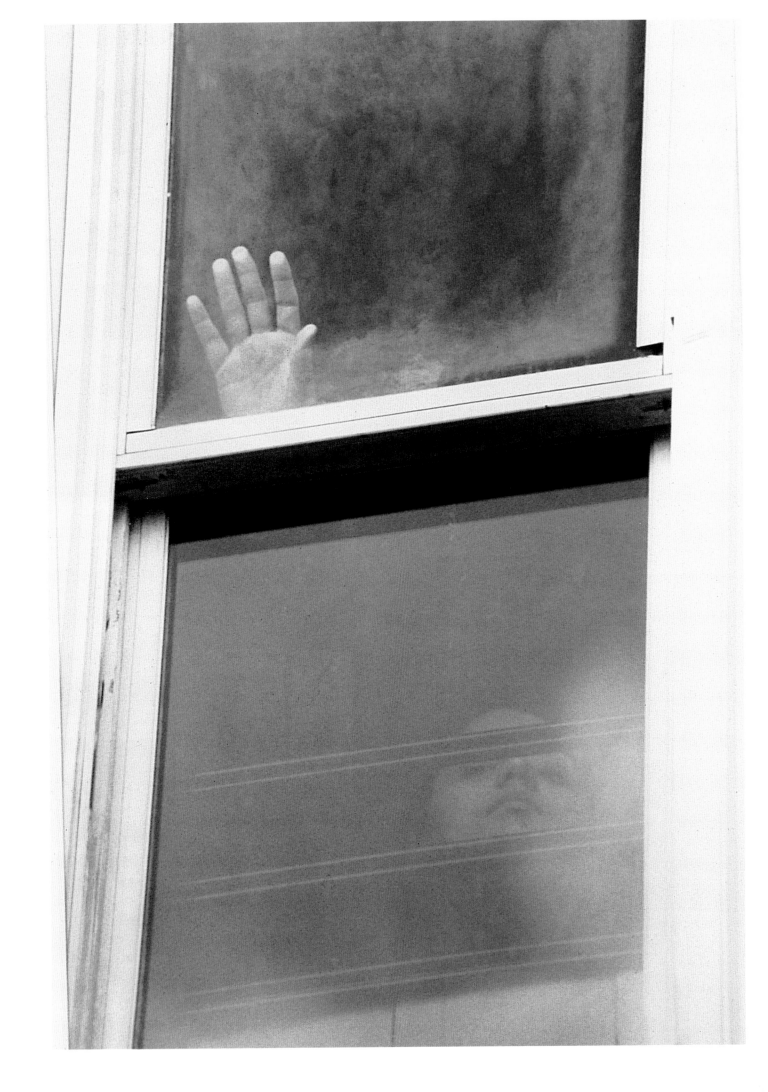

[1]
[2]
[3]

[1] **Conozca México**, 1996-2000, from the book **No Turisme**, postcard, 15 x 10 cm, 3.8 x 5.8 inches
[2] **Vulnerabilia I**, 2002-4, from the book **Vulnerabilia**, digital print, 55.9 x 38.1 cm, 22 x 15 inches
[3] **Rongwrong IV**, from the series "**Rongwrong**", 2005, collage, 129.5 x 91.4 cm, 51 x 36 inches

Photography plays an important role in **Jonathan Hernández**'s multidisciplinary practice, though one would not classify him as a photographer in the traditional sense of the word since he does not necessarily require the use of a camera. Rather, Hernández mostly relies on the plethora of images that surround us. He often appropriates existing images, such as press photographs, snapshots, postcards and advertising photography both to probe the status of the image in the world today and to examine different mass cultural phenomena, such as tourism. Hernández's works often take the shape of editorial projects—a particular preference of the artist—such as *No Turisme* (2000-1), a postcard book of collected archetypal tourist photos, and *Vulnerabilia* (2004), a publication comprised of cut-out newspaper photos with captions removed. On the one hand, Hernández probes the condition of being a tourist and the desire to "consume" places and spaces through the image; on the other he eliminates the titles and any textual information that allow us to identify the origins or content of the photograph, leaving us with only the image per se and its potential meanings. Interpretation thus rests with the viewer.

Questions of representation, dissemination, classification and juxtaposition lie at the core of Hernández's interest in the contemporary photographic image. He appropriates and rearranges images to illustrate, highlight and, at times, ironize the conventions of a media-orientated world: from the cultural, economic and social implications of travel and tourism to the effects of media image saturation. In that sense Hernández is more of an observer and collector of images—a kind of picture editor—producing assemblages and combinations of images, from which new associations and correlations emerge and shed light on contemporary social systems and relationships.

Hernández is also interested in the notion of public space —whether in an urban context or in newspapers and magazines. In his series of photographs entitled "Couples et Célibataires" (2001-2), taken in Mexico City, Paris and Madrid, he focuses on and juxtaposes physical details of the city fabric, seeking out and highlighting formal and typological similarities between different physical urban structures and scenarios, and casting his eye on the inconsequential, the banal or the overlooked. In this way he pinpoints not only the dysfunctional side of city planning and architecture but also the quirky aesthetics of these trivial physical details, many of which seem to resemble ready-made sculptures and possess a humble yet poetic beauty.

Hernández's new series, "Rongwrong" (2005), comprises collages of newspaper clippings arranged in delicate calligraphic forms; its title refers to a one-off 1917 magazine edited by Marcel Duchamp. These intricate, Dada-like images, dense in visual information, can be read as metaphors for the complex network of contemporary life, as reflected in the power structures, hierarchies and social inequalities which dominate current affairs, and the myriad "wrongs" that exist within society and are often personified by figures in the public spotlight.

Clearly in Hernández's practice, the message takes precedence over the medium. Rather than questions of authorship or uniqueness, he is interested in exposing the mechanics of contemporary imagery; the ways in which it is conceived, marketed, disseminated, consumed and interpreted.—Katerina Gregos

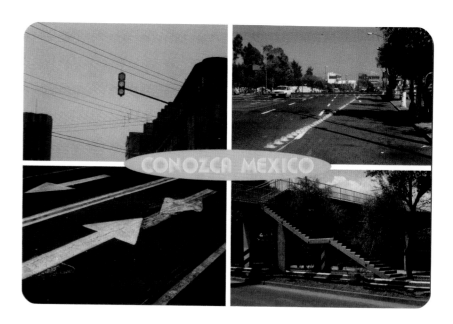

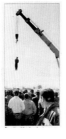
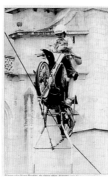
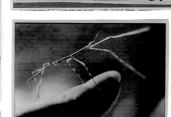

[1]
[2]
[3]

Sarah Hobbs constructs and then photographs uninhabited domestic spaces whose aberrations and excesses illustrate psychological pathologies. In her series of large-scale images taken with a 4 x 5 camera, entitled "Small Problems in Living" (1999-2004), benign and familiar settings become overwhelming and threatening, as they might be perceived by a person suffering from paranoia, obsessive compulsive disorder, agoraphobia, anxiety or the type of generalized post-modern neurosis embodied by Woody Allen's comic manifesto, "I can't express anger. I just grow a tumour instead."

Under the full lighting of Hobbs's photographs, rooms absorb their absent occupants' symptoms, and everyday objects such as paint-coated strips of masking tape, printing paper, an old phone or chocolate wrappers become as weirdly aggressive as cabinets and toys in shadow-filled rooms appear to children afraid of the dark. In *Untitled (Perfectionist)* (2002), a sunlit room becomes a writer's nightmare as an empty chair and desk are nearly buried in an avalanche of screwed-up paper. A companion photograph shows a stool, plainly a dunce's perch, sitting in the corner of a room covered in electric blue wallpaper lined with glaring eyes. Dangling over an unmade bed in *Untitled (Insomnia)* (2000) hangs a modern sword of Damocles, dozens of marked up Post-it notes, keeping us awake with their urgent reminder of things we still need to do, and the awful certainty that they will never get done.

Hobbs's work eloquently evokes the psycho-social pressures associated with big city living—she currently lives and works in Atlanta, Georgia. Her work is especially powerful because of its empathetic treatment of people suffering from irrational fears, whose legacy of alienation from those who are not afflicted is often as painful as the symptoms of the disorder. Though her images are not intended to be self-referential, Hobbs writes, "Being alone can be very comfortable, but there can also be a great discomfort when you are alone with your own psyche. Little neuroses, phobias or the like can have room to grow. Further, at one time or another each of us has probably had the idea that we were the only person in the world with a certain foible, and possibly on a certain level felt that this made us weird or compelled us to keep it a secret. What a relief when we realize that, not only are we not the only one, but that the problem is quite common. Psychology connects us, just as sociology does."

The absorbing scale of the photographs, their lucidly labelled titles and clear metaphorical illustration of complex emotional states lead viewers to empathize with other people whose conditions transform daily life into an unceasingly harrowing ordeal. At the same time, the overt artifice of her sets may reassure sufferers that their perspective of reality is disorientated and that, while banal things can be frightening, they might also be harmless.
—Ana Finel Honigman

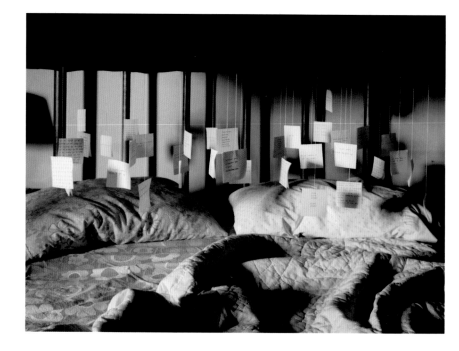

[1] **Untitled (Social Phobia)**, from the series **"Small Problems in Living"**, 2000, C-print, Fuji NPL, 121.9 x 152.4 cm, 48 x 60 inches

[2] **Untitled (Insomnia)**, from the series **"Small Problems in Living"**, 2000, C-print, Fuji NPL, 121.9 x 152.4 cm, 48 x 60 inches

[3] **Untitled (Perfectionist)**, from the series **"Small Problems in Living"**, 2002, C-print, Fuji NPL, 121.9 x 152.4 cm, 48 x 60 inches

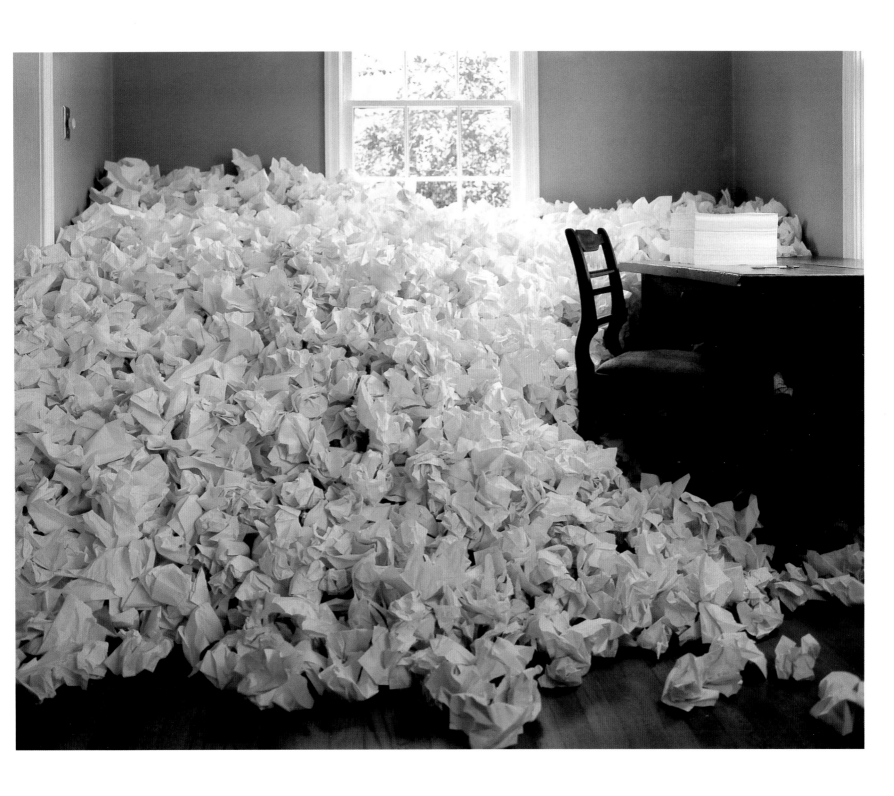

Emily Jacir's use of documentary photography is as strategic as it is powerful. In *Linz Diary* (2003), composed of a set of twenty-six photographs accompanied by brief journal entries, a webcam captures Jacir's small figure in an Austrian square every day at 6pm over the course of a month. Recalling conceptual uses of photography and video during the 1970s that documented banal activities performed in studios or on the street, this project surpasses such precedents by revealing the advances in our current society of control. Jacir's work exposes how systems of surveillance —the omnipresent CCTV cameras situated in public spaces —now do the job of systematic documentation for us whether we like it or not. It also reveals the increasing similarity of quotidian areas set in disparate geographies, both showing the homogenizing effects of globalization and dramatizing how everyday spaces across the globe can be indistinguishable despite their being in very different locations both within as well as outside the spaces of war and exile. In addition to these worthy investigations, Jacir's documentation can be seen to function as a means of survival.

Jacir shares her time between New York City and Ramallah in the West Bank. Palestinian, but the bearer of an American passport, she can travel freely in and out of Israel during times of peace. Many Palestinians do not have the same freedom. In response to these restrictions Jacir surveyed Palestinians in both Israel and in exile asking them: "If I could do something for you, anywhere in Palestine, what would it be? *Where We Come From* (2001–2003), an installation of thirty-two photographs with accompanying texts, gives us the answers. The original requests are recorded in English and Arabic text panels alongside photographs of Jacir dutifully carrying out the missions she has been set: playing soccer with a boy in the street, taking gifts to family members, visiting a mother's grave, eating traditional foods. While her camera acts as witness, the images dramatize the impossibility experienced by some Palestinians of performing these everyday activities. As a result, photography acts as a way both to rebuild a sense of shared belonging among a diasporic community that Jacir's piece reconstructs, and to forge an empathic link to the viewer, whomever it may be. This audience address is remarkably performed in those photographs that construct the viewer in first-person position within the image—as if I were leaning over *my* mother's grave, or eating dinner with a date. By inviting the viewer to inhabit its images, *Where We Come From* draws on the inherently deracinating force of the photographic and thereby defines exile generously: it references first and foremost the specificity of Palestinian experience, split between the reality of displacement and the need to repair it through new forms of national and cultural belonging; and it generates a mobile flexibility in terms of the position of the viewer, suggesting a path to overcome the essentialism of identity and the homogeneity of community that can drive cultures apart.—TJ Demos

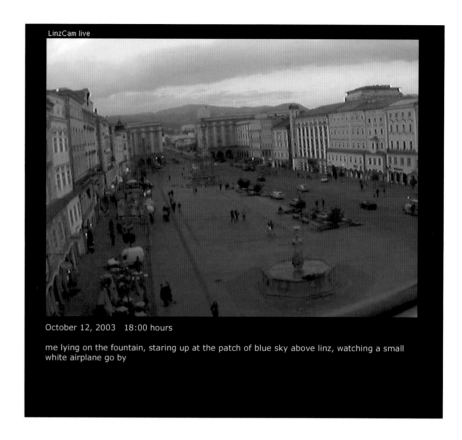

LinzCam live

October 12, 2003 18:00 hours

me lying on the fountain, staring up at the patch of blue sky above linz, watching a small white airplane go by

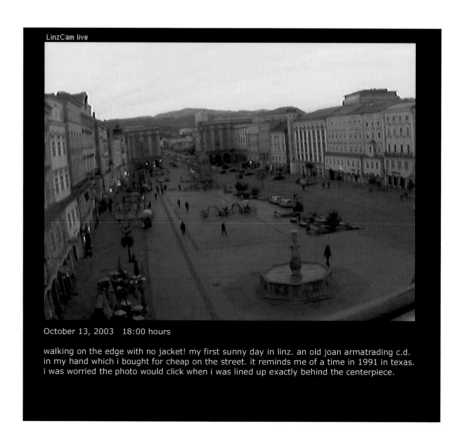

LinzCam live

October 13, 2003 18:00 hours

walking on the edge with no jacket! my first sunny day in linz. an old joan armatrading c.d. in my hand which i bought for cheap on the street. it reminds me of a time in 1991 in texas. i was worried the photo would click when i was lined up exactly behind the centerpiece.

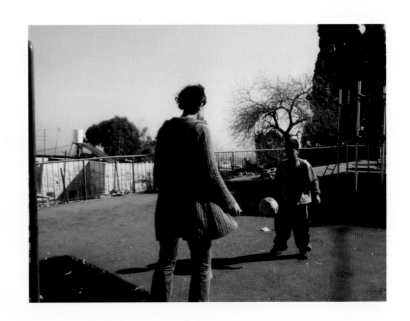

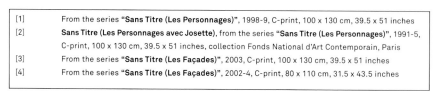

[1] From the series "**Sans Titre (Les Personnages)**", 1998-9, C-print, 100 x 130 cm, 39.5 x 51 inches

[2] **Sans Titre (Les Personnages avec Josette)**, from the series "**Sans Titre (Les Personnages)**", 1991-5, C-print, 100 x 130 cm, 39.5 x 51 inches, collection Fonds National d'Art Contemporain, Paris

[3] From the series "**Sans Titre (Les Façades)**", 2003, C-print, 100 x 130 cm, 39.5 x 51 inches

[4] From the series "**Sans Titre (Les Façades)**", 2002-4, C-print, 80 x 110 cm, 31.5 x 43.5 inches

French artist **Valérie Jouve** came fortuitously to photography while compiling a portrait dossier of the subjects of her ethnographic research. Switching from humanities to art, she has created since 1994 an impressive body of work structured around ongoing series, which she refers to as "families of images". Each series has an emblematic generic name: "Sans Titre (Les Façades)" [Untitled (Façades)], "Sans Titre (Les Paysages)" [Untitled (Landscapes)], "Sans Titres (Les Personnages)" [Untitled (Characters)]. In 2003, she shot her first short film in Marseille, *Grand Littoral (Open Seashore)*, presented in 2004 at The Museum of Modern Art in New York.

Jouve delves into the rhythmic and visual tensions of standard cityscapes photographed in Paris, Marseille and New York: frontal views of buildings, streets and suburbs, chosen for their sheer architectural radiance or as backdrops for isolated figures. She asks her performers simply to embody a feeling. The photographer and the models then work together to find the best way to perform it: the figure participates in his or her own reception, frozen in a choreographic, pictorial or theatrical expression co-produced with the artist in a shared consciousness of the photograph's result. Each picture requires rehearsal and repeated photographing to achieve the perfect unsettling image that oscillates between documentary and cinematography; close, in this respect, to Jeff Wall's social pictures of the 1980s, and borrowed from Jean-Luc Godard, Robert Bresson and Jean Eustache.

Jouve uses a cold luminosity—what she calls, quoting Eric Rohmer, the "blue hour"—a floating light that flattens the photographic plane, and consequently denies as much as possible perspectival depth. Every motif is brought forward to the surface of the photograph, within the same layer. By shooting grid-like modernist architecture, the artist structures her photographs as abstract compositions and generates motifs that extend and proliferate beyond the borders of the image. A further dimension is added by the inclusion of mirrored surfaces which display a repetition of motifs: reflections of windows in windows. Jouve carefully avoids framing whole scenes, and photographs only parts and corners of the hazardous rhythm in the urban architectural pattern, acknowledging the inability of photography to apprehend any kind of totality.

On rare occasions Jouve digitally manipulates her images to flatten further the photographic depth. She collapses two contradictory movements in the same image: flatness of depth and lateral extension. This tension creates an intellectual and visual vertigo that questions urban spaces, how they are inhabited and how they can be represented: the weird and common dizziness of expansion and simultaneous concentration in contemporary cities. The dense photographic spaces include their figures with difficulty: her models barely fit in the expansive architecture of modern cityscapes. There is a feeling that they do not fully belong in the image, trapped in the distorted space of a photographic paradox, isolated in their own absorption, hiding a private inner life just as Jouve's building façades do.
—Vincent Honoré

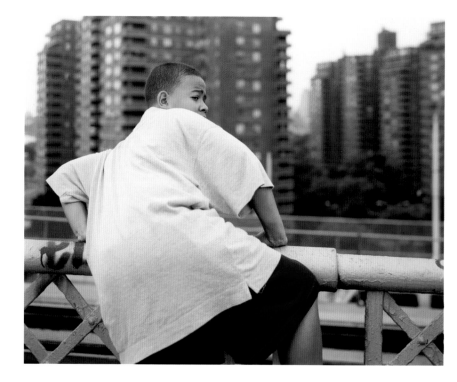

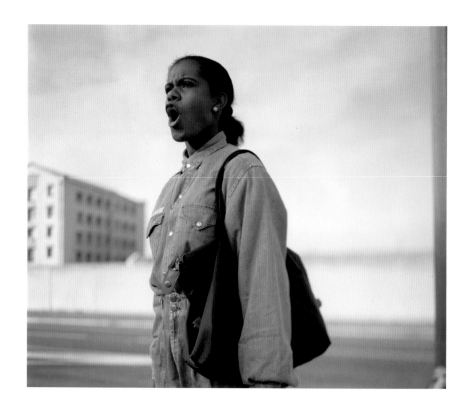

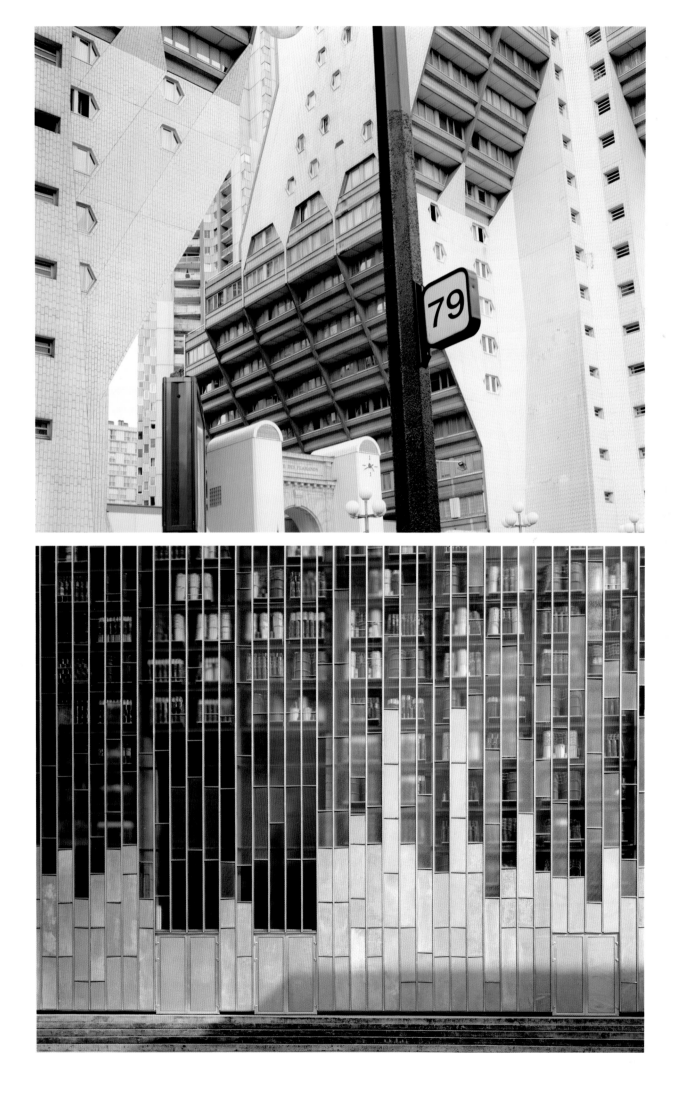

While many photographers exploit their models in using them as props, **Yeondoo Jung** is generous with his talent. The Korean-born photographer lends himself and his camera to "average" people, allowing them to realize wondrous, stifled and personal fantasies.

In his 2001 series, "Evergreen Tower", Jung shot thirty-two portraits of families stiffly posing inside their standard tower-block apartments in Gwangjang-Dong, on the east side of Seoul. Though the white walls, tan-wood floor, low ceilings, bulbous light fixtures and sliding windows in the rectangular living rooms are the same in every slide, each family and its use of the basic space is compellingly unique. It is unlikely that the apartment dwellers were familiar with their neighbours' furniture arrangement, but even without such baseline information, each family cultivates, cherishes and asserts its individuality through an idiosyncratic use of decoration. In Jung's images the rooms all appear meticulously formal, the children carefully groomed and the adults' smiles unnaturally bright, but it is easy to imagine that when Jung and his camera departed, the occupants and the rooms themselves relaxed again and resumed their daily lives.

In 2001 Jung invited people he met travelling in nine cities —Seoul, Beijing, Tokyo, Amsterdam, New York, Istanbul, Liverpool, Nice and Frankfurt—to enact their hidden ambitions for his camera. As Goya did with *The Clothed Maja* and *The Nude Maja* in the eighteenth century, Jung juxtaposes his subjects in identical poses. Yet, unlike Goya, Jung's subjects shed their everyday attire to fulfil their own fantasies, not his or those of his viewers. The resulting series is named "Bewitched"(begun 2001), after the iconic 1960s American TV series, which is popular in Korea, where the occult powers of Samantha, an innovative young witch, are repressed by her straight-laced husband and by her unaccountable desire to live the life of a suburban housewife. Jung's subjects, whose strengths and dreams are similarly repressed or deferred, are empowered to actualize their ambitions for a single portrait.

With Jung's encouragement, a gawky disgruntled low-level employee in a generic ice-cream parlour in Korea is temporarily relocated to Alaska, where she becomes a radiant, beautiful Eskimo hunter; the son and grandson of chefs who works as a waiter in a Chinese eatery is recast as the head chef in a posh and polished restaurant where he serves food he has created to his proud grandmother; and a man in Istanbul who serves Turkish tea in the street stands before a class of children as their calculus teacher. Though most of Jung's subjects have surprisingly admirable and seemingly achievable ambitions, Jung makes no distinction between prosaic goals and impossible reveries,so in addition to dreams of teaching, working and travelling, Jung also photographs a wheelchair-bound man in Liverpool having a conversation with John Lennon, Einstein, Jesus and Bob Marley.

Jung is equally unrestrained by concrete concerns in his most recent project, "Wonderland" (2004-5), where he photographically approximates children's gravity- and reality-defying crayon drawings. Jung, who has taught kindergarten, asserts that he uses "photography as a medium for expressing reality" and that his use of children's drawings was a method of "revealing an embedded reality" through the children's far-fetched understanding of the world around them. So real-life models pose as fairies floating over flowers, and pretty pony-tailed girls croon in glittery auditoriums in Jung's "Wonderland". Like the crayon drawings left to yellow when children learn to become serious, Jung's photographs are souvenirs of the child-like delight and magical desire most adults still hold inside.
—Ana Finel Honigman

[1-2] **#13**, from the series **"Bewitched"**, 2003, C-print, multi-slide projection, dimensions variable
[3-4] **#1**, from the series **"Bewitched"**, 2001, C-print, multi-slide projection, dimensions variable

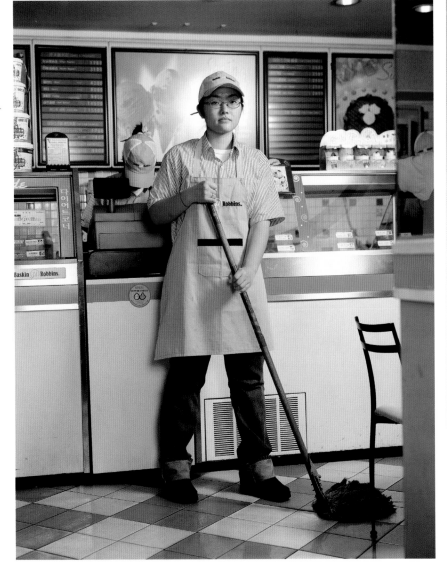

"There was a thump. The sound of the moment we fell. The sound that says we can never go back to the moment before".

These tender words appear in **Rinko Kawauchi**'s most recent collection of photographs entitled "the eyes, the ears", a compact volume of images Kawauchi took in 2005 paired with her spare texts, that reflect her fascination with life's ephemeral moments. The colour images that fill "the eyes, the ears" appear as a series of chance encounters and isolated details from her daily life. For instance, she gives us the strange image of a deer with its mouth open in the woods made almost unrecognizable by a solar flare in the lower right corner, or the translucent wings of a white moth fanned out over a gravel road. Kawauchi's photographs manage to transform the incidental or overlooked into a solemn attitude, as in another work from the series in which she deftly frames the intersection between a single strand of brown hair and a stiff black eyelash against an azure sky, managing to upstage the eye as the source of intrigue in the photograph.

Kawauchi's sentiment that she "likes shooting bugs, flowers, and living things that are small ... that live for a short time" is confirmed in her choice of repeated subjects and motifs found in her three photographic books: a chick's soft body visible through a crack in its shell, a dead wasp lying on its back with its legs standing straight up, a phalanx of carp gasping for air at the surface of a muddy pond, and a small vase of gem-coloured ranunculus flowers that Kawauchi managed to capture at the height of their short-lived bloom. The romantic associations of Kawauchi's favourite subjects belie her complex definition of beauty. She tells us in "the eyes, the ears" that she is attracted to "even the spots, the wrinkles, the shapes of nails, body hair, pubic hair, hair on a mole and the way veins rise." Moreover, many of Kawauchi's photographs show her tendency to frame her experiences in melancholic, almost macabre, tableaux. For instance, she photographs birds soaring overhead, but also the body of a grey pigeon camouflaged against a slate sidewalk except for the scarlet red orb formed around its crooked neck. Alongside a photograph of an abstract field of plush, pastel-coloured toy birds, she presents an image of a cat's dried-out skin, its eyes only gaping holes.

Much of what has been written about Kawauchi associates her ongoing interest in the natural cycles of life and death with a specifically Japanese or Asian aesthetic. However, she seems more attuned to a contemporary diaristic mode of photography, sharing the banal scenes of her daily life as a thirty-three-year-old artist living in Tokyo. And like her contemporaries Richard Billingham and Wolfgang Tillmans, Kawauchi often trains her camera on her close friends and family members for extended periods of time, as in a recent series in which she documented the effects of her grandfather's failing health and subsequent death on other family members. Kawauchi also posts texts and images on a visual blog. While the texts are only in Japanese, her images are clearly decipherable to her international audience and, as she reminds us in "the eyes, the ears", "a point of contact is sweetly fragile with infinite possibility".—Gloria Sutton

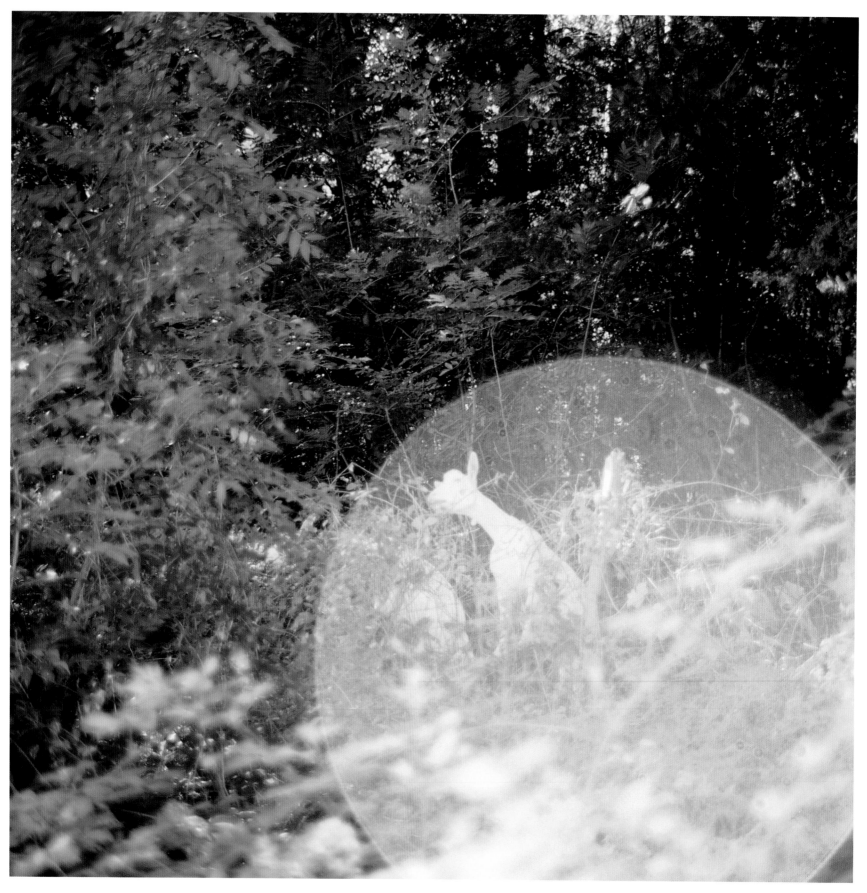

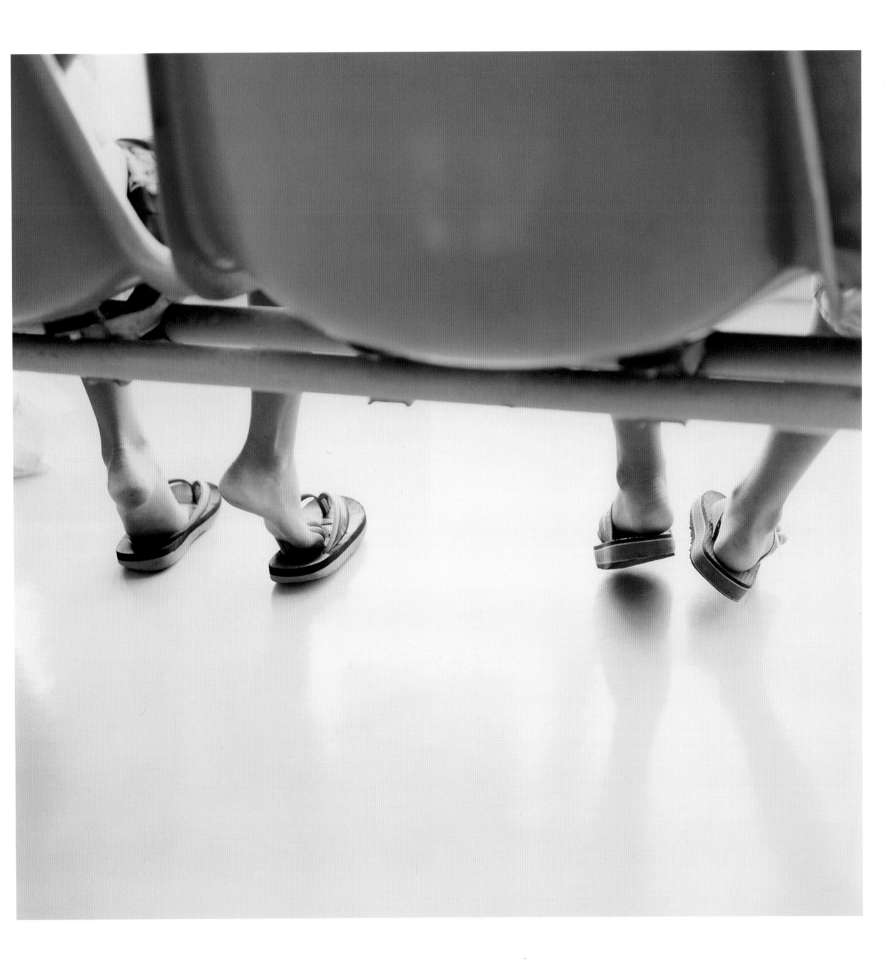

[1] House on Haunted Hill I (night), 2005, C-print, 50.8 x 63 cm, 20 x 24 inches
[2] House on Haunted Hill II (day), 2005, C-print, 80 x 100 cm, 31 x 39 inches
[3] Cave #1, 2004, C-print, 40.6 x 50.8 cm, 16 x 20 inches
[4] After Lunch: Trying to Build Railway Ties, 2005, C-print, 50.8 x 61 cm, 20 x 24 inches,
 collection Sammlung zeitgenössischer Kunst der Bundesrepublik Deutschland, Berlin

Deceptively simple at first glance, **Annette Kelm**'s images are typified by an immediately graspable form—whether this is a pair of gloves, a burnt log in a fireplace, a house on a hill or a cowboy on a horse. Indeed the images themselves are so perfectly executed in their framing and clarity, one has the impression these are perhaps found images taken and cropped from the pages of an interiors magazine, a fashion spread or an advertisement. One is quickly made aware of the details in the image that may have attracted the artist in the first place. And then we realize that an image like this could never have been found—a magazine image would not have included the careful reflection that we notice in the shiny black porcelain fireguards, and the composition of the cowboy on the horse is simply too complex for commercial use.

So why would the artist have chosen to photograph these images? Each of Kelm's works, and in particular their accumulative effect once installed by the artist in carefully selected groups or diptychs, begins to unfold a precisely executed combination of formal, historical and contextual references. The house on the hill, for example, appears twice, in daylight and darkness, and the titles already supply a clue to the artist's interest: *House on Haunted Hill I (night)* (2005) and *House on Haunted Hill II (day)* (2005). The titles alone would indicate to some that the house was not only the location for the B film of the same name but also the set for other productions, and was originally a well-known building designed by Frank Lloyd Wright. The building was partially destroyed because Lloyd Wright used too much sand in the concrete—a fact that made it the perfect location for a film set, a piece of history that has been co-opted by the fictionalizing world of the film industry for quite another set of histories. One story overlaps the next, and so on. This complex layering of meaning is typical of Kelm's work.

Two more examples reveal this tendency. An image of a eucalyptus branch in a glass of water placed atop a piece of fabric with a Hawaiian island motif, titled cryptically *After Lunch: Trying to Build Railway Ties* (2005), refers to the over-abundance of this tree in California. The wood proved to be unsuitable for its intended use in the early twentieth-century railway system, and so the trees were left to flourish. "After Lunch" simply refers to the time at which the artist took the photograph, a personal touch, however, that suggests other narrative possibilities. Similarly leading is the untitled photograph taken in 2005 of a jute bag from the 1950s, which advertises a steamboat called the "American Queen". The boat's name plays on the title of the film *African Queen,* but conjures associations with other phrases such as "Homecoming Queen" and "American Dream". The bag's bamboo handle evokes the 1950s Hawaiian theme that appeared in the eucalyptus image, and suggests another aspect of American cultural history to be unpacked in Kelm's subtly complex cultural investigation.—Jens Hoffmann

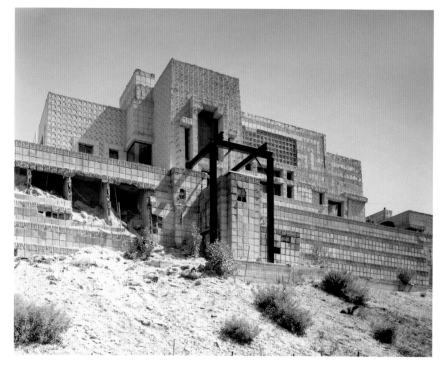

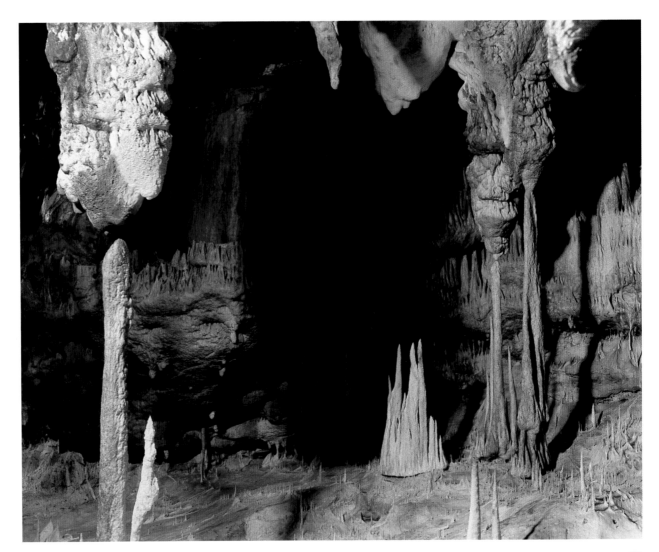

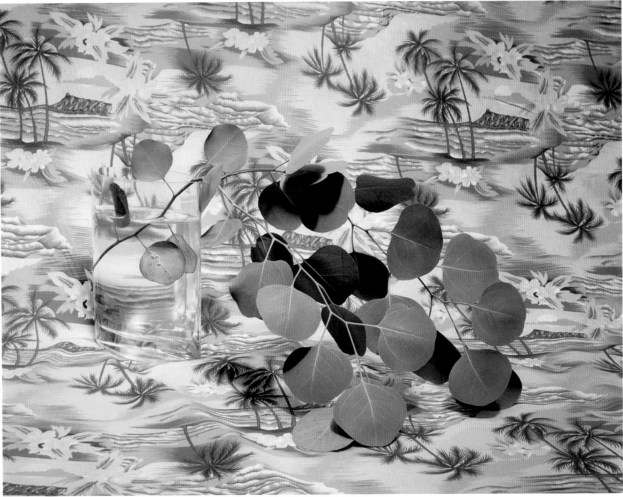

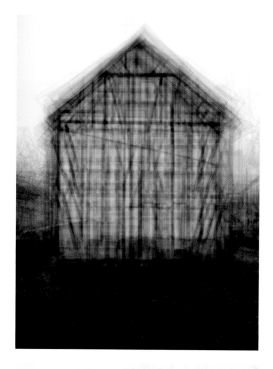

Idris Khan		[1]	[4]
	Ik	[2]	
		[3]	

Idris Khan is a stalker, both in the sense of the hunter and the very devoted fan. What constitutes his recent prey are key moments in both the theory and practices of photography. It seems that when Khan likes something it isn't a casual interest. There is adoration but also tenacity. It's about knowledge that can only be gained through a kind of ownership.

Khan takes pictures of images or texts that are multiple (like all the photographs he took of his ex-girlfriend on holidays in Portugal, or all the pages of the Koran) and overlays them digitally to make one single image. His earlier work had to do with personal narratives (although he calls them "generic"), but recently Khan has shifted to photographers who produced their work in series, namely Bernd and Hilla Becher, Eadweard Muybridge and Karl Blossfeldt. All of them were interested in the way photography could rationalize activities and classify objects. Khan works in the opposite direction, taking that multiplicity and returning it to singularity. Nevertheless, the repetition remains so evident that Khan's work sits ambiguously between recovering the strength of a unique and iconic image, and letting whatever original meaning there was be either obscured or drained away.

When Khan rephotographs the work of other photographers he is also performing a straightforward act of artistic homage. Take the Bechers for example. The triptych Khan made is both honouring and irreverent. You sense that he loves their work, but he alters it in a fairly major way. (This is how it should be.) For the Bechers the deadpan image of vernacular industrial architecture, usually small scale and repeated in a grid, presents a bland (yet oddly compelling) facticity. This mode of representation is converted—in Khan's version—to a looming, impenetrable, fast-forward impression. Khan's images carry a wealth of information all at once, and imply a complex object that potentially reveals a whole history of activity repressed by the Bechers' approach. Other aspects of Khan's work are at odds with the Bechers' method and presentation, like the scale (Khan's photographs are very large), their lack of legibility and their "touch". The key difference is between the Bechers' serial strategy and Khan's collage one. His image is not merely evidence of a predetermined process but *made*, on the computer. Khan takes the Bechers' archive of standardized buildings and, by layering and filtering them, constructs a new image, which shows that instead of an endless trail of sameness, when you really examine objects every one is profoundly singular.

Nevertheless, there is the issue of Khan's copying rather than making images. He appears to have internalized the postmodern idea that all images are copies with no originals. But then again, Khan has written that his approach is meant to be different from the way in which Sherrie Levine rephotographed the work of Walker Evans and others. Indeed, Levine was staging a patricide, wanting you to see how ideologically bankrupt modernist photography was. Khan's relationship to photography is very different. He wants pictures to get inside objects, to penetrate the world of appearances and to record, in another photographic tradition, an impression of the energy of things, their strange and idiosyncratic power.—Alison Green

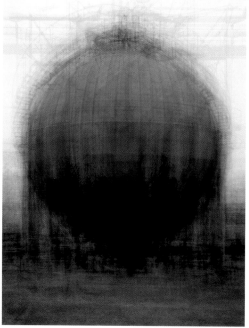

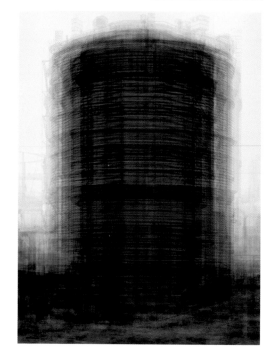

[1] The Kant Walks #1, 2004, C-print, 48 x 60 cm, 18.5 x 23.5 inches
[2] The Kant Walks #3, 2004, C-print, 48 x 60 cm, 18.5 x 23.5 inches
[3] The Abbey of Thelema #2, from the series "Morning of the Magicians", 2005, C-print, 48 x 60 cm, 18.5 x 23.5 inches
[4] Room of Nightmares #2, from the series "Morning of the Magicians", 2005, C-print, 48 x 60 cm, 18.5 x 23.5 inches

Joachim Koester makes manifest the barely visible traces of history that are deeply embedded within the various sites he photographs. Investigating locations hovering at the intersection of entangled tales—factual as well as fictional—Koester restages alternate realities of those places through the descriptive, and necessarily interpretive, act of documentation.

Since his earliest work Koester has exploited the vacillation between documentation and dramatization, what Jean-Luc Godard (a continuing influence on the artist) refers to as "research" and "spectacle". The artist employs the seemingly objective tool of photography—and occasionally film and video—to dramatize, or fictionalize, an actual location by unleashing the narrative potential latent within his subject matter, which has included the ruins of a Sicilian house occupied by an early twentieth-century occultist commune; the ancient Bialowieza Forest in eastern Poland—the only existent example of primeval woods in Europe; the site of a nineteenth-century scientific expedition on the Greenland ice cap; and recovered film stock from Salomon August Andrée's ill-fated attempt to reach the North Pole in a balloon in 1897—material etched with prophetic stains as a consequence of being encased in ice for three decades.

Through extensive research Koester exhumes vestiges of interwoven information about these locations—a collision of political, social and geographical narratives—which are insinuated across a succession of images within a single series. "Row Housing" (1999), for example, presents a suite of images of a suburban-style community in Arctic Canada. The area, which was recently declared an autonomous Inuit state, is where the explorer Sir John Franklin met his fate trying to find the Northwest Passage. It is also the site of the architect Ralph Erskin's failed model town, as well as derelict military stations from the Cold War. Evidence of this complex and turbulent history surfaces in some of the images, while others portray a picturesque landscape. The series contains black-and-white images, as well as colour, which are intended to evoke the realism of documentary photography.

Another work, *Day for Night, Christiania, 1996* (1996), focuses on the dilapidated utopian community, Christiania, founded in 1971 by squatters of a former seventeenth-century military fort in Copenhagen. Koester photographed the district through a bluish filter akin to the "day for night" cinematic technique used to simulate night. The crepuscular effect lends a romantic, if uncanny, atmosphere to what might otherwise seem like objective documentation of the disputed and controversial territory.

In a more recent series, "From the Travels of Jonathan Harker" (2003), Koester journeys through Transylvania on the heels of *Dracula* author Bram Stoker. Koester reveals the post-Soviet reality of the legendary Romanian region, offering evidence of a dubious tourist industry that has traded on the notoriety of the blood-sucking villain. With "The Kant Walks" (2004), another recent series, the artist traces the steps of Immanuel Kant and his daily constitutional habit. Here, walking serves as a manual for engaging with a particular location. Koester's photographs of the philosopher's home town of Kaliningrad, a city formerly known as Königsberg, suggests a place fallen between the cracks of political nomenclature. Like all the subjects of the artist's work, Kaliningrad is a location suspended between its past and its present. And, as with all his images, it is the gap between documentation and depiction that is paramount, as Koester achieves a fictionalized version of current reality.—Catsou Roberts

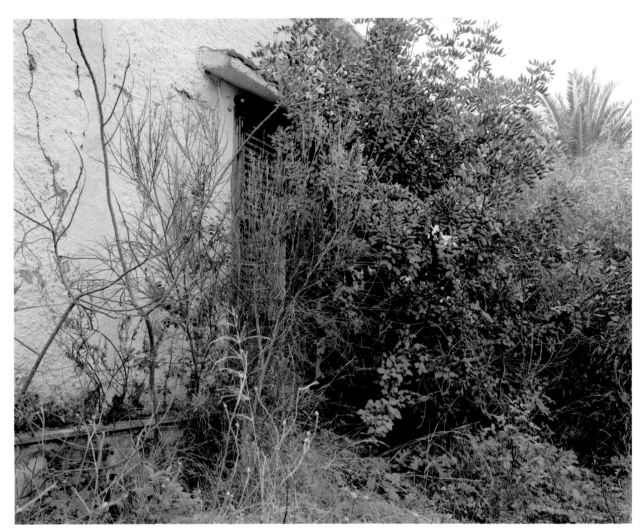

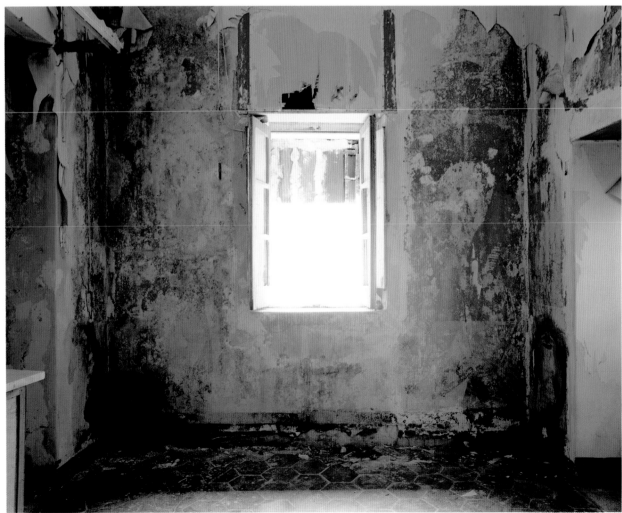

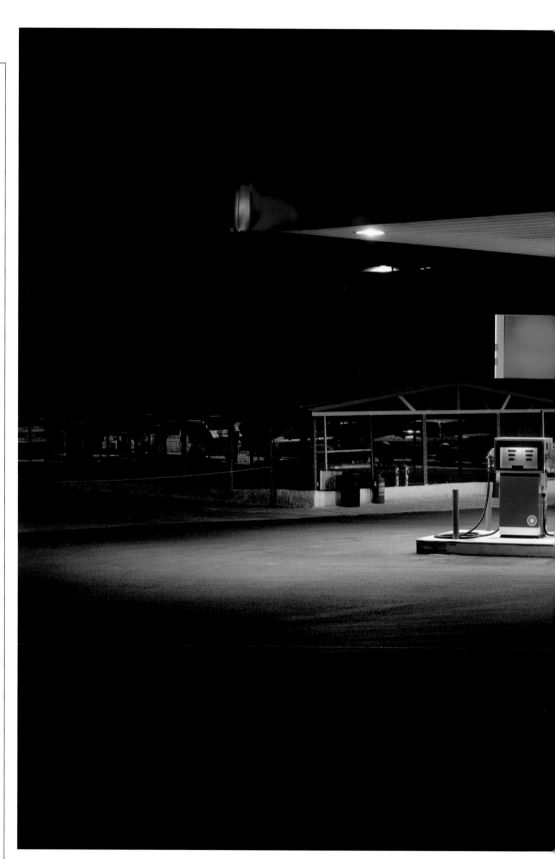

[1]

Panos Kokkinias's photographs are all meticulously yet discreetly staged. In his landscapes or cityscapes, improbable, bizarre and often uncanny scenarios unfold in which the psychological relationship of human beings to their environs is the conceptual point of departure. Kokkinias keeps a physical distance from his subjects and sets up incidents or situations that are unobtrusively positioned in the picture frame. Initially it would appear that the landscape is of primary concern but upon closer observation the work becomes clearly anthropocentric. Solitary, enigmatic, mostly diminutive figures almost invariably inhabit his pictures; figures that seem to be at odds with the world around them. His photographs possess the same kind of metaphysical mystery and dark surreality that can be found in the work of Gregory Crewdson, for example, but the artifice in Kokkinias's images is constructed in a less conspicuous way, and there is less a sense of drama and more one of pathos and existential angst.

There is no fixed narrative in these photographs; instead they appear to the viewer as highly charged, distilled moments impregnated with meaning and symbolism, open to interpretation. Kokkinias seems more interested in creating an immersive mood than embarking upon a literal treatise on the unadapted, the maladroit, the lonely and the lost, which, as in *Gas Station* (2003), is how almost all the figures in his photographs seem to be. These are images saturated with a Kafkaesque sense of entrapment but also a feeling of disenchantment and futility, solitude and melancholy that seems to point to an underlying contemporary ennui or dissatisfaction with the world at large.

It is no wonder, then, that a sense of alienation and dissociation seems to permeate these introverted figures who appear ill at ease with the space they occupy and rather seem to inhabit an asocial sphere, an impenetrable world of their own. In *Itea* (2004), a lonely man treks through what seems to be a quarry, suitcases in hands, on a road to the unknown. Where is he going? What does he wish to escape from? The answer is left to the viewer. In *Syrna* (2001) the microscopic, barely discernible figure of a man is seen aimlessly dragging a chair through a burnt forest. In *Gas Station* (2003), a glamorous woman in a red dress faces the darkness of night, bracing herself. Blackness and a sense of brooding pervades the atmosphere. *Megla* (2004) features a nude woman holding a red apple, reminiscent of Eve, in a lush green and pink Eden. The purpose of their presence there remains a mystery. This sense of enigma can be traced through many of the artist's photographs, and is enhanced by the bizarre, uncanny, absurd or inexplicable actions Kokkinias's figures engage in. It is precisely this sense of narrative ambiguity, this mystification and sense of the unknown that make his pictures so engaging but also rewarding for the viewer. The artist offers hints but never definitive answers, thus sparking off associations in our imagination enabling us to construct our own stories. Quiet yet disquieting, subtle yet poignant, Kokkinias's pictures seem to penetrate our subconscious and linger as metaphorical or allegorical reminders of the lonely individual struggling to come to terms with his existence.
—Katerina Gregos

[1] **Gas station**, from the series **"Here We Are"**, 2003, digital chromogenic Fujicolor Crystal
Archive print, 127 x 230 cm, 50 x 90.5 inches, collection Telefónica Foundation, Madrid

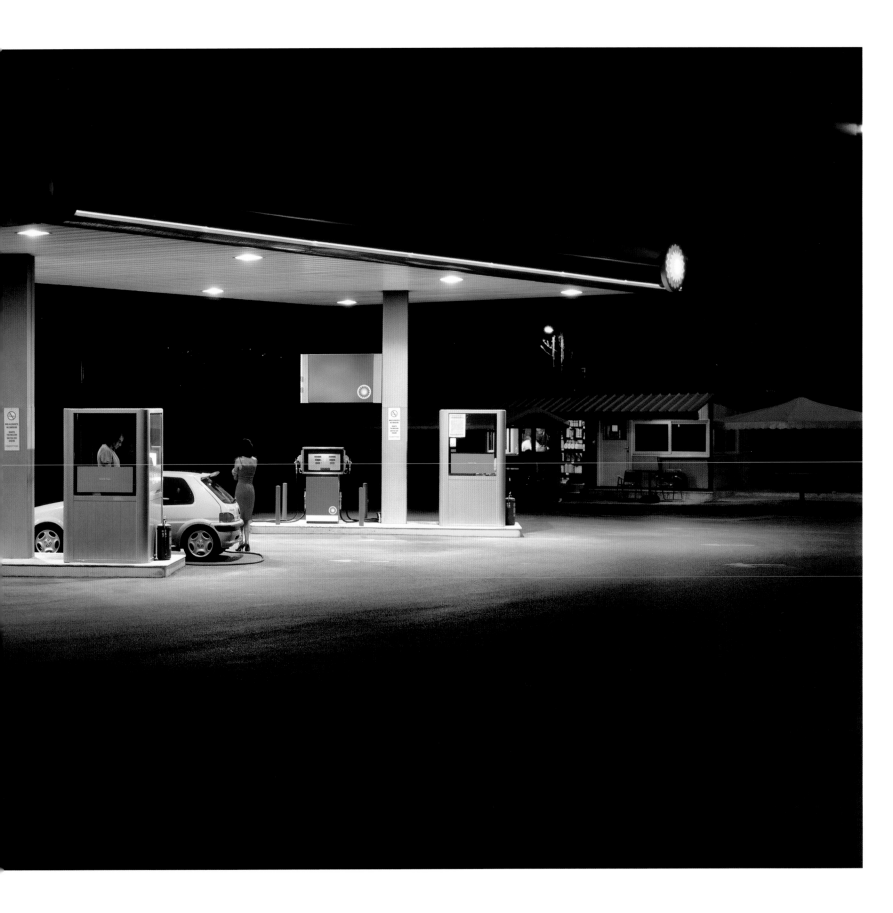

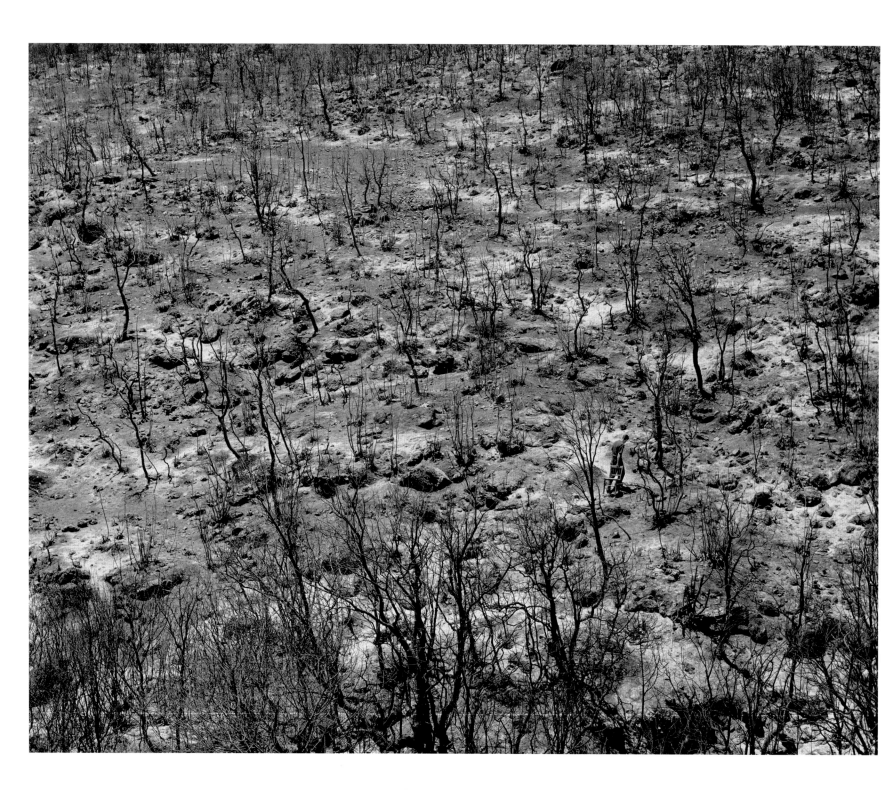

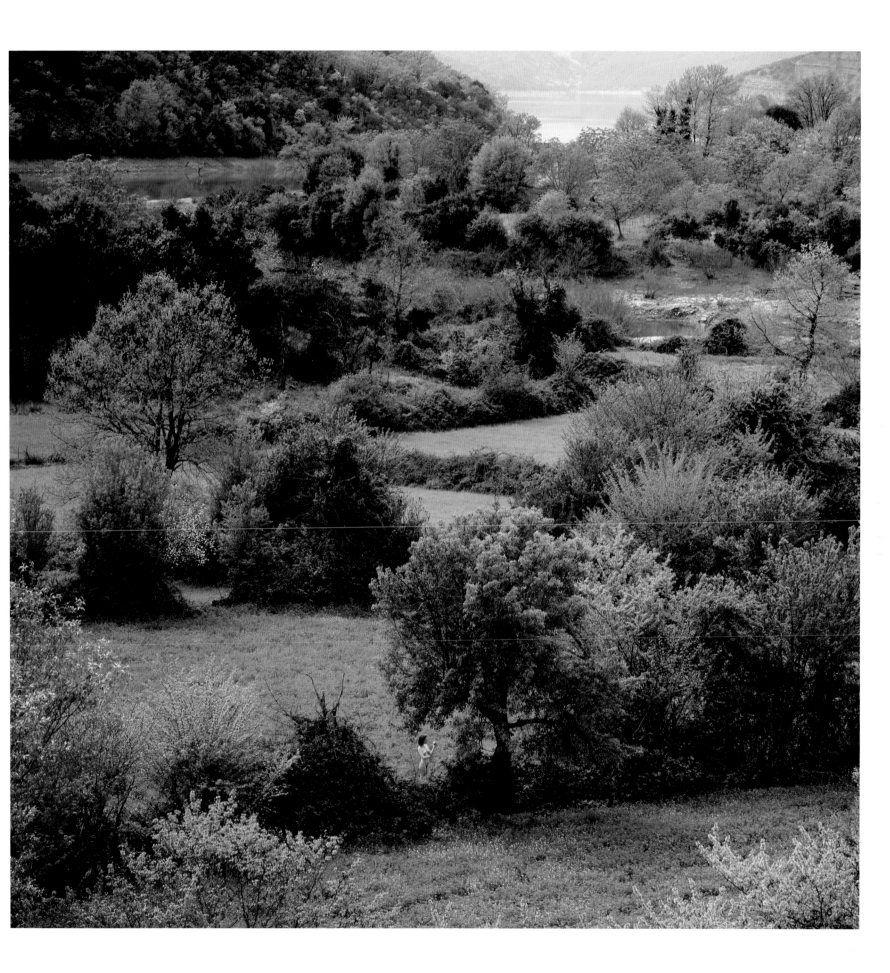

Luisa Lambri trains her eye on iconic architectural interiors and delivers spare colour photographs that, despite being devoid of people and personal effects, still manage to convey a warm sense of inhabitability. She has photographed structures by famed architects such as Le Corbusier, Alvar Aalto, Mies van der Rohe and Richard Neutra among others; subjects that occupy many contemporary artists. Lambri differentiates herself by presenting a particular space or architectural detail through a series of multiple prints, drawing our attention to the same viewpoint photographed at different times or at slightly different angles. Lambri's work stands out conceptually and operationally in that her photographs cannot be reduced to a formal investigation of modernist grids or be read as merely an effort to convey structural or design information, but instead manage to produce subjective impressions of the specific details under consideration. For example, the series of untitled laserchrome prints showing a room full of wardrobes with their doors slightly ajar—*Untitled (Menil House, #24)* (2002), *Untitled (Menil House, #25)* (2002)—offers a subtle interpretation rather than a straight documentation of the house Philip Johnson completed in 1951 for John and Dominique de Menil's extensive art collection in Houston. In addition to conveying the symmetry and minimalist geometry associated with Johnson's "International Style", the variegated pastel tones of the wardrobe doors and the organic shapes of the shadows cast on the wooden floor all work to suggest that in addition to being an architectural landmark for mid-century Modernism, the Menil House was also a domestic space with its own particular history. The Menil House series is indicative of the larger operation in Lambri's practice; her photographs reflect the ways in which architectural space is inhabited, experienced and lived rather than how it was designed or drawn.

In a more recent series from 2005, Lambri tracks a progression of light emanating from a square window divided by four shutters in the former Mexico City home of architect Luis Barragán built between 1947 and 1948—*Untitled (Barragán House, #10)*, *Untitled (Barragán House, #08A)*, *Untitled (Barragán House, #21)*. Positioned at intermittent angles, the square shutters allow light to enter the room as well as her camera in a variety of grid-like patterns while also casting their own geometric shadows against the walls. The restrained composition conveys a poignant mix of solemnity and promise, belying its simple construction from light and form, the fundamental tenets of photography itself. Under Lambri's astute direction, the modernist grid formation is transformed into a poetic refrain, seen in both the individual photographs and the series as a whole. The window itself is made from a series of connected boxes that can be opened or closed, echoing Barragán's design for his home which links a series of courtyards that intermittently expose interior spaces to the outside and vice versa.

Like much of her modernist subject matter, Lambri's colour photographs are usually dominated by sober tones of grey, white and black. A notable exception is *Untitled (Barragán House, #03A)* (2005), a view of one of the second-storey courtyard walls of Barragán's house painted a rich lavender. More disquieting are the overgrown green vines interrupting the geometric patterning of the tiled floor and the surrounding walls. This photograph is indicative of another important element at play in Lambri's photographic practice. Like Barragán himself, who built his home incorporating elements from an earlier structure located on the plot, Lambri manages to take pre-existing expectations of modernist architecture and give them a radically new meaning.—Gloria Sutton

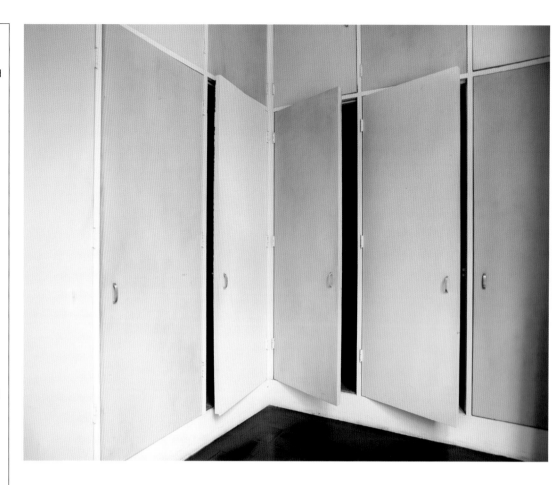

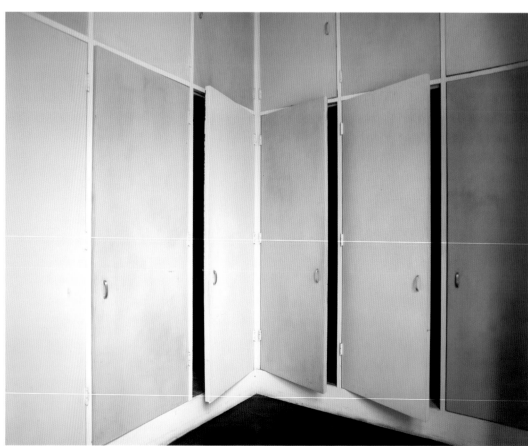

[1] **Untitled (Menil House, #24)**, 2002, Laserchrome print, 84 x 71.3 cm, 33 x 28 inches, produced by the Menil Collection
[2] **Untitled (Menil House, #25)**, 2002, Laserchrome print, 84 x 71.3 cm, 33 x 28 inches, produced by the Menil Collection
[3] **Untitled (Barragán House, #03A)**, 2005, Laserchrome print, 83.7 x 106 cm, 32.5 x 41.5 inches

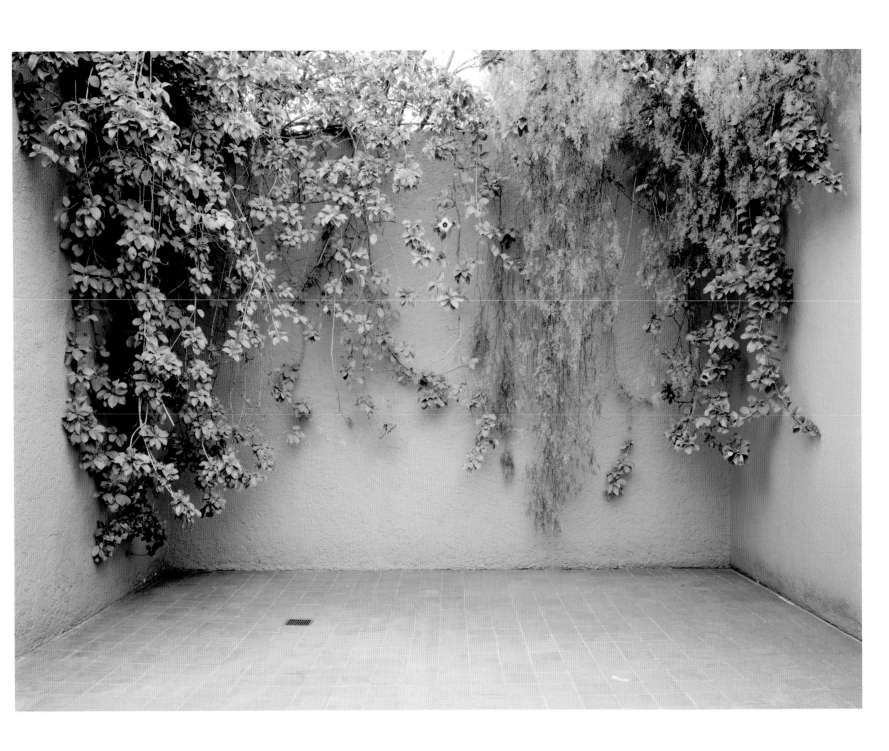

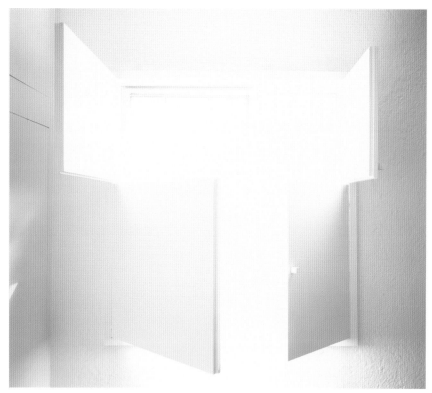 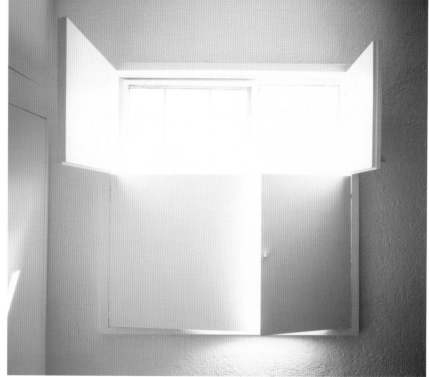

[4] **Untitled (Barragán House, #10)**, 2005, Laserchrome print, 86 x 96 cm, 34 x 38 inches, collection Museum of Contemporary Art, Chicago, Huis Marseille, Foundation for Photography, Amsterdam

[5] **Untitled (Barragán House, #08A)**, 2005, Laserchrome print, 86 x 96 cm, 34 x 38 inches, collection Museum of Contemporary Art, Chicago

[6] **Untitled (Barragán House, #21)**, 2005, Laserchrome print, 86 x 96 cm, 34 x 38 inches

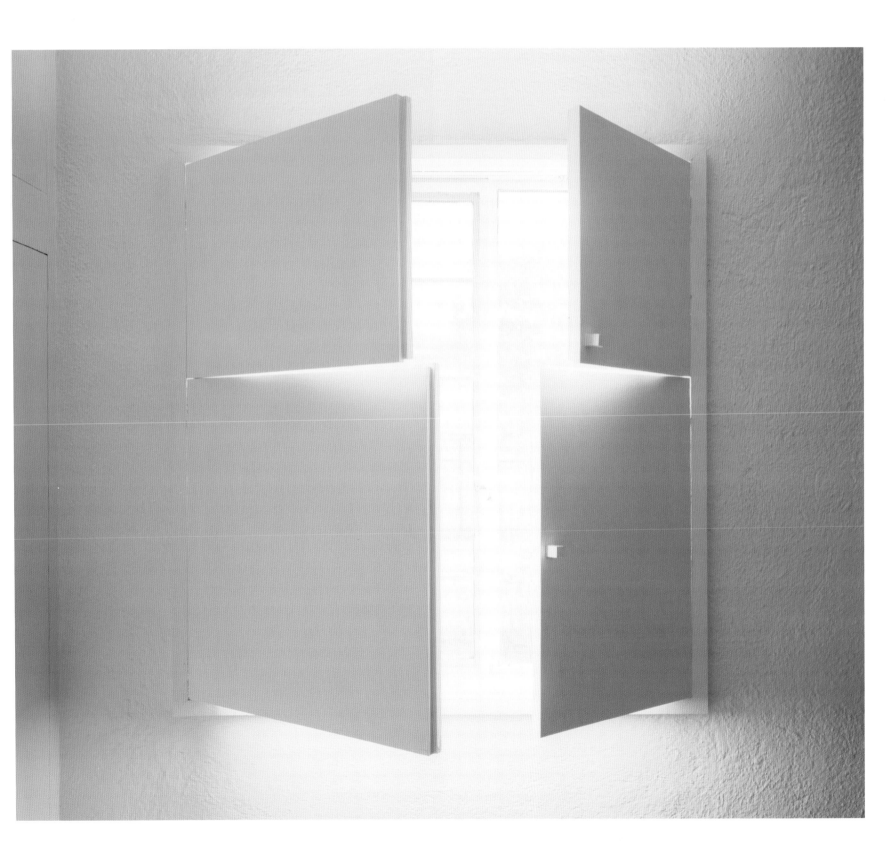

[1] **Security and Stabilization Operations, Graffiti I**, from the series **"29 Palms"**, 2003-4, silver gelatin print, 66 x 94.2 cm, 26 x 37.5 inches

[2] **Mechanized Assault**, from the series **"29 Palms"**, 2003-4, silver gelatin print, 66 x 94.2 cm, 26 x 37.5 inches

[3] **Night Operations III**, from the series **"29 Palms"**, 2003-4, silver gelatin print, 66 x 94.2 cm, 26 x 37.5 inches

An-My Lê takes large-scale black-and-white photographs with a 5 x 7 view camera to achieve extraordinarily detailed images that capture the way the world is "drawn". Black and white also destabilizes a sense of the photographs' historical moment. "The world seen in black and white", she says, "feels one step removed from its reality, so it seems fitting as a way to conjure up memory or to blur fact and fiction".

Lê was born in Saigon but has lived since she was a child in France and America. She returned to Vietnam in the mid-1990s to make her first major series. The "Viêt Nam" photographs (1994-8) were her attempts to document a place known to her as much through memory as through the kind of representations available to her growing up abroad. Returning to the States, Lê became more interested in American representations of Vietnam and specifically in Vietnam battle recreation societies. The photographs of "Small Wars" (1999-2002) were made with a group of men in Virginia during their long-weekend re-enactments. While some images depict the mock fights from a distance, others are taken from odd, low angles, as if the photographer was hiding from the figures seen in the image. And this was the case: to ensure the authenticity of the scenario, Lê was permitted to photograph only if she played a part in the recreation. The photographs represent somewhat ridiculous machismo activities without ridicule, and also show how the "fighters" forge a real bond with the landscape during their weekends. Though the precondition of their trip is a violent game, they nonetheless inhabit the woods with an unusual level of appreciation.

Lê's initial response to the Iraq War was to travel there as an embedded photographer, but eventually she produced a series of images of the US Marines training for Iraq in the Californian desert, entitled "29 Palms" (2003-4). In these we see tanks moving across a plain, marines entering a mocked-up Iraqi town, night manoeuvres, fake arrests and military lessons. Fiction and reality collide: though the "Iraq" the marines create is a complete fantasy (the shacks are adorned with graffiti as the marines imagine it will look, all squiggly "Arabic" script and "Kill Bush" slogans), these are real documents of their fantasy. As such they are perhaps the most authentic representation of the contemporary crisis, for it was the Iraq of America's imagination that pushed the troops to war. The series has as complex a relationship to the history of photography as it does to current events. Some images recall Roger Fenton's Crimean War landscapes, but there is a persistent absence of the sense of imminent danger that we would find in Robert Capa's work. Lê's subject also torques a mode of recent art photography, the mise-en-scène or set-up image associated so strongly with Jeff Wall and Gregory Crewdson. Where such artists elaborately construct fake scenes to photograph, Lê found her faked scenes readymade. Perhaps the most compelling quality of the "29 Palms" (2003-4) series is its ability to forge a profound critique of American aggression without criticizing the subjects it images. The marines are as much victims of the war of fact and fiction as they are its perpetrators. And the extraordinary beauty of the photographs continually mitigates against any danger of them being taken for two-dimensional political statements.— Mark Godfrey

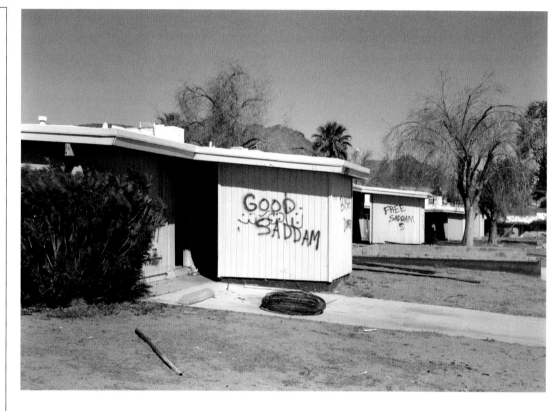

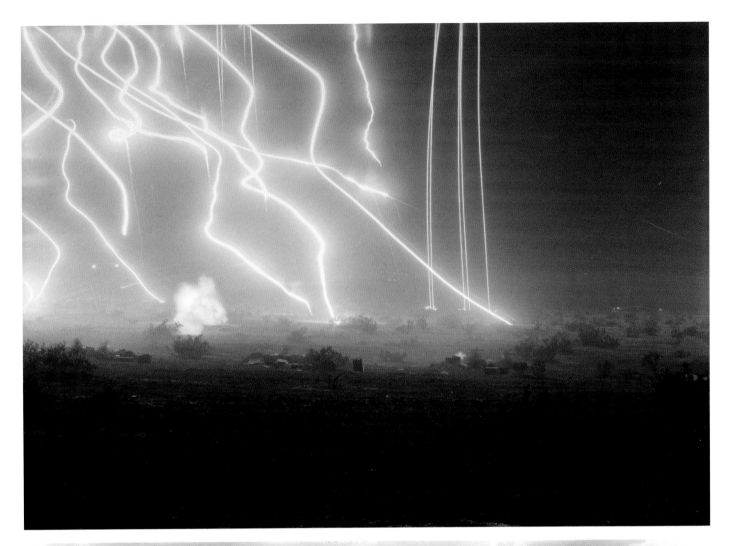

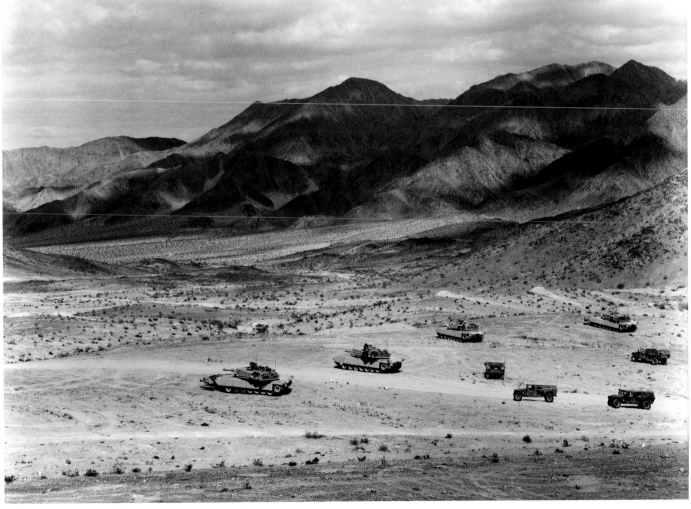

An-My Lê

[4] [5]
 [6]
 [7]

[4] **Infantry Platoon, Alpha Company**, from the series **"29 Palms"**, 2003-4, silver gelatin print,
 66 x 94.2 cm, 26 x 37.5 inches
[5] **Security and Stabilization Operations, Marines**, from the series **"29 Palms"**, 2003-4,
 silver gelatin print, 66 x 94.2 cm, 26 x 37.5 inches
[6] **Security and Stabilization Operations, George Air Force Base**, from the series **"29 Palms"**,
 2003-4, silver gelatin print, 66 x 94.2 cm, 26 x 37.5 inches
[7] **Marine Palms**, from the series **"29 Palms"**, 2003-4, silver gelatin print, 66 x 94.2 cm, 26 x 37.5 inches

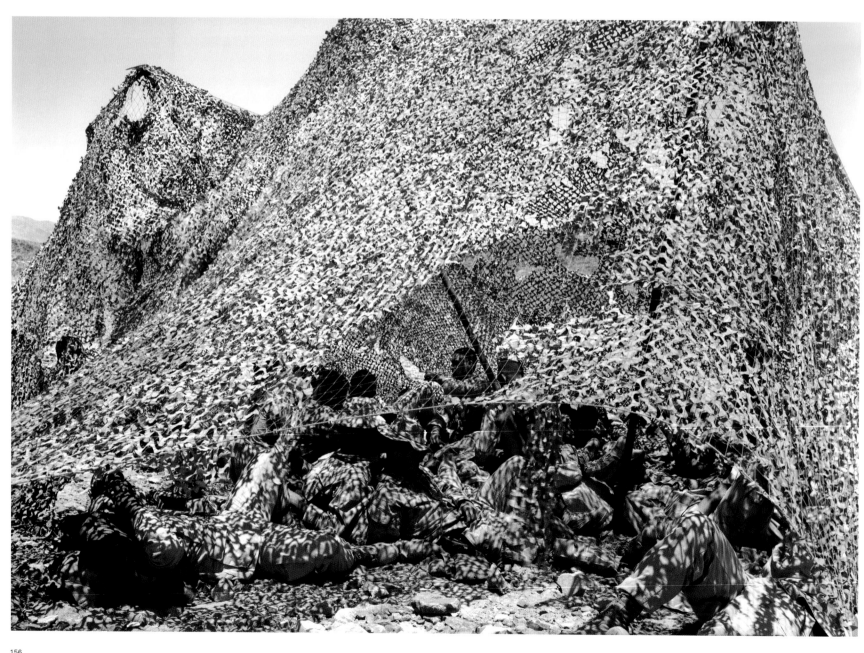

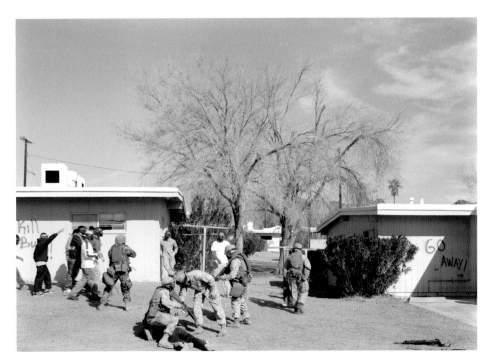

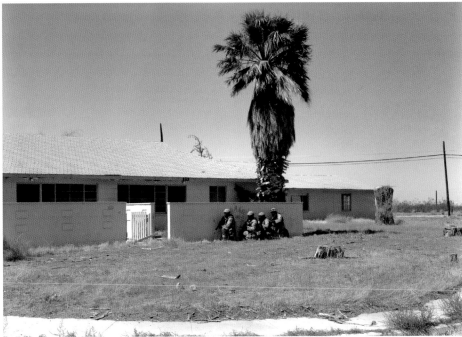

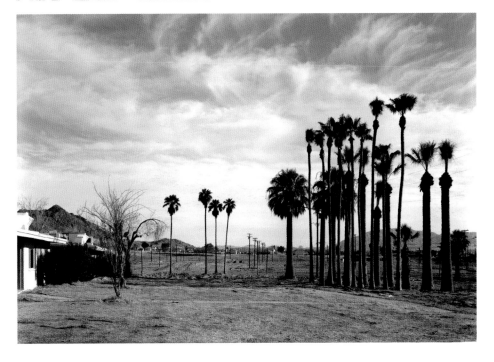

[1-2] **Duck Soup, The Marx Brothers, 1933**, 2002, C-print, 2 parts, 127 x 101 cm, 50 x 40 inches

[3] **The Jerk, The Opti-grab, 1979**, 2004, C-print, 43 x 50 cm, 17 x 21 inches

[4] **The Jerk, Carl Reiner, 1979**, 2004, C-print, 213 x 183 cm, 84 x 72 inches, collection Museé des Beaux-Arts, Montréal

[5] **Upside-down Water Torture Chamber, Harry Houdini, 1914**, 2004, C-print, 152 x 122 cm, 48 x 60 inches, collection Art Gallery of Ontario, Toronto, Tate Modern, London

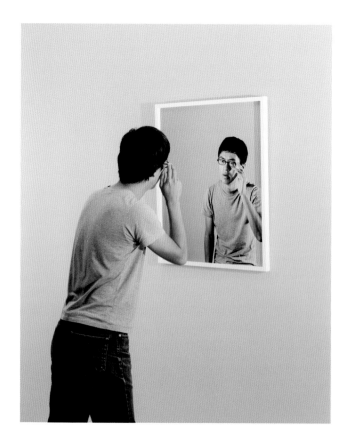

Tim Lee's work is clearly influenced by his adopted home city Vancouver's conceptual photography tradition and in particular artists such as Jeff Wall, Ken Lum, Stan Douglas and Rodney Graham, though Lee's work typically refers not only to these local stars but also to the major figures in Conceptual art from Dan Graham to Robert Smithson and Bruce Nauman. But what, anyway, is a performance artist doing in a book about photography? Like many other artists working today, Lee uses photography only as one among other media (film and live performance) to develop his artistic concerns. His work stages complex relationships between iconic artworks and artists of classic Conceptualism, canonical moments of popular culture and issues of racial identity.

At the centre of this is Lee, constructing an "on stage" persona that we encounter in a variety of eccentric and ridiculous postures that ultimately are nothing short of a travesty of the above-mentioned references. Looking at his work it is possible to take any of his photographs and to begin to decode them by peeling back layer upon layer of allusion. *The Jerk, Carl Reiner, 1979* (2004) is probably one of Lee's most complex and equally most ridiculous works, offering a good example of the combination and confusion of elements from popular culture, Conceptual art, the staging of race and the search for identity. The film *The Jerk*, written by Steve Martin, who also stars as the main character Navin Johnson, was directed by Carl Reiner in 1979 and is in itself a complex story of self-searching by Martin and Reiner hidden behind a thick layer of absurd comedy. Martin plays a man-child who sees himself as a poor, black kid in search of his own identity. He is seen travelling across the country heading towards Los Angeles, where he invents a ludicrous device called the Opti-grab that, attached to one's nose, prevents spectacles from falling down. Martin's character becomes a millionaire overnight but the success of the Opti-grab is short-lived as he is sued by the real life Carl Reiner, appearing as himself in his own movie, who has become cross-eyed from using the device.

The work itself is an absurdly oversized (1.8 x 2.1 m [6 x 7 ft]) colour photograph of the artist who himself has poor sight and appears cross-eyed in the image. To make things more complex, Lee brings in another element by flipping the photograph upside down and referencing Rodney Graham, who in the same year as Reiner shot the movie produced his seminal work *Camera Obscura*. Lee sees the relationship between Reiner, in 1979 already a comedian of an older generation, and Martin as similar to the one he has with Graham. Graham's upside-down photographs of trees speak in a comparable manner about the workings of vision by introducing a rather silly twist on the conventions of photography that is not unlike Martin's deliberately dumb twist on the standards of comedy. Lee describes his outsized cross-eyed self-portrait as a "perfect photographic portrait of perfectly ruined vision".— Jens Hoffmann

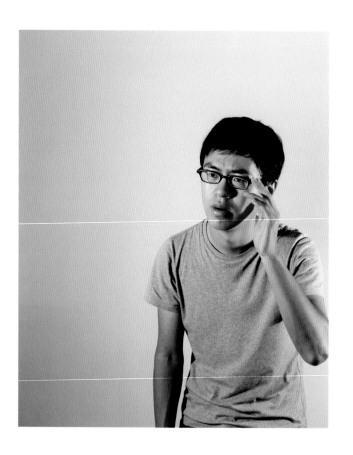

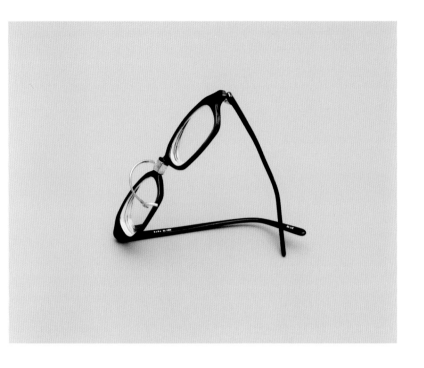

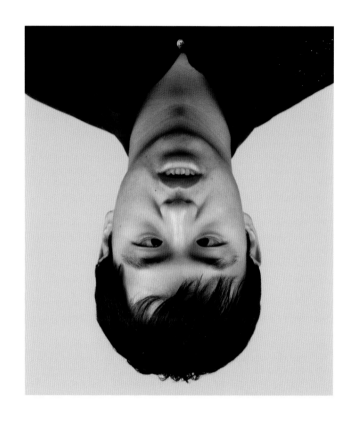

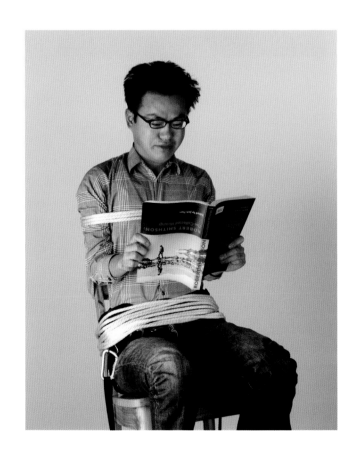

[1] **The Bourgeoisie (4)**, from the series **"Bourgeoisie"**, 2004, Lambda print mounted on aluminium, 182.9 x 86.4 cm, 72 x 34 inches

[2] **Part (14)**, from the series **"Parts"**, 2002, Lambda print mounted on aluminium, 121.9 x 114.3 cm, 48 x 45 inches

[3] **Part (20)**, from the series **"Parts"**, 2003, Lambda print mounted on aluminium, 182.9 x 111.8 cm, 72 x 44 inches

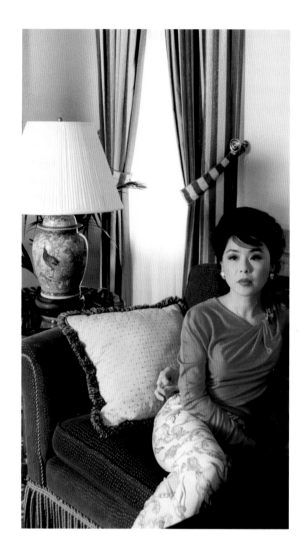

After moving to New York from Korea in 1994, **Nikki S Lee** studied fashion photography, interned with the photographer David LaChapelle, changed her name from Seung Hee to Nikki and started a Masters in Fine Art at New York University (completed in 1999). All of these biographical elements are important in understanding Lee's famous "Projects", started in 1997, in which she performed numerous different identities, from yuppie to exotic dancer, documented by snapshots taken by a friend or passer-by. Although Lee's work has often been compared with that of Cindy Sherman, the influence of fashion photography and the experience of being an immigrant in New York created a different set of terms for her immersion in various subcultures. Whilst Lee's work is primarily photographic, these works are not just performances for the camera; rather they can be seen as durational pieces in which Lee takes the position of the "participant-observer", as favoured by early twentieth-century anthropologists in their attempts to get "true" insights into other cultures.

Lee's examination of the role of photography in the construction of identity is pushed further in the series "Parts", started in 2002. Lee has commented that one of the reasons for this series was that she herself was becoming stereotyped as an artist who dealt with stereotypes, and that she wanted to try and consider the role of the snapshot in everyday life as still representing some kind of "truth" about ourselves. The images themselves are staged moments that could come from many people's photograph albums—a photograph cut in half to remove an offending lover from view. What remain are fragments of moments that appear to be from very different lives—from a glamorous wife in an airport lounge to a boyish figure laughing with a man wearing headphones who is half cropped from the frame. Lee's transformations through hair, make-up and pose are echoed by the intrusion of the hands, backs and legs of various "boyfriends", focusing on the fact that the people we are with contribute to our identity as much as the way we look.

In an offshoot of the "Parts" series Lee has created the "Bourgeoisie" series, which combines the consistency of the role-playing from her earlier photographs with the cut-up, staged romance. Rather than maintaining the casual snapshot styling of many of the "Parts" images, this series takes on the glamour of films such as Wong Kar Wai's *In the Mood for Love*, and the New Wave thrillers of Claude Chabrol, with their 1960s fashion and narratives of doomed love and constrained lives. Here Lee appears to perform the fantasy of romance, rather than its everyday reality; an apt transformation as this series was commissioned for the art and style magazine *Black Book*. She returns to her beginnings in fashion photography, creating images that veer from the immaculately composed to the slightly grotesque, as the fantasy of the glamorous, troubled lover does not quite fit with the performances that she gives for the camera. Here the way in which photography enables us to perform our private lives in dialogue with fashion, film and magazines is underlined and then taken apart by Lee's razor-sharp performances of the beautiful, desirable heroine who hovers over so many people's romances.
—Catherine Grant

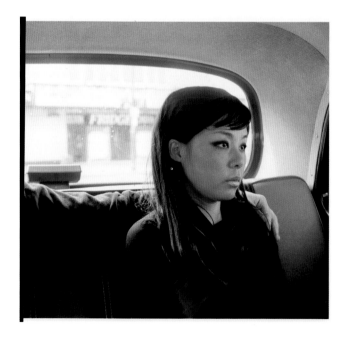

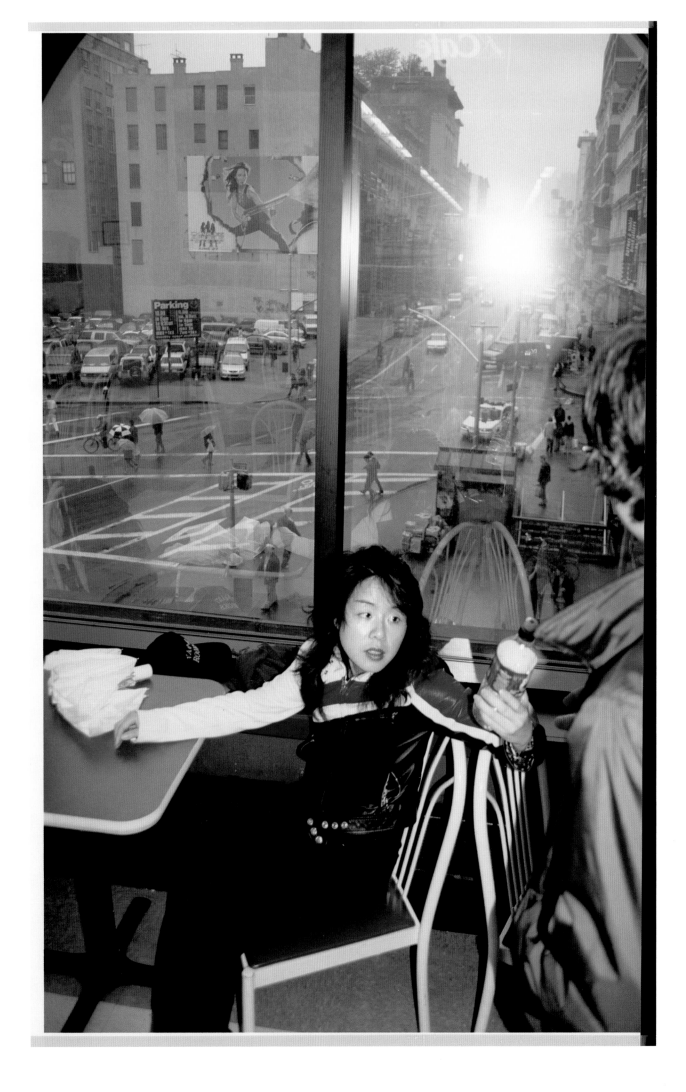

[1] **Green Window**, 2001-2, C-print, 58.4 x 38.7 cm, 23 x 15 inches
[2] **Red Wall**, 2001-2, C-print, 92.7 x 63.5 cm, 36 x 25 inches
[3] **Wall**, 2002, silver gelatin print, 101.3 x 67.9 cm, 40 x 26 inches

Zoe Leonard hunts the American landscape for the debris of everyday life. Her discreet, understated portraits of objects as diverse as trees, animal carcasses, dolls and museum installations elevate the refuse of our culture with quiet dignity. Drawing out myriad untold narratives from the mundane and the overlooked, her lens has the ability to "animate the inanimate", she has said, with a focused, minimalist gaze that evokes Walker Evans or Ernest Hemingway. As Leonard herself describes it, she is simply showing us how she sees. "I point my camera at something that interests me. Then I show it to you." And yet her eye, like the objects it captures, is more complex and less innocent than it seems.

Underlying much of Leonard's investigations are the intersecting structures of power and culture. Her earlier work in black and white sought out museum oddities: an eighteenth-century female anatomical figure bedecked with pearls and a wig; the preserved head of a bearded woman; and her infamous Documenta 9 installation in the Neue Galerie, Kassel, of shots of female genitalia interspersed among eighteenth-century paintings of women. The unexpectedness of Leonard's subject matter raises politically charged questions about the constructs of our acquired cultural memory. Under what circumstances did that bearded head end up in a jar in a museum? What roles do women occupy as both subjects and viewers of art? By unearthing the obscure and spotlighting the unconventional, her photographs expose the problematic, often biased, roots of contemporary knowledge.

Leonard has also used other subjects, such as maps and runway models, to peek under the skirts of our societal architecture. She has even created a false archive of the career of Fae Richards, an invented African-American actress of the 1930s. Perhaps the most literal articulation of this idea was her sculpture of a tree, made out of actual tree parts and bolts—an arboreal Frankenstein on a gallery floor. Trees are something of a recurring character in Leonard's photography as well. A lonely bag caught on some branches, a trunk bulging over a pavement, images that suggest human neglect and the strained relationship between nature and urban life. In another picture, an apple tree stands squarely in the frame. The leaves have all blown away, the season is over, but no one has picked the fruit, which cling, perfect, to the branches. Leonard, who spends much of her time in Alaska and New York, captures the valiant struggle of these trees to thrive amid our struggle to contain them.

Absence and memory overwhelm many of these pictures: an empty niche for the Virgin Mary, the outline of a missing chimney, a bricked-up window. Unlike documentary photographs, which record what has already happened, the subjects of Leonard's photographs contain active, persistent imprints of loss, embedding in her deceptively simple images a deep and textured melancholy.—Dina Deitsch

[1]

Photography is the only universal language, a form of communication that can be understood all over the world, beyond all borders, outside of cultural difference and independent from political circumstances. Innumerable photographs by **Armin Linke** tell us about distant and seemingly different places. They create a web from our present world, a matrix that is understandable and recognizable for everyone, yet seemingly unfamiliar—the images appear somewhat artificial. Linke has performed countless journeys to regions of the world as distinct and far away as an oil rig in the Arctic sea, a gigantic water dam in the Chinese desert, a dazzling street market in a suburb of Calcutta, a synagogue in Lagos, a massive glacier in Patagonia and a space station somewhere in the Siberian wasteland. But more often than anything else Linke photographs cities and the process of their creation, cities of all types and on many continents: Hong Kong, Tokyo, São Paulo, Berlin, Moscow, Lagos, Pyongyang and many more. He takes pictures of all the good, bad and ugly sides our world has to offer. He allows us to participate in the dreams, visions and sorrows of those places as he catches the making of a world on the verge of another time, including all the social and cultural changes this transformation brings about. Like a chronicler of the global era, Linke travels restlessly, constantly on the move, a postmodern flâneur of the twenty-first century. But, in contrast to a documentary photographer, Linke is careful about the display and presentation of his works. He likes the pictures to be approached and viewed slowly and with rest.

Correspondingly, the size of the images plays a significant part in Linke's efforts to manipulate the process of perception —the images are large and need space to breathe, to disclose their energy and vigour. At other times Linke has created installations in which his photographs are grouped together in large books displayed on tables in the gallery. Inviting the audience to flip through these books, Linke extends the act of discovering the sites he photographs to the viewer. The often breathtaking views of landscapes and architectural structures in his images prompt the question of whether digital manipulation has been involved. Indeed the photographs seem at first glance like the construction of a fictitious vision, strangely artificial and inorganic—but they mirror our world, and turn out to be an uncorrupted reproduction of reality. The act of looking at Linke's work makes us understand the power of photography—we never saw the world in such a light.

He documents how our civilization shapes the planet and its surface, how we try to take control of our world and build our future. Looking at his images of the North Pole and imagining the structure of a city—where the ice that closes and opens creates gigantic channels, streets and towers forming an organic network—it might be that his photographs also tell us about a loss of scale that we are experiencing in our contemporary world. Looking at his apocalyptic images of São Paulo, an urban labyrinth made of concrete, steel and glass, with twenty million inhabitants, more than a hundred thousand streets, thousands of skyscrapers and even more cardboard houses, it is true that mankind is in charge. Even though these megalopolises suggest pure chaos, we know there is no space for an alternative and realize that this is our world, this is our future. A future we created ourselves.
—Jens Hoffmann

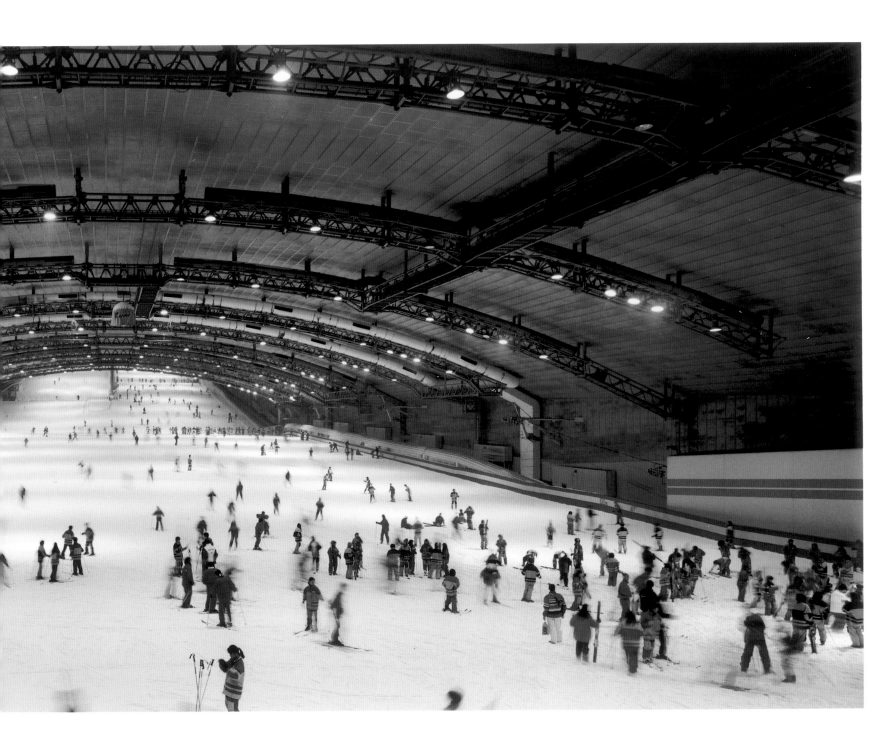

[1] Untitled, 2005, C-print, 127 x 101.6 cm, 49.5 x 39.5 inches

[2-3] Lunch Break installation, "Duane Hanson: Sculptures of Life," Scottish National Gallery of Modern Art (Detail 1 and 2), 2003, C-prints, 182.9 x 307.3 cm, 72 x 121 inches

Sharon Lockhart's photographs are elegant balancing acts cunningly poised between structural precision and visual seduction. They offer evidence that extending the dialectical relationship between the past and the present can be a beautiful, complicated and productive lie in which the double register of fact and fiction is consistently destabilized. Her images are structured as acts of anthropology and direct observation, but the passing familiarity of their documentary approach quickly unravels into dynamic uncertainty. Her work recalls what John Roberts has highlighted as a hidden agenda of Surrealism: "a realist insistence on the power of photography to bring the contradictions of social reality into view", such that meaning is produced in the act of reception (*The Art of Interruption: Realism, Photography and the Everyday* [1998]). Questioning how we perceive and represent the essential moments and tasks through which we construct and maintain everyday life, Lockhart's hyperrealism is rigorously constructed as a collaborative space in which the traditional contract between viewer, subject and artist is playfully realigned.

Lockhart's work presents an art of relationships and connections between people, objects, communities, movements, actualities, subjectivities, fictions, fabrications, history and the present. These correlations coalesce into a restless catalogue of captured moments in which an excess of objective detail ironically destabilizes the bond between reality and representation. Alluding to various twentieth-century photographic genres—portraiture, images of labour, still lifes, film stills and performance documentation—her photography's structural and performative logic ultimately defies such convenient categories.

Produced in tandem with her filmmaking practice, Lockhart's images act on the thresholds of photography, performance and cinema. In her films she acknowledges a debt to the task-based actions and "everyday bodies" of Yvonne Rainer's minimalist dance and the durational, anti-narrative "real time" cinema of Chantal Akerman. This link between Minimalism and hyperrealist strategies from the 1970s is cleverly reconsidered in a recent series of four large photographs in which two gallery technicians install Duane Hanson's lifelike 1989 *Lunch Break* sculpture. The photographs recall a statement of Rainer's: "I love the duality of props, or objects: their usefulness and obstructiveness in relation to the human body. Also the duality of the body: the body as a moving, thinking, decision-making entity and the body as an inert entity, object-like." (*Works 1961-73* [1974]). Rainer's film *The Lives of Performers* (1972) concerns itself with "works-in-progress" and rehearsals. Similarly, as Lockhart documents the restoration and "reactivation" of Hanson's sculpture, her subjects are caught in a moment suspended between the space of the archive and that of the exhibition. The camera enacts its own complex choreography in which live bodies and static objects become interchangeable as images and artifacts, while everyday life and art history collapse into one another.

Lockhart has frequently concerned herself with photographing acts of labour in the service of culture, such as a stonemason repairing the floor of Mexico City's Museum of Anthropology, female Japanese gallery attendants silently guarding an exhibition of works by On Kawara, or a recent photograph of a man restoring a cello, which he holds upside down, inverted from its usual playing position. Lockhart's camera witnesses the rhythms of a post-industrial culture of conservation and maintenance in which bodies and actions, objects and traces of the past fall in and out of time, teasing out the limits and possibilities of representation.—Stuart Comer

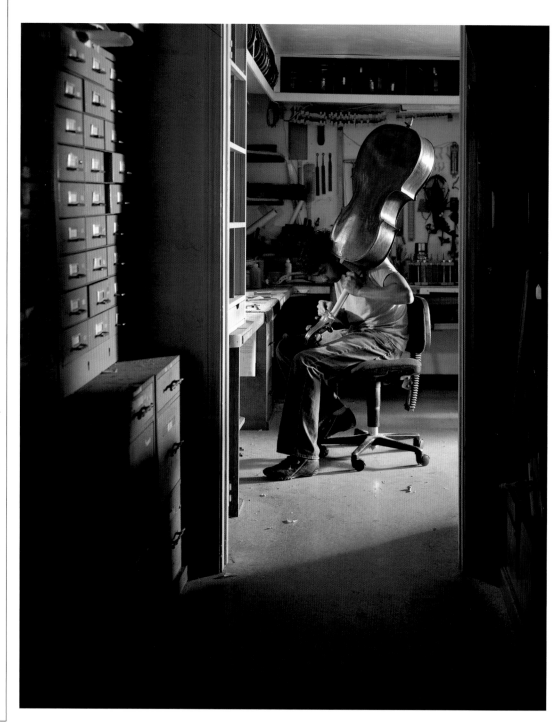

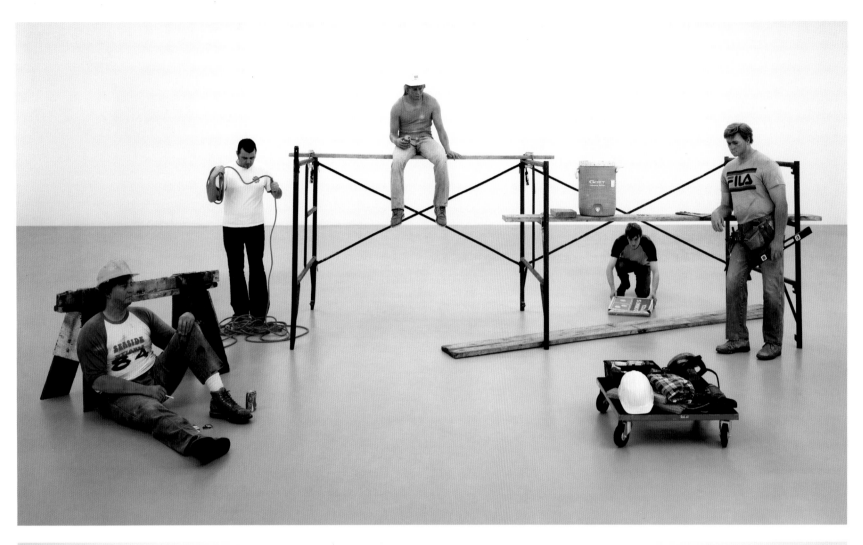

Using a camera obscura, usually devised from a shipping
container (an appropriate choice given her interest in
transportation, transfer and exchange)—if not an actual
room—**Vera Lutter** creates monumental photographs
that record layers of information and the passage of time.
Through a tiny aperture, an inverted view of the originary
field is ushered into the darkened chamber and projected
on to photosensitive paper lining the wall. It is an extended
procedure, with exposures for each work lasting hours,
days or weeks—and, on occasion, months—during which
time Lutter herself is a consistent, yet unregistered,
presence within the camera, enacting a performative role
in the image's gradual appearance.

Lutter's camera surveys urban landscape and industrial
terrain with particular historical resonance. She has, over
the years, aimed her aperture at the iconic skylines and
waterfronts of New York, Chicago, Cleveland and Berlin, at
the Frankfurt Airport and at a Rostock shipyard. She has also
constructed her camera within vast interior spaces, including
a Zeppelin hanger, London's vacant Battersea Power Station,
the derelict factory premises of Nabisco in upstate New York,
and those of Pepsi Cola in Queens—whose 23 m (75 ft) neon
sign, an unofficial landmark threatened with demolition,
has also been subject matter for the artist.

The captured views, rendered in reverse and in negative,
beckon the observer of Lutter's work to visually reposition
light and dark, and left and right, in order to recognize
identifiable objects through the preternatural atmosphere
of white shadows and black sunshine. The images are
made all the more uncanny and indecipherable by ghostly
traces and overlapping transparent objects. This is a result
of movement outside the camera during exposure, an
inevitability given that the photographs do not capture a
single moment, but document an extended temporality, like
a film telescoped into a single frame. Within the Frankfurt
Airport project, multiple layers of dematerialized aircraft
are superimposed—evidence of successive aeroplanes
arriving and departing from the same spot over the duration
of the exposure. The deictic clarity of her titles specifies the
location and date—or dates, should the exposure exceed a
twenty-four-hour period—of each image, and lend the work
a scientific and documentary gravitas.

There is a physicality to Lutter's images, beyond the
enormity of the photographs themselves and the apparatus
of the camera, that is remarkable for two-dimensional
work. Because of the direct exposure, the chemically treated
paper, albeit flat, is "carved" by light, taking on a sculptural
quality. Lutter's practice can also be seen as installational
—if one considers the stasis of the camera and the fluidity
of the pro-filmic object as part of the work—as well as
performative, with the artist as active agent inhabiting the
camera. And, of course, there are also architectural and
cinematic aspects to the work.

Lutter has not only revived the camera obscura, according
to Peter Wollen (*Bomb*, Fall 2003), but she has also "reinvented
photography itself, creating a new sensitivity to both time and
space". Indeed, the temporal and spatial indeterminacy of
Lutter's work seems simultaneously to compress and expand
time and space. This sense is reinforced by a playful *mise en
abyme* structure, revealing pictures within pictures and the
endlessly shifting dynamic between light, movement and
time that is central to Lutter's practice.—Catsou Roberts

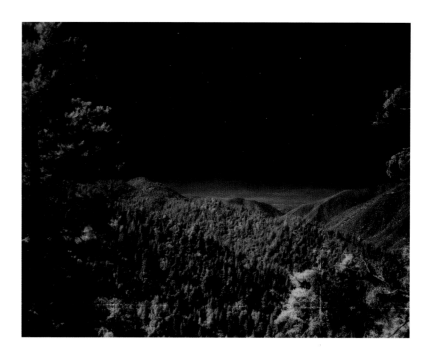

Florian Maier-Aichen's graphically arresting, large-scale photographs often contrast one's subjective experience with broader issues of urbanization, mobility and the environment. Since finishing his Masters in Fine Art at the University of California, Los Angeles, in 2001, Maier-Aichen has ricocheted between Los Angeles, Cologne and sparsely populated Alpine villages, rendering the ephemeral iterations of geographic space into uncanny photographs that often cause a double take. At first glance, Maier-Aichen's saturated desert vistas and snow-capped mountains register a familiar generic beauty not unlike the alluring images found in glossy travel guides for Southern California or the Swiss Alps. Upon closer inspection, subtle details go missing: in one a segment of the tree line forming the contours of a mountain becomes illegible and then abruptly stops, or in a hyper-colourized view of the San Fernando Valley, the horizontal asphalt line of one of Los Angeles' iconic freeways suddenly disappears into the scrub brush.

Maier-Aichen's obvious digital manipulations of his photographs have an unexpected effect. Rather than hiding or obscuring technical inconsistencies in the photograph, the "imperfections" digitally input by the artist draw the viewer in closer from the distant position one usually assumes in order to take in an expansive panorama. Instead of presenting a macro view of trees, mountains and water that reads as a cohesive scene or landscape, his photographs are composites of micro points: rocks, ripples of water, even individual pine needles, painstakingly compiled by Maier-Aichen. While many artists rely on digital photography as a means to eschew authorship or convey a detached or "de-skilled" style, Maier-Aichen seems more invested in photography's renewed relevance in examining the norms of Western pictorial traditions: the formal, the technical and the range of subject matter. His controlled photographs remind us that while painting and sculpture have moved away from depiction (because they can), photography (even digital photography) remains a depictive or representational operation.

His starkly rendered pictures of twisted bridges in Germany, capsized sea freighters and aeroplanes suspended in mid-flight are not the loose sketches of a personal diary or chance encounters experienced while travelling, but represent a more studied and exacting practice. While Maier-Aichen's 2004 series of black-and-white photographs of the port of Long Beach taken from a rented helicopter are spectacular to behold in their exacting level of detail and graphic clarity, they are devoid of spectacle. Rather than merely depicting the logic of a grid or other formal system of representing a city, his aerial views rely on a more subjective form of Global Positioning System. Fixed cartographic markers such as waterways and skylines are rendered almost crystalline, turning a banal, crowded aerial scene into a precise satellite-like perspective offering an almost other-worldly view. Maier-Aichen's images of Southern California landscapes and Swiss Alpine scenes remain compelling because of his unique ability to transform familiar iconic landmarks into strange and alien terrain.

Using the slightest of digital editing, he sets out to undermine the viewer's psychological and technical expectations of photography. Beyond simply demonstrating the unreliability of photography as a documentary medium, Maier-Aichen shows us that a picture is never just the sum of its parts.
—Gloria Sutton

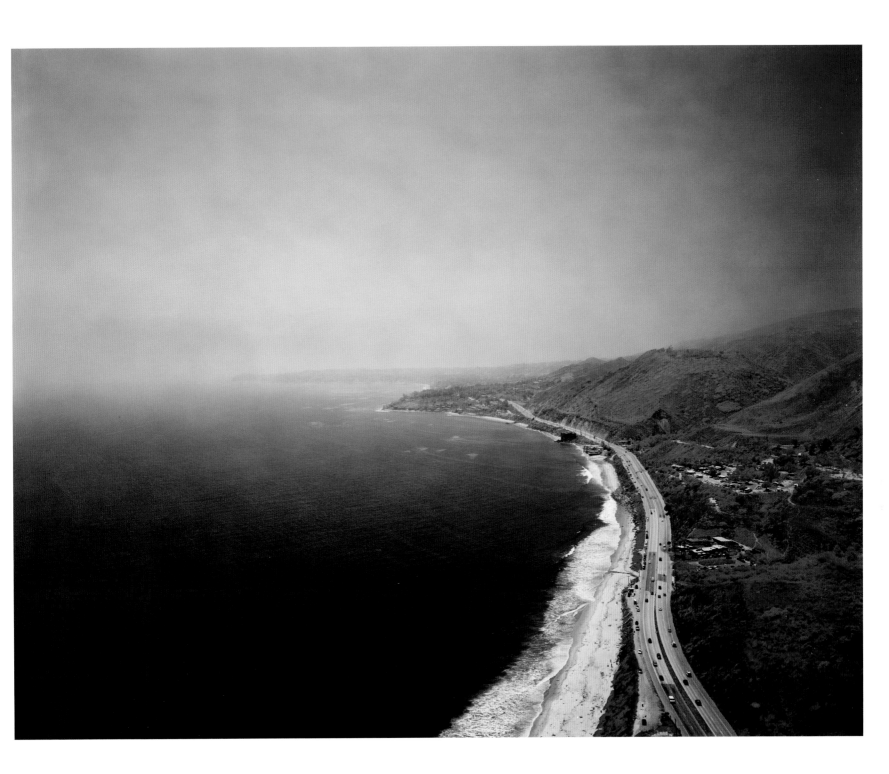

Florian
Maier-
Aichen

[4] [5]

[4] **Untitled (Long Beach)**, 2004, C-print, 181.6 x 235 cm, 71.5 x 92.5 inches
[5] **Untitled**, 2005, C-print, 62.2 x 73.7 cm, 24.5 x 29 inches

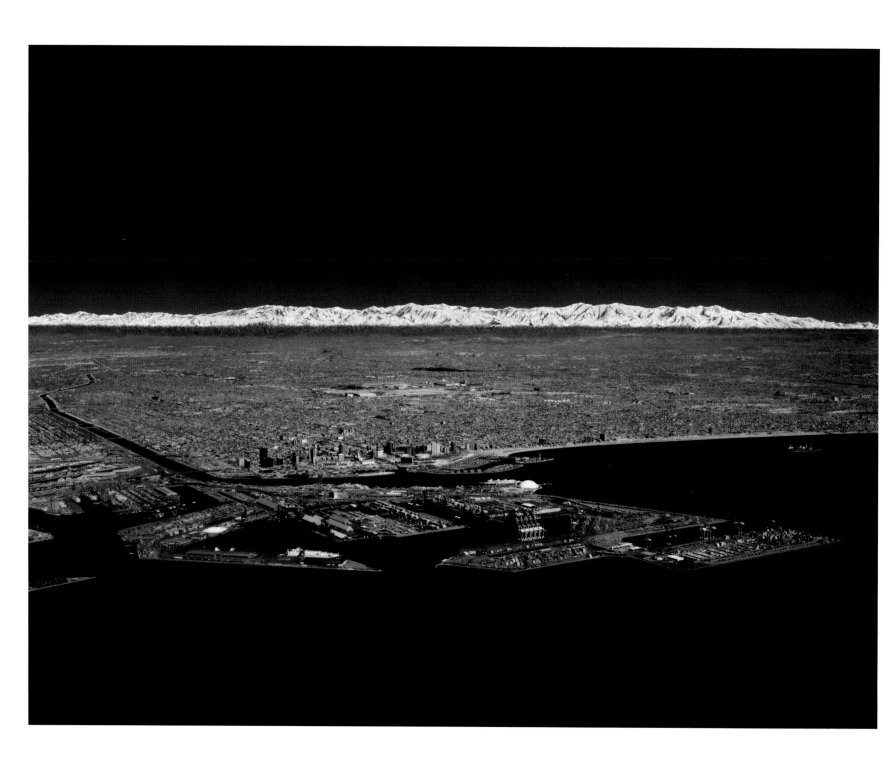

Florian
Maier-
Aichen

[4] [5]

[4] **Untitled (Long Beach)**, 2004, C-print, 181.6 x 235 cm, 71.5 x 92.5 inches
[5] **Untitled**, 2005, C-print, 62.2 x 73.7 cm, 24.5 x 29 inches

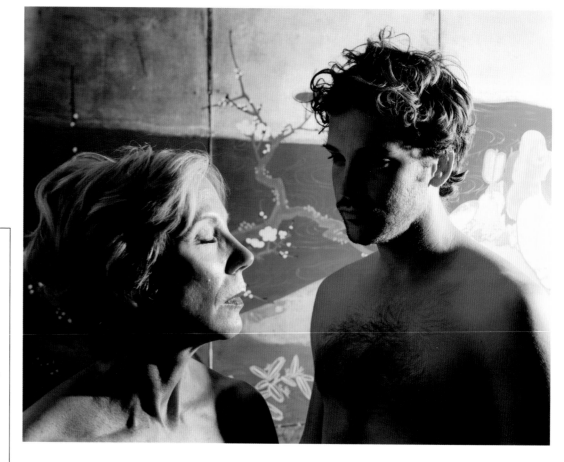

"I do like to make people feel disturbed, a little ill at ease," explained Los Angeles-based artist **Malerie Marder** in an interview a few years ago. Since graduating from Yale University's Masters in Fine Art programme in 1998, Marder has used the camera to dissect sexual tension, placing friends, family, lovers and occasionally herself before the lens, often without clothing. The vulnerable positions and awkward juxtapositions she depicts—or, rather, composes, as all of her photographs are staged—agitate cultural sore spots, such as incest and voyeurism, without slipping into pedantry. Marder's gaze is revealing without being mocking, and what emerges from her coolly insistent observations are scenarios in which suburban ennui leads to a more encompassing definition of intimacy, one that incorporates unease as well as bliss.

"Because I Was Flesh", a series of images that comprised Marder's first solo exhibition, in 2000, takes its name from Edward Dahlberg's mid-1960s autobiography of the same title. The book, as much a portrait of the writer's mother as of himself, gives shape to the psychologically fraught portraits. In one, Marder's then-boyfriend stands naked in the shower, gazing at her mother, who is perched on the edge of the nearby vanity. In another, the roles are reversed, with Peter standing near the corner of a bed, facing out of the frame, while Diane, unclothed and bathed in a light that casts a dramatic shadow on the wall behind her, gazes at his back. *Victor Marder* (2000) depicts the artist's father, also nude, sitting on his rumpled blue bathrobe near the fireplace; the picture would seem casual, like a snapshot, were it not so abnormal a scenario to happen upon.

The slanting light cutting across the deep shadows of more recent works, collected under the banner "Inland Empire" (2004), recalls other mid-twentieth-century precedents, from Edward Hopper's moody interiors to noir films. These cinematic photographs, shot in motel rooms in the little towns east of Los Angeles that are like blood clots along the asphalt arteries snaking through the desert, pick up where those earlier tales of isolation, deceit and illicit activity left off. One photograph, showing a naked woman with long wavy blonde hair seemingly about to join a man lying prone on the bed, was taken through the room's window. The clandestine vantage point imparts to other pictures of couples in the series a thrilling double meaning. It also serves as a narrative catalyst, reminding one that what has just happened (or is about to happen) has ramifications beyond the room's four walls.

It's worth remembering that in Marder's pictures, every person depicted alone is actually one half of a pair, every couple is part of a threesome and every group has a phantom member. She is both witness to and participant in the complex emotions presented by her photographs.— Brian Sholis

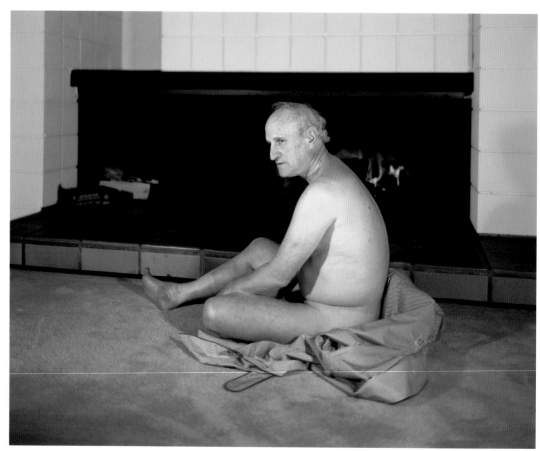

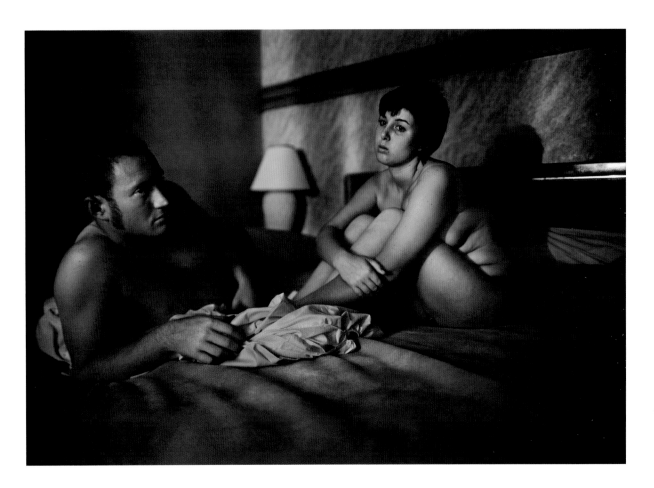

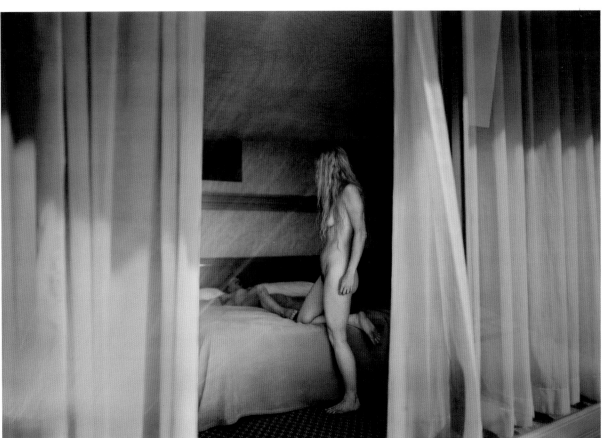

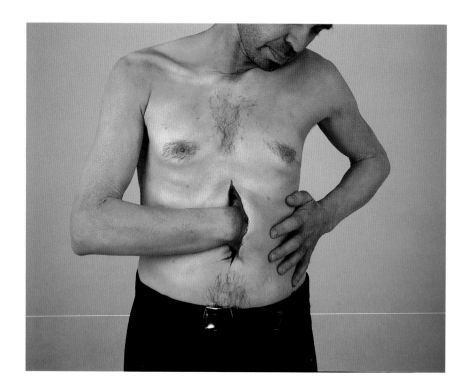

Working in the same vein as feminist performance artists such as Ana Mendieta, Eleanor Antonin and Marina Abramovic, **Daniel Joseph Martinez** does symbolic harm to his own body as a means of illustrating political violence inflicted on those placed outside the dominant power structure.

His 1999-2000 series of photographs of performances staged for the camera, "More Human than Human" (presented at The Project gallery as "Without Anaesthesia" in 2002), was inspired by Nietzsche's injunction to "destroy your idols". In these photographic self-portraits, Martinez appeared to be mutilating himself. The poses and their titles alluded to digital manipulation, although only prosthetics and make-up were used, and referenced both popular culture and art history. Along with images of rough suture marks across Martinez's skull, evoking the conclusion that the hyper-aware and vocal artist had been forcibly lobotomized, and his patiently pulling the bloody intestine from a wound in his belly, he also displayed an animatronic self-portrait kneeling face down until computerized pneumatic devices awoke the silicon, rubber and fibreglass sculpture, which then slashed its own wrists and cackled horrifically before curling back to sleep.

Martinez began to exhibit work addressing issues of multiculturalism and identity in the 1980s. But the Los Angeles-based conceptual artist gained international attention when curator Thelma Golden included him in the 1993 Whitney Biennial. Martinez altered the museum admission tags handed to visitors as they paid. Usually printed with WMAA, the six tags he created were printed with fragments of the phrase "I can't imagine ever wanting to be white", and one tag containing the entire phrase. In 2004, at The Project gallery in New York, Martinez displayed "The House America built"—a replica of Unabomber Theodore John Kaczynski's Montana cabin painted in woodsy hues from Martha Stewart's signature line of house paint. Martinez drew upon Stewart's insidious banality and the Unabomber's outsider status to propose that the two figures are linked through the American capitalistic culture, instead of being hostile to its ethos or even to each other. As Martinez says, "In my photographs schizophrenia is a form of political critique." By moulding himself into an apparent madman, Martinez reveals the lunatic perversity of how we categorize ourselves and each other.

Martinez's performances are motivated by recent critical theory as well as by more established thinkers such as Michel Foucault or Nietzsche. Martinez typically includes the names of contemporary political and cultural figures such as John F Kennedy, the author JG Ballard, Black Panthers' Bobby Seale and Huey Newton or film director David Cronenberg in his lengthy titles, and at the same time appropriates poses from historical paintings by Gustave Moreau or Caravaggio. As Martinez explains, "My use of titling comes from the eighteenth-century tradition of using titles as active agents." But unlike other artists whose work can best be described as illustrating theory, rather than engaging with it, Martinez's acidic sense of humour and appreciation of cinematic horror keep his work from becoming didactic or dry. "I think there is always humour in my work," Martinez explains. "It might not be the driving force but it's there, somewhere between William Burroughs and Hakim Bey." — Ana Finel Honigman

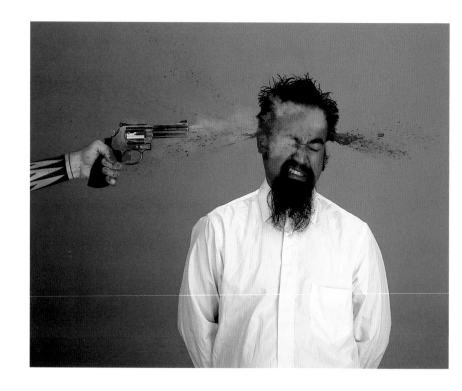

[1] Self Portrait #9c. Fifteenth attempt to clone mental disorder or How one philosophizes with a hammer. After Gustave Moreau, Prometheus, 1868; David Cronenberg, Videodrome, 1982, from the series "More Human than Human", 1999-2001, digital lightjet print, mounted on plexiglas, 152.4 x 121.9 cm, 60 x 48 inches

[2] George and Daniel. In an insane world it was the sanest choice or How one philosophizes with a hammer. After Harold Edgerton, 1964; Eddie Adams, 1969, from the series "More Human than Human", 1999-2001, digital lightjet print, mounted on plexiglas, 152.4 x 121.9 cm, 60 x 48 inches

[3] Self Portrait #4b. Fifth attempt to clone mental disorder or How one philosophizes with a hammer. After Mary Shelley, 1816, from the series "More Human than Human", 1999-2001, digital lightjet print, mounted on plexiglas, 152.4 x 121.9 cm, 60 x 48 inches

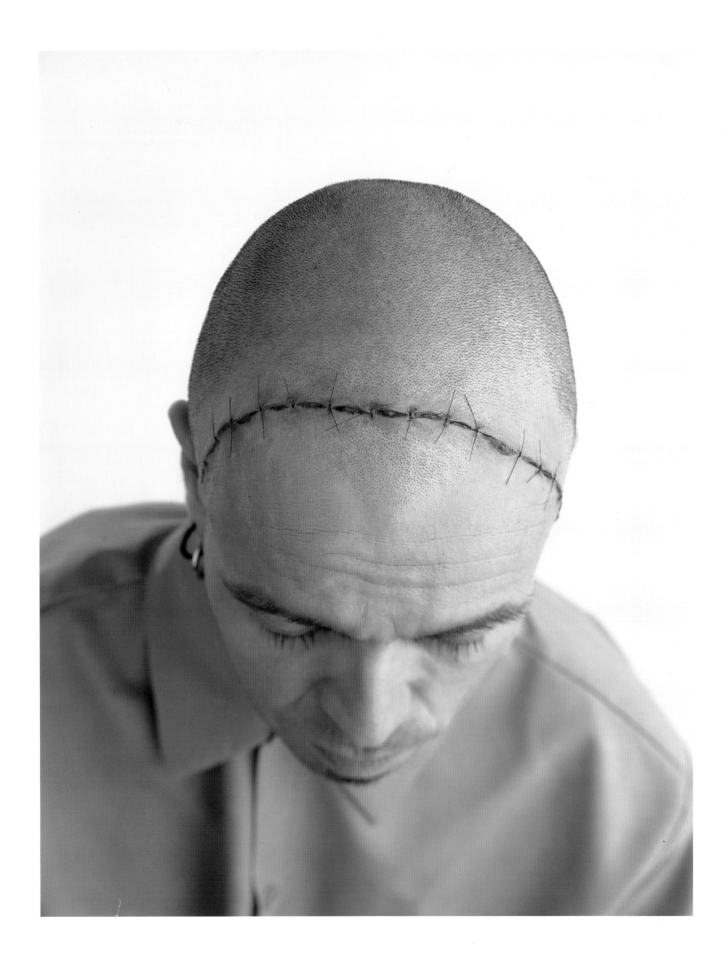

Can pain be represented in a photograph? Can it be seen
in a photograph of a flower? I think so. Flowers are, of
course, deeply symbolic of renewal. Their beauty is bound
up in the knowledge that it is momentary. Beauty pierces
your heart because it is painful. It is about loss, transience
and wonder at its very existence.

 Gareth McConnell's recent photographs of his bed and
flowers have to be understood with his other work in
mind. The motivation and poignance behind the images in
"Meditations" (begun 2003), "Night Flowers" (2002), and
"Night Flowers Part 2" (2004-5) make little sense if you
don't know McConnell's shocking and affective images
in the series "Anti-Social Behaviour Parts 1 & 2" (1995)
—victims of paramilitary punishment beatings in his
homeland of Northern Ireland, or intravenous drug users
who were his friends and sometime community. This is true
of beautiful things, isn't it? Beauty is cloying and saccharine
when it's too easily granted. Against McConnell's more
graphic material, photographs of an empty bed (reminiscent
of Felix Gonzalez-Torres's similar imagery) and flowers
(calling to mind, but importantly different from, Robert
Mapplethorpe's highly stylized examples of horticulture)
force those scenes outside the frame.

 In the ongoing "Meditations" series, McConnell photographs
his own bed after getting out of it in the morning. Sheets
and pillow are tousled, preternaturally poetic in blue,
morning light. They mark time, and contain the imprint of
a warm body, recently inside, now outside. McConnell
meditates here before starting his day. This space—his
small bedroom, in reality cluttered—is a cipher of a private,
internal life. Meditation is an active practice marking a
liminal place between the world of dreams (or nightmares)
and public, official business. We straddle this divide all the
time; resolving it means we are functioning well, and not
doing so means the opposite (sleeping during the day is
classic avoidance behaviour). Photographically, the empty
bed marks an absence of the main protagonist. It's a conceit
McConnell has explored in others series of work, such as
"Community Meeting Rooms" (begun 2004). Far from being
pictures of empty spaces, these are portraits that happen to
have no people in them. They are ruminations on the things
that a person comes into contact with; our folly is that
we think, plan and imagine, but most of what we do is much
more mundane.

 McConnell shoots "Night Flowers" in ambient light and
with a long exposure. He takes the pictures during nocturnal
walks, another temporal experience outside of the workaday.
Similar to the beds, the flowers become still, central objects,
isolated from their context (they are not hothouse but urban
flowers, growing alongside commercial strips and housing
estates). In some, a spray is classically composed against
a background, blossoms burgeoning; in others the image is
blurred, or the light intensely artificial, acidic. They are
the dusty, forlorn cultivars grown on the streets of any city,
but they are prizewinners, too. McConnell asks with these
pictures, can you find hope when and where it's least
expected?— Alison Green

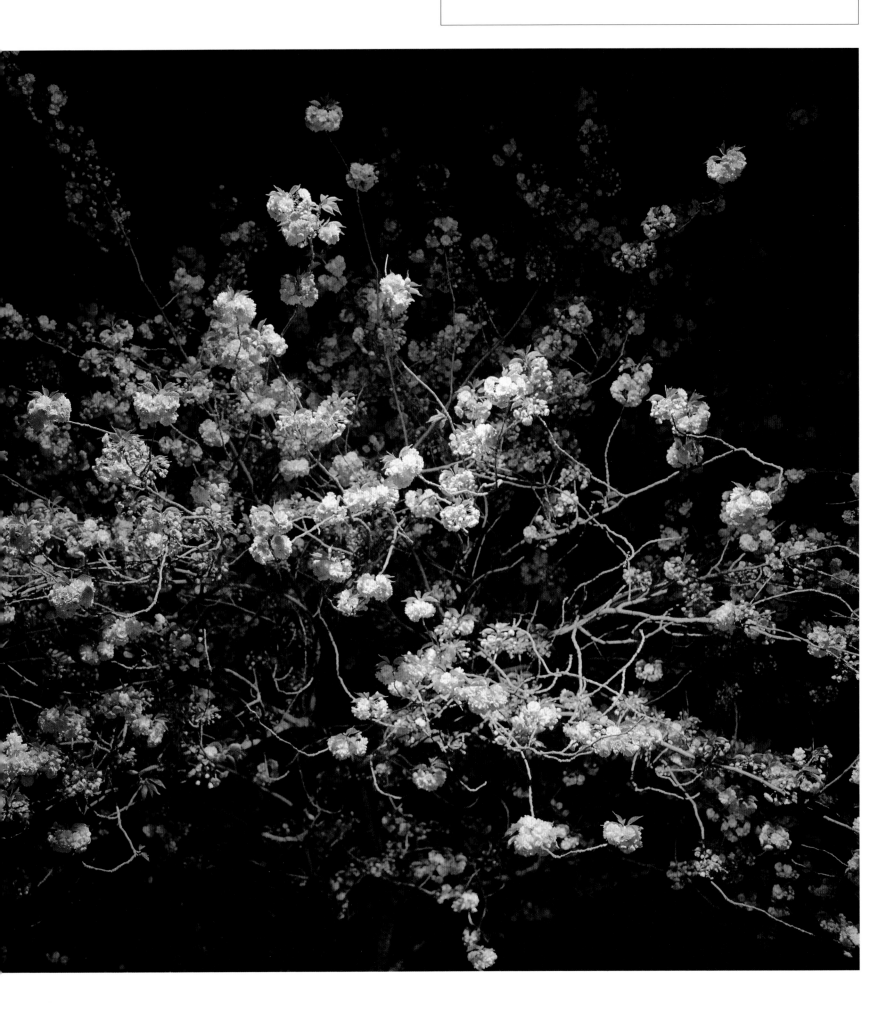

In his photographs, Canadian artist **Scott McFarland** explores the complex relationship between time and space. His subjects, which he often shoots over a period of years, are unspectacular and present prosaic or mundane places and actions: a friend's family cabin in Robert's Creek in British Columbia and its worn-out sofa (*Torn Quilt the Effects of Sunlight* [2003]); the gardens of affluent Vancouver homes (*On the Terrace Garden, Joe and Rosalee Segal with Cosmos altrosanguineus* [2004]); cacti at the Californian Huntington Botanical Garden. These groups appear to look like straight photographs that depict unique instants or events witnessed and captured from a single perspective at a particular time. The titles—literal descriptions or location names—tend to emphasize this impression. Yet the images we see are meticulously constructed illusions.

With his rich and subtle use of colours and tones and his carefully framed images, McFarland reminds us that each photograph is not only a composition but also a fiction. The presence of inconsistent shadows or out-of-season flowers is evidence of a conjured world made of simultaneous temporalities in which the present is made of several pasts. Yet, although each isolated part has been shot at different times, the location and shooting angle are the same and remain coherent. In a work such as *Orchard on Dr Young's Property, 3226 W 51 St Vancouver* (2005), the same view of a garden is photographed over a period of several weeks. Trees of the same species are shown at different points in the spring season and therefore at different stages in their sexual cycle, creating an impossible correlation of time and space. *Torn Quilt the Effects of Sunlight* presents an emblematic association between subject and process. The image of an old patchwork quilt on a small couch in a sunlit cabin shows a dense cartography of shadows in the wrinkles of torn fabric. The picture is taken from the same perspective over an entire day, capturing the changing light of the setting. Assembled from several photographs, the image is, like its subject, a patchwork, producing a "forced" and fallacious unity. Many of McFarland's photographs are made by digitally compositing a variety of negatives, which are arranged and altered to achieve a single, seamless picture. In recent work, the artist has made his process more explicit by leaving visible seams in the trees or the sky of his garden photographs.

Light and natural cycles are common marks of duration in the work of conceptual photographers. Jan Dibbets, for example, has shown in a series of related pictures the movement of sunlight across a gallery floor during the course of a day, *Shadows on the Floor of the Sperone Gallery* (1971), and has recorded the changing light from dawn to dusk in *The Shortest Day at the Van Abbemuseum* (1970). McFarland, by melding several temporalities of one subject in the same photograph, denies photography's homogeneous time, commonly conceived as an instant. Rather, he explores photographic space as positively linked to time as duration and succession, in the lineage of nineteenth-century photographic experiments. In doing so, he considers the notion of representation as an intensive, rather than a repetitive, mode, not copying but presenting an object in its complex spatial and temporal realities. McFarland's photographs fascinate in their comprehension of what a space is. They also offer a multi-layered consideration of photography's representational potential. To stick to the artist's visual metaphor, just as a garden is a fiction of a landscape so photography is a fiction of authenticity.
—Vincent Honoré

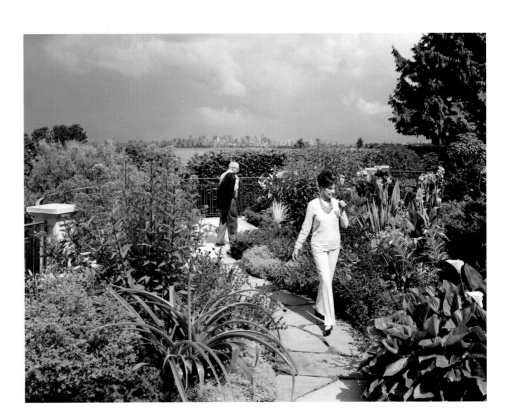

[1] **Wade Wave**, 2004, C-print, 76.2 x 101.6 cm, 30 x 40 inches
[2] **Whirlwind**, 2004, C-print, 68.6 x 101.6 cm, 27 x 40 inches
[3] **Simone**, 2003, C-print, 50.8 x 61 cm, 20 x 24 inches
[4] **Tree #1**, 2003, C-print, 68.6 x 101.6 cm, 27 x 40 inches

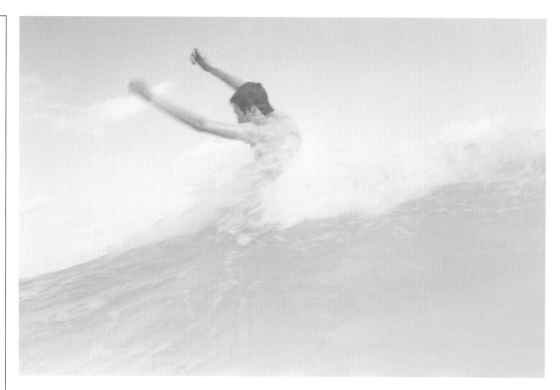

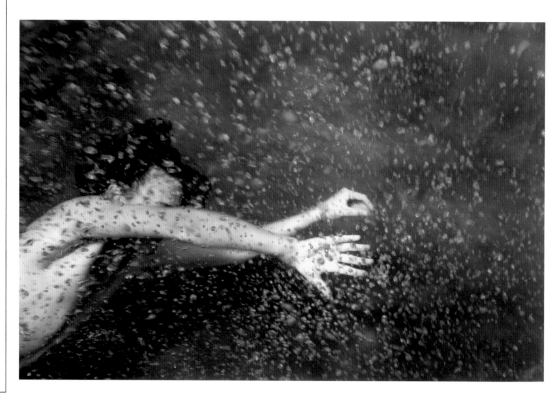

Images of youth seem increasingly prone to "packaging" by the mass media in such a way as to create a sense of identity for particular age groups through products and lifestyles. These pictures attempt, yet ultimately fail, to capture the vulnerability of youth by glossing over the fleetingly intimate interstitial moments or clumsily addressing the very intense, complex and formative sexuality of adolescents and young adults. **Ryan McGinley**'s sensuous and evocative images provide a rebuttal of sorts to this crisis of representation through their depiction of young people through a dreamy yet awkward perspective. His photographs possess a lush romanticism that is strangely offset by a visual sensibility informed by the furtive arbitrariness of surveillance and espionage. We the viewers are thus placed in an unsettling position between the pleasurable immersion in and enjoyment of the moody physicality of his subjects and an eerie feeling of invading those same subjects' privacy.

McGinley's work follows in an ongoing photographic tradition of creating intensely engaging visual narratives out of one's own (often marginalized) social milieu. While frequently discussed in relationship to more prominent figures such as Wolfgang Tillmans, Nan Goldin and Larry Clark, his project seems closer to the dark and moody romanticism of Mark Morrisroe or the laconic impressionism of Jack Pierson. Early photographs captured those close to him participating in various mundane or transgressive activities. The images strike a tenuous balance between the subjects' self-awareness and willingness to reveal aspects of their more intimate life to the camera (and by extension the viewer), and the viewer's complicated appreciation of both the formal qualities of the photographs and the unmitigated presentation of otherwise private spaces or moments.

McGinley is, of late, best known for nocturnal images of friends cavorting (mostly) naked in natural settings created in 2002 and 2003. These photographs alternate between the presentation of ethereally crepuscular scenes in which bodies seem to disappear and re-emerge between branches, grasses and other foliage as if in a hazy dream (the paintings of nineteenth-century Symbolist Odilon Redon come to mind) and a more creepy and sinister sort of spying in which the figures appear to be starkly forced into the harsh light of revelation. McGinley's use of underwater photography provides an even more sensuous texture to his images of figures in groupings that waver between compositionally staged and spontaneously social. The murky shadowiness of these images serves to underscore their representation of a strange new sense of hippyesque communality utterly foreign to the depiction of young people on television and in other mass-media outlets.

A recent series of portraits of Olympic swimmers for *The New York Times Magazine* section shows McGinley expanding his visual approach beyond his immediate social circle. The resulting images counter the typical glorification of the athlete as a physical specimen by creating dissonantly surreal representations of these figures in their expected surroundings. McGinley's views of the swimmers from odd, unexpected vantage points within the pool remind the viewer of their own sense of displacement within this situation, while emphasizing the sublimely beautiful results of a human body moving through water. — Dominic Molon

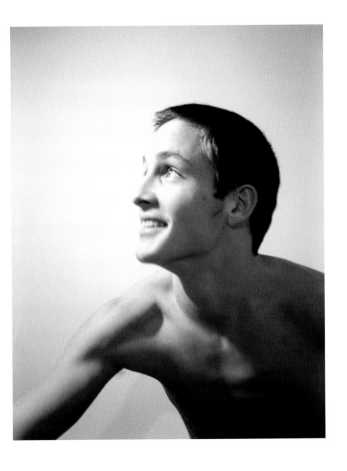

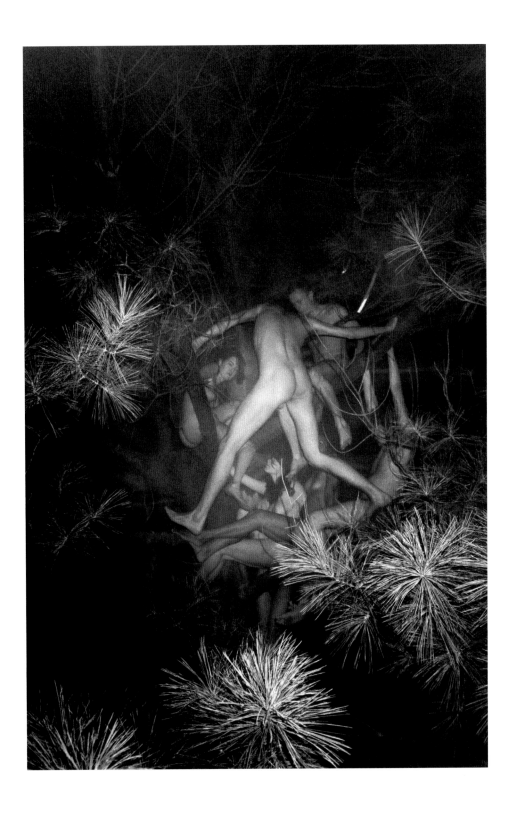

[1] **Amanda Percy, May 28th, 2005,** from the series **"Front"**, 2005, C-print, 76.2 x 101.6cm, 30 x 40 inches

[2] **Sylvia Westbrook, August 2nd, 2005,** from the series **"Front"**, 2005, C-print, 76.2 x 101.6 cm, 30 x 40 inches

[3] **January 25th, 1979,** from the series **"Seven Years"**, 2003, C-print, 76.2 x 101.6 cm, 30 x 40 inches

[4] **April 16th, 1967,** from the series **"Seven Years"**, 2003, C-print, 76.2 x 101.6 cm, 30 x 40 inches

[5] **September 20th, 1985,** from the series **"Seven Years"**, 2004, C-print, 76.2 x 101.6 cm, 30 x 40 inches

For several years **Trish Morrissey** used her parents' house in Dublin as the location for her photographs. At first, she investigated the house itself. Her mother and father were in some pictures, but they might have their backs turned, or be partially obscured by a door. Then Morrissey turned more explicitly to the inhabitants of that house, and enlisted her brothers and sisters to appear in photographs that restaged family events. In the end, one sister became half of a double act with Morrissey herself in a series of photographs entitled "Seven Years" (2002-4), which refers to the age difference between them. Of course neither of them lives at home any more, and the scenarios they played out were only partially based on their family's history. But the photographs from "Seven Years" have the haunting, stilled (or stultifying) quality of one's own memories of privately painful experiences of ordinary events. As in a more recent series of work, "Front" (begun 2005), taken on British beaches where Morrissey inserts herself into other families, the image she makes is never the one that would go into the family album. She courts the awkwardness, unhappiness or anguish displayed on the body in spite of the smile fixed for a conventional "happy" image.

There are important doublings and displacements that go on in Morrissey's photographs. She and her sister play men in some, people of different ages in others. Clothing and hair—usually self-determining markers of character function here to take us back in time, but also to make identity fluid and unreliable (Morrissey first used actual clothes from her parents' attic, then got a stylist to add more). In the series "Front", Morrissey doesn't merely sit for the picture, but takes on the persona—mother, sister, friend—of one of the group's members, who herself becomes the photographer. These photographs become at once ordinary holiday snaps and very strange exchanges between public and private spaces (she usually tried to borrow an item of clothing from the woman she replaced). In a sense, Morrissey's motivations are dual: she wants to bring photographic clichés into high relief, but also to open these dramas up, to create more play within them to counter the ossifying effects both of memory and group dynamics.

Morrissey's practice can be described broadly by the term "documentary aesthetic". In some regards this is verging on becoming a genre of photography that courts the real by staging pictures. Such artists as Jeff Wall and Cindy Sherman are cited as precedents, and the theorizing inevitably gets tangled up in photography's historical relationship with "truth" and its postmodernist critique. With Morrissey, however, staging is more than an arch gloss on the impossibility of representation; it is a door left open to let us view her in the act of constructing photographic meaning—imagining, remembering, planning, staging, acting, looking, deciding. It is her way into the heart of such issues as family experiences and national identities, pastimes and fashion, Irish middle-class values, feminine and masculine roles, and relationships between strangers. Her work does not so much define these subjects, but rather uses photography to probe their boundaries, often left intact in everyday life.—Alison Green

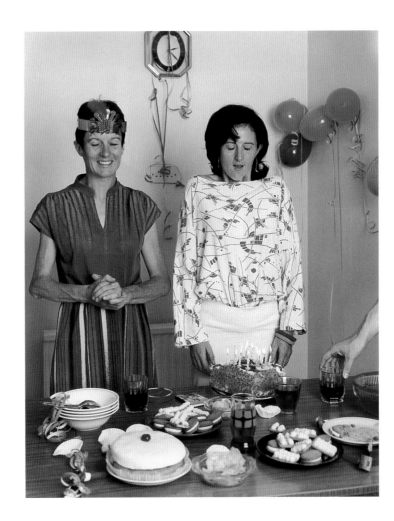

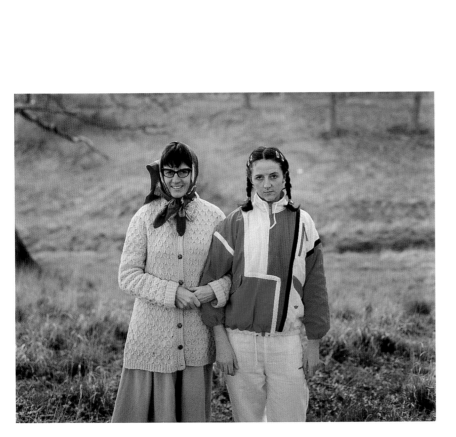

[1] **Untitled**, from the series **"Sugar Cane"**, 2003, C-print, 149.9 x 194.3 cm, 59 x 76 inches
[2] **Untitled**, from the series **"Interior"**, 2002, C-print, 179.1 x 241.3 cm, 70 x 95 inches
[3] **Untitled**, from the series **"Sugar Cane"**, 2003, C-print, 149.9 x 194.3 cm, 59 x 76 inches
[4] **Untitled**, from the series **"Interior"**, 2002, C-print, 179.1 x 241.3 cm, 70 x 95 inches

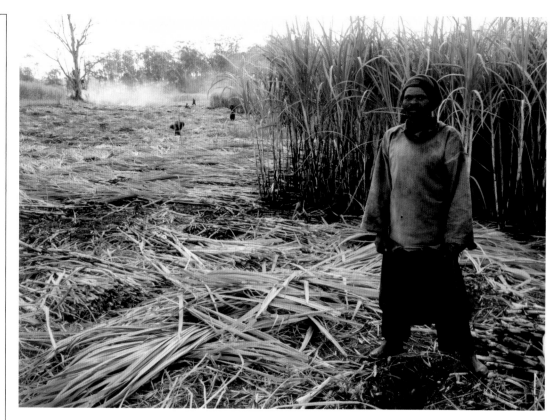

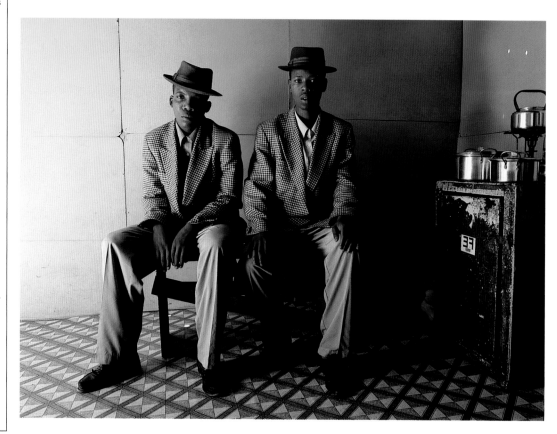

Whether photographing South African domestic spaces or labour conditions in the country, **Zwelethu Mthethwa** focuses on marginalized lives in need of reportrayal. The suggestive terms he establishes in the titles of his exhibitions and series —such as "Lines of Negotiation", a 2004 exhibition at Jack Shainman Gallery, New York, or the series "Men in Private Spaces" (2001) and "Black Men and Masculinity" (1999) —set up questions that he partially answers: negotiation between whom and over what? private spaces to whom? masculinity constructed in what context and for what group of men? Mthethwa's images respond to the history of photojournalism on the African continent that, whether sensationalistic, exploitative, reductive or some combination of the three, has rarely offered its subjects authority over their self-presentation. His figurative images are also part of the tradition of African studio photography, exemplified by, among others, Malian photographers Seydou Keïta and Malick Sidibé. Engaging with both photojournalism and portraiture, Mthethwa's images show those on the economic margins in states of self-possession.

Mthethwa's subjects consistently become his "collaborators"; they negotiate their presentation within their given space. In his 2002 "Interior" series of people in their homes outside Cape Town, he records how they would like to be remembered — sitting placidly at an empty kitchen table with a hat stylishly placed off-centre, or next to a made-up bed with some surrounding personal belongings neatly in order. Mthethwa enlarges the contours of representations of marginalized lives by a focus on details — hanging clothes above a partially made bed and personal objects half-masked by beds and desks — making one feel privileged by the access given to underprivileged people and places and restoring honour to his subjects.

Mthethwa's images are not only acts of restoration, but also of strategic disruption, targeting fictions that have hardened into facts. Mthethwa's "Sugar Cane" series, of sugar-cane workers in KwaZulu-Natal, attempts to rupture what he calls the "mythology of labour". He positions himself not as an intruder, but as a strategic "interrupter" in the fields where workers perform tasks more akin to high-risk industrial than agricultural labour. Photographed in between periods of intense work, they pose in front of multi-hued green hills of work yet to be done or nearly completed with their machetes, their tool of choice, and, despite the heat, wear multiple layers of clothing as necessary protection from noxious chemicals, cut cane and snakes that lie within the fields that unfold in the distance. Mthethwa's collaborators show a range of attitudes from weariness to defiance, rigidity or playfulness. Yet they each convey cool composure in a field of violent labour that can also be read as a proprietorial stance, renegotiating, if only for that photographic instant, the relationship between worker, landowner and the land, and finally coming out on top.

As sugar cane is a product of international trade and cultivation, Mthethwa hopes that the "Sugar Cane" series is read as a reflection of conditions found around the globe. He crops out clues in the landscape that would point to any regional specificity, creating a strategic geographic disorientation. Working within South Africa, Mthethwa manages to create both culturally specific images and ones of geographic abstraction, revealing that the universal is, in fact, often simply the local without walls. — Sarah Lewis

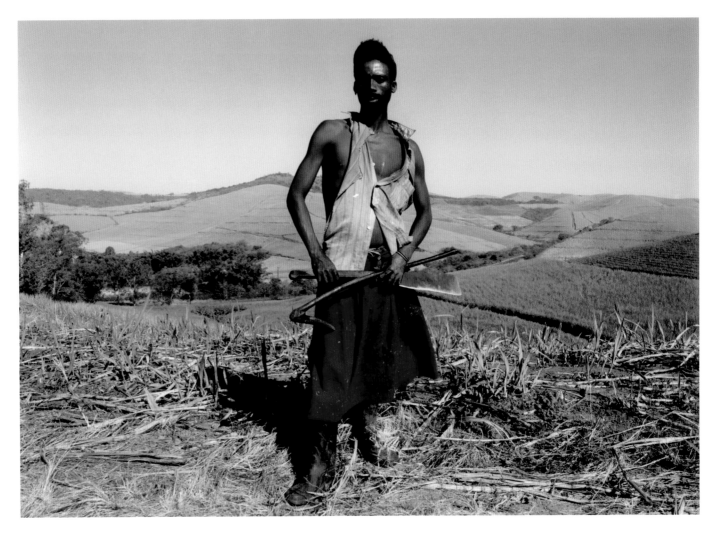

[1] **Skin2Skin**, 2003, silver gelatin print, 25.4 x 38.5 cm, 10 x 15 inches
[2] **Id Crisis**, 2003, silver gelatin print, 32.5 x 48.5 cm, 12.5 x 19 inches
[3] **Aftermath**, 2004, Lambda print, 39.5 x 60 cm, 15.5 x 23.5 inches
[4] **Self portrait – Zol**, 2002, Lambda print, 70 x 51 cm, 27.5 x 20 inches

Born in 1972 in Umalzi, Durban, **Zanele Muholi** has become known for her photographs that allow sensitive and intimate insights into the lives of South African black lesbian women, and her exhibitions that have stirred up much controversy among the South African mainstream audience. A prominent gender and sexual rights activist in a very heterocentric and patriarchal South African society, Muholi works as a reporter for *Behind the Mask*, an online magazine on lesbian and gay issues in Africa, and as a community relations officer for the Forum for the Empowerment of Women, a black lesbian organization based in Johannesburg. If her photographs unmistakably address the same issues as her social work — the lack of lesbian visibility and the identity confusion that it causes, or the tragic fact that black lesbians in South Africa are routinely attacked and raped because they are lesbian — they do not belong to the documentary genre as such. One could even distinguish Muholi as one of the rare African photographers whose work evades the conventions of documentary or commercial images.

With a rigorous attention to composition, she has developed a highly personal style with a radical aesthetic, an "activist photography" that is raw, physical and unsettling, sometimes in order to push the boundaries of social tolerance. Her subjects of choice are menstruation, lesbian desire and breast binding: *Period* (2003), for instance, is a picture of a blood-smeared sanitary towel on a plate with a knife and fork on either side; *Skin2Skin* (2003) shows the tattooed torsos of two women pressed against each other; *Id Crisis* (2003) shows a woman bandaging her breasts, and *Aftermath* (2004) reveals a woman's thighs with a long scar — the result of a hate crime — running down one leg, her hands crossed in front of her genitals, a photograph that was taken two days after the woman was raped and an indication of how much Muholi is trusted by her subjects to tell their story and depict their pain without resorting to victimization.

Other pictures capture moments of intimacy; two women kissing or embracing, a woman strapping down her breasts. The impetus behind her photographic work, says Muholi, is "the desire to get beyond what lesbians do in bed and confront key issues, such as the lack of ownership gay, lesbian, bisexual and transgendered people feel over their voices, their personal spaces and in the places where they live, learn and work". Muholi is also the author of a recent documentary film entitled *Enraged by a Picture* (2005) that stems from some of the comments of people who have viewed her exhibitions across South Africa, framed as examples of the fear that homophobia arouses. Capturing and deconstructing the layered experiences of black lesbian women, Muholi not only condemns such reactions of hatred, but she invites black women themselves to challenge the stereotypes traditionally attached to their sexuality, or in her own words, she "provides the radical aesthetic for women to speak".—Thomas Boutoux

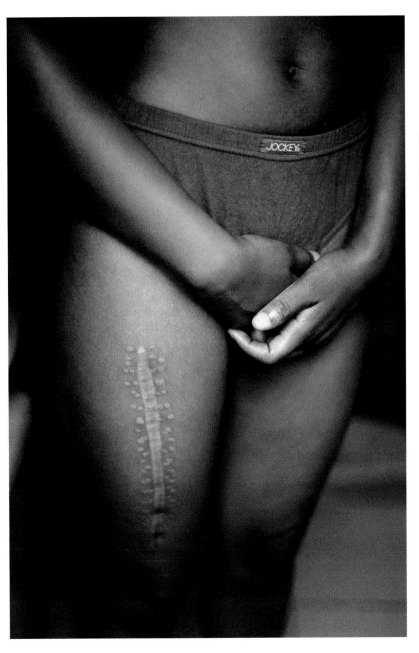
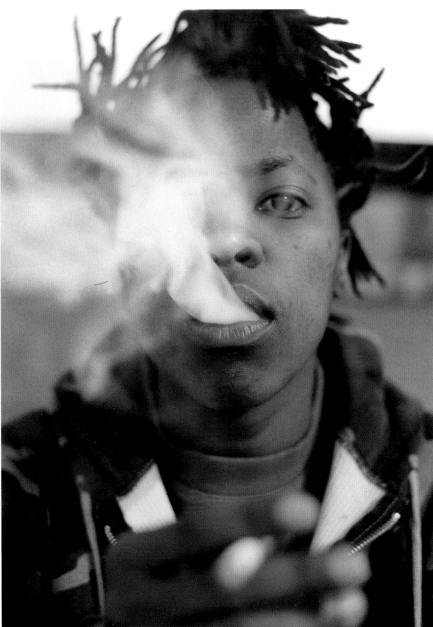

[1] From the series **"Neighbours"**, 1999, inkjet print, 42 x 29.7 cm, 16.5 x 11.5 inches
[2] From the series **"Neighbours 2: The Yard"**, 2002, inkjet print, 70 x 100 cm, 27.5 x 39.5 inches
[3] From the series **"My Best Friends"**, 2003, inkjet print, 28.5 x 41 cm, 11.5 x 16 inches

Straddling documentary, portraiture and Conceptual art, **Oliver Musovik** draws our attention to currents in photography in Eastern Europe, and specifically the Balkans. Much of Musovik's work is blatantly and unapologetically personal, usually produced in or around his home in Skopje, Macedonia. He investigates, documents and questions the individual, most often in relation to himself, to "types" and to structures: the concepts of best friends, neighbours or the artist. His work draws comparisons to someone like Emily Jacir, with a shared use of personal experience and photography to navigate laws, places and spaces that shape identity.

"Neighbours" (1999) is a series of simple, elegant images taken in Musovik's building in Dracevo, the blue-collar suburb of Skopje. He photographed the physical traces of his neighbours in the structures they share; someone's cat in the stairwell or a rubbish bag in the hallway. Without ever depicting the residents themselves, Musovik turns a Jacob Riis-style investigation of living spaces into a study on presence and communication, on how the inhabitants of this apartment block use and adapt its spaces and structures to their personal needs, and how others learn to read and respond to them. Musovik's experience of his neighbours is through the physical proximity they cohabit.

This interest in social systems and communal or interpersonal experience through the physical environment is carried into a later series, "Neighbours 2: The Yard" (2002). Here, Musovik turns his attention to various shared structures that adorn the building block's communal yard: a basketball hoop erected by a local politician to win the community's votes; a gazebo built of disused bus seats; a bench made of birch trees chopped down to clear the view. They are, like the first "Neighbours" series, photographed without the people who use them, as evidence or remains.

Personal relationships are the template in series like "Mama Loves Teleshop" (2003) and "My Best Friends" (2003). But they're not unmediated; external structures continue to shape the relationships. "Mama Loves Teleshop" is a humorous and lushly photographed series (the portrait of his mother leaning out of the window taken from behind strikes a surprisingly odd resemblance to Gerhard Richter's *Betty* [1991]) that documents Musovik's personal experience with a consumer culture still finding its capitalist feet. The portraits, also presented with textual notes, record his mother and himself using the various ingenious devices that she purchased from infomercials and home shopping channels: ionic toothbrushes, medical pillows, infinite absorption mops and twelve-part "Multi Wonder" graters and choppers, all presented on pedestals underneath the images. Suddenly, items of excess intrude into the personal space of the apartment block, where the gazebo outside, as seen in "Neighbours 2: The Yard", was cobbled together by the elderly of the community out of discarded bus seats. With tighter frames and no eye contact from the figure (whose focus is entirely on the newly acquired object), they are portraits of devotion, simultaneously humorous and grave, not to the complicated and dubious products that never quite work right but to the pure and simple idea of possession and consumption. It's another quietly incisive series characterized by refreshing candour, weight and wit.—Bethany Pappalardo

apartment #11

He is head of the tenants' council.

He is worried because somebody has stolen one of the building's entrance doors.

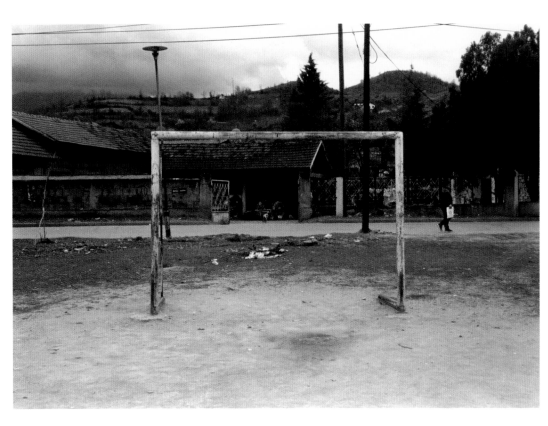

With contributions from all of us from the neighbourhood the old playground was renovated and new goals were erected. But since we got the new street basketball court, and basketball being much more popular sport in my neighbourhood, the soccer field is literally abandoned, with the goal posts only occasionally being used when beating carpets.

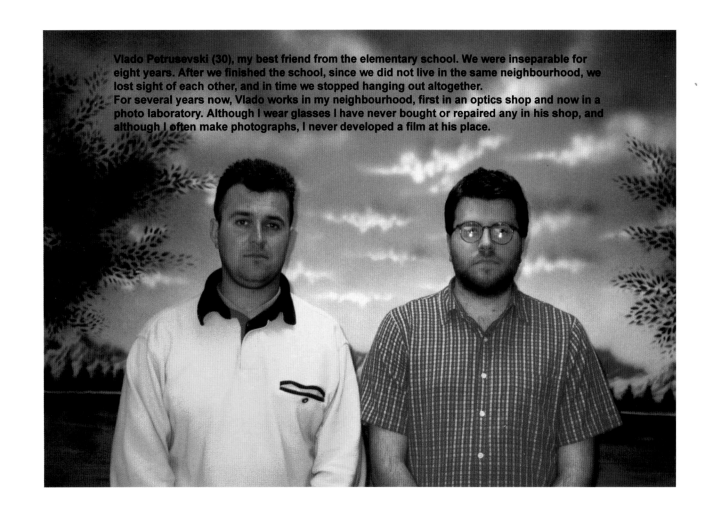

Vlado Petrusevski (30), my best friend from the elementary school. We were inseparable for eight years. After we finished the school, since we did not live in the same neighbourhood, we lost sight of each other, and in time we stopped hanging out altogether.
For several years now, Vlado works in my neighbourhood, first in an optics shop and now in a photo laboratory. Although I wear glasses I have never bought or repaired any in his shop, and although I often make photographs, I never developed a film at his place.

While many artists are interested in contesting photography's ability to function as material proof, **Kelly Nipper**'s work suggests that photography operates as a proof itself—a test or sequence of steps or stages used in establishing the validity of a mathematical or philosophical proposition. Her photographs do not function as evidence of a past moment; rather they push photography's capacity to perform, forcing the image to act within a prescribed set of parameters. The result is that the subject of Nipper's photographs may not necessarily be what transpired, but what one experiences while viewing the work. She tests the notion of duration: the act of isolating discrete movements, both physical and temporal, is critical to her inimitable photographic practice.

Core to her projects is the formulation of a hypothesis about a structure or system of meaning. Using the studio as a lab, she often works with professional dancers to stage a series of exercises bearing on the system in question. While the activity unfolds under Nipper's close direction, the constructs she establishes inevitably succumb to happenstance and human error, reflecting the body's idiosyncratic ability to measure time, balance and change. Take, for example, "timing exercises" (2001-2), a series of chromogenic diptychs featuring individuals with their eyes closed alongside a digital clock. Nipper asked her sitters to stop the digital clock when they felt ten minutes had elapsed. The relative nature of time, a fixed universal measure, is exposed through the titles of the works, which tell us how long the person actually kept their eyes closed.

Critics have claimed that the seeming neutrality of Nipper's subjects drains any cultural specificity from her photographs, thus making them purely formal endeavours. While she certainly privileges austere compositions, a precise sense of scale and a limited palette, Nipper's photographs almost always carry very particular modernist cultural markers. Since she received her Masters in Fine Art from Cal Arts, Los Angeles, in 1995, her work has been deeply engaged with 1960s avant-garde art practices, addressing an activated viewer. The formal vocabulary of her videos and photographs is very much in dialogue with the experimental nature of Merce Cunningham's fluidity of movement, Yvonne Rainer's adaptation of pedestrian tasks, Helio Oiticica's suggestion of "free-form space and colour", and Allan Kaprow's prolific instruction pieces of the 1970s, which overtly addressed audience participation as the work itself. Above all, Nipper's use of seemingly generic costumes and geometric dance movements reflects her long-standing interest in modern dance theorists Rudolph Laban and Oskar Schlemmer, who both advanced the notion of dance as marking space. Nipper expands on their ideas through the deliberate installation of her photographs, which she synchronizes with the context of their surrounding architecture, be it in a gallery or the pages of a book. Conceptually charged and rigorous, her installations are often the result of months of research and hours spent in rehearsals and editing sessions. Nipper's photographs enact rather than simply mimic the theories and ideas underlying her work.

Her recent series "Evergreen" (2004)—images featuring a stage technician adjusting a microphone at various intervals in front of a yellowing theatrical curtain—exemplifies Nipper's controlled brilliance. As our attention is focused on the unremarkable technician and the empty stage, the real action takes place outside the frame of the image. In these works Nipper manages to turn photography, one of the most fraught forms of representation, into a phenomenological experience.—Gloria Sutton

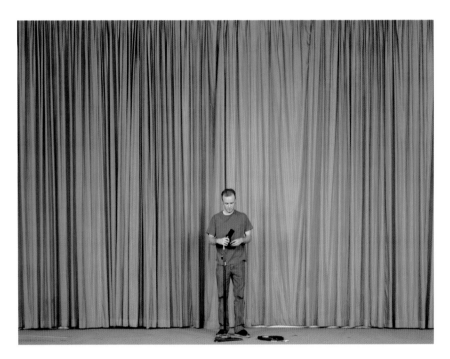

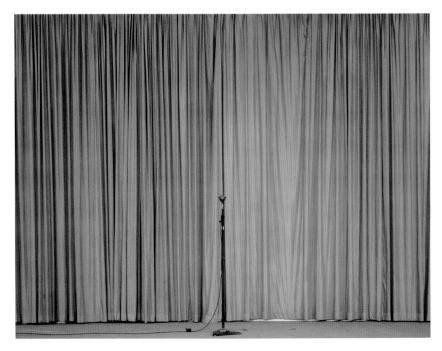

Nils Norman's photographs form an ever-expanding archive of images that document the shifting conditions of urban space. Placing in deadpan relief the proliferation of CCTV cameras, minuscule bus-stop benches and anti-behavioural devices like anti-stick paint and anti-climb surfaces, these often wry and humorous snapshots expose the systems of surveillance, defensive architecture and manipulative street furniture that monitor and control the behaviour of city dwellers. The subtle gestures of everyday life are increasingly subject to instituted manipulations, which discourage certain activities (sitting for extended periods of time, sleeping in public, billposting surfaces) and promote acceptable behaviour (efficient circulation and consumerism). From them, we learn that urban space is conflicted between the forces of private interests, which exert growing control on non-private areas, and those of the public, through which people constitute themselves as civic subjects outside of the logic of market interests. By focusing on major cities in developed countries in the Western world, including London, New York and Berlin, Norman's archive suggests that the privatization and militarization of urban space is a global phenomenon.

In addition to presenting these photographs individually, Norman also digitally integrates them into poster designs, as in *Edible Playscape Bristol* (2001), which contest the power of the property market by pairing documentary images with texts of urban geography critical of gentrification, and includes them in books that incisively analyse urban conditions, as in *The Contemporary Picturesque* (2000). These projects develop an allegorical approach to photography, prefigured in the conceptual work of artists such as Robert Smithson and Dan Graham, whereby single images are dialectically related to their framing conditions, which include other photographs, language (in the form of socio-economic analyses) and the designs of their material support structures that extend the potential for mass distribution (books and posters). Placed within this cross-referential matrix, documentary photography merges with its discursive apparatus, the result of which is an inexhaustible interpretive framework that eschews any claim of aesthetic autonomy or authoritative political doctrine.

Norman's recent book, *An Architecture of Play: A Survey of London's Adventure Playgrounds* (2004), functions as an antidote to his earlier focus on the fortress city. It documents the obsolescence of unique urban areas designed by and for children. Originating in the years following World War II, after the German blitz had reduced whole neighbourhoods of London to rubble, these playscapes were spontaneously constructed from the ruins. Today they figure as remarkable models of childhood creativity unsupervised by adults. The often chaotic arrangements of random pieces of wood and functionless appendages, the hotchpotch use of diverse materials and sometimes threatening or dangerous designs all testify to a remarkable aesthetic of bricolage, one that starkly contrasts with the eminently safe, lawsuit-proofed and controlled environments of today's playgrounds. By documenting these quickly disappearing ludic architectures, Norman protects them from historical destruction. In his archive, they exist as the ruins of the democratic and non-commercial creation of public space that might someday be recovered.—TJ Demos

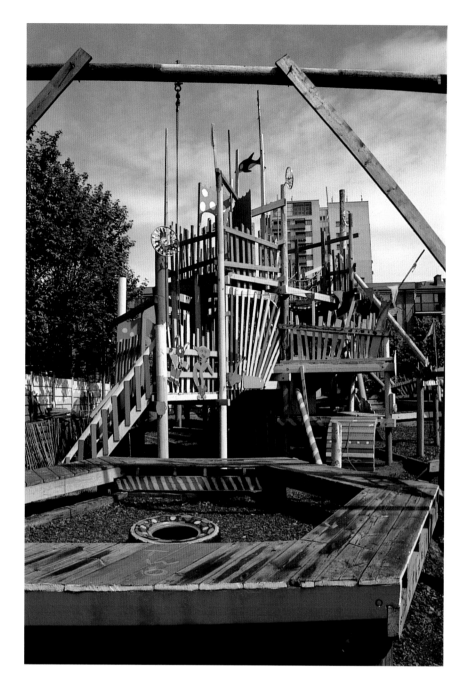

With her emergence in the early 1990s, **Catherine Opie** was immediately acknowledged as a significant, if controversial, figure in contemporary photography. Opie is probably best known for her 1993-7 series of "Portraits": these forthright photographs of individuals and couples from queer, S/M and other communities—including several notorious self-portraits —gave new visibility to marginalized subcultures and helped define a charged current of "identity politics" in art. Opie positioned her compelling subjects, often heavily pierced and tattooed, against lush monochromatic backdrops in jewel colours of emerald, ruby and topaz. The power of the "Portraits" still resides in the categorical instability of sexual signifiers, with Opie's highly aesthetic presentation of her subjects aggressively pushing photographic indexicality to the threshold of the imaginary.

Over the past decade, Opie has explored the range of the medium and its often tenuous claims on documentary factuality. In many ways, the German photographer August Sander—who shifted from empathetic *Volk* portraits to the landscape genre—provides a precursory model for Opie, who has repeatedly revealed her willingness to change course, take on new subject matter and complicate the thematic tidiness of her own project by broadening her sights (and sites) of investigation. Turning to the landscape of her native Los Angeles, Opie created the "Freeway" series (1994-5)—black-and-white panoramas emphasizing the sculptural elegance of the urban forms—as well as a series documenting urban mini-malls and a quietly creepy series presenting façades (and ubiquitous security gates) of private houses in Beverly Hills and Bel Air. These series evidence a local kinship with Ed Ruscha's gas stations, swimming pools and parking lots, but Opie subverts the inert factuality of Ruscha's photographs by allowing a noir-like mood to enter the frame, subtly acknowledging the pervasive shadow of Hollywood in her photographic work.

If one thread ties together Opie's cumulative body of work it is interdependence: emblematized in the elegant convergence of colossal architectural forms in the "Freeway" series, implied in portraits of sadomasochistic couples who develop complex relationships built upon trust, and even suggested in the precarious relationship of surfer, board and ocean wave in her 2003 "Surfers" and "Surfer Portraits". Opie has recently undertaken a large portrait series of "Children". In fact, this series began—and abruptly paused—in 1995 with *Jesse*, a striking photograph of a shirtless girl head tilted, her bright blue eyes looking directly into the camera. Jesse's long hair is stuffed imperfectly into a backwards baseball cap; her dark, full, "adult" eyebrows converge above her nose; a thin necklace delicately circles her neck. In the light of Opie's early body of mature work, it is impossible not to read this photograph as a catalogue of conflicting signs: "masculine" and "feminine", instability both natured and nurtured. Resuming the series a decade later, the "Children" are photographed in front of richly hued backdrops that specifically recall her earlier "Portraits". As a new mother, Opie's recent *Self Portrait/Nursing* (2004) finds the artist returning full circle. While seemingly less confrontational than earlier self-portraits, the photograph is nevertheless revealing—implicating Opie in a new relationship of trust and interdependence.—Michael Ned Holte

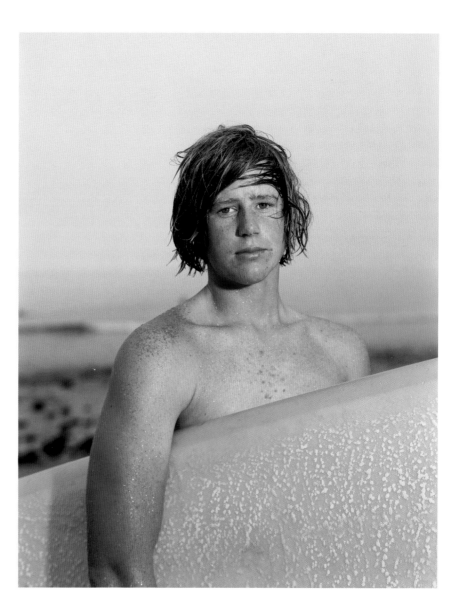

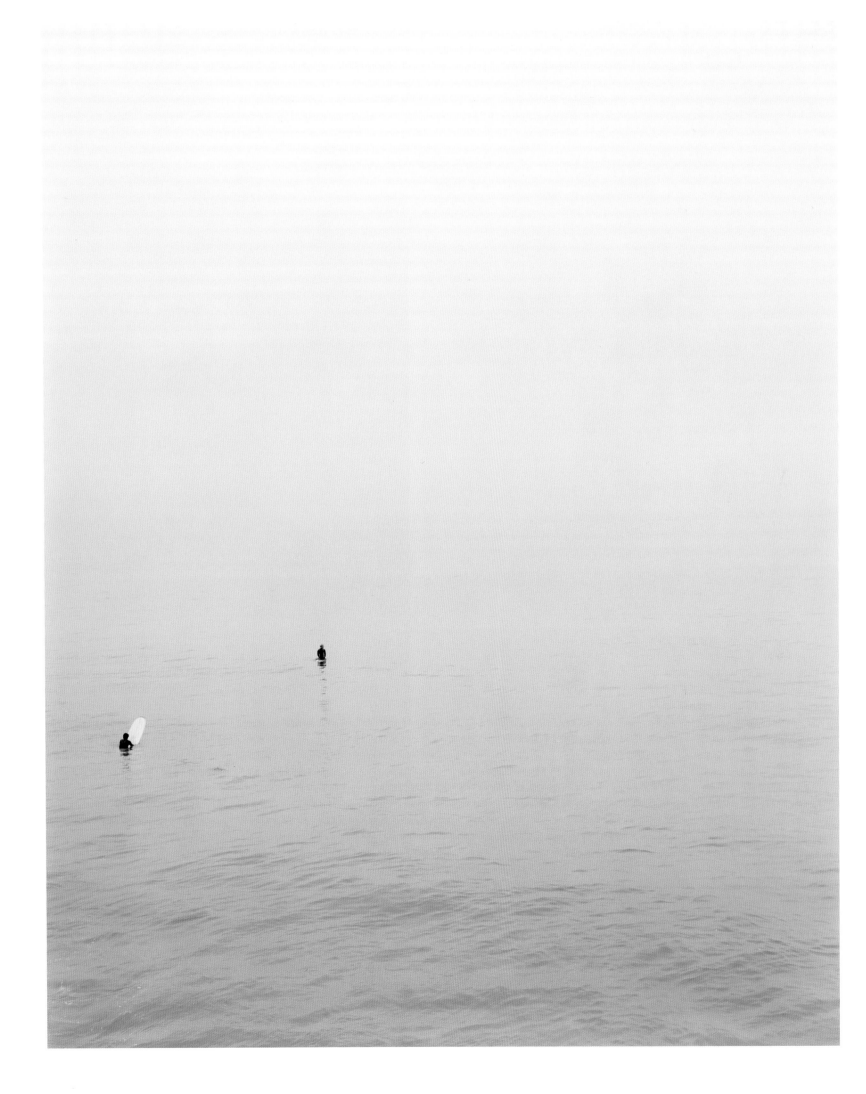

[3] [4] [5]

[3] **Jesse**, from the series **"Children"**, 1995, C-print, 50.8 x 40.6 cm, 20 x 16 inches
[4] **Petey**, from the series **"Children"**, 2004, C-print, 50.8 x 40.6 cm, 20 x 16 inches
[5] **Self Portrait/Nursing**, 2004, C-print, 101.6 x 81.3 cm, 40 x 32 inches

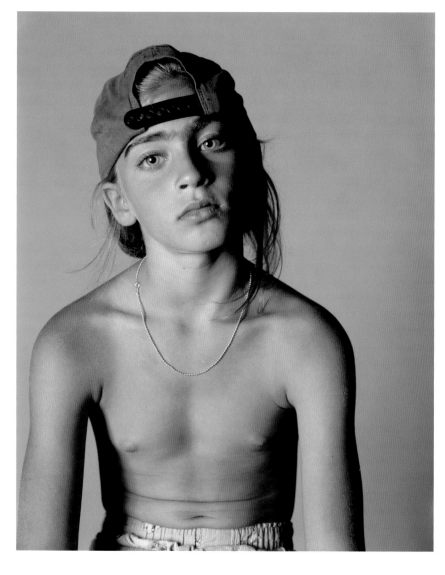

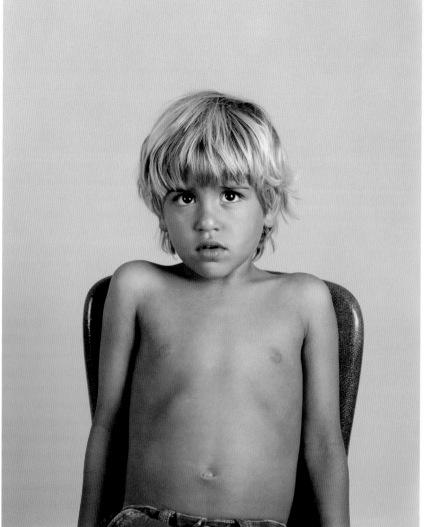

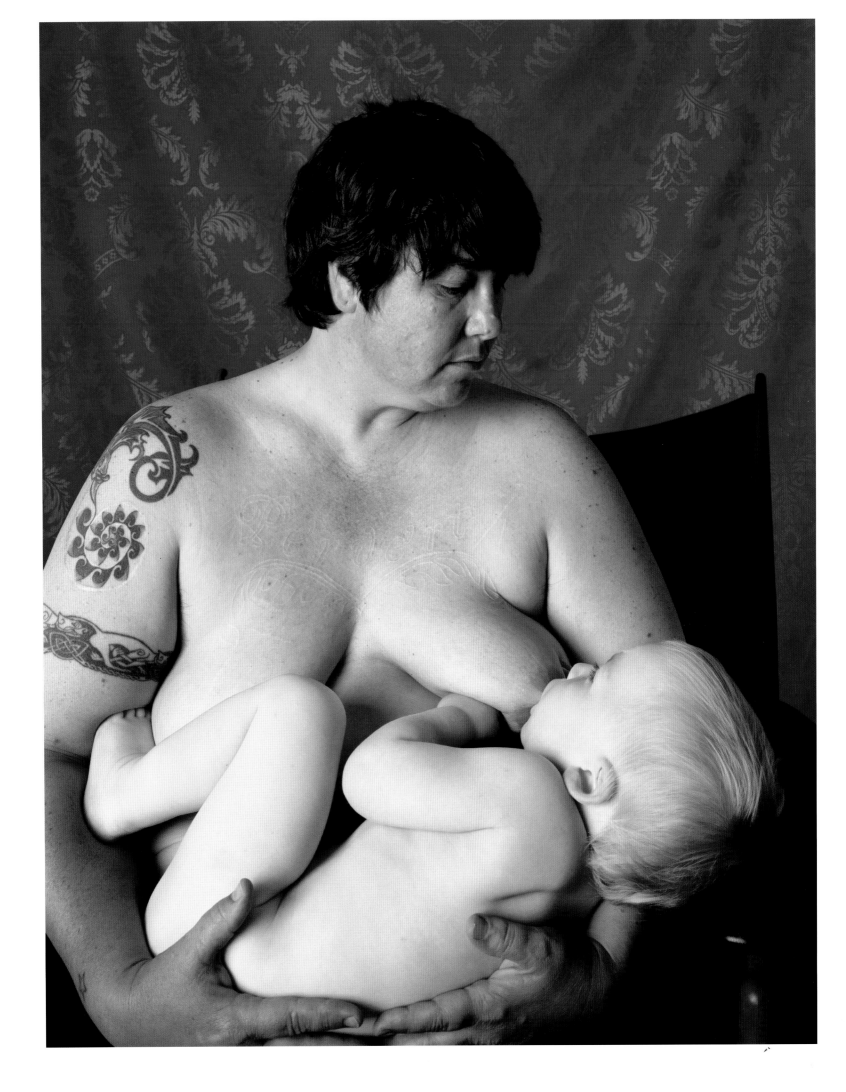

Surpassing mere glossy seduction, **Esteban Pastorino Díaz** explores the fundamentals of how photographic images are produced: the far-reaching metaphors and meanings embedded in the process of creation itself. His photographs are the outcome of an ongoing experimentation with image-making processes and their relation to depicted reality. Through mechanical camera modifications and other tricks, he unfurls new possibilities for photography, which in turn reveal unusual approaches to viewing and comprehending the world.

For each series Pastorino Díaz designs a precise photographic device. He gained recognition following a series of elongated urban landscapes created with a camera adapted to expose the whole film continuously in each shot. The camera was attached to a car driven by the artist, so he could neither frame nor compose the final images. The photographs were in fact produced by the device itself; the artist was involved only at the very end of the process. Movement and time are imprinted on these pictures as much as people, buildings and objects. Defying central perspective, they develop the "decisive moment"—the core of photographic practice according to Henri Cartier-Bresson —on to space, transforming time into a linear succession of entrapped moments. Sometimes movement acquires a physical presence, as in *Marathon* (2004), where the runners' feet leave their trails imprinted on the photograph, reminiscent of Étienne-Jules Marey's chronophotographs and futuristic paintings. Sometimes movement dissolves the figures, turning them into a dizzy presence or a passing ghost. At other times the objects appear curiously sharp and defined, creating a conflict between the whole and its parts: focusing on details erases a sense of the whole picture, while heeding the complete image forces its components to dissolve. In any case, the city becomes like a river, everything fluid within it. Not surprisingly Venice plays a part in this series.

More recently Pastorino Díaz has been working on aerial photographs taken by a remote-controlled camera mounted on a kite. Again, chance is a key feature in this series: the artist can see the images only after the film is developed, so his control is reduced to the final selection of the prints. Even when he manages to capture the decisive moment, no subjectivity, no personal view is imposed on the pictures; instead the gaze is that of a distant camera, modelled by the soft edges of the lens. The photographs show suburban areas from a low altitude, at just the point where things begin to look unreal. Cars, planes and boats seem like toys, houses like pieces of an architectural model. The selection of particularly ordered places and the frequent absence of people reinforce this impression. Even when the pictures have been taken in motion, everything is perfectly quiet, as if stillness and solitude were attributes of these places—no doubt a camera effect, but, in the realm of photography, what is reality other than a camera effect?
—Rodrigo Alonso

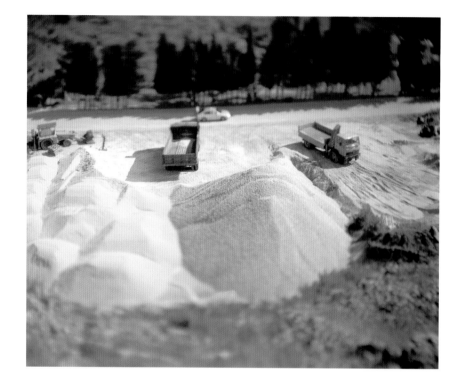

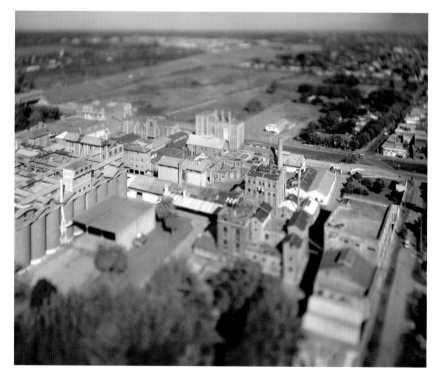

[1] **Camiones en cantera. Skopelos. Greece**, 2002, C-print, Kodak Portra 160 VC 4 x 5,
97.5 x 117.5 cm, 38.5 x 46.5 inches

[2] **Malteria Hudson**, 2003, C-print, Kodak Portra 160 VC 4 x 5, 97.5 x 117.5 cm, 38.5 x 46.5 inches,
collection Museum of Modern Art, Buenos Aires

[3] **Maquinaria vial. Piriapolis**, 2004, C-print, Kodak Portra 160 VC 4 x 5, 97.5 x 117.5 cm, 38.5 x 46.5 inches

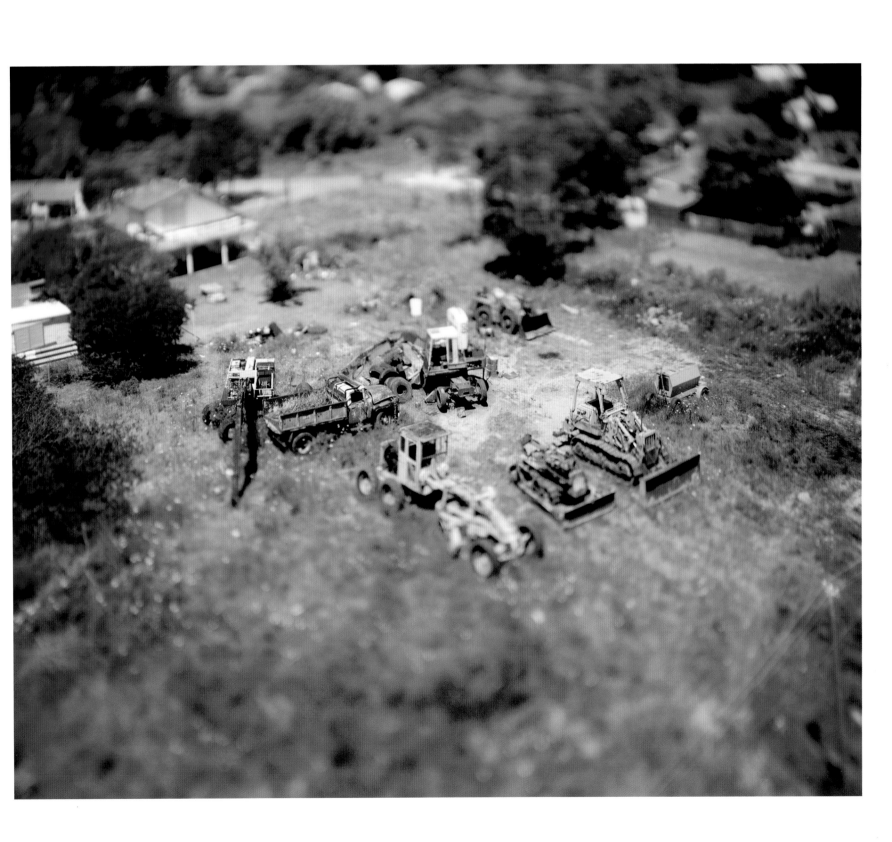

Esteban
Pastorino
Díaz

[4]
[5]
[6]
[7]

[4] **Marathon** (detail), 2004, Stereophotograph in lightbox, Fuji RVP220, 5.7 x 160 cm, 2 x 63 inches
[5] **Taxi 147**, 2005, Stereophotograph in lightbox, Fuji RVP120, 5.7 x 78.7 cm, 2 x 31 inches
[6] **Shinjuku #1** (detail), 2005, Stereophotograph in lightbox, Fuji RVP220, 5.7 x 160 cm, 2 x 63 inches
[7] **Shinjuku #1** (detail), 2005, Stereophotograph in lightbox, Fuji RVP220, 5.7 x 160 cm, 2 x 63 inches

[1] **Four Horsemen of the Apocalypse (17)**, from the series **"Four Horsemen of the Apocalypse"**, 2004, Fugiflex digital C-print, 152.4 x 121.9 cm, 60 x 48 inches

[2] **Four Horsemen of the Apocalypse (8)**, from the series **"Four Horsemen of the Apocalypse"**, 2005, Fugiflex digital C-print, 152.4 x 121.9 cm, 60 x 48 inches

The highly nuanced video and photographic work of **Paul Pfeiffer** gives credence to Lev Manovich's assessment in *The Language of New Media* (2000) that at the end of the twentieth century the problem was no longer how to create new media objects such as an image, but how to find an object that already exists. Pfeiffer's medium is thus the act of filtering. His work often begins with locating and sifting through thousands of images that circulate via television, magazines, film, the web and other forms of popular media. As he describes in a recent interview, "It's like a manual database search in which I'm looking for the one-in-a-thousand image that fulfils a number of criteria—specifically, the rare instance where a central figure's face is hidden by an arm, a flare from a light. It's pretty intuitive ... and tedious. I usually know I have found something when I retain a memory of the image long after I've looked at it."

The source images Pfeiffer selected for his ongoing series of photographic works, collectively titled "Four Horsemen of the Apocalypse" (begun 2000), derive from seemingly disparate worlds: online archival footage from the National Basketball Association and studio portraits of Marilyn Monroe. Through a process of digital erasure and what he describes as camouflaging, Pfeiffer offers a poignant meditation on race, religion and disappearance, underscoring the implicit role that spectators play in the production of spectacle. The photographs measure almost 122 x 150 cm (48 x 60 inches), transferring the figures from the intimate, domestic space of the television or computer screen to a public, devotional scale—another reference to the almost religious spectacle of professional sports.

The dramatic title of the series follows Pfeiffer's habit of invoking both biblical and art-historical works and specifically recalls Albrecht Dürer's fifteenth-century woodcut personifying Death, Famine, War and Pestilence. But for Pfeiffer, Dürer's role as an innovator of figural representation is the draw. Pfeiffer's appropriation and subsequent erasure of found imagery in "The Four Horsemen of the Apocalypse" pressures the formal conventions of the figure study and at the same time suggests a catastrophic or violent end for figural representation. By shifting the focus to the process of erasure and camouflaging, Pfeiffer's digitally edited photographs can be read not just in technologically determinist terms, but as discursive objects that have the potential to address a different type of collective audience, located somewhere between the singular, modernist viewing subject associated with photography, and the atomized, mass audience of television.—Gloria Sutton

[3] [4]

[3] **Four Horsemen of The Apocalypse (2)**, from the series **"Four Horsemen of the Apocalypse"**, 2000,
Fugiflex digital C-print, 152.4 x 121.9 cm, 60 x 48 inches
[4] **Four Horsemen of The Apocalypse (3)**, from the series **"Four Horsemen of the Apocalypse"**, 2000,
Fugiflex digital C-print, 152.4 x 121.9 cm, 60 x 48 inches

[1] **Artillery**, from the series **"Explosion"**, 2005, C-print, 125cm x 125 cm, 49 x 49 inches

[2] **Shellburst Day**, from the series **"Explosion"**, 2005, C-print, 82 x 188 cm, 32 x 73.5 inches

[3] **Napalm**, from the series **"Explosion"**, 2005, C-print, 82 x 188 cm, 32 x 73.5 inches

Despite the weathered brick façades, boarded-up windows, charred gates and graphically unglamorous signage, the depressed urban streets in UK artist **Sarah Pickering**'s "Public Order" (2002-4) series are not suffering from neglect. Instead, they are serving the purpose for which they were built. Though they resemble a host of rough streets in the UK or US, these alleys, high streets and housing areas were actually designed by the Metropolitan Police Public Order Training Centre as facsimiles of riot-prone areas to be trashed and burnt in training squad simulations. Every day, bricks are thrown and fires lit on these sets, as future riot police assemble on them to learn how to protect effectively the placid breeze-block buildings and their imaginary inhabitants. For Pickering, the physical damage done to them is less intriguing than the symbolic information that is required to transform an artificial setting into a viable simulacrum of a vulnerable urban area.

When designing the expendable streets, the Public Order architects consider the infrastructure of areas previously destroyed by riots and seek to predict the appearance of areas where disturbances might occur in the future. In an attempt to avoid provocative assumptions, however, all the signs on the imaginary streets are ethnically neutral and surfaces are unmarked by any graffiti or distinctive details. Pickering began photographing these purpose-built training environments for her Masters in Photography thesis at the Royal College of Art. As she notes, the point of the sets is to provide the most basic three-dimensional sketch possible, not to replicate reality in any full-blooded filmic sense. Yet the tension between fantasy and reality is central to her purpose. "My work" says Pickering, "explores the idea of imagined threat and response, and looks at fear and planning for the unexpected, merging fact and fiction, fantasy and reality."

Pickering is currently photographing controlled military explosions. Like the "Public Order" sets, many of these blasts are located in isolated areas and form part of training exercises for soldiers and the emergency services. Some explosions are set off in a rocky field dotted with random clapboard structures, such as a triangular house and a tiny church, and are sprinkled with healthy-looking evergreen trees. Pickering recognizes the need for these realistic, yet safely maintained, tests in an era when soldiers are reared on hyperreal video games and intense fictions. Pickering explains, "I am interested in identifying where exactly our imaginative references lie. Witnesses to extreme events describe to news reporters that what they saw was 'like a film', documentaries often use reconstruction to help illustrate the reality of their subject, and a new breed of infotainment programs use CGI and special effects to reveal to the viewer an imminent disaster." The explosions have to compete with soldiers' media-made images in order to rouse them into taking the appropriate action. While the clouds of napalm and Electric Thunderflash exploding on a grey English day may appear festive and playful in her large-scale prints, the "Explosion" series, Pickering explains, "further develops this investigation into the crux of reality and its simulation".—Ana Finel Honigman

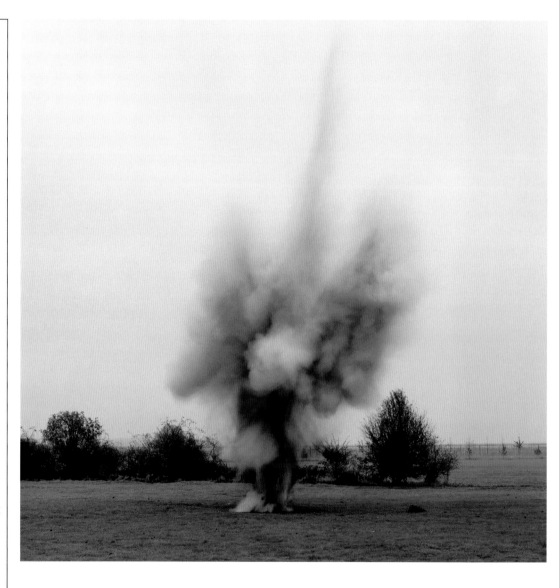

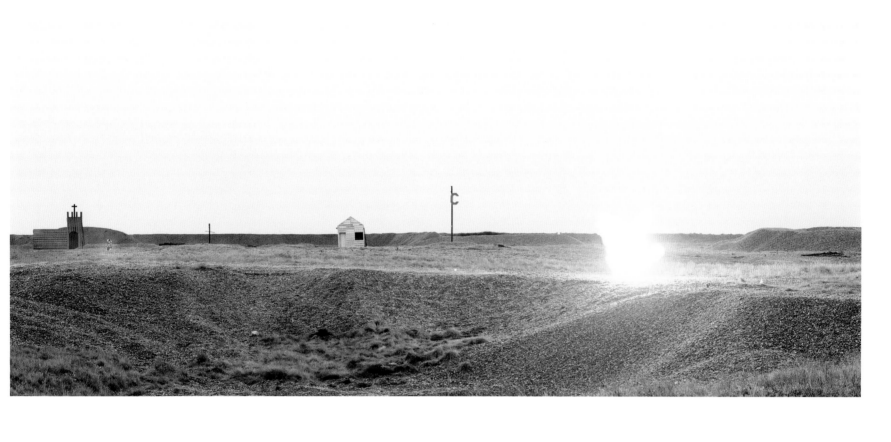
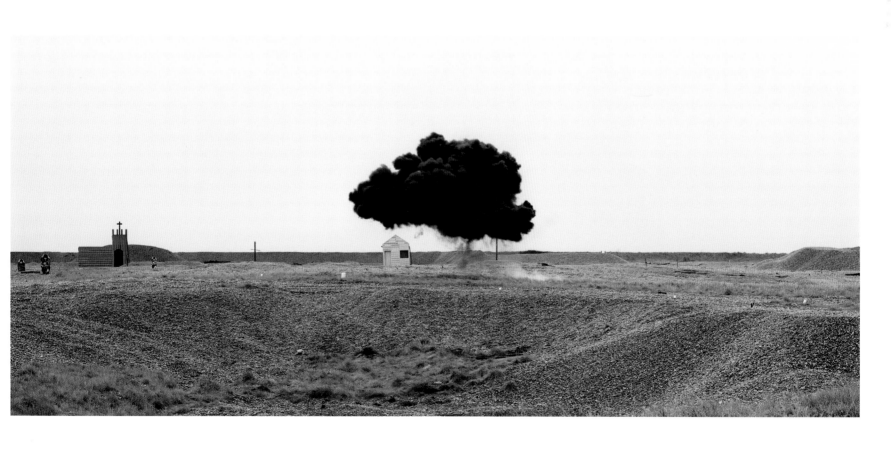

Sarah Pickering

[4] [5]

[4] **Farrance Street**, from the series **"Public Order"**, 2004, C-print, 76.2 x 101.6 cm, 30 x 40 inches
[5] **Semi-Detached**, from the series **"Public Order"**, 2004, C-print, 76.2 x 101.6 cm, 30 x 40 inches

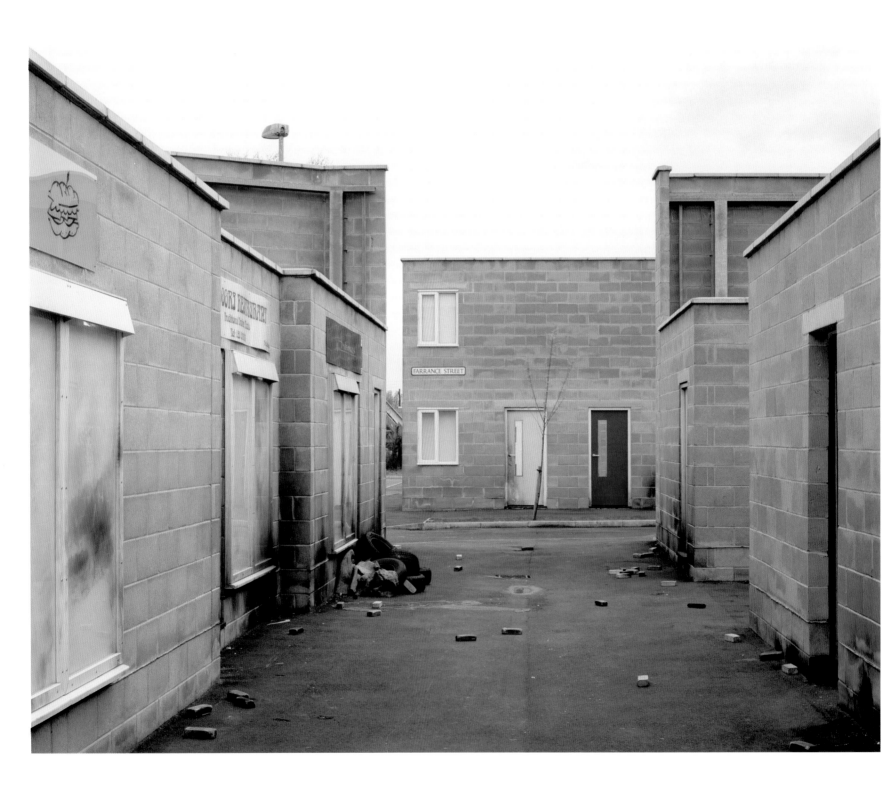

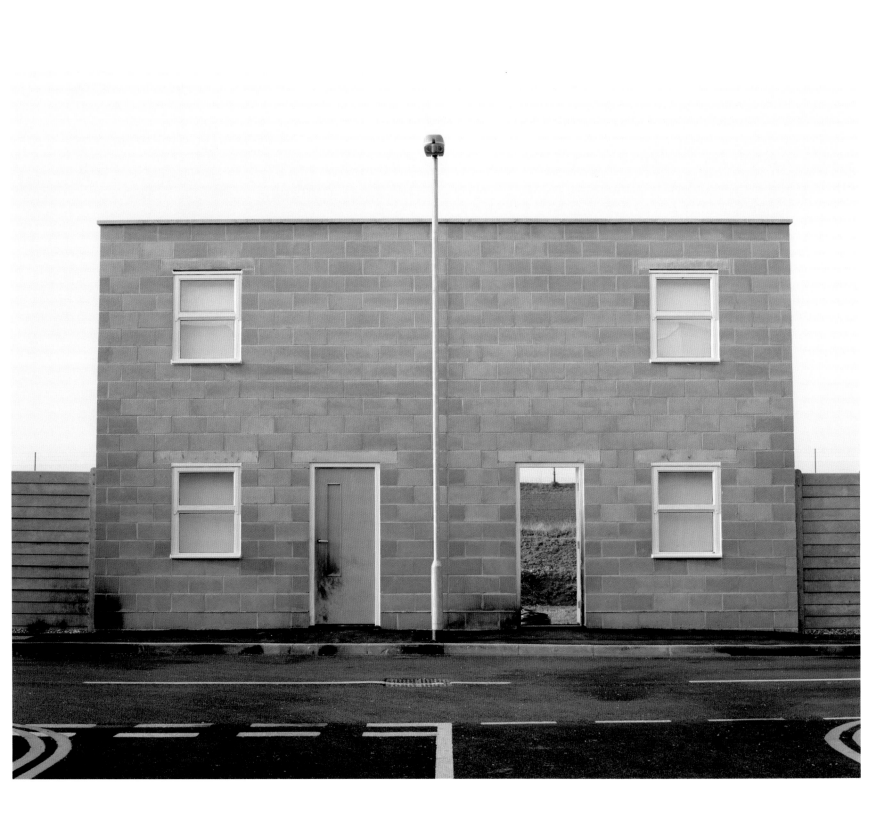

Peter Piller performs the role of photographer, collector and archivist—occupations that, according to Walker Evans, constitute "almost the same thing". Using serial images to document and catalogue aspects of the built environment and the everyday, Piller comes from a lineage that includes Evans himself, Dan Graham, and Bernd and Hilla Becher. But equally he responds to a class of anonymous commercial photographers who, as an unintended by-product, often produce a photographic record of their times. Piller draws directly from this source, culling images from the archives of local newspapers and from the thousands of negatives produced and stored by now defunct businesses. Using these as the material basis for his practice, he manages to reconnect the relatively minor category of art photography to the much broader one of photography in general.

Piller's appropriation is not intended as a celebration of this genre but neither is it a critique. Instead, the artist is interested in the way that images are constantly available to new interpretations according to the context in which they are shown—a characteristic that reveals both the essential ambiguity of the photographic record as well as its potential. While Bernd and Hilla Becher pursue the remnants of an industrial age as it slips into the past, Piller ploughs the furrows of a more recent history, and in particular the banality of suburban life and its ragged fringes. An example of this is "Forsythia Blossoms" (1994), a set of pictures that in this instance were taken by the artist himself, in which forsythia bushes are shown flourishing along the neglected margins of the city—beside rubbish bins, between slabs of broken concrete, in muddy puddles and among discarded clothing.

The images that Piller collects are equally marginal, having lost their function as well as current meaning. Piller sorts and catalogues these into new configurations, sometimes using stock categories to define the set, but often using deliberately absurd and seemingly random ones. The titles that he gives these new arrangements include "Sites of Crime", "Suspects", "Pointing at Plains", "People Touching Cars", "Local Glow" and "Looking into Holes". A set of photographs called "Tongues" (shown at the Museum für Gegenwartskunst, Siegen, Germany in 2004) features aerial views of almost identical houses, each with a bright red sheet or mattress hanging from the window. These images were originally produced by commercial companies who flew over the suburbs and took photographs of people's houses to try and sell to their owners. The red textile must have appeared in only a small percentage of these images, an irrelevant detail unnoticed by the company and its clients. But by singling it out for special attention, Piller makes the red dot the organizing principle, allowing it to punctuate and colour-code the green, brown and grey of suburbia and fly like a host of revolutionary flags visible from the air.—Grant Watson

[1] From the series **"Looking into Holes"**, 2000-5, inkjet prints, width 37 cm, 14.5 inches,
height variable

[2] From the series **"Tongues"**, 2002-4, C-print, 25 x 25 cm, 9.8 x 9.8 inches

According to Roland Barthes, the adherence of photography to its referent renders it invisible: "Whatever it gives to be seen and in whichever way this is done," he states in *Camera Lucida*, "a photograph is always invisible: it is not the photograph that we see."

The core component of **Rosângela Rennó**'s work is making photography itself visible: as material reality, as a system of representation, as a support for collective memory, as a power device. Sometimes she does this by giving a *body* to the images, printing them on unusual supports—metal, vinyl, smoke—or highlighting the different ways in which they circulate within the social weave—albums, frames, films, IDs, slides. At times she addresses the viewers' bodies and perceptions by making images opaque or difficult to see through colourization, reduction of contrasts, fragmentation or resizing. On other occasions, she focuses on classification and description systems, narrative procedures, archiving and coding, as a way to explore the use of images in information-based societies. Finally, she inquires into the political employ of photographs, unveiling strategies of control, discipline and identity construction.

Most of Rennó's works are based on appropriation. Rather than producing images herself, she prefers to analyse and rearticulate large bodies of photographs, usually from archives, second-hand stores and the media—photographs not meant to be viewed as art and generally considered as valueless. In the process of selection, arrangement and exhibition, the artist exposes the ways in which images depend on complex interpretation techniques and precise politics of vision rather than inherent historical meanings.

In her work the past is not so much a temporal fact as a cultural one; an old photograph may embody a present conflict and show it in a new light. Referential information is often surpassed by connotation and metaphor. In "Série Vermelha [Militares] (Red Series [Soldiers])" (2000-3), the artist reproduces red-coloured photographs of men in military uniforms, from real soldiers to children playing at being soldiers. The images have unambiguous roots in Brazilian history, in the military dictatorship that ruled the country from 1964 to 1985, even when the soldiers depicted are not actually of that time. Rennó resorts here to the social impact of these images and to collective memory to find a context for her artistic practice. The colour and low contrast of the pictures make them both imperceptible and latent. These effects defy the omnipotence of conventional military images, but at times the soldiers still pose a threatening presence behind the chromatic surface.

Nevertheless, the images have an evanescent quality; they look precarious. Rennó's photographs are both strong and fragile. Their fragility stands for their lack of adherence to a world founded on the permanent replacement of easy-to-consume images, on historical indifference and on the politics of oblivion. Their strength comes from the artistic practice itself, from Rennó's insistence on recovering the material, iconic, indexical, symbolic and political basis of photography. After all, a photograph is not mere reality; a photograph is a photograph.—Rodrigo Alonso

[1] **Experiência de Cinema (experiencing cinema)**, 2004, 21 minutes of image projection on intermittent smoke curtain, in loop, dimensions variable,
collection Tate Modern, London, Fundação Sorigue, Lleida, Museo de Arte Contemporáneo de Castilla y León, Léon, Culturgest, Lisbon

[2-5] **Untitled (castle king), Untitled (old nazi), Untitled (school boy), Untitled (shy man)**, from the series **"Série Vermelha [Militares] (Red Series [Soldiers])"**, 2000-3, digital lightjet print on
Fuji Crystal Archive Paper, 180 x 100 cm, 70 x 39 inches, collection Stedelijk Museum voor Actuele Kunst, Gent, Museu de Arte da Pampulha, Belo Horizonte

[6] **Gonzaga (foto João Castilho)**, from the series **"Body of Soul"**, 2003-5, engraving on stainless steel, 160 x 110 x 5.5 cm, 62.5 x 43 x 2 inches

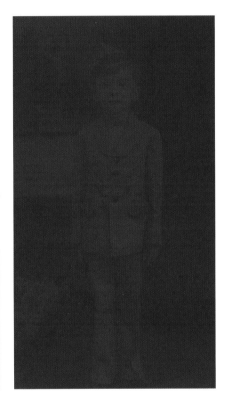

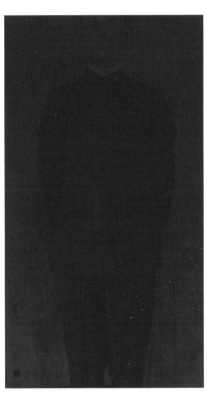

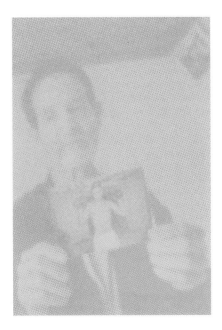

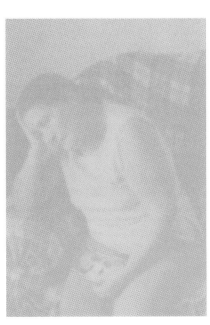

[1] **Carpet**, 2004, black-and-white silver print, 125 x 200 cm, 49 x 78 inches

[2] **Pyramid**, 2004, black-and-white silver print, 132 x 198 cm, 51.5 x 77 inches

[3] **#8**, from the series "**Empossamento [Inauguration]**", 2003, black-and-white silver print, 121 x 175 cm, 47 x 68.5 inches

[4] **#2**, from the series "**Empossamento [Inauguration]**", 2003, black-and-white silver print, 117 x 175 cm, 45.5 x 68.5 inches

Mauro Restiffe's work hovers ambiguously between the tradition of the photographic document and the aesthetically driven image. At times it appears that the photographer may even have set out intentionally to record or make manifest a particular time, place or moment, but despite his best intentions to capture something of this, a quite different impulse takes over. Take, for example, his series of photographs of the governmental capital Brasilia, taken on the Inauguration Day of Brazilian President Lula on January 1, 2003. This series, titled "Empossamento [Inauguration]", contains numerous ambiguities. The black-and-white film typically used by Restiffe immediately imbues the work with historical value—it is unclear if what we see, despite the date of the image itself, was taken three, ten or even forty years ago, due also to the manner in which the artist has avoided including any details of contemporary life— clothing, advertisements, ephemera and even posture are obscured. The wide angle and distant perspective echo the type of photography associated with various well-documented and familiar historical events, such as the political parades and demonstrations that took place in the United States, and Washington DC in particular, during the 1960s. Undoubtedly the striking backdrop of the architecture of Brasilia plays no small part in this impression of historical specificity; the familiar modernist buildings have become something akin to a film set in Restiffe's scenes of mass populist activity. One is left doubting whether what we see is in fact a series of stills from the set of a historical reconstruction.

The conceptual or analytical approach of Restiffe's photographic project only becomes apparent, however, when one compares these images to another architecture-orientated series. Photographing the equally striking urban environment of Istanbul, Restiffe uses a different approach. Though still characterized by subtle black-and-white tones, these images reflect the cramped, dense environment of the city through closely cropped images focusing both on the unexpected found sculpture of the street, and the characteristic densely patterned environment of Islamic architecture and design. In *Pyramid* (2004), for example, the artist isolates the narrow end of a residential building that sits at the corner of one of the city's steep and narrow streets. Starkly lit by unforgiving street light, the building's ornate façade is disrupted by the apparently random placement of a functionally modern window. The title of the image points to the pyramidal structure of the small flight of stairs, again an entirely use-orientated design but one that contains the abstract appeal of found sculptural form. Firmly placing the image in the present day, Restiffe has included a purposefully striding figure, a passer-by who conveys the ordinariness of this Istanbul street scene. Another image from this series, *Carpet* (2004), unexpectedly resonates with "Empossamento". The endlessly repeated pattern of the eastern design distinctly recalls the modernist façades of the buildings of Brasilia. Once again, the complex layers of Restiffe's work become apparent.—Jens Hoffmann

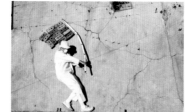
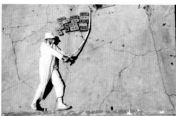

Primarily engaged with the incorporation of performance principles into photography, as well as film and video, **Robin Rhode** has consistently relied on his own familiarity with the rough, segregated neighbourhoods of Cape Town and Johannesburg where he grew up to address political aspects of the troubled South African landscape. Presented sequentially in storyboard format, his photographs record situations in which the artist interacts with a set of objects that he has rudimentarily drawn, erased and redrawn in black charcoal or white chalk on the dilapidated concrete pavements and walls of his native country, or of anonymous urban locales. While the idea of constructing a narrative by simultaneously sketching and effacing a single drawing recalls the work of William Kentridge, Rhode singles out as his inspiration a classic high school initiation rite he has experienced—the practice whereby freshmen are taken into the toilets and asked to draw a series of objects on the walls, such as a bicycle, a skateboard or a candle. They are then forced to interact with the objects by riding the bike, performing a jump on the board or blowing out the candle.

In an early performance titled *Park Bench* (2000), Rhode, clad in dark hoodlum-like clothes, outlines in charcoal a precariously angled bench on the white façade of the House of Parliament in Cape Town. He then tries, unsuccessfully, to take a seat. With a gesture of the utmost simplicity, he exposes his country's apartheid past, in which not long ago public benches were labelled "coloured". In *Untitled, Dream Houses* (2005), comprising a sequence of twenty-eight colour photographs, Rhode mimics the act of struggling to catch a television set, a table, a chair and a car, which have been thrown at him from above. In reality, these items are drawn in cartoonish lines on an exterior wall. Referencing the New Year custom of tossing out old objects, the artist identifies society's two opposing poles: consumerism and dispossession. And, in *Stone Flag* (2004), one of his most resonant photographic works, Rhode strides towards the barricades, wielding a sculptural flag made of red-clay bricks, bending it into the wind in an ode to his nation's newly found democratic identity. Shot from a single viewpoint above in simulated stop-action, the sequence of pictures visually recalls Eadweard Muybridge's motion studies of the late nineteenth century. In political sensibility, however, it is closely related to David Hammons's *African-American Flag* (1990), a work in which Black Liberation concepts mesh with American ideals to re-empower through subterfuge a culture traumatized by colonial repression. The starkly white boiler suit Rhode wears in *Stone Flag* was initially designed for a 2001 dance show in collaboration with the rap group *Black Noise*, in which performers threw handfuls of charcoal dust on the floor, slowly becoming smeared with dust themselves. Significantly, Rhode's outfit relates upscale sports such as cricket or tennis to an economy of difference. Drawing on the subcultural codes of urban youth culture, from hip-hop to graffiti and from fashion to sports, *Stone Flag* is a meditation on the nature of national representation, which also extends into questions of personal identity. In all his photographs, Rhode documents a broad spectrum of symbolic and concrete actions, which can be understood as gestures of direct political licence and dissent.
—Roxana Marcoci

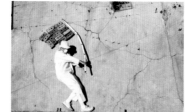
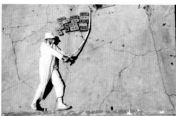
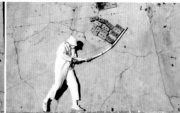
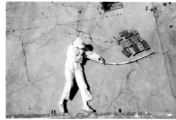
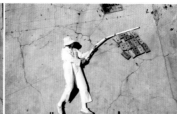
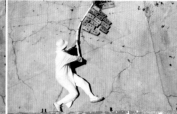
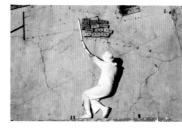
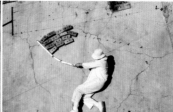

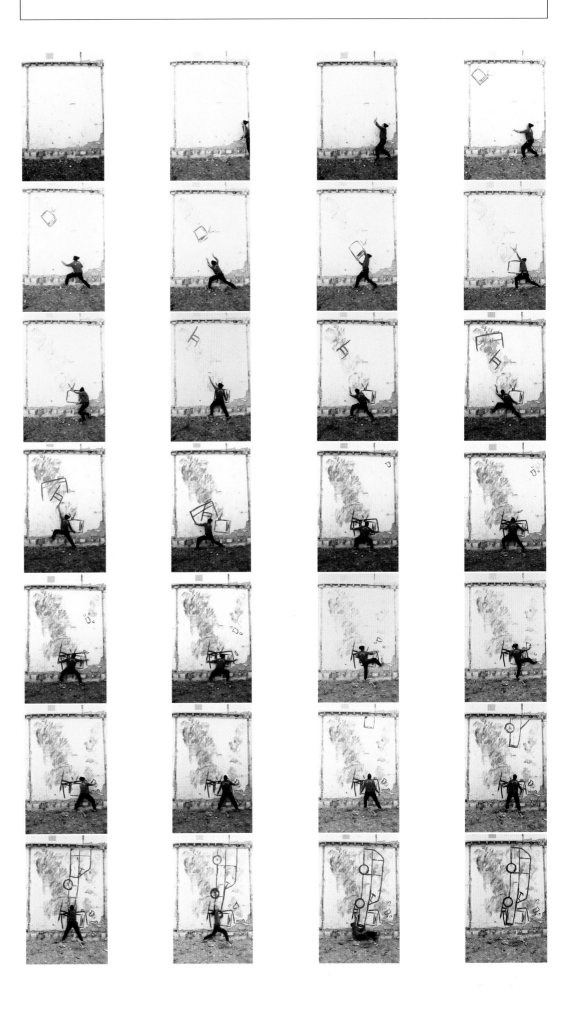

The word "photography" means something like "writing with light," but **Sophy Rickett** often seems preoccupied with something quite the opposite, more like what art historian Victor Stoichita once called "skiagraphy"—writing with shadows. In the most extreme of Rickett's images, particularly those in black and white, it's as if a minimal quantity of light has slowly, against some sort of resistance, seeped into them—just the least amount that could possibly allow the surface of the photograph to register the presence of an image at all. And just as one feels that the image has formed itself only gradually, the viewer needs a certain amount of time to take it in, to let the nocturnal landscape or empty studio become clear, like the underlying cruciform structures of Ad Reinhardt's black paintings. In contradiction to our predisposition to think of the photograph as instantaneous —in French the word for snapshot is instantané—Rickett's pictures ask us to slow down, to hesitate, to wait and see. And one does, eventually, see something. Usually, something utterly mundane. Disappointing? No, never, because the quality of demand elicited by this slow and attentive looking that Rickett has cultivated in us reveals the enigmatic character that always persists secreted in the mundane. If one makes out a tiny, distant figure in the light of the horizon, the gaze itself lights up with a voyeur's curiosity or the fascination of a private eye who's become obsessed by the person he's been hired to tail: instead of film noir, call it image noir.

In Rickett's colour pictures, darkness still dominates but light gets turned up a few notches to flare up in artificial glory, with poisonous greens and sulphurous, Mephistophelean yellows. Here, the artist reveals herself as a sensualist. Darkness itself unveils its nuances, its strange hollows and depths, while the landscape it encloses takes on an eerie, spectral brightness that reveals nothing— but ravishingly.

Like many photographers today, in the wake of artists like Jeff Wall who pioneered the contemporary type of gallery-orientated photography scaled to the body in contrast to the classic photographic print intimately scaled to the hand and head, Rickett conceives her photographs specifically for the wall. Particularly in her works comprising multiple panels, she provides for the possibility of various, possibly contradictory viewpoints, so that a kind of active viewership is called for. In tension with the slow, determined looking evoked by the individual image's obscurity, the relation between them provokes mobile scanning. "I'd like to encourage the viewer to track, to use a filmmaker's terminology, rather than pan," Rickett has said, "to move along the picture rather than stand away and survey it from a fixed point"—citing Chinese scrolls in which the lack of any fixed vanishing point frees the viewer from any determinate location. In Rickett's hands, this creates a sort of voluptuous uneasiness: ordinary looking turns into a wary sort of watching, interminable and seductive.
—Barry Schwabsky

[1]

In the early 1990s, when the so-called "economic bubble" in Japan burst, Japanese society experienced a curious phenomenon: girls in their late teens or early twenties began to equip themselves with small cameras and take snapshots of everyday life. Some of them won prizes and eventually became professional photographers. Although **Noguchi Rika** made her photographic debut around the same time, and received several awards, she distinguishes herself significantly from other Japanese female photographers of her time and generation.

Noguchi's photographs show a wide variety of subject matter, from divers to vast landfills, climbers on Mount Fuji to a rocket-launching base. One can't really call any of these everyday scenarios; these places are remote—in both a physical and emotional sense—from the city where the artist is based. She takes time when tackling her subjects, approaching them as affairs of her own daily life rather than turning familiar scenes into photographic subjects.

While Noguchi reportedly loved novels and movies when she was a young girl, her interest as a photographer is not so much literary or cinematic, but rather scientific in nature. She has tried diving, climbed Japan's highest mountain and witnessed a number of rocket launches—all to reduce the distance between herself and her subjects. Fieldwork and research, certainly, but perhaps even more important than that, these are ways to internalize, through taking pictures, the dialogue with her photographic subjects. In this sense, Noguchi is an adventurer.

The adventurer tries to get "even further" and "even higher", or when exploring underground or underwater, "even deeper". In the topics mentioned above, and in such exhibitions as "Did He Reach the Moon?" (2001), one can see a propensity for verticality in Noguchi's work. "I Dreamt of Flying" (2003) is a series of photographs of paper rockets shot into the sky by amateur rocketeers (unrelated to the photos of real rocket launches), and in 2004 she went in the opposite direction and photographed ruins on the bottom of the sea off Yonaguni Island ("Colour of the Planet" [begun 2004]). The titles of Noguchi's images often include indications of periods of time rather than dates, which allows her to continue work on a series, as she explained in an interview for *ART iT* magazine's spring/summer 2004 issue, "Photography in Japan".

Most of Noguchi's works show specific sites, but at the same time they create the impression of showing anonymous, exchangeable places. The flawless composition of every photograph, and the precisely thought-out presentations in exhibitions or books, make looking at her work an intense and moving experience. "I think I'm always trying to learn something through photographs," she explains, and each of her pictures shows a certain "something" she is keen to get to know: a specific thing at a particular place, and at once a universal, almost cosmic "something".—Tetsuya Ozaki

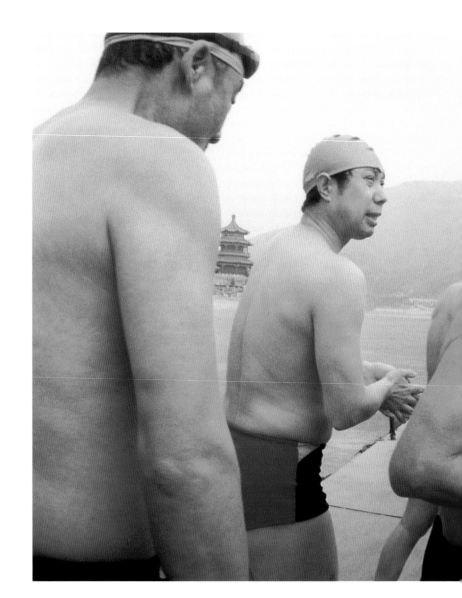

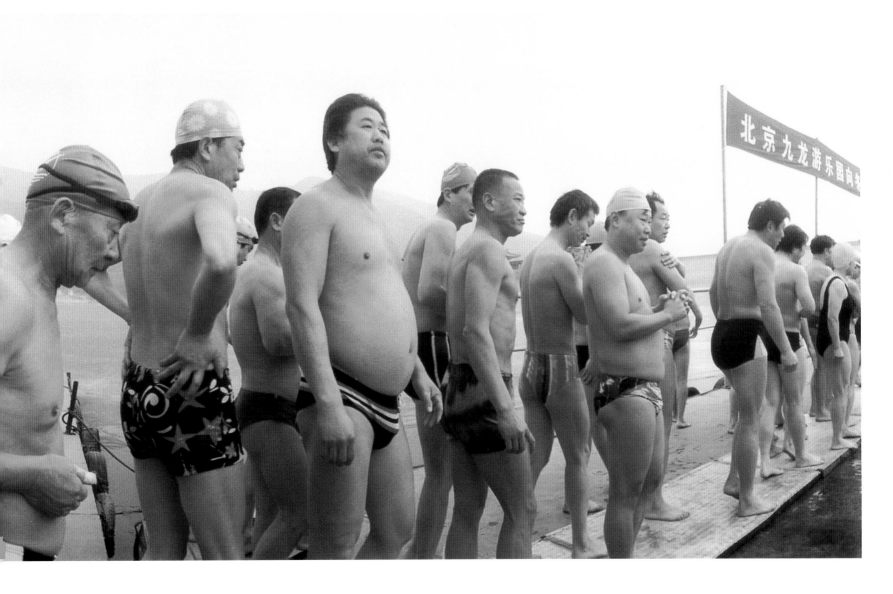

[1]	**About the World below Zero #1**, 2001-2, C-print, 96 x 240 cm, 37.5 x 93.5 inches

It is said that modern architecture is increasingly conceived and designed as a photographic subject, and constructed in ways better appreciated in two dimensions than three. Much of the work of collaborators **Andrea Robbins** and **Max Becher** extends this relationship, insisting on the manner in which architecture and social groupings internalize photography's capacity to incorporate its subjects into series. "770" (2005), named after the Brooklyn headquarters of an ultra-orthodox Jewish group, encompasses the Lubavitchers' original building at 770 Eastern Parkway and eleven near-identical copies of it in places like Tel Aviv, Los Angeles, Montreal, São Paulo, Melbourne, Buenos Aires and Milan. The photographs of the neo-gothic brownstone look by turns placidly banal and awkwardly grandiose, as insistent repetition builds a sense of weird incongruity.

Buried in Robbins's and Becher's use of repetition is a historical *déjà-vu*: their formats refer back to Walker Evans's black-and-white photographs of American houses and storefronts during the Depression. Evans's pictures play familiar, even homey, details of American vernacular architecture off a sense of terrible desolation. Evans used frontal views and three-quarter angles to show off advertising signs and harsh shadow contrasts. As Robbins and Becher adopt exactly the same angles in their vivid colour panoramics, they lift Evans's famous photographic trope into the strange new world of globalized communities. The barest evocation of community and kinship in these photographs competes with the jarring absurdity of architectural forms caught in a seemingly endless transfer from place to place, and time to time.

The sense of foreboding that runs through Evans's work is largely realized in "Global Village", one of Robbins's and Becher's most devastating series. This time, the photographic formats used by artists like Evans and Dorothea Lange are applied to a place that is already a copy of those famous historical images of poverty. "Global Village" is the name of Habitat for Humanity's "poverty theme park" in Americus, Georgia. Robbins's and Becher's eponymous series reproduces the park's displacement of the "reality" of poverty in a county of the American South that is plagued by terrible economic hardship. Their photographs depict a scene of poverty antiseptically cleaned of any sensory information beyond the visual: without music, smells, food and people, as the artists describe, these "park" structures become *sculptural*. And indeed, as worn upholstered lawn chairs bake in the Georgia sun, or old-fashioned hand lettering nostalgically evokes a one-room schoolhouse, we absorb the look and injustice of poverty without contending with anything that would exceed or challenge what we already recognize.

Robbins and Becher insist on history and specificity in a culture that perpetually deprives us of the information with which to understand our surroundings—or those of others. But the surprising turn in their work involves transforming that insistence into a critique of photography itself. Exploring the ways in which "classic" photographic tropes have formed our architecture, our cities and, most painfully, our ideas of community and history, Robbins and Becher defy the power of traditional artistic criteria like "originality" and "discovery" as they haunt our understanding of how to look.—Rachel Haidu

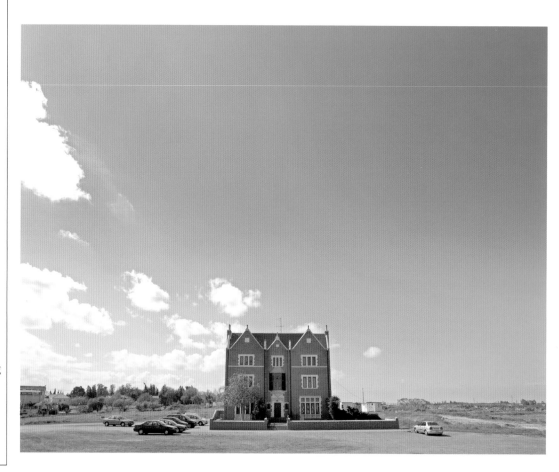

[1] **Original 770 Eastern Parkway, Brooklyn, New York**, from the series "**770**", 2005, digital archival print, 137 x 75 cm, 54 x 30 inches
[2] **Far View, Kfar Chabad, near Tel Aviv, Israel**, from the series "**770**", 2005, digital archival print, 87 x 75 cm, 35 x 30 inches
[3] **Far View, Ramat Shlomo, Jerusalem, Israel**, from the series "**770**", 2005, digital archival print, 87 x 75 cm, 35 x 30 inches
[4] **Far View, São Paulo, Brazil**, from the series "**770**", 2005, digital archival print, 87 x 75 cm, 35 x 30 inches

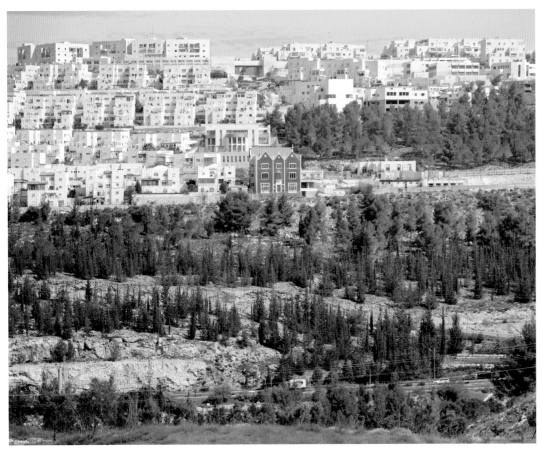

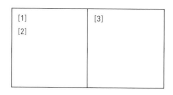

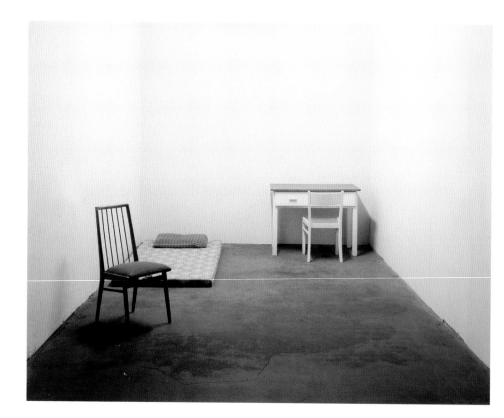

Amongst all the photographers who stage and arrange their subjects, **Ricarda Roggan** could probably be considered the purest. Her confidence in the physiognomy of the objects she combines and portrays has no need for Baroque opulence. This is a result of the origin of the items: aptly described by the series' title "Stuhl, Tisch und Bett" [Chair, Table and Bed] (2001-2), her subjects come from a Leipzig spinning mill, abandoned by a bankrupted company. In the white cube of the photographer's studio they are re-presented, almost always without any further additions; a cardboard box on the table or a towel on the bed as the maximum accessory. What Roggan captures in her precise 100 x 125 cm (39 x 49 inches) photographs is a vision of simple utilitarian furniture with distinct signs of use.

These items of furniture act as props for various scenarios with titles as laconic as *Zwei Stühle und ein Tisch* [Two Chairs and a Table] or *Bett, Tisch und Eimer* [Bed, Table and Bucket]. One is reminded of prison cells and interrogation rooms without ever feeling the urge to mentally add any human protagonists—the performing furniture is sufficient and its mustiness is counteracted by the cold severity of the composition. Sentimentality does not feature in Roggan's approach: she mercilessly douses her carefully assembled subjects in light, like nineteenth-century portraits.

In the puzzling diptych *Zimmer I* [Room I] and *Zimmer II* [Room II] (2000), a small number of objects such as an open suitcase and an improvised bed, which seem entirely provisional, are arranged in exactly the same way in two separate rooms so as to instantly thwart an assumption that one might just have chanced upon this scene. Do these simple items mean so much to their owner that he furnishes all his temporary dwellings in such a way, creating a home? Narrative aspects are mostly ignored in Roggan's images however. *Interieur I-V* (2000) depicts furniture placed in groups and covered with plastic sheets, as if protected for decorating or prepared for storage. The sculptural energy of these arrangements unfolds, independent from such associations: before these items disappear for ever, they may, freed of all functionality, take centre stage in front of the camera.

Roggan's most radical clear-up operation is her 2005 series "ATTIKA". The attics, located in the German cities of Cottbus and Dresden, no longer contain any treasures, old toys, useless furniture, magazines that no one will ever look at again and photo albums with pictures of the long dead. The discoveries to be made here after the artist cleared out and cleaned—no spider webs or residual dust remain—apply just to the structures of the gloomy rooms. Light only occasionally penetrates their outer walls and one has to adjust to the darkness of these large-scale images, as much as one would have to when actually entering the rooms. In their own way these silent images also acknowledge their subjects, conveying an eerie presence. Simultaneously Roggan's staged reality maintains a connection with the real world: the scenarios appear to address the viewer's sense of smell as much as vision, but the past is evoked without melancholy.—Kerstin Stremmel

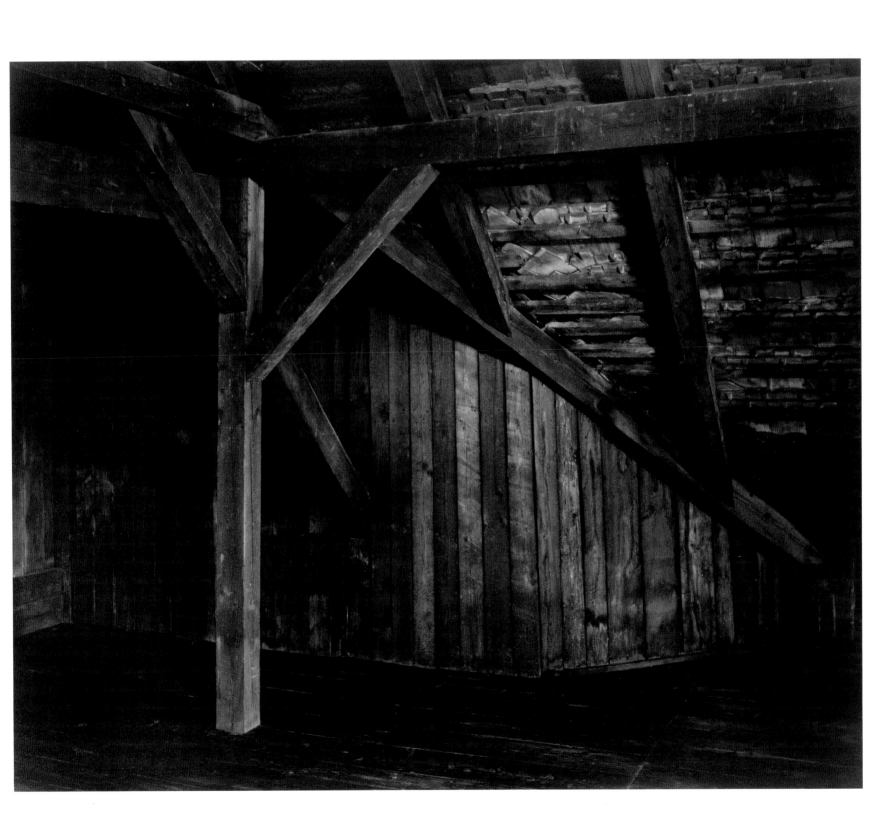

[1]
[2] [3]

Though he is best known as a filmmaker, **Anri Sala**'s work as a photographer has taken on increasing significance in the artist's production over recent years. Reflecting the same attention, aesthetically and conceptually, to the careful framing of place and time as is evident in the artist's film work, Sala's photography uses singular images to convey a condition of disorientation, requiring a negotiation of location, time and perception. The ambiguity of Sala's images is achieved through a process of withholding or distorting information such that a sensorial and intellectual uncertainty results, a confusion that elicits the unexpected or unconditioned response. Images of desolate airports, rudimentary building sites and deserted terrain purposefully remain unidentifiable and could have been taken anywhere from certain parts of Europe, Africa, Latin America or his native Albania. By seeking out such apparently exchangeable sites, the work suggests not the endless sameness of our contemporary landscape, but rather calls into question our very desire to locate, define, identify, "comprehend" and thereby make certain assumptions about the perceived image. Freed from the normative process of apprehending, the viewer instead is drawn to examine the peculiar ambiguities of the image, projecting potential meaning, and made conscious ultimately of our idle, daily assumption that "what we see is what we see".

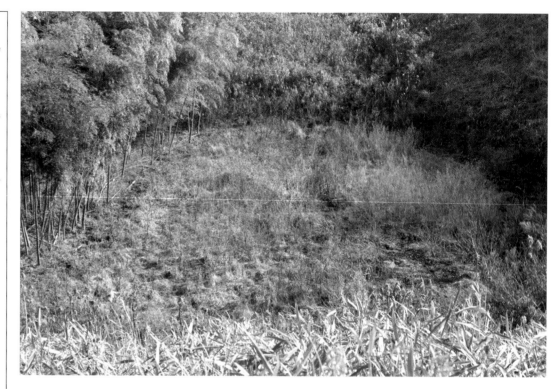

The relationship between film and music has been the subject of Sala's most recent films, which structure a disparity between what we see and what we hear, elaborating on the idea of the fiction or the lie and calling into question our reliance on our senses for observational truth. In his photographic work, the extreme stillness of the image seemingly performs a similar disjunction between apprehension and comprehension. The selected locations are frozen in such a way that there is the suggestion of staging and yet the nature of the chosen image is such that this is clearly not the case. In *31' 131'* (2002), a photograph of a sudden clearing among trees, for example, that forms a sculptural semicircle of flattened grass bordered by high dense growth gives no explanation for how or why this change in vegetation occurred. Perhaps the clearing is the result of an abandoned building project or event? The flatness of the cleared area of land in the image further distorts our sense of scale and we could also imagine this rounded area to be the result of a large animal's resting place.

The "found sculpture", identified and recorded, is a frequent trope in Sala's photographs, such as *Untitled yet* (2005). The artist is drawn to liminal constructions that could be read as either in the process of realization or becoming undone. Partly built edifices, the randomly associative placement of building materials, an improvised construction technique or the unusual reuse of materials are all elements that Sala conceptually frames in order to emphasize their often overlooked sculptural and formal potential. Locations themselves often appear to be caught in a state of economic transience and flux: the vacant plot of land or construction site could portend either economic "progress" or "recession". Sala's questioning of such metaphors of development and growth aptly reflect the uncertainties of our time.
—Jessica Morgan

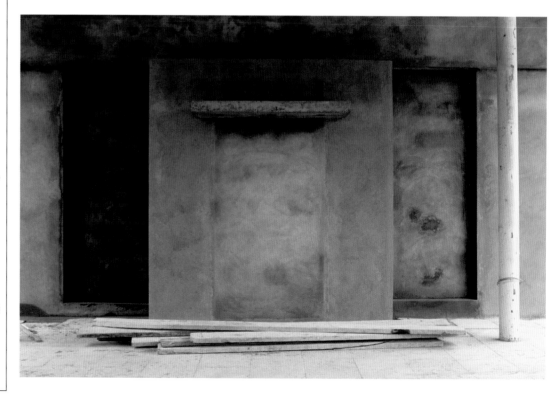

[1] **31' 131'**, 2002, black-and-white print on baryte paper, 160 x 110 cm, 62.5 x 43 inches

[2] **Untitled yet**, 2005, C-print, 160 x 110 cm, 62.5 x 43 inches

[3] **Untitled (airport)**, 2005, C-print, 160 x 110 cm, 62.5 x 43 inches

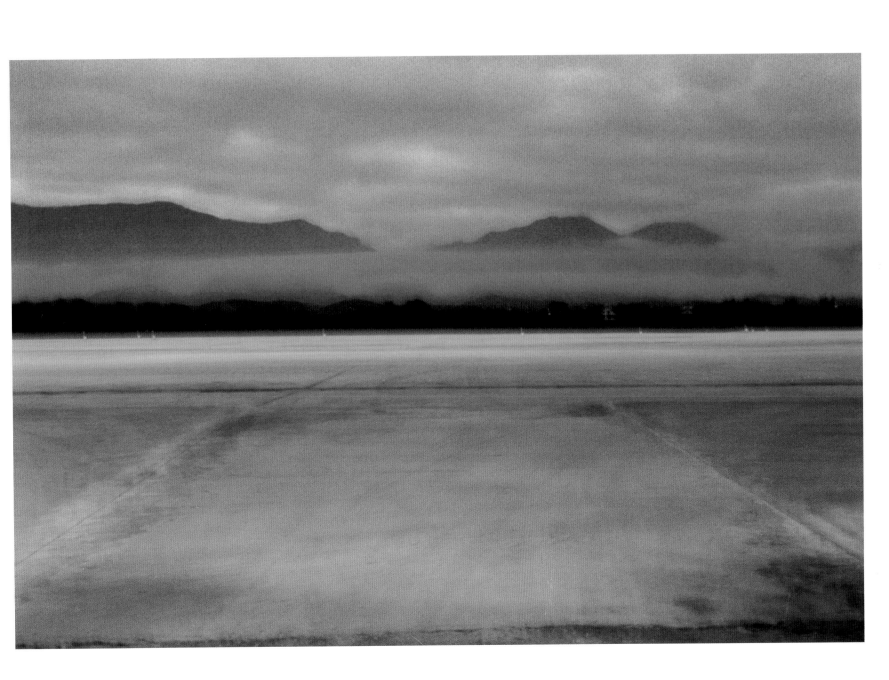

Anri Sala

[4]

[5]
[6]

[4] **No Barragán No Cry**, 2002, colour photograph, 160 x 198.1 cm, 63 x 78 inches
[5] **Untitled (Tagplant 1)**, 2005, black-and-white photograph, 74 x 104 cm, 29 x 40.5 inches
[6] **Untitled (Tagplant 2)**, 2005, black-and-white photograph, 74 x 104 cm, 29 x 40.5 inches

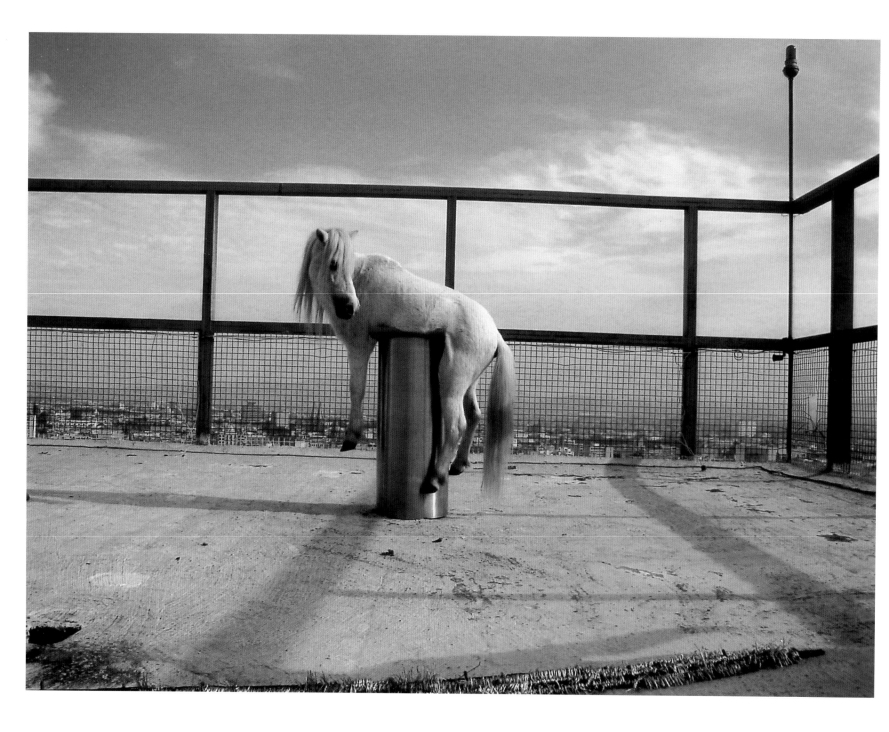

[1]	**No. 11**, from the series **"Figures of Lust, Furtively Encountered in the Night"**, 2004, lightjet print, 76.2 x 57.2 cm, 30 x 22.5 inches
[2]	**YMAP (Art)**, from the series **"Young Men at Play II"**, 2005, lightjet print, part of a diptych, 101.6 x 63.8 cm, 40 x 25 inches
[3]	**Untitled (Ejaculation)**, from the series **"Outlaw"**, 2003, Fujiflex print, 24.5 x 31 cm, 9.5 x 12 inches
[4]	**Untitled (Climax)**, from the series **"Outlaw"**, 2003, Fujiflex print, 24.5 x 31 cm, 9.5 x 12 inches

"A society that has lost its gestures tries at once to reclaim what it has lost and to record its loss."—Giorgio Agamben, "Notes on Gesture" (1992).

Dean Sameshima's photographic project presents a typology of loss, a sexually charged, serial examination of traces left by the sun-bleached excesses of Los Angeles. Although clearly indebted to the codes of Minimalism and conceptual photography, Sameshima renegotiates familiar strategies of repetition and re-photography to recover the detritus of Southern California's waning gay subcultures. With the precision of Bernd and Hilla Becher, or Ed Ruscha's systematic architectural photographs, his early work documents an anonymous, light-industrial landscape of empty sex clubs and cruising grounds. As these sites—and the artist's own subjectivity—are transformed by the rise of Internet chat rooms and webcams, Sameshima has turned his camera away from physical topographies towards the figures and gestures of the furtive online world and homoerotic physique magazines from the 1950s and '60s. His appropriation of Internet self-portraiture, and his reuse of earlier amateur beefcake images, examine photography's shifting role within the anatomy of homoerotic desire and facilitate Sameshima's aspiration to rebuild an archive of radical sexuality and longing.

By courting the virtual world, Sameshima charts the gradual disappearance of the urban homosexual "cruiser", the sexual outlaw whose rambles recall Baudelaire's *flâneur* but who maps the modern city through illicit erotic encounters and connections, rather than in a mode of artful detachment. Sameshima's mid-1990s urban landscapes are devoid of any visible human presence. They present an archive of palpable absence and deferred desire.

The human figure first appears in Sameshima's work in photographs appropriated from fashion magazines. The slim, white models in "Modern Boys" (1998/9), posed against a backdrop of lush bushes, present a full-frontal, bare-chested standoff with the camera. Their eyes are cropped, confirming their anonymity but emphasizing that their seductions do not derive from the charged, physical confrontation of the modern street or park. The "secret and divine signs" Walt Whitman imagined in everyday urban encounters have been relocated to the static pages of Sameshima's vast collection of style periodicals. Fusing the critique of Richard Prince's re-photography with an investigation into personal yearning, Sameshima stages desire as commodity and spectre, as a symptom of the accelerated dissolution of the public into the private.

Roland Barthes wrote, in *A Lover's Discourse: Fragments* (1977), that "the description of the lover's discourse has been replaced by its simulation". Sameshima's series of an allegedly deaf model enacting a vocabulary of sexual acts in sign language is a sly nod to Barthes's remark. Appropriated from a 1984 issue of *In Touch* magazine, the images provide a tongue-in-cheek atlas of the coded gestures through which gay sexuality was once corresponded.

The community that such communication engendered is now one increasingly connected through keyboards and computer screens. "Figures of Lust, Furtively Encountered in the Night" (2004) is a series of online self-portraits that Sameshima has collected from cruising websites. The subjects are all shown with camera in hand, and the blaze of a flashbulb obscures each man's face. The power of the reciprocal gaze has been replaced by a void, by the erasure of identity. Just as Sameshima's appropriations indicate what Judith Butler has called "the loss of loss", they also mark peculiar moments in which the camera simultaneously documents and conceals its subject.—Stuart Comer

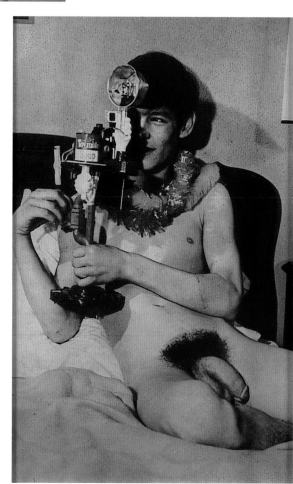

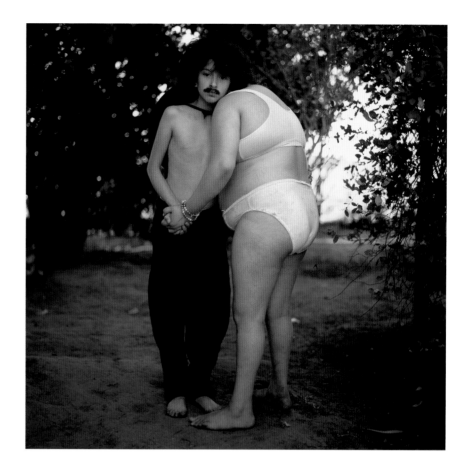

Alessandra Sanguinetti explores the life of small towns in rural Argentina, effortlessly moving from straight documentary photographs to vividly staged tableaux. Shot with a Hasselblad camera, the one hundred colour pictures comprising "The Adventures of Guille and Belinda and the Enigmatic Meaning of their Dreams" (1999-2005) chronicle the coming of age of two young female cousins. The mismatched girls—the corpulent Guille and thin, androgynous Belinda—enact vignettes that range from the mythological and biblical, such as Ophelia and the Virgin Mary, to domestic vaudeville. In a gender-bending scene titled *El Casalito (The Couple)* (1999) the two play at husband and wife, slow-dancing half-naked amidst a grove of trees. Sanguinetti mentions Astrid Lindgren's fictional character Pippi Longstocking as a source of inspiration, but her pictures are equally informed by Lewis Carroll's Victorian photographs of young girls or by the melancholy mood of Pre-Raphaelite paintings, as seen in such images as *Ophelias* (2002). Sanguinetti began taking pictures at the age of nine and as a teenager learned about the works of Lee Friedlander and Robert Frank in a photography workshop. In the late 1990s she studied at the International Center of Photography in New York where she was exposed to the teachings of Nan Goldin, whose work's diaristic sensibility was instrumental in the reintroduction of psychological narrative in contemporary photography. Sanguinetti is equally interested in this type of narrative. Working in the area between fact and fiction, she probes the subjectivity of her protagonists in the act of playing a repertoire of roles or during idle moments of distraction. Viewed as a group, Sanguinetti's portraits offer poignant intimations of each girl's personality at the point when blithe childhood gives way to pubescent awakening.

In the photographic series "On the Sixth Day" (1996-2004) Sanguinetti examines the symbiotic relationship between nature, farmers and cattle. The series takes its title from the biblical day on which God created humans and animals. Fascinated by how animals can be mutually worshipped and destroyed, the artist evokes in some eighty colour-saturated pictures the natural environment as a place of primal flux. In these pictures, at once gruesome and tender, the sequences of birth, nurture and death are routine. Especially affecting is the magical, fairytale-like quality of the images—rarely captured in photography but explored in the early 1900s in the paintings of Der Blaue Reiter [The Blue Rider] group —the phenomenon of seeing the world through the animal's eyes. In her pursuit of empathy Sanguinetti proposes that the common point between human and animal is the natural suffering that unites all creatures. Yet her work touches on the limits of this union and ultimately on the inevitable separation between beings: butchered carcasses often reveal the inhumanity of nature. Slaughter is an everyday activity in farm life, even though death retains its sacramental presence. Whether addressing the idylls of childhood or the brutal life cycle of farmlands, Sanguinetti's photographs are emotionally attached to Argentina where her sensibility and vision of the world have been formed.—Roxana Marcoci

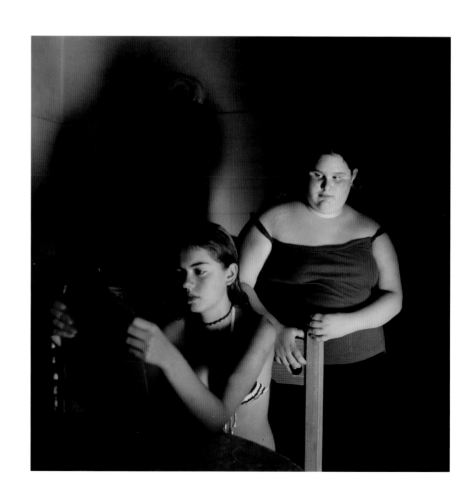

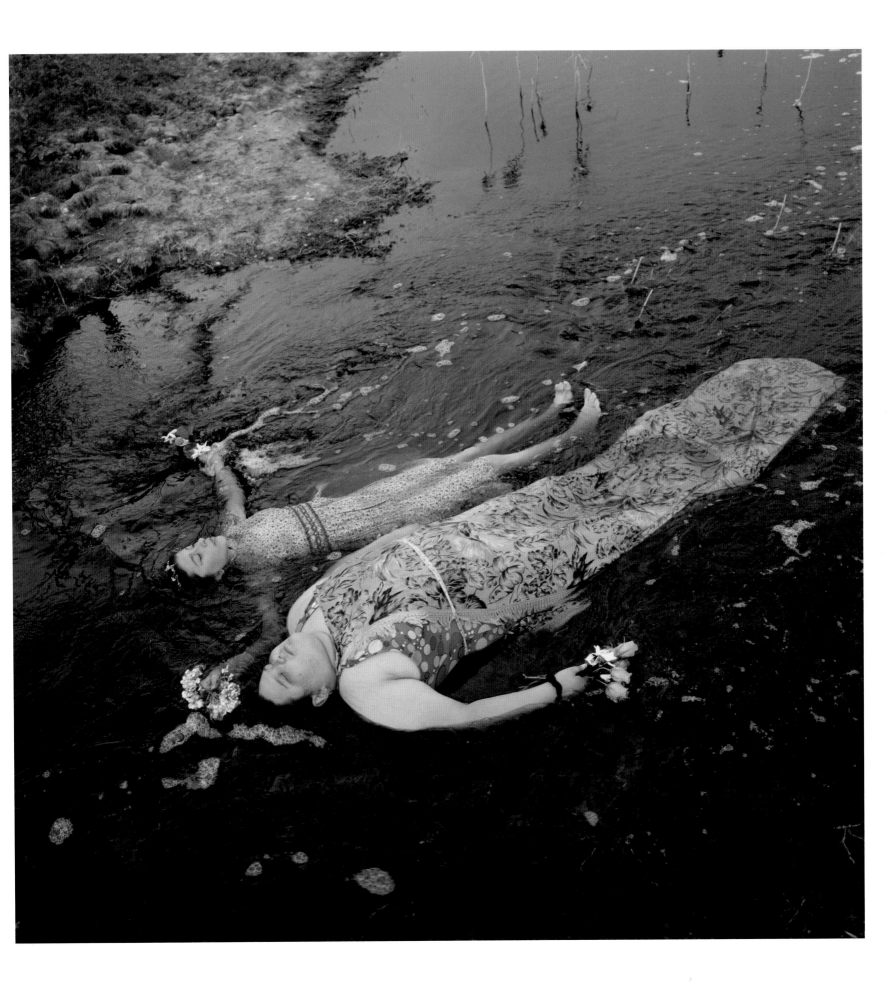

[4] [5] [6]

[4] **Dogs**, from the series **"On the Sixth Day"**, 2000, C-print, 73.7 x 73.7 cm, 29 x 29 inches

[5] **Hens watching over fetus**, from the series **"On the Sixth Day"**, 2001, C-print,
73.7 x 73.7 cm, 29 x 29 inches

[6] **Broken Horse**, from the series **"On the Sixth Day"**, 2002, C-print, 73.7 x 73.7 cm, 29 x 29 inches

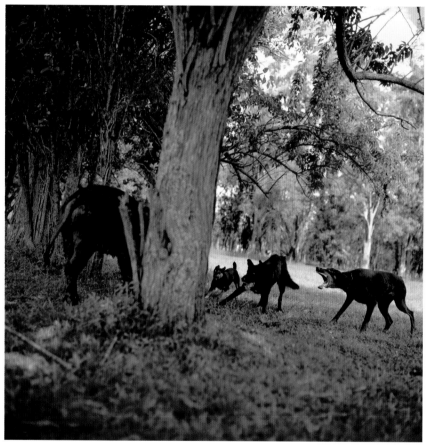

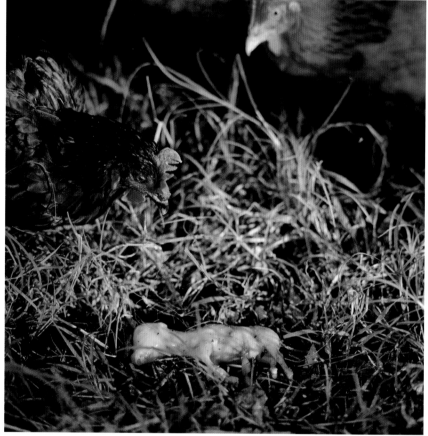

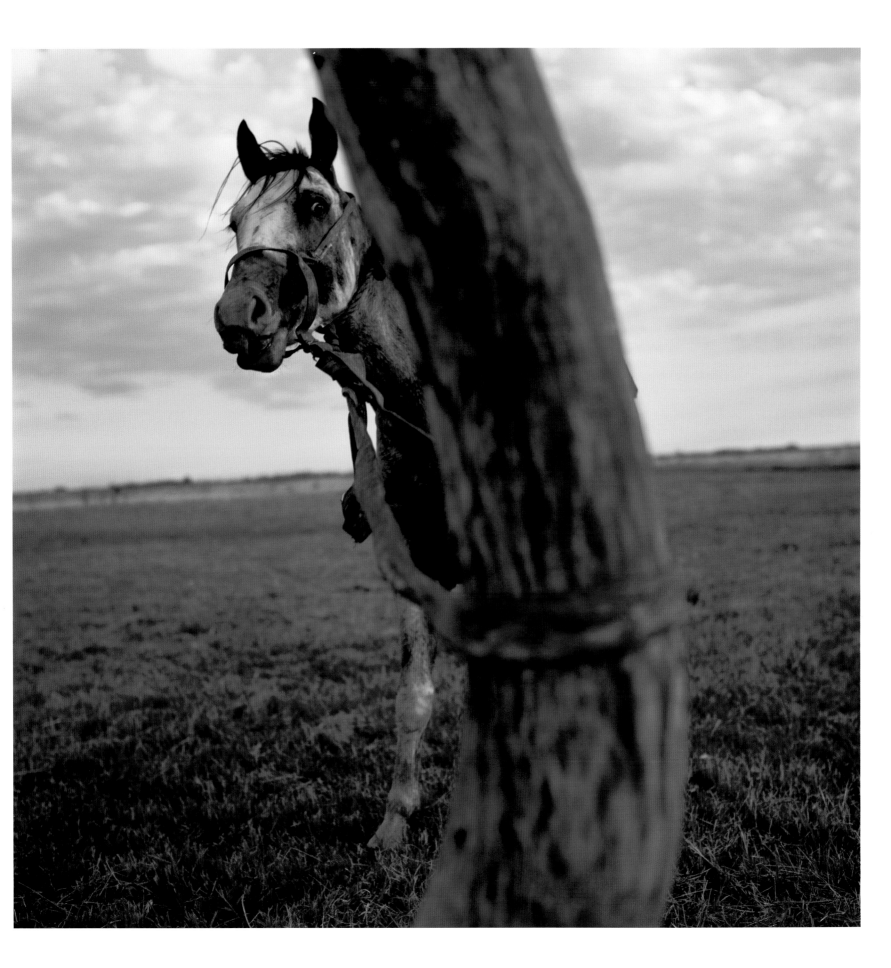

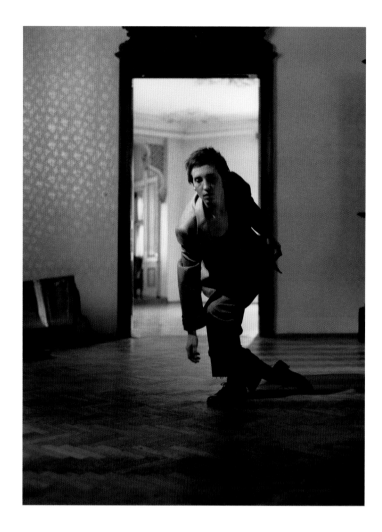

Markus Schinwald's work has included sculpture, dance, fashion, film, photography and performance, all of which allude to psychoanalysis and a history of gesture and the body. Schinwald originally studied fashion design and first became known for wearable sculptures that restrict movement: *Celebration Shirt* (1997), for instance, forces its wearer to hold up his hands, while *Low Heels* (1998) are mutated shoes that force the wearer to limp awkwardly, collapsing on a heel-less sole in a manner opposite to the archetypal teetering of the stiletto-clad woman. More recently Schinwald has worked in film and photography, exploring strategies of theatrical gesture with a polished cinematic style.

Schinwald's highly choreographed films and photographs follow no logical narrative. Instead the artist weaves together fragmentary stories of disjointed emotions and longings, deliberately invoking narrative stereotypes and cultural clichés. *Dictio pii* (2001) is a group of five 35 mm films (shown as one work) and a series of photographs. The action takes place in a vacant hotel where seven characters in various forms of physical constraint move in and out of view according to no easily definable motivation. Doors open, strangely garbed figures enter through them only to vanish again in the next room. An old man in a lift (the attendant?) incessantly brushes dust off his jacket. An ageing diva in a white dress with a fetishist prosthesis around her neck smokes one cigarette after another. A young man perpetuates his artificial smile by gripping a taut silver chain between his teeth. A girl's body inflates, pulsating, and a man lets a woman bind his arms. The films are accompanied by the same deep male voice intoning an internal monologue. Towards the end of the duration, this voice is superseded by a female one that sums up the sequence with the credo-like final line "We are deranged."

No individual film contains a cohesive story but characters from each appear across films while the narrative remains frustratingly inconclusive. The photographs and film of *Dictio pii* appear to be driven by the logic of the unconscious and are concerned with the power of gestures and the potential of repulsion. The characters perform specific, repeated and more or less meaningless sequences of actions, creating the chilling and compelling mood of a dream or nightmare.

For The Museum in Progress in Vienna, Schinwald was commissioned to make the billboard project "Stage" (1999). The artist's interdisciplinary interests were made explicit in his imagery and placement of this work, which consisted of seven different shots of a large theatrical stage with three solitary figures appearing occasionally in a selection of the images. The billboards were shown both individually and in combination with approximately a hundred variations put up according to the artist's choreography. Schinwald's insertion into the Viennese streets brought to mind questions about the nature of the world as a stage, the choreography of our daily existence and movements, while also humorously turning the lonely bus stop or deserted street into a public theatre by means of this striking backdrop.
—Jessica Morgan

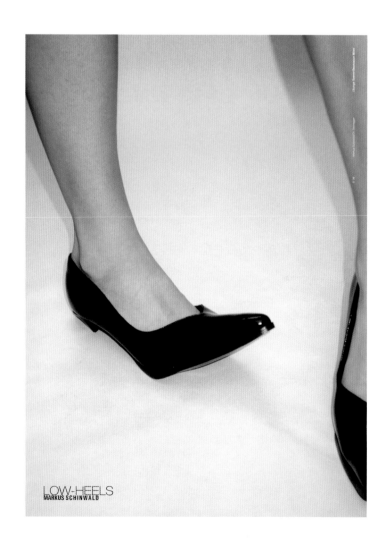

LOW-HEELS
MARKUS SCHINWALD

[1] **1st part conditional**, 2004, Duraclear on mirror, 90 x 120 cm, 35.5 x 47 inches

[2] **Low Heels**, 1998, offset print, 25 x 35 cm, 10 x 13.5 inches

[3] **Stage**, 1999, offset print, 200 x 600 cm, 78.5 x 236 inches

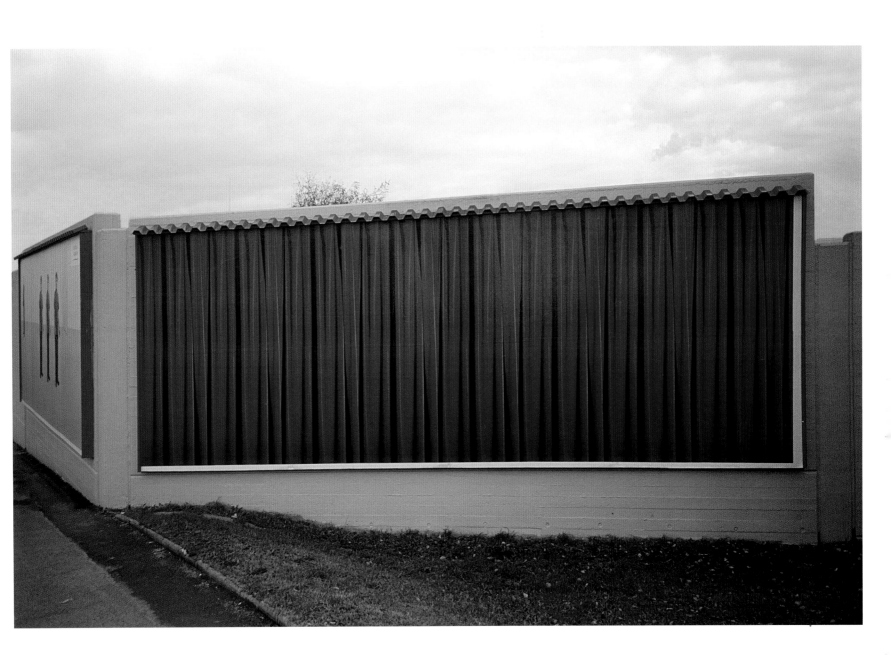

[1] **1st part conditional**, 2004, Duraclear on mirror, 90 x 120 cm, 35.5 x 47 inches

[2] **Low Heels**, 1998, offset print, 25 x 35 cm, 10 x 13.5 inches

[3] **Stage**, 1999, offset print, 200 x 600 cm, 78.5 x 236 inches

[1] **Waldenstreet 14, bathroom**, from the series **"Die Familie Schneider"**, 2004, digital photograph, 18 x 24 cm, 7 x 9.5 inches

[2] **Waldenstreet 16, bathroom**, from the series **"Die Familie Schneider"**, 2004, digital photograph, 18 x 24 cm, 7 x 9.5 inches

[3] **Totes Haus u r, Venezia**, 2001, black-and-white photograph, 10 x 15 cm, 4 x 6 inches

[4] **U 30 Haus u r, Rheydt**, 1989-93, black-and-white photograph, 10 x 15 cm, 4 x 6 inches

[5] **Cube Venice**, 2005, digital photograph, 50 x 75 cm, 19.5 x 29.5 inches

At the age of sixteen, German artist **Gregor Schneider** began modifying the interior of a nondescript three-storey home on Unterheydener Strasse in Rheydt, near Cologne, that belonged to his family but was deemed unsuitable for habitation due to its proximity to a lead plant. For the past twenty years, the inside of this building, which he calls *Haus u r*, has undergone constant change, as Schneider builds and removes rooms, inserts walls, blind windows and narrow passages, and creates an ever-changing installation. As its title suggests, all his other "rooms" (Schneider doesn't use the terms "installation" or "environment") derive from this work. In many cases, he literally slices away parts of *Haus u r*, crates them up and exhibits them elsewhere.

One can imagine Schneider's black-and-white documentary photographs as a spectral version of these rooms. They are evocations of that which is no longer there, a visual epitaph for the "dead space" they depict. Perhaps their closest counterpart is an early work of monumental importance for another artist who has plumbed the depths of the uncanny: Robert Gober's *Slides of a Changing Painting* (1982-3). That work consists of eighty-nine colour slides documenting the year-long metamorphosis of a single painting. In the years since, Gober has revisited almost every motif incorporated in its images.

Since exhibiting rooms carved from *Haus u r* at the Venice Biennale in 2001, Schneider has increasingly taken his practice beyond the domestic sphere, creating artworks *ex nihilo* at Barbara Gladstone Gallery in New York and (for an Artangel commission) in a residential neighbourhood in London. The former, with the address of 517 W 24th, reversed the gallery's main room, converting its pristine white walls to a picture-perfect replica of a sooty, oil-stained concrete alleyway, accessible only from the street and complete with storm drain, curb and a single sodium lamp. Schneider's moody photographs of the work capture the sense of impending menace it exuded, a noirish air that was furthered with *Die Familie Schneider* (2004). For this project, the artist created identical side-by-side dwellings and hired identical-twin actors to repetitively enact disquieting scenes. The Hitchcockian air is given an unsettling twist in twinned photographs of a man, facing away, hunched over in the shower. In the performance he was masturbating vigorously, apparently unaware of viewers' presence.

Cube Venice (2005) and its offshoot, *Cube Berlin* (2006), is a project unrealized at the time of this writing. It is known only through photographic montages that Schneider created to illustrate his concept. In conjunction with last year's Venice Biennale, Schneider proposed installing a large black cube, akin to the Kaaba at Mecca, in the middle of Piazza San Marco. The montages make it look as if Claes Oldenburg got his hands on Tony Smith's *Die* (1962), but the uncomfortable feelings evoked by the abstract object are so acute that it has thus far been rejected by art officials at every turn. Schneider remains a subtle agitator. The physical unease inspired by the cramped spaces in *Haus u r* now finds its complement in the cultural anxiety provoked by his most recent project.—Brian Sholis

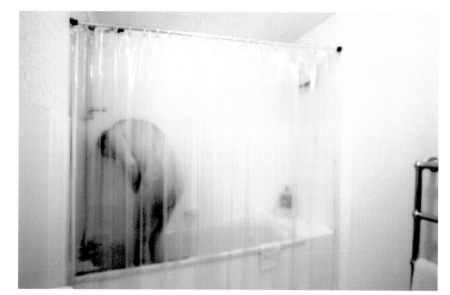

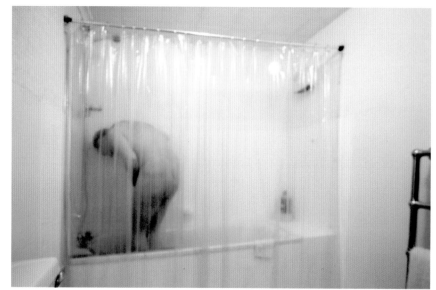

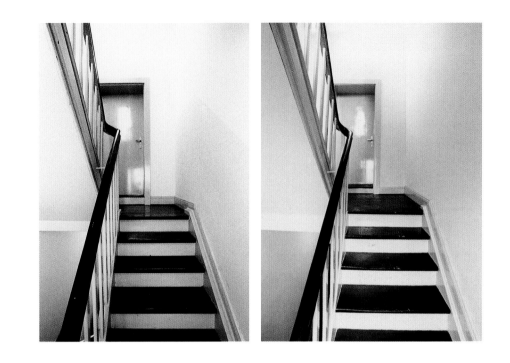

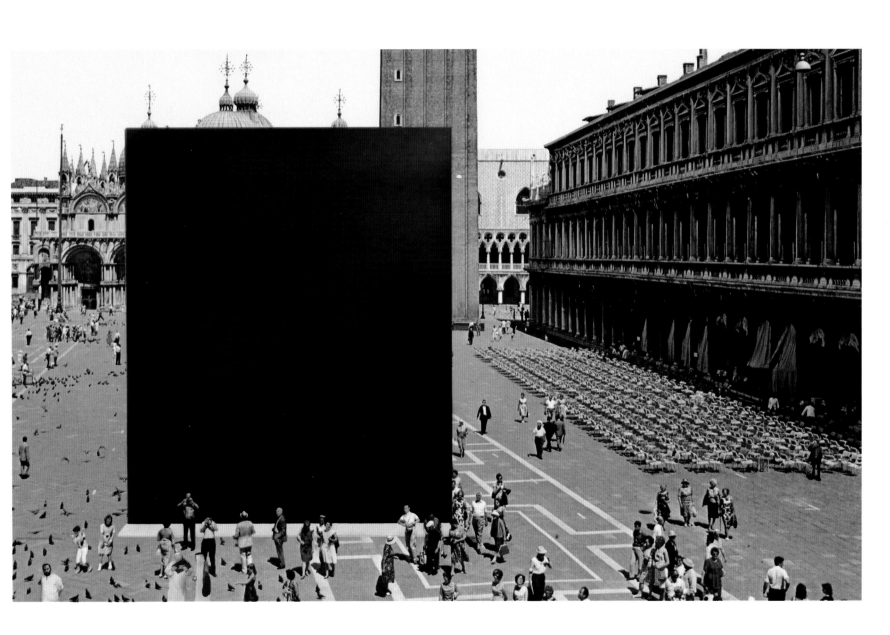

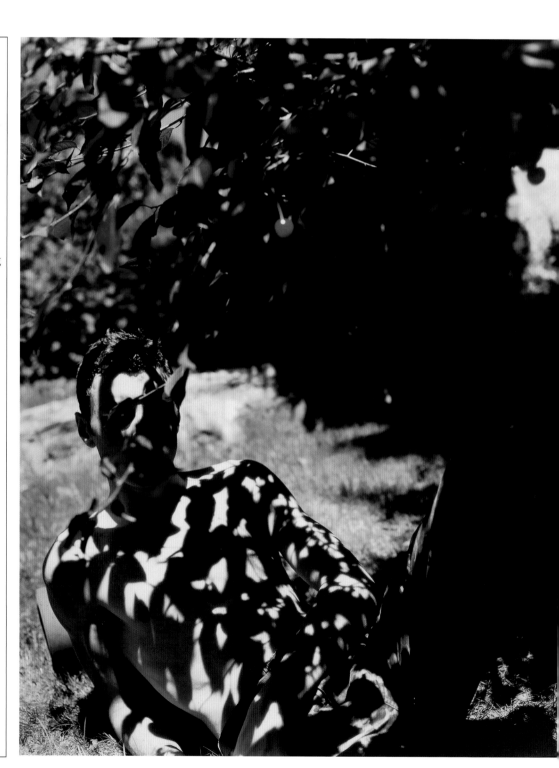

Collier Schorr's photographs share troubling secrets. They take the form of documentary shots, fictionalized portraits and hybrid still-life/landscapes. Whatever the genre, they exist in the realm of fantasy, providing the viewer with just enough evocative detail for bucolic innocence to flip into beguiling perversity.

One of the most puzzling aspects of Schorr's oeuvre is her gaze. Often mistaken for that of a gay man, the androgyny of her adolescent subjects is matched by the sexual uncertainty of her loving eye. Her perspective defies easy categorization even though her sitters look straight into the camera, locked in an exchange that is curiously intense. Schorr gives us a clue to this amorous dynamic when she quips, "Taking pictures is the most sincere form of promiscuity".

Another conundrum of Schorr's work relates to national identity, particularly the patriotic uniforms of war. Whether her subjects are all-American high school wrestlers or young German soldiers dressed in Nazi gear, her ethnographic fascination with WASPs as exotic others is raw and unadorned. At first the knowledge that she is Jewish would seem to clarify this theme but, after consideration, it just makes it more complex. In *Andreas, POW (Every Good Soldier was a Prisoner of War)* (2001), the boy poses neutrally, an integral part of the Teutonic landscape. The tall grass both veils and reveals his uniform, suggesting a small but not insurmountable conflict between nature and culture.

Many of Schorr's photographs seem to ask the question: what is the relationship between nature and desire? In *Herbert, Weekend Leave (A Conscript Rated T1), Kirschbaum* (2001), the two forces appear mysteriously at one. Cast in equal amounts of mottled light and shade as if he were his own doppelgänger, a half-naked soldier lounges under a small tree. A bright red cherry dangles—ripe for the plucking. In *Arrangement #2 (Blumen)* (2005), a constructed collage of flowers is carefully strung up in front of an expansive vista. The grassy horizon is severely off kilter, while the floral composition is in perfect equilibrium, suggesting the triumph of artistic solutions when Mother Nature is out of whack.

Schorr's carefully crafted photographs engage with myriad sources. They play with the subliminal messages and sexual objectification of fashion campaigns, the overt constructions and identity politics of feminist artists like Cindy Sherman and the historical "realities" and typologies of documentary photographers like August Sander. The sultry tone and narrative ambiguity of Schorr's work is almost novelistic and she admits an affinity to authors of dark dramas from the American South, such as Truman Capote. In *Smoke Ring* (1999), the boy looks out seductively through the phallic trunk and yonic hole of his smoky exhalation. As in the southern literary tradition, here passion is all the more enticing for being infused with psychological danger. The boy is part animal, part soulful ghost. He has a visceral impact that is fundamental to the sinister beauty of Schorr's photographic world.—Sarah Thornton

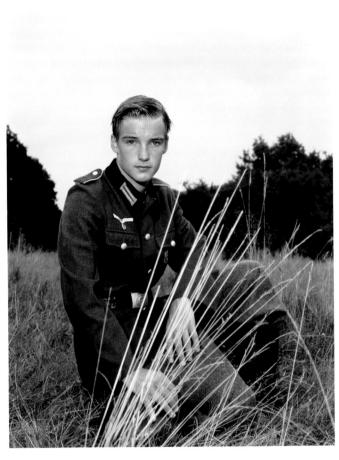

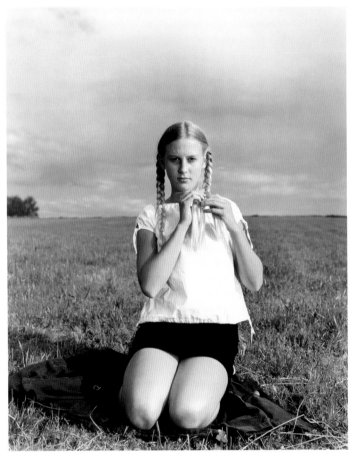

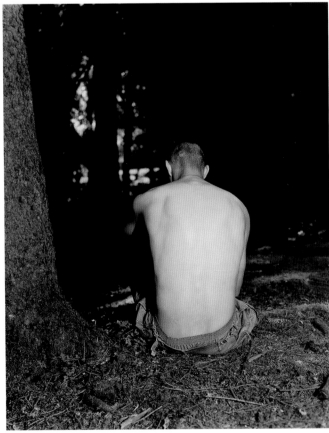

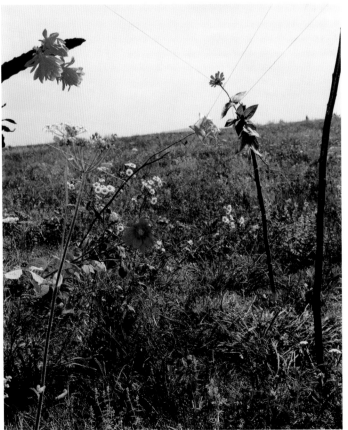

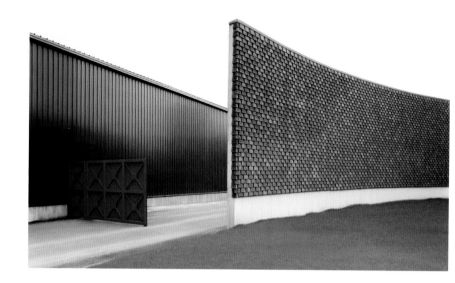

Josef Schulz's photographs deal with our world in rigorously structured groups of works. His series "Centre Commercial" (1999-2000) makes use of images taken in France; scenes from those functional shopping centres that proliferate on the outskirts of cities and represent a form of Americanized shopping culture exceedingly unpopular with the bourgeoisie. The pictures from this series, about 20 cm (8 inches) high and up to 5 m (16 ft) in length, show colourful and seemingly artificial panoramic views of mostly single-storey warehouses in front of an ever-blue sky. There are a surprisingly large number of furniture stores with their familiar stereotypical merchandise, which subsequently finds its way into people's homes, only to increase this conformity further.

The montages consist of fifteen to thirty-five sections and prove disturbing due to their inconsistencies in perspective, which become obvious only upon closer examination, making positioning a real challenge for the viewer. Schulz was intent on taking pictures of locations that cannot be captured with conventional photographic means, but which at first sight present an apparently convincing picture of reality. The manipulations in the groups of works "Sachliches" (begun 2001) and "Formen" (begun 2001), however, are far more apparent. The storehouses and production facilities look decidedly artificial, almost virtual, like brightly coloured, hermetic toy-models with which no one chooses to play. He also manipulated the surfaces upon which these functional buildings stand—a concrete floor of such homogenous grey, or grass with the look of having been trimmed with nail scissors, are reminiscent of model railway accessories.

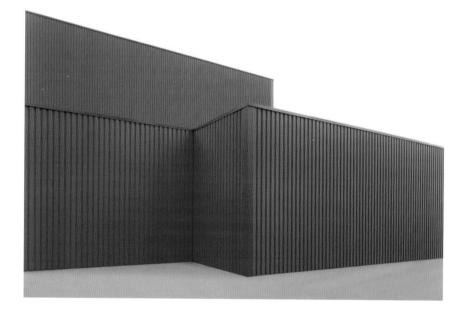

The artist does not deny the deliberate creation of artificiality; the photographs betray his pronounced interest in a new way of dealing with documentary material. Step by step, he creates a new picture from the photographic material at hand. The analysis of photographic evidence turns into the main feature of Schulz's pictures. A logical continuation of choosing the dynamic relationship between reality and meaningful manipulation as his central theme, this act of disfiguring things until they become recognizable is also evident in his latest project. The series "Übergang" (begun 2005) consists of a plethora of central European border-post huts, some of which have the air of abandoned petrol stations on never-ending motorways, whilst others look like little huts whose shutters are closed for all eternity or decorated with graffiti. No border guards on duty emerge from these buildings which, despite their functionality, appear surprisingly capable of variation. Yet looking at the pictures, one cannot quite shake off the feeling that one will be subjected to scrutiny any moment now. The sense of being nowhere is evoked, with the background obscured by blurring, taking the buildings out of context. It makes one wonder about the purpose of these disintegrating "monuments" and places where borders still exist, and how much the differences between nations are manifest in their architecture. What unites Schulz's works in a single concept is the act of doubting the obvious.—Kerstin Stremmel

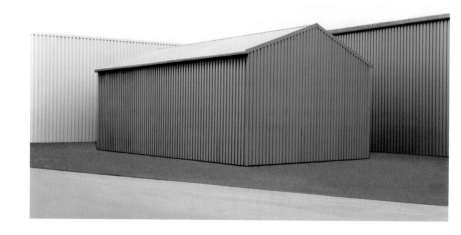

As much as systems theory, complexity theory and overarching analysis of globalism attempt to clarify the large forces that affect us, they often obfuscate rather than reveal. **Paul Shambroom**'s photography distils these systems into singular profound images that for a brief moment clarify. Whether it is the monstrous nuclear arsenal developed during the Cold War, the practice of labour tucked away in factories, the process of day-to-day American politics or the pragmatics of an increasingly emergency-driven economy, his work retains an active agenda of producing agency through photography. Revealing the machinations behind the curtain is not a particularly new photographic endeavour. In the 1930s Walker Evans used the camera to bring the poverty of the Depression to the eyes of the public. His political strategy was simple: if people can see the suffering of others, surely they would do something. In his form of photographic reportage, Evans brought America closer to itself and carved out a political form of photography that Shambroom surely draws from.

Yet the visual terrain of the early twenty-first century is markedly different, and the strategy of producing action by documenting the tragedy of inaction seems to have lost its lustre. Instead, the operating question has become: what are the forces at work today that produce the world and its corollary injustices? Shambroom sets out to depict succinctly complex systems of power and in so doing his project is decidedly for the present. In appreciating his photographic oeuvre, a viewer often feels the banality of their condition placed within a larger framework of operating principles.

Shambroom's photographic series "Meetings" (1999-2003) depicts the workings of local government in historic terms. The photographs show democracy in action, and yet their often provincial qualities, such as the podgy adolescent boy taking notes or the soda machine in the background, present an all-too-familiar image. Shambroom, equipped with a copious database of 15,000 small towns and a list of their schedules, crisscrossed the US. He dutifully attended hundreds of meetings and documented their goings on. The photographs often present a community grappling with its local issues, but in their quaintness a viewer can see the potential for his or her own participation. And while a faint hint of irony can be detected in the work, the cynicism is counterbalanced by Shambroom's intention to elevate the banality of small-town democracy on to a historic stage. The photographs are printed on canvas, and with their panoramic format they gain a semblance of historic portent. The everyday minutiae of town politics shifts from the periphery of political life towards the centre of what makes democracy function or not.

Shambroom's most recent series "Security" (2005) tackles the state of emergency and its manifestation in the US today. Finding evidence in protective suits, such as *Level A Hazmat Suit, Yellow* (2004), training sites in New Mexico and car bomb tests, Shambroom once again detects the vernacular sites where the global psychological condition takes physical form. If town meetings give tangible meaning to the democratic process, then the "Security" series provides a physical reality to national paranoia. Far removed from a mental haze of fear, it brings to the viewer's attention the operations at work on an infrastructural level to address an insecure nation state. The very presence of the sites included in the series allows Shambroom to remove the state of paranoia from an abstraction to a concrete reality embedded in the land, its people and its homes.—Nato Thompson

WILLIAM M. WARD, SR.
Mayor

CHRISTINE G. DAVIS
COUNCILPERSON

GRACIE C. JACKSON
Mayor Pro Tem

[2] [3]

[2] **Level A Hazmat Suit, Yellow**, from the series **"Security"**, 2004, archival pigmented inkjet on
 canvas with varnish, 96.5 x 160 cm, 38 x 63 inches
[3] **1987 Toyota Celica, 500 lbs ANFO explosive**, from the series **"Security"**, 2005, archival pigmented
 inkjet on paper, 106.7 x 160 cm, 42 x 63 inches

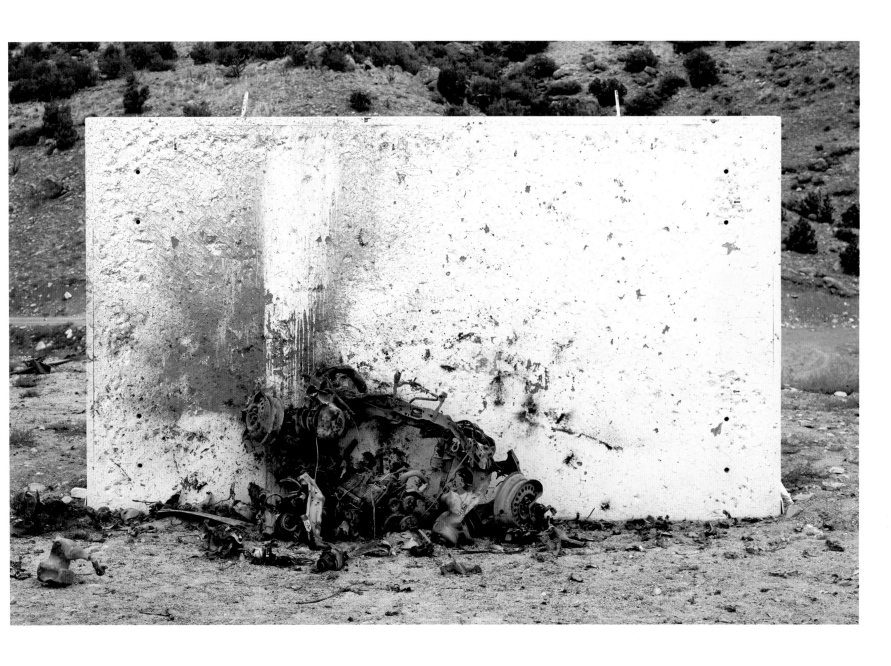

[1] No. 5 (Shooting, Army base, 31/5/2005), from the series "Trackers", 2005, silver gelatin print,
 37 x 55.5 cm, 14.5 x 22 inches
[2] No. 76 (Graduation Ceremony, Army base, 20/4/2005), from the series "Trackers", 2005,
 silver gelatin print, 37 x 55.5 cm, 14.5 x 22 inches
[3] No. 66 (Tent, Army base, 1/6/2005), from the series "Trackers", 2005, silver gelatin print,
 37 x 55.5 cm, 14.5 x 22 inches

Ahlam Shibli makes documentary photographs that engage with the fierce, complex and confusing issues of home, and national and personal identity. Her photography ranges widely, from intimate close-ups and portraiture to landscapes. This disparate and apparently incoherent approach seems to mirror the very essence of her subject. Her series "Trackers" (2005) consists of eighty-five photographs taken over several months in both colour and black and white, and addresses the everyday life of young Palestinian volunteers in the Israeli army, in the so-called Tracker Units. Brought into being by the Israeli Defence Forces, these units of Palestinians of Bedouin descent, with special knowledge of the outlying regions in and around Israel, are deployed on the borders of and within the West Bank and Gaza Strip. Many of these young volunteers see their service in the Israeli army as an opportunity both to improve their home, both at a personal level and as a homeland, to earn enough money to buy a plot of land for building.

Shibli became a tracker herself, following the units during the four months of their basic training between January and July. Avoiding the heroic and dangerous encounters that might have yielded sensational and therefore "newsworthy" images, her camera focuses on the more banal aspects of the soldiers' lives. Her main concern is with ideas of home and how the trackers work hard to achieve a better standard of living for themselves and their families. Shibli's images present the issues in an apparently factual way, but intentionally leave them open to interpretation. They avoid contextualizing the situation with documentary or political statements. It is, however, impossible for us not to engage with the basic issues at stake, such as the extent to which people will go to improve their social and family status. In *No. 37 (Domestic monument, 'Arab al-Shibli, 19/3/2005)* (2005) we are shown the tangible outcome of one tracker's period of service, where a well-ordered and calm domesticity prevails.

Shibli's photographs reveal quiet, perhaps even tender, moments, as in the image of a man slumped across a set of concrete steps, in both physical and mental repose, in *No. 61 (Siesta, Army base, 1/6/2005)* (2005). Shibli shows the men around the training base when they are relaxed, never when they are fighting or defending themselves in combat. Another image of a prostrate man shows him with a towel over his face and is more ambiguous. Is he asleep? Is he dead? Is he weeping? One of Shibli's major influences is Frantz Fanon, who wrote about life as a black intellectual in a white world, emphasising the psychological dimension, in *Black Skin, White Masks* (1952). She feels her work is part of a dialogue inspired by some of Fanon's concerns. Shibli treats her subjects with respect and avoids showing them as merely soldiers in uniform; her images reveal their humanity, and their hopes and aspirations. In Shibli's work, the tensions of the world seem to have dissolved while individual dreams become clear.—Phaidon Editors

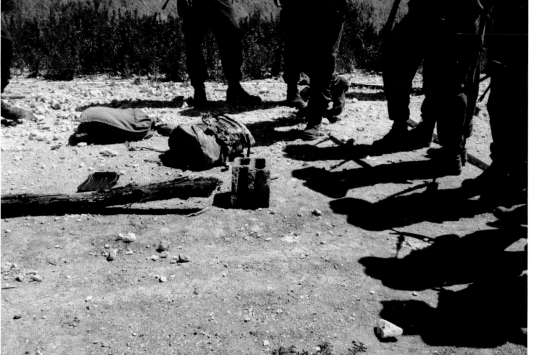

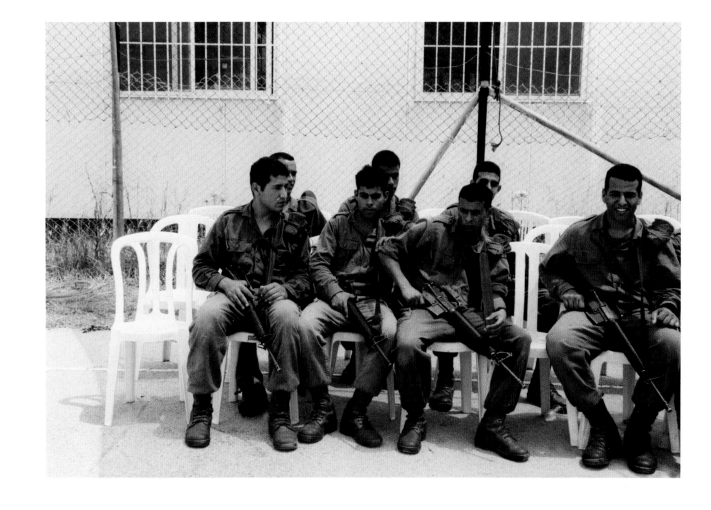

[4] **No. 37 (Domestic monument, 'Arab al-Shibli, 19/3/2005)**, from the series **"Trackers"**, 2005, digital
 print, 37 x 55.5 cm, 14.5 x 22 inches
[5] **No. 61 (Siesta, Army base, 1/6/2005)**, from the series **"Trackers"**, 2005, digital print,
 60 x 90 cm, 24 x 35.5 inches

[1] **Un Ballo in Maschera (VII)**, 2004-5, Giclée print on Hannemühle rag paper, 51 x 76 cm, 20 x 30 inches
[2] **Un Ballo in Maschera (III)**, 2004-5, Giclée print on Hannemühle rag paper, 51 x 76 cm, 20 x 30 inches
[3] **Un Ballo in Maschera (I)**, 2004-5, Giclée print on Hannemühle rag paper, 51 x 76 cm, 20 x 30 inches

Seek out wit and you will often find a site of seductive subversion. **Yinka Shonibare**'s engagements in sculpture, installation, film and photography gratify this search every time. The targets of Shonibare's trickster brand of humour range from cultural expectations of Modernism and understandings of cultural identities, from class identification to universal themes such as the desire for power. Deliberately choosing "Dutch wax" fabric to outfit figurative sculptures and characters in his mise-en-scène photographs and films, he creates textured works that question surface understandings of cultural identities. Though presumed to be authentically "African", the cloth was in fact created by the Dutch in the early twentieth century, inspired by Indonesian designs, produced by the British in Manchester factories and then sold to the West African market. The apocryphal belief that the material is truly African has made it an essential constant in Shonibare's work, for it functions as a metonym, a stand-in for the tenuous foundations of cultural assumptions exposed by Shonibare's formal and figurative interventions. His use of the fabric points out the bi-directional influence of colonialism, highlighting not only Europe's effect on Africa, but also the influence of colonies on the seat of former colonialist empires.

Never didactic or histrionic, Shonibare's work derives its seductive yet sharp critique from his sense of play. With the coyly interrogative title for a headless sculpture wearing a Victorian dress made from "African" cloth, *How Did a Girl Like You Become a Girl Like You?* (1995), for example, Shonibare states the question at the heart of his project, investigating interwoven cultures occasioned by colonialism. Shonibare's tightly corseted figures offer an adroit reply, suggesting that colonized Africa provided the support for European lifestyles while colonizing Europe held up inauthentic representations of African cultures. In Shonibare's hands, cloth reveals more than it conceals.

Shonibare's shift into photography is natural—an extension of sculptural gestures into space. In his photographic series "Diary of a Victorian Dandy" (1998), he unsettles familiar associations at the nexus of race, class and authority through staged movement. In these photographs white servants and yes-men fawn over Shonibare, the consistent centre of activity, who assumes postures of power in each scene—receiving lavish amounts of attention and bedside care, proudly accepting displays of adulation, and seductive activity. Substituting himself for a Victorian gentleman in scenes of domestic life, he fashions critique out of what could be a halcyon tableau.

Shonibare conveys the pursuit of power as a universal theme in his film *Un Ballo in Maschera* [A Masked Ball] (2004-5). He directs a cast of actors to stage the assassination of King Gustav III of Sweden in 1792, where women in clothes and masks made from Dutch wax fabric perform all the key roles—king, assassin and co-conspirators. The re-enactment repeats with subtle alterations, indicating that in each circumstance there are always multiple possibilities. Juxtaposing Swedish history and faux African material, he lifts the work out of a culturally specific context and suggests the universality of the struggle for authority.

Trafficking in fabric(ations), Shonibare locates what has fallen in between the fault lines of cross-cultural contact. As in *Un Ballo in Maschera*, where he creates new interpretations through subtle alterations, his work finds form by filling out the contours of fragmented notions of one another. Like an expert tailor, he not only points out a dropped stitch, but nimbly weaves in new thread.
—Sarah Lewis

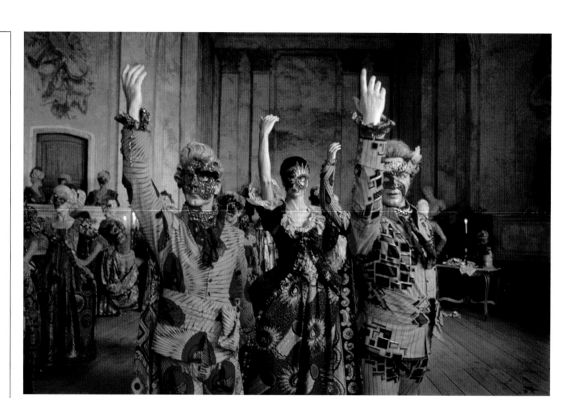

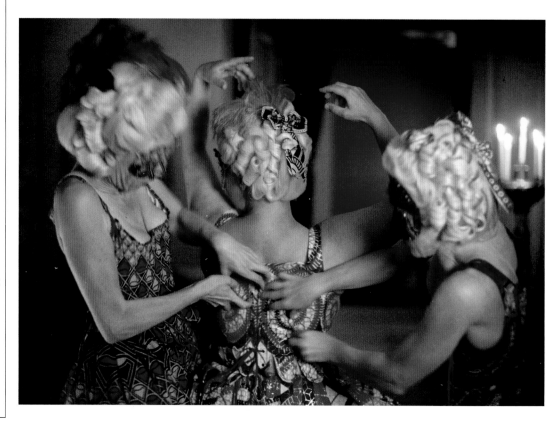

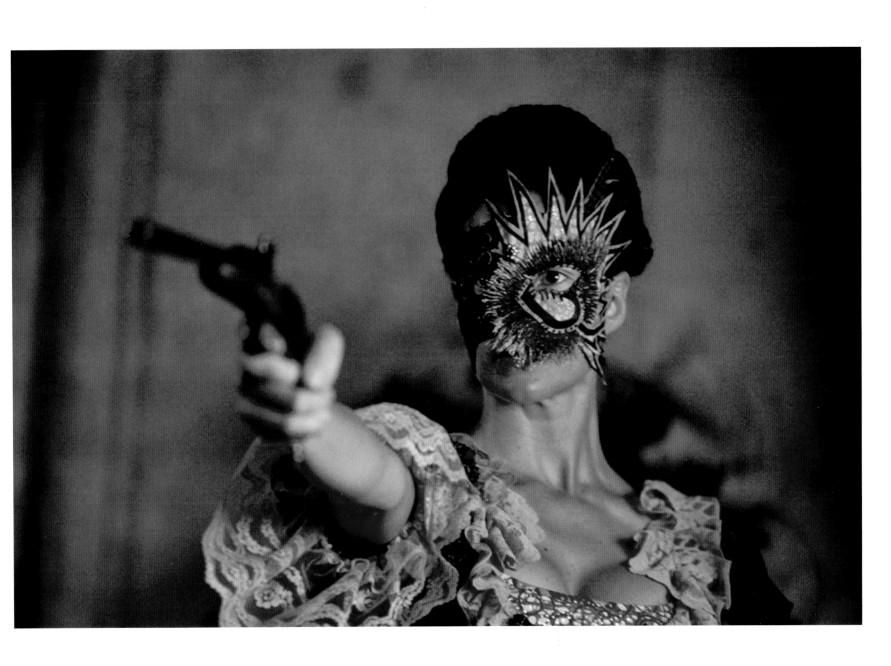

[1] Ma'ale Adumim, from the series "New Homes in Israel and the Occupied Territories", 1998, black-and-white print, 40 x 50 cm, 15.5 x19.5 inches, collection Fonds National D'Art Contemporain, Puteaux

[2] Jerusalem, Gilo, from the series "New Homes in Israel and the Occupied Territories", 1992, black-and-white print, 40 x 50 cm, 15.5 x 19.5 inches, collection Fonds National D'Art Contemporain, Puteaux

[3] Dr Riad Zanoun – Minister of Health, from the series "Palestinian Cabinet Ministers", 2000, black-and-white print, 40 x 50 cm, 15.5 x 19.5 inches

[4] Hisham Abdel Razeq – Minister of Detainees and Freed Detainees Affairs, from the series "Palestinian Cabinet Ministers", 2000, black-and-white print, 40 x 50 cm, 15.5 x 19.5 inches

Investigating the challenges of representation, identity and belonging, Israeli artist **Efrat Shvily** creates multi-layered photography and video work that operates on the level of objective documentary. Since the early 1990s, Shvily has been quietly documenting the chequered political landscape of Israel, the Palestinian Authority and the peace process. Employing a strictly documentary approach, Shvily avoids sensationalizing her highly charged subject matter, whilst her authorial distance lends sobriety to her black-and-white photographs.

Drawing on the history of photography, as well as photography as political gesture, "New Homes in Israel and the Occupied Territories" (1992-8) is a series of landscape format black-and-white photographs that address the difficulties of identity and belonging in a harsh and inhospitable landscape. The houses and neighbourhoods depicted, unvaryingly constructed in a Modernist architectural style and situated in arid environments, are devoid of human presence or movement. Unclear if they were once inhabited and are now abandoned, or are just built and soon to be occupied, these apparently empty and anonymous homes subtly play upon the problematic relationship between Israelis and their land. Shvily's photographs sensitively address the issues of space, and its occupation, defence and control in extreme conditions.

Disconnected from the context of their immediate environment, these minutely observed photographs appear to mimic reality rather than represent it. The buildings, which seem to have landed in the rocky terrain as if by accident, look like architectural models of past or future dwellings. Rows of half-built poured-concrete foundations and box structures on a hillside seem both in process and interrupted, both invested with hope for a new beginning and abandoned, both a utopia in the making and one that seems impossible to achieve. Further, the photographs possess a surreal and uncanny quality: images of desolate houses and apartment blocks with closed shutters and empty windows gaze out at the viewer revealing no signs of homeliness.

In May 2000, as the peace process, chaperoned by Bill Clinton, appeared to be making strides, Shvily travelled to Ramallah in the West Bank to make a series of "official" portraits of the cabinet ministers-to-be of the state of Palestine. Later that year after Yasser Arafat, in Clinton's words, "missed the opportunity to make that nation into being", riots erupted in Ramallah and the Second Intifada began. Shvily did not return. Her black-and-white photographs of Arabs, attired in Western-style suits and ties staring directly at the viewer, offered a photographic record of the new Palestinian state on the verge of existence. With six portraits still to be taken, the artist decided to leave the project unfinished, marking the end of this short period of history, when peace was so close on the horizon.

Arabs have often been represented in Western art as unruly and exotic figures brandishing swords. Shvily's photographic project broke with this Orientalist portrayal of the archetypal Arab, providing potential Palestinian politicians with an alternative image of representation.
—Alona Pardo

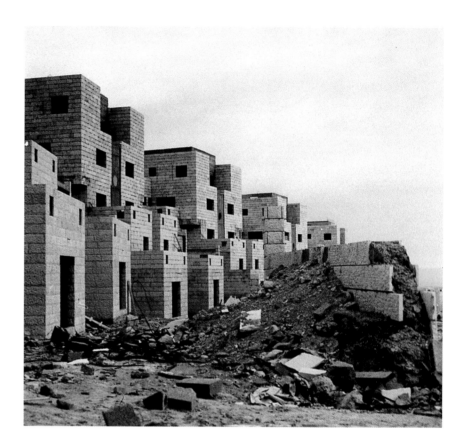

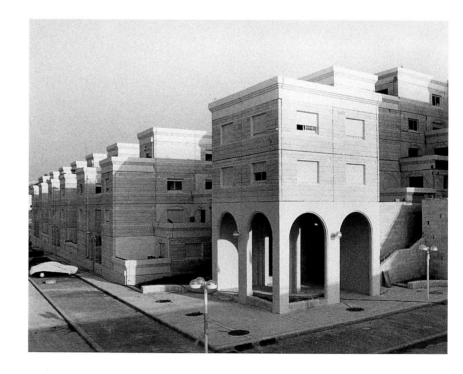

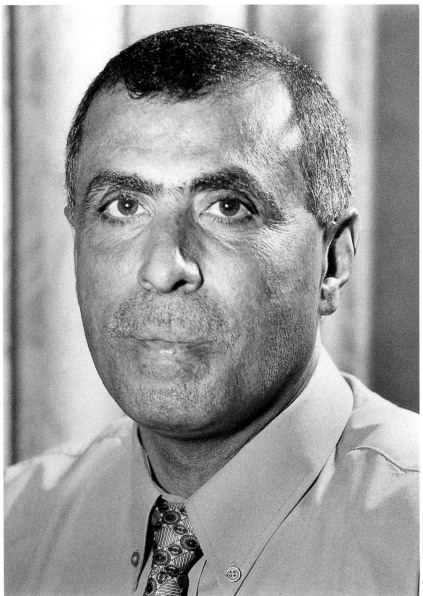

Santiago Sierra directly addresses exploitation and exclusion in the capitalist system by paying beggars, prostitutes and illegal immigrants as well as regular workers to perform, or submit to, a range of unjustified, more or less violent gestures (for example, to masturbate or to be tattooed). Society's margins and those who have been rejected or left behind make up the raw material of these actions. Sierra lays bare the structures that underpin the economy and the community, and draws up a caustic report on the question of power and its connections. Despite the so-called social advances that have been made, and regardless of their culture or nationality, humans remain objects—readymades —and the mechanical sale of their bodies and/or time means nothing more than that. Work has no ontological value; it embodies nothing more than a loss—of time, identity and meaning—and a violence. Sierra's works are acts that demand a precise understanding of their geopolitical context. Hence the black-and-white documents (photographs and videos), along with the accompanying objective descriptions, which sometimes take the form of contracts, such as *A Person Paid for 360 Continuous Working Hours* (2000), are as biting as the performances they relate without the least touch of pathos.

Sierra's deliberately artless images ignore the aesthetic aspects of lighting, cropping, composition and print quality. He does not engage with the fictional potential of photographic representation: what is shot is what happened. Sierra's photographs assume a fully representational function, involving language as reportage alone. This photographic strategy is rooted in the search for and documentation of the real by conceptual photographers and performance artists of the 1970s, and is close to works such as, among others, Adrian Piper's *Catalysis III* (1970) and Vito Acconci's *Seedbed* (1972). Sierra uses photographic mechanical reproduction as a neutral visual record, suppressing any potential for symbolic, anecdotal or expressive interpretation: a simple still image that intrinsically needs its co-dependent caption to be structured and to convey the full artistic construction of the work.

Sierra's practice is founded on an easily identifiable vocabulary of forms. His work relates to the traditions of Minimalism, Conceptual and performance art. Since his beginnings as a sculptor, he has created works at the intersection of minimal sculpture and Land Art (*Cubic Container Each Side Measuring 200 x 200 cm* [1990], *Cement Wall Measuring 300 x 300 cm and Facing Upwards* [1992]). Cubes, lines, squares and modular repetitions are common in his creations (*30 Loaves of Bread Lined Up* [1996]), recalling the aesthetic processes and materials of Richard Serra, Carl Andre and Walter de Maria. His minimalist style of photography responds to the minimalism of his sculptural and performance works: their intense presence brutally contradicts their simplicity of form, deceptive in result (black and white and seemingly artless) but spectacular in reception.

As automatic, anonymous (the photographs are sometimes taken by an assistant) and artless records of reality, Sierra's photographs follow the artist's conceptualization of commercial exchange as useless and of photography as trace or testimony. Sierra's use of photography at degree zero—mechanical, repetitive, anonymous, documentary —is part of a photographic tradition that has played with the authorless potential of the camera as a simple recording instrument. Yet the resulting photographs mean more: they convey the process and the philosophy of a whole and genuine artistic approach.—Vincent Honoré

Santiago
Sierra

[2] [3]
 [4]

[2] **133 personas remuneradas para ser teñidos de rubio (133 people paid to have their hair dyed blond)**,
 Arsenale, Venice, Italy, June, 2001, 2001, black-and-white photograph, 154.5 x 201.5 cm, 61 x 79.5 inches
[3] **Palabra tapada (Covered word), Spanish Pavilion, Venice Biennale, Venice, Italy, June, 2003**, 2003,
 black-and-white photograph consisting of four parts, 153 x 103 x 3.5 cm, 60 x 40.5 x 1.5 inches
[4] **Brazo de obrero atravesando el techo de una sala de arte desde una vivienda (A worker's arm passing
 through the ceiling of an art space from a dwelling), Calle Orizaba, 160, Mexico City, Mexico, January,
 2004**, 2004, black-and-white photograph, 220 x 150 cm, 86.5 x 59 inches

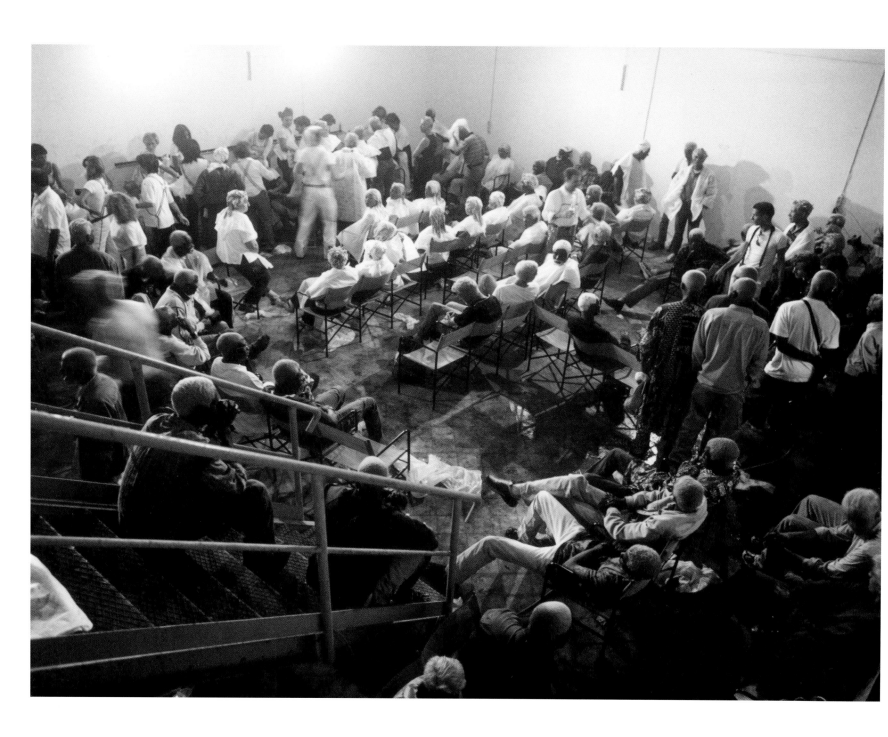

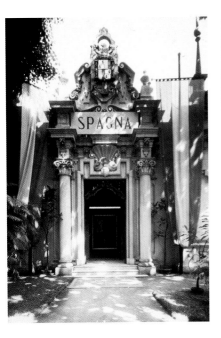
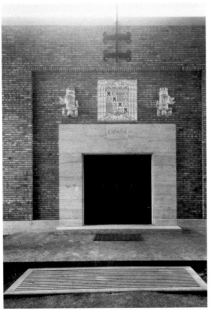
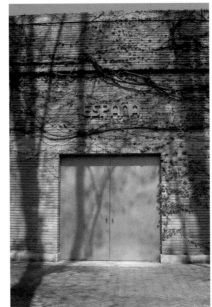
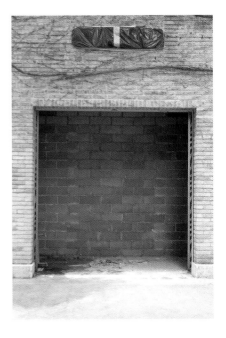
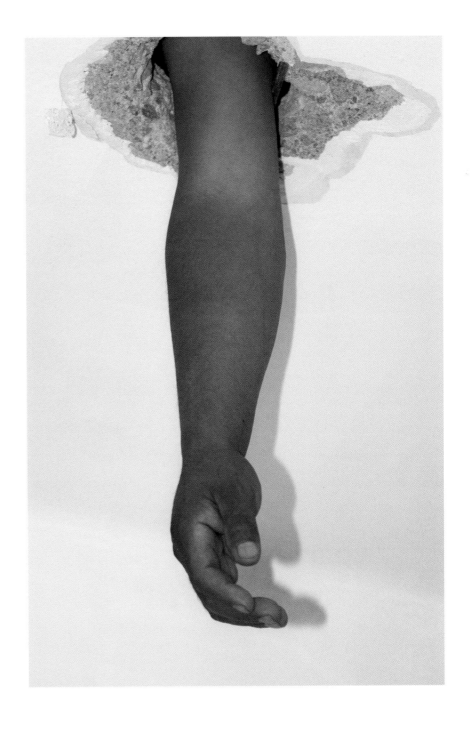

In his photography and film-based works made over the past eight years, **Paul Sietsema** has been consistently investigating the construction of visual perception as experienced through space—the physical evidence of built space, the psychological effects of modern spaces and the formal conventions of cinematic space. Sietsema's works can be seen as a forced intersection of different media—film, photography, sculpture and architecture. Rather than simply extending his photographic repertoire to include architectural or sculptural terms, his photographs address the construction of space as an integral part of their very structure. This intersection generates a sort of "intermediary art", comprised of collaged photographic works that are situated ostensibly in either photography or film, but require the interpretive vocabulary of the other for its explication. He describes his filmic constructions as "attempts to enter worlds that exist within the space of photographic representation".

This complex relationship between media and form is most directly articulated in *Empire* (2002), which includes a twenty-four-minute silent super-16 mm film in six parts, drawings, notebooks and photographs. The work generates a patchwork of locations and time periods, reflecting his interest in the anachronistic nature of mediated histories. Among the key references in *Empire* is the Upper East Side living room of Clement Greenberg as photographed in *Vogue* magazine in 1964, a moment when the formalism championed by the venerable American critic was being replaced by the Pop-orientated work that he had dismissed as kitsch. Sietsema suspends both this lived and historicized moment in a photographic collaged diptych titled *Disrupted Space Drawing (White History)* (2003), made from cut photographs that resemble black-and-white stills of the same room from *Empire*. It not only provides an example of Greenberg's idealized models of abstraction, but also reflects Sietsema's larger interest in locating cultural turning points within Modernism.

In addition to being conceptually charged, Sietsema's photographs are exquisitely crafted in that he produces all of the material that appears in the films and photographs by hand. He shoots in the highly controlled environment of his studio, experimenting with lighting, exposure times and multiple-point perspectives that accentuate photography's materiality. The fact that the photographs are often then cut, layered and taped moves them into that intermediary space between photography and sculpture. This can be seen in the framed work *Organic Sculpture* (2001) or the abstract forms in *Black Sticks* (2001), which suggest a three-dimensional space, as well as in the prismatic blocks of colour that link a black-and-white image to its void within a series of cubes that converge in *Motherwell's room* (2001).

While *Disrupted Space Drawing (White History)* is made from positive images of Greenberg's living room from the film, another photo-based work, *Untitled (Black History)* (2003), also made from cut photographs and tape, conveys the same image but in reverse negative. Together these works present two facets of Sietsema's attempt to point formally to a mediated cultural moment. His decision to use reversal film and print the photos in the negative points to what could be thought of as a crisis in attention; the tension between empirical observation and introspection. It is an attention that bypasses everything non-formal, so that the purely formal aspects can be discovered.—Gloria Sutton

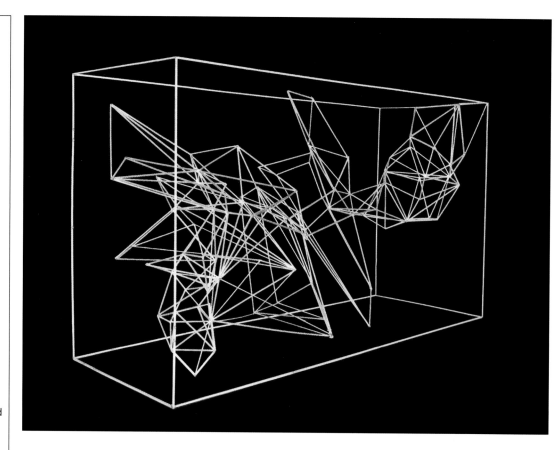

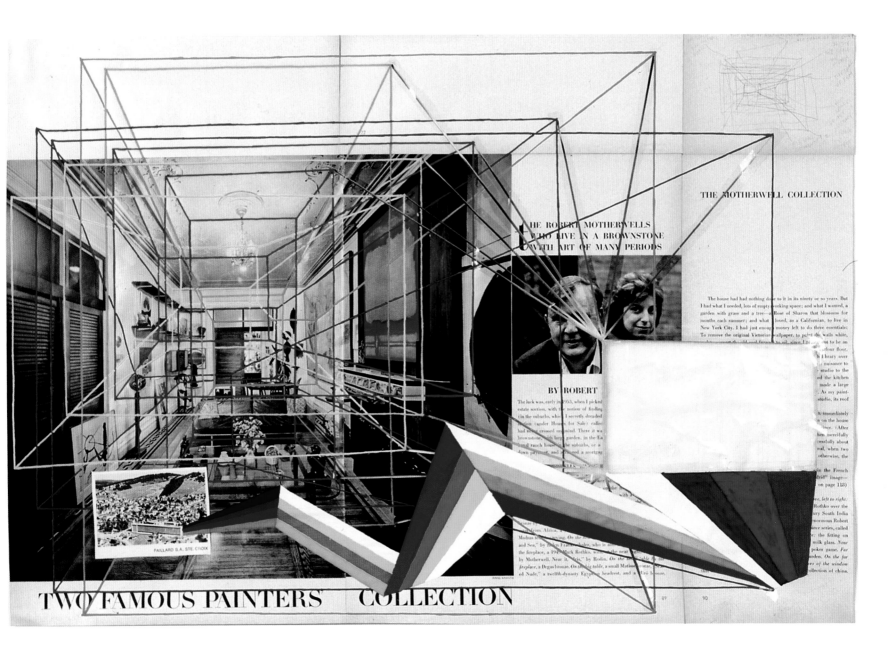

[3] [4]

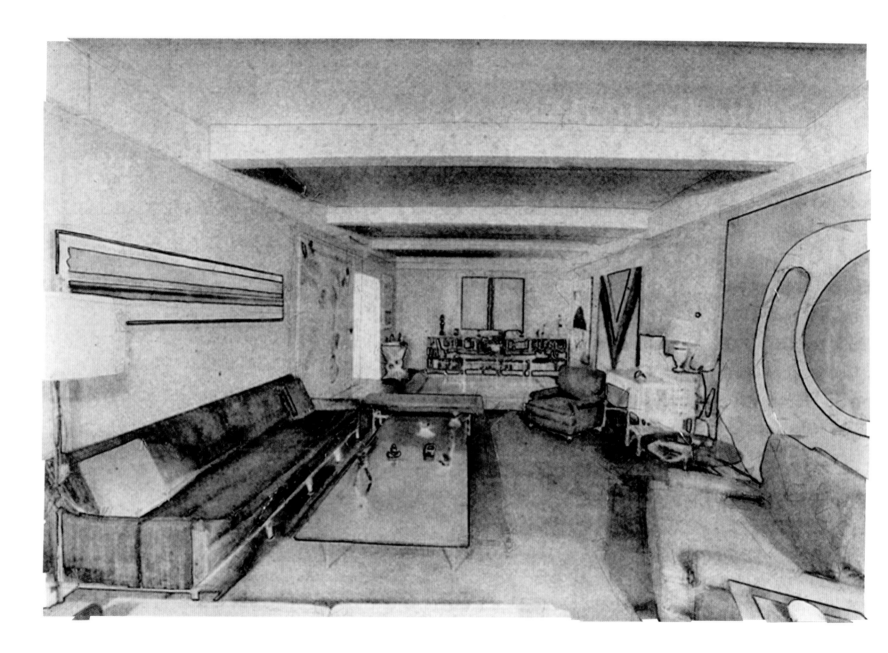

Photography and sculpture maintain a curiously codependent existence in contemporary art and recent artists have increasingly focused their efforts on the interrelationship between these two expressive formats. While the former provides an illusion of space and objecthood within a two-dimensional plane, sculpture asserts itself materialistically in the real, lived space of the viewer. Indeed, the photograph's documentary function is often utilized to record the existence of more ephemeral sculptural presentations. **Alex Slade**'s work since the early 1990s has engaged both photography and sculpture to identify and examine the subtle systems that inform both our man-made and natural surroundings. In doing so, he creates a heightened awareness of our relationship to various environments and how those environments have been and continue to be transformed by human intervention. Slade's work also attentively creates a quiet yet intensive dialogue between the different media that comprise his projects, emphasizing the sculptural nature of the forms and structures that he photographs, as well as the imagistic qualities of the materials he assembles within a space.

His "Fischerinsel" project (1999-2000), for example, featured various interior and exterior views of the eponymous socialist housing project in Berlin. Moving between the seven towers that comprise the building development, Slade created images that are simultaneously evocative and dispassionate, personally expressive in their use of shadows and light, yet also detached in their subjugation to an overall documentary project. The accompanying sculptures underscore this tension between the subjective and the objective, establishing themselves first as formal and physical extensions of an abstracted idea in space, while ultimately revealing their forms to have been determined by the routes that Slade took in documenting the Fischerinsel buildings. One's appreciation of the sculpture's elegant metal lines interrupted by panels of colour (inspired by Ellsworth Kelly's *Sculpture for a Large Wall* [1957]) is qualified by their articulation of the history of the project's very creation. Similarly, an emotional response to the various moods conveyed by the play of light or cloud formations in the photographs is frustrated by their coldly straightforward formality.

A more recent body of work, titled *Wandering Through the Inland Empire* (2005), chronicles the increasing development of various properties in Southern California. Slade's project comprises numerous views of homes in the process of being constructed in relationship to a landscape that still boasts scenic and even picturesque natural formations despite the steady intrusion of power lines, telephone poles, cables and highways. Though the images are informed by an extensive history of landscape painting and photography, their presentation as a whole subsumes their more expressive properties to a categorical sense of purpose. This dichotomy is represented materially in the sculpture that accompanies the photographs—an object that reproduces the "map" of Slade's wanderings through the terrain of the new developments, including his detours and sidetracks that evoke an errant "humanity" within the structure of the grid.—Dominic Molon

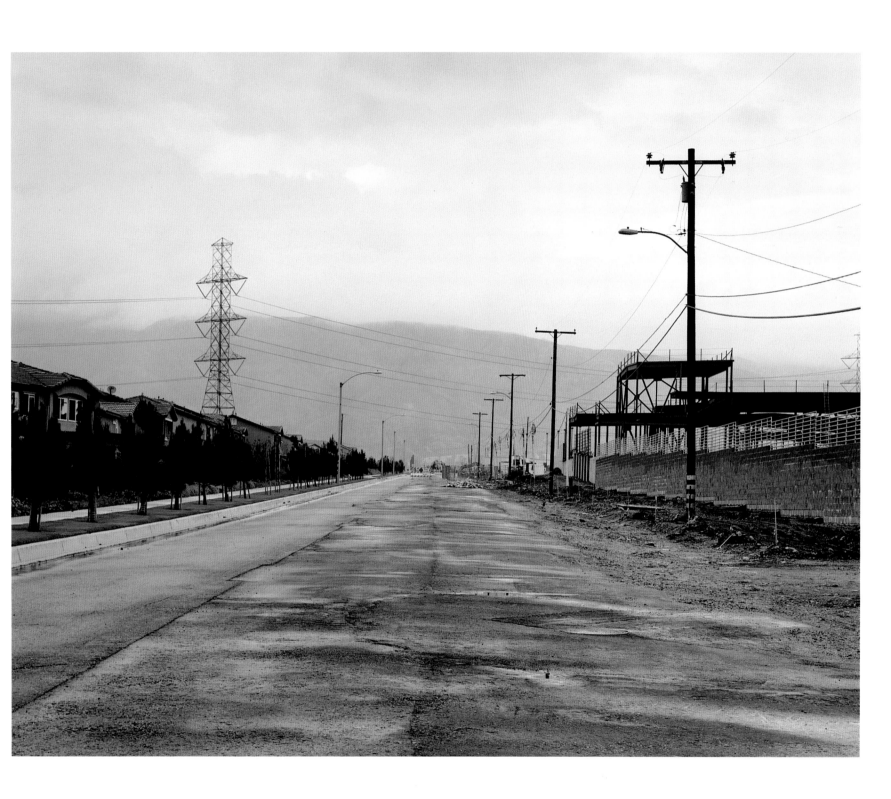

During the last five years, **Sean Snyder**'s photographic project
has exposed and analysed the convergence of geopolitics,
advanced capitalism and the increasingly consolidated mass
media. In "Dallas Southfork in Hermes Land, Slobozia Romania"
(2001), a mixed-media piece that groups photography, video,
architectural models, text and bibliographic references,
Snyder investigates how globalization progresses via the
American culture industry, focusing on the story of a wealthy
Romanian who reconstructed a replica of the ranch house
from the 1980s television series *Dallas* in his home town.
The similarly composed "Bucharest/Pyongyang" (2003-4)
investigates the surprising socialist-style architectural
affinities once shared by two isolationist communist
governments—Romania and North Korea—which was
paradoxically fostered through global exchange. In each
example, photography opens up representation to
contemplative and critical ends.

Snyder's recent work assembles photographs from global
news circuits, including the Internet, Reuters news agency
and the Associated Press, in order to scrutinize the media's
representation of the recent political past. Submitting
these images to structural analysis by uncovering their
formal logic or joining them to sociopolitical investigation
in the form of descriptive captions, he deploys his own
counter-archive as what he terms a "tactical counterpoint
to dominant knowledge". "Untitled, (archive Iraq)" (2003-5)
presents a series of amateur photographs taken by US
soldiers and the army's private contractors, downloaded by
the artist from the web and acquired through media image
suppliers, that document the theatre of operations inside
Iraq following the takeover of the country by American-led
coalition forces. The diptych-orientated presentation is as
tactical as the groupings are unsurprising: Iraqi children
pose guardedly on dirt streets, stunning sunsets light up
desert landscapes, army tanks roll through urban traffic
and bombed-out palaces display their exoticism and former
glory. By pairing random images Snyder elicits forms of
repetition—in terms of composition, theme and viewpoint
—familiar to the conventions of popular documentary
photography. His work thereby both exposes how Iraqis are
commonly fitted into a readymade image repertoire through
which the occupier understands the occupied, and reveals
how war is fought through the power of representation,
dramatized in those images of soldiers with video cameras
attached to their machine guns.

An earlier series, "The Site" (2003-4), investigates the
mass media's coverage of the discovery of Saddam
Hussein's "spider hole". A series of photographs culled from
commercial news archives shows the hideaway and nearby
house of the ex-dictator, as well as their interiors, the
contents of which became the focus of an obsessive
cataloguing effort by every major network. Positioned next
to the grid of photographs, text panels record media
descriptions that humorously cycle through repetition and
variation, inevitably wrongly characterizing the ex-dictator's
belongings. Viewers can thus perceive the flow of
information as it travels from one broadcast to another.
With no conclusions drawn in his work, Snyder pries open
discourse to dissection, a process that is facilitated by the
montage structure of his work. Through the comparative
juxtaposition of images and texts, "The Site" signals the lim-
its of each register and renders insufficient any singular
description of reality. By contesting the media's claims
regarding the truth of their representations, Snyder's project
assumes a heightened urgency as globally circulating
information and power increasingly intersect.—TJ Demos

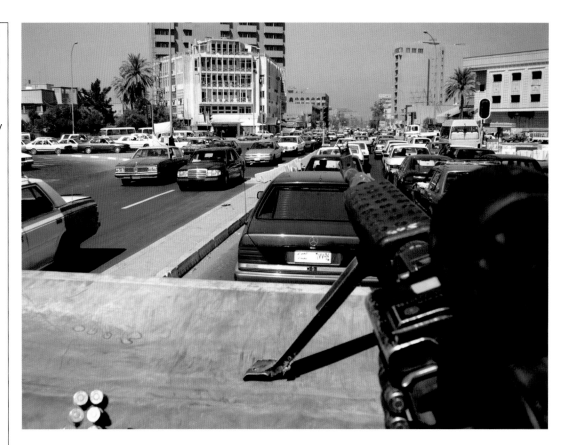

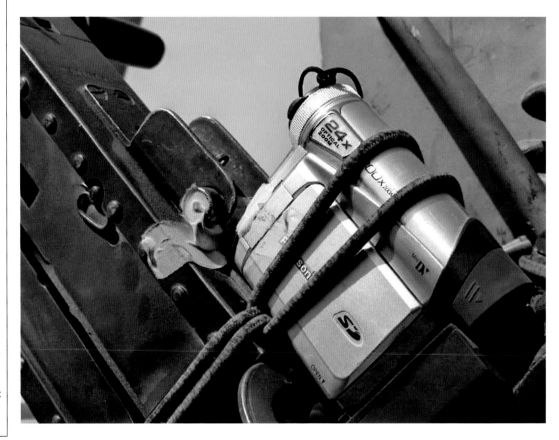

[1-10] From the series "Untitled, (archive Iraq)", 2003-5, digital prints on colour proofing paper presented in grids of 56 images, 13.5 x 19 cm, 5.5 x 7.5 inches

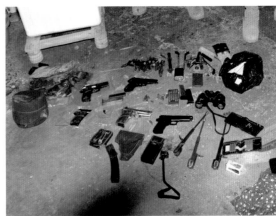

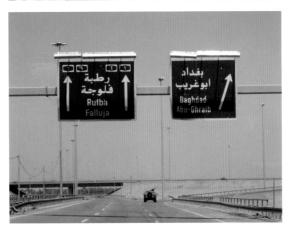

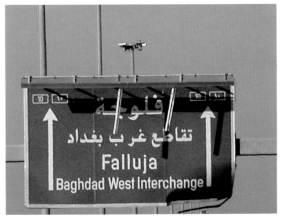

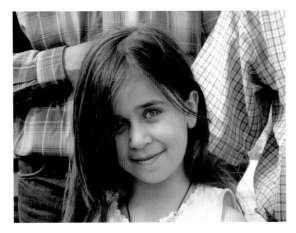

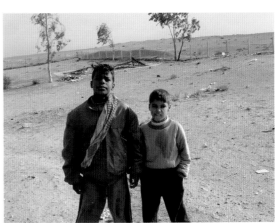

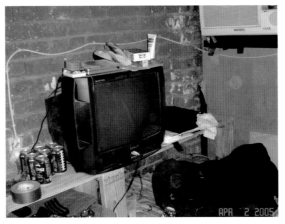

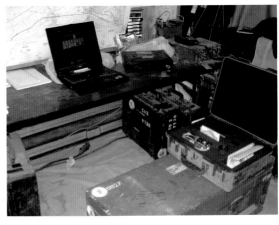

[1] **Melissa**, from the series **"Niagara"**, 2004-5, C-print, 147 x 122 cm, 58 x 48 inches, collection Walker Art Center, Minneapolis

[2] **Michele and James**, from the series **"Niagara"**, 2004-5, C-print, 122 x 102 cm, 48 x 40 inches, collection Walker Art Center, Minneapolis

[3] **Fontaine Bleu**, from the series **"Niagara"**, 2004-5, C-print, 147 x 122 cm, 58 x 48 inches

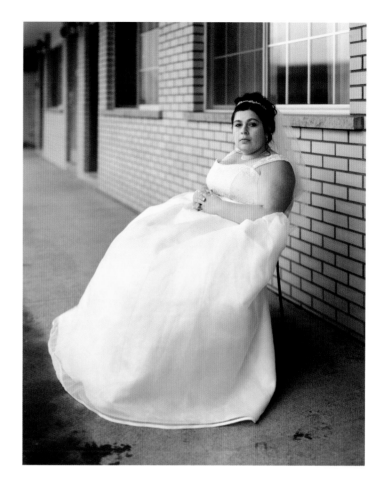

The aesthetic credo **Alec Soth** quotes from Vladimir Nabokov is a surprising one: "Beauty plus pity—that is the closest we can get to a definition of art." Not necessarily a position one might have expected from the butterfly-collecting constructor of chess puzzles, nor one likely to appeal to the proponents of the post-human or the anti-aesthetic in photography or any other art, but then Soth seems comfortable enough with a rather old-fashioned humanism whose virtues seem to have become clearer again now that they are so rare. No wonder he fits as easily into the renowned Magnum Photos stable of independent photojournalists as he does into the gallery world. His first big project, "Sleeping by the Mississippi" (1999-2002), picked up the gauntlet thrown down by such road-riding witnesses of the American hinterland as Robert Frank ("The Americans" [1955]) and Stephen Shore ("Uncommon Places" [1973-81])—especially the latter, thanks to the more contemplative and composed construction of Shore's imagery, a feature shared with Soth's work by virtue of their common predilection for the 8 x 10 view camera, a lumbering device originally made for studio use rather than spontaneous documentation on the street. Soth ventures into more elusive, perhaps more intimate, resonances than his precursors. Although he is far from a Surrealist, "sleeping", with its attendant burden of dreams, rather than the watery reality of the Mississippi River, seems to be the operative term: the series concludes with the image of a bed half-submerged in water and weeds.

Soth's new series, "Niagara" (2004-5), is less about moving around, more about brooding over and digging into a single place, America's honeymoon capital near the Canadian border. Over a century ago Oscar Wilde saw the falls as emblematic of the "disappointments of American married life", and the trays full of hocked rings Soth has photographed in a pawnshop, a handwritten sign advertising "JOY'S DIVORCE PARTY", or an abandoned jacket with the inscription "CRY BABY" still seem to bear out Wilde's mordant observation. Soth's pensive eye, at once ardent and disenchanted, seems caught by the marks and traces of past or future disillusion wherever he looks—these cheap motels seem to have been built for no other reason than to stand as emblems of disheartenment and regret—even as he allows his subjects the dignity of their seemingly inextinguishable hopes and resolutions. If Soth shies away from the narratives towards which his pictures inevitably gesture, maybe it's because he's not sure he wants to know how they will turn out. Yet there is no trace of condescension or caricature in the portraits that form a large part of the series; it is precisely because the photographer seems so wholeheartedly to want to see Aleisha and Joe, Michele and James, Melissa, Rebecca or even the newlywed Fleches, whose "only guests were their children from previous marriages", just as they want to see themselves—because he allows himself to fall in love with them, almost, for the time it takes to make the picture—that the discrepancies between aspiration and reality become so poignant, taking us into the deep Nabokovian mysteries of beauty and pity.
—Barry Schwabsky

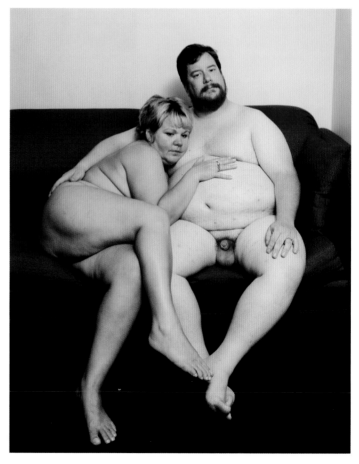

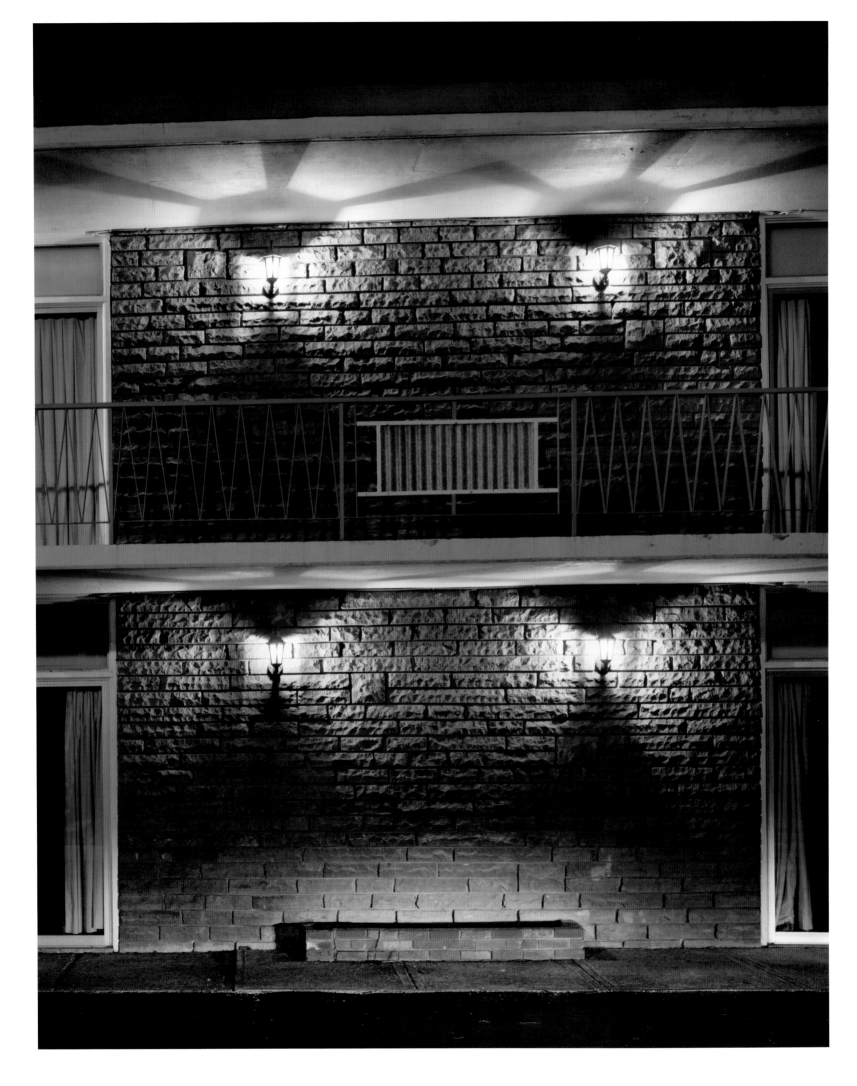

[1] **Botschaft**, from the series **"Im Garten"** [**In the Garden**], 2003-4, fine art print, 120 x 90 cm, 47 x 35 inches

[2] **Punkte**, from the series **"Im Garten"** [**In the Garden**], 2003-4, fine art print, 66.7 x 50 cm, 26 x 19.5 inches

The work of **Heidi Specker** can be understood as a systematic investigation into the visual representation of urban spaces, one that focuses as much attention on the effects of the produced image as on its subjects. The images from her series "Im Garten" [In the Garden] (2003-4) appear at first glance to be a reflection on the coexistence of nature and culture. This impression becomes qualified through the formal composition of the images, which are strongly cropped and have flat, apparently artificial colouring. Comparable with photographs of the *Neue Sachlichkeit* [New Objectivity] movement, the view is quickly directed to the various surfaces of the depicted objects. One observes how the folds of the tree trunk or the plaster on the wall are translated into "image", and how they ultimately texture the photographic surface like an ornament.

"I am interested in the contrast between recorded reality and the effect of the image that I create," says Specker. In the earlier series, "Speckergruppen" [Specker Groups] (1995-6), the artist used digital photography techniques, still crude at the time, and manipulated the images with poor resolution and heightened colour. The limitations of a young technology were used as a tool to create particular effects, and this process was directly connected to the depicted object. Although the portrayed buildings are not individually titled, they appear, in all their blurriness, familiar. The series depicts architecture that had fallen out of view, especially in Berlin post-1989—buildings now commonly considered to be faceless, but which are examples of an internationally formulated and ideologically disputed post-war Modernism in the East and West. Specker's generation grew up with this architecture, yet a visual archive of these buildings was distinctly absent. The "Speckergruppen", arranged like the other series in clusters, form an archive in which the buildings are transformed into almost idealized prototypes.

In later works the effects of digital photography have become more subtle. In "Concrete" (2002-3), produced shortly before "Im Garten", it is no longer the house but its fragmented details and surfaces that are foregrounded. The various grey tones of the reinforced concrete, the preferred material of Modernism, cover the image plane with intermittently abstract patterns. In this series we are given topographical information about the structures, helping to locate them within architectural history. The depicted buildings, such as a lecture hall of the University of Cologne or the National Theatre in London, belong to a later phase of Modernism in the 1960s and '70s that had departed from the first energetic uprisings of the avant-garde, and had already become more self-critical. The "Concrete" series portrays such moments as when the poured concrete itself becomes ornamental, much opposing a functionalist credo. In images from the series "Im Garten" similar motifs are recognizable, such as Egon Eiermanns IBM building in Berlin. The reference to these reflexive architects could be seen as metaphoric, in that Specker seems to share a similar sensibility in the handling of the mouldable material of concrete through her treatment of the digital image.
—Axel Wieder

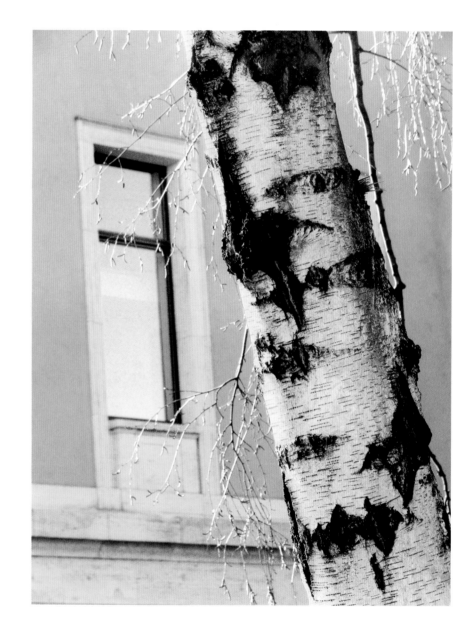

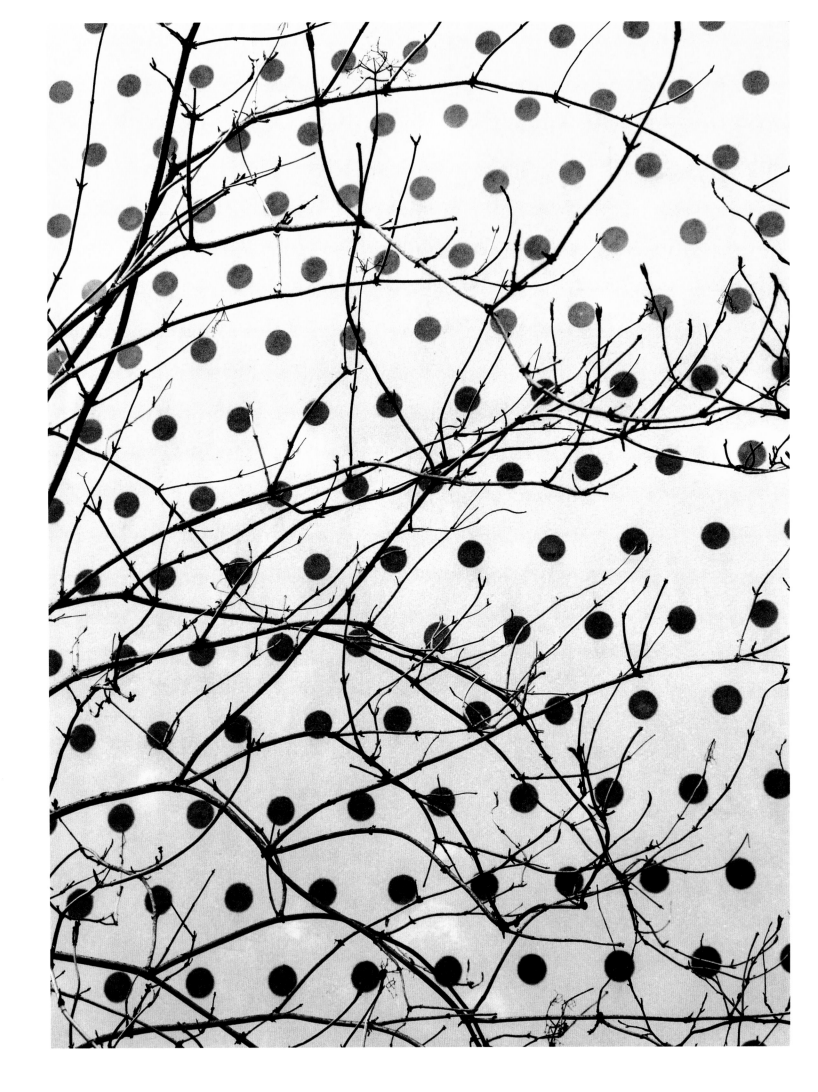

[1] [2]

Hannah Starkey takes fascinatingly ambiguous photographs that demand to be understood but resist easy explanation. While most photographers work in discrete series of closely related images, Starkey does not follow this convention. Even when depicting similar subject matter each photograph is singular. Just as her imaginative labour starts anew with every picture she takes, so Starkey demands that our engagement with the work does the same.

We are compelled to figure out each image, yet given very few conventional cues to help us. Starkey does not even title the majority of her images, preferring to name works by following a simple formula: *Month*, *Year*. Whereas the date-stamp on a snapshot is added to reinforce its objectivity, Starkey date-stamps her work in order to promote subjectivity. The vague timeframe associated with each print is a framing device, the "once upon a time..." that we must complete with stories of our own elaboration. There is however a serious intent underlying this apparently playful deferral of meaning. No matter how long we linger on their seductive surfaces, Starkey's photographs always return us in the end to the plight of their isolated subjects. She causes us to reflect on the real social relations that her fictions subtly allegorize.

Despite the singularity of her images, as Starkey's work develops it is inevitable that we search for overarching concerns in her practice. The sequential dating of otherwise disparate pictures further encourages us to seek an overall direction in the work, to discern its artistic progress. Starkey certainly seems to be working in phase with contemporary practitioners of constructed photography. Along with many others, she has switched from meticulously staging her photographic tableaux to assembling them digitally from discrete elements. Impossible reflections, enhanced colours and *trompe l'oeil* devices are now apparent where we were formerly accustomed to improbable events and psychologically revealing nuances.

These developments could be explained as Starkey exploring the ways in which the photograph is brought into a new relationship with the painterly as a result of the possibilities presented by digital imaging. Or perhaps, like other artists indebted to a cinematic aesthetic, she is simply tracking the film industry, emulating its move away from expensive in-camera effects and towards cost-efficient postproduction. Yet neither of these explanations feels convincing. Unlike Jeff Wall, Starkey is not interested in making overt references to the history of painting. Nor is she concerned to appropriate cinematic imagery, like Cindy Sherman. In fact, if we catch any allusions in her work it is to classic female photographers: an echo of Diane Arbus, a compositional device reminiscent of Helen Levitt. Rather than entering into a dialogue with art or film history then, it is the photographic tradition of urban documentary that Starkey's practice updates. Making use of digital manipulation, she reveals the postindustrial urban environment to be more expressive than its inhabitants. Her famously ambiguous subjects have become all the more so, reflecting the increasingly uncertain status of the human in the twenty-first century.—Luke Skrebowski

[1] **Newsroom 2005**, 2005, C-print, 122 x 163 cm, 48 x 64 inches
[2] **May 2004**, 2004, C-print, 122 x 163 cm, 48 x 64 inches

[1] **Newsroom 2005**, 2005, C-print, 122 x 163 cm, 48 x 64 inches
[2] **May 2004**, 2004, C-print, 122 x 163 cm, 48 x 64 inches

[3] [4]

[3] **March 2002**, 2002, C-print, 122 x 183 cm, 48 x 60 inches
[4] **Library 2005**, 2005, C-print, 122 x 152 cm, 48 x 60 inches

[1] Bicycle Wheel (Failed), 2004, platinum palladium print, 30 x 26.7 cm, 12 x 10.5 inches

[2] By Night the Swiss buy cheap-rate electricity from their neighbours which they use to pump water into holding reservoirs. By day they use the stored water to generate hydro-electric power which they then sell back to their neighbours at peak-rate prices (After Christopher Williams/After Jean-Luc Godard), 2005, 21 framed platinum/palladium prints, 104 x 130 cm, 41 x 51 inches (each 41 x 51 cm, 16 x 20 inches)

[3] One Ton II (installation detail), 2005, 5 handmade platinum/palladium prints of the Anglo American Platinum Corporation mine at Potgieterus, South Africa, produced using as many platinum group metal salts as can be derived from one ton of ore, 85 x 65 cm, 33.5 x 25.5 inches

Simon Starling initially used photography as an essential part of a broadly sculptural practice. Often his projects involved sourcing a natural material from a place of origin, transporting it to a place of transformation, and then exhibiting a finished sculpture in a third site, the gallery. In the exhibition, Starling's photographs, printed on take-away posters or reproduced in accompanying catalogues, would display the sculptural material in earlier configurations at the previous two locations. In this way the photographs contributed to the overall work by supplying a narrative of its production, and also served to undermine the primacy of the exhibition space, insisting that the previous sites were just as essential to the overall work as the final one.

Photography had a documentary role in these early projects, but it also functioned to provoke the viewer's imagination. Though he had undertaken all the journeys himself, it was important for Starling to keep his own image out of the photographs. These were not to be typical documents of "sculptural process", but should instead prompt the viewer to imagine the transformations and transports of the materials more freely. Photography's fantastical capacity became even more crucial in *Burn Time* (2000). Starling made a model of a museum dedicated to Bauhaus designer William Wagenfeld, and installed the model as a henhouse on a chicken farm in Scotland. The model was eventually brought to exhibition and disassembled, its wood used to fuel a stove on which the eggs were cooked in Wagenfeld's coddlers. Starling's photographs showed the Scottish scenario, and in front of the miniature museum the hens appeared as giant monsters, extraordinary creatures in an otherwise mundane landscape.

By 2001, Starling began to consider the photograph as a sculptural object in itself, made from specific materials, and produced in particular places for precise economic reasons. Invited to make an exhibition at FRAC Languedoc-Roussillon in Montpellier, France, Starling discovered that the institution's catalogues were made in Romania. The photographs that would document his exhibition would thus be printed, collated and bound into a catalogue at a site chosen because of its economic status, where production costs were low. Determined to acknowledge this situation, Starling made the production process of the catalogue into the very subject of his project, travelling to Romania to take photographs of the printing works there. Stacks of these photographs were presented back in Montpellier as his finished sculpture and the exhibition space reconfigured to resemble the Romanian printing works: the economic preconditions of photographic production were therefore laid bare.

In a series of more recent projects, Starling has produced photographs using the almost-extinct platinum printing process. The most reflexive series of these are five identical photographs, such as *One Ton II* (2005), of the South African platinum mine where the metal used to produce the photographs is sourced. One ton of ore must be mined for the few grams of platinum necessary to make the five photographs, and then the material must be transported from Africa to Europe. As one admires the beauty and detail of the prints, so the work as a whole acknowledges the absurd waste required for its production, a kind of expenditure typical in today's over-resourced environment. Rather than celebrating platinum printing as a romantic and obsolete mode of pre-digital photography, Starling therefore uses the antiquated process to address questions of materiality and globalization in the immaterial context of digitization.
—Mark Godfrey

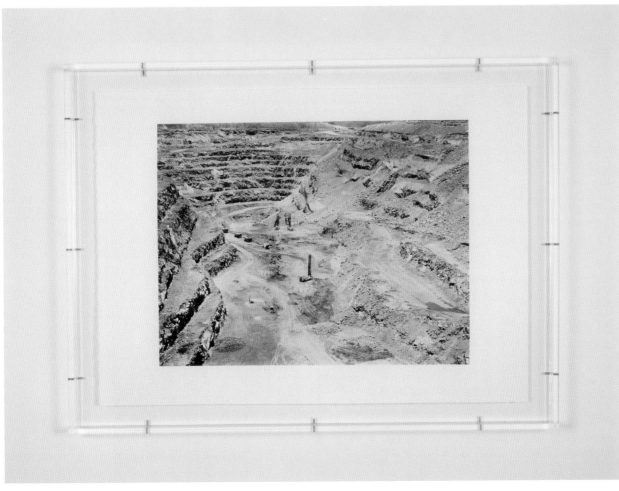

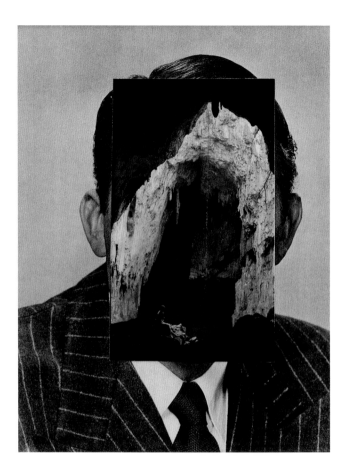

John Stezaker is not a photographer but, like many artists
of whom the same is true (among them John Baldessari or
Thomas Bayrle), his art is entirely concerned with photography
—or rather with photography's poor cousin, photomechanical
reproductions. He was part of the early wave of conceptual
artists in London—his peers include such figures as Victor
Burgin and John Hilliard—and he has recently re-emerged
on the gallery scene after a long absence. Among his most
fascinating images are those from the ongoing "Third Person
Archive", some three decades in the making, in which found
urban scenes from the 1920s are cropped and enlarged
so as to call attention to the isolated, anonymous passers-by
who so fleetingly and futilely populate their otherwise
vacant streets and piazzas, reminiscent of the settings of
Giorgio de Chirico's metaphysical cityscapes, but somehow
bleaker, thanks to their resolute literalness, and because
they evoke some sort of primitive surveillance. Yet they are
also poignant in their sense of humanity at loose ends,
harbouring a nostalgic atmosphere that envelops the viewer
in the romance of lost time.

The colour images in Stezaker's "City" works (2000-4), by
contrast, view the urban landscape from too great a distance
for the individual figure to count for anything. In fact, the
jagged geometries of these metropolitan agglomerations seem
irrational and possibly uninhabitable—dizzying Piranesian
prisons for the gaze. These images are entirely foreign
to any system of perspectival construction, and one might
think they had been collaged together from dissonant
shards of unrelated scenes. Oddly, their malign fascination
does not dissolve when one notices the absurdly simple
trick behind them: Stezaker has simply taken existing pictures
and turned them upside down. On the contrary, one suspects
that the artist has perfected a system for seeing into the
truth of these places.

Precisely because the "City" pictures are the least
manipulated of Stezaker's works, they manifest with greatest
clarity the "art of seeing" he has cultivated. It's paradoxical:
there is something ponderously slow, yet also lightning
fast about these pieces. One imagines the great patience
involved in looking through multitudes of images to find
ones that would work for the "City" images as for the
"Third Person Archive", and then the decisive moment of
recognition: a stillness and then a swooping down on
something so minute another sort of eye would not have
noticed it. Stezaker himself has spoken about a "cut", a
"decisive interruption of the flow" of images.

More open and playful, on the other hand, are Stezaker's
collages, often made from magazine photographs from
the 1950s and '60s. In the "Underworld" and "Film Portrait"
works, the silhouette of one figure has typically been
superimposed on the positive image of another, this "shadow"
often being filled in with some completely unrelated
landscape (sometimes sideways) or even the features of
some third face. Whereas in the "City" group and "Third
Person Archive" we sense that the artist is merely noticing
the "unconscious" that was already in the images, the
collages represent a conscious construction, and evince
a broader humour.—Barry Schwabsky

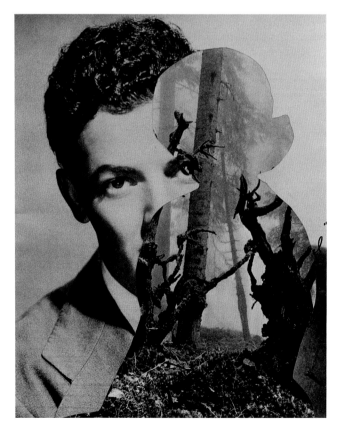

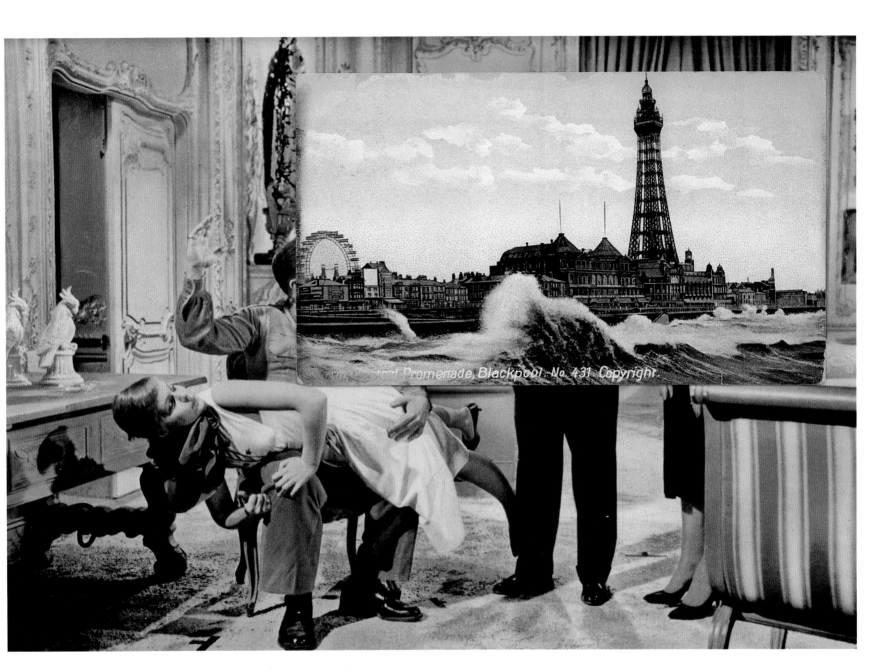

[1] [2]

Clare Strand's crisp and chilling photographs confront us with evidence of our fears, loneliness, decay, frailty and death. She photographs what philosopher Julia Kristeva refers to as "the abject", or "what we permanently thrust aside in order to live".

For her 1994 series "The Mortuary", Strand photographed post-mortem devices. Her radiant images of shiny, cold-looking, metal objects used to pull us apart and splice us back together mock any sentimental fear of death. By the same token, a 1995 photograph of a banal and benign waste-paper bin overflowing with torn pink paper becomes horrific when it is coupled with the title, *Shredded tax bills used to fill body cavities*.

Strand also brings a sense of disquiet to the subject of childhood. In 1997 she created portraits of awkward, average-looking teenage girls standing before red cloth backdrops, like the hangings used for school pictures, for her "Spots and All" series. She included a quartet of isolated portraits of English girls, aged ten to twelve, posing as the four Spice Girls. Falling far short of the band's simplistic "Girl Power" jargon and persona, these pre-teens pressing close to Strand's camera and preening in tawdry approximations of the Spice Girls' costumes appear insecure, vulnerable, feral and precociously jaded in their prematurely provocative yet unflattering poses. By contrasting her young subjects with the stereotyped range of femininity embodied by their role models, Strand highlights how beauty, not "personality" or individuality, predetermine viewers' sympathies and projections for the girls' futures. *Sporty Spice: Katie Murphy, aged 10 years* (1997), a pixyish, big-eyed brunette leaning in aggressively towards the camera, possesses unassailable star power and appears genuinely "empowered" by adopting her popstar role model's image, while *Baby Spice: Charlotte Evans aged 10 years* (1997), a chubby redhead puckering her lips and squeezing her round shoulders tight to push up a non-existent cleavage, just seems deluded.

As an artist in residence at London College of Communication, Strand created "Gone Astray" (2002), a project inspired by Clerkenwell, the southern-most part of the London Borough of Islington, where Charles Dickens set scenes for *Oliver Twist*. To represent this historically rich area, she wrote a series of fragmented stories and constructed a cryptic narrative—read by her and her partner Gordon McDonald—to accompany portraits she took of distressed, damaged and dishevelled subjects (such as a pretty office worker with a conspicuous rip in her tights) standing against generic Victorian photo-studio backdrops decorated with Arcadian landscapes. "'Gone Astray' is the product of research looking at City commentators from Baudelaire to Jarvis Cocker, as well as being a personal diary of observation and experience," explains the artist.

In 2004-5 Strand carried out a fellowship for the IPRN at the Folkwang Museum in Essen, Germany. Here, with the one-word brief of "Work", she made her most recent series, entitled "The Betterment Room – Devices for Measuring Achievement" (2004-5). This body of work consists of a sequence of time and motion type images—inspired by the Gilbreths amongst others—depicting static post-industrial workers, as well as the "Cyclegraph" (2004-5) series, recording, through light traces, the artist's actions whilst making the project. In "Work", Strand highlights the loneliness of labour, and here, as in all her work, she can be seen to illuminate Kristeva's insight that "there is no imagination that is not, overtly or secretly, melancholy".
—Ana Finel Honigman

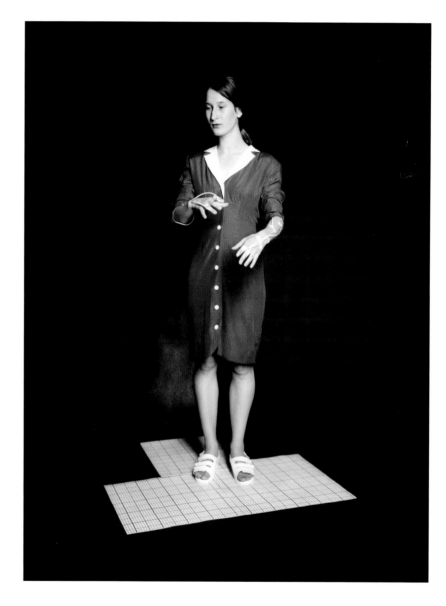

[1] From the series **"The Betterment Room – Devices For Measuring Achievement"**, 2004, matt heat-sealed lightjet print mounted on MDF, 121.9 x 166.4 cm, 48 x 65.5 inches

[2] **Cyclegraph 11. Sorting through Healthy Living Catalogue (left to right)** from the series **"The Betterment Room – Devices For Measuring Achievement"**, 2004, matt heat-sealed lightjet print mounted on MDF, 121.9 x 157.5 cm, 48 x 62 inches

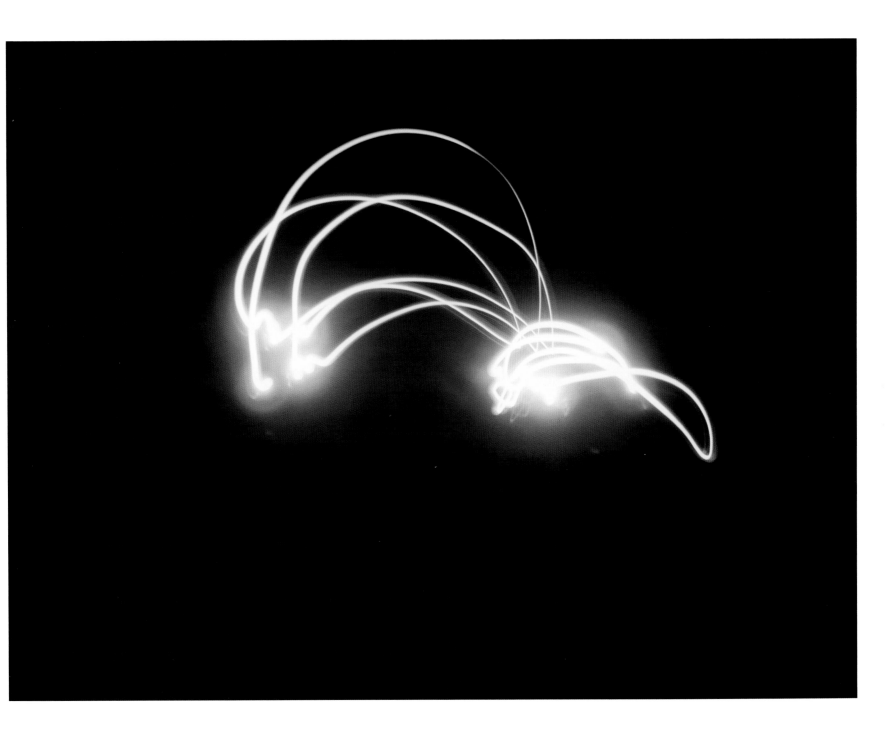

[3] [4]
 [5]

[3] From the series **"Gone Astray Portrait"**, 2002/3, fibre-based bromide print mounted on PVC,
 suspended in white frame, 134.6 x 109.2 cm, 53 x 43 inches
[4] From the series **"Signs Of A Struggle"**, 2003, web-based work scanned from 10 x 8
 black-and-white prints, dimensions variable
[5] From the series **"Gone Astray Detail"**, 2002/3, matt heat-sealed lightjet print mounted on PVC
 with black frame, 101.6 x 76.2 cm, 40 x 30 inches

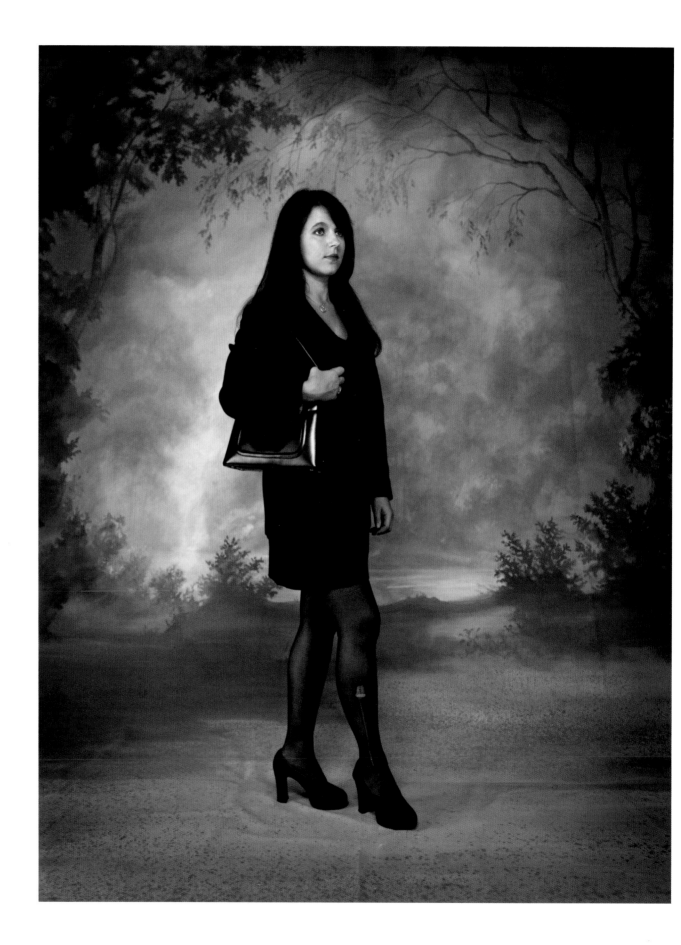

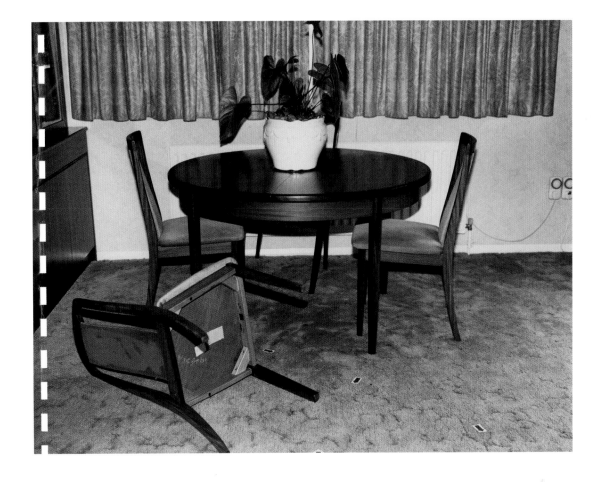
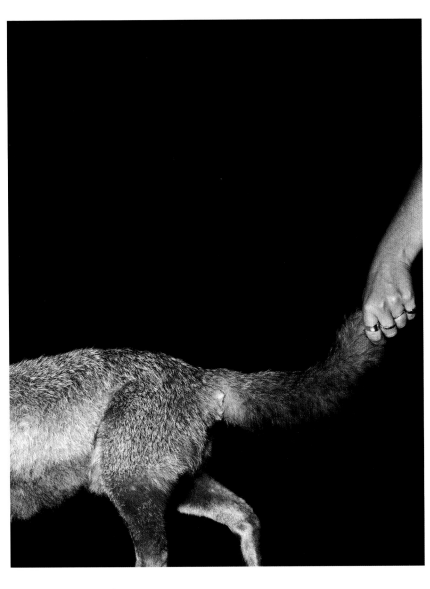

Darren Sylvester's work has been extensively compared to advertising. In fact, his extremely orchestrated scenarios, his precise control of every aspect of image production—from casting to makeup and costumes, from lighting to final print—and the flawlessness of the results mimic the core features of contemporary commodity imagery production.

The artist himself has not denied this affinity. But Sylvester's photographs have a distinct appeal, quite far from the goals of advertising. On the one hand, they are accompanied by eloquent titles that displace the emphasis on situations and objects to often ambiguous statements on emotions, communication, alienation, human relationships and contemporary life. Through these titles the artist directly addresses his viewers, making the images the occasion for the manifestation of a world-view, a perspective that reflects on but also surpasses the way advertising and consumer society frame our living experience. On the other hand, Sylvester's images function in a very different way. While commercial imagery extracts common situations from the everyday and turns them into something extraordinary, the artist prefers to highlight prosaic events as they happen day by day, suggesting that any single moment of our lives could be arresting. But maybe there is nothing more than that ... as the artist has stated in an interview; "Often a banal object can bring some sense of completion—happiness—if only for a short while, and I think that's the best we can hope for." Sylvester likes to consider his work as post advertising: "It's about what happens when you buy something and nothing changes," he has declared in the same interview.

Though he states that there is no irony in his photographs, they convey something quite disturbing. *If All We Have is Each Other, That's OK* (2003) shows a group of happy girls sharing a fast-food meal; they seem to be having a good time but it is not clear whether their happiness will last beyond the brief glamour of their food. The constant association of emotions with commodities induces a transient character in the former. In such works as *Your First Love is Your Last Love* (2005) and *Single Again* (2005), emotional breakdowns are also connected to consumed junk food. Within this universe, feelings are often fragile and vulnerable, upsetting and uneasy.

Sometimes this outlook jumps from the personal to the universal, as in *For the Most Part Humans Seem Ugly and Annoying* (2003), a picture that depicts a young man inside a car viewing dusk. Together with *Let Hopes and Dreams Be Things We Can Achieve* (2005), a photograph that shows a couple facing an imposing landscape, they have a clear connection to the metaphysical overtones of Romantic painting, where human beings are frequently overwhelmed by the immensity of nature. Another reference to painting could be found in the glossy artificial beauty and the transitory nature of many of his ad-like scenes; a kind of *memento mori* of our time. Still-life painters used to show that "all beauty will perish" ... like the charm of commercial products and fast food, one might add.—Rodrigo Alonso

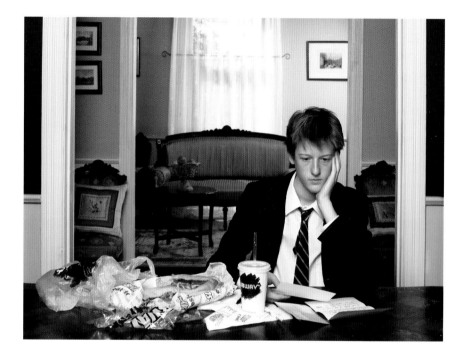

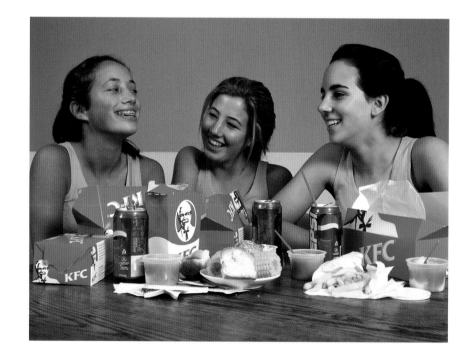

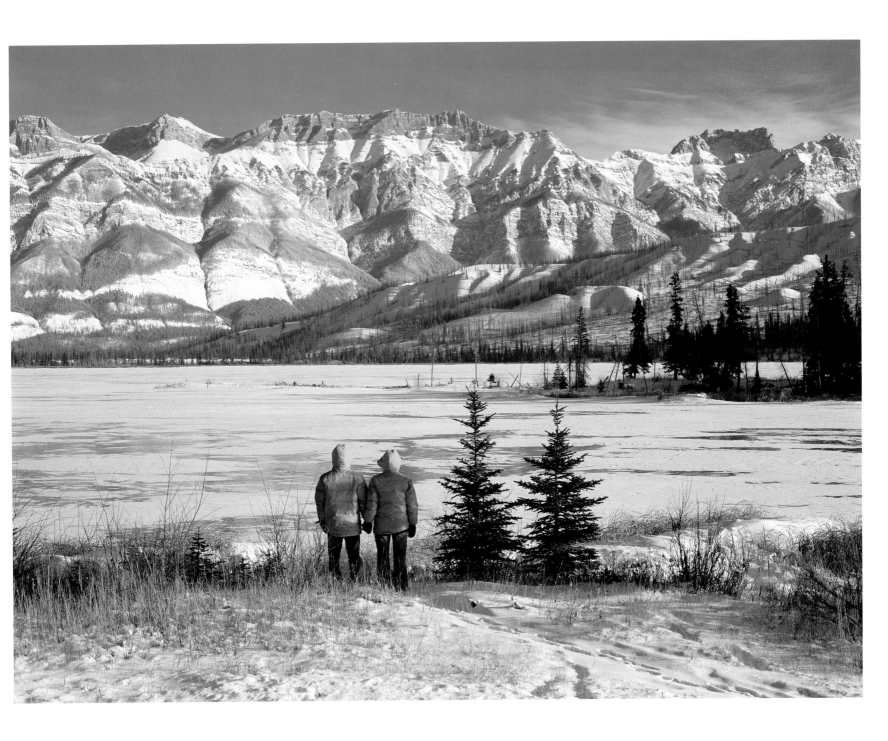

[1] Mobutu Sese Seko's looted residence at Gbadolite, Democratic Republic of Congo, September
 2004, from the series "Leopold and Mobuto", 2003-4, archival pigment ink on 300 g coated cotton
 paper, 47.5 x 73 cm, 18.5 x 28.5 inches

[2] On the road between Bikoro and Mbandaka on the Congo River, Democratic Republic of Congo,
 September 2003, from the series "Leopold and Mobuto", 2003-4, archival pigment ink on 300 g
 coated cotton paper, 54 x 79 cm, 21 x 31 inches

[3] Russian AN-12 cargo plane loads goods for Kinshasa, Goma, Democratic Republic of Congo,
 September 2003, from the series "Leopold and Mobuto", 2003-4, archival pigment ink on 300 g
 coated cotton paper, 47.5 x 73 cm, 18.5 x 28.5 inches

Guy Tillim's professional trajectory exemplifies the radical shift that has taken place in South African photography in the years following the end of apartheid. Photojournalists who had embraced the medium for its confrontational quality, and ability actively to contribute to the struggle against state oppression, found themselves stripped of the central object of their work, and of their certainties. Like many of his colleagues at Afrapix, the Johannesburg-based self-funded group of freelance photojournalists that operated throughout the 1980s, Tillim was forced to redefine thoroughly his relationship with the medium of photography. "My brand of idealism, that had its roots in the time I started photographing in South Africa during the apartheid years, has dimmed. There was right and wrong, it seemed clear to me on which side I stood. One would forgo what I might now call subtlety for the sake of making a statement about injustice," Tillim commented in the 1990s.

While he continued to work in a reportage mode, and in association with international media groups, Tillim's photographs developed into more precise, cogent responses to social and political realities, and he has seen his work become increasingly recontextualized within art books and galleries. The main thread of Tillim's work from the post-apartheid years is maybe one that could be defined as the "post-war moment". During the 1990s, he embarked on a journey around the world, connecting disparate places from Guyana to Kabul, Transkei to Jerusalem, recording the aftermath of wars or violent happenings, focusing on the physical residue and psychic ghosts that haunt conflict zones. Looking at these images, the viewer is reminded of the broader context of conflicts, not through reports of bloody violence but rather in the textures (a bullet-riddled wall, a cracked windscreen) and details (an amputee's prosthesis, an ominous helicopter) that constitute the background of seemingly ordinary everyday scenes and activities (children playing or swimming, people dancing, working or watching television).

Tillim has also researched the conflicts and civil wars that have taken place in Africa, again by turning his lens to the scars that the African landscapes bear rather than directly to the carnage that these wars have wrought. In one of his most praised series to date, "Leopold and Mobuto" (2004), he examines the impact of the Congolese tragedy—the move from the colonial era to post-colonial independence and the contemporary situation—through details of palaces in decay, serving as metaphors for the corrosion of a nation and the dissolution of power structures. The "Johannesburg" series (2004), his first significant work since returning home from his extensive travels, reports the radical transformation of the city since the end of apartheid, and how it has become yet another field of violent contestation, between extreme wealth and extreme poverty. In this series, Tillim considers the private lives of the people who are the often forgotten subjects of the decay and renewal of apartment blocks in the city. He documents another type of war in contemporary South Africa: a war between the haves and have-nots, not the aftermath this time, but a war in progress, not dissimilar to the one that was raging in South Africa during the apartheid years—the origin of his vocation to be a photographer.—Thomas Boutoux

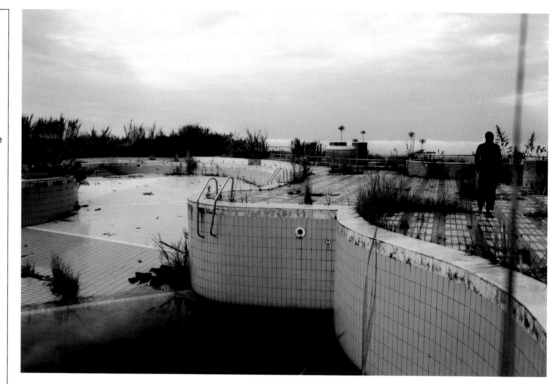

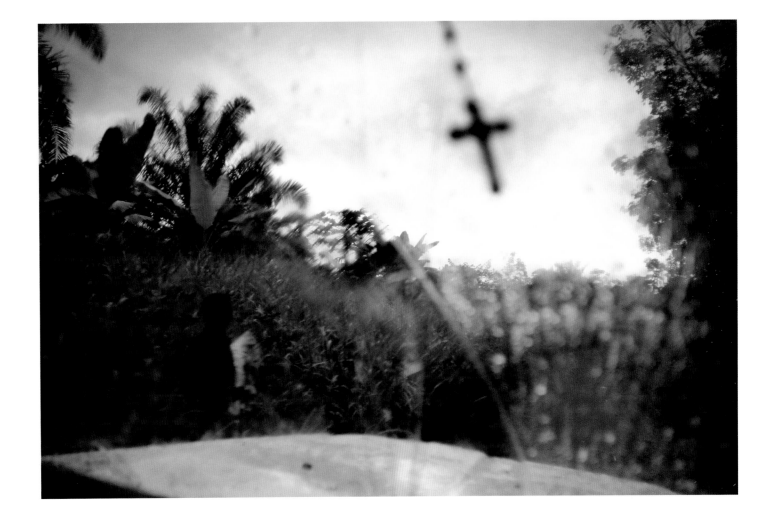

[4] [5]

[4] **View of Hillbrow looking north from the roof of the Mariston Hotel, Johannesburg, South Africa, 2004**, from the series "**Johannesburg**", 2004, archival pigment inks on 300 g coated cotton paper, 42 x 59.4 cm, 16.5 x 23 inches

[5] **Manhattan Court, Plein Street, Johannesburg, 2004**, from the series "**Johannesburg**", 2004, archival pigment inks on 300 g coated cotton paper, 49.6 x 71.5 cm, 19.5 x 28 inches

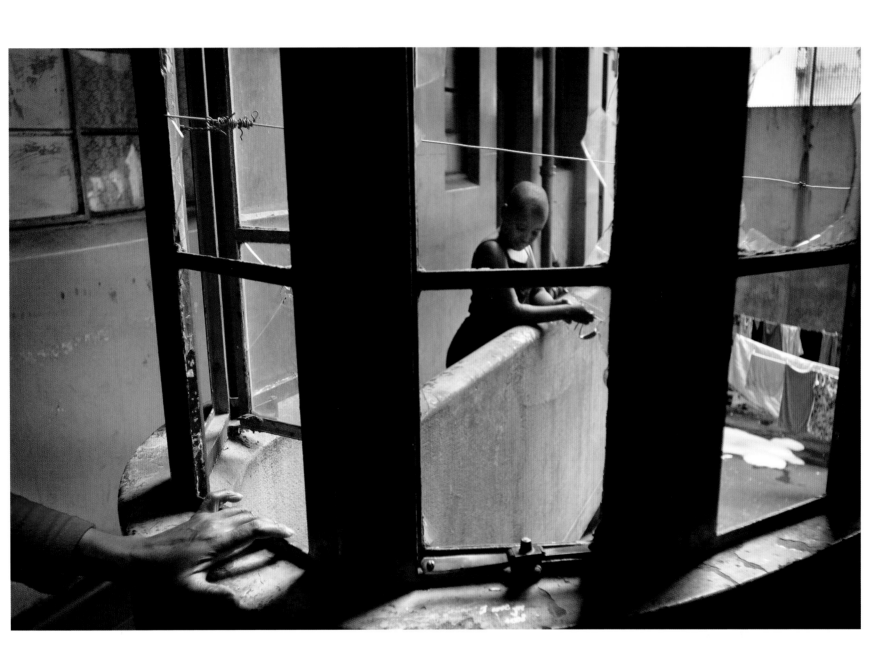

Nazif Topçuoglu works in the domain of constructed, staged photography. Over the years, he has created a consistent body of work that predominantly features young girls set in period backdrops and engaged in a variety of symbolic actions and roles. Topçuoglu's photographs are almost akin to painting in their rich colour and detail, as well as their conscious sense of composition, while also resembling stills from a theatre play. There is a distinct emphasis on dramatic gesture and composition that echoes Caravaggio, but also an adolescent sense of mischief. Apart from the boarding-school costumes and vaguely nineteenth-century decor, great attention is paid to colour, lighting and cropping. This is a highly controlled kind of photography where nothing is left to accident and artifice is the order of the day. Topçuoglu's most recent works take place in what seems to be an old-fashioned, English-style library. Here the girls—normally featured in twos, threes or fours—are engaged in a variety of highly stylized physical actions and interactions. In *Cain and Abel* (2003), two girls are seen engaged in a fight with books as their weapons, and in *Complications of Stitching* (2004) one girl takes another over her knee and examines what might be under her skirt, while in *Tryn'a Read!* (2004), a seemingly annoyed girl tries to continue reading despite her friend's persistent attempts to distract her.

The prevalence of books and the library in this body of work have a particular resonance. Topçuoglu comes from Turkey, a country that still has a relatively high level of illiteracy, especially among women. The books function not only as symbols of knowledge but, more importantly, as tools for female self-empowerment. But perhaps the most interesting thing about these photographs is the sense of narrative ambiguity that resides within them. There is an undeniable hint of female sexuality and erotic undertones, and a tendency to submissive behaviour; but also, the girls are depicted in assertive, powerful and even aggressive positions that indeed seem to challenge stereotypical definitions of young femininity as shy or passive. At the same time there is an uncanny, even disturbing, side to these photographs, perhaps because they seem to challenge another stereotype: the notion that women are not prone to violence or physical struggle.

There is a characteristic duality in these images; hovering between intimations of innocence and experience, passivity and aggression, masculinity and femininity, they register an unconventional terrain. In capturing this transitional stage of female identity and coming-of-age, and in articulating a vaguely sinister subtext, Topçuoglu's photographs recall those of Anna Gaskell. However, Topçuoglu seems to almost yearn for a nondescript imagined past where women would have occupied a more empowered and privileged place in society; hence the distinctly romantic, nineteenth-century sensibility pervading all his images. Despite the old-fashioned mise en scène, however, the subtexts in Topçuoglu's photographs remain purely contemporary: from the issue of gender politics to questions of voyeurism and desire associated with the male gaze and, above all, the problems of representing women.—Katerina Gregos

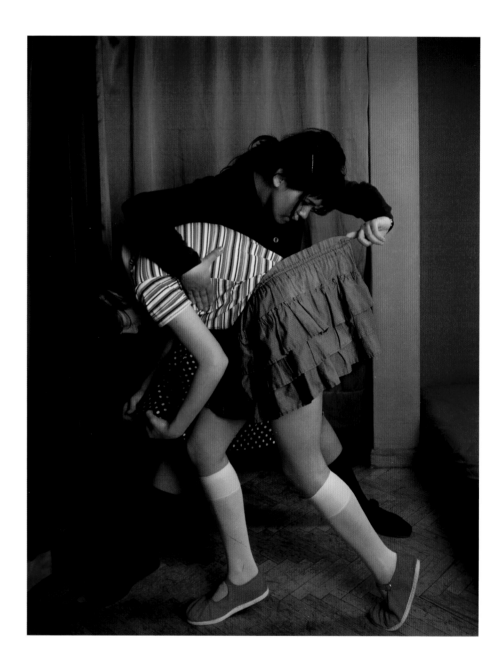

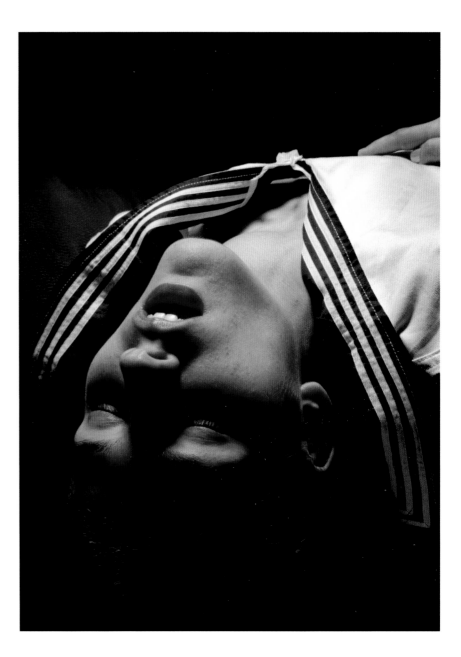

[1]

[2]

[1] **Them 2**, from the series **"Them"**, 2002, C-print, 250 x 200 cm, 99 x 79 inches
[2] **Them 12**, from the series **"Them"**, 2005, C-print, 250 x 200 cm, 99 x 79 inches

Anyone completely honest with themselves would acknowledge that their intellectual passions and hobbies and even scholarly or professional pursuits are motivated, at least in part, by sexual interests, from curiosity to full fetish. Arousal is one incentive that compels London-based artist **Danny Treacy** to visit marginal or isolated areas, collecting as trophies garments abandoned by strangers in circumstances that he will never know but can project upon. "If I find a pair of knickers in a car park, the reasons for them being there are quite obvious," explains Treacy. "But there are other more passive items of clothing that allow me to project my fantasy of how they arrived." All items are somehow sexualized by the act of collecting; the mysterious circumstances that led them to be abandoned in a public place give them an erotic charge, and the frisson Treacy feels at finding a soiled jacket or a single, filthy shoe comes from his awareness that these banal objects are artefacts of a stranger's intimate history.

Currently Treacy is producing and photographing a series of sculptures using found fabric, entitled "Those" (begun 2005). The forms in the images resemble orifices, organs, fingers and other body parts, which he dubs "protuberances, the parts of the body which stick out or intrude into space". Treacy's intimate portraits of each object against a black background contrast with his trophies' sensual textures and erotically suggestive forms.

For his ongoing series "Them" (begun 2002), Treacy accumulates a collection of garments that he lovingly re-tailors into a composite costume for the explicit, highly detailed, life-size self-portraits, standing and facing the camera, covered completely with other people's clothes, emerging from an empty black background behind him. Treacy believes that "the process is as important, perhaps more important, than the resulting image. If the motive is sexual, then why not go in and portray that instead of pretending the motive is purely intellectual?" Instead of trying to reassemble or repair the abused pieces of clothing, Treacy uses them to build creatures whose distorted resemblance to the human being inside them evokes horror-movie aliens and monstrous presences; the fact that each item was a potential witness to whatever happened to its former owner makes the work genuinely threatening. The arresting slickness of their textures and the distracting forensic presence of stains and burnt patches make potentially comic incongruities frightening. The complex gendering of these ominous creatures' bodies displays a mixture of masculine and feminine attire, including in one instance a men's suit jacket and a bleached wedding dress.

"'Them' also allows me to be very, very close to people, to strangers," Treacy explains. "When I am in these constructed suits in which people have lived and functioned and may have fucked or died, I put myself in closest proximity to them. Proximity motivates me, plus the intimacy gained and its subversion. Another driving urge is the time spent in the locations and with the materials." Treacy's work brilliantly and powerfully evokes Georges Bataille's encomium on sex, death and perversion in his 1939 essay "Le Coupable" [Guilty]: "How sweet to enter filthy night and proudly wrap myself in it."—Ana Finel Honigman

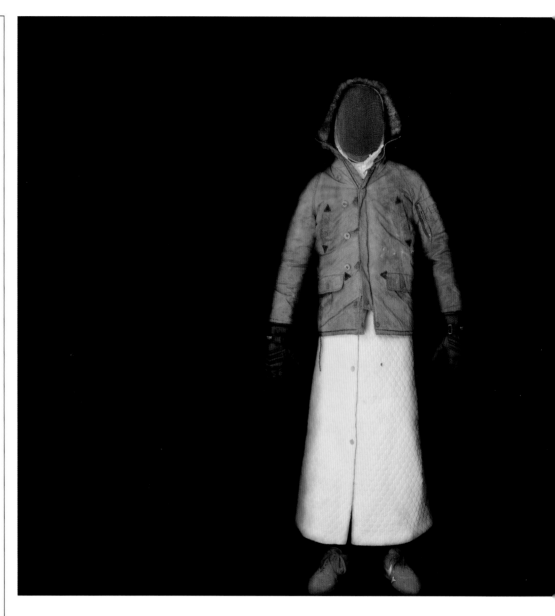

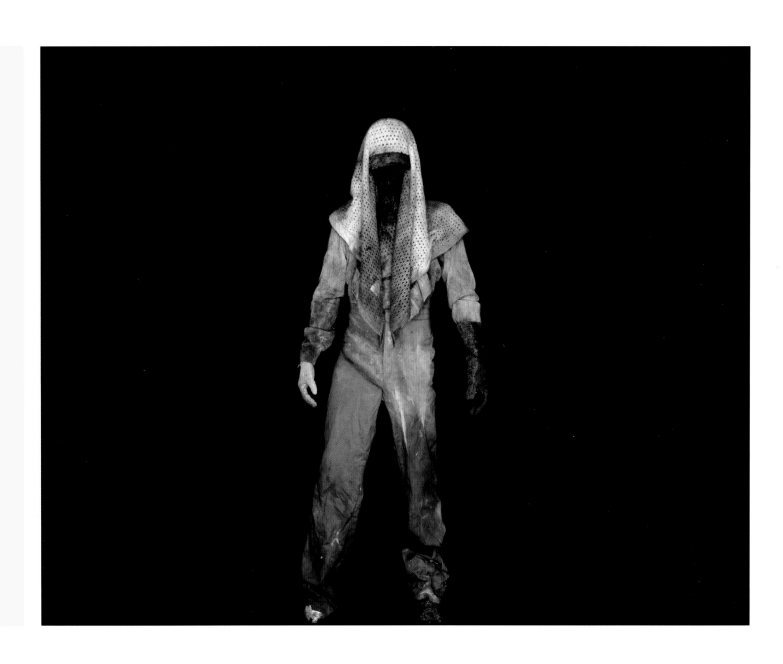

**Danny
Treacy**

[3]　　[4]

[3]　　**Grey Area 11**, 2003, C-print, 150 x 120 cm, 48 x 60 inches
[4]　　**Those 1**, from the series **"Those"**, 2006, C-print, 50 x 40 cm, 20 x 16 inches

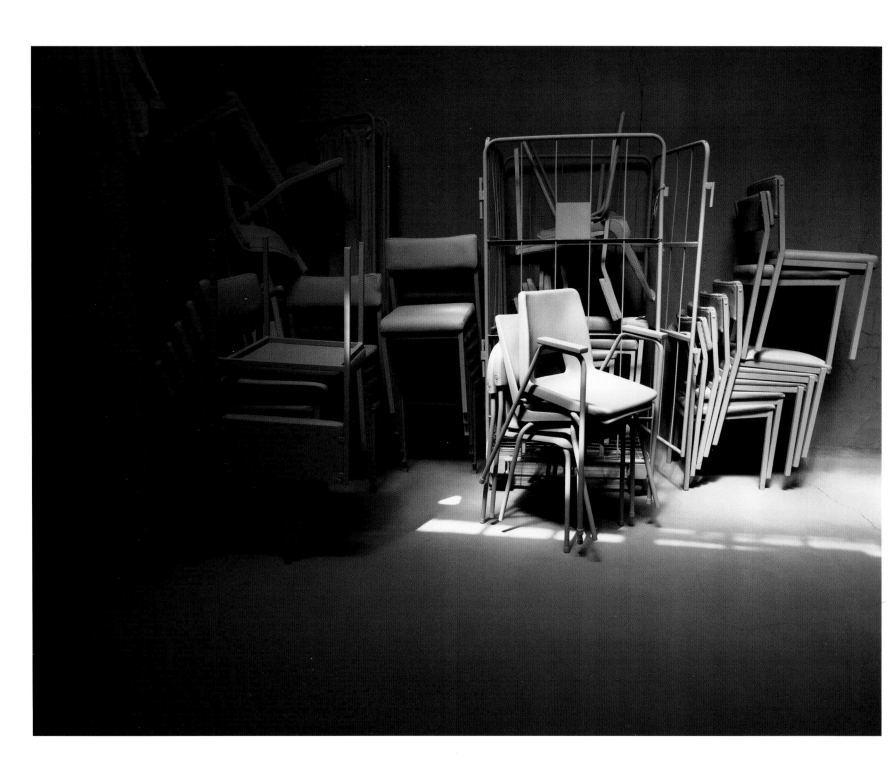

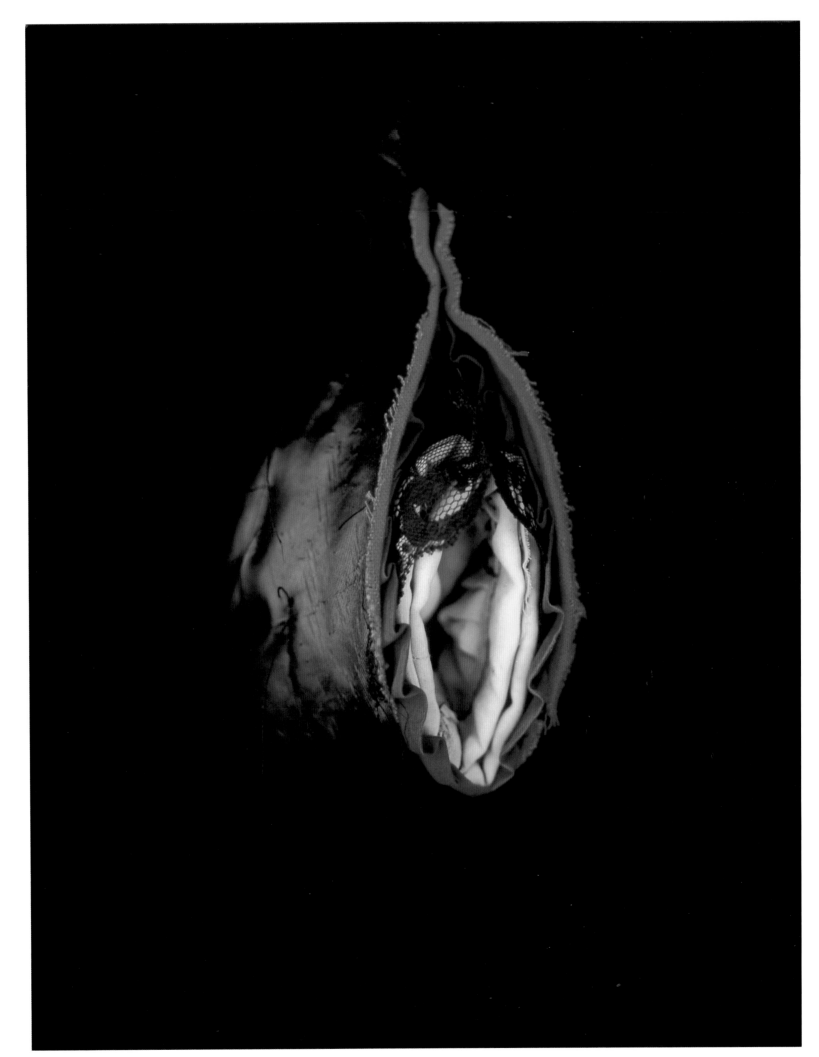

[1] **Comfort Barn**, 2005, computer montage, inkjet on vinyl, 121 x 142 cm, 48 x 56 inches

[2] **Hot Water for Tea**, 2001, computer montage, inkjet on vinyl, 182 x 121 cm, 72 x 48 inches

[3] **Minor Control**, 2005, computer montage, inkjet on vinyl, 96 x 244 cm, 38 x 96 inches

[4] **Skinning Sheep**, 2001, computer montage, inkjet on vinyl, 182 x 115 cm, 72 x 45 inches

Images possess an undeniable ability to frame realities, construct identities and inform perceptions. For **Fatimah Tuggar**, computer-generated photographs provide both rich content and a critical technological component of her practice. An intense focus on new media and computer imaging—her works actively emphasize their own technological production—enables Tuggar to examine the multiple possibilities of visualizing both the internal relationships between the people, places and things within her pictures while also exploring how technology influences people's daily lives. She directs our attention towards the computerized images' construction and artifice as a way of engaging ideas of power, boundaries, truth, reality and social difference.

In *Minor Control* (2005), Tuggar combines and layers images of the "first" and "third" worlds, racialized and gendered subjectivities, as well as symbols of history, power and the state by appropriating and altering and then cutting, splicing, pasting and merging seemingly disparate parts within one frame. She uses perspective, a sharp delineation between foreground and background created by the visual disjuncture of these elements, to draw her viewers into her dynamic and complex scenes. We are to look carefully at what is before us: white tourists, African children and a "hut" situated in a European piazza of sorts, juxtaposed with neo-classical columns and statues. To the left, tension builds as we witness this scene posited under the "surveillance" of armed guards. There is an ordered chaos in this image with each aspect existing both in conversation with and opposition to another. In *Comfort Barn* (2005), Tuggar also takes up the issue of power and surveillance, positioning an African woman within a private, "Western" interior being confronted by white, uniformed policemen. At the top right, a projector "invades" this personal space, projecting additional elements of scrutiny and authority against the back wall. This emphasizes the use of technology and images as tools of social distortion and control.

Tuggar makes little effort to hide anything in her images; rather she leaves everything open and on the surface. She intentionally reveals her process, the small but crucial details of her pictures, and the ideas she wants to convey; her commentary on and critique of both aesthetic and socio-cultural issues. Tuggar's emphasis on digitization is among the most recent iteration of the discussion of alterity and belonging, and the justification of surveillance and neo-colonialism. Perhaps, above all, she clearly underscores visually her assertion that what we think we know and understand about one culture is more often than not contingent upon carefully developed and assembled accounts of reality and truth.—Isolde Brielmaier

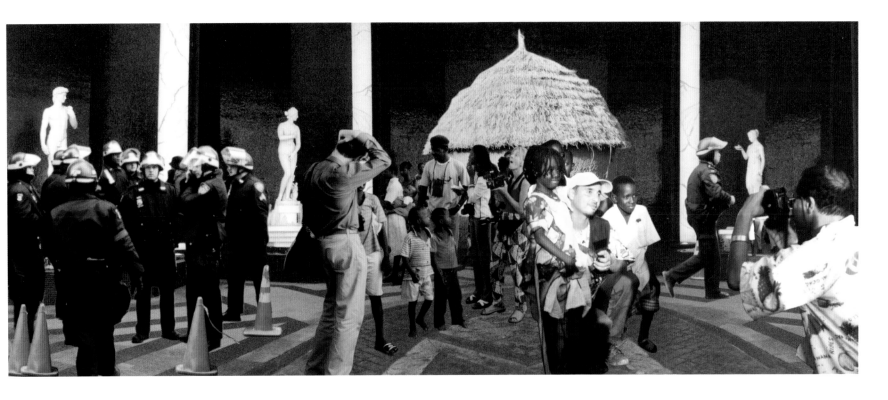

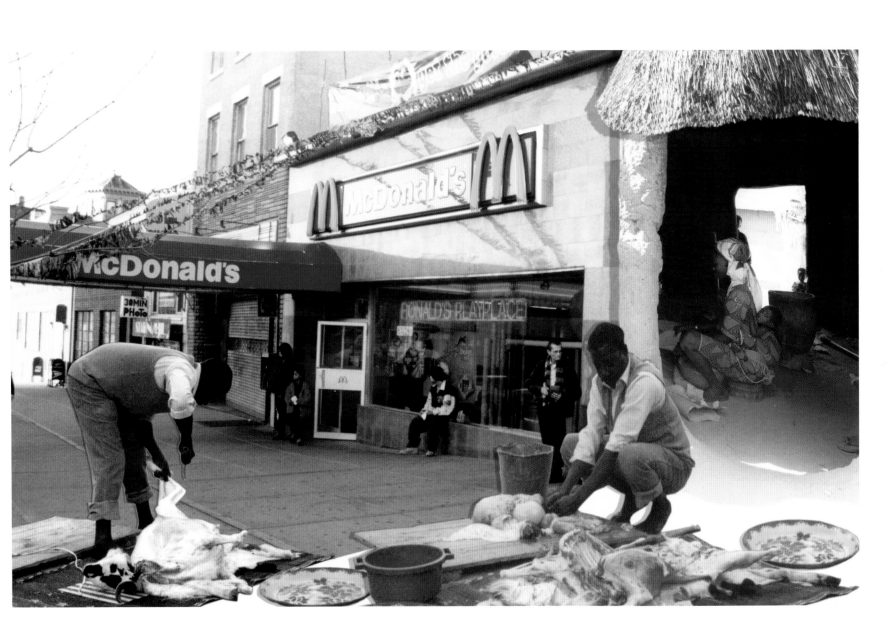

Though her images are stark and direct, Dutch artist **Céline van Balen** plays with stereotypes by tweaking each project slightly to highlight the potential viewer's prejudices. For a series of arresting portraits of young blue-eyed Berliners taken in 2000, van Balen photographed her models in front of blue backgrounds that made the colour of their eyes even denser and more disarming, as if reminding us of the racial characteristics embodied by the Aryan beauty ideal. To similar effect, she underscored racial difference by shooting a series of 2003 portraits in Africa with black-and-white film. Earlier, in 1999, van Balen photographed twenty-eight seven-year-olds living in the Netherlands and framed each image to make adult viewers aware of how rarely they kneel down and engage children face to face.

Van Balen's arguably most striking project, "Islamic Girls", was a series of portraits of girls from the ethnically diverse immigrant Muslim communities in the Netherlands photographed in the late 1990s. Ranging from children to adolescents, the girls look directly into her camera with precocious intensity. But their solemn expressions do not necessarily represent their personalities. Instead they may unintentionally reinforce a Western viewer's assumptions about Muslim life, and the expectation that rigidity, emotional neglect and repression dominate these girls' dour daily lives. In reality, the stern gazes and tightly clenched lips of Yesim and Muazez, who appear in their 1998 photographs to be between seven and ten years old, could demonstrate their shy, demure, culturally determined demeanour or their own mistrust of van Balen as a stranger from a mutually alienated culture.

Like all her work, "Islamic Girls" is compelling largely because van Balen's portraits are physically intimate but psychologically unrevealing. Through the photographs' rich tones and luminescence, "Islamic Girls" draws upon aesthetic origins from Northern Renaissance iconography. Where the girls' faces, some with distinctly Caucasian features, are framed by the hijab, the resemblance to Mary's veils or a Catholic nun's traditional habit further complicates the mystery of what is knowable or merely assumed about van Balen's young subjects.

In an essay for "Politically Correct? Dutch!", a group show held at Vienna's Krinzinger Projekte gallery in 2002 for which she presented her Berlin portraits, van Balen wrote that she is "fascinated by people who are ostracized by others … most people want to look beautiful in photographs, but that's not what I'm aiming at. People look beautiful when they are completely themselves … smiling for photographs is rubbish. It's a way of adopting a certain attitude."

Van Balen, who lives and works in Amsterdam, regularly shoots with a Linhof Technika 4 x 5 camera, which produces extra-sharp images that can be enlarged without blurring but demands that subjects remain perfectly still for up to thirty seconds. While that span of time forces van Balen's subjects to relax and shed their affectations, they still remain unknowable. Throughout her career, van Balen's portraits have tantalized viewers by combining the subjects' names with their impassive visages. Without enough information to sustain the illusion that viewers are receiving a real introduction to the person who is photographed, her subjects are presented as unique individuals, yet as easily typecast as any other strangers.—Ana Finel Honigman

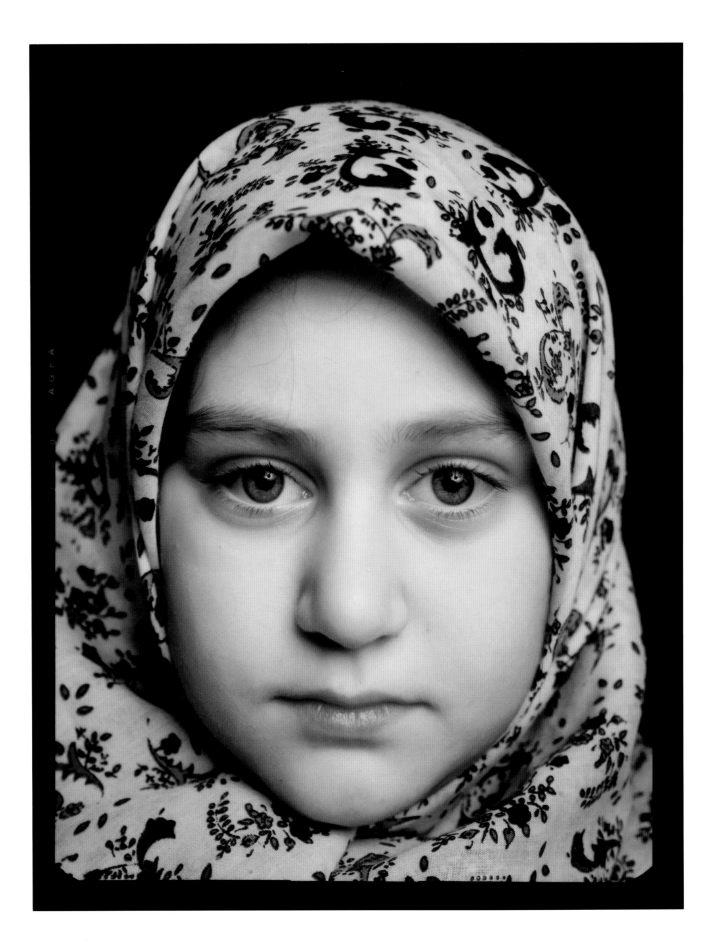

When I look at **Annika von Hausswolff**'s photographs, I think first about *things*, about objects. One of her images, showing a red couch with its cushions all disarrayed, is called *Domestic Sculpture* (2002)—a title that might recall Bernd and Hilla Becher designating the nineteenth-century industrial structures they photograph as "anonymous sculpture". Traditionally, sculpture was always a representation of a body, of a living being, so we could define it as an object that uncannily seems to take on a sort of life. The couch in *Domestic Sculpture* possesses this uncanny animation. Likewise in *Attempting to Deal with Time and Space* (1997), a sequence showing a young woman using both arms to wrestle with a white balloon; or perhaps it's a giant bubble she holds in front of her, as in the earlier *Alone with Bubble* (1994). The thing itself—a skin-like membrane without definite form, changing according to the pressure put on it—conceals the person who, grappling with it, embraces it like a lover. Yet it paradoxically becomes her surrogate portrait. In another instance, familiar domestic objects, furniture or clothing may affect the body in such a way as to create a symbiotic sculpture out of the pairing of person and object, as in *The Memory of Water* (2005) or the marvellously titled *The Third Position in Between Two Worlds Where One is Called Infidelity and the Other One Decay* (2004).

Self-concealment as self-containment. Someone once complained of my solipsism: "You live in a bubble!" In *The 21st Century Transitional Object* (2004) a couple stands stiffly as if posing for an amateur portrait, but concealed by a lacy white textile, perhaps a curtain for the window behind them. The thing substitutes for the face. This trope is repeated in *Sad Memories of Pink #2* (2004), where toes emerge from behind a full-length, pink and thick, silky curtain.

Some of von Hausswolff's earliest works were straightforwardly political, though mostly she is concerned not to decry objectification but to explore her own fascination with it. Just as things appropriate human character, so people, bodies, become object-like. In *Mom and Dad Making Out* (1999), two partially unclothed bodies —seemingly too limber and exuberant to embody parental authority—form an X of flesh, his feet on the ground and hers in the air, a living minimalist sculpture.

If von Hausswolff is so fascinated by objects—by the humanization of the object and the objectification of the human—then why work with photographs and not directly with objects? One answer is that, along with her photographs, she sometimes has. *The Memory of My Mother's Underwear Transformed into a Flameproof Drape* (2003) is just that —a fabric window drape. All the more reason to see that her choice of photography as a medium is not fortuitous. Photography is a way of looking at things—a gaze—and it's one that machines and humans collaborate on together. "To photograph is to objectify," in von Hausswolff's words. The eye alone could not construct these domestic sculptures of people and things. Through this collaboration between a thing and a person, things and people become sinister, enigmatic, perverse, melancholy, dissociated, or absurd; yet somehow all the more beautiful and poignant for that, just like von Hausswolff's pictures.—Barry Schwabsky

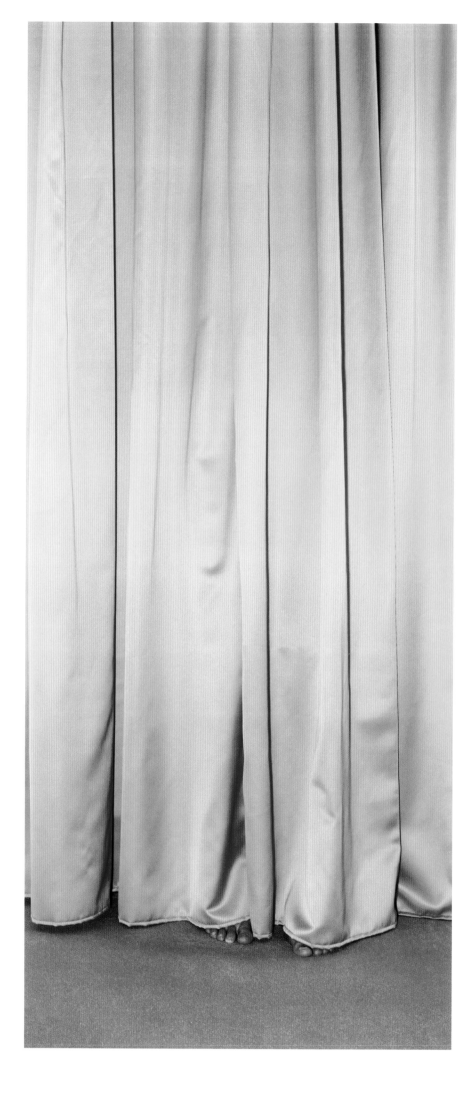

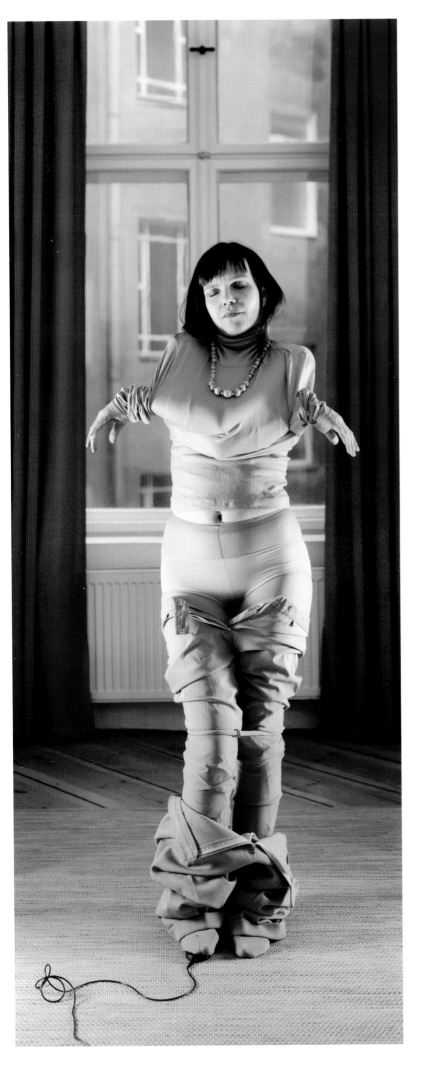

[1] **Sad Memories of Pink #2**, 2004, C-print, 180 x 80 cm, 71 x 31.5 inches

[2] **The Third Position in Between Two Worlds Where One is Called Infidelity and the Other One Decay**, 2004, C-print, 180 x 80 cm, 71 x 31.5 inches

[3] **The Memory of Water**, 2005, Lambda print, 70 x 100 cm, 27.5 x 39.5 inches

Bettina von Zwehl doesn't believe in the portraitist's quest for the essence of the sitter. Instead, she works in series to chart the differences between individuals in comparable circumstances. She maintains a number of constants, not only within a series, but between them too. Sitters may be limited by age range or gender, for instance, and the light source is always in front of them, casting few shadows, while proliferating gradations in skin tone and texture. This might at first seem a scientific approach—a misconception that is often compounded by the blankness of von Zwehl's backdrops. Yet these monochromatic non-spaces signify neither the neutrality of the laboratory nor serial objectivity.

Von Zwehl is conscious of her interaction with her sitters to such an extent that her relationship with them is paramount. She constructs a participatory situation in the hope that they will engage with the moment, temporarily forgetting their public façade. In the series "Rain" (2003), for instance, women were asked to stand outside while a rain machine bombarded them with a downpour—cold rain in steamy Miami and hot rain in chilly London. Their responses range from near-alarm to deadpan, depending on the water pressure, although their expressions describe no simple sliding scale between the two extremes. Human disposition is, as we always suspected, more complex than language.

There are many conditions under which we forget ourselves. We might apply such conditions in the name of leisure, or perhaps they are imposed on us as a form of social control. Music is a particularly divisive atmospheric tool, which von Zwehl explores in the series "Alina" (2004), made during a residency at the Royal College of Music. Arvo Pärt's *Für Alina* was played to young women as they sat in a dark room; an instantaneous flashlight captures their image in mid reverie. Each woman was dressed in a white vest, instructed to fold her arms and look downwards, but control only goes so far: there are marked differences in tension between postures, and the red nose of one sitter betrays her weeping.

Von Zwehl is currently working on a third series of profiles, which have developed from an interest in Renaissance portraiture, and Piero della Francesca's portraits of the Duke and Duchess of Montefeltro in particular, hung side by side in the Uffizi, Florence, as if regarding one another from within their separate frames. The intensity of the averted gaze takes on different connotations in von Zwehl's most recent series of babies' pictures, entitled "Profiles Three" (2005). Boys and girls around the one-year-old mark sit in profile to the camera while von Zwehl coaxes them into eye contact with her off frame. We are so used to the symmetry of a smiling baby seen from the front that their stoic composure seems false. Yet von Zwehl constructs a moment of intelligent self-absorption that is in fact more naturalistic than the usual passive cuteness of the genre.—Sally O'Reilly

[1-4] From the series **"Rain"**, 2003, C-prints, 122.4 x 151.6 cm, 48 x 59 inches
[5-8] From the series **"Alina"**, 2004, C-prints, 46.4 x 59.8 cm, 18 x 23.5 inches

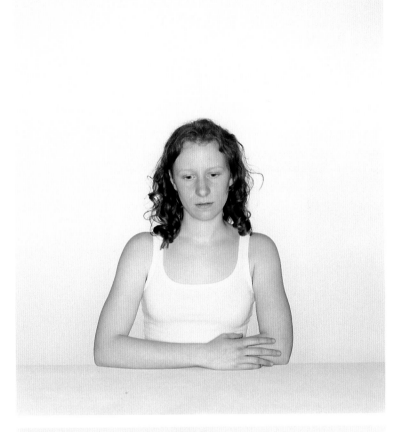

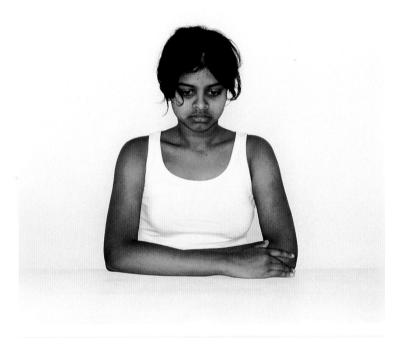

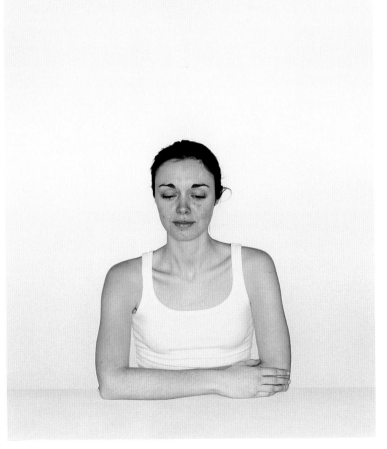

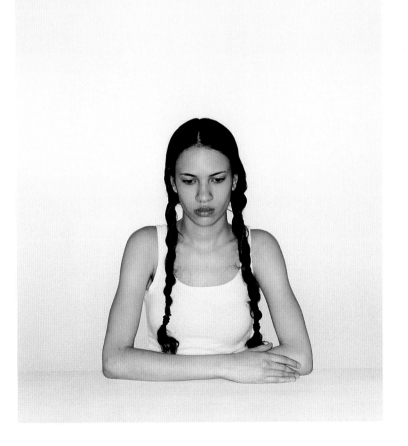

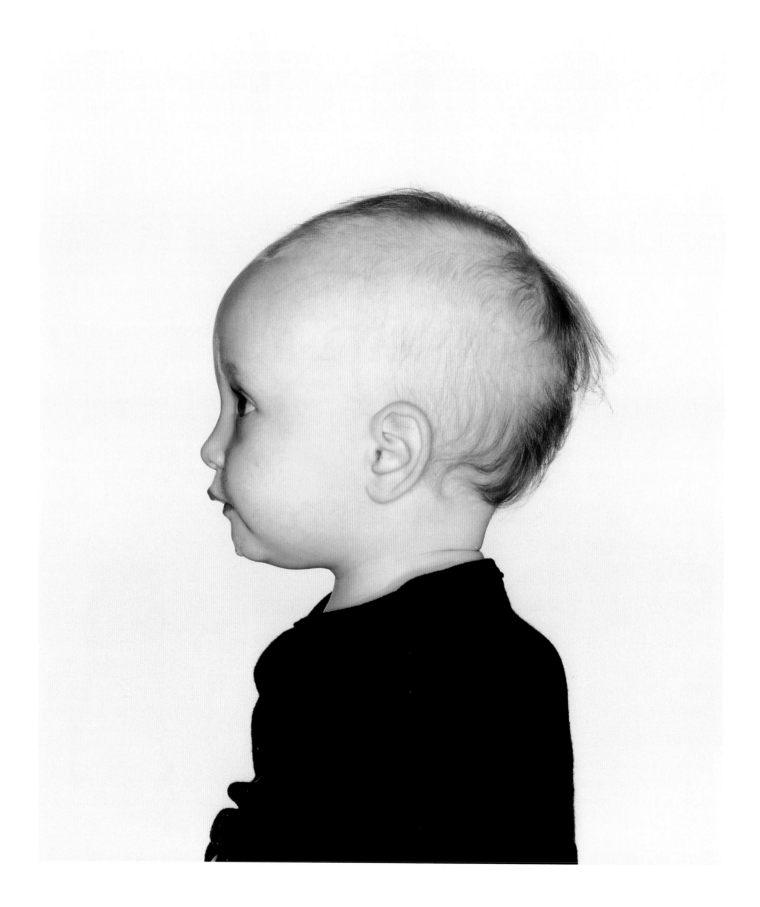

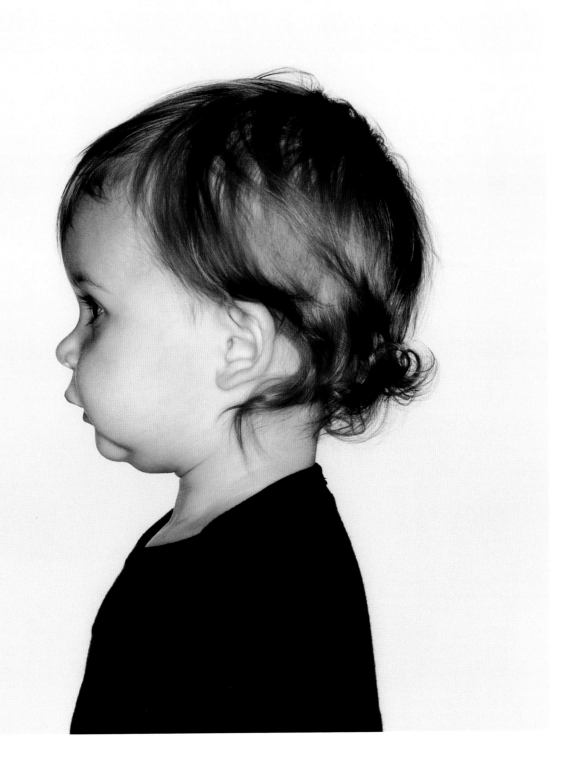

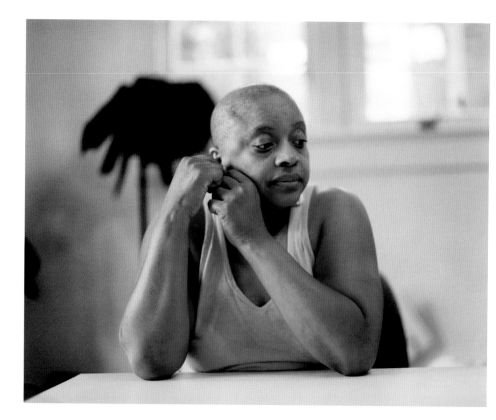

Within their literal frames, photographic images present evidence of human experiences, recording collective memories and documenting individual narratives. For **Deborah Willis**, photography offers a realm in which to compile a visual diary. It is at times a deeply private and personal means through which she explores her life and the world that surrounds her. She then invites her viewers selectively to look at and participate in the lives of her subjects. Willis brings all of these possibilities to her practice through keen observation and an intense focus on the expressive modes of the body and face. Her images reveal her interest in the feelings and ideas conveyed by a glance, a stare, a gesture or a pose. They maintain the importance that she places on the concrete establishment of place; a clear, visual reference to the specific location in which each of her subjects is situated. Within this context, Willis has often compared her work to the long-standing African-American tradition of quilting, affirming this connection by frequently printing her photographs on fabric. This presentation of her images—as individual pictures and as a collective series—encourages her viewers to link them together, intimately connecting her subjects with one another. In this way, Willis explores the relationship, the fluid interconnectedness, between identity, community and ideas. She locates the bonds between people, places and things and asks us, too, to piece together parts of a larger story.

Consider the flurry of activity that takes place in Willis's beauty salon, where we can imagine all things as shared between the community she pictures. A shotgun house (a house one room wide and three rooms deep, built by the first free blacks in the American South) occupies seemingly barren land upon which lives were lived, crops were sown and human experiences—stories of love, pain, joy, toil and sacrifice—unfolded. The powerful words of a preacher still echo from the empty pulpit in her image of the Eatonville Church, the camera angle placing us up front before the congregation.

In Willis's series "Nancy Lewis: Bodybuilder" (1999) she has run her camera over the tendons, muscles and limbs of Lewis's body, emphasizing the ways in which physical work and strength (which are often associated with men) are manifested clearly in the female body. Perhaps most strikingly, this sentiment is captured quietly but no less poetically in Willis's strong, frontal self-portrait in which she presents herself in a thoughtful moment post-cancer. She exudes a solid presence while, through the soft gesturing of her hands adjusting her earring and her calm sideways glance, she urges us to pause with her in a tender, reflective moment; a brief rest to contemplate, feel, be tentative, be thankful.—Isolde Brielmaier

[1]
[2] [3]

How do you photograph the people and places of Israel without getting caught up in the fighting, the religion and the party politics? **Sharon Ya'ari**'s work is characterized by its refusal of photojournalism, high drama and overwrought emotion. His photographs are quiet but not tranquil, stoical but never blank. Ya'ari has an eye for the subtle immanent politics of his visual world. His pictures make us wonder: what happened here?

In Ya'ari's work, one can see traces of Walker Evans's "documentary style", Joel Sternfeld's social landscapes, Thomas Struth's modernist cityscapes and Thomas Ruff's experiments with post-production techniques. Ya'ari uses digital technology to combine multiple negatives, alter his palette and remove overt markers. In fact, by eliminating conspicuous signs of the times, Ya'ari increases the ambiguity of his work and enhances its sense of history. Each photograph bears witness to the idea that the future is to be found in the past.

Ya'ari's black-and-white series "500m radius" (2006) is part urban landscape, part architectural photography. In Tel Aviv during the 1930s and '40s, over 4000 Bauhaus buildings were constructed. Taken close to home in the early morning hours, Ya'ari's intimate back-alley views contrast with official images of the architecture and shed new light on the idealism of the Bauhaus movement. Although they document neglect, the photographs offer a glimmer of optimism in the sculptural beauty of the debris that litters the forlorn landscape.

History is also a key theme in Ya'ari's colour photography. In *Chairs* (2001), the cheap post-war plastic seats act as ghosts for the people who seem to have just abandoned this uncertain room. The arrangement of chairs is puzzling because it suggests neither the strict hierarchy of a lecture nor the democratic discussions of a meeting. On closer inspection, details such as a heap of prayer shawls or sheets in the corner indicate that the interior could be a makeshift synagogue or funeral home. Here we encounter the temporary feel of the ancient religion that, over the centuries, has rarely had the dominion to invest in permanent cathedrals. Moreover, the picture suggests the social rather than the spiritual functions of the faith.

Not all of Ya'ari's photographs are taken in Israel. In a photograph entitled *Sebastian* (2003), for example, the grey light and lush ivy hints at northern Europe, while the explosion of overexposure and white "dust" threatens to wipe out evidence of the young man portrayed. In fact, the location is a Jewish cemetery in Poland and Sebastian is a local Christian man who makes a living through using his detailed knowledge of the graveyards to help Jews find long-lost family. He holds a stick of white chalk in his right hand that he uses to trace the worn-out Hebrew lettering on the tombstones. Like many of Ya'ari's photographs, this one tenuously balances a range of contradictions: the real and the imagined, tenderness and brutality, amnesia and remembrance.—Sarah Thornton

When she began to work with photography in the mid-1980s, **Catherine Yass** was distrustful of its presumed objectivity and of the repressive causes the medium had traditionally served. She searched for a photographic language that would express her scepticism, initially overlaying several transparencies of the same image to render it opaque. Eventually she chanced on a process that would subvert the authority of the single photograph whilst also acknowledging the beauty and seductiveness of the medium. Two photographs were taken of the same subject, moments apart. One was produced as a positive, and the other as a blue negative transparency. Sandwiched together, they were enlarged to produce a composite transparency that sat in the front of a deep white-painted lightbox. Because of the combination of the positive and negative, any area of extreme light was rendered in the image as an Yves Klein-like ultramarine blue. The fluorescent tube in the lightbox intensified the colour even more. This is the process Yass continues to use.

Yass's early works were portrait series of individuals and groups of people usually involved in the commissioning of her work, such as the Selection Committee for the collection of the Arts Council of England. For her first exhibition in a private gallery, Yass photographed the four people she thought comprised the system in which her work would circulate: the artist, the gallerist, the critic and the collector. A strict logic persisted in these series since the circumstances of their production determined the choices of photographic portrait subjects, but the photographs themselves were unpredictably odd. In the small interval between the two exposures, Yass's subjects would often move slightly, and this resulted in patches and auras of blue light strangely invading the contours of their faces.

In 1994 Yass embarked on a project to photograph patients in a psychiatric hospital, but eventually produced a series of images of empty corridors. Though most of the photographs showed spaces receding in deep perspective from the camera, the colours unsettled the sense of depth in the images: pools of blue light seemed to lie on the surface of the lightbox as much as within the space of the corridor. These distorting effects captured the atmosphere of the hospital and dramatized many of Yass's subsequent series of architectural interiors. She photographed various spaces, but often sites associated with death (a graveyard and a meat market), waste (a series of public urinals) and dereliction (old and disused synagogues). Though her practice of taking photographs in series suggested she was not seeking any particularly eerie or spectacular image, these were hardly archival projects aiming to document particular architectural typologies. The colour of the images always produced a sense of unfamiliarity exacerbated by the absence of human beings.

In recent years Yass has explored many avenues at once. Portraiture resumed in a series of photographs of Bollywood stars, and she has begun to use new techniques to disturb the cohesion of the photographic image: one transparency showing an East London canal was left in water to deteriorate before being mounted in the lightbox. Photographs taken above a skyscraper were exposed while Yass tilted the camera down, resulting in near abstract images showing streams of blurry light, the kind of image you would see when falling. Most recently she produced a series of photographs based on spaces and images that might be imagined when asleep: a derelict warehouse, an overgrown pathway, an empty room and a woman seen from behind. Alongside her familiar blues, the high-pitched purples turn dreamscapes into nightmares.—Mark Godfrey

[1] **Corridor: Daffodil II**, 1994, Ilfochrome transparency, lightbox, 89 x 72.5 x 14 cm,
 34.5 x 28.5 x 5.5 inches, collection Tate, London
[2] **Sleep (room)**, 2005, Ilfochrome transparency, lightbox, 68 x 86 x 12.5 cm, 27 x 34 x 3 inches
[3] **Sleep (path)**, 2005, Ilfochrome transparency, lightbox, 68 x 86 x 12.5 cm, 27 x 34 x 3 inches

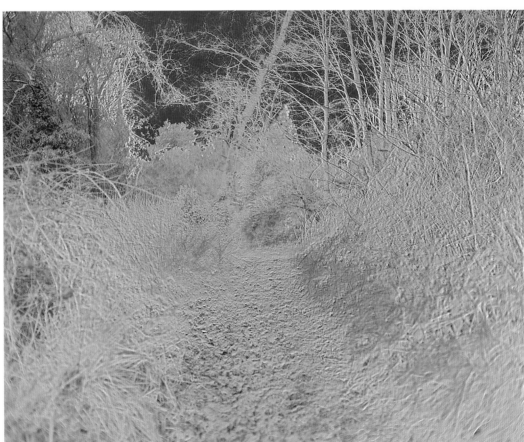

[4] [5]

[4] **PET/in**, 2005, Ilfochrome transparency, lightbox, 68 x 86 x 12.5 cm, 26.5 x 33.5 x 5 inches
[5] **PET/out**, 2005, Ilfochrome transparency, lightbox, 68 x 86 x 12.5 cm, 26.5 x 33.5 x 5 inches

[1] **Stranger (1)**, from the series **"Stranger"**, 1998, C-print, 108 x 127 cm, 42 x 49.5 inches, collection
 San Francisco Museum of Modern Art, San Francisco, The Japan Foundation, Tokyo
[2] From the series **"Untitled/Hitorigoto"**, 2002, digital C-print, 65 x 52 cm, 25.5 x 20.5 inches
[3] From the series **"Untitled/Hitorigoto"**, 2002, digital C-print, 65 x 52 cm, 25.5 x 20.5 inches

Born in Japan, **Shizuka Yokomizo** has lived and worked in London for the past fourteen years. This exiled condition has, consciously or not, framed her photographic explorations of intimacy, solitude and individual vulnerability in the contemporary megalopolis. Each of her series explores, formally and conceptually, the modern urban condition, forming new ways of working with the genre of portrait photography.

For the "Stranger" series (1998-2000), produced in various cities including New York, London, Tokyo and Berlin, Yokomizo sent anonymous letters to residents of random ground-floor apartments, asking them to stand in front of their window for ten minutes at a certain time (always during the evening) on a certain date. The letter stated that she would be waiting with her camera outside their window and would take their portrait as they looked outside and then leave, stressing that she refused to meet them and that if they tried to meet her, she would not photograph them. They had to remain strangers. This conceptual device provided Yokomizo with a gallery of images of people living in the same kinds of settings but in different parts of the world, caught in their domestic environments but disrupted in their everyday routines. The expressions and postures are unusual within the genre of domestic portraiture. A certain tension unfolds in "Stranger", displaying moments of scepticism, slight embarrassment and apprehension. The photographs convey little of their subjects' lives. As Yokomizo says, "I didn't try to create a personality, you don't know them, it is simply an encounter."

In her subsequent series "Untitled/Hitorigoto" (2002), Yokomizo opted for a radically different, if not completely opposite, method: she collaborated only with people she knew, inside their homes, asking them not to look outwards to acknowledge the camera, but to look inwards, to the point that they are almost momentarily unaware of the artist's presence. Although meticulously constructed, using a single light source unique to the setting such as an open fridge, a lamp or a window, and thus based on a fictional apparatus, these photographs stand as equally powerful documents on the conditions of anonymity, solitude and melancholy in our seething world.

But Yokomizo is not just an eloquent interpreter of contemporary social conditions. It is the process of making the photographs that ultimately carries the meaning of her work more than the resulting images. The social component that underlies her practice—incorporating invited participants into the work, using varied approaches (sometimes an anonymous exchange, sometimes a substantial dialogue), always with a deep sense of humanity—is essential to her exploration of the practicalities of sociability.
—Thomas Boutoux

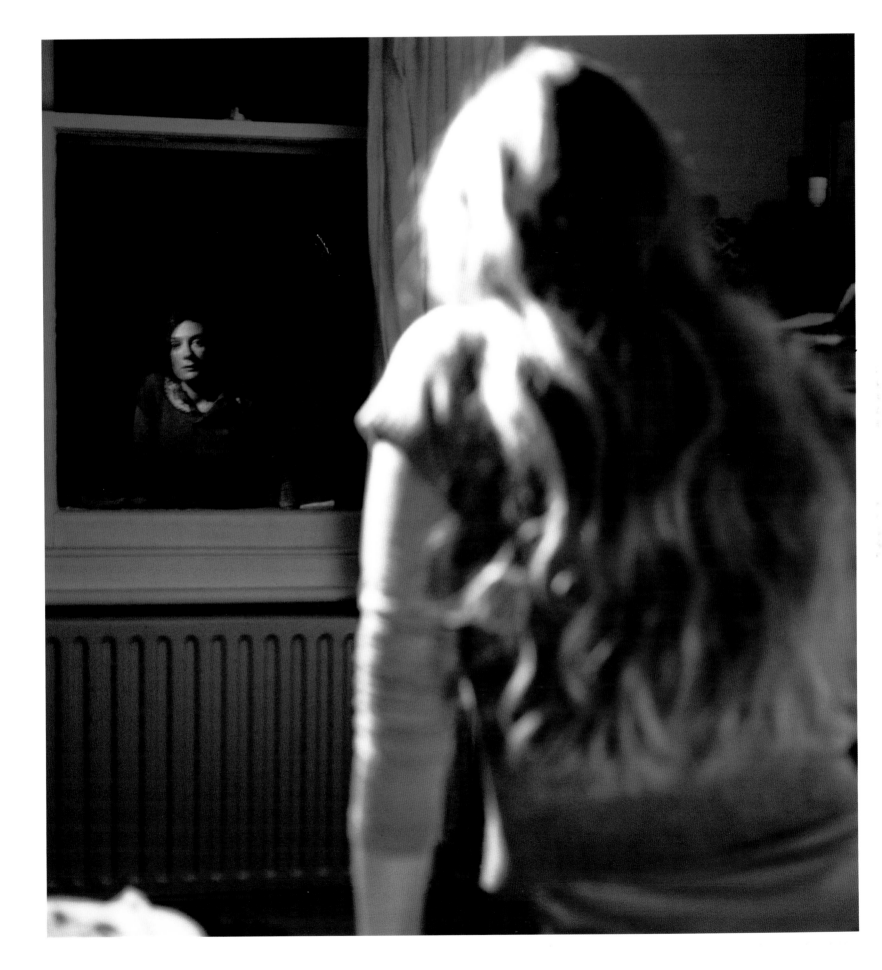

[1] **Untitled (OH-04X)**, from the series **"Spring Through Winter"**, 2004, lightjet C-print, 175.3 x 223.5 cm, 69 x 88 inches

[2] **Untitled (FPFE02)**, from the series **"Spring Through Winter"**, 2004, Ultrachrome archival photograph, 46.9 x 52 cm, 18 x 20 inches

[3] **Untitled (Winter Pool_5)**, from the series **"Spring Through Winter"**, 2004, Ultrachrome archival photograph, 145.4 x 114.3 cm, 57 x 45 inches

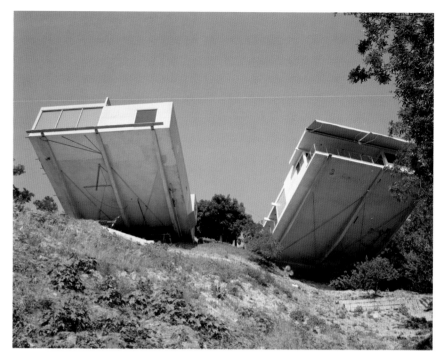

Born in 1974 in Southern California, Los Angeles-based artist **Amir Zaki** has spent his life among the modernist homes that proliferated across the region's hillsides throughout the 1950s and '60s. His most recent body of work, titled "Spring Through Winter" (2004), is comprised of interrelated photographic suites that take these fabled buildings as their subject matter. If Julius Shulman's stately black-and-white shots of Case Study houses are akin to formal portraits, all right angles and sweeping views over the valley, Zaki's unexpected vantage points and digitally manipulated prints offer a more complex psychological profile of his structures. *Untitled (OH-04X)* (2004) is representative of this series: not only has Zaki situated his lens beneath the two houses cantilevered out over a steep slope like two buck teeth, he has also digitally erased the columns that make their tenuous placement possible, thus heightening the sense of unease that pervades the image. (It's worth noting the similarity between this image and scenes from films in which cars are launched off cliffs.) Modernist pioneer Richard Neutra designed several of the houses Zaki photographed in this manner, but his firm later disowned the buildings after they were structurally retrofitted to better withstand the earthquakes and mudslides that regularly occur in this region. Zaki's photographs highlight the semi-delusional fantasy inherent not only in building on top of an unstable fault line but also in the formalist aspirations—purity of form, transparency, weightlessness—of those responsible for the buildings in the first place.

A related suite of pictures uses the outdoor swimming pool as a foil for an exploration of the limits of photographic realism. Zaki shoots this iconic feature of the Southern California landscape from above—an equally unexpected vantage point that likewise renders it strange. These deadpan, naturally lit pictures evince little of the spatial depth one would expect from a bird's-eye view: in *Untitled (Winter Pool_5)* (2004), a red ball floating on (or falling towards) the mesh netting covering the water's surface is unmoored from its shadow, and another long, thin shadow that cuts across the bottom of the frame diagonally is cast by an unseen source. Because the image walks the line between representation and abstraction, the viewer can cognitively nudge it in either direction: on the one hand, the photograph recalls early modernist pictures shot by André Kertész, Berenice Abbott and others depicting the streets and parks of Paris and New York from the Eiffel Tower or newly built skyscrapers; on the other hand, its immaculate balance of colour and line places it in an abstract lineage descending from Aleksandr Rodchenko and Wassily Kandinsky.

A third series moves inside the house. These "portraits" show fireplaces that have been sealed off by what seems like digital manipulation of the photograph. One can view closing up the aperture at the heart of the home as an attempt to shore up the house's ability to ward off that which is outside (or to protect the artist from outside influences). In an essay included in *Slouching Towards Bethlehem* (1979), Joan Didion described the San Bernardino Valley as being "haunted by the Mojave … the last stop for all those who come from somewhere else." Zaki's project can be seen as a visual corollary to Didion's Southern California dispatches; both are nuanced examinations of the interplay between a very particular environment and its inhabitants.—Brian Sholis

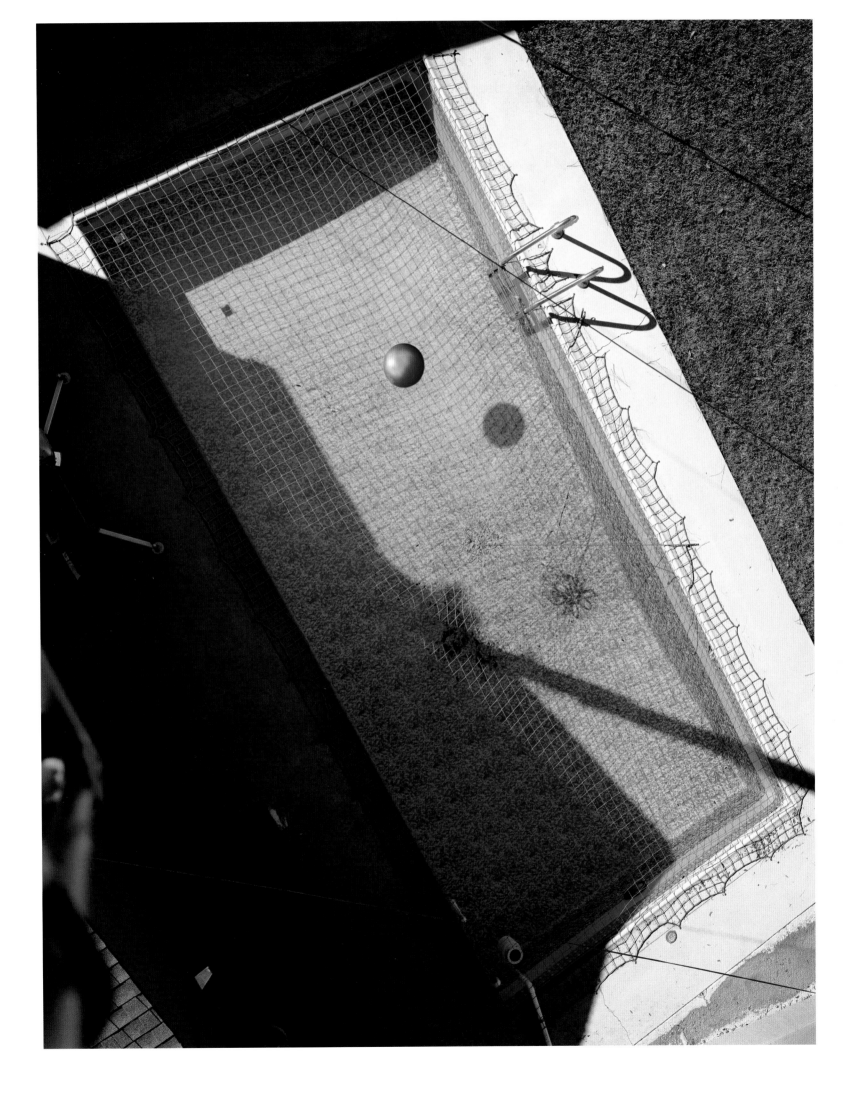

Liu Zheng studied optical engineering and worked for several years as a newspaper photojournalist before eventually quitting his job to work full-time as an artist. His career traces the development of ambitious Chinese photographic practice as a whole. Experimental photographic work (*Shiyan sheying*) has grown up outside the institutions of mainstream, state-sanctioned Chinese photography (*Zhongguo sheying*) and it is against this cultural backdrop, but emphatically not reduced to it, that Liu's images must be understood.

The short history of avant-garde photography in China, and the ways in which it has assimilated, inflected and developed Western influence, speaks through Liu's practice. His first major series, "The Chinese" (1994-2000), comprises an extensive body of black-and-white reportage. Here Liu seems to emulate the earliest Chinese experimental photography (*Sheying xinchao*—the "New Wave" of the 1980s), which was itself explicitly indebted to European precedents. The series is shot in a familiar documentary style and reveals its social commitments through portraiture. "The Chinese" presents a selection of types (miners, entertainers, convicts, the rich...) in what at first sight looks like an accomplished, yet rather derivative, update of August Sander for a domestic market.

Yet if we spend longer with the series we are resolutely disabused of this interpretation. The universalizing, modernist assumptions of Sander's project are not present here. Liu makes no attempt at a complete, or even representative, social typology. In fact, he includes the occasional "trick" image, photorealistic but shot from museum waxworks, not life. Here Liu conflates the artificial and the real even more artfully than Hiroshi Sugimoto's celebrated Madame Tussauds portraits. With this gesture Liu subtly demonstrates that his work is as contemporary as anything coming out of Europe, Japan or the US. Knowingly exhibiting his inflection of the Western photographic tradition, Liu's eclectic, postmodern sensibilities are acute.

His more recent series move away from documentary work altogether. They reflect a broader trend in contemporary experimental photography, which is increasingly defined by its preoccupation with constructed, conceptual image-making. Liu's latest long-term project, "Three Realms (Heaven, Earth and Hell)" (begun 1997), consists of intricately arranged, highly theatrical tableaux reflecting on traditional Chinese high culture. Sub-series within "Three Realms", such as "Peking Opera" (1997) and "Four Beauties" (2004), work through specific contemporary concerns in relation to established Chinese arts and their contexts. Topical content is superimposed over traditional forms in elaborate trans-historical montages.

Perhaps most striking though is Liu's latest work, the "Survivor" (2004) series. High-resolution headshots present traumatized individuals, their faces coated with cement-dust and blood. The viewer is confronted face to face and in forensic detail with the (fictionalized) survivors of a (fictional) terrorist attack. In creating a set of staged images that brave a trauma too fresh in the Occidental psyche to have generated a meaningful home-grown artistic response, Liu successfully moves his art into an international cultural context. Here then Westerners can no longer reflect on the "Chineseness" of his photographs, but must instead account for the powerful effect these images have on them.—Luke Skrebowski

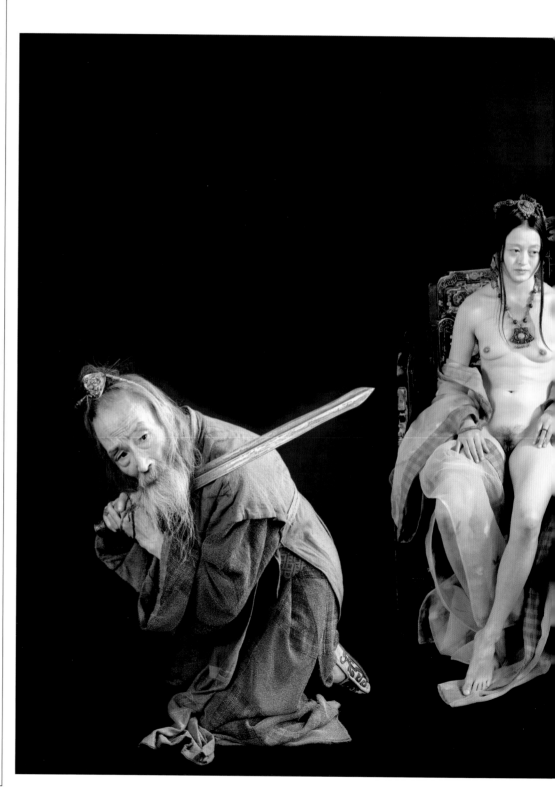

[1] **Xi Shi**, from the series **"Three Realms (Heaven, Earth and Hell) – Four Beauties"**, 2004, C-print, 100 x 200 cm, 39 x 78 inches or 50 x 100 cm, 19.5 x 39 inches

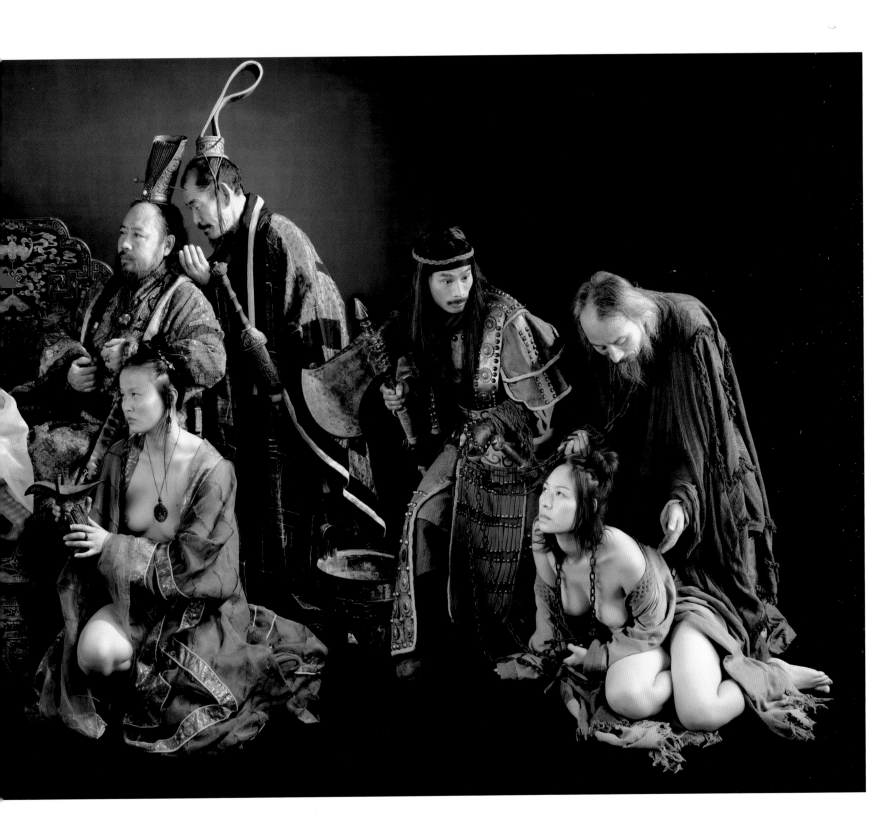

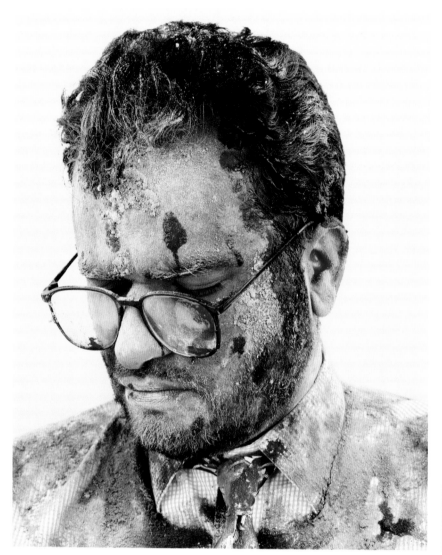
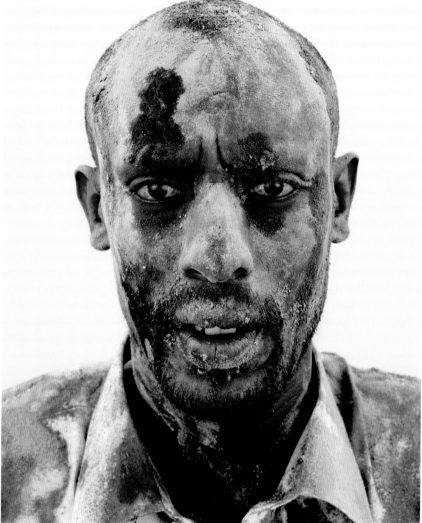

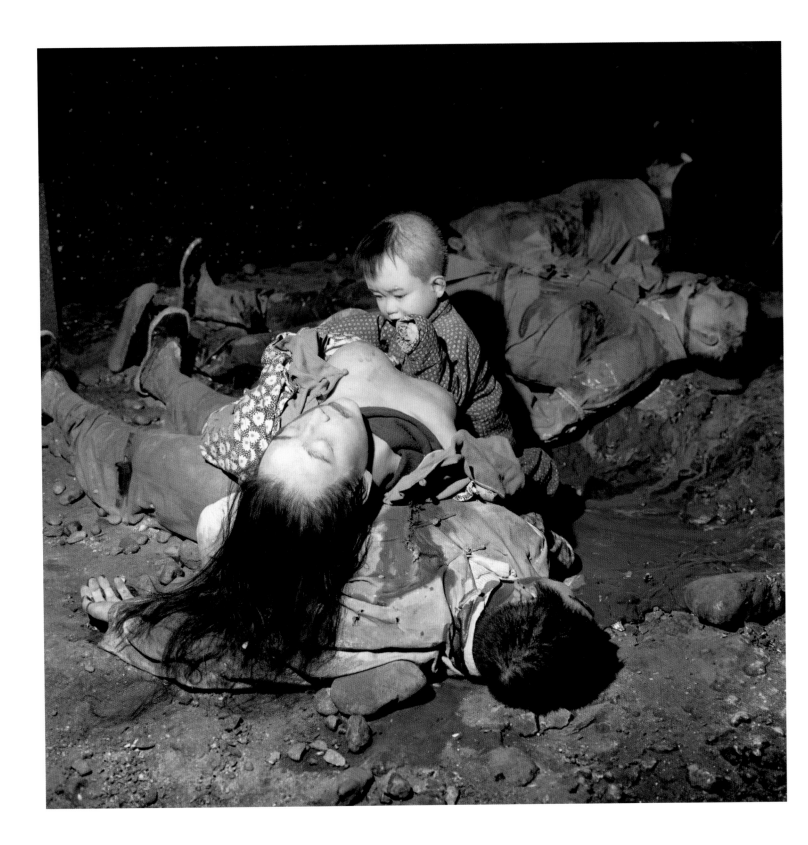

[1] **Campfire Day**, from the series **"Campfire Day"**, 2001, C-print, 41 x 62 cm, 16 x 24 inches
[2] **Aral-1**, from the series **"Tankstelle"** [**Gas Station**], 2005, C-print, 46 x 69 cm, 18 x 27 inches
[3] **Aral-2**, from the series **"Tankstelle"** [**Gas Station**], 2005, C-print, 46 x 69 cm, 18 x 27 inches

"The question of authenticity has become very complex today with regard to documentary photography", **Tobias Zielony** says. "This is not just a question of whether or how much the photos are posed or manipulated". This ambiguity is the core of his practice. Zielony, who studied documentary photography at the University of Wales and received his Masters in Fine Art from the Academy of Visual Art Leipzig, creates portrait series of young people that are infused with near cinematographic qualities.

Zielony photographs places with which he has no personal links. He investigates a location, meets its people and ends up knowing his subjects well. For the 2001-4 series "Behind the Block", published in Leipzig in 2004, Zielony immersed himself in the peripheries of three European cities: Halle-Neustadt in Germany, Marseille in France and Bristol in the UK. These three cities have enforced restrictive measures to contain violence and criminality, including curfews for youths. They also share a failed ideal of housing estates rooted in the 1930s and a devastated local economy, with its contingent unemployment and boredom. Zielony's photographs document the survival of youth community and culture and their ceremonies of social interaction. Following the same protocol, his series "Tankstelle" [Gas Station] (begun 2004) captures a certain typology of space and young people's occupations around it. Gas stations are, in some East German cities, the last commercial venues still in operation. Another ongoing series, "Big Sexyland" (begun 2005), consists of black-and-white photographs of a derelict porn cinema and the nearby park where young male prostitutes sleep and spend their time.

Zielony photographs a mutated European identity— generationally specific protocols of cultural survival and codes of group behaviour in economically wrecked urban areas. He observes the immediate effects of ancient and recent migration flows on the construction of social interaction at the edges of cities and standard cultural models. As Zielony states, "The disintegration of traditional industries, as well as migration and the changing role of the family, mean a loss of collective identity and security." Despite his heavy social and economic themes, Zielony avoids any narrative, moral or symbolic reading as well as any sensationalizing or scandalizing impact. The titles he gives to his pictures are short and descriptive. He refuses to adhere to a highly formalized photography, always bearing in mind the nature of his subjects. In these respects, his approach is similar to that of Boris Mikhailov, Michael Schmidt and Paul Graham.

Nevertheless, his carefully framed images reveal an aesthetic strategy in accord with their subjects. Often shot at night, in situ urban electric lights, as in *Aral-1* (2005) and photographic flash (as in the "Big Sexyland" series) isolate scenes and models and disconnect them from their surroundings on to an ephemeral stage, amid the wrecked decor of modernist structures and anonymous standard architecture, under the spotlight of neon gas station signs or lobby entrances. In these improvised sets, models —who know they are being photographed—perform a choreographed scene or pose for the camera with the clear intention of being perceived in a specific way, thus positioning the photograph in an unsettling grey zone between staged and simply observed pictures.
—Vincent Honoré

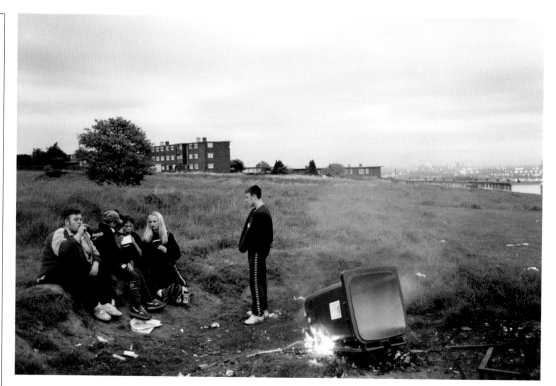

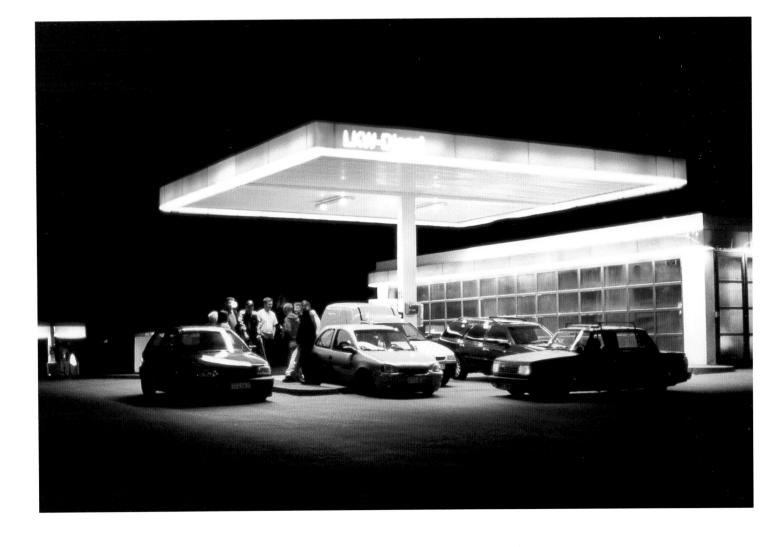

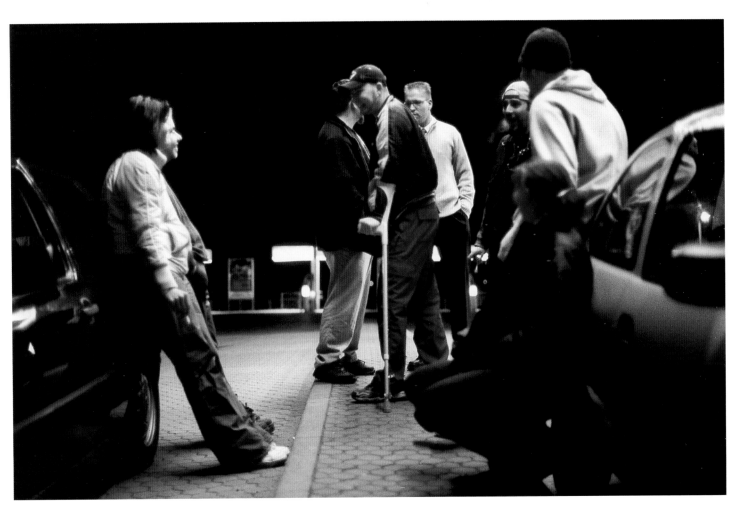

AES+F group
Ag
012
Born 1955, 1958 and 1958, Moscow, Russia. All live in Moscow, Russia.

Selected solo exhibitions: 2005 Claire Oliver, New York/ 2005 Ruzicska, Salzburg/ 2005 "Starz", Moscow Museum of Contemporary Art, Moscow/ 2004 Guelman Gallery, Moscow/ 2003 Claire Oliver, New York/ 2002 Galerie Knoll Wien, Vienna **Selected group exhibitions:** 2006 "ARS 06", Museum of Contemporary Art, Kiasma, Helsinki/ 2005 "Baroque and Neobaroque. The Hell of the Beautiful", Domus Artium 2002, Salamanca/ 2005 "Mixed-up Childhood", Auckland Art Gallery, Auckland/ 2004 "Sydney Biennale of Contemporary Art", Museum of Contemporary Art, Sydney/ 2004 "Rencontres d'Arles", Arles **Selected bibliography:** 2005 Susan Bright, *Art Photography Now*, Thames & Hudson, London/ 2005 Janita Craw and Robert Leonard, *We are the World* (exhibition catalogue), Juan Ruiz Galeria, Maracaibo/ 2004 Ekaterina Dyogot, "The desecration of the image of a child", *On Reason and Emotion* (exhibition catalogue), Sydney/ 2004 Sophie Bernard, "Songes anticipation réalité? Collectif AES+F", *Images* no 5, July/August/ 2003 Simona Vladikova, "Profile: AES", *Fotograf*/ 2002 Rosa Olivares, "I Am The Other", "AES+F group", *Exit*, no 7

Armando Andrade Tudela
Aa
014
Born 1975, Lima, Peru. Lives Saint Etienne, France.

Selected solo exhibitions: 2006 Counter Gallery, London/ 2003 Annet Gelink Gallery, Amsterdam **Selected group exhibitions:** 2006 "27th Bienal de São Paulo", São Paulo/ 2005 "Torino Triennale", Castello di Rivoli/ 2005 "InSite05", San Diego Museum of Art, San Diego, Centro Cultural, Tijuana/ 2005 "Tropical Abstraction", Stedelijk Museum Bureau, Amsterdam **Selected bibliography:** 2005 Roos Gortzak, "Armando Andrade Tudela", *Metropolis M*, June/ 2005 Mark Godfrey, "Image Structures", *Artforum*, February

Alexander Apostól
Aa
016
Born 1969, Barquisimeto, Venezuela. Lives Caracas, Venezuela and Madrid, Spain.

Selected solo exhibitions: 2006 Los Angeles Contemporary Editions, Los Angeles/ 2006 David Rockefeller Center for Latin American Studies, Harvard University, Boston/ 2006 Palau de La Virreina, Barcelona/ 2004 Sala Mendoza, Caracas/ 2003 Casa de América, Madrid **Selected group exhibitions:** 2005 "Emergencias", Museo de Arte Contemporáneo de Castila y León MUSAC, León/ 2004 VIII Internacional Cuenca

Biennial, Cuenca/ 2003 "8th International Istanbul Biennial", Istanbul/ 2003 "Prague Biennale", Prague/ 2002 "25th Bienal de São Paulo", São Paulo **Selected bibliography:** 2005 Susan Bright, *Art & Photography*, Thames & Hudson, London/ 2003 Christine Paul, *Digital Art*, Thames & Hudson, London/ 2003 Alejandro Castellote, Iván de La Nuez, Juan Antonio Molina, *Mapas Abiertos*, Lunverg, Madrid/ 2002 *Blink*, Phaidon Press, London

The Atlas Group/ Walid Raad
Ag
018
Born 1967, Chbanieh, Lebanon. Lives Beirut, Lebanon and New York, NY, USA.

Selected solo exhibitions: 2006 The Kitchen, New York/ 2006 Leonard and Bina Ellen Gallery, Montreal/ 2005 FACT, Liverpool/ 2005 Agnes Etherington Art Centre, Kingston/ 2004 Art Gallery of York University, Toronto **Selected group exhibitions:** 2006 "Without Boundary: Seventeen Ways of Looking", The Museum of Modern Art, New York/ 2006 "Neo Sincerity: The Difference Between the Comic and the Cosmic is a Single Letter", apexart, New York/ 2005 "Greater New York 2005", PS1 Contemporary Art Center, New York/ 2005 "I Feel a Great Desire to Meet the Masses Once Again", Homworks III, Beirut/ 2005 "Incorporated", Cincinnati Arts Center, Cincinnati **Selected bibliography:** 2004 Amei Wallach, "The Fine Art of Car Bombing", *The New York Times*, June 20/ 2003 Deborah Root, "Mapping the Disaster", *Prefix Photo*, May/ 2003 Saul Anton, "A Secret History", *Frieze*, January/ 2003 *Cream 3*, Phaidon Press, London/ 2002 Dina Al-Kassim, "Crisis of the Unseen", *Parachute*, October

Miriam Bäckström
Mb
020
Born 1967, Stockholm, Sweden. Lives Stockholm, Sweden.

Selected solo exhibitions: 2005 "51st Venice Biennale", Venice/ 2004 Museum für Gegenwartskunst, Basel/ 2002 Centro de Arte de Salamanca, Salamanca/ 2000 The National Gallery of Iceland, Reykjavik/ 2000 Institute of Contemporary Arts, London **Selected group exhibitions:** 2006 "Modernautställningen", Moderna Museet, Stockholm/ 2006 "Unlimited ID, the portrait as concept", Dazibao, Centre de Photographies actuelles, Montreal/ 2006 "Visibilities, Between Facts and Fiction", Edith-Russ-Haus für Medienkunst, Oldenburg/ 2005/6 "Shadow Play", Kunsthallen Brants Klaedefabrik, Odense, Kunsthalle zu, Kiel, Landesgalerie, Linz/ 2005 "Rebecka", Kasseler Documentarfilm & Videofest, Kassel **Selected bibliography:** 2005 Massimo Bartolini, Nancy Spector, "Miriam Bäckström & Carsten Höller, Swedish Pavilion", *Domus* no 883/ 2005 Jennifer Allen, "Miriam Bäckström", *Frog*, no 2/ 2005 Ronald Jones, "Miriam Bäckström at IASPIS", *Artforum*, January/ 2000 *Fresh Cream*, Phaidon Press, London

Yto Barrada
Yb
024
Born 1971, Paris, France. Lives Tangier, Morocco.

Selected solo exhibitions: 2006 The Kitchen, New York/ 2006 Jeu de Paume-Site Sully, Paris/ 2005 Mead Gallery, Warwick Arts Centre, Warwick/ 2005 Open Eye Gallery, Liverpool/ 2004 Witte de With Centre for Contemporary Art, Rotterdam **Selected group exhibitions:** 2006 "Deutsch Borse Photography Prize", The Photographers' Gallery, London/ 2006 "Snap Judgements", International Center of Photography, New York/ 2004–6 "Africa Remix", Museum Kunst Palast, Düsseldorf, Hayward Gallery, London, Centre Pompidou, Paris, Mori Art Museum, Tokyo, Moderna Museet, Stockholm **Selected bibliography:** 2005 *A Life Full of Holes – The Strait Project*, Autograph ABP, London/ 2004 *Fais un fils et jette le à la mer*, Edition Sujet-Objet, Paris/ 2004 *Cabinet*, no 16/ 2003 *Strangers: The First ICP Triennial of Photography and Video*, Steidl, Göttingen/ 2003 *Un quintet pour demain*, Editions Galerie Claude Bernard, Paris/ 2002 *Blink*, Phaidon Press, London

Erica Baum
Eb
028
Born 1961, New York, NY, USA. Lives New York, NY, USA.

Selected solo exhibitions: 2005 The Gallery at Hi Art, New York/ 2004 D'Amelio Terras, New York/ 2003 D'Amelio Terras, New York/ 2000 D'Amelio Terras, New York **Selected group exhibitions:** 2005 "Library", Contemporary Art Galleries, University of Connecticut, Storrs/ 2002 "Gravity Over Time", 1000 Eventi, Milan/ 2001 "Snapshot", The Contemporary Art Museum, Baltimore **Selected bibliography:** 2005 Stephen Robert Frankel, "Erica Baum at D'Amelio Terras", *Art On Paper*, January/ 2003 Johanna Burton, "Erica Baum Play Direction", *Time Out New York*, September 18–25/ 2002 "Artists Visualize Information Today", *NY Arts*, no 5, vol 7, May/ 2001 Erica Baum, "The Following Information", *Open City*, Summer/Fall/ 2000 Frances Richard, "Erica Baum", *Artforum*, October

Valérie Belin
Vb
030
Born 1964, Boulogne-Billancourt, France. Lives Paris, France.

Selected solo exhibitions: 2005 Galerie Ulrich Fiedler, Cologne/ 2005 Brent Sikkema Gallery, New York/ 2004 Galerie Xippas, Paris/ 2004 Centro de Arte de Salamanca, Salamanca/ 2003 Koldo Mitxelena Kulturunea, San Sebastián **Selected group exhibitions:** 2005 "Star Star: Toward the Center of Attention", Contemporary Art Center, Cincinnati/ 2005 "Contenance, Fassung Bewahren", Württembergischer Kunstverein Stuttgart, Stuttgart/ 2005

"(my private) HEROES", Marta Herford Museum, Herford/ 2005 "Suddenly Older", Clifford Art Gallery, Colgate University, Hamilton/ 2004 "Making Faces: the Death of the Portrait", Hayward Gallery, London **Selected bibliography:** 2005 Régis Durand, "Valérie Belin's Deep Surfaces", *Art Press*, November/ 2005 Giorgia Losio, "Valérie Belin, Galerie Xippas", *Tema Celeste*, March/April/ 2005 Lynn Hirschberg, "Sleeping Beauty", *The New York Times Magazine*, April 17/ 2004 Michel Guerrin, "Les enveloppes de Valérie Belin", *Le Monde*, December 11/ 2004 Michel Poivert, "Morbidezza"in *Valérie Belin* (exhibition catalogue), Fundación Salamanca Ciudad de Cultura, Salamanca

Walead Beshty
Wb
032
Born 1976, London, UK. Lives Los Angeles, CA, USA.

Selected solo exhibitions: 2006 Armand Hammer Museum of Art, Los Angeles/ 2005 China Art Objects Galleries, Los Angeles/ 2004 Wallspace, New York/ 2004 PS1 Contemporary Art Center, New York **Selected group exhibitions:** 2006 "California Biennial: Orange County Living Dead", Art 2102, Los Angeles/ 2005 "Manufactured Self", Museum of Contemporary Photography, Chicago **Selected bibliography:** 2006 Chris Balaschak, "Walead Beshty at China Art Objects", *Frieze*, January/ 2005 Magali Arriola, "A Victim and a Viewer: Some Thoughts on Anticipated Ruins", *Afterall*, no 12, Fall/ 2005 Joe Scanlan, "First Take: Walead Beshty", *Artforum*, January/ 2005 Daniel Kunitz, "The Art Review 25: Emerging US Artists", *Art Review*, March/ 2004 Jeffrey Kastner, "Exhibition Review: Walead Beshty at Wallspace", *Artforum*, December

Rut Blees Luxemburg
Rb
036
Born 1967, Trier, Germany. Lives London, UK.

Selected solo exhibitions: 2004 Institute of Contemporary Arts, London (opera performance)/ 2004 Galerie Dominique Fiat, Paris/ 2004 Union Gallery, London/ 2003 Tate Liverpool, Liverpool/ 2003 Glynn Vivian Gallery, Swansea **Selected group exhibitions:** 2005 "Go Between", Kunstverein Bregenz, Austria/ 2005 "In Limbo", Denver Art Museum, Denver/ 2004 "The Pattern of the Plans and the Lack of Plan Plan", T1&2, London/ 2003 "A Bigger Splash: British Art from the Tate", Oca, São Paulo/ 2003 "Passages", Art 3, Valences **Selected bibliography:** 2005 Yann Perreau, "To Delphi", *Art Press*, January/ 2005 Jennifer Higgie, "Liebeslied/My Suicides", *Frieze*, January/February/ 2004 Tom Service, "All together now one very unusual opera", *The Guardian*, October 21/ 2003 David Campany, *Art and Photography*, Phaidon Press, London/ 2002 *Blink*, Phaidon Press, London

Luchezar Boyadjiev
Lb
040

Born 1957, Sofia, Bulgaria. Lives Sofia, Bulgaria.

Selected solo exhibitions: 2004 Arte Fiera, Bologna/ 2003 Institute of Contemporary Art at ATA Centre, Sofia/ 2001 Knoll Gallery, Vienna/ 2000 ArtMediaCenter TV Gallery, Moscow **Selected group exhibitions:** 2005 "Urban Realities: Focus Istanbul", Martin Gropius Bau, Berlin/ 2005 "Sous les ponts, le long de la rivière…", Casino Luxembourg, Luxembourg/ 2005 "Sharjah Biennial", Sharjah/ 2003 "In the Gorges of the Balkans", Kunsthalle Fridericianum, Kassel/ 2003 "Blood & Honey/Future's in the Balkans", The Essl Collection, Klosterneuburg, Vienna **Selected bibliography:** 2005 *Trans:it. Moving Culture Through Europe*, Fondazione Adriano Olivetti, Rome/ 2004 *Sofia as a Sight. VS1. Luchezar Boyadjiev/Hot City Visual* (exhibition catalogue), ICA, CAS, Revolver, Sofia/ 2003 *Installation Art in the New Millennium*, Thames & Hudson, London/ 2002 Werner Fenz, "Listen to Boyadjiev's Eyes", *Lichtungen Magazine*, 91/XXIII Jg/ 2000 *Fresh Cream*, Phaidon Press, London

Frank Breuer
Fb
042

Born 1963, Rheinbach, Germany. Lives Cologne, Germany.

Selected solo exhibitions: 2005 Jousse Entreprise, Paris/ 2005 Goethe Institut, Beijing and Hong Kong/ 2004 Rencontres d'Arles 2004, Arles/ 2004 fiedler contemporary, Cologne/ 2003 The Photographers' Gallery, London **Selected group exhibitions:** 2005 Musée de la Publicité, Paris/ 2004 "Photographs from the Collection Lila Acheson Wallace", Metropolitan Museum of Art, New York/ 2004 "Regarde la neige", Centre National d'art et du paysage, Ile de Vassivière/ 2003 "New Fall Faculty", Carpenter Center, Harvard University, Cambridge/ 2003 "New Order", fiedler contemporary, Cologne **Selected bibliography:** 2005 *Frank Breuer Logos Warehouses Containers*, fiedler contemporary, Cologne, Jousse Entreprise, Paris, Schaden.com, Cologne/ 2004 *Arles Rencontres de la Photographie 2004* (exhibition catalogue), Actes du Sud, Arles/ 2003 Marcus Verhagen, "Frank Breuer", *Art Monthly*, no 8/ 2003 Roy Exley, "Warehouses and Logos", *Art Press*/ 2003 Elisabeth Mahoney, "Photographers' Gallery, London/2003 Frank Breuer", *The Guardian*, June 5

Olaf Breuning
Ob
044

Born 1970, Schaffhausen, Switzerland. Lives New York, NY, USA.

Selected solo exhibitions: 2005 Chisenhale Gallery, London/ 2005 Chapter Visual Arts, Cardiff/ 2005 Nicola von Senger Galerie, Zürich/ 2004 Metro Pictures, New York/ 2003 Magasin-Centre National d'Art Contemporain, Grenoble **Selected group exhibitions:** 2005 "Burlesques Contemporains", Jeu de Paume, Paris/ 2005 "When Humor Became Painful", Migros Museum, Zürich/ 2005 "First we take the Museums Urban Arts Now", Museum of Contemporary Art, Kiasma, Helsinki/ 2004 "Mind the Gap", Kunstverein Freiburg, Freiburg/ 2004 "Sommerfrische: Künstlervideos mit Esprit", Hamburger Kunsthalle, Hamburg **Selected bibliography:** 2005 Adam Sutherland, "The captain is dead but that is no problem", *They Live*, Chapter, Cardiff/ 2004 Maika Pollack, "Olaf Breuning Metro Pictures", *Flash Art*, March/April/ 2004 "Dossier Olaf Breuning", *Parkett*, no 71/ 2001 *Ugly, Olaf Breuning*, Hatje Cantz Verlag, Ostfildern-Ruit/ 2000 *Fresh Cream*, Phaidon Press, London

Gerard Byrne
Gb
048

Born 1969, Dublin, Ireland. Lives Dublin, Ireland.

Selected solo exhibitions: 2005 Beaumont Public Project Space, Luxembourg/ 2004 Green on Red Gallery, Dublin/ 2004 Project Arts Centre, Dublin/ 2004 BAK Utrecht/ 2003 Frankfurter Kunstverein, Frankfurt **Selected group exhibitions:** 2005 "Eindhoven Istanbul", Van Abbemuseum, Eindhoven/ 2005 "3rd Göteborg Biennial", Göteborg Kunsthall, Göteborg/ 2003 "Institution @", Museum of Contemporary Art, Kiasma, Helsinki/ 2003 "8th International Istanbul Biennial", Istanbul/ 2003 "The American Effect", Whitney Museum of American Art, New York **Selected bibliography:** 2005 Maeve Connolly "Abstraction and dislocation in recent works by Gerard Byrne", *Circa*, 113, Autumn/ 2004 George Baker, *Gerard Byrne*, Lukas & Sternberg, New York / 2004 Jessica Lack, "Homme à femmes", *Untitled*, no 32, Summer/ 2004 Willem De Rooji, "A country road, a tree, evening", *BAK*/ 2002 Annie Fletcher, Raul Zamudio, Jacob Fabricius, *Op-Ed* (exhibition catalogue), Limerick City Gallery, Limerick, The Douglas Hyde Gallery, Dublin

Elinor Carucci
Ec
050

Born 1971, Jerusalem, Israel. Lives New York, NY, USA.

Selected solo exhibitions: 2005 Fotografie Forum International, Frankfurt/ 2005 51 Fine Art Photography, Antwerp/ 2005 Herzliya Museum of Contemporary Art, Herzliya/ Ricco/Maresca Gallery, New York/ 2004 Noga Gallery, Tel Aviv/ 2003 Gagosian Gallery, London **Selected group exhibitions:** 2004 "New Faculty", Carpenter Center, Harvard University, Cambridge/ 2003 "Contemporary Art/Recent Acquisitions", The Jewish Museum, New York/ 2002 "Ten years: A Celebration 1993–2002 John Kobal Award", National Portrait Gallery, London/ 2002 "Skin", Cooper-Hewitt National Design Museum, New York **Selected bibliography:** 2005 *Diary of a Dancer*, Steidl, Göttingen/ 2005 *Family*, Phaidon Press, London/ 2004 Charlotte Cotton, *The Photograph as Contemporary Art*, Thames & Hudson, London/ 2003 David Campany, *Art and Photography*, Phaidon Press, London/ 2002 *Closer: Photographs by Elinor Carucci*, Chronicle Books, San Francisco

David Claerbout
Dc
054

Born 1969, Kortrijk, Belgium. Lives Antwerp, Belgium and Berlin, Germany.

Selected solo exhibitions: 2004/5 Lehnbachhaus, Munich, Berliner Künstlerprogramm, DAAD, Berlin, Van Abbemuseum, Eindhoven, Dundee Contemporary Arts Centre, Dundee/ 2004 Herbert Read Gallery, Canterbury/ 2003 CGAC Centro Gallego de Arte Contemporánea, Santiago de Compostela/ 2002 Kunstverein Hannover, Hanover **Selected group exhibitions:** 2006 "Click Doubleclick", Haus der Kunst, Munich/ 2005 "Belgique Visionnaire", Palais des Beaux-Arts, Brussels/ 2003 "War (What is it Good for?)", Museum of Contemporary Art, Chicago/ 2003 "Outlook", Athens/ 2001 "Berlin Biennale", Berlin **Selected bibliography:** 2004 Susanne Gaensheimer, Friedrich Meschede et al (eds), *David Claerbout* (exhibition catalogue), Verlag der Buchhandlung Walther König, Cologne/ 2004 David Green, Joanna Lowry, *David Claerbout* (exhibition catalogue), Herbert Read Gallery, Canterbury/ 2003 *Cream 3*, Phaidon Press, London/ 2003 Stephan Berg, Rachel Kushner, *David Claerbout* (exhibition catalogue), CGAC Centro Galego de Arte Contemporánea Santiago de Compostela/ 2002 Kunstverein Hannover (ed), *David Claerbout* (exhibition catalogue), A Prior, Brussels

Anne Collier
Ac
056

Born 1970, Los Angeles, CA, USA. Lives New York, NY, USA.

Selected solo exhibitions: 2005 Corvi Mora, London/ 2004 Marc Foxx Gallery, Los Angeles/ 2004 Jack Hanley Gallery, San Francisco/ 2002 Marc Foxx Gallery, Los Angeles/ 2001 Marc Foxx Gallery, Los Angeles **Selected group exhibitions:** 2006 "Whitney Biennial", Whitney Museum of American Art, New York/ 2005 "Drunk Vs Stoned 2", Gavin Brown Enterprise, New York/ 2005 "Bridge Freezes Before Road", Gladstone Gallery, New York/ 2005 "Greater New York", PS1 Contemporary Art Center, New York/ 2004 "Likeness: Portraits of Artists by Other Artists", CCA Wattis Institute, San Francisco **Selected bibliography:** 2005 Roberta Smith, "Along the Blurry Line Between Blotto and Buzzed", *The New York Times*, August 26/ 2005 Jerry Saltz, "Lesser New York", *The Village Voice*, March 30/ 2004 Christopher Miles, "Anne Collier at Marc Foxx", *Artforum*, December/ 2004 Pablo LaFuente, "The Faces of the Future", *Art Review*, October/ 2002 Christopher Miles, "Anne Collier at Marc Foxx", *Artforum*, December

Phil Collins
Pc
058

Born 1970, Runcorn, UK. Lives Glasgow, UK.

Selected solo exhibitions: 2006 Tate Britain, London/ 2006 S.M.A.K. Stedelijk Museum voor Actuele Kunst, Gent/ 2006 Nederlands Fotomuseum, 35th International Film Festival, Rotterdam/ 2005 Wexner Center for the Arts, Ohio State University, Columbus/ 2005 Milton Keynes Gallery, Milton Keynes **Selected group exhibitions:** 2006 "Deutsche Börse Photography Prize", The Photographers' Gallery, London/ 2005 "British Art Show 6", BALTIC The Centre for Contemporary Art, Gateshead/ 2005 "9th International Istanbul Biennial", Istanbul/ 2005 "Populism", Stedelijk Museum, Amsterdam, Frankfurter Kunstverein, Frankfurt, Centre for Contemporary Arts, Vilnius/ 2005 "Universal Experience: Art, Life and the Tourist's Eye", Museum of Contemporary Art, Chicago, Hayward Gallery, London **Selected bibliography:** 2006 Claire Bishop, "The Social Turn: Collaboration and its Discontents", *Artforum*, February/ 2006 "Who Said An Artwork Shouldn't Be An Imposition?: A conversation between Phil Collins & Jeremy Millar", *Deutsche Börse Photography Prize 2006* (exhibition catalogue), The Photographers' Gallery, London/ 2005 Alex Farquharson, "Minority Report", *Frieze*, October/ 2005 "24 Frames of Lies: Phil Collins & Todd Haynes in conversation", *yeah.....you, baby you* (exhibition catalogue), Milton Keynes Gallery, Milton Keynes, Shady Lane Publications, Brighton/ 2005 Claire Bishop, Francesco Manacorda, "The Producer As Artist", *yeah.....you, baby you* (exhibition catalogue), Milton Keynes Gallery, Milton Keynes, Shady Lane Publications, Brighton

Kelli Connell
Kc
062

Born 1974, Oklahoma City, OK, USA. Lives Youngstown, OH, USA and Dallas, TX, USA.

Selected solo exhibitions: 2006 Yossi Milo Gallery, New York/ 2005 Barry Whistler Gallery, Dallas/ 2005 Zone VI Photography Gallery, Dayton/ 2004 Columbus Museum of Art, Columbus/ 2004 Lawndale Art Center, Houston **Selected group exhibitions:** 2005

"Heartfelt", FSU Museum of Fine Arts, Tallahasee/ 2005 "Out of the Darkroom", Miami University, Oxford/ 2005 "Portraits", Weinstein Gallery, Minneapolis/ 2004 "David Hilliard and Kelli Connell: Real Time", Diverse Works, Houston/ 2004 "Kelli Connell and Cortney Andrews", Society for Contemporary Photography, Kansas City **Selected bibliography:** 2006 Richard Woodward, "Altered States", *ARTnews*, March/ 2006 *MP3: Midwest Photographers' Publication Project: Kelli Connell*, Aperture, New York/ 2005 Robert Hirsch, *Exploring Color Photography: From the Darkroom to the Digital Studio*, McGraw Hill, New York/ 2004 Leo Costello, "Kelli Connell: Double Life, Lawndale Art Center," *Artlies*, Spring/ 2004 *NA, Fotofest 2004: Celebrating Water*, Fotofest Inc, Houston

<table>
<tr><td>Eduardo Consuegra

Ec

064</td><td>Born 1974, Bogotá, Colombia. Lives Los Angeles, CA, USA.</td></tr>
</table>

Selected solo exhibitions: 2006 Art Center College of Design, Pasadena/ 2002 Alianza Colombo-Francesa, Bogotá **Selected group exhibitions:** 2006 "Dark Places", Santa Monica Museum of Art, Los Angeles/ 2005 "InSite05", San Diego Museum of Art, San Diego, Centro Cultural, Tijuana/ 2004 "39 National Art Show", Museo de Arte Moderno, Bogotá/ 2003 "To be political, it has to look nice", Apexart, New York/ 2001 "El Grupo de los Miercoles", La Panaderia, Mexico City **Selected bibliography:** 2005 Jan Tumlir, "InSite05", *Artforum*, November/ 2005 *InSite05 Farsites: Urban Crisis and Domestic Symptoms in Recent Contemporary Art* (exhibition catalogue), San Diego Museum of Art, San Diego, Centro Cultural, Tijuana/ 2004 Diego Garzon, "Territorio VHS", *Revista Semana*, September 6/ 2003 Pablo Leon De la Barra, *To be political, it has to look nice* (exhibition catalogue), Apexart, New York

<table>
<tr><td>Sharon Core

Sc

066</td><td>Born 1965, New Orleans, LA, USA. Lives Esopus, NY, USA.</td></tr>
</table>

Selected solo exhibitions: 2004 Bellwether Gallery, New York/ 2001 Clementine Gallery, New York/ 2000 White Columns, New York **Selected group exhibitions:** 2006 "Taken For Looks", Southeast Museum of Photography, Daytona Beach/ 2005 "Painting", Anthony Reynolds Gallery, London/ 2005 "Pictures", Gallery Hyundai, Seoul/ 2004 "Art History: Photography References Painting", Yancey Richardson Gallery, New York/ 2002 "Cucina Mobile", Gallery W139, Amsterdam **Selected bibliography:** 2005 Barbara Pollock, "Moonlight Sonata", *ARTnews*, September/ 2005 Reena Jana, *Pictures* (exhibition catalogue), Gallery Hyundai, Seoul/ 2004 Ken Johnson, "Sharon Core: Thiebauds", *The New York Times*, March 5/ 2004 Maura

Egan,"Cake Masters",*Style and Entertaining, The New York Times*, Spring/ 2004 Barbara Pollock, "Sharon Core: Thiebauds", *Time Out New York*, March 4–16

<table>
<tr><td>Rochelle Costi

Rc

068</td><td>Born 1967, Caxias do Sul, Brazil. Lives São Paulo, Brazil.</td></tr>
</table>

Selected solo exhibitions: 2005 Instituto Tomie Ohtake, São Paulo/ 2003 Galeria Brito Cimino, São Paulo **Selected group exhibitions:** 2005 "InSite05", San Diego Museum of Art, San Diego, Centro Cultural, Tijuana/ 2005 "Something of the Night", Leeds City Art Gallery, Leeds, UK/ 2005 "Beyond Delirious: Architecture in Selected Photographs from the Ella Fontanals Cisneros Collection", Cisneros Fontanals Art Foundation (CIFO), Miami, USA/ 2001 "Ultrabaroque: Aspects of Post-Latin American Art", Museum of Contemporary Art, San Diego/ 2000 "26th Bienal de Pontevedra", Pontevedra, Spain **Selected bibliography:** 2005 Rochelle Costi, *sem título/ untitled/sin título*, Metalivros, São Paulo/ 2004 Rafael Vogt Maia Rosa, "Everyday Sights", *Arte al Dia*, December/January/ 2001 Elizabeth Armstrong, Miki Garcia, Victor Zamudio-Taylor, *Ultrabaroque: Aspects of Post-Latin American Art*, Museum of Contemporary Art, San Diego/ 2000 Tadeu Chiarelli, "*26th Bienal de Arte de Pontevedra*", Pontevedra/ 2000 Rosa Olivares, *Mirades Impudiques*, Sala Montcada de la Fundación "la Caixa", Barcelona

<table>
<tr><td>Gregory Crewdson

Gc

070</td><td>Born 1962, New York, NY, USA. Lives New York, NY, USA.</td></tr>
</table>

Selected solo exhibitions: 2006 Fotomuseum, Winterthur/ 2005 Gagosian Gallery, Los Angeles/ 2005 Luhring Augustine, New York/ 2005 White Cube, London/ 2003 John Berggruen Gallery, San Francisco **Selected group exhibitions:** 2006 "The Magic Hour of Twilight", Victoria and Albert Museum, London/ 2005 "Highlights New Acquisitions",John Berggruen Gallery, San Francisco/ 2005 "The World is a Stage: Stories Behind Pictures", Mori Art Museum, Tokyo/ 2005 "My Own Cinema", Galerie Georges-Philippe & Nathalie Vallois, Paris/ 2005 "I Never Thought What You Were Telling Me Was True or a Product of Your Imagination", Galeria Estrany De La Mota, Barcelona **Selected bibliography:** 2005 Stephan Berg, Martin Hochleitner, Katy Siegel, *Gregory Crewdson: 1985–2005* (exhibition catalogue), Kunstverein Hannover, Hatje Cantz Verlag, Ostfildern-Ruit/ 2003 Rick Moody, *Twilight: Photographs by Gregory Crewdson*, Harry N Abrams Inc, New York/ 2002 *Gregory Crewdson Early Work (1986–88)* (exhibition catalogue), Emilio Mazzoli Galleria d'Arte Contemporanea, Modena/ 2000 Darcey Steinke, Bradford Morrow, *Gregory*

Crewdson: Dream of Life, Ediciones Universidad De Salamanca, Salamanca

<table>
<tr><td>Nancy Davenport

Nd

074</td><td>Born 1965, Vancouver, Canada. Lives New York, NY, USA.</td></tr>
</table>

Selected solo exhibitions: 2005 Gardner Art Center, Brighton/ 2004 Nicole Klagsbrun Gallery, New York/ 2002 Photo & Contemporary, Turin/ 2001 Nicole Klagsbrun Gallery, New York **Selected group exhibitions:** 2005 "Campus", John Hansard Gallery, Southampton/ 2005 "Campus", Mead Gallery, Coventry/ 2003 "Strangers: The First ICP Triennial of Photography and Video", International Center of Photography, New York/ 2003 "Urban Dramas", de Singel International Kunstcentrum, Antwerp/ 2002 "25th Bienal de São Paulo", São Paulo **Selected bibliography:** 2006 Jonathan Griffin, "Campus," *Frieze*, February/ 2005 George Baker, "Photography's Expanded Field", *OCTOBER*/ 2005 Jonathan Lipkin, "Photography Reborn: Image Making in the Digital Era", Abrams, New York/ 2005 Mary Haus, "Struck by Lightning," *ARTnews*, February/ 2004 Fred Ritchin, *Strangers: The First ICP Triennial of Photography and Video*, Steidl, Göttingen

<table>
<tr><td>Tim Davis

Td

076</td><td>Born 1969, Blantyre, Malawi. Lives New York, NY, USA and Tivoli, NY, USA.</td></tr>
</table>

Selected solo exhibitions: 2006 Greenberg Van Doren Gallery, New York/ 2006 Susanne Vielmetter Los Angeles Projects, Los Angeles/ 2004 Bohen Foundation, New York/ 2003 Brent Sikkema Gallery, New York/ 2001 White Cube, London **Selected group exhibitions:** 2006 "The New City: Sub/urbia in Recent Photography", Whitney Museum of American Art, New York/ 2005 "Leopold Godowsky, Jr Color Photography Award", Photographic Resource Center, Boston/ 2004 "Art and Architecture 1900–2000", Genova Palazzo Ducale, Genoa/ 2003 "Office", The Photographers' Gallery, London/ 2001 "Workspheres", The Museum of Modern Art, New York **Selected bibliography:** 2006 Tim Davis, Jack Hitt, *My Life in Politics*, Aperture Foundation, New York/ 2006 Tim Davis, Robert Fitterman, *Illilluminations* (exhibition catalogue), Greenberg Van Doren Gallery, New York/ 2005 Walead Beshty, Bill Berkson, *Permanent Collection*, Nazraeli Press, Portland, Oregon/ 2004 Tim Davis, *American Whatever*, Edge Books, Washington, DC/ 2002 David Levi-Strauss, *Lots: Tim Davis*, Coromandel Design, Paris

<table>
<tr><td>Tacita Dean

Td

078</td><td>Born 1965, Canterbury, UK. Lives Berlin, Germany.</td></tr>
</table>

Selected solo exhibitions: 2006 Schaulager, Basel/ 2006 The National Museum of Art, Architecture and Design, Oslo/ 2005/6 Tate St Ives, St Ives/ 2005 South Presentation Convent, Cork/ 2004 Royal Institute of British Architects, London **Selected group exhibitions:** 2006 "27th Bienal de São Paulo", São Paulo/ 2005 "Universal Experience: Art, Life and the Tourist's Eye", Hayward Gallery, London/ 2004 "Likeness: Portraits of Artists by Other Artists", CCA Wattis Institute, San Francisco/ 2003 "50th Venice Biennale", Venice/ 2003 "The Moderns", Castello di Rivoli, Turin **Selected bibliography:** 2006 *Tacita Dean*, Phaidon Press, London/ 2006 *Die Regimentstochter*, Steidl, Göttingen/ 2005 *Tacita Dean* (exhibition catalogue), Tate St Ives, St Ives/ 2003 *Tacita Dean*, Paris-Musées, Éditions des Musées de la Ville de Paris, Paris, Steidl, Göttingen

<table>
<tr><td>Hans Eijkelboom

He

082</td><td>Born 1949, Arnhem, The Netherlands. Lives Amsterdam, The Netherlands.</td></tr>
</table>

Selected solo exhibitions: 2005 Gallery A, Amsterdam/ 2004 Nederlands Fotomuseum, Rotterdam **Selected group exhibitions:** 2005 "Respect", Dar Si Saïd Museum, Marrakesh/ 2004 "PIP Festival: International Photography Festival 2004", PingYao/ 2001 "Sonsbeek 9", Arnhem **Selected bibliography:** 2004 "Bulletin", Stedelijk Museum, Amsterdam, December/ 2004 Hans Eijkelboom, *Photo Notes 1992–2004, a selection from the photographic diary* (artist book)/ 2004 *Hans Eijkelboom, a meeting on the street*, KesselsKramer, Amsterdam

<table>
<tr><td>Olafur Eliasson

Oe

084</td><td>Born 1967, Copenhagen, Denmark. Lives Berlin, Germany.</td></tr>
</table>

Selected solo exhibitions: 2005 Hara Museum of Contemporary Art, Tokyo/ 2005 Museum Boijmans van Beuningen, Rotterdam/ 2005 Emi Fontana West of Rome, Los Angeles/ 2004 The Menil Collection, Houston/ 2003 Tate Modern, London **Selected group exhibitions:** 2005 "Tirana Biennale 3", Tirana/ 2005 "Here Comes the Sun", Magasin 3 Stockholm Konsthall, Stockholm/ 2005 "Always a little further", Arsenale, "51st Venice Biennale", Venice/ 2005 "Our Surroundings", Dundee Contemporary Arts, Dundee/ 2004 "The Encounters in the 21st Century: Polyphony Emerging Resonances", 21st Century Museum of Modern Art, Kanazawa **Selected bibliography:** 2006 *Your Engagement Has Consequences on the Relativity of Your*

Reality, Lars Müller Publishers, Baden/ 2005 Autostadt Wolfsburg (ed), *Olafur Eliasson: Dufttunnel*, Hatje Cantz Verlag, Ostfildern-Ruit/ 2004 *Olafur Eliasson: Minding the World* (exhibition catalogue), ARoS Århus Kunstmuseum, Århus/ 2004 *Olafur Eliasson: Your Lighthouse. Works with Light 1991–2004* (exhibition catalogue), Kunstmuseum Wolfsburg, Wolfsburg/ 2003 Susan May (ed), *Olafur Eliasson: The Weather Project* (exhibition catalogue), Tate Modern, London

JH Engström
Je
088
Born 1969, Karlstad, Sweden. Lives Stockholm, Sweden.

Selected solo exhibitions: 2005 Hasselblad Center, Gothenburg/ 2004 Galerie VU, Paris/ 2002 The Nordic Museum, Stockholm/ 2002 Arthotèque d'Angers, Angers/ 2002 Contretype, Brussels **Selected group exhibitions:** 2006 "One-man's land", Noorderlicht Fotogallery/ 2005 "Deutsche Börse Photography Prize", The Photographers' Gallery, London/ 2005 "Der Traum vom Ich, der Traum von der Welt", Fotomuseum, Winterthur/ 2005 "Heyra Festival", Seoul/ 2005 "Instable", Bildhuset, Umea **Selected bibliography:** 2006 *Haunts*, Steidl, Göttingen/ 2004 JH Engström, *Trying to Dance* (artist journal)/ 2004 *Deutsche Börse Photography Prize* (exhibition catalogue), The Photographers' Gallery, London/ 2004 *Scandinavian Photography* (exhibition catalogue), Faulconer Gallery, Grinell

Lalla Essaydi
Le
090
Born 1965, Marrakesh, Morocco. Lives Boston, MA, USA.

Selected solo exhibitions: 2006 The New Britain Museum of American Art, New Britain/ 2006 Williams College Museum, Williamstown/ 2005 Laurence Miller Gallery, New York/ 2005 Columbus Museum of Arts, Columbus **Selected group exhibitions:** 2006 "NAZAR", The IFA Gallery, Stuttgart/ 2005 "Images of the Middle East: Identity in the Process of Change", Danish Centre for Culture and Development, Copenhagen/ 2005 "Only Skin Deep: Changing Visions of the American Self", Museum of Photographic Arts, San Diego/ 2005 "The Painted Word", Lafayette College, Williams Center for the Arts Museum, Easton/ 2005 "The DeCordova Museum Annual Exhibitions", The DeCordova Museum, Lincoln/ 2005 "In the Company of Women", Williams College Museum of Art, Williamstown **Selected bibliography:** 2005 "NAZAR", *The New York Times*, October 21/ 2005 "Muslim Women: Traversing Boundaries", *Aperture*, January/ 2005 "Lalla Essaydi: Converging Territories", *NY Arts*, October 24/ 2005 *Converging Territories*, Power House Publishers, New York/ 2004/5 *Expose*, Harvard University Annual Magazine/ 2004 "Converging territories", *Nka, Journal of Contemporary African Art*, November

Roe Ethridge
Re
092
Born 1969, Miami, FL, USA. Lives New York, NY, USA.

Selected solo exhibitions: 2006 Gagosian Gallery, Los Angeles/ 2005 Andrew Kreps Gallery, New York/ 2005 Institute of Contemporary Art, Boston/ 2005 greengrassi, London/ 2004 Art Basel 34, Basel **Selected group exhibitions:** 2005 "Christopher Williams, Zoe Leonard and Roe Ethridge", Mai 36 Gallery, Zürich/ 2005 "Sutton Lane in Paris", Galerie Ghislaine Hussenot, Paris/ 2004 "The Big Nothing", Institute of Contemporary Art, University of Pennsylvania, Philadelphia/ 2004 "Never Never Landscape", Atle Gerhardsen Gallery, Berlin/ 2003 "my people were fair and had cum in their hair (but now they're content to spray stars from your boughs)", Team Gallery, New York **Selected bibliography:** 2005 Helen Sumpter, "Roe Ethridge, greengrassi, Elsewhere", *Time Out London*, June 8–15/ 2005 Bennett Simpson, *Roe Ethridge County Line* (artist book)/ 2004 Bennett Simpson, "Roe Ethridge in der Andrew Kreps Gallery, New York", *Texte zur Kunst*, June/ 2004 Charlotte Cotton, *The Photograph as Contemporary Art*, Thames & Hudson, London/ 2004 Lisa Pasquariello, "Profile: Roe Ethridge", *contemporary*, no 67

Peter Fraser
Pf
094
Born 1953, Cardiff, UK. Lives London, UK.

Selected solo exhibitions: 2003 University of Brighton Gallery, Brighton/ 2002 The Photographers' Gallery, London **Selected group exhibitions:** 2004 "Citigroup Photography Prize 2004", Kunst Palast, Düsseldorf, The Photographers' Gallery, London/ 2003 "Jede Fotografie ein Bild, Siemens Collection", Pinakothek der Moderne, Munich/ 2001 "Nothing exhibition", Northern Gallery for Contemporary Art, Sunderland, Contemporary Art Centre, Vilnius, Rooseum, Malmö **Selected bibliography:** 2006 *Peter Fraser*, Nazraeli Press, Portland/ 2004 *Citigroup International Photography Prize* (exhibition catalogue), The Photographers' Gallery, London/ 2004 Heinz-Norbert Jooks, "Citigroup Photography Prize Exhibition", *Kunstforum 171*, July/August/ 2004 Michael Bracewell, "Peter Fraser photographs 2002–2003", *Portfolio*, no 39/ 2004 Interview with Rachel Withers, "Peter Fraser Material", *FOAM Magazine*, no 5

Yang Fudong

Yf
096
Born 1971, Beijing, China. Lives Shanghai, China.

Selected solo exhibitions: 2006 Parasol Unit, London/ 2005 Kunsthalle Wien, Vienna/ 2005 Castello di Rivoli, Turin/ 2005 Stedelijk Museum, Amsterdam/ 2004 The Renaissance Society, Chicago **Selected group exhibitions:** 2005 "First Moscow Biennale of Contemporary Art", Moscow/ 2004 "Carnegie International", Carnegie Museum of Art, Pittsburgh/ 2003 "50th Venice Biennale", Chinese Pavilion, Venice/ 2003 "Alors la Chine? (What about China?)", Centre Pompidou, Paris/ 2002 "Dokumenta, Platform 5: Exhibition", Kassel **Selected bibliography:** 2003 "Yang Fudong", *Artforum*, September/ 2003 Jane Perlez, "Casting a Fresh Eye on China with Computer, not Ink Brush", *The New York Times*, December/ 2003 *Camera*, Musée d'Art Moderne de la Ville de Paris, Paris/ 2002 Lisa Movius, "Celluloid Purgatory: Shanghai's Independent Cinema Inches Forward", *Asian Wall Street Journal*, November 8–10

Anna Gaskell
Ag
098
Born 1969, Des Moines, IA, USA. Lives New York, NY, USA.

Selected solo exhibitions: 2004 Casey Kaplan, New York/ 2004 Galerie Yvon Lambert, Paris/ 2003 Galerie Gisela Capitain, Cologne/ 2002 The Menil Collection, Houston/ 2002 Des Moines Art Center, Des Moines **Selected group exhibitions:** 2005 "Out There: Landscape in the New Millennium", The Museum of Contemporary Art, Cleveland/ 2003 "Constructed Realities: Contemporary Photographers", Orlando Museum of Art, Orlando/ 2002 "Moving Pictures", Solomon R Guggenheim Museum, New York, Guggenheim, Bilbao/ 2002 "Visions from America", Whitney Museum of American Art, New York/ 2002 "Stories", Erzählsstrukturen in der zeitgenössischen Kunst, Haus der Kunst, Munich **Selected bibliography:** 2005 Uta Grosenick (ed), *Art Now Vol 2*, Taschen, Cologne, Los Angeles/ 2004 Lisa Dennison, Nancy Spector, Joan Young, *Moving Pictures*, Guggenheim, Bilbao/ 2002 Adam Weinberg, *Anna Gaskell*, Addison Gallery of American Art, Andover/ 2002 Melissa Harris (ed), *Photography Past/ Forward: Aperture at 50* (exhibition catalogue), Aperture Foundation, New York/ 2001 *Anna Gaskell*, Power House, New York

Simryn Gill

Sg
102
Born 1959, Singapore. Lives Sydney, Australia.

Selected solo exhibitions: 2004 Shiseido Gallery, Tokyo/ 2004 University of California Berkeley Art Museum, Berkeley/ 2002 Art Gallery of New South Wales, Sydney/ 2001 Galeri Petronas, Kuala Lumpur **Selected group exhibitions:** 2004 "Bienal de São Paolo", São Paolo/ 2002 "Biennale of Sydney", Sydney/ 2000 "Flight patterns", Museum of Contemporary Art, Los Angeles **Selected bibliography:** 2005 Chaitanya Sambrani, "Other realities, someone else's fictions: The tangled art of Simryn Gill", *Art and Australia*, no 2, vol 22/ 2003 Kate Bush, "Simryn Gill: Portfolio", *Artforum*, February/ 2003 Lee Wong Choy, "The spectre of comparisons", *Art AsiaPacific*, no 37/ 2002 Kevin Chua, "Simryn Gill and migration's capital", *Art Journal*, Winter/ 2000 *Fresh Cream*, Phaidon Press, London

Anthony Goicolea
Ag
104
Born 1971, Atlanta, GA, USA. Lives New York, NY, USA.

Selected solo exhibitions: 2005 The Arizona State University Museum of Art, Tempe/ 2005 Postmasters Gallery, New York/ 2004 Sandroni-Rey Gallery, Los Angeles/ 2003 Contemporary Centre of Photography, Melbourne/ 2002 Museum of Contemporary Photography, Chicago **Selected group exhibitions:** 2006 "Middle Ground: Photographs from the Whitney Museum of American Art", Columbia University, New York/ 2005 "Nocturnal Emissions", The Groninger Museum, Groningen/ 2005 "In Focus: Contemporary Photography from the Allen G Thomas Jr Collection", The North Carolina Museum of Art, Raleigh/ 2005 "Will Boys be Boys? Questioning Adolescent Masculinity in Contemporary Art", Independent Curators International, New York/ 2003 "How Human: Life in the Post-Genome Era", International Center of Photography, New York **Selected bibliography:** 2005 *Anthony Goicolea: Drawings*, Twin Palms Press Publishing, Santa Fe/ 2005 Alan Riding, "Photos that Change Reality", *The New York Times*, November 19/ 2005 Steven Stern, "Anthony Goicolea", *Absolute April*, no 2/ 2005 Linda Yablonsky, "To thine own selves be True", *ARTnews*, November/ 2003 *Anthony Goicolea* (book and CD-ROM), Twin Palms Press Publishing, Santa Fe

Geert Goiris
Gg
108
Born 1971, Bornem, Belgium. Lives Antwerp, Belgium.

Selected solo exhibitions: 2006 Galerie Catherine Bastide, Brussels/ 2005 Galerie Edward Mitterand, Geneva/ 2005 Zach Feuer Gallery, New York/ 2004 Galerie Art: Concept, Paris/ 2003 Roger Vandaele Editie, Antwerp **Selected group exhibitions:** 2006 "Outreach Award exhibition", Rencontres d'Arles, Arles/ 2005 "Buenos días Santiago", Attitudes extra muros, Museo de arte contemporáneo, Santiago de Chile/ 2005 "Croiser des Mondes", Jeu de Paume, Paris/ 2004 "Frammenti", Platform Garanti Contemporary Art Centre, Istanbul/ 2004 "Manifesta", San Sebastián **Selected bibliography:** 2005 Emily Hall, "Geert Goiris", *Artforum*, November/ 2005 Ken Johnson, "Geert Goiris", *The New York Times*, August/ 2005 Daniel Balice, "Geert Goiris", *Flash Art*, March/April/ 2005 Emmanuelle Lequeux, "Ceci n'est pas un rhinocéros", *Le Monde*

(Aden), November/ 2005 Dominique Baqué, "Concepts á l'oeuvre", *Art Press*, March

David Goldblatt

Dg

112

Born 1930, Randfontein, South Africa. Lives Johannesburg, South Africa.

Selected solo exhibitions: 2005 Johannesburg Art Gallery, Johannesburg/ 2005 Museum Kunst Palast, Düsseldorf/ 2003 Lenbachhaus, Munich/ 2003 Modern Art, Oxford/ 2002 Museu d'Art Contemporani de Barcelona, Barcelona **Selected group exhibitions:** 2005 "Faces in the Crowd", Whitechapel Art Gallery, London/ 2005 "Unsettled 8 South African Photographers", National Museum of Photography, Copenhagen/ 2004 "History, Memory, Society", Tate Modern, London/ 2004–6 "Africa Remix", Museum Kunst Palast, Düsseldorf, Hayward Gallery, London, Centre Pompidou, Paris, Mori Art Museum, Tokyo, Moderna Museet, Stockholm/ 2002 "Documenta 11", Kassel **Selected bibliography:** 2005 *David Goldblatt, South African Intersections*, Prestel, Munich/ 2004 *David Goldblatt, Particulars*, Goodman Gallery Editions, Johannesburg/ 2001 *David Goldblatt 55*, Phaidon Press, London/ 2001 *David Goldblatt Fifty-One Years* (exhibition catalogue), Museu d'Art Contemporani de Barcelona, Barcelona

Katy Grannan

Kg

114

Born 1969, Arlington, MA, USA. Lives San Francisco, CA, USA and New York, NY, USA.

Selected solo exhibitions: 2006 Greenberg Van Doren Gallery, New York/ 2006 Fraenkel Gallery, San Francisco/ 2005 Greenberg Van Doren Gallery, St Louis/ 2005 Fifty One Fine Art Photography, Antwerp/ 2005 Jackson Fine Art, Atlanta **Selected group exhibitions:** 2005 "Several Exceptionally Good Recently Acquired Pictures XVIII", Fraenkel Gallery, San Francisco/ 2005 "Sad Songs", University Gallery, Illinois State University, Normal/ 2005 "Recent Acquisitions", International Center for Photography, New York/ 2005 "This Must Be the Place", Center for Curatorial Studies, Bard College, Annandale-on-Hudson/ 2005 "Some Body Not Mine. The Beauty and Pain of Puberty", Rudolfinum, Centre of Contemporary Art, Prague **Selected bibliography:** 2005 Philip Gefter, "Embalming the American Dreamer", *The New York Times*, August 21/ 2005 Vince Aletti, "Critic's Notebook Extra Exposure", *The New Yorker*, May 2/ 2005 "Katy Grannan", *Blind Spot*, no 29, Spring/ 2003 Jerry Saltz, "At Two Locations, Photographer Katy Grannan Returns With Richer, Riskier New Work, Only the Lonely", *Village Voice*, September 12/ 2003 Martin Parr, "New Kids on the Block", *Art Review*, International Edition, Fall

Mauricio Guillen

Mg

116

Born 1971, Mexico City, Mexico. Lives London, UK.

Selected solo exhibitions: 2006 fa projects, London/ 2005 Art Projects/I-20/Art Basel Miami Beach, Miami Beach/ 2005 Guild and Greyshkul, New York/ 2004 fa Projects, London **Selected group exhibitions:** 2006 "As If By Magic", Peace Centre, Bethlehem/ 2005 "5th Bienal do Mercosul", Porto Alegre/ 2005 "Misunderstandings", GAM, Mexico City/ 2004 "East End Academy", Whitechapel Art Gallery, London/ 2004 "Newcontemporaries", Barbican Art Gallery, London, "Liverpool Biennial", Liverpool **Selected bibliography:** 2006 Chris Townsend, "Mauricio Guillen", *New Art from London*, Thames & Hudson, London/ 2006 Markus Mienssen (ed), *Did Someone Say Participate?*, MIT/ Revolver/ 2005 Kim Dhillon, "Threshold", *Frieze*, October/ 2004 Pablo Lafuente, "Faces of The Future", *Art Review*/ 2004 Richard Leslie, "To Be Political It has To Look Nice", *Art Nexus*

Jitka Hanzlová

Jh

118

Born 1958, Náchod, Czechoslovakia. Lives Essen, Germany.

Selected solo exhibitions: 2006 Raffaella Cortese, Milan/ 2005/6 Museum Folkwang, Essen/ 2001 Stedelijk Museum, Amsterdam/ 2001 Fotomuseum, Winterthur/ 2000 Deichtorhallen Hamburg, Hamburg/ 2000 Raffaella Cortese Galerie, Milan **Selected group exhibitions:** 2005 "Donna Donne", Palazzo Strozzi, Florence/ 2005 "Japan Today", Kanagawa Prefectural Gallery, Kanagawa/ 2005, "Jitka Hanzlová, Juul Kraijer", Kunstverein, Arnsberg/ 2005 "Nach Rokytník", Sammlung der EVN MUMOK, Vienna/ 2005 "Der Traum vom Ich, der Traum von der Welt", Sammlung, Fotomuseum, Winterthur **Selected bibliography:** 2005 John Berger, *Forest*, Steidl, Göttingen/ 2002 *Blink*, Phaidon Press, London/ 2001 Hripsimé Visser, "Jitka Hanzlová", *Bulletin Stedelijk Museum*, Amsterdam/ 2001 Urs Stahel, *Bewohner*, Fotomuseum, Winterthur/ 2000 Zdenek Felix, Peter Brinkemper, *FEMALE*, Schirmer/Mosel Verlag, Munich, Deichtor Hallen, Hamburg

Anne Hardy

Ah

120

Born 1970, St Albans, UK. Lives London, UK.

Selected solo exhibitions: 2006 Maureen Paley, London/ 2005 ArtSway, Sway/ 2004 Laing Art Gallery, Newcastle-upon-Tyne **Selected group exhibitions:** 2005 "to be continued.../jatkuu...", Helsinki Photography Festival, Helsinki/ 2005 "Faux Realism Part 1", Royal Academy Pumphouse, London/ 2004 "The House in the Middle", Towner Art Gallery, Eastbourne/ 2004 "Really True! Photography and the Promise of Reality", Ruhrlands-Museum, Essen/ 2004 "Handluggage", K3, Zürich **Selected bibliography:** 2005 to be continued.../jatku (exhibition catalogue), Photographic Gallery Hippolyte and British Council/ 2005 *Photography Now* (French edition), Autumn/ 2005 "Fash N Riot", *FluffAntiFluff*/ 2004 Charlotte Cotton, *The Photograph as Contemporary Art*, Thames & Hudson, London/ 2004 "Interior Landscapes", *Photoworks*, Autumn/Winter

Rachel Harrison

Rh

122

Born 1966, New York, NY, USA. Lives New York, NY, USA.

Selected solo exhibitions: 2006 Galerie Christian Nagel, Cologne/ 2005 Transmission Gallery, Glasgow/ 2004 San Francisco Museum of Modern Art, San Francisco/ 2002 Milwaukee Art Museum, Milwaukee/ 2001 Greene Naftali Gallery, New York **Selected group exhibitions:** 2005 "Carnegie International", Carnegie Museum of Art, Pittsburgh/ 2005 "When Humor Becomes Painful", Migros Museum, Zürich/ 2004 "Posh Floored as Ali G Tackles Beck", Arndt + Partner, Berlin/ 2003 "The Structure of Survival", "50th Venice Biennale", Venice/ 2002 "Whitney Biennial", Whitney Museum of American Art, New York **Selected bibliography:** 2005 Brian Sholis, "Two Into One", Catherine Wood, "The Stuff: Rachel Harrison's Sculpture", *Afterall*, no 11/ 2004 John Kelsey, "Lakta/Latkas", *Artforum*, November/ 2004 Johanna Burton, "the Urmaterial Urge", *Parkett*, no 70/ 2002 Saul Anton, "Shelf Life", *Artforum*, November/ 2002 Bruce Hainley, "Blind Alleys", *Artforum*, November

Jonathan Hernández

Jh

124

Born 1972, Mexico City, Mexico. Lives Mexico City, Mexico.

Selected solo exhibitions: 2006 SAPS, Mexico City/ 2006 La Caja Negra, Madrid/ 2004 Kurimanzutto, Mexico City/ 2003 Centro de Arte Contemporáneo, Málaga/ 2002 Mexico City International Airport, Mexico City **Selected group exhibitions:** 2006 "Metro Pictures", Museum of Contemporary Art, Miami/ 2006 "Políticas Urbanas", "9th Bienal de La Habana, Havana"/ 2005 "InSite05", San Diego Museum of Art, San Diego, Centro Cultural, Tijuana/ 2005 "Works on Paper", Arndt & Partner, Berlin/ 2005 "En algún lugar alguien esta viajando furiosamente hacia ti", La Casa Encendida, Madrid/ 2004 "Always Already Passé", Gavin Brown Enterprise, New York **Selected bibliography:** 2005 *Art Now Vol 2*, Taschen, Los Angeles/ 2005 Itala Schmelz, "Un ensayo sobre el tiempo", *Curare*, no 25/ 2005 *Universal Experience: Art, Life and the Tourist's Eye*, Museum of Contemporary Art, Chicago/ 2004 Interview by Issa Benítez, "Jonathan Hernández", *Tema Celeste*, January/ February/ 2003 Issa Benítez, Tatiana Escobar, Vicente Verdú, *Bon Voyage*, Centro de Arte Contemporáneo, Málaga

Sarah Hobbs

Sh

126

Born 1970, Lynchburg, VA, USA. Lives Atlanta, GA, USA.

Selected solo exhibitions: 2006 Solomon Projects, Atlanta/ 2004/5 Knoxville Museum of Art, Knoxville/ 2004 Yossi Milo Gallery, New York/ 2003 Solomon Projects, Atlanta/ 2000 Athens Academy, Athens **Selected group exhibitions:** 2005 "The Empire of Sighs", Numark Gallery, Washington, DC/ 2005 "Human Conditions", Maryland Art Place, Baltimore/ 2005 "Diorama", Lobby Gallery, Shorenstein Realty Services, New York/ 2003 "Forward Arts Foundation Emerging Artist Award Finalists", Swan House Gallery, Atlanta/ 2002 "girl", Georgia State University Gallery, Atlanta **Selected bibliography:** 2005 Rebecca Dimling Cochran, "Sarah Hobbs at the Knoxville Museum of Art", *Art In America*, October/ 2005 Dana Self, *Suburban: Sarah Hobbs* (exhibition catalogue), Knoxville Museum of Art, Knoxville/ 2005 Audrey Mascina, "T. O. C.", *Blast Magazine* (France), February/March/ 2005 Susan W Knowles, "Sarah Hobbs at the Knoxville Museum of Art", *Art Papers Magazine*, March/April/ 2003 Jerry Cullum "Problems in Living Engagingly Shown", *The Atlanta Journal-Constitution*, March 7

Emily Jacir

Ej

128

Born 1970, Jerusalem, Israel. Lives New York, NY, USA.

Selected solo exhibitions: 2005 Anthony Reynolds, London/ 2005 Alexander and Bonin, New York/ 2004 Kunstraum Innsbruck, Innsbruck/ 2004 The Khalil Sakakini Cultural Centre, Ramallah/ 2003 O-K Centre for Contemporary Art, Linz **Selected group exhibitions:** 2005 "Classified Materials: Accumulations, Archives, Artists", Vancouver Art Gallery, Vancouver/ 2005 "Always a little further", Arsenale, 51st Venice Biennale, Venice/ 2005 "Sharjah Biennial", Sharjah/ 2004 "Transcultures", National Museum of Contemporary Art, Athens/ 2004 "Whitney Biennial", Whitney Museum of American Art, New York **Selected bibliography:** 2005 Frederick N Bohrer, "borders (and borders) of art: notes from a foreign land", *Belonging: Sharjah Biennial 7*, Sharjah Art Museum, Sharjah/ 2005 Frances Richard, "Reviews: Emily Jacir", *Artforum*, May/ 2005 Roberta Smith, "Art in Review: Emily Jacir", *The New York Times*, March 25/ 2004 Stephen Wright, "Emily Jacir", *contemporary*, no 65/ 2003 Edward Said, "Emily Jacir", *Grand Street*, no 72

| Valérie Jouve **Vj** 130 | Born 1964, Saint Etienne, France. Lives Paris, France. |

Selected solo exhibitions: 2005 Sprengel Museum, Hannover/ 2003 "Grand Littoral", Ateliers de la ville de Marseille, Marseille/ 2003 Institut d'Art Contemporain, Villeurbanne/ 2003 Galerie Anne de Villepoix, Paris/ 2002 Winterthur Museum, Winterthur **Selected group exhibitions:** 2004 "Premiere", The Museum of Modern Art, New York/ 2004 "L'Ombre du Temps", Jeu de Paume, Paris/ 2004 "Ficcions, documentals", Sala Montcada de la Fundación "la Caixa", Barcelona/ 2003 "Valérie Jouve, Jean Luc Moulène, Florence Paradeis", Le Plateau, Paris/ 2003 "Cardinales", MARCO Museo de Arte Contemporaneo, Vigo **Selected bibliography:** 2005 Sandra Danicke, "Focus auf Valérie Jouve", *Frankfurter Rundschau Magazine*, September 17/ 2004 Miriam Rosen, "Valérie Jouve Musée d'Art Contemporain", *Artforum*, Summer/ 2003 Valérie Jouve, Enitsirc Noterb, Jean-Pierre Rehm, "Grand Littoral", Les Ateliers d'Artistes de la ville de Marseille, Marseille/ 2003 Michel Guerrin, "Valérie Jouve, un objectif dans la cité", *Le Monde*, July 26/ 2003 *Valérie Jouve, David Leyval*, Espace arts plastiques, Vénissieux

| Yeondoo Jung **Yj** 132 | Born 1969, Seoul, South Korea. Lives Seoul, South Korea. |

Selected solo exhibitions: 2005 Tina Kim Fine Art, New York/ 2004 Insa Art Center, Seoul/ 2003 Gallery Loop, Seoul/ 2002 1A Space, Hong Kong/ 2002 Koyanagi Gallery, Tokyo **Selected group exhibitions:** 2005 "Secret Beyond the Door", Korean Pavilion, "51st Venice Biennale", Venice/ 2005 "4 from Korea", East Asian Art Museum, Staatliche Museum, Berlin/ 2005 "Seoul Until Now", Charlottenborg Museum, Copenhagen/ 2005 "Fast Forwards", Galerie Porticus, Frankfurt/ 2005 "Banana Surfer", IEUM Gallery, Beijing **Selected bibliography:** 2005 Park Sook-Hee, "Real-Fantasy, Photography-Painting", *The Korea Daily*, New York, March 15/ 2005 "Dreams Come True", *The Sun, Weekend Edition*, New York, March 11–13/ 2004 Georgina Adam, "Focus on Nations: Korea", *The Art Newspaper: Art Basel Miami Beach Daily Newspaper*, December 2/ 2004 Yukie Kamiya, "Dreamweaver: Jung Yeondoo", *Art Asia Pacific*, Winter/ 2004 Craig Burnett, "Liverpool Biennial", *Art Monthly*, November

| Rinko Kawauchi **Rk** 136 | Born 1972, Siga Prefecture, Japan. Lives Tokyo, Japan. |

Selected solo exhibitions: 2006 The Photographers' Gallery, London/ 2005 Fondation Cartier pour l'Art Contemporain,

Paris/ 2005 Cohan and Leslie, New York/ 2004 California Museum of Photography, Riverside/ 2004 Recontres Internationales de la Photographie, Arles **Selected group exhibitions:** 2005 "AILA", Paris Photo, Paris/ 2005 Huis Marseille, Amsterdam/ 2004 "Lonely Planet", Art Tower Mito, Contemporary Art Centre, Mito-shi, Tokyo/ 2003 "Love Planet", The 41st Okayama City Arts Festival Program, Okayama **Selected bibliography:** 2005 *Cui Cui*, FOIL, Fondation Cartier, Actsud, Paris/ 2005 *the eyes, the ears*, FOIL, Tokyo/ 2004 *AILA*, Little More, Tokyo/ 2001 *Utatane*, Little More, Tokyo/ 2001 *Hanabi*, Little More, Tokyo

| Annette Kelm **Ak** 140 | Born 1975, Stuttgart, Germany. Lives Berlin, Germany. |

Selected solo exhibitions: 2006 Galerie Crone Andreas Osarek, Berlin /2006 Artothek, Cologne/ 2006 Marc Foxx Gallery, Los Angeles/ 2005 Art Cologne Young Artist Programme, Cologne/ 2004 Galerie Crone Andreas Osarek, Berlin **Selected group exhibitions:** 2006 "Don Qijote", Witte de With, Rotterdam /2006 "Das Stipendium", Kunstverein, Hamburg/ 2006 "Having New Eyes", Aspen Art Museum, Aspen/ 2006 "A Lovers Discourse", Peres Projects, Los Angeles/ 2005 "John Taylor. Imagination of Things Imaginable", Galerie Christian Nagel, Berlin **Selected bibliography:** 2006 Walead Beshty, "Discrete Cosmologies", *Das Stipendium* (exhibition catalogue), Revolver, Frankfurt/ 2004 Judith Hopf, *The Hour of Hair* (exhibition catalogue), Hamburg-Stipendiaten, Hamburg/ 2004 *Hamburger Arbeitsstipendium für bildende Kunst*, Kulturbehörde der Freien und Hansestadt Hamburg, Hamburg/ 2004 Stefanie Diekmann, "Voller Möglichkeiten", *Texte zur Kunst*, June/ 2002 Yilmaz Dziewior, Katrin Sauerländer, *Ausnahmeorte* (exhibition catalogue), Kunstverein, Hamburg, Revolver, Frankfurt

| Idris Khan **Ik** 142 | Born 1978, Birmingham, UK. Lives London, UK. |

Selected solo exhibitions: 2006 The Fraenkel Gallery, San Francisco/ 2006 Victoria Miro Gallery, London/ 2005 Art Basel Miami Beach, Miami **Selected group exhibitions:** 2005 "Something of the Night: Imagining the City 1875–2005", Leeds City Art Gallery, Leeds/ 2005 "to be continued.../jatkuu...", Helsinki Photography Festival, Helsinki/ 2005 "Andmoreagain", Open Eye Gallery, Liverpool/ 2005 "Art Basel 2005", Basel/ 2005 "Young Masters", 148a St John Street, London **Selected bibliography:** 2005 *reGeneration: 50 Photographers of Tomorrow*, Thames & Hudson, London/ 2005 Alicia Miller, "A Generational Statement", *Photoworks*, April/ 2005 Idris Khan, "every...", *Next Level*, edition 2, vol 3/ 2005 Idris Khan, "every...", *Portfolio*, no 40/ 2005

Brian Dillon, "Photography 2005", *Modern Painters*, March

| Joachim Koester **Jk** 144 | Born 1962, Copenhagen, Denmark. Lives Copenhagen, Denmark and New York, NY, USA. |

Selected solo exhibitions: 2005 Danish Pavilion, "51st Venice Biennale", Venice/ 2005 Galerie Jan Mot, Brussels/ 2005 Green Naftali Gallery, New York/ 2004 De Verbeelding, Museum Zeewolde, Zeewolde/ 2002 Kunsthalle Nürnberg, Nürnberg **Selected group exhibitions:** 2005 "Black Market Worlds", 9th Baltic Triennial of International Art, Vilnius/ 2005 "Some Trees", Neue Aachener Kunstverein, Aachen/ 2004 "Rear View Mirror", Kettle's Yard, Cambridge/ 2003 "Prophetic Corners", Iasi/ 2003 "Territories", Witte de With Centre for Contemporary Art, Rotterdam **Selected bibliography:** 2005 *Message from Andrée*, Lukas & Sternberg, New York/ 2002 *different stories different places*, Kunsthalle Nürnberg, Nürnberg/ 2000 *Row Housing*, Galleri Nicolai Wallner, Copenhagen

| Panos Kokkinias **Pk** 146 | Born 1965, Athens, Greece. Lives Athens, Greece. |

Selected solo exhibitions: 2005 Athens International Airport, Athens/ 2004 Galerie Xippas, Paris/ 2003 F1, 365 Art Project, Athens/ 2001 Kappatos Gallery, Athens **Selected group exhibitions:** 2004 "Ausderferne ausdernähe ausdermitte", European Patent Office, Munich/ 2004 "The Mediterraneans", MACRO, Rome/ 2004 "Self-aboutness, Canal Isabel II, Hola Grecia!", ARCO, Madrid/ 2004 "Zeitgenössische Fotokunst", Neuer Berliner Kunstverein, Berlin/ 2003 "OUTLOOK International Art Exhibition", Cultural Olympiad, Benaki Museum, Athens **Selected bibliography:** 2004 Katerina Gregos, *Panos Kokkinias*, Galerie Xippas, Paris/ 2004 K Schoenert, S Bahtsetzis, T Moutsopoulos, *Ausderferne ausdernähe ausdermitte*, European Patent Office, Munich/ 2004 Marilena Karra, *Self-aboutness*, *Hola Grecia!*, ARCO 2004, Madrid/ 2004 Hercules Papaioannou, *Zeitgenössische Fotokunst*, NBK, Berlin/ 2003 Christos Joachimides (ed), *OUTLOOK International Art Exhibition*, Cultural Olympiad, Hellenic Cultural Organization, SA, Athens

| Luisa Lambri **Ll** 150 | Born 1969, Como, Italy. Lives Milan, Italy. |

Selected solo exhibitions: 2006 Luhring Augustine, New York/ 2004 The Menil Collection, Houston/ 2001 Palazzo Re Rebaudengo, Guarene d'Alba/ 2000 Kettle's

Yard, Cambridge **Selected group exhibitions:** 2005 "Vanishing Point", Wexner Center for the Arts, Columbus/ 2004 "Metamorph", "9th Biennale Internazionale di Architettura", Venice/ 2003 "Living Inside the Grid", New Museum of Contemporary Art, New York/ 2003 "Dreams and Conflicts: The Dictatorship of the Viewer", "50th Venice Biennale", Venice/ 2000 "Contemporary Photography II: Anti-Memory", Yokohama Museum of Modern Art, Yokohama **Selected bibliography:** 2004 Matthew Drutt, *Locations* (exhibition catalogue), The Menil Collection, Houston/ 2004 Adriano Pedrosa, *Untitled (Casa das Canoas, 1953), 2002–4*, Colecção Teixeira de Freitas, Rio de Janeiro/ 2003 Dan Cameron, *Living inside the grid* (exhibition catalogue), New Museum of Contemporary Art, New York/ 2003 Massimiliano Gioni, "The shadow line", *Untitled (Experience of Place)*, Walther Koenig Verlag, Cologne/ 2002 *Blink*, Phaidon Press, London/ 2000 *Fresh Cream*, Phaidon Press, London

| An-My Lê **Al** 154 | Born 1960, Saigon, Vietnam. Lives New York, NY, USA. |

Selected solo exhibitions: 2006 Marion Center, Santa Fe, Rhode Island School of Design, Providence, Museum of Contemporary Photography, Chicago, San Francisco Museum of Modern Art, San Francisco, Henry Art Gallery, Seattle, Johnson Museum, Ithaca/ 2004 Murray Guy, New York/ 2002 PS1 Contemporary Art Center, New York **Selected group exhibitions:** 2006 "Ecotopia: The Second ICP Triennial of Photography and Video", International Center of Photography, New York/ 2005 "The Pentagruel Syndrome, T1 Torinotriennale Tremusei", Fondazione Merz, Turin/ 2005 "The Forest: Politics, Poetics and Practice", The Nasher Museum at Duke University, Durham/ 2005 "Stages of Memory: The War in Vietnam", Museum of Contemporary Photography, Chicago/ 2005 "The Art of Aggression", Reynolds Gallery, Richmond/ 2005 The Moore Space, Miami **Selected bibliography:** 2005 Richard B Woodward, "Essay", *Small Wars: An-My Lê*, Aperture, New York/ 2005 Hilton Als, "Interview", *Small Wars: An-My Lê*, Aperture, New York/ 2004 Karen Rosenberg, "An-My Lê Murray Guy", *Artforum*, November/ 2004 Vince Aletti, "An-My Lê", *The Village Voice*, October 6–12/ 2004 *The New Yorker*, October 4/ 2004 Holland Cotter, "An-My Lê", *The New York Times*, September 24

| Tim Lee **Tl** 158 | Born 1975, Seoul, South Korea. Lives Vancouver, Canada. |

Selected solo exhibitions: 2006 Lisson Gallery, London/ 2006 Cohan and Leslie, New York/ 2005 Tracey Lawrence Gallery, Vancouver/ 2004 Cohan and Leslie, New York/ 2003 YYZ Artists' Outlet, Toronto/ 2002 Or Gallery, Vancouver **Selected group exhibitions:** 2006 "Wrong", Klosterfelde,

Berlin/ 2005 "Intertidal", Museum Van Hedendaagse Kunst Antwerpen, Antwerp/ 2005 "New Work/ New Acquisitions", The Museum of Modern Art, New York/ 2005 "Appearances", Musée d'art contemporain, Montreal/ 2005 "Sharjah Biennial", Sharjah **Selected bibliography:** 2005 Clint Burnham, "Tim Lee", *Flash Art*, January/February/ 2005 Joan Jonas, Jens Hoffman (eds), *Art Works: Perform*, Thames & Hudson, London/ 2004 Ken Johnson, "Tim Lee", *The New York Times*, June 11/ 2004 Christopher Brayshaw, "Changing Illusions of 'Reality'", *The Globe and Mail*, November 6/ 2003 Ralph Rugoff et al, *Baja to Vancouver: The West Coast in Contemporary Art*, CCA Wattis Institute, San Francisco

Nikki S Lee	Born 1970, Kye-Chang, South Korea. Lives New York, NY, USA.
Nl 160	

Selected solo exhibitions: 2006 LT/Shoreham Gallery, New York/ 2005 Kemper Museum of Contemporary Art, Kansas City/ 2005 Galerie Anita Beckers, Frankfurt/ 2003 Cleveland Museum of Art, Cleveland/ 2001 Institute of Contemporary Art, Boston/ 2001 Yerba Buena Center for the Arts, San Francisco **Selected group exhibitions:** 2006 "Metro Pictures", The Moore Space, Miami/ 2005 "Morir de Amor", Museo Nacional de Ciencias y Artes, Mexico City/ 2005 "The Jewish Identity Project: New American Photography", The Jewish Museum, New York/ 2003 "8th International Istanbul Biennial", Istanbul/ 2002 "Liverpool Biennial", Liverpool/ 2001 "Open City: Street Photographs 1950–2000", Modern Art, Oxford **Selected bibliography:** 2006 Carly Berwick, "Nikki S Lee: Extreme Makeover", *ARTnews*, March/ 2005 RoseLee Goldberg, "Only Part of the Story: Nikki S Lee in Conversation with RoseLee Goldberg", *Nikki S Lee Parts*, Hatje Cantz Verlag, Ostfildern-Ruit/ 2005 Nancy Spector, "Nikki S Lee: Of Self and Others", *Hermès Korea Missulsang* (exhibition catalogue), Artsonje Art Center, Seoul/ 2001 Maurice Berger, "Picturing Whiteness: Nikki S Lee's Yuppie Project", *Art Journal*, Winter/ 2000 *Fresh Cream*, Phaidon Press, London

Zoe Leonard	Born 1961, Liberty, NY, USA. Lives New York, NY, USA.
Zl 162	

Selected solo exhibitions: 2003 Paula Cooper Gallery, New York/ 2003 Galerie Giti Nourbakhsch, Berlin/ 2001 Anthony Meier Fine Arts, San Francisco/ 2001 Galerie Gisela Capitain, Cologne/ 2001 Raffaella Cortese, Milan **Selected group exhibitions:** 2005 "The New City: Sub/urbia in Recent Photography", Whitney Museum of American Art, New York/ 2003 "Clear Vision Photographic works from the F.C. Gundlach collection", Deichtorhallen, Hamburg/ 2001 "Parkett Collaborations", The Museum of Modern Art, New York/ 2000 "Voilà: Le Monde Dans la Tête", Musée d'Art Moderne de la Ville de Paris, Paris **Selected**

bibliography: 2003 Hal Foster, Rosalind Krauss, Yves-Alain Bois, Benjamin Buchloh, *Art Since 1900*, Thames & Hudson, London/ 2004 Charlotte Cotton, *The Photograph as Contemporary Art*, Thames & Hudson, London/ 2002 Zoe Leonard, "Out of Time", *October*, Spring

Armin Linke	Born 1966, Milan, Italy. Lives Milan, Italy.
Al 164	

Selected solo exhibitions: 2006 Galleria Massimo de Carlo, Milan/ 2005 Galleria Luisa Strina, São Paulo/ 2004 Storefront for Art and Architecture, New York/ 2003 Klosterfelde, Berlin **Selected group exhibitions:** 2005 "Guangzhou Triennial", Guangzhou/ 2005 "InSite05", San Diego Museum of Art, San Diego, Centro Cultural, Tijuana/ 2005 "Atmospheres of Democracy", ZKM, Centre for Art and Media, Karlsruhe/ 2003 "50th Venice Biennale", Venice/ 2000 "7th Voilà Le Monde dans la Tête", Musée d'Art Moderne de la Ville de Paris, Paris **Selected bibliography:** 2003 Hans Ulrich Obrist, Stefano Boeri, *Transient*, Skira, Milan/ 2002 Bruce Sterling, *4flight*, a+mbookstore, Milan

Sharon Lockhart	Born 1964, Norwood, MA, USA. Lives Los Angeles, CA, USA.
Sl 166	

Selected solo exhibitions: 2006 Walker Art Center, Minneapolis/ 2005 Sala Rekalde, Bilbao/ 2001 Museum of Contemporary Art, Chicago, Museum of Contemporary Art, San Diego/ 2000 MAK, Vienna **Selected group exhibitions:** 2005 "An Aside", Camden Arts Centre, London/ 2004 "Videodreams: between the cinematic and the theatrical", Kunsthaus Graz am Landesmuseum Joanneum, Graz/ 2004 "Whitney Biennial", Whitney Museum of American Art, New York/ 2004 "Made in Mexico", Institute of Contemporary Art, Boston/ 2004 "Universal Experience: Art, Life and the Tourist's Eye", Museum of Contemporary Art, Chicago **Selected bibliography:** 2003 Rosetta Brooks, "A Fine Disregard", *Afterall*, no 8/ 2003 Chus Martinez, "The Possible's Slow Fuse: The Works of Sharon Lockhart", *Afterall*, no 8/ 2001 Dominic Molon, Norman Bryson, *Sharon Lockhart*, Museum of Contemporary Art, Chicago/ 2001 Martha Schwendener, "Sharon Lockhart Exotic Structures", *Flash Art*, October/ 2000 *Fresh Cream*, Phaidon Press, London

Vera Lutter	Born 1960, Kaiserslautern, Germany. Lives New York, NY, USA.
Vl 168	

Selected solo exhibitions: 2005 The Modern Art Museum of Fort Worth, Fort Worth/ 2004 Gagosian Gallery, London/ 2004 Galerie Max Hetzler, Berlin/ 2002 Museum of Contemporary Photography, Chicago/ 2001 Kunsthalle Basel, Basel **Selected group exhibitions:** 2005 "Roger Ballen, Alec Soth, Vera Lutter", Gagosian Gallery, New York/ 2004 "26th Bienal de São Paulo", Fundação "Bienal de São Paulo"/ 2003 "Strange Days", Museum of Contemporary Art, Chicago/ 2003 "Defying Gravity: Contemporary Art and Flight", North Carolina Museum of Art, Raleigh/ 2003 "The Eye and the Camera. A History of Photography", Sammlung Albertina, Vienna **Selected bibliography:** 2004 Virginia Heckert, *The Amazing & The Immutable*, Contemporary Art Museum University of South Florida, Tampa/ 2004 Jonathan Crary, Will Self, *Vera Lutter: Battersea*, Gagosian Gallery, New York/ 2004 Alfons Hug, "*26th Bienal de São Paulo*", Pavilhão Ciccillo Matarazzo, São Paulo/ 2004 Lynne Cooke, *Inside In*, Kunsthaus Graz, Graz, Verlag der Buchhandlung Walther König, Cologne/ 2003 Huston Paschal, Linda Johnson-Dougherty, *Defying Gravity: Contemporary Art and Flight*, North Carolina Museum of Art, Raleigh

Florian Maier-Aichen	Born 1973, Stuttgart, Germany. Lives Cologne, Germany.
Fm 170	

Selected solo exhibitions: 2006 Blum & Poe, Los Angeles/ 2006 303 Gallery, New York/ 2005 Baronian-Francey, Brussels/ 2004 Blum & Poe, Los Angeles/ 2003 Gallery Min Min, Tokyo **Selected group exhibitions:** 2006 "Whitney Biennial", Whitney Museum of American Art, New York/ 2005 "The Blake Byrne Collection", Museum of Contemporary Art, Los Angeles/ 2005 "Photography 2005", Victoria Miro Gallery, London/ 2005 "Photo London", London/ 2005 "Set Up: Recent Acquisitions in Photography", Whitney Museum of American Art, New York **Selected bibliography:** 2006 Isabelle Durpis, "Review", *Flash Art*, March/April/ 2006 Christopher Knight, "Primitive Hidden in the Modern", *Los Angeles Times*, February 2/ 2005 *The Blake Byrne Collection* (exhibition catalogue), Los Angeles Museum of Contemporary Art, Los Angeles/ 2005 Mariuccia Casadio, "sunset rising", *Vogue (Italia)*, January/ 2000 *Snapshot: New Art from Los Angeles* (exhibition catalogue), UCLA Hammer Museum, Los Angeles

Malerie Marder	Born 1971, Philadelphia, PA, USA. Lives Los Angeles, CA, USA.
Mm 174	

Selected solo exhibitions: 2006 Greenberg Van Doren Gallery, New York/ 2005 Maureen Paley, London/ 2004 McKinney Avenue Contemporary, Dallas/ 2003 Salon 94, New York/ 2001 Maureen Paley, London **Selected group exhibitions:** 2006 "Shoot the Family", Cranbrook Art Museum, Bloomfield Hills/ 2005 "Remote Control", National Gallery of Victoria, Melbourne/ 2005 "Double Exposure", Godt-Cleary Projects, Las Vegas/ 2005 "NYC BLING-BLING", Modena/ 2004 "2004 California Biennial", Orange County Museum, Newport Beach **Selected bibliography:** 2005 Sarah Kent, "Malerie Marder Maureen Paley", *Time Out London*, July 13–20/ 2005 Jessica Lack, "Malerie Marder London", *The Guardian Guide*, July 2–8/ 2004 Christopher Knight, "Biennial arrives, and so does a museum", *Los Angeles Times*, October 13/ 2003 Siobhan McDevitt, "A Thousand Words", *Artforum*, January/ 2003 David Ebony, Jane Harris, Frances Richard, Martha Schwendener, Sarah Valdez, *Curve: The Female Nude Now*, New York University Press, New York

Daniel Joseph Martinez	Born 1957, Los Angeles, CA, USA. Lives Los Angeles, CA, USA.
Dm 176	

Selected solo exhibitions: 2006 American Pavilion, "Cairo Biennial", Cairo/ 2006 LAXART, Los Angeles/ 2005 ArtPace Foundation, San Antonio/ 2004 The Project, New York/ 2002 Museo de Arte Carrillo Gil, Mexico City **Selected group exhibitions:** 2006 "An Image Bank for Everyday Revolutionary Life", RED-CAT, Los Angeles/ 2005 "Indelible Images", Museum of Fine Arts, Houston/ 2005 "Touch of Evil", Estación Tijuana, Tijuana/ 2005 "Why Didn't God Invent Coco-Cola Sooner", San Juan Triennial, San Juan **Selected bibliography:** 2005 David Levi Strauss, Daniel Joseph Martinez, "After the end: Strategies of Resistance", *Art Journal*, Spring/Winter/Fall/ 2005 Anjali Gupta, "San Antonio" *Artpapers*, September/October/ 2004 Jan Avgikos, "Daniel Joseph Martinez: The House America Built", *Artforum*, November/ 2004 Benjamin Carlson, "Daniel Joseph Martinez, The House America Built", *Time Out New York*, September 23–30/ 2004 Ken Johnson, "Daniel Joseph Martinez, The House America Built", *The New York Times*, September 10

Gareth McConnell	Born 1972, Carrickfergus, Northern Ireland. Lives London, UK.
Gm 178	

Selected solo exhibitions: 2005 Counter Gallery, London/ 2004 Belfast Exposed, Belfast/ 2004 Byam Shaw School of Art, London/ 2003 Unit 2 Gallery, London/ 2002

Lighthouse, Poole **Selected group exhibitions:** 2005 "to be continued.../jatkuu...", Helsinki Photography Festival, Helsinki/ 2005 "Presence", Gimpel Fils, London/ 2005 "Rencontres d'Arles", Arles **Selected bibliography:** 2005 *Gareth McConnell*, Steidl, Göttingen, Photoworks, Brighton/ 2004 *Back2Back*, All Change, London/ 2003 *Wherever You Go*, Lighthouse, Poole

Scott McFarland

Sm

182

Born 1975, Hamilton, Canada. Lives Vancouver, Canada.

Selected solo exhibitions: 2005 Regen Projects, Los Angeles/ 2005 Union Gallery, London/ 2004 Monte Clark Gallery, Vancouver/ 2003 Monte Clark Gallery, Toronto/ 2003 Contemporary Art Gallery, Vancouver **Selected group exhibitions:** 2006 "Click Doubleclick", Haus der Kunst, Munich/ 2006 "Faking Death", Jack Shainman Gallery, New York/ 2005 "Intertidal", MUHKA, Antwerp/ 2005 "Variations on the Picturesque", KWAG, Kitchener Waterloo/ 2005 "The Space of Making", Neuer Berliner Kunstverein, Berlin **Selected bibliography:** 2005 Lee Henderson, "The Empire Grows Back", *Border Crossings*, Summer/ 2004 Ines Rae, "More Plant Matters", *Source*, Summer/ 2003 Bill Wood, *Coastal Cabin*, Contemporary Art Gallery, Vancouver/ 2001 Chris Brayshaw, "Garden Optics", *CV Photo*, no 54/ 2000 Roy Arden, "After Photography", *Canadian Art*, December

Ryan McGinley

Rm

186

Born 1977, Ramsey, NJ, USA. Lives New York, NY, USA.

Selected solo exhibitions: 2005 Museum of Contemporary Art, Leon, Spain/ 2004 PS1 Contemporary Art Center, New York/ 2004 University of the Arts, Philadelphia/ 2003 The Red Eye Gallery, Rhode Island School of Design, Providence/ 2003 Whitney Museum of American Art, New York **Selected group exhibitions:** 2005 "Greater New York", PS1 Contemporary Art Center, New York/ 2004 "Color Wheel Oblivion", Marella Arte Contemporanea, Milan/ 2004 "Summer Solstice", Ratio 3, San Francisco/ 2004 "Beautiful Losers: Contemporary Art, Skateboarding, & Street Culture", Contemporary Arts Center, Cincinnati, Yerba Buena Center for the Arts, San Francisco/ 2004 "Fresh: Youth Culture in Contemporary Photographs", The Center for Photography at Woodstock, New York **Selected bibliography:** 2004 *Ryan McGinley* (exhibition catalogue), PS1 Contemporary Art Center, New York/ 2002 *Ryan McGinley*, Index Books, New York/ 2000 Ryan McGinley, *The Kids Are Alright* (artist book), New York

Trish Morrissey

Tm

188

Born 1967, Dublin, Ireland. Lives London, UK.

Selected solo exhibitions: 2005 Pump House Gallery, London/ 2005 Yossi Milo Gallery, New York/ 2005 Gallery of Photography, Dublin/ 2004 Impressions Gallery, York/ 2000 Tom Blau Gallery, London **Selected group exhibitions:** 2006 "Family Photos", Galerie Photo du Pôle Image, Rouen/ 2006 "EuropART", Contemporary Art from Europe, Billboard project in Vienna and Salzburg/ 2005 "ev + a", Limerick City Gallery of Art, Limerick/ 2004 "EAST International", Norwich Gallery, Norwich/ 2002 "John Kobal Portrait Award 10 Years", National Portrait Gallery, London **Selected bibliography:** 2005 Sarah Lookofsky, *Flash Art*, March/April/ 2004 Camilla Jackson, *EAST International* (exhibition catalogue), Norwich Gallery, Norwich/ 2004 Edward Welch, "Family Remade", *Source*, Autumn/ 2004 Charlotte Cotton, *The Photograph as Contemporary Art*, Thames & Hudson, London/ 2004 *Seven Years* (exhibition catalogue), Impressions Gallery, York

Zwelethu Mthethwa

Zm

190

Born 1960, Durban, South Africa. Lives Devil's Peak, South Africa.

Selected solo exhibitions: 2004 Jack Shainman Gallery, New York/ 2003 Cleveland Museum of Art, Cleveland/ 2003 Galerie der Gegenwart, Hamburg/ 2002 Marco Noire Contemporary Art, San Sebastián/ 2001 Goodman Gallery, Johannesburg **Selected group exhibitions:** 2005 "The Forest Politics, Poetics, and Practices", The Nasher Museum at Duke University, North Carolina/ 2005 "51st Venice Biennale", Venice/ 2005 "New Work/New Acquisitions", The Museum of Modern Art, New York/ 2005 "A Passion for Pictures", North Carolina Museum of Art, Raleigh/ 2005 "The Whole World is Rotten: Free Radicals and the Gold Coast Slave Castles of Paa Joe", Jack Shainman Gallery, New York **Selected bibliography:** 2005 Olivia Fernando, "Ripening Process", *Lápiz 207*, June/ 2005 *Frieze*, January/February/ 2004 Richard Vine, "The Luminous Continent", *Art in America*, October/ 2004 Mark Jenkins, "Insights into Faraway Lands", *The Washington Post*, March 26/ 2000 *Fresh Cream*, Phaidon Press, London

Zanele Muholi

Zm

192

Born 1972, Durban, South Africa. Lives Johannesburg, South Africa.

Selected solo exhibitions: 2006 Vienna Kunsthalle project space, Vienna/ 2006 Michael Stevenson, Cape Town/ 2004 JHB Art Gallery, Johannesburg **Selected group**

exhibitions: 2006 "Olvida Quien Soy Erase me from who I am", Centro Atlàntico de Arte Moderna, Las Palmas de Gran Canaria/ 2005 "South African art 1848 to now", Michael Stevenson, Cape Town/ 2005 "World Beyond Words", Centre for African Studies, Cape Town/ 2005 "Month of Photography", The Castle, Cape Town **Selected bibliography:** 2006 *Zanele Muholi: Only half the picture*, Michael Stevenson and STE, Cape Town

Oliver Musovik

Om

194

Born 1971, Skopje, Macedonia. Lives Skopje, Macedonia.

Selected solo exhibitions: 2004 Experimental Art Foundation, Adelaide/ 2003 Remont Gallery, Belgrade/ 2002 Mala Galerija, Ljubljana/ 2002 Museum of Contemporary Art, Skopje **Selected group exhibitions:** 2004 "Mediterraneo", MACRO al Mattatoio, Rome/ 2003 "In the Gorges of the Balkans", Kunsthalle Fridericianum Kassel, Kassel/ 2003 "Para>Sites/Who is Moving the Global City?", Badischer Kunstverein, Karlsruhe/ 2002 "Manifesta", Frankfurt **Selected bibliography:** 2005 Vahland, Kia, "Ich-Erzähler der neuen Zeit", *Art Das Kunstmagazin*, no 1/ 2004 Barbara Steiner, Jun Yang, Ilina Koralova, *Autobiography*, Thames & Hudson, London/ 2003 Iara Boubnova, "Tell me Who's your Neighbor...", *Para>Sites/Who is Moving the Global City?* (exhibition catalogue), Badischer Kunstverein, Karlsruhe/ 2002 "Artist portraits (28): Oliver Musovik", *Frankfurter Rundschau*, June

Kelly Nipper

Kn

196

Born 1971, Edina, MN, USA. Lives Los Angeles, CA, USA.

Selected solo exhibitions: 2004 galleria francesca kaufmann, Milan/ 2002 galleria francesca kaufmann, Milan **Selected group exhibitions:** 2005 "Kelly Nipper and Adrian Paci", MC, Los Angeles/ 2005 "Kelly Nipper Aida Ruilova", galleria francesca kaufmann, Milan/ 2005 "Bidibidobidiboo", Fondazione Sandretto Re Rebaudengo, Turin/ 2005 "Untitled", Santa Barbara Contemporary Arts Forum, Santa Barbara/ 2003–6 "Girls' Night Out", Orange County Museum of Art, Newport Beach, Addison Gallery of American Art, Andover, Aspen Art Museum, Aspen, Contemporary Art Museum, Saint Louis **Selected bibliography:** 2005 Holly Meyers, "Mesmerized by Two Strangers", *Los Angeles Times*, June 17/ 2003 Irene Hofmann, *Girls' Night Out* (exhibition catalogue), Orange County Museum of Art, Newport Beach/ 2002 Rosanna Albertini, "Kelly Nipper", *Art Press*, June/August/ 2002 Ilaria Ventriglia, "Kelly Nipper: Photographing Time", *Domus*, March/April/ 2001 Russell Ferguson, "Kelly Nipper: Test Patterns", *Artext*, no 74

Nils Norman

Nn

198

Born 1966, Kent, UK. Lives London, UK.

Selected solo exhibitions: 2006 Galerie Christian Nagel, Cologne/ 2005 City Projects, London/ 2004 Galerie für Landschaftskunst, Hamburg/ 2003 Galerie Christian Nagel, Berlin/ 2001 American Fine Arts Co Ltd, New York **Selected group exhibitions:** 2005 "Beyond Green", Smart Museum, University of Chicago/ 2005 "British Art Show 6", touring show, UK/ 2005 "I Really Should...", Lisson Gallery, London/ 2005 "Invisible Insurrection of a Million Minds", Sala Rekalda, Bilbao/ 2005 "Down the Garden Path: Artists' Gardens since 1960", Queens Museum, New York **Selected bibliography:** 2005 Haegue Yang, "Nils Norman", *SPACE*, September/ 2005 Alex Farquharson, "Invisible Insurrection of a Million Minds", *Frieze*, September/ 2004 Simon Ford, "Nils Norman, Artist's Books", *Artforum*, March/ 2004 Nils Norman, *Thurrock 2015*, comic commissioned by General Public Agency, London/ 2004 Nils Norman, *An Architecture of Play: A Survey of London's Adventure Playgrounds*, Four Corners, London

Catherine Opie

Co

200

Born 1961, Sandusky, OH, USA. Lives Los Angeles, CA, USA.

Selected solo exhibitions: 2006 Aldrich Museum, Ridgefield, Connecticut/ 2004 Regen Projects, Los Angeles/ 2002 Walker Art Center, Minneapolis/ 2000 The St Louis Art Museum, St Louis/ 2000 The Photographers' Gallery, London **Selected group exhibitions:** 2005 "Universal Experience: Art, Life and the Tourist's Eye", Museum of Contemporary Art, Chicago/ 2005 "Bidibidobidiboo", Fondazione Sandretto Re Rebaudengo, Turin/ 2004 "Whitney Biennial", Whitney Museum of American Art, New York/ 2004 "26th Bienal de São Paulo", Pavilhão Ciccillo Matarazzo, Parque do Ibirapuera, São Paulo/ 2001 "Open City Street Photographs Since 1950," Modern Art, Oxford **Selected bibliography:** 2006 *1999 & In and Around Home* (exhibition catalogue), Aldrich Museum, Ridgefield/ 2005 *Universal Experience: Art, Life and the Tourist's Eye*, Museum of Contemporary Art, Chicago/ 2004 Gilda Williams, "Catherine Opie", *Art Monthly*, March/ 2003 David Campany, *Art and Photography*, Phaidon Press, London/ 2000 *Catherine Opie* (exhibition catalogue), The Photographers' Gallery, London

Esteban Pastorino Díaz

Ep

204

Born 1972, Buenos Aires, Argentina. Lives Buenos Aires, Argentina.

Selected solo exhibitions: 2006 Galerij Erasmus, Rotterdam/ 2005 "KAP" Centre for Photography at Woodstock, New York/ 2004 Photographs Do Not Bend Gallery, Dallas/ 2003 Museum of Modern Art, Buenos Aires/ 2003 RED Gallery, Hull **Selected group exhibitions:** 2006 "Discoveries of the meeting place", Fotofest, Houston/ 2005 "Points of View", Photography in El Museo del Barrio's Permanent Collection, El Museo del Barrio, New York/ 2004 "+Malba. Donaciones, adquisiciones y comodatos", Museum of Latin American Art, Buenos Aires/ 2003 "Visions d'un mythe. Un siècle de photographie en Argentine", Musée de la Photographie de Charleroi, Charleroi/ 2003 "Mapas abiertos. Fotografía Latinoamericana 1991–2002", Fundación Telefónica, Madrid, Palau de la Virreina, Barcelona **Selected bibliography:** 2005 Fernando Castro, "Esteban Pastorino Díaz: A View From Somewhere", *Aperture*, 181/ 2005 Esteban Pastorino Díaz, *Fotografías* (exhibition catalogue), Galeria KBK, Mexico/ 2004 Eva Grinstein, "Esteban Pastorino Díaz", *Art Nexus*, no 51/ 2004 Manfred Zollner, "Art Deco Noir", *Photo Technik Internacional*, 5/ 2004 Charissa N Terranova, "From Buenos Aires to Bush-ville", *Dallas Observer*, September 23–29

Paul Pfeiffer

Pp

208

Born 1966, Honolulu, HI, USA. Lives New York, NY, USA.

Selected solo exhibitions: 2005 carlier | gebauer, Berlin/ 2004 The Project, New York/ 2004 Thomas Dane, London/ 2004 K 21 Kunstsammlung, Düsseldorf/ 2004 Melina Mercouri Centre, Athens **Selected group exhibitions:** 2005 "Blur of the Otherworldly: Contemporary Art, Technology and the Paranormal", Center for Art and Visual Culture, UMBC, Baltimore/ 2005 "Getting Emotional", Institute of Contemporary Art, Boston/ 2004/5 "Faces in the Crowd: Picturing Modern Life from Manet to Today", Whitechapel Art Gallery, London/ 2005 "Log Cabin", Artist Space, New York/ 2005 "marking time: moving images", Miami Art Museum, Miami **Selected bibliography:** 2004 *Paul Pfeiffer* (exhibition catalogue), K21, Berlin/ 2003 *Paul Pfeiffer* (exhibition catalogue), Museum of Contemporary Art, Chicago/ 2003 *Cream 3*, Phaidon Press, London

Sarah Pickering

Sp

212

Born 1972, Durham, UK. Lives London, UK.

Selected solo exhibitions: 2006 Daniel Cooney Fine Art, New York **Selected group exhibitions:** 2005/6 "Jerwood Photography Prize", touring show, UK/ 2005 "Sarah Pickering & Gonzalo Lebrija", PynerContreras, London/ 2005 "EAST International", Norwich/ 2005 "The Great Unsigned", Zoo Art Fair, London/ 2005 "Summer Salon '05", Daniel Cooney Fine Art, New York **Selected bibliography:** 2006 "Sarah Pickering", *Portfolio*, no 43/ 2006 Blake Gopnik, "Up in Smoke: An Explosive Approach to Art", *Washington Post*, January 15/ 2006 Amy Benfer, "Napalm with a side of Fuel Air Explosion", *Metro*, New York, January 10/ 2005 "Sarah Pickering", *Portfolio*, no 42/ 2005 "The Best Emerging Photographers of 2005", *Art Review*, October

Peter Piller

Pp

216

Born 1968, Fritzlar, Germany. Lives Hamburg, Germany.

Selected solo exhibitions: 2005 Witte de With Centre for Contemporary Art, Rotterdam/ 2004 Frehrking Wiesehöfer Gallery, Cologne/ 2004 Museum for Contemporary Art, Siegen/ 2004 Barbara Wien, Berlin/ 2004 Galeria ProjecteSD, Barcelona **Selected group exhibitions:** 2005 "Multiple Räume (2): Park", Staatliche Kunsthalle, Baden-Baden/ 2004/5 "Ars viva 04/05", Kunsthalle Mannheim, Kunstverein Düsseldorf, Zacheta National Gallery of Art, Warsaw/ 2004 "Recherche entdeckt! Bildarchive der Unsichtbarkeiten", Villa Merkel, Esslingen/ 2004 "Utopia's Backyard", Museum of Contemporary Photography, Chicago/ 2003 "Gegenwärtig: Feldforschung", Hamburger Kunsthalle, Hamburg **Selected bibliography:** 2005 Catrin Lorch, "Peter Piller. Museum für Gegenwartskunst, Siegen", *Frieze*, May/ 2005 Manisha Jotady, "Peter Piller", *Camera Austria*, Graz, no 89/ 2004 Peter Piller, *Von Erde schöner*, Revolver Publishers, Frankfurt/ 2004 Peter Piller, "Vorzüge der Absichtslosigkeit", Revolver Publishers, Frankfurt/ 2004 Michael Hakimi, Peter Piller, Katja Strunz, David Zink Yi, *ars viva 04/05: Zeit/Time*, Revolver Publishers, Frankfurt

Rosângela Rennó

Rr

218

Born 1963, Belo Horizonte, Brazil. Lives Rio de Janeiro, Brazil.

Selected solo exhibitions: 2006 Galeria Vermelho, São Paulo/ 2005 Passage du Désir, Festival d'Automne à Paris, Paris/ 2003 Cristina Guerra Contemporary Art, Lisbon/ 2003 Centro Cultural Banco do Brasil, Rio de Janeiro/ 2002 Museu de Arte da Pampulha, Belo Horizonte **Selected group exhibitions:** 2006 "Brazilian Photography in Berlin", Neue Berliner Kunstverein, Berlin/ 2005 "The Hours Visual Arts of Contemporary Latin America", Irish Museum of Modern Art, Dublin/ 2004 "Histoires des Amériques", Musée d'Art Contemporain de Montréal, Montréal/ 2003 "Brazilian Pavillion", "50th Venice Biennale", Venice/ 2001 "Berlin Biennale", Berlin **Selected bibliography:** 2005 Alícia Duarte Penna, "Imaginação do Desastre", *Apagamentos. Rosângela Rennó*, Cosac Naify Edições, São Paulo/ 2005 Hervé Gauville, "Rosângela en boucle", *Libération*, Cahier de Culture, November 10/ 2003 Maria Angélica Melendi, "Bibliotheca: ou das possíveis estratégias da memória", *O Arquivo Universal e outros arquivos*, Cosac Naify Edições, São Paulo/ 2002 Hans-Michael Herzog, "Conversation with Rosângela Rennó", *La Mirada Looking at Photography in Latin America Today*, Edition Oehrli, Zurich/ 2002 Pedro Lapa, "Rosângela, community without a name", *Rosângela Rennó: Espelho diário*, Museu do Chiado, Lisbon

Mauro Restiffe

Mr

220

Born 1970, São Jose do Rio Pardo, Brazil. Lives São Paulo, Brazil.

Selected solo exhibitions: 2005 Galeria Casa Triângulo, São Paulo/ 2002 Galeria Casa Triângulo, São Paulo/ 2002 Henry Urbach Architecture Gallery, New York/ 2001 Centro Cultural São Paulo, São Paulo/ 2000 Espaço Cultural Sergio Porto, Rio de Janeiro **Selected group exhibitions:** 2006 "Taipei Biennial", Taipei Fine Arts Museum, Taipei/ 2004 "27th Bienal de São Paulo", "Pavilhão da Bienal", São Paulo/ 2006 "Zeitgenössische Fotokunst aus Brasilien", Neue Berliner Kunstverein, Berlin/ 2005 "Alem da Imagem", Espaço Cultural Telemar, Rio de Janeiro/ 2005 "Panorama de Arte Brasileira", Museu de Arte Moderna, São Paulo **Selected bibliography:** 2005 Fabio Cypriano, "Mauro Restiffe mistura carisma de Lula e religião em Istambul", *Folha de São Paulo*, May/ 2005 Camila Molina, "A arquitetura cheia e vazia de Brasília e Istambul", *O Estado de São Paulo*, May/ 2002 Fabio Cypriano, "Restiffe registra o mundano casualmente", *Folha de São Paulo*, October/ 2002 Ken Johnson, "In Process Mauro Restiffe", *The New York Times*, July/ 2000 Dan Cameron, "A Moment Much Like Any Other", *Mauro Restiffe* (exhibition catalogue), Galeria Thomas Cohn, São Paulo

Robin Rhode

Rr

222

Born 1976, Cape Town, South Afica. Lives Berlin, Germany.

Selected solo exhibitions: 2006 Shiseido Gallery, Tokyo, Japan/ 2006 FRAC, Champagne-Ardenne/ 2005 Rubell Family Collection, Miami/ 2004 Perry Rubenstein Gallery, New York/ 2004 Artists Space, New York **Selected group exhibitions:** 2005 "New Photography", The Museum of Modern Art, New York/ 2005 "Art Circus", Yokohama Triennial, Yokohama Museum of Art, Yokohama/ 2005 "51st Venice Biennale", Venice/ 2005 "I Still Believe in Miracles," ARC, Musee d'Art Moderne de la ville de Paris, Paris/ 2003/4 "How Latitude Becomes Forms," Walker Art Center, Minneapolis, Museo Tamayo Arte Contemporáneo, Mexico City **Selected bibliography:** 2006 Philip Auslander,

"Straight Out of Cape Town," *Art Papers*, March/April/ 2005 Sean O'Toole, "At the Centre's Edge," *Art South Africa*, no 1, vol 4, Spring/ 2005 Andrea Bellini, "Robin Rhode: The Dimension of Desire", *Flash Art*, October/ 2005 Richard Gefter, "Defining the Moment, for the Moment, Anyway", *The New York Times*, October/ 2004 Roberta Smith, "Art in Review", *The New York Times*, October 29

Sophy Rickett

Sr

224

Born 1970, London, UK. Lives London, UK.

Selected solo exhibitions: 2005 EmilyTsingou Gallery, London/ 2004 Alberto Peola Arte Contemporanea, Turin/ 2003 Nichido Contemporary Art, Tokyo/ 2003 British School at Rome, Rome/ 2003 Saint Gervais Centre pour l'Image Contemporaine, Geneva **Selected group exhibitions:** 2006 "Il Potere delle Donne", Il Museo di Trento, Rovereto/ 2006 "Responding to Rome", Estorick Collection, London/ 2005 "Autowerke", Museum of Visual Arts, Leipzig/ 2004 "Everything's Gone Green", National Museum of Photography, Film and TV, Bradford/ 2004 "Identity II", Nichido Contemporary Art, Tokyo/ 2003 "Order and Chaos", Fotomuseum, Winterthur **Selected bibliography:** 2005 *Sophy Rickett*, Steidl, Göttingen, Photoworks, Brighton/ 2005 Darian Leader, "Sophy Rickett", *Portfolio*, no 41/ 2005 Martin Herbert, "Untitled (Afternoon of a Faun)", *Time Out London*, June/ 2003 Clare Manchester, "Sophy Rickett", *Art Monthly*, March/ 2003 Barry Schwabsky, "Sophy Rickett", *Artforum*, May

Noguchi Rika

Nr

228

Born 1971, Saitama, Japan. Lives Berlin, Germany.

Selected solo exhibitions: 2005 D'Amelio Terras, New York/ 2004 Ikon Gallery, Birmingham/ 2004 Hara Museum of Contemporary Art, Tokyo/ 2002 Gallery Koyanagi, Tokyo/ 2001 Marugame Genichiro-Inokuma Museum of Contemporary Art, Kagawa **Selected group exhibitions:** 2003 "Moving Pictures", Guggenheim, Bilbao/ 2003 "Spread in Prato 2003", Dryphoto arte contemporanea, Prato/ 2002 "Photography Today 2 [sáit] site/sight", The National Museum of Modern Art, Tokyo/ 2001 "Facts of Life: Contemporary Japanese Art", Hayward Gallery, London/ 2000 "Sensitive", Printemps de Cahors, Cahors **Selected bibliography:** 2004 Monty Dipietro, "She dreams of flying", *ARTnews*, no 10, vol 103, November/ 2004 Atsuo Yasuda, Jonathan Watkins, *The Planet* (exhibition catalogue), Hara Museum of Contemporary Art, Tokyo, Ikon Gallery, Birmingham/ 2001 Koichi Nakata, *Mimoca's Eye Vol 1: Noguchi Rika a feeling of something of happening* (exhibition catalogue), Marugame Genichiro-Inokuma Museum of Contemporary Art, Kagawa/ 2001 Martha Schwendener, "Rika Noguchi", *Artforum*, May/

2001 Shimabuku, Yuri Mitsuda, Takashi Serizawa, *Seeing Birds-Rika Noguchi*, P3 art and environment, Tokyo

Andrea Robbins/ Max Becher

Ar/Mb

230

Born 1963, Boston, MA, USA, and 1964, Düsseldorf, Germany. Both live New York, NY, USA.

Selected solo exhibitions: 2005 Photographische Sammlung, Cologne/ 2005 Museum Kunstpalast, Düsseldorf/ 2005 LOOP festival, Barcelona/ 2004 Bernard Toale Gallery, Boston/ 2004 Sonnabend Gallery, New York **Selected group exhibitions:** 2005/6 "Universal Experience: Art, Life and the Tourist's Eye", Mart Museum, Rovereto, Museum of Contemporary Art, Chicago, Hayward Gallery, London/ 2005 "The Jewish Identity Project", The Jewish Museum, New York/ 2004 "White: Whiteness and Race in Contemporary Art", International Center of Photography, New York/ 2004 "Only Skin Deep", Seattle Art Museum, Seattle/ 2003 "Selections from the Lewitt Collection", New Britain Museum of American Art, Lexington **Selected bibliography:** 2006 Lucy Lippard, Maurice Berger, *The Transportation of Place: the Work of Andrea Robbins and Max Becher*, Aperture Press, New York/ 2006 Johanna Di Blasi, "Auch Max Becher probt den Paarlauf", *Kunstzeitung* 115, March/ 2005 *Universal Experience: Art, Life and the Tourist's Eye*, Museum of Contemporary Art, Chicago/ 2005 Thomas Linden, "Bayern per Gesetz verordnet", *Welt Magazin,* October/ 2005 Simon Calder, "The art of travel", *The Independent News*, October

Ricarda Roggan

Rr

234

Born 1972, Dresden, Germany. Lives Leipzig, Germany.

Selected solo exhibitions: 2006 Städtische Galerie Fotohof, Salzburg/ 2006 Landesgalerie, Linz/ 2005 "ATTIKA", Galerie EIGEN + ART, Berlin/ 2004 "Das Paradies der Dinge", Museum der bildenden Künste, Leipzig **Selected group exhibitions:** 2006 "Berlin Biennale", Berlin/ 2005 "Zwischen Wirklichkeit und Bild: Positionen deutscher Fotografie der Gegenwart", The National Museum of Modern Art, Tokyo/ 2005 "From Cotton to Culture", Bunkier Sztuki, Krakow/ 2003 "Zeitgenössische Deutsche Fotografie", Museum Folkwang, Essen/ 2002 "Zurückgelassen", Kupferstich-Kabinett, Dresden **Selected bibliography:** 2006 Arthur Lubow, "The New Leipzig School", *The New York Times Magazine*, January 8/ 2005 Thea Herold, "Leere Speicher", *Der Tagesspiegel*, September 3/ 2005 Christian Herchenröder, "Machtvolle Malerei lockt mit vielen Facetten", *Handelsblatt*, September 30/ 2005 Charlotte Edwards, "The art review 25", *Art Review*, July/ 2004 *Ricarda Roggan. Das Paradies der Dinge* (exhibition catalogue), Museum der bildenden Künste, Leipzig

Anri Sala

As

236

Born 1974, Tirana, Albania. Lives Berlin, Germany.

Selected solo exhibitions: 2005 Fondazione Nicola Trussardi, Milan/ 2005 Centre for Contemporary Art Ujazdowski Castle, Warsaw/ 2004 The Art Institute of Chicago, Chicago/ 2004 ARC Musée d'Art Moderne, Paris, Deichtorhallen Hamburg, Hamburg/ 2003 Kunsthalle Wien, Vienna **Selected group exhibitions:** 2006 "Berlin Biennale", Berlin/ 2005 "EindhovenIstanbul", Van Abbemuseum, Eindhoven/ 2005 "Preis der Nationalgalerie für Junge Kunst 2005", Hamburger Bahnhof, Berlin/ 2004 "Time Zones", Tate Modern, London/ 2003 "Utopia Station", "50th Venice Biennale", Venice **Selected bibliography:** 2006 *Anri Sala*, Phaidon Press, London/ 2005 Bice Curiger, Jacqueline Burckhardt, Dieter von Graffenried (eds), "Ellen Gallagher, Anri Sala, Paul McCarthy", *Parkett*, no 73/ 2005 Adrian Searle, "Frieze. If contemporary art is all a fraud, why do people keep on looking? Why do I keep going back to it?", *The Guardian*, October 21/ 2004 *Anri Sala. Entre chien et loup/When the Night Calls it a Day* (exhibition catalogue), Musée d'Art Moderne de la Ville de Paris, Paris, Verlag der Buchhandlung Walther König, Cologne/ 2003 *Anri Sala* (exhibition catalogue), Kunsthalle Wien, Vienna/ 2003 *Cream 3*, Phaidon Press, London

Dean Sameshima

Ds

240

Born 1971, Torrance, CA, USA. Lives Los Angeles, CA, USA.

Selected solo exhibitions: 2005 Peres Projects, Los Angeles/ 2005 Taka Ishii Gallery, Tokyo/ 2005 asprey jacques, London/ 2004 Peres Projects, Los Angeles/ 2002 Art/33, Basel **Selected group exhibitions:** 2006 "Andere Raüme/Other Spaces", Kunstverein, Hamburg/ 2005 "Log Cabin", Artists' Space, New York/ 2005 "InSite05", San Diego Museum of Art, San Diego, Centro Cultural, Tijuana/ 2005 "Will Boys Be Boys? Questioning Adolescent Masculinity in Contemporary Art", Indianapolis Museum of Art, Indianapolis/ 2005 "Swallow Harder: Selections from the Collection of Ben and Aileen Krohn", Frye Art Museum, Seattle **Selected bibliography:** 2004 *Young Men at Play*, nos 1 & 2 (artist books), DIS Publications, Los Angeles/ 2003 Holland Cotter, "Log Cabin", *The New York Times*, January 28/ 2003 *Cream 3*, Phaidon Press, London/ 2000 Martin Prinzhorn, "Conceptualism With a Splash of Cranberry", *Camera Austria*, no 71/ 2000 *Hysteric 7*, Hysteric Glamour, Tokyo

Alessandra Sanguinetti

As

242

Born 1968, New York, NY, USA. Lives Buenos Aires, Argentina.

Selected solo exhibitions: 2004 Yossi Milo Gallery, New York/ 2003 Museum of Modern Art, Buenos Aires/ 2003 Robert B Menschel Gallery, Syracuse University, Syracuse/ 2001 Ruth Benzacar Gallery, Buenos Aires **Selected group exhibitions:** 2005 "The (S) Files", "Museo del Barrio Bienal", New York/ 2005 "On the Sixth Day", Rencontres d'Arles, Arles/ 2005 "5th Mercosul Visual Arts Biennial", Porto Alegre/ 2001 "Premio Banco Ciudad", National Museum of Fine Arts, Buenos Aires/ 2000 "National Hall of the Arts", Palais de Glace, Buenos Aires **Selected bibliography:** 2006 *On the Sixth Day*, Nazraeli Press, Tucson/ 2005 Edgar Beem, "The art of make believe", *Photo District News*, April/ 2005 Jean Dykstra, "Alessandra Sanguinetti at Yossi Milo", *Art in America*, February/ 2004 Lyle Rexer, "Focus on: Alessandra Sanguinetti", *Art on Paper*, November/ December/ 2004 Nell McClister, "Alessandra Sanguinetti", *Artforum*, December

Markus Schinwald

Ms

246

Born 1973, Salzburg, Austria. Lives Vienna, Austria and Los Angeles, CA, USA.

Selected solo exhibitions: 2006 Museo d'Arte Moderna, Bologna/ 2005 Ausstellungshalle zeitg Kunst, Münster/ 2004 Frankfurter Kunstverein, Frankfurt/ 2001 Moderna Museet, Stockholm **Selected group exhibitions:** 2006 "Berlin Biennale", Berlin/ 2005 "Vilnius Biennial", Vilnius/ 2004 "3' condensed information", Schirn Kunsthalle, Frankfurt/ 2004 "Manifesta", San Sebastián/ 2003 "Bewitched, Bothered", Migros Museum, Zurich **Selected bibliography:** 2005 Daniele Perra, "Markus Schinwald", *Tema Celeste*, January/ 2005 Kirsty Bell, "Markus Schinwald", *Frieze*, June/ 2004 Reinhard Braun, Markus Schinwald, "Bilder als Versuchsanordnung", *Camera Austria*, no 88/ 2004 Vanessa Joan Müller, *Markus Schinwald*, Lukas & Sternberg, New York/ 2001 Stella Rollig, "Puzzling the Connoisseur", *Parkett*, no 61

Gregor Schneider

Gs

248

Born 1969, Rheydt, Germany. Lives Rheydt, Germany.

Selected solo exhibitions: 2005 Gallery Konrad Fischer, Düsseldorf/ 2005 Museuerralves Museu Arte Contemporanea, Porto/ 2004 Artangel, London **Selected group exhibitions:** 2005 "What's New, Pussycat?", Museum für Moderne Kunst, Frankfurt/ 2005 "Snow-White and the Seven Dwarfs", Fundación Marcelino Dotin, Santander/ 2005 "51st Venice Biennale", Venice/ 2005 "Bidibidobidiboo", Fondazione Sandretto Re

Rebaudengo, Turin/ 2005 "Trials and Terrors", Museum of Contemporary Art, Chicago **Selected bibliography:** 2005 *Gregor Schneider* (exhibition catalogue), Museuerralves Museu de Arte Contemporânea, Porto/ 2004 *Die Familie Schneider* (exhibition catalogue), Artangel London, London/ 2003 *Death House u r* (exhibition catalogue), Museum of Contemporary Art, Los Angeles/ 2003 *Gregor Schneider* (exhibition catalogue), Aspen Art Museum, Aspen/ 2003 *Uneasy Space* (exhibition catalogue), SITESantaFe, New Mexico/ 2003 *Cream 3*, Phaidon Press, London

Collier Schorr

Cs

250

Born 1963, New York, NY, USA. Lives New York, NY, USA.

Selected solo exhibitions: 2006 Modern Art, London/ 2004 303 Gallery, New York/ 2002 Consorcio Salamanca, Salamanca **Selected group exhibitions:** 2006 "Human Game", Fondazione Pitti, Stazione Leopolda, Florence/ 2006 "Youth of Today", Schirn Kunsthalle Frankfurt, Frankfurt/ 2005 "The Forest: Politics, Poetics, and Practice", Nasher Museum of Art, Duke University, North Carolina/ 2005 "Boys will be Boys? Questioning Masculinity in Contemporary Art", The Salina Art Centre, Salina/ 2003 "Strangers: The First ICP Triennial of Photography and Video", International Center of Photography, New York **Selected bibliography:** 2006 Vince Aletti, "Gender Blender", *Modern Painters*, February/ 2005 Collier Schorr, *Jens F*, Steidl Mack, London/ 2004 Craig Garrett, "Collier Schorr: Personal Best", *Flash Art*, January/February/ 2004 Jan Avigikos, *Artforum*, March/ 2003 *Strangers: The First ICP Triennial of Photography and Video*, Steidl, Göttingen

Josef Schulz

Js

252

Born 1966, Bischofsburg, Poland. Lives Düsseldorf, Germany.

Selected solo exhibitions: 2005 Kunstverein Ingolstadt, Ingolstadt/ 2004 Museum für Wahmehmung, Graz/ 2004 Galerie Heinz Martin Weigand, Ettlingen/ 2004 Studio Manuela Klerkx, Milan/ 2001 Fiebach & Minninger Galerie, Cologne **Selected group exhibitions:** 2005 "ReGeneration", Musée de l'Elysée, Lausanne/ 2004 "Chassez le naturel...", "Biennale de Liège", Liège/ 2002 "Von Zero bis 2002", Museum für Neue Kunst, Karlsruhe/ 2002 "In Szene gesetzt: Architektur in der Fotografie der Gegenwart", Museum für Neue Kunst, Karlsruhe/ 2001 "db architekturbild 2001", Bundeskunsthalle, Bonn **Selected bibliography:** 2005 William A Ezwing, Nathalie Herschdorfer and Jean-Christoph Blaser, *reGeneration: 50 Photographers of Tomorrow*, Thames & Hudson, London/ 2004 Ilka and Andreas Ruby and Philip Ursprung, *Images, Architecture in Focus*, Prestel, Munich/ 2003 Deutsche Börse AG, *XL Photography 2, Art Collection Deutsche Börse*, Hatje Cantz Verlag, Ostfildern-Ruit/ 2002 Götz Adriani, *In Szene*

gesetzt, MNK/ZKM Karlsruhe, Hatje Cantz Verlag, Ostfildern-Ruit/ 2001 Wilfried Dechau and Bettina Michel, db Architekturbild Visionen in der Architektur, DVA, Munich

Paul Shambroom

Ps

254

Born 1956, Teaneck, NJ, USA. Lives Minneapolis, MN, USA.

Selected solo exhibitions: 2006 Julie Saul Gallery, New York/ 2005 Rocket Gallery, London/ 2005 Nederlands Fotomuseum, Rotterdam/ 2003 Museum of Contemporary Photography, Chicago/ 2002 Julie Saul Gallery, New York **Selected group exhibitions:** 2004 "Rencontres d'Arles", Arles/ 2004 "About Face: Photographic Portraits from the Permanent Collection", Whitney Museum of American Art, New York/ 2001 "American Tableaux", Walker Art Center, Minneapolis **Selected bibliography:** 2005 Diane Smyth, "Small Town Democracy", British Journal of Photography, January/ 2004 Meetings, Chris Boot Ltd, London/ 2004 Philip Gefter, "The Tableau Inside Your Town Hall", The New York Times, October/ 2004 Robert Hirsch, "Paul Shambroom, Interview", Afterimage, May/June/ 2003 Paul Shambroom, Face to Face With the Bomb: Nuclear Reality after the Cold War, Johns Hopkins University Press, Baltimore/ 2003 Jessica Ostrower, "Paul Shambroom at Julie Saul", Art in America, January

Ahlam Shibli

As

258

Born 1970, 'Arab al-Shibli, Israel. Lives Haifa, Israel.

Selected solo exhibitions: 2006 Kunsthalle Basel, Basel/ 2006 Herzliya Museum of Contemporary Art, Herzliya/ 2003 Ikon Gallery, Birmingham/ 2003 Tel Aviv Museum of Art, Tel Aviv/ 2002 El Kahif Gallery, Bethlehem **Selected group exhibitions:** 2006 "27th Bienal de São Paulo", São Paulo/ 2005 "The Pantagruel Syndrome", Torino Triennial Three Museums, Turin/ 2005 "9th International Istanbul Biennial", Istanbul/ 2004 "Non-Sect/Radical: Contemporary Photography III", Yokohama Museum of Art, Yokohama/ 2004 "Staying or Leaving", Art Pavilion Umjetnickom paviljon u Zagrebu, Zagreb, Camera Austria, Graz **Selected bibliography:** 2005 Alexandra MacGilp, 9th International Istanbul Biennial (exhibition catalogue), Istanbul Foundation for Culture and Arts, Istanbul/ 2005 Martina Corgnati, Mediterranean Encounters: Sud/Est (exhibition catalogue), Parco Horcynus Orca, Messina/ 2004 Christine Frisinghelli, Sandra Krizic Roban, Ostati ili Otici/Bleiben oder Gehen/Staying or Leaving (exhibition catalogue), Croatian Photographic Union, Art Pavilion, Zagreb/ 2004 Taro Amano, Non-Sect/ Radical: Contemporary Photography III (exhibition catalogue), Yokohama Museum of Art, Yokohama/ 2003 John Berger, Ulrich Loock and Kamal

Boullata, Lost Time (exhibition catalogue), Ikon Gallery, Birmingham

Yinka Shonibare

Ys

262

Born 1962, London, UK. Lives London, UK.

Selected solo exhibitions: 2005 Cooper-Hewitt, National Design Museum of the Smithsonian Institution, New York/ 2004 Boijmans van Beuningen Museum, Rotterdam/ 2003 The Fabric Workshop and Museum, Philadelphia/ 2003 Museum of Contemporary Art, Kiasma, Helsinki/ 2002 Studio Museum, Harlem **Selected group exhibitions:** 2004–6 "Africa Remix", Museum Kunst Palast, Düsseldorf, Hayward Gallery, London, Centre Pompidou, Paris, Mori Art Museum, Tokyo, Moderna Museet, Stockholm/ 2004 "Turner Prize", Tate Britain, London/ 2004 "African Art, African Voices: Long Steps Never Broke a Back", Philadelphia Museum of Art, Philadelphia/ 2004 "Continental Drift: Installations by Ilya Kabakov, Joan Jonas, Juan Muños, Yinka Shonibare", Norton Museum, West Palm Beach/ 2004 "Fashination", Moderna Museet, Stockholm **Selected bibliography:** 2004 Double Dutch, Boijmans van Beuningen Museum, Rotterdam, Kunsthalle, Vienna/ 2003 Looking Both Ways, Museum for African Art, New York/ 2002 Double Dress, The Israel Museum, Jerusalem/ 2001 Unpacking Europe, Museum Boijmans Van Beuningen, Rotterdam/ 2001 Yinka Shonibare. Be-Muse, Museo Hendrik Christian Andersen, Rome

Efrat Shvily

Es

264

Born 1955, Jerusalem, Israel. Lives Jerusalem, Israel.

Selected solo exhibitions: 2004 Sommer Contemporary Art, Tel Aviv/ 2004 Galerie Martine & Thibault de La Châtre, Paris/ 2002 Centre de la Photographie, Geneva **Selected group exhibitions:** 2005 "Die Neuen Hebräer: 100 Jahre Kunst In Israel", Martin Gropius Bau, Berlin/ 2004 "Mediterranean: Between Reality and Utopia", The Photographers' Gallery, London/ 2003 "7th International Istanbul Biennial", Istanbul/ 2003 "Strangers: The First ICP Triennial of Photography and Video", International Center of Photography, New York/ 2003 "50th Venice Biennale", Venice **Selected bibliography:** 2004 Christophe Catsaros, "Architecture de Guerre: Efrat Shvily et la Série Nouvelles Maisons en Israél...", Art Présence, January–March/ 2003 Efrat Shvily: New Homes in Israel and the Occupied Territories, Witte de With Centre for Contemporary Art, Rotterdam/ 2003 Yasmine Youssi, "Efrat Shvily: L'architecture: Une Arme de Guerre", D'Architecture, October/ 2003 Efrat Shvily: Palestinian Cabinet Ministers 2000, Witte de With, Rotterdam

Santiago Sierra

Ss

266

Born 1966, Madrid, Spain. Lives Mexico City, Mexico.

Selected solo exhibitions: 2006 Synagoge Stommeln, Pullheim-Stommeln/ 2005 Kestnergesellschaft, Hannover/ 2004 Kunsthaus Bregenz, Bregenz/ 2003 The Spanish Pavilion, "50th Venice Biennale", Venice/ 2001 PS1 Contemporary Art Center, New York **Selected group exhibitions:** 2006 "TRANSIT", ARTFrankfurt, Frankfurt/ 2006 "Inverting the Map: Latin American Art from the Tate Collection", Tate Liverpool, Liverpool/ 2005 "Minimalism and After IV", Daimler Chrysler Contemporary, Berlin/ 2005 "51st Venice Biennale", Venice/ 2003 "Eco: Arte Contemporáneo Mexicano", Museo Nacional Centro de Arte Reina Sofía, Madrid **Selected bibliography:** 2005 Claudia Seidel, "Santiago Sierra", Minimalism and After IV (exhibition catalogue), Daimler Chrysler Collection, Berlin/ 2005 Alexander Braun, "Santiago Sierra El Degüello", Video II: Allegorie (exhibition catalogue), NRW-Forum Kultur und Wirtschaft, Düsseldorf/ 2004 Eckhard Schneider, Santiago Sierra/300 Tons and Previous Works (exhibition catalogue), Kunsthaus Bregenz, Bregenz/ 2003 Margit Rosen, fast forward (exhibition catalogue), Media Art/Sammlung Goetz, Munich, ZKM, Karlsruhe/ 2003 Rosa Martínez, Cuauhtémoc Medina, Santiago Sierra. Spanish Pavilion. "50th Venice Biennale", Ministerio de Asuntos Exteriores, Dirección General de Relaciones Culturales y Científicas, Turner, Madrid

Paul Sietsema

Ps

270

Born 1968, Los Angeles, CA, USA. Lives Los Angeles, CA, USA.

Selected solo exhibitions: 2003 Whitney Museum of American Art, New York/ 2002 Regen Projects, Los Angeles **Selected group exhibitions:** 2006 "Le Mouvement des images", Centre Pompidou, Paris/ 2005 "Ecstasy: In and About Altered States", Museum of Contemporary Art, Los Angeles/ 2005 "Uncertain States of America", Astrup Fearnley Museum of Modern Art, Oslo/ 2004 "Real World: The Dissolving Space of Experience", Modern Art, Oxford/ 2001 "The Americans. New Art", Barbican Art Galleries, London **Selected bibliography:** 2005 Uncertain States of America: American Art in the 3rd Millennium (exhibition catalogue), Astrup Fearnley Museum of Modern Art, Oslo/ 2005 LA Artland: Contemporary Art from Los Angeles, Black Dog Publishing, London/ 2003 Empire: Paul Sietsema, Whitney Museum of American Art, New York/ 2003 Giovanni Intra, "Paul Sietsema: Empire", Flash Art, January/February/ 2002 Bruce Hainley, "Model Theory", Frieze, November/December

Alex Slade

As

274

Born 1961, Toledo, OH, USA. Lives Los Angeles, CA, USA.

Selected solo exhibitions: 2005 Mary Goldman Gallery, Los Angeles/ 2004 Santa Monica Museum, Santa Monica/ 2002 Els Hanappe Underground, Athens/ 2002 Westwerk, Hamburg/ 2002 Mary Goldman Gallery, Los Angeles **Selected group exhibitions:** 2005 "Empire", Art 2102, Los Angeles/ 2004 "Topographies", San Francisco Art Institute, San Francisco/ 2003 "Prague Biennale", Prague/ 2002 "Vacant", Gallery Luisotti, Santa Monica/ 2001 "Snapshot: New Art from Los Angeles", UCLA Hammer Museum, Los Angeles, Museum of Contemporary Art, Miami **Selected bibliography:** 2005 Christopher Miles, "Expansion Plan", Los Angeles Times, November 11/ 2004 Elizabeth Pence, "Alex Slade at SMMoA", Artweek, October/ 2004 Karen Moss, A Curator's Legend (exhibition catalogue), San Francisco Art Institute/ 2000 Harold Fricke, "Von Block zu Block", Die Tageszeitung, April

Sean Snyder

Ss

276

Born 1972, Virginia Beach, VA, USA. Lives Berlin, Germany, and Tokyo, Japan.

Selected solo exhibitions: 2005 Portikus, Frankfurt/ 2005 Secession, Vienna/ 2005 Galerie Neu, Berlin/ 2004 De Appel, Amsterdam/ 2004 Galerie Chantal Crousel, Paris **Selected group exhibitions:** 2005 "9th International Istanbul Biennial", Istanbul/ 2005 "I Really Should...", Lisson Gallery, London/ 2005 "Black Market, 9th Baltic Triennial", CAC, Vilnius, Institute of Contemporary Art, London/ 2005 "InSite05", San Diego Museum of Art, San Diego, Centro Cultural, Tijuana/ 2005 "Covering the Real", Kunstmuseum Basel, Basel **Selected bibliography:** 2005 Jan Verwoert, "The Silent Landscapes of Information", Sean Snyder, Verlag der Buchhandlung Walther König, Cologne/ 2005 Sven Lutticken, "De Appel", Artforum, January/ 2005 Matthais Dusini, On Sean Snyder's Work – A Revisionist Model of Solidarity (exhibition catalogue), Secession, Vienna/ 2004 Krystian Woznicki, "Embedded Pyongyang", Springerin, no 1/ 2003 Cream 3, Phaidon Press, London

Alec Soth

As

278

Born 1969, Minneapolis, MN, USA. Lives Minneapolis, MN, USA.

Selected solo exhibitions: 2006 Gagosion Gallery, New York/ 2006 Des Moines Art Center, Des Moines/ 2005 Minneapolis Institute of Arts, Minneapolis/ 2005 Open Eye Gallery, Liverpool/ 2004 Wohnmaschine, Berlin **Selected group exhibitions:** 2006 "Click Doubleclick", Haus der Kunst, Munich/ 2006

"Picturing Eden", George Eastman House, Rochester/ 2005 "Regarding the Rural", Massachusetts Museum of Contemporary Art, North Adams/ 2004 "Picturing the South", Pace Macgill, New York/ 2004 "Whitney Biennial", Whitney Museum of American Art, New York **Selected bibliography:** 2005 Julie Caniglia, "Reviews: Alec Soth/Minneapolis Institute of Arts", *Artforum*, September/ 2005 Vince Aletti, "Top 25 Books of 2004", *The Village Voice*, January/ 2004 Roberta Smith, "Southern Photography Inspired by a Yankee", *The New York Times*, December/ 2004 Michael More, "Writing with Light: Ten Books for your Wish List", *Camera Arts*, December/ 2004 Colin Pantall, "Mississippi Dreaming", *The British Journal of Photography*, November

Heidi Specker

Hs
280

Born 1962, Damme, Germany. Lives Berlin, Germany.

Selected solo exhibitions: 2005/6 Sprengel Museum, Hannover/ 2005 Gallery K, Tokyo/ 2004 Galerie Barbara Thumm, Berlin/ 2003 fiedler contemporary, Cologne/ 2002 Former Staatsbank, Berlin **Selected group exhibitions:** 2006 "Zwischen Wirklichkeit und Bild", Tokyo/ 2005 "Global Players", Bank Art 1929, Yokohama/ 2005 "50 Jahre documenta, archive in motion", Kunsthalle Fridericianum, Kassel/ 2005 "Art conneXions", Bangkok University Gallery, Bangkok/ 2004 "Berlinskaya Lazur", Haus der Fotografie, Moscow **Selected bibliography:** 2005 *Bangkok Heidi Specker Germaine Krull* (artist book), Collection Ann and Jürgen Wilde/ 2005 *Heidi Specker Im Garten*, Steidl Verlag, Göttingen/ 2006 *Click Doubleclick*, Verlag Walther König, Cologne

Hannah Starkey

Hs
284

Born 1971, Belfast, Northern Ireland. Lives London, UK.

Selected solo exhibitions: 2005 "Lisboa Photo 2005", Lisbon/ 2004 Maureen Paley, London/ 2002 Maureen Paley, London/ 2000 Irish Museum of Modern Art, Dublin/ 2000 "Progetto" Castello di Rivoli, Turin **Selected group exhibitions:** 2006 "Jugend von Heute/ Youth of Today", Schirn Kunsthalle Frankfurt, Frankfurt/ 2005 Berlin Photography Festival, Berlin/ 2004 "Take Five! Huis Marseille turns five", Huis Marseille, Amsterdam/ 2003 "Sodium Dreams", Center for Curatorial Studies Museum, Bard College, New York/ 2001 "No World Without You, Reflections of Identity in New British Art", Herzliya Museum of Contemporary Art, Herzliya **Selected bibliography:** 2005 Susan Bright, *Art Photography Now*, Thames & Hudson, London/ 2004 Charlotte Cotton, *The Photograph as Contemporary Art*, Thames & Hudson, London/ 2003 David Campany, *Art and Photography*, Phaidon Press, London/ 2002 *Blink*, Phaidon Press, London/ 2000 *Hannah Starkey* (exhibition catalogue), Irish Museum of Modern Art, Dublin

Simon Starling

Ss
288

Born 1967, Epsom, UK. Lives Berlin, Germany.

Selected solo exhibitions: 2005 Cuttings Museum für Gegenwartskunst, Basel/ 2004 Fundació Joan Miró, Barcelona/ 2003 Villa Arson, Nice/ 2002 Portikus, Frankfurt/ 2001 Secession, Vienna **Selected group exhibitions:** 2005 "Universal Experience: Art, Life and the Tourist's Eye", Museum of Contemporary Art, Chicago/ 2004 "26th Bienal de São Paulo", São Paulo/ 2003 "Zenomap: New Works from Scotland for the Venice Biennale", "50th Venice Biennale", Venice/ 2002 "Zusammenhange Herstellen", Kunstverein in Hamburg, Hamburg/ 2001 "Squatters", Museu Serralves, Porto **Selected bibliography:** 2004 Francesco Manacorda, Simon Starling, *Simon Starling* (exhibition catalogue), Villa Arson, Nice/ 2003 Gianfranco Maramiello, *Simon Starling* (exhibition catalogue), Museo d'Arte Contemporanea, Rome/ 2002 Katarina M Brown, *Djungel* (exhibition catalogue), Dundee Contemporary Arts, Dundee/ 2000 *Fresh Cream*, Phaidon Press, London

John Stezaker

Js
290

Born 1949, Worcester, UK. Lives London, UK.

Selected solo exhibitions: 2005 White Columns, New York/ 2005 Kunstverein Muenchen, Munich/ 2004 The Approach, London/ 2001 Wigmore Fine Art, London **Selected group exhibitions:** 2006 "Tate Triennial", Tate Britain, London/ 2005 "Time Lines", Kunstverein, Düsseldorf/ 2005 "1979", Bloomberg Space, London/ 2005 "CUT", The Approach, London/ 2005 "Girls on Film", Zwirner & Wirth, New York **Selected bibliography:** 2006 Brian Sholis, "John Stezaker at White Columns", *Artforum*, February/ 2005 *Collage Signs & Surfaces* (exhibition catalogue), Pavel Zoubok Gallery, Edinburgh/ 2005 Michael Bracewell, "Demand the Impossible: interview", *Frieze*, April/ 2005 Mark Harris, "John Stezaker, The Approach", *Art in America*, May/ 2003 David Campany, *Art and Photography*, Phaidon Press, London

Clare Strand

Cs
292

Born 1973, Sevenoaks, UK. Lives Brighton, UK.

Selected solo exhibitions: 2006 Senko Studio, Viborg/ 2003 Research Space, LCC, London/ 2001 Gardner Arts Centre, Brighton/ 2000 Galleri Image, Aarhus **Selected group exhibitions:** 2006 "Changing Faces", Folkwang Museum, Essen/ 2006 "Restage", The Arts Gallery, LCC, London/ 2005 "Made in Britain", Huis Marseille, Amsterdam/ 2004 "Gone Astray and Gilt City", Fotografins Hus,

Stockholm/ 2003 "Fantastic Realism", Tallinn Art Hall, Tallinn **Selected bibliography:** 2006 David Chandler, John Kippen, *Work In Progress, International Photographic Research Network*, Sunderland/ 2006 Colin Wiggins, Julian Rodriguez, Anne Williams, *Restage*, London University of the Arts, London/ 2005 "The Betterment Room Devices For Measuring Achievement", *Photoworks*, no 4/ 2003 Val Williams, "London Portraits", *Portfolio*, no 37/ 2002/3 Dr Chris Mullen, *Gone Astray Newspaper* (artist publication)

Darren Sylvester

Ds
296

Born 1974, Sydney, Australia. Lives Melbourne, Australia.

Selected solo exhibitions: 2005 Sullivan and Strumpf Fine Art, Sydney/ 2004 William Mora Galleries, Melbourne/ 2003 William Mora Galleries, Melbourne/ 2001 William Mora Galleries, Melbourne/ 2000 William Mora Galleries, Melbourne **Selected group exhibitions:** 2006 "NEW 06", Australian Centre for Contemporary Art, Melbourne/ 2005 "Remote Control: Artists Making Moving Pictures", National Gallery of Victoria, Melbourne/ 2004 "Supernatural Artificial", Tokyo Metropolitan Museum of Photography, Tokyo/ 2002 "Bittersweet", Art Gallery of New South Wales, Sydney/ 2002 "Photographica Australia", Sala de Exposiciones del Canal de Isabel II, Madrid **Selected bibliography:** 2006 Edward Colless, "The Right Stuff", *Australian Art Collector*, no 36/ 2006 Anthony Gardner, "Fuck Me, I'm Famous", *NEW06*, Australian Centre for Contemporary Art, Melbourne/ 2005 Natasha Bullock, *We Can Love Since We Know We Can Lose Love* (exhibition catalogue), Sullivan and Strumpf Fine Art, Sydney/ 2005 Catriona Moore, "Decoration, Aspiration & Nostalgia", *Art & Australia*, vol 42/ 2004 Steph Marinovich, "Ennui Forever", *Photofile*, no 73

Guy Tillim

Gt
298

Born 1962, Johannesburg, South Africa. Lives Cape Town, South Africa.

Selected solo exhibitions: 2005 The Photographers' Gallery, London/ 2005 PhotoEspaña, Madrid/ 2004 South Africa National Gallery, Cape Town/ 2004 Michael Stevenson Gallery, Cape Town/ 2004 Sala Uno, Rome **Selected group exhibitions:** 2004–6 "Africa Remix", Museum Kunst Palast, Düsseldorf, Hayward Gallery, London, Centre Pompidou, Paris, Mori Art Museum, Tokyo, Moderna Museet, Stockholm/ 2004 "A Decade of Democracy: South African art from the permanent collection", South African National Gallery, Cape Town/ 2004 "Festival Internazionale di Roma", Rome **Selected bibliography:** 2005 *Jo'burg*, Filigranes Editions, Paris, STE, Johannesburg/ 2004 *Leopold and Mobutu*, Filigranes Editions, Paris/ 2004 *Guy Tillim*, Daimler Chrysler, Berlin/2003 *Departure*, Michael Stevenson, Bell-Roberts, Cape Town

Nazif Topçuoglu

Nt
302

Born 1953, Ankara, Turkey. Lives Istanbul, Turkey.

Selected solo exhibitions: 2006 Central House of Artists, "6th Photobiennale", Moscow/ 2006 Flatland Gallery, Utrecht/ 2006 Galeri Nev, Istanbul/ 2005 Kunstraum-Syltquelle, Sylt/ 2004 Galerie Nev, Ankara **Selected group exhibitions:** 2006 "Rendez-vous avec une femme" (on International Women's Day), Galerie Bertin-Toublanc, Galerie Adler, Paris/ 2006 "Flatland Gallery", Rotterdam Art Fair, Utrecht/ 2005 "Flatland Gallery", Paris Photo, Paris/ 2004 "Galeri Nev", Athens Art Fair, Athens/ 2004 "Call Me Istanbul", ZKM (Zentrum für Kunst und Medientechnologie), Karlsruhe **Selected bibliography:** 2006 Arjan Reinders, *Kunstbeeld*, March/ 2005 Pinar Cartier, "Hersey Kontrol Altinda", *Picus*, October/ 2003 Marisa Kula, "Turkish Delights", *Surface*, no 45/ 2003 Ozge Baykan, "Bilgi Cin'de de Olsa", *Genisaci*, March/ 2003 BD, "Turkei", *Art das Kunstmagazin*, June

Danny Treacy

Dt
304

Born 1975, Manchester, UK. Lives London, UK.

Selected group exhibitions: 2005 "to be continued.../jatkuu...", Helsinki Photography Festival, Helsinki/ 2005 "The Instant of My Death", Gallery Dels Angels, Barcelona/ 2004 "The Jerwood Photography Prize", Stills Gallery, Edinburgh/ 2003 "Them", University of California, Davis/ 2003 "Twenty White Chairs", The Wapping Project, London **Selected bibliography:** 2005 *to be continued.../ jatkuu...* (exhibition catalogue), Photographic Gallery Hippolyte and British Council/ 2004 "Danny Treacy", *Camera Austria*, no 88/ 2004 *The House in the Middle*, Photoworks, Brighton/ 2003 "Danny Treacy", *Portfolio*, no 38/ 2003 "Danny Treacy", *Photoworks*, Autumn/Winter

Fatimah Tuggar

Ft
308

Born 1967, Kaduna, Nigeria. Lives New York, NY, USA, and Kano, Nigeria.

Selected solo exhibitions: 2006 Roebling Hall, New York/ 2006 Fundación, NMAC Montenmedio Arte Contemporáneo, Cádiz/ 2001 Galeria João Graça, Lisbon/ 2000 Greene Naftali Gallery, New York/ 2000 The Kitchen, New York **Selected group exhibitions:** 2006 "Rethinking Nordic Colonialism", Nordic Institute of Contemporary Art, Helsinki/ 2004–6 "Africa Remix", Museum Kunst Palast, Düsseldorf, Hayward Gallery, London, Centre Pompidou, Paris, Mori Art Museum, Tokyo, Moderna Museet, Stockholm/ 2005 "Dialectics of Hope", "Moscow Biennale of Contemporary Art", Moscow/ 2003 "Vers Rencontres", "Bamako Biennal" 2003, Bamako/ 2002 "Tempo", The Museum of Modern Art, New York **Selected**

bibliography: 2005 Sylvie Fortin, "Digital Trafficking, Fatimah Tuggar's Imag(in)ing of Contemporary Africa", *Art Papers*, March/April/ 2005 Nicole R Fleetwood, "Visible Seams: Gender, Race, Technology, and the Media Art of Fatimah Tuggar", *Signs, Journal of Women in Culture and Society, Film Feminisms*, no 1, vol 30, Autumn/ 2003 *Cream 3*, Phaidon Press, London/ 2001 Carol Kino, "Fatimah Tuggar at Greene Naftali", *Art in America*, September/ 2001 Elizabeth Janus, "Fatimah Tuggar, Art & Public Geneva", *Artforum*, January

Céline van Balen

Cv

310

Born 1965, Amsterdam, The Netherlands. Lives Amsterdam, The Netherlands.

Selected solo exhibitions: 2004 Krinzinger Gallery, Vienna/ 2002 De Hallen, Haarlem/ 2001 Van Zoetendaal Gallery, Amsterdam Selected group exhibitions: 2006 "Netherlands Now", l'École du Nord Maison Européene de la Photographie, Paris/ 2005 "Dutch Insight", Kumho Art Museum, Seoul/ 2005 "Cadres Revisités Fondación Custodia", L'Institut Néerlandais, Paris/ 2000 "Remake Berlin", Fotomuseum, Winterthur/ 2000 "Human Conditions, Intimate Portraits", Netherlands Institute for Photography, Rotterdam Selected bibliography: 2006 Jhim Lamoree, Elizabeth Nora, *Netherlands Now*, Maison Européene de la Photographie, Paris/ 2005 *Dutch Insight*, Kumho Art Museum, Seoul/ 2002 Remko Campert, *Céline van Balen*, Van Zoetendaal Publishers, Amsterdam/ 2001 Pam Emmerik, "Céline's UFOs, De portretten van fotografe Céline van Balen", *NRC Handelsblad Cultureel Supplement*, February 9/ 2000 Kathrin Becker, Urs Stahel (eds), *Remake Berlin*, Fotomuseum, Winterthur, Daadgalerie, Berlin, Neuer Berliner Kunstverein, Berlin

Annika von Hausswolff

Av

312

Born 1967, Gothenburg, Sweden. Lives Gothenburg, Sweden.

Selected solo exhibitions: 2005 Baltic Art Centre, Visby/ 2004 Norrköping Konstmuseum, Norrköping, Konsthallen, Bohusläns Museum, Uddevalla, Galleri F15, Moss, Uppsala Konstmuseum, Uppsala/ 2003 Statens Museum for Kunst, Copenhagen/ 2002 Andréhn-Schiptjenko, Stockholm/ 2002 Casey Kaplan, New York Selected group exhibitions: 2006 "Moderna Utställningen", Moderna Museet, Stockholm/ 2005 "The Exposed Colour: Pink", University Art Museum of the National University of Fine Arts and Music, Tokyo Geijutsju Daigaku, Tokyo/ 2004 "Berlin North", Hamburger Bahnhof, Berlin/ 2000 "Hybrid", Fotomuseum, Winterthur/ 2000 "Weegee, Jane & Louise Wilson & Annika von Hausswolff", Magasin 3, Stockholm Selected bibliography: 2004 Annika von Hausswolff, *Berlin North*, Hamburger Bahnhof, Berlin/ 2004 Marianne Torp, *Domestic Sculpture 1999–2003*, Konsthallen

Bohusläns Museum, Uddevalla, F15, Moss, Uppsala Konstmuseum, Uppsala, Norrköping Konstmuseum, Norrköping/ 2004 Sarah Arrhenius, *Annika von Hausswolff in Dialogue with Sarah Arrhenius*, Iaspis + Propexus, Stockholm/ 2003 Marianne Torp, *Room for Increased Consciousness of the Parallel Day*, Statens Museum for Kunst, Copenhagen/ 2000 Sara Arrhenius, *Weegee, Jane & Louise Wilson & Annika von Hausswolff*, Magasin 3, Stockholm

Bettina von Zwehl

Bv

314

Born 1971, Munich, Germany. Lives London, UK.

Selected solo exhibitions: 2004 The Photographers' Gallery, London/ 2004 Lombard-Freid Fine Arts, New York/ 2002 Victoria Miro Gallery, London/ 2002 Galleria Laura Pecci, Milan/ 2001 Lombard-Freid Fine Arts, New York Selected group exhibitions: 2006 "Unlimited ID", Dazibao, Montreal/ 2005 "Photography 2005", Victoria Miro Gallery, London/ 2004 "Fiction", Timothy Taylor Gallery, London/ 2002 "Reality Check", British Council, London, The Photographers' Gallery, London, 14 Wharf Road, London, Moderna Galleria, Ljubljana, The House of Artists, Zagreb, Rudolfinum, Prague, Poland Bunkier Gallery, Cracow, Latvia Arsenals, Riga/ 2000 "Breathless! Photography and Time", Victoria and Albert Museum, London Selected bibliography: 2006 *Bettina Von Zwehl*, Steidl, Göttingen, Photoworks, Brighton/ 2006 Nairne & Howgate, *The Portrait Now*, National Portrait Gallery, London/ 2005 Charlotte Cotton, *The Photograph as Contemporary Art*, Thames & Hudson, London/ 2004 Mark Coetzee, *Not Afraid: The Rubell Family Collection*, Phaidon Press, New York/ 2003 *Imperfect Innocence* (exhibition catalogue), The Scholl Collection, Contemporary Museum Baltimore, Baltimore

Deborah Willis

Dw

318

Born 1948, Philadelphia, PA, USA. Lives New York, NY, USA.

Selected solo exhibitions: 2005 Bernice Steinbaum Gallery, Miami/ 2003 University of Wisconsin, Madison/ 2001 Steinbaum Gallery, Miami/ 2000 Kemper Museum of Art, Kansas City/ 2000 Project Row Houses, Houston Selected group exhibitions: 2006 "Double Exposure", Wadsworth Atheneum, Hartford/ 2005 "A Sense of Place: Contemporary African American Art", Frick Gallery, University of Pittsburgh, Pittsburgh/ 2005 "African Queen", Studio Museum in Harlem, New York/ 2005 "Family Matters: Mother to Son", Light Factory, Charlotte/ 2003 "HairStories", Scottsdale Museum of Contemporary Art, Scottsdale/ 2000 "Picturing the Modern Amazon", New Museum, New York Selected bibliography: 2005 Deborah Willis, *Family History Memory: Photographs by Deborah Willis*, Hylas Publishing, New York/ 2001 *In Their Mothers' Eyes: Women Photographers*

Photographing Their Children, Edition Stemmle, Zurich/ 2001 Stuart Hall, Mark Sealy, *Different*, Phaidon Press, New York

Sharon Ya'ari

Sy

320

Born 1966, Holon, Israel. Lives Tel Aviv, Israel.

Selected solo exhibitions: 2006 Tel Aviv Museum of Art, Tel Aviv/ 2003 Lombard-Freid Fine Art, New York/ 2002 Lisson Gallery, London/ 2002 Sommer Contemporary Art, Tel Aviv/ 2002 Drexler University Art Gallery, Philadelphia Selected group exhibitions: 2005 "The New Hebrews", Martin Gropius Bau Museums, Berlin/ 2005 "Such Stuff as Dreams Are Made On", Chelsea Art Museum, New York/ 2004 "Romantica", Sommer Contemporary Art, Tel Aviv/ 2004 "A Point of View", Tel Aviv Museum of Art, Tel Aviv/ 2004 "Behind Faces", Galerie Martin Janda, Vienna Selected bibliography: 2006 *500m radius* (exhibition catalogue), Tel Aviv Museum of Art, Tel Aviv/ 2003 *Strangers: The First ICP Triennial of Photography and Video*, Steidl, Göttingen/ 2002 *Sharon Ya'ari* (exhibition catalogue), Lisson Gallery, London, Sommer Contemporary Art, Tel Aviv/ 2001 Gregory Williams, "Sharon Ya'ari", *Artforum*, March/ 2001 Judith Cotton, "Sharon Ya'ari", *ARTnews*, May

Catherine Yass

Cy

322

Born 1963, London, UK. Lives London, UK.

Selected solo exhibitions: 2006 Galerie Lelong, New York/ 2006 Khalil Sakakini Cultural Centre, Ramallah/ 2005 Centro Atlántico de Arte Moderno, Gran Canaria/ 2005 Herzliya Museum of Contemprary Art, Herzliya/ 2005 Foam Photography Museum, Amsterdam Selected group exhibitions: 2006 "New Territories", Cultuurcentrum Brugge, Brugge/ 2005 "Expo Nagoya", British Pavilion, Nagoya/ 2005 "Les Grandes Spectacles", Museum der Moderne Salzburg, Salzburg/ 2004 "WOW", Henry Art Gallery, Seattle/ 2004 "Interior View, Artists explore the language of architecture", De Zonnehof, Centrum voor Moderne Kunst, Amersfoort, First Site, Colchester, Fri-Art, Centre d'Art Contemporain, Fribourg Selected bibliography: 2006 Sandy Nairne, Sarah Howgate, *The Portrait Now*, National Portrait Gallery, London/ 2005 Alvaro Rodriguez Fominaya, Michael Newman, Andrew Renton, Mark Godfrey, *Filmografia*, Centro Atlantico de Arte Moderno, Gran Canaria/ 2004 Alicia Foster, *Women Artists*, Tate, London/ 2004 Felicity Lunn, Hans Ibelings, *Interior View, Artists Explore the Language of Architecture*, De Zonnehof Centrum voor Moderne Kunst, Amersfoort/ 2000 Parveen Adams, Greg Hilty, *Catherine Yass*, asprey jacques, London

Shizuka Yokomizo

Sy

326

Born 1966, Tokyo, Japan. Lives London, UK.

Selected solo exhibitions: 2003/4 Spacex, Exeter/ 2003 Wako Works of Art, Tokyo/ 2003 Cohan and Leslie, New York/ 2002 Museo Arte Contemporanea di Roma, Rome/ 2002 The Approach, London Selected group exhibitions: 2005 "New Photography", The Norton Museum of Art, Florida/ 2004/5 "Past in Reverse: Contemporary Art of East Asia", San Diego Museum of Art, San Diego/ 2003 "Clandestine", "50th Venice Biennale", Venice/ 2003 "Strangers: The First ICP Triennial of Photography and Video", International Center of Photography, New York/ 2003 "Days Like These: The 2nd Tate Triennial", Tate Britain, London Selected bibliography: 2004 Tom Trevor, Claire Doherty, *Distance* (exhibition catalogue), SPACEX, Exeter/ 2003 Matthew Guy Nichols et al, *Strangers: The First ICP Triennial of Photography and Video*, Steidl, Göttingen/ 2002 Martin Herbert, Gian Franco Maraniello, *Shizuka Yokomizo* (exhibition catalogue), Museo Arte Contemporanea di Roma, Rome

Amir Zaki

Az

328

Born 1974, Beaumont, CA, USA. Lives Los Angeles, CA, USA.

Selected solo exhibitions: 2005 Perry Rubenstein Gallery, New York/ 2005 Mak Center for Art and Architecture, Schindler House, Los Angeles/ 2003 Roberts & Tilton Gallery, Los Angeles/ 2002 Roberts & Tilton Gallery, Los Angeles/ 2000 James Harris Gallery, Seattle Selected group exhibitions: 2006 "California Biennial", Orange County Museum of Art, Newport Beach/ 2005 "The New City: Sub/Urbia in Recent Photography", Whitney Museum of American Art, New York/ 2005 "Still, Things Fall from the Sky", California Museum of Photography, Riverside/ 2005 "Happenstance", Harris Lieberman Gallery, New York/ 2002 "Anti-form", Center for Contemporary Photography, Kansas City Selected bibliography: 2006 Françoise-Alaine Blaine, "Fait Son Show", *Beaux Arts Magazine*, March/ 2005 Jan Tumlir, "Amir Zaki", *Artforum*, April/ 2005 Amir Zaki, "Portfolio and Tripartite Cover", *Domus*, October/ 2003 Amir Zaki, *VLHV (Valley Lake Hollywood Village)*, Roberts & Tilton Gallery, James Harris Gallery, Los Angeles/ 2001 Bruce Hainley, "Amir Zaki", *Artforum*, November

Liu Zheng

Lz

330

Born 1969,
Wuqiang County,
China.
Lives Beijing,
China.

Selected solo exhibitions: 2005 Yossi Milo Gallery, New York/ 2003 Rencontres d'Arles, Arles/ 2002 2nd Pingyao International Photography Festival, Pingyao/ 2002 International Asian Photography Festival, Sagamihara City/ 2001 Central Academy of Fine Arts, Beijing **Selected group exhibitions:** 2005 "Beauties", CourtYard Gallery, Beijing/ 2005 "Baroque and Neo-Baroque", DA2 Domus Artium 2002, Salamanca/ 2005 "Between Past and Future: New Photography and Video From China", Victoria and Albert Museum, London/ 2005 "Follow Me", Mori Art Museum, Tokyo/ 2005 "About Beauty", House of World Cultures, Berlin/ 2003 "Strangers: The First ICP Triennial of Photography and Video", International Center of Photography, New York/ 2003 "50th Venice Biennale", Venice **Selected bibliography:** 2004 Chris Phillips, Meg Maggio (eds), *Liu Zheng: The Chinese*, International Center of Photography, New York, Steidl, Göttingen/ 2002 Meg Maggio, "Interview with Liu Zheng", *Asian Art News*, July/August/ 2001 "The Chinese: Liu Zheng Monograph", *Photographers International*, no 58/ 2001 Wu Hung, "Photographing Deformity: Liu Zheng and his Photo Series 'My Countrymen'", *Public Culture*, no 3, vol 13

Tobias Zielony

Tz

334

Born 1973,
Wuppertal,
Germany.
Lives Berlin,
Germany.

Selected solo exhibitions: 2006 Kunsthaus Glarus, Glarus/ 2006 Museum am Ostwall, Dortmund/ 2006 Centre National de la Photographie, Geneva **Selected group exhibitions:** 2005 "local", Goethe-Institut, Paris/ 2005 "Migration", Kölnischer Kunstverein, Cologne/ 2005 "Populism", Stedelijk Museum, Amsterdam/ 2004 "Shrinking Cities", Kunstwerke, Berlin **Selected bibliography:** 2005 *Populism* (exhibition catalogue), Stedelijk Museum, Amsterdam/ 2005 *Tobias Zielony*, Marion-Ermer-Preis, Weimar/ 2004 Tobias Zielony, *Behind the Block*, Institut für Buchkunst, Leipzig